D0926989

A View of Delft

Vermeer and his Contemporaries

A View of Delft
Vermeer and his Contemporaries

Walter Liedtke

Waanders Publishers, Zwolle

Author
Walter Liedtke

Copy Editor
Diane Webb

Design
Roelof Koebrugge

Printing
Waanders Printers, Zwolle

ISBN 90 400 9490 x
NUGI 921, 911

Cover: (front) J. Vermeer, *View of Delft* (detail), ca. 1661, Koninklijk
Kabinet van Schilderijen Mauritshuis, The Hague (plate I)

Contents

For my wife, Nancy
For my mother, Elsa
And in memory of
my father, Walter

Preface

The main concern of this book – or collection of essays – is painting in Delft during the period 1650-1675. Four artists, Carel Fabritius, Gerard Houckgeest, Pieter de Hooch, and Johannes Vermeer, are discussed at length. However, these chapters are neither monographic nor intended as a survey of art in Delft. If there is a consistent theme it is the relationship between style and observation, especially in paintings that press the issue through their apparent fidelity to visual experience. The obvious examples include Vermeer's great canvas in the Mauritshuis, *A View of Delft*; Fabritius's small townscape in the National Gallery, London, *A View in Delft*; and Houckgeest's large panel in the Hamburger Kunsthalle, *The Nieuwe Kerk in Delft with the Tomb of William the Silent* (see pls. I-III).

There are no comparable works by Pieter de Hooch, although impressive passages of naturalistic description may be found in his domestic interiors and courtyard views. Like Hendrick van Vliet when he turned to interior views of actual churches (following the examples in Delft of Houckgeest and Emanuel de Witte), De Hooch is of greater interest to this study for his adaptations of patterns and motifs that had already been employed by other artists: for example, Bartholomeus van Bassen, Quiringh van Brekelenkam, Dirck van Delen, Ludolf de Jongh, Isaack Koedijck, Nicolaes Maes, and Hendrick Sorgh. These names take us beyond the walls of Delft; in the fourth chapter, they are considered under a rubric borrowed from the shelves devoted to seventeenth-century portraiture at the Netherlands Institute for Art History (RKD), The Hague: "South Holland." The label cannot be found on maps dating from before the eighteenth century, and several of my Dutch colleagues have objected to its use for that reason. But the purely art-historical use of the term seems to me comparable with "Emilian" and other harmless anachronisms, and far less objectionable than those convenient catchalls, "Netherlandish" and "Flemish." In this book "South Holland" refers to a region, and especially to regional artistic traditions in the southern part of the seventeenth-century province of Holland. The area extends (with a view to artists, not borders) from Leiden in the north to Dordrecht in the south, and is centered around The Hague and Delft. Rotterdam, Schiedam, Gouda, and Gorinchem are also in the region.

These chapters were first envisioned in 1996 as "revised collected essays" on painting in Delft. At the time, the "Johannes Vermeer" exhibition in Washington and The Hague and the "Delft Masters" exhibition in Delft stimulated interest in topics that the present writer had addressed before, but as much as twenty years earlier, or in out-of-the-way publications. Furthermore, my own exhibition, "Vermeer and the Delft School," originally planned in 1992 for 1996, had been rescheduled for 2001 – March 5 to May 27 at the Metropolitan Museum of Art, New York; a smaller version of the exhibition (the paintings only) goes on to the National Gallery, London, from June 20 to September 16. An exhibition catalogue is not the place for extended discussions of academic questions, at least not the ones that are considered here. However, this material is directly relevant to many of the objects that will be on view: the first four known works by Vermeer and about ten other paintings by him, a dozen church interiors, a variety of Delft De Hoochs, *A View in Delft* and other pictures by Fabritius, and a strong representation of the "Delft School" in the first half of the century. My essays in the exhibition catalogue differ almost completely from those in the present publication: a sketch of the city's history is accompanied by a fairly full survey of the arts in Delft from about 1550 until 1675. A discussion of Delft society, culture, and collecting (by Marten Jan Bok) and an essay and catalogue entries on drawings (by Michiel Plomp) are also included, as are short sections representing the decorative arts.

This book, by contrast, offers "a view of Delft" not to the general public but to those who already have

views on the subject, and to innocent but interested bystanders. The first chapter, on the "Delft School," is introductory: it explores the question of whether such a community or tradition ever existed and reviews earlier opinions. Here again, as with "South Holland," we are in trouble with terminology, since many scholars reject the very notion of local or regional "schools" in the Netherlands, which indeed cannot be compared with Italy in the fourteenth or fifteenth century. They are right, of course, but only relatively, depending upon where and when the Dutch artists under discussion worked. My concern here is not what we mean by "school" but what Montaigne meant by "essay," and what actually happened in Delft.

The second chapter is devoted to Fabritius's *View in Delft*: its reconstruction as an illusionistic image originally mounted in a perspective box and the painting's significance in both the narrowest and the broadest sense. The essay goes well beyond my article on the subject in *The Burlington Magazine* of February 1976, and incorporates, with gratitude, Larry Keith's discoveries in the course of conservation in 1993 (see Keith 1994 in the bibliography). All the known evidence of Fabritius's work on perspective boxes and illusionistic murals is reviewed afresh, and the contemporary taste for such things is explored.

For many readers the third chapter on architectural painting will seem the longest, which it is. Unlike the second chapter it does not attempt a sustained argument but is a detailed examination of a specialized genre in Delft – views of actual church interiors – with particular attention to the formative period of the early 1650s. Those in search of essential information on individual painters (Houckgeest, De Witte, Van Vliet, Cornelis de Man, and Johannes Coesermans) will find it with the help of the Index and may wish to skip some sections. Taken as a whole, however, the essay offers another explanation of how naturalistic paintings, even those that carefully record existing sites, inevitably depend upon pictorial precedents.

The fourth chapter on genre painting prepares one for some aspects of the fifth, on Vermeer's early work. Disputed topics such as Vermeer's debt to the camera obscura and the importance of his presumed patron, Pieter Claesz van Ruijven, are revisited, but the central issue remains that of style. My under-standing of the subject owes much to Ernst Gombrich in general and to Lawrence Gowing in the case of Vermeer. His monograph on the artist is perhaps best known for its subjective observations and a prose style that requires close attention (not unlike its subject). Conclusions distilled from years of reflection and weeks of comparing photographs are interspersed throughout Gowing's text like passing remarks, and occasionally like provocations, if one is accustomed to

more straightforward appraisals of the artist. What would Thoré-Bürger make of lines such as: "wherever Vermeer's sources can be traced beyond doubt it is clear that they were common knowledge among the artists of his school"; or, "it would be hard to find a theme of any boldness in his work which is not based on precedent" (*Vermeer*, 1970, pp. 84, 33)? More to the point, how do these observations sit with Gowing's less surprising statement that "nothing in Vermeer's painting is more distinctive than the insistence with which he pursues appearances" (ibid., p. 25). Perhaps it was because Gowing was a painter himself that he saw nothing inconsistent in these remarks, and in my view neither should we.

The last chapter on Vermeer's mature work does not, like the others, derive partly from earlier publications. It attempts to carry their concerns forward into difficult territory, where a great artist has completely mastered his means. Both chapters on Vermeer also go into questions of iconography, not in an attempt to "cover" the material but because conventions of meaning were treated by the artist rather like those of style. Vermeer constantly reconsidered what he borrowed or learned in the light of what he saw, felt, and thought. The more one understands how Vermeer was conventional – meaning not unimaginative, but well informed – the more one appreciates how exceptional he was.

These essays have benefited from the writings and occasional counsel of colleagues and friends: Christopher Brown, Michael Montias, Michiel Plomp, Peter Sutton, and others who are often encountered in the footnotes. I am especially thankful to Dr. Brown for years of friendship and for his impatience, akin to mine, with received opinions and speculative ideas. (On this score I also have fond memories of John Pope-Hennessy.) My greatest debt when it comes to Vermeer and other Delft painters is to Arthur Wheelock, which is why he often serves as a foil for my arguments. For nearly three decades we have scrutinized the same material from different angles and with different temperaments, mine being the more disagreeable. I am grateful to Dr. Wheelock for his forbearance and hope readers will see how often my ideas support his own.

This volume's appearance has benefited substantially from the support of the Stichting Foundation Siebold Council, which contributed a generous grant, and from the benevolence of a number of friends. I would like to mention especially Jim and Donna Brooks, Phoebe Cowles, Jan De Maere, Johnny Van Haeften, Otto Naumann, and Robert Noortman. Several colleagues at the Metropolitan Museum donated their time and talent: Joseph Coscia and Oi-Cheong Lee in the Photograph Studio, and Janet Barad and Christine Hiebert in Design. Ms. Hiebert devoted many hours of patient

expertise to the computer simulation of how Fabritius's *View in Delft* might have appeared in a perspective box (pl. iv). Many colleagues in other museums were also helpful: Christopher Brown, Frits Duparc, Larry Keith, Wouter Kloek, Axel Rüger, Jørgen Wadum, and those of whom I beg forgiveness for not having room here to mention all their names. Finally, my thanks to everyone at Waanders for their endless patience and exemplary taste.

Michiel Jonker and Reindert Falkenburg read my manuscript before it went to the publisher. I deeply appreciate their many words of support and dissent, the latter often followed by exclamation marks. Two scholars, Lisa Duffy-Zeballos and Vanessa Schmid, helped me with innumerable editorial details. Ms. Duffy compiled the judicious index, which covers not only the text but also the 350 illustrations and 1,243 footnotes.

As always, my most heartfelt thanks go to my wife Nancy. She has, in a way, given this project as much time as I have, without the same rewards, or the hope of any other, apart from my own happiness. WL

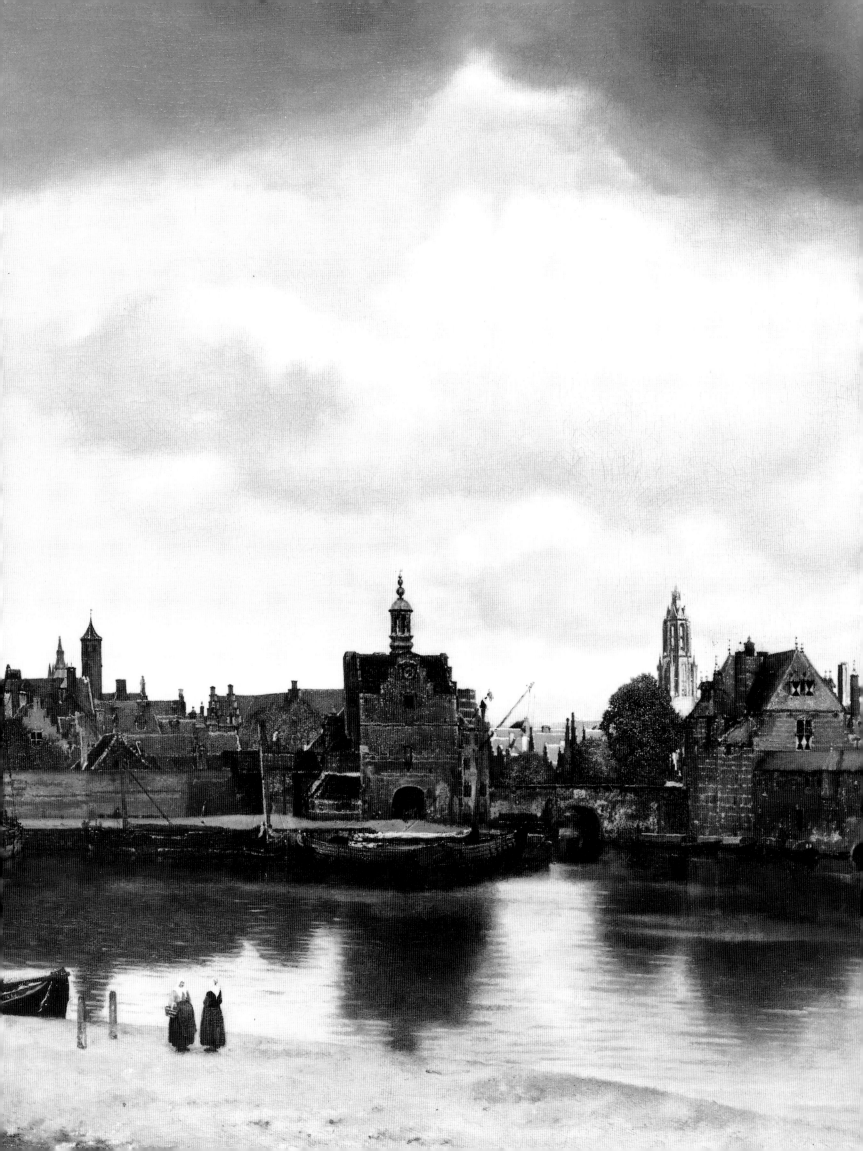

Chapter One
The Delft School

The very idea of a "Delft School" has been much debated, with such shifting frames of reference as style, subject matter, economics, patronage, and pure semantics. Scholars use the term, dismiss it, or hedge their bets, for example, by referring to "the so-called Delft school style."[1] This is understandable, given the need to address different readerships: there are occasions upon which an historian might speak of the "Delft School" or describe a Dutch painting as "Baroque" and other times when one would not dare to employ such dubious descriptions.

In more academic contexts the response to De Vries's query "Hat es je eine Delft Schule gegeben?"[2] has tended toward impatience. Sluijter, for example, considers the term "Delft School" to be a modern concept which arbitrarily assigns a leading rôle to a few artists active between 1645 and 1660. He emphasizes the "great variety" of pictures that were produced in Delft during earlier decades, and cautions us about missing evidence: "[there are] countless painters" whose names are listed in the registers of the Guild of Saint Luke "by whom we know not one picture."[3] In a pendant essay on artists active in Delft during the period 1650-70, J. Breunesse concludes that "with the use of the term 'Delft school' a problem [is] created rather than solved."[4]

Nearly identical words were written at the same time by Christopher Brown, who not only rejected (in 1981) the notion of a local school in Delft but also observed that any "school of painting named after a town, a concept taken over from the study of Italian painting, is largely inappropriate when applied to the United Provinces in the seventeenth century."[5]

In response to these reservations, the term Delft School or "Delft School" (capitalized or in quotation marks) refers in the following pages to the received notion or concept generally found in earlier literature, whereas the occasional reference to the Delft school (with a small "s") simply refers to all the painters who worked in Delft during the seventeenth century.

Modern objections to the idea of a Delft School take us far away from the program described by Max Eisler in his hoary classic of 1923, *Alt-Delft: Kultur und Kunst*. Under his direction, Anthonie Palamedesz, Paulus Potter, Gerard Houckgeest, and Carel Fabritius work together like a string quartet, each artist coming in at the right moment, adding something sympathetic to the others and something new, while Vermeer waits in the wings.[6] For this performance Brown cannot sit still. He cites three fairly unfamiliar artists who were active in Delft before 1650 – the conservative portraitist Jacob Delff, the still-life painter Evert van Aelst, and the history painter Christiaen van Couwenbergh – in order to demonstrate how little ("nothing") these local figures had "in common besides the medium of oil paint." As for the focus of his attention, Carel Fabritius, Brown sees "little in the work of even the more imaginative and talented of Dutch painters, such as Leonaert Bramer, that could have offered sufficient stimulus" in a direction leading toward *A View in Delft* (pl. III) and other key works of the Delft School dating from about 1650 onward.[7]

This skepticism has a certain period flavor. Many writers of the 1980s reveal signs of frustration with the art-historical platitudes of the past. However, the recent substitution of detail and shading for Eisler's outline still leaves the picture incomplete. Even Montias, who resurrected many of the "countless" names to which Sluijter refers, considers a rather small circle of artists – Fabritius, De Hooch, Vermeer, Houckgeest, Hendrick van Vliet, and a few others – to have formed an artistic "community with intersecting interests in subject matter and techniques, with some similarity in aesthetic approaches, and with significant cross-influences." Thus, "a genuine school … had at last come into existence" by the mid-1650s in Delft.[8] Similarly, Bob Haak suggests that "Fabritius's feeling for illusion and especially his sensitive use of natural light formed part of the basis for the development of the Delft school."[9]

1
JOHANNES VERMEER,
A View of Delft (detail),
ca. 1661. Oil on canvas,
96.5 x 115.7 cm.
The Hague, Koninklijk
Kabinet van Schilderijen
"Mauritshuis." See also
plate I.

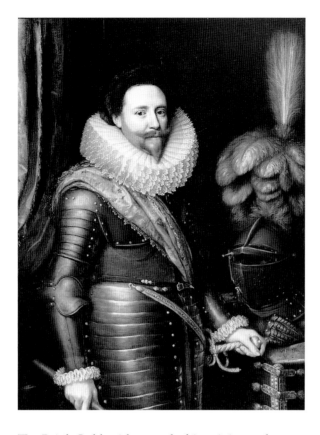

Michiel van Miereveld, *Portrait of Frederick Hendrick*, ca. 1610. Oil on panel, 110 x 84 cm. Delft, Stedelijk Museum "Het Prinsenhof" (photo: Tom Haartsen)

Ten Brink Goldsmith seconds this opinion and observes that "paintings by Fabritius, De Hooch, Houckgeest, and Vermeer consistently embody an interest in the local scene." Their efforts "do not translate into a Delft 'school' of painting," but they do reveal "an emerging sense of civic pride and civic awareness" which culminate in Van Bleyswijck's voluminous history and description of Delft published in 1667. Ten Brink Goldsmith detects "optical concerns" in the oeuvres not only of Fabritius and Houckgeest but also of Bramer, and "the use of a *camera obscura*" not only by Vermeer but also by Fabritius in *A View in Delft*. The author refers more persuasively to "the extent of Flemish influence evident in works by both native and nonnative artists," which she considers "a notable feature of painting in Delft prior to 1650." Finally, "the exemplary craftsmanship and quiet restraint that inform Vermeer's paintings are also in some sense a survival of qualities that have been noted [by the present writer] as peculiar to paintings produced in Delft," which could in turn be said to reflect the "dignity, restraint, and stateliness" that Eisler discerned as characteristics of Delft society.[10]

Addressing a general audience in the catalogue of the "Delft Masters" exhibition (1996), Michiel Plomp mostly left questions of social context aside, apart from noting the city's relationship with the House of Orange, and the most important local industries: beer, textiles, and earthenware. A greater emphasis might have been placed upon luxury goods, especially François Spiering's suites of tapestries for the States General and foreign dignitaries (Sir

Walter Raleigh, the Earl of Arundel, and the King of Sweden), and fine objects by Delft's many gold- and silversmiths. The high quality evident in both fields and the fact that they flourished at all may be explained in good part by Delft's close proximity to the court at The Hague.[11] Parallels in painting are found in courtly portraits by Van Miereveld (fig. 2) and his followers, and in murals and other large canvases painted for Frederick Hendrick by Van Couwenbergh. The importance of Delft's closeness to The Hague is further considered below, and is touched upon often in the following chapters.

The Potter hypothesis

Eisler assigned a pivotal rôle to Paulus Potter, who entered the Delft painters' guild in August 1646 and the guild at The Hague in 1649.[12] The author's eloquent remarks about Potter's drawing and detail (which he dubbed "die lineare Konstante"), brilliant light and color, and carefully ordered compositions (see fig. 5) have influenced many later writers, if not always directly. The tribute paid to Potter in Plomp's essay on Delft painting between 1600 and 1650 follows Eisler's section, "Ein Malerbesuch," although the Dutch writer's reference to a "loose, informal arrangement of figures and animals" suggests that he had different examples in mind.

According to Plomp, it was especially Potter's "provocative, naturalistic handling of light [that] prompted the experiments and innovations of Delft painters around the middle of the century." In preparation for Potter's surprising impact upon Fabritius and company, several older artists paved the way: "a preoccupation with light and space [was] already evident in the portraits of Van Miereveld," and "effects of light are also a major concern in the still lifes of Van der Ast." Even "the history painters Willem van Vliet, Emanuel de Witte, and especially Leonaert Bramer" reveal analogous passages of light and space, since they "clearly had a penchant for dramatic chiaroscuro." As if unsure about these remarks, Plomp proposes, "we can at least be certain that Anthonie Palamedesz was skilled at creating the illusion of space, and that, like his follower Jacob van Velsen, he was keenly interested in light" (see figs. 3, 4). And so, "with all this talent on hand, it did not take much for the artistic life of the city to ignite; the arrival of Paulus Potter in 1646 [when he was twenty-one] was presumably the spark."[13]

This hypothesis, original with Eisler, follows a nineteenth-century model of artistic development. One painter, like Courbet and Monet in Eisler's own lifetime, is seen as the innovator and standard bearer of a new artistic movement in a particular place. But as Plomp himself makes clear on other pages, Dutch

painters worked for a very different public than the kind with which we have become familiar in modern times. Like Van Miereveld, Van der Ast, Van Couwenbergh, Bramer, Houckgeest, and others, Potter worked for discerning patrons, including clients at the Dutch court such as Johan Maurits and Amalia van Solms. For example, *The Farmyard* (*"The Pissing Cow"*) of 1649 (The Hermitage, St. Petersburg), one of the luminous, meticulous, agreeably rustic landscapes by Potter that are most reminiscent of artists in Delft, was painted as an overmantel for the widowed princess's private quarters in the Noordeinde Palace.[14] It was probably not the candid account of barnyard life that earned Potter's panel its intended place of honor (Amalia was talked out of the idea) so much as its extraordinary craftsmanship, radiant palette, and exquisite light effects. The quality of his best pictures (see fig. 5) lends some support to Plomp's comparisons with Van Miereveld, Van der Ast, and other Delft artists. However, one wonders whether Potter's place in the story of Delft may be explained in terms of artistic influence, a regional tradition, or patterns of taste and patronage.

While indisputably an innovator, Potter may also be associated with several landscapists of the time who employed light and calmly balanced compositions to suggest Arcadian tranquility, whether the nearest water was the Mediterranean or the North Sea, the Rhine or the Maas. In a view sweeping over South Holland, embracing artists in

Dordrecht and Rotterdam as well as in Delft and The Hague, and also the Utrecht painters who were well established in the court city, Potter seems a less isolated and less crucial figure. Pictures by Poelenburch and Both, Cuyp and Herman Saftleven, the pastoral landscapes painted by Ludolf de Jongh and, during the 1630s and 1640s, by Simon de Vlieger who was in Delft and Rotterdam, and even the finest farmyard scenes by Egbert van der Poel (fig. 6) set Potter's approach and his contemporary appeal in a broader context. Other artists could be added to the list, but none so relevant to Potter's supposed position in Delft as Adam Pynacker, who

3
ANTHONIE PALAMEDESZ,
Merry Company, 1632.
Oil on panel,
45.3 x 70.5 cm.
Raleigh, North Carolina
Museum of Art

4
JACOB VAN VELSEN,
A Musical Party, 1631.
Oil on panel, 40 x 55.8 cm.
London, The National Gallery

5
PAULUS POTTER,
Cows Reflected in the Water, 1648.
Oil on panel,
43.4 x 61.3 cm.
The Hague, Koninklijk
Kabinet van Schilderijen
"Mauritshuis"

6
EGBERT VAN DER POEL,
A Peasant Cottage, 1647.
Oil on panel, 58 x 82.5 cm.
Vienna, Kunsthistorisches
Museum

was from Schiedam (next to Rotterdam) and worked in Delft from about 1649 until 1651 (and also later).[15] He was probably influenced by Potter, but that alone would not account for the luminosity, serenity, and gently geometric order of his landscapes and outdoor architectural views of the early 1650s (fig. 7), which remind one of Fabritius's *Sentry* (pl. VI), De Hooch's courtyards (pls. XIV, XV), and Daniel Vosmaer's views of Delft (figs. 28, 29).

Another view of Delft

An essential argument of this chapter and those that follow (especially Chapter Four) is that the Delft school must be considered in a regional context, taking into account developments elsewhere in South Holland (for example, in Rotterdam, Dordrecht,

Gouda, and Leiden) and next door at The Hague. Both the similarities and the differences between Delft and these other centers of artistic production may contribute to a closer understanding of painting and collecting in Delft.

In this approach one finds some refreshing answers to what is "typical" of Delft, as opposed to what is most memorable or extraordinary. Of course, individual personalities and different sectors of the art market resulted in a variety of styles and subjects and different levels of quality, as would have occurred in any school of a certain size and vitality. It is in such a context that consistencies are most revealing, though these are not always the first thing that the modern viewer is inclined to see.

From this point of view it is not the "naturalistic handling of light" or optical effects, to say nothing (for the moment) of the camera obscura, that may be considered most typical of Delft, but other characteristics which were mentioned above: outstanding craftsmanship, exquisite or refined effects, orderly composition, restrained movement and expression, and a resulting sense of dignity or contemplation. These mostly conservative values may be considered sympathetic to some artistic innovations and not to others (Bramer is an obvious exception). For example, an emphasis upon linear perspective or an intellectual interest in optical effects seems consistent with these qualities: the measured temperament meets the measuring eye. The close, curious study of how things actually appear, whether the subject is Van der Ast's flowers or Vermeer's

figures in a sun-filled room, calls for careful description and minimal movement. It is, to put it simply, the top end of the art market in Delft that is most distinctive, both in its preferences and in its prevalence (as compared, for example, with Haarlem, where the most typical products were not luxury goods to the same degree). The numerous subtleties or refinements of meaning and style in seventeenth-century Delft painting contribute to the general impression of sophistication, of acquired taste.

This brings us back to the question of patronage and Delft's proximity to The Hague. To what extent did Delft artists and artisans (meaning tapestry weavers, silversmiths, and so on) work for clients at the court, for professional people in court circles (including foreign diplomats), or for patrician families in Delft who were to some extent influenced by princely examples of patronage? The present state of research does not allow a clear answer, but much may be learned by comparing the schools of Delft and The Hague, by taking into account the Flemish or other visiting artists who worked in the latter city (especially in the 1640s) and by comparing these neighboring communities of artists with those in the northern area of Holland and elsewhere in the Netherlands.[16]

Of course, what did not happen locally or regionally is nearly as important for the question of a Delft school as what did. "Low genre" paintings were almost absent from Delft and The Hague until about 1650, when Van der Poel (like Potter to some extent) invented picturesque views of agrarian environments, rather than pictures of peasants per se. (Adriaen van de Venne's grisaille representations of peasants involve literature and politics and can hardly be considered analogous to Adriaen van Ostade's early peasant scenes.) There is also very little in the Delft school that one would describe as "Baroque" except for some works by Bramer, whose style is not close to Rembrandt's dramatic manner of the 1630s or anything comparable in Amsterdam, Haarlem, Utrecht, or Antwerp. Indeed, Rembrandt and his followers have little to do with the history of the Delft school, apart from his influence upon Fabritius (which is considered briefly below). This is not explained by the distance between Amsterdam and Delft; a few artists from Dordrecht, further to the south, were among the most prominent members of the Rembrandt school (Bol, Van Hoogstraten, Maes, De Gelder et al.).

The connection with Utrecht

Painters from Utrecht are often cited in connection with Delft. Hendrick ter Brugghen and Gerard van Honthorst, in whom the young Vermeer took an

interest, are the first to come to mind. But Delft's artistic relationship to the bishopric (to which it deferred in religious matters before 1572) may be traced back at least as far as Jan van Scorel's high altarpiece for the Nieuwe Kerk in Delft (commissioned in 1550) and to the Delft artist Anthonie Blocklandt's career in Utrecht (where Van Miereveld was his pupil in the early 1580s). The Utrecht portraitist Paulus Moreelse was Van Miereveld's pupil, but influences usually flowed in the other direction, especially with Honthorst's success at The Hague (where he opened a second studio in 1637). Van Couwenbergh (figs. 15-17) was the Delft history painter most conspicuously indebted to Honthorst, but the court painter's impact is also obvious in works by Willem van Vliet (fig. 8) and by Bramer, and in the candlelit history pictures (which have been confused with Van Vliet's) painted by Crijn Volmarijn in Rotterdam.[17] Not only Bramer's most Caravaggesque pictures (such as the well-known *Denial of Peter* of 1642 in the Rijksmuseum, Amsterdam),[18] but also his illusionistic murals and his frequently observed affinity with Nicolaus Knupfer

7
ADAM PYNACKER,
View of a Harbor in Schiedam, ca. 1650-53.
Oil on canvas,
55.5 x 45.5 cm.
Los Angeles, Collection of Mr. and Mrs. Edward William Carter (photo: Los Angeles County Museum)

WILLEM VAN VLIET,
A Philosopher and Pupils,
1626.
Oil on panel, 85 x 113 cm.
The National Trust for
Scotland, Brodie Castle
(photo: C. Hutchison)

reveal the celebrated Delft painter's sympathy with
the Utrecht school, which was first aroused in Rome
and later enhanced by his work for the Dutch court
(described below). A number of drawings by Bramer
(see fig. 21) recall such decorative works by Hont-
horst as the *Musical Group on a Balcony*, 1622, in the
J. Paul Getty Museum.

Other parallels between the Delft and Utrecht
schools may be discovered among the still-life
specialists. Pieter Cornelisz van Rijck (1568-1628)
and Cornelis Delff (1571-1643) are usually associated
with Pieter Aertsen (who painted an altarpiece for
Delft),[19] but their kitchen scenes come closer to those
of Joachim and Pieter Wtewael. Jacob Vosmaer's
flower still lifes (fig. 9), which were certainly
influenced by those of Jacques de Gheyn II at The
Hague, remind one equally of contemporary works
by Roelant Savery in Utrecht. Balthasar van der Ast
(1593/94-1657), originally from Middelburg, worked
in Utrecht for about thirteen years before moving in
1632 to Delft, where he spent the remaining quarter-
century of his life (see fig. 10).

The comparison may also be extended to the
seemingly antediluvian landscapes by Jacob van Geel
(fig. 11), which are reminiscent of Savery's forests;
to Willem van den Bundel's woodlands, which grew
out of Gillis van Coninxloo's and resemble terrain
surveyed by Gillis d'Hondecoeter; and to Pieter

Anthonisz van Groenewegen's views of Roman
ruins, which recall the *campagna* as conceived by
Poelenburch.[20]

To some extent, the links between artists in Delft
and Utrecht were forged by their common back-
ground in Flemish art, but then one could say the
same for Haarlem. The Delft *amateur* Abraham van
der Houve imitated Cornelis Cornelisz van Haarlem,
and Karel van Mander the Younger designed
tapestries for François Spiering in Delft before
establishing his own manufactory there in 1615.[21]
However, the endurance of artistic traditions
depends upon taste. Court patronage of various Delft
and Utrecht painters and the impression made by
princely commissions upon patrons in Delft and The
Hague must have encouraged continued relations
between the Delft and Utrecht schools.

Painting in Delft before 1650

Figure painters

History painting and portraiture, both practiced in
comparatively conservative styles, dominated painting
in Delft during the first half of the seventeenth
century. This is not entirely clear from the available
surveys, which give nearly equal space to still-life,
landscape, and genre painting, although artists such

as Jacob Vosmaer, Jacob van Geel, and Anthonie Palamedesz were hardly comparable in importance to Van Miereveld, Willem van Vliet, Bramer, or even Van Couwenbergh. Of course, portraiture would be the mainstay of Dutch painters in a provincial place like Enkhuizen or Hoorn.[22] But portraiture in Delft was far more sophisticated than the local manner of many Dutch towns and was strongly associated with portraiture at The Hague (where Jan van Ravesteyn, Daniel Mijtens, and Van Miereveld himself were succeeded by Honthorst, Adriaen Hanneman, and Jan Mijtens).[23]

Van Miereveld, more than any other painter in Delft, was connected with the court. His lifelong residence in Delft and business at The Hague were hardly impractical. The centers were separated by about an hour and a half on foot, or about an hour in a barge or carriage (less on horseback). Housing in The Hague, which was somewhat smaller and less populous than Delft, presented a choice between the crowded court district around the Vijverberg and less central and desirable areas.[24] Of course, Van Miereveld could have managed a fine house at The Hague, which would have invited comparison with some of the wealthiest families in the Netherlands, the court itself, and the foreign ambassadors who employed about twelve hundred attendants. But this was completely unnecessary, and Van Miereveld's distinguished social position was deeply rooted in Delft.

He entered the painters' guild there in 1587, a few

years after his training in Utrecht. In 1607 the portraitist was appointed court painter to Prince Maurits, and he continued in that position when Frederick Hendrick (fig. 2) became stadholder in 1625. Numerous Dutch courtiers, foreign diplomats like Sir Dudley Carleton, and patrician patrons in The Hague, Delft, Leiden and elsewhere were portrayed by Van Miereveld, who met the demand with the help of several assistants. Among them were his sons Pieter (1596-1623) and Jan (1604-1633), who both died while still in their twenties. In 1641 the studio passed to Van Miereveld's grandson, Jacob Willemsz Delff the Younger (1619-1661), who had produced replicas of portraits by Van Miereveld and served as a costume specialist. The master trained, in addition to members of his own family and Moreelse, Willem van Vliet (about 1584-1642) and Anthonie Palamedesz (1601-1673). He also influenced Van Ravesteyn and Daniel Mijtens, who carried Van Miereveld's reserved and meticulous manner to the court of Charles I (where the Delft master declined to go). Van Miereveld's portraits became widely known through the engravings of his son-in-

9
Jacob Vosmaer,
Still Life of Flowers with a Fritillary, 1618.
Oil on panel, 110 x 79 cm.
Private Collection

10
Balthasar van der Ast,
Still Life with Flowers, Fruit, and Shells by a Window, ca. 1650.
Oil on panel, 38 x 71 cm.
Dessau, Staatliche Galerie

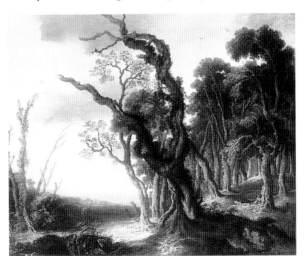

11
Jacob van Geel,
Forest Landscape,
ca. 1633-34.
Oil on panel, 32.5 x 39 cm.
Vienna, Kunsthistorisches Museum

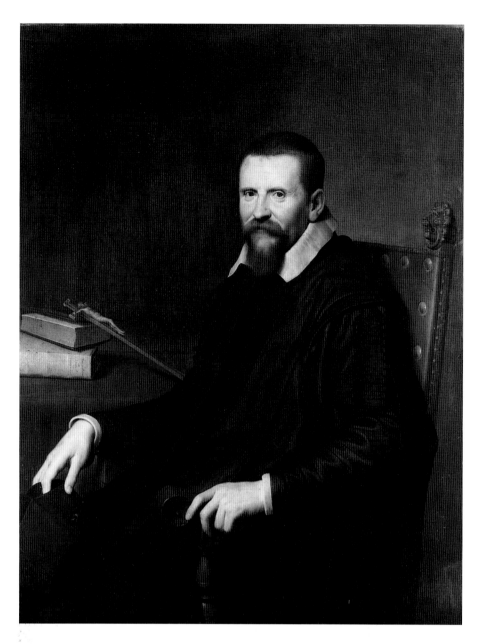

12
WILLEM VAN VLIET,
*Portrait of Suitbertus
Purmerent*, 1631.
Oil on panel,
113.5 x 85.4 cm.
London, The National
Gallery

Willem van Vliet's portrait of the Catholic priest Suitbertus Purmerent (fig. 12) is more accessible than court portraits by Van Miereveld, but shares with them a perusal of surfaces and a disinclination to gesture or react.[25] By comparison, not only contemporary portraits by Hals and Rembrandt but even a sober work like Jacob Backer's similarly arranged *Johannes Uyttenbogaert* of 1638 (Rijksmuseum, Amsterdam) appear slightly agitated, and of course more fluidly painted. The formality of South Holland portraiture often distracts the modern viewer from its qualities of light and atmosphere, but the sitter in Van Vliet's portrait presumably appreciated the softening of his features by subtle transitions of light and shadow and the finely nuanced palette of grays and greens. Depth is established through the thoughtful placement of the figure and objects and by a consistent impression of atmosphere, while understated modulations of light distinguish the different textures of leather and linen, wood and brass, hair and skin.

Similar qualities may be found in portraits painted elsewhere, for example, by Moreelse in Utrecht. What is perhaps most distinctive about South Holland portraits is that their manner of execution coincides with a particular temperament, which is thoughtful, conservative, composed, perhaps even imperturbable. The confident figure seems to stand for certain virtues without making a show of them or alluding to their opposites. What has been termed the classical quality of painting in Delft, usually with regard to Vermeer's quieter images (pl. XXVI), appears consistent with the traditional tenor of the school and has its foundation not in formal sources (which have sometimes been traced to France) but in the character of society in Delft and The Hague. The clientele for finer pictures was and had been for some time either courtly or professional, and cosmopolitan in a manner more suggestive of wealth and education than of experience in commerce and trade. Some idea of this culture's demeanor is conveyed in portraits of Constantijn Huygens, including Delff's engraving (inscribed "Constanter") after Van Miereveld's painting of the courtier at the age of twenty-seven, and in the well-known works by Jan Lievens and Thomas de Keyser. One never has the sense, as in Rembrandt, that the sitter aspires to a certain stature, which would imply that it was in doubt.

Frederick Hendrick and his secretary Huygens supported not only Utrecht artists such as Honthorst and Poelenburch, and of course the Leideners Lievens and Rembrandt (whose works of the early 1630s may be more closely associated with court taste than they usually have been), but also a variety of Flemish painters, including Rubens, Van Dyck, Jacob Jordaens, Thomas Willeboirts Bosschaert, Theodoor van Thulden, and Gonzales Coques.

law, Willem Jacobsz Delff (1580-1638).

The tradition of court portraiture in South Holland descended in good part from Anthonis Mor (ca. 1516/19-ca. 1575/76), the Utrecht portraitist who flourished in Antwerp, Brussels, and Spain. Van Miereveld's style lacks the hint of Venetian animation that may be discerned in Mor's work, but enhances the Dutch qualities of close description and conspicuous craftsmanship. Illumination is rendered studiously, in order to articulate surface incidents and to suggest forms in space. A similar approach is found not only in portraits by Willem van Vliet (fig. 12) and his nephew Hendrick (fig. 24), but also in still lifes by Cornelis Delff and Harmen Steenwyck (fig. 26). The quiet, at times contemplative nature of Delft still lifes and history pictures by Willem van Vliet (fig. 8) might be compared with the dignified composure of Van Miereveld's portraiture. Whether the stillness of Delft church interiors and genre scenes of the 1650s is related to this tendency is difficult to say.

The "overwhelming predominance" of paintings by Southern Netherlandish masters in the stadholder's collection has perplexed Dutch scholars ("no satisfactory explanation has been advanced for this phenomenon"),[26] but it would have made sense to noble patrons in Brussels, London, Madrid, Genoa, Vienna, Prague, Paris, and other centers of international culture. Of course, Frederick Hendrick stood in the vanguard of Netherlanders who did not consider the southern and northern provinces as separate entities, let alone different cultures. It is also important to remember the large number of Flemish immigrants among artists and collectors in cities such as Delft, The Hague, and Middelburg (where Van der Ast, Van Geel, and the Delft native Van de Venne began their careers).[27] Thirteen of the thirty-two painters listed as members of the Delft guild in 1613 were born in the Southern Netherlands, as compared with twelve born in Delft and the rest from South Holland or other southern regions.[28] Like these artists, the Flemish art market had also been "displaced to the north" because of economic conditions in Flanders and, in Delft itself, because of liberal regulations for imported art works.[29] There were no restrictions to collecting at the court. Thus, cosmopolitan taste, convenient sources of supply (Antwerp itself is only half again as far from The Hague as Amsterdam and Utrecht), and perhaps the legacy of previous generations encouraged a Flemish or Flemish-like manner in various genres, including portraiture, history painting, landscape, still-life, and architectural painting. To be sure, locally produced works would not have been confused with those imported from Antwerp, but they bear even less resemblance to paintings of the Haarlem school, unless one means pictures by Haarlem artists that the court actually patronized (for example, Jacob van Campen and Pieter de Grebber).

These circumstances are relevant to a fair number of Delft artists – Van Miereveld, Jacob Vosmaer, Van der Ast, Van Geel, Hans Jordaens, and others – who have been seen as having little in common, but in fact form a group as coherent as any that may be found in Utrecht and Middelburg (when surveying three or four genres). Hans Jordaens the Elder must have been one of the most successful painters in Delft from the 1590s until his death in 1630, to judge from "the very large number of his pictures in Delft collections and their high prices."[30] Born about 1555 in Antwerp, he was a pupil of the genre painter Marten van Cleve and joined the Antwerp painters' guild in 1581. Jordaens settled in Delft by 1589 and became a prominent member of the Lutheran community. He went to Antwerp several times during the Twelve Years' Truce in order to settle family affairs. The inventory of his estate, which sold for 1059 guilders, suggests that the artist dealt in

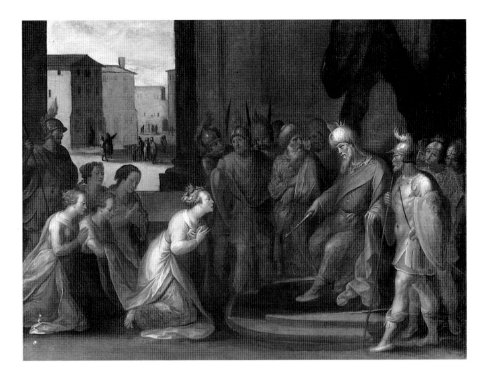

pictures.[31] He worked together with Van Miereveld in the Stadholder's Quarters in The Hague, and (according to Van Mander) was commissioned by Prince Maurits to make copies in oil of Bernard van Orley's cartoons for the tapestry series known as the Nassau Genealogy.

Jordaens's small history pictures (fig. 13) have reminded some writers of Frans Francken II, but the more obvious similarity is to cabinet pictures by Cornelis Cornelisz van Haarlem and Karel van Mander. The latter considered Jordaens "an excellently good master as well in figures as in landscapes and histories, and also most spirited and ingenious at many different subjects: peasants, soldiers, sailors, fishermen, nocturnes, fires [one thinks ahead to Bramer and Van der Poel], rocks and such like clever things."[32] The proportions and tapering limbs of his protagonists, as well as the colorful palette, recall Cornelis Cornelisz after about 1600, but Jordaens's compositions are more classically ordered, with frontal architecture or coulisse-like landscape elements and balanced blocks of sometimes isocephalic figures.[33] Like Van Mander, Jordaens also painted peasant scenes, but in a more Bruegelian-Van Clevian mode. A painting of couples dancing to bagpipe music before an inn (fig. 14), with the sign of the swan drawing attention to the church in the background, is one of the many distant antecedents to Fabritius's view of a church from the vantage point of an inn (pl. III).

Hans Jordaens's place in Delft may seem fortuitous if one is more familiar with history painters such as Bramer, Van Couwenbergh, and Willem van Vliet. But when one recalls that Van Blocklandt was his predecessor, that Van der Houve also emulated Cornelis Cornelisz in the 1610s, that

13
Hans Jordaens
the Elder,
Esther before Ahasuerus,
ca. 1610-20.
Oil on panel,
67.3 x 87.8 cm.
Montreal, Musée des
Beaux-Arts, Horsley and
Annie Townsend Bequest

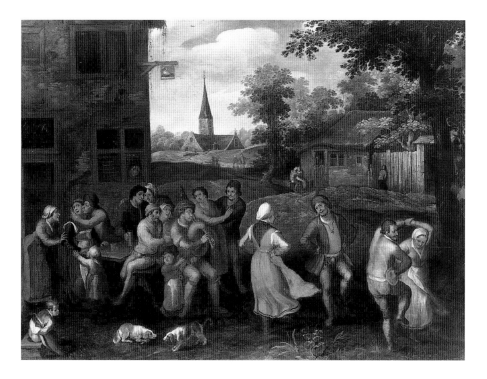

14

tradition was not far removed from that of Poelenburch and other court-favored artists such as Dirck van der Lisse, Salomon de Bray, and Caesar van Everdingen.[34] The differences in style between paintings by Poelenburch and Van der Lisse on the one hand and Honthorst, Moreelse, and other Utrecht artists on the other (as found, for example, in their life-size pictures of shepherdesses) appear broadly paralleled in Delft if one compares works by Hans Jordaens and Pynas with the larger and more theatrical paintings of Van Couwenbergh and the wealthy *amateurs* Van der Houve and Willem Verschoor (Bramer was more eclectic). Needless to say, this outline is distressingly simplistic, but any survey of painting in Delft before 1650 remains a remedial course.

Christiaen van Couwenbergh

The career of Christiaen van Couwenbergh (1604-1667) sheds useful light on our image of the Delft school in the second quarter of the century. He was not very gifted or innovative, but his oeuvre and success are reliable reflections of taste at the court and in Delft. Not long ago the very identity of "Master C B" was an enigma,[35] and there are no paintings by him in any of the major Dutch museums. Many readers will be aware of his painted doors (*Minerva and Hercules Open the Doors for Victory*) in the Oranjezaal of the Huis ten Bosch, where the flaccid figures look like fugitives from Jacob Jordaens's

Jacob Pynas worked in Delft for a decade after Jordaens's death (from 1632 until 1641), and that Bramer painted classical and biblical subjects reminiscent of Adam Elsheimer and Domenico Fetti as well as his more familiar nocturnes, then one realizes that there was a fairly consistent tradition of Italian- and Flemish-influenced history painting in Delft during the first half of the century, especially in the production of cabinet pictures, and that this

15

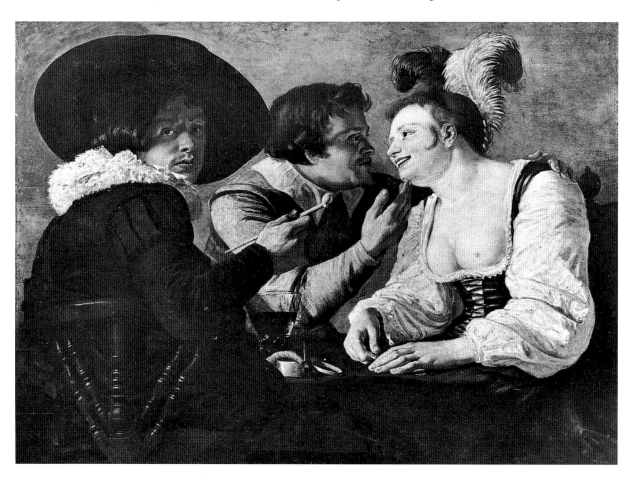

adjoining murals, making way for a nude lent by Van Everdingen.[36] Van Couwenbergh's *Samson and Delilah* of about 1630 (Stadhuis, Dordrecht) is also well known.[37] But the image one gains from a passing glance – even in essays on painting in Delft, Van Couwenbergh is treated as a provincial imitator of Honthorst – is out of proportion to his standing in the local community and in service to the stadholder.[38]

His father, Gillis van Couwenbergh, was a master silversmith from Mechelen who became a citizen of Delft in 1606, two years after Christiaen was born there. Gillis married a silver- and goldsmith's daughter, Adriaentje Vosmaer, sister of the flower

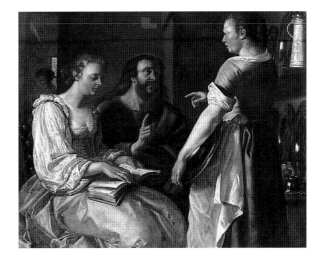

16
CHRISTIAEN VAN
COUWENBERGH,
*Christ in the House of
Mary and Martha*, 1629.
Oil on canvas,
122 x 147 cm.
Nantes, Musée des
Beaux-Arts

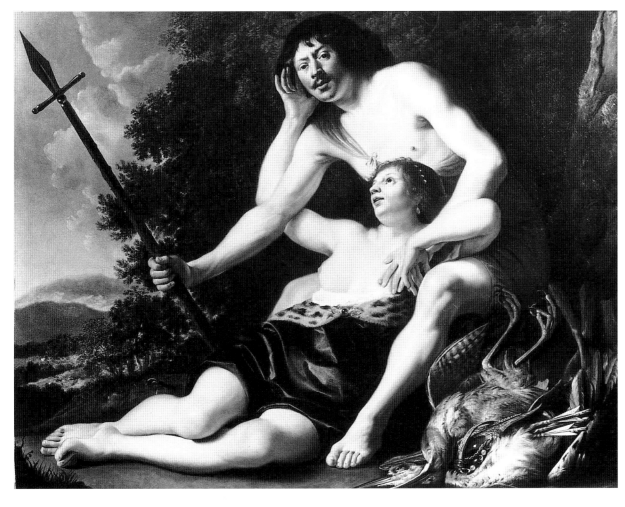

17
CHRISTIAEN VAN
COUWENBERGH,
Venus and Adonis, 1645.
Oil on canvas,
135.5 x 171 cm.
Brussels, Galerie
d'Arenberg

painter Jacob Vosmaer. Christiaen raised the already respectable standing of his family when, in 1630, he married Elizabeth van der Dussen, daughter of Dirck Bruynsz van der Dussen, who was a distinguished businessman (brewer and VOC officer), burgomaster, and sheriff.

After training with the Van Miereveld disciple Jan Dircksz van Nes, who joined the Delft guild in 1618 and died in 1650, Van Couwenbergh probably studied in Utrecht (ca. 1622-24).[39] Maier-Preusker draws this conclusion (overruling a conjectural trip to Italy) on the plausible grounds that from the first – paintings date from 1626 (fig. 15), one year before he

joined the guild – Van Couwenbergh's work is obviously derived from Honthorst, Dirck van Baburen, and other Utrecht Caravaggisti. No doubt many of the artist's paintings of merry drinkers, smokers, and musicians, and even his topical bordello scenes found homes in Delft, although they would also have circulated on the art market.[40] The *Samson and Delilah* was cited in its present location, the town hall of Dordrecht, in 1632. Other history pictures, such as the *Christ in the House of Mary and Martha* dated 1629 (fig. 16), could have hung in any large home or suitable institution, but one imagines that some of Van Couwenbergh's more erotic

mythological and biblical pictures (fig. 17), of which there are many, were intended for a particular audience which included courtiers at The Hague. On December 28, 1638, Van Couwenbergh received the enviable sum of fl. 800 for a "Diana, the Goddess of the Hunt, vivaciously painted," which had been ordered for the great dining room at Honselaarsdijk, and another fl. 800 for a frieze of hunting motifs in the same palace. A "Venus and Adonis" (fl. 600) and an "Offer to Venus" (fl. 400) were painted in 1642, and a "Diana with various other figures and game" (fl. 600) in the following year, all for Frederick Hendrick's palace at Rijswijk (Huis ter Nieuburch). In 1647 Van Couwenbergh painted a corridor of the Oude Hof in The Hague (Paleis Noordeinde), and in 1651 he finished his work at the Huis ten Bosch.[41]

Works by Van Couwenbergh are also listed in a number of Delft inventories, including those of Herman Pietersz van Ruijven (an uncle of Vermeer's patron), Willem van Vliet's daughter, and Dirck van Bleyswijck's parents.[42] The artist appears to have done quite well in Delft, commanding high prices, owning two houses, and supporting his wife and seven children. In about 1647-48 he raised the stakes by moving to The Hague, evidently anticipating a major rôle at the Huis ten Bosch (which was begun in the fall of 1645). However, Huygens and Jacob van Campen reserved most of the project for Van Campen himself, for Jacob Jordaens and Theodoor van Thulden, and for Pieter Soutman and Pieter de Grebber. Whether or not this setback was the cause, Van Couwenbergh soon accumulated debts at The Hague and left for Cologne in about 1655.

This is not the place to trace Van Couwenbergh's development, which has been done in Maier-Preusker's generously illustrated article. It suffices here to recognize that the painter's many biblical and mythological subjects and large-scale genre scenes, with their background in Honthorst and references to Baburen, Ter Brugghen, Abraham Bloemaert, and Rubens, represent an important aspect of painting in Delft during the second quarter of the century. The main interest in Van Couwenbergh for some readers will be in relation to early works by Vermeer, such as *Diana and her Companions* (which is organized like several of Van Couwenbergh's outdoor groupings, although the figures exhibit a reticence more typical of Delft) and especially *The Procuress* (see fig. 15; pl. XIX). The encounter of the couple in the *Cavalier and Young Woman* (pl. XXII), which is often compared with Honthorst's *Procuress* of 1625 (Centraal Museum, Utrecht), bears nearly as much resemblance to the figures in Van Couwenbergh's bordello scenes of 1626-30 and might be more closely related to a lost or unknown work.[43] The arrangement of the figures in Vermeer's *Christ in the House of Mary and Martha* (pl. XVIII) resembles one of Van

Couwenbergh's usual designs of the 1640s.[44] Too much has been made of the figure of Christ, who assumes (as Wheelock noted) "a standard rhetorical pose used by a number of Italian, Flemish, and Dutch artists, including Bramer, Quellinus, and Jan Steen."[45] The point is not that Vermeer had sources closer to home than those normally cited, but that his interest in Antwerp and Utrecht masters continued a tradition in Delft and The Hague.

Leonaert Bramer

The usual explanation of Bramer's position in the Delft school is that he occupied "a place very much his own."[46] The artist was certainly eccentric, but his peculiarities have been overemphasized to the detriment of understanding why he was so esteemed by his colleagues and collectors.

Baldinucci (writing about 1700) reports that Bramer (1596-1674) "spent a long time in Italy with the prince Mario Farnese, for whom he worked a great deal. Returning to Delft, he painted for Rijswijk, for His Highness the Prince of Orange Frederick Hendrick, for Count Maurits of Nassau and for other *potentati*."[47] This text is lifted almost word for word from the inscription beneath the engraved portrait of Bramer in Jean Meyssens's *Images de divers hommes desprit sublime* (Antwerp, 1649), which adds that the works painted for Farnese were both large and small.[48]

Bramer's reputation in Delft was surely enhanced by his work for princes, not least Frederick Hendrick. De Bie, writing at the time that Bramer was decorating the meeting room of the painters' guild in Delft (1661), describes him as famous throughout Italy and Germany, "and in his native Holland renowned at court and home."[49] A large "Venus and Adonis" and an overmantel depicting "Flora" are listed in the 1707 inventory of Huis ter Nieuburch at Rijswijk (where Van Couwenbergh had installed a "Venus and Adonis"); Houbraken mentions "an impressive example of his admirable work" in the same palace. A painting by Bramer representing Fortuna distributing treasures was in the "second princely gallery" at Honselaarsdijk.[50]

Perhaps the artist's small paintings on wood and copper (see fig. 18) were also admired at court, as they were by patrician collectors in Delft (only Hans Jordaens is cited more often than Bramer in Delft inventories between 1630 and 1679).[51] His often learned, even obscure subjects,[52] and his unusual style (which, however, recalls Goudt's engravings after Elsheimer, and paintings by artists who worked for the court, such as Van de Venne and Hendrick van Steenwyck II) were obviously intended for cosmopolitan collectors, not the open market. To his likely patrons, if not to critics today, Bramer's theatrically illuminated history pictures might have

seemed similar to Rembrandt's small dramas of the
Leiden years, such as *Judas Returning the Pieces of
Silver* (1629) which Huygens famously praised.[53]
But unlike Rembrandt and Lievens, Bramer had
distinguished himself in Italy. In this regard, at least,
he was comparable to much more famous masters
such as Rubens and Honthorst.

A question that deserves further consideration is
whether Bramer painted works on slate in Holland
as well as in Italy. There was no shortage of the stone
in the Netherlands, where slate was commonly
employed on the roofs of churches and public
buildings. Bramer's use of slate would probably have
added to the allure of his work in Holland. A dealer
in Delft, Hendrick Vockestaert, sold objects of silver
and gold and in particular paintings on alabaster, for
which (according to Montias) many clients at The
Hague still owed him money at his death in 1624.[54]

What is known of Bramer's patrons in Delft is
consistent with the assumption that he worked for
a sophisticated clientele. Montias found that his
collectors included "burgomasters and aldermen and
other highly situated patricians of Delft."[55] Works by
Bramer are also cited in the inventories of prominent
dealers, such as De Renialme in Amsterdam (who
was active in Delft), Bernards in Middelburg, and
Volmarijn in Rotterdam (the painter mentioned
above, who as a dealer had many contacts with
Delft artists). That Volmarijn, Willem van Vliet,
Honthorst, Van Couwenbergh, and Bramer all
represented a Caravaggesque fashion in South
Holland is probably less apparent now than it would
have been shortly after "Gherardo delle Notti" and
"Leonardo delle Notti" earned their Italian names.[56]

Bramer's flashing light effects in the dark spaces of
colossal temples (which might be compared with
the one Rembrandt painted for the prince),[57] ruins,
graveyards, and frightful landscapes also bring to
mind the contemporary collectors' taste for bizarre
subjects and scenery, such as hell scenes (by Jan
Brueghel I and II and many others), torchlit temples
and dungeons (Hendrick van Steenwyck II), and
Saint Anthony or Job being tormented by satanic
freaks (Cornelis Saftleven).[58] The wierder wave-
length of Bramer's imagination was shared with the
draftsman Jacques de Gheyn II, who was active at
The Hague.

Bramer's Italian sojourn has not been sufficiently
studied, as Brown has shown.[59] The artist left Delft
for Italy in 1615 at the age of nineteen and returned
twelve or thirteen years later. His earlier training is
a mystery. Brown considers Wichmann's suggestion
that Bramer studied with Adriaen van de Venne
"very attractive," but the dates present a problem:
Van de Venne was in Leiden before his Middelburg
period of 1614 to 1624. Other candidates include
the obscure Hieronymus van Diest (not the marine

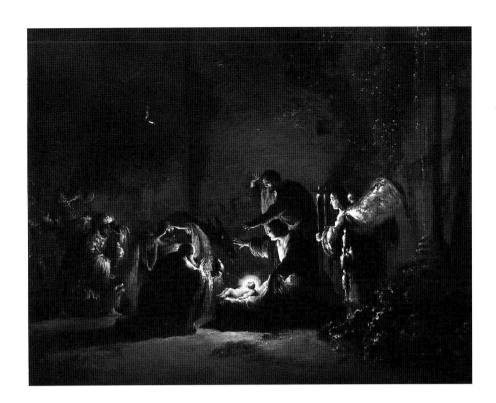

painter) who, according to De Bie, taught Van de
Venne and was "extremely fine in painting in black
and white,"[60] and Hans Jordaens, whose nocturnes, as
noted above, were cited by Van Mander. However,
Bramer's long experience in Italy makes the identity
of his teacher a moot point.

Mario Farnese (1548?-1619), the prince cited by
Meyssens and Baldinucci as Bramer's patron, was a
nephew of Pope Paul III and captain-general of the
papal armies (he served in Flanders and Hungary).
He lived mainly in his palace in Parma and was
known for his support of young artists. Meyssens also
mentions "le Cardinal Schalie," who must be Didier
Scaglia of Cremona and Rome (elected in 1621).
Another important patron of Bramer in Italy was
Gaspar Roomer, a Flemish collector (and dealer?) on
a prodigious scale (he reportedly had sixty landscape
paintings by Goffredo Wals, the German teacher in
Naples of Claude Lorrain). "Forty small paintings"
by Bramer were owned by Roomer.[61]

Bramer's relationship with Italian painters need
not be discussed here, except to say that Brown's
references to Pasquale Ottino (1578-1630) and
Marcantonio Bassetti (1586-1630) are convincing.
These artists of Verona painted on slate, employed
highlights and colors quite like Bramer's, and often
set their religious scenes in cavernous churches or
under night skies.[62] Bramer could have become
acquainted with their works in northern Italy or in
Rome, where Bassetti and his co-pupil from Verona,
Alessandro Turchi (1578-1649), worked with
Lanfranco, Saraceni, and others in the Palazzo del
Quirinale in 1616-17 (Ottino is also said to have
been in Rome). It seems likely that Bramer was
inspired partly by Turchi, although works by Ottino

18
Leonaert Bramer,
Adoration of the Magi,
ca. 1628-30.
Oil on panel,
43.2 x 53.3 cm.
Detroit, Detroit Institute
of Arts

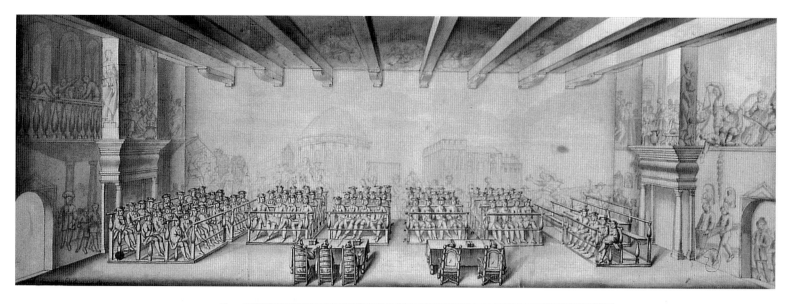

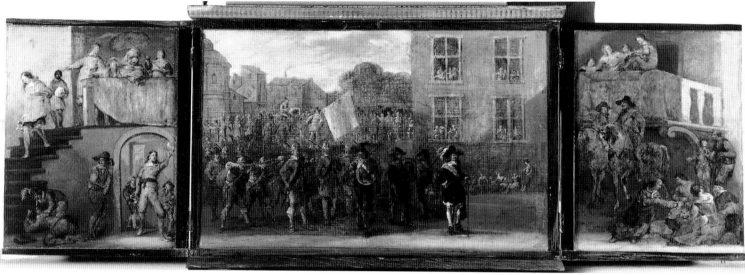

19
Augustinus Terwesten
the Younger,
Main Hall of the Prinsenhof,
Delft, with Leonaert
Bramer's Wall and Ceiling
Decorations, 1742.
Delft, Gemeentearchief

20
Leonaert Bramer,
Design for Wall Paintings
for the Delft Civic Guard
Headquarters (Doelen),
early 1660s.
Oil on three panels
joined in triptych form,
30 x 48 cm (center) and
29 x 23 cm (each wing).
Delft, Stedelijk Museum
"Het Prinsenhof" (photo:
Tom Haartsen)

and Bassetti bear a closer resemblance to Bramer's Italian inventions, such as the *Soldiers Resting,* 1626, in the Museum Bredius, The Hague.[63]

Bramer lived at different addresses in Rome between 1616 and 1627.[64] Like Poelenburch and Bartholomeus Breenbergh he was a founding member of the *Schildersbent* in 1623. Of course, Baburen was painting altarpieces in Rome between 1615 and 1620 (and in Parma in 1615), and Honthorst enjoyed great success there in the same years (his *Christ before the High Priest* in The National Gallery, London, was painted in 1617 for the Marchese Vincenzo Giustiniani and was much celebrated and copied).[65]

All of this may seem a long way from Delft, but it helps to explain Bramer's stature there and perhaps his invitation to work at the court. That he painted murals *al fresco* during the 1650s in Delft suggests that he enjoyed (or successfully perpetuated) a reputation for working in the Italian medium more than twenty years after he had returned to his unsuitably saturated fatherland.[66]

The works that Bramer and Van Couwenbergh painted on a comparatively large scale for the

princely palaces were part of an ambitious program to decorate walls and ceilings in a manner reminiscent of Italian villas, especially as seen in Veronese's Villa Barbaro at Maser, outside Vicenza. Bramer himself would have seen many more illusionistic murals and ceilings in Italy, for example, by Correggio in Parma, Niccolo dell' Abbate in Bologna, and Gentileschi, Lanfranco, and Tassi in Rome. However, apart from some arms and legs dangling over cornices and balustrades, which could be considered an Early Baroque step (or reach) beyond Correggio and Veronese, there is really little in the known evidence of works by Honthorst, Paulus Bor, and Pieter de Grebber (at Honselaarsdijk; see fig. 260), or Bramer (in Delft) to suggest models for Bramer other than Veronese and Honthorst himself.[67]

Mural painting is one of the more obvious areas of continuity between the Delft school before 1650 (Bramer and Van Couwenbergh at the palaces) and after 1650 (Bramer and Fabritius in private homes), or would be, if any of the works had survived. Bramer's wall paintings are known from documents; from the well-known drawing by Terwesten of the

24

main room in the Prinsenhof (fig. 19); from the unusual triptych on wood which appears to be the painter's model of the early 1660s for a painted room in the *Doelen* (civic guard headquarters) in Delft (fig. 20); from a few drawings which were probably intended as ideas for wall and ceiling decorations (fig. 21; also fig. 22?); and from one large canvas of the 1660s.[68] Bramer's first known commission for a fresco, which was to decorate a corridor in Anthony van Bronchorst's house in Delft, dates from 1653 and is therefore of special interest as regards Fabritius's activity as an illusionistic muralist (see pp. 64-65 below, nos. 2 and 4).[69] One recalls that in 1647 Van Couwenbergh painted a corridor in the Oude Hof at The Hague, but there is no way of knowing whether these works were similar. The painted doors by Van Couwenbergh in the Oranjezaal (life-size, illusionistic figures on an actual door) recall Veronese (as well as Rubens) and look forward to Bramer in the *Doelen* and the Prinsenhof (see fig. 19, far right, and fig. 20, left).[70]

Two other areas of work by Bramer may be associated with sophisticated patrons, whether princely or patrician. In the 1660s Bramer drew at least two sets of tapestry designs for the famous weaver in Delft, Maximiliaan van der Gucht. A set of eight sheets of marine subjects was sent to the Swedish field marshal Count Karl Gustav von Wrangel. The other set appears to have been made for the Town Hall of Leiden.[71] These were important commissions, reminiscent of major projects by Rubens and Jacob Jordaens, and of local examples by Karel van Mander II (following in his father's footsteps), Hendrick Vroom, and Van Couwenbergh.

Even more remarkable is Bramer's voluminous production of drawings en suite which were ends in themselves. Five series of Old Testament subjects, at least fourteen series of New Testament subjects, six series of classical themes (drawn from Livy, Virgil, Ovid, etc.), four series of subjects drawn from contemporary literature, and a dozen other series are known.[72] In some cases only a few drawings of a series have been traced, but other sets are known to have been large, with about fifty or more sheets. These series were not made in connection with book illustrations or prints, but were unique works of art commissioned by or intended for private collectors. It has been suggested that in the case of the Aeneid drawings, a set of 140 sheets made in the 1650s, "Bramer's illustrations presume a viewer … who has already read Virgil in Vondel's lively prose translation," someone who knows "the conventional ways in which such elevated subject matter was normally portrayed" and would consequently be "amused by the artist's highly inventive and extraordinarily individualistic manner" of representing it.[73]

21
LEONAERT BRAMER,
Men on a Balcony, ca. 1660.
Pen and ink,
19.3 x 28.6 cm.
Formerly Atlanta,
Curtis O. Baer Collection

Very little is known about the original owners of Bramer's series of drawings. One set of seventy-two pen and ink drawings, *The Life of Lazarillo of Tormes* (Staatliche Graphische Sammlung, Munich), was owned by the wealthy art dealer and artist Abraham de Cooge, and includes a title page inscribed *L. Bramer fecit 1646/ voor A. D. Cooge*.[74] Two series, *Metamorphoses* and *Tyl Eulenspiegel*, were owned by Caspar Netscher's widow (1694), and a *Life of Christ* of 1666 was in the sale of Dirck van Beresteyn (1695), a member of one of the city's more illustrious families. *The Life of Alexander the Great*, *The History of Rome* (Livy) and the *Aeneid* (Virgil), drawing series of 48, 50, and 140 sheets, respectively, were in the 1691 sale of the Leiden scholar Snellonius.[75] The provenance of Bramer's series illustrating *Il Pastor Fido* (about 1645) is unknown, but this pastoral drama was popular at the court of Frederick Hendrick, to which Van Dyck and a team of Dutch artists (Bloemaert, Poelenburch, Dirck van der Lisse, and others) sent paintings based on Guarini's play.[76]

22
LEONAERT BRAMER,
Musicians in a Loggia (verso
of *Musicians in an Interior*,
fig. 285), ca. 1660. Brush
and gray ink, with gray
wash, on paper prepared in
yellow, 37.2 x 46.3 cm
(three pieces of paper
stuck together).
Amsterdam, Rijksprenten-
kabinet, Rijksmuseum

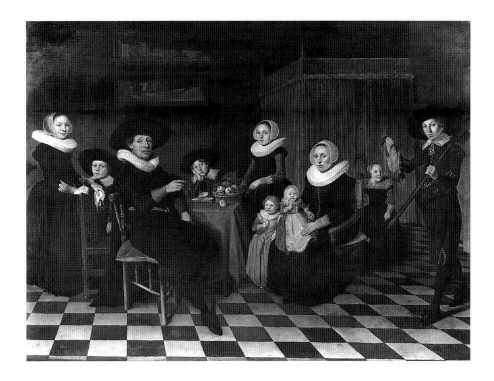

In retrospect, Bramer's claim to fame is that of an "inventor": he produced extensive series of drawings, an astonishing number of small, sketch-like paintings (one recalls the forty owned by Roomer in Italy), canvas murals, frescoes, and tapestry designs. There is some similarity with Adriaen van de Venne's output, as represented by his album of colored drawings in The British Museum and his paintings in grisaille.[77] The small painting by Bramer that is now encountered in a museum collection or in a sale room, where it appears as a comparatively minor work of art, was perhaps perceived originally as a fragment from a voluminous and celebrated oeuvre, one swirl in a steady stream of ideas. This may be why De Bie (1661) discusses Bramer as a draftsman, while Jan van Goyen and Herman Saftleven do not rate the same distinction in his book.[78] Bramer was admired for his imagination, for interpreting subjects and inventing compositions *uyt den geest*.[79]

In 1661 Bramer painted ceiling decorations for the meeting room of the Guild of St. Luke (while Cornelis de Man depicted a triumphal arch, incorporating the fireplace and overmantel). He received over a thousand guilders between 1660 and 1667 for his execution and conservation of the frescoed hall in the civic guard headquarters (fig. 20). At the same time, Bramer was producing designs for the leading tapestry firm in the United Provinces and making series of drawings for private collectors. While continuing to paint small works on wood and slate, he probably made a greater proportion of works on a larger scale than he had before. Then, in the late 1660s, Bramer painted canvas murals for all the walls of the main hall ("Grote Zaal") in the Prinsenhof and also embellished the wooden ceiling (see fig. 19).

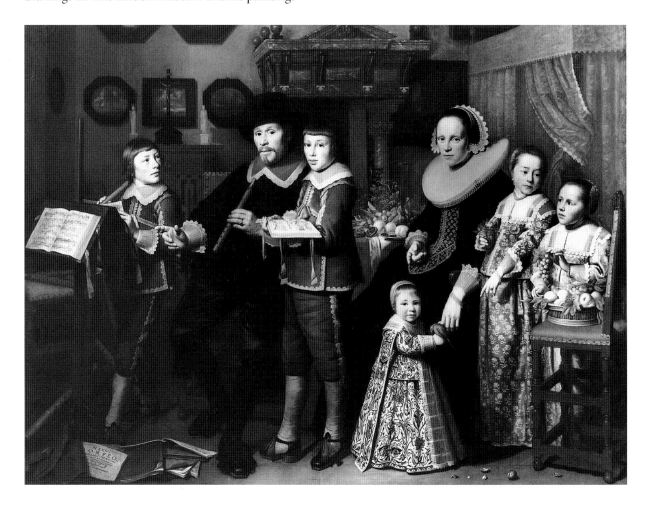

Which "Delft School"?

The various public and private commissions that Bramer received between the ages of sixty-five and seventy-five testify to his fame (if not his fortune) in the 1660s. But what does this say about the "Delft School," the one that supposedly came into existence when "innovative 'foreigners'" such as Potter, De Witte, Fabritius, and De Hooch joined Houckgeest and "weaker personalities" like Hendrick van der Burch, Daniel Vosmaer, and Hendrick van Vliet; or about the school represented primarily by De Hooch and Vermeer in the late 1650s and by Vermeer in virtual isolation after that? Of course, it is reasonable to assign considerable weight to what was new and would best be remembered in later centuries when characterizing a school. But if the city fathers, the civic guard, patrician families, and prominent dealers in Delft were assigned our textbook questions about who represented the Delft school and whether it revealed any continuity over the decades, what weight would they assign to Bramer as opposed to Vermeer? Or to the short-term visitors from out of town? Montias suggests that "the upper-classes of Delft with their fondness for fine craftsmanship and their sense of good taste could not fail to give a hospitable reception to the simplifying-clarifying ('classicizing') tendencies that were spreading over Holland at the time."[80]

That many of the most talented artists had died or left town by the early 1660s is an important consideration. Montias observes that the "burst of creativity [in the early 1650s] could scarcely have occurred if there had not been a critical mass to sustain it," meaning like-minded painters not patrons. "Because there were many painters in town [during the 1650s], young people had a choice of masters from whom to learn; a wide variety of ideas sprouted to fructify even the barest soil; and there were good statistical chances that an extraordinary talent such as Vermeer's would one day or another reveal itself. It is paradoxical that by the time Vermeer's talent had ripened the critical mass that had nurtured it had vanished."[81]

It is also paradoxical that this hypothesis concerning statistical chances and primordial clay omits the ingredient of patronage, considering that Montias, in the same volume and in *Vermeer and his Milieu* (where the painter's protector, Pieter Claesz van Ruijven, appears), treated that factor so fully in his discussions of the Delft school.[82] And it is our fault not his, for no one since Eisler and until Montias paid the slightest attention either to the question of patronage in Delft or to the character of the city, to say nothing of neighbors in The Hague. In the eras of nationalism, formalism, iconology, social context (ironically enough), the "art of

describing," and lit-crit mumbo jumbo (that is, ca. 1930-1980), Delft was discussed by art historians as a little Florence without any Medici, indeed with no society at all. As for the artists themselves, only certain ones counted: Montias claims that "Delft in 1640 could still not be said to host an original 'school' of painting" – why "original"?[83] This is like the American call for democracy in other countries as long as people vote for the right thing.

Some thought might also be given, when describing the Delft school of the 1650s and 1660s, to the older artists who were still around. A good example, after Bramer, is Palamedesz, whom Ekkart considers "a highly influential portraitist and genre painter in Delft in the third quarter of the seventeenth century."[84] In the year of his death he served as *hoofdman* in the guild and painted the *Elegant Company* in the Virginia Museum of Fine Arts.[85] The composition may respond to examples by De Hooch, but it is also consistent with interior scenes by Palamedesz dating from the 1630s (and with his family portrait of the same period; fig. 23).[86]

25
WILLEM VAN AELST,
Still Life of Fruit in a Basket, 1650.
Oil on canvas,
37.5 x 49.5 cm.
Private collection (photo: P. Cuming, courtesy Johnny Van Haeften Ltd., London)

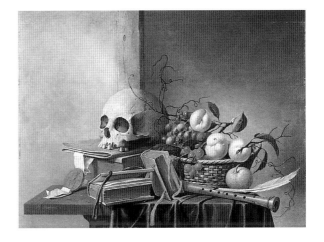

26
HARMEN STEENWYCK,
Vanitas Still Life with a Skull, Books, and Fruit, ca. 1650.
Oil on panel, 58.9 x 74 cm.
Instituut Collectie Nederland

Hendrick van Vliet had also been a portraitist in Delft during the 1630s (see fig. 24) and after 1650 continued in a style reminiscent of both Willem van Vliet and Palamedesz.

As discussed below, and at greater length in *Vermeer and the Delft School* (the catalogue of the exhibition in 2001),[87] there were consistent traditions not only of portraiture but also of history painting, still-life (especially flower pictures), landscape, and certain kinds of genre painting in Delft during the first half of the seventeenth century, and to some extent these traditions continued into the period of the "Delft School" as it is usually defined. According to this view of Delft, certain characteristics of style and expression were not welcomed into the city as they spread around Holland (for example, the "classicizing tendencies" to which Montias refers) but were already evident in the oeuvres of local artists. If the Delft school may be considered (as it is here) to consist simply of all the painters who worked there during the city's years of artistic efflorescence – that is, from about 1600 to about 1675 – then the key questions are not who introduced daylight, perspective, or "perfect truth to life" into Delft painting,[88] but what conventions of form and meaning were regional (and therefore help to define the Delft school), which qualities were more precisely distinctive of Delft, and, finally, what was personal but part of the story because it happened there.

Painting in Delft after 1650

The preceding section offers a somewhat different view of the Delft school than that found in earlier surveys. The writer would prefer to qualify Montias's statement that Delft "was no place for high-class patronage,"[89] which he defends by noting that the court moved from Delft to The Hague before 1600, and that the Princes of Orange did not award many commissions to artists in Delft. Speaking strictly of known commissions (apart from Van Miereveld's portraits), this is true enough. But the suggestion that the arts in Delft represent a routine level of patronage is hardly consistent with the quality and character of the paintings discussed in this volume, to say nothing of tapestries, silver, and so on. Van Miereveld, Bramer, Van Couwenbergh, Palamedesz, Potter, Houckgeest, Hendrick van Vliet, Vermeer, and others all worked for "high-class" patrons, if some of the leading figures at court, in the national government, and in Delft society may be considered a notch above "middle-class."

The approach taken here mostly concerns matters of style, quality, and fashion. These considerations suggest that the city's immediate proximity to The Hague was important to many of Delft's artists and artisans, especially tapestry weavers, silver- and goldsmiths, jewelers, faience workers, portraitists, and history painters. In addition, Delft and The Hague both were home to numerous wealthy individuals, including city officials, prominent merchants, and some of the art dealers and artists themselves (Van Miereveld, Palamedesz, Van Velsen, Houckgeest and others were fairly well off). For this level of clientele, which must have offered "high-class patronage" on occasion (Montias's surveys of prices for pictures and values of estates tend to bear this out), the Dutch court would have presented models of taste, or at least set a certain tone. Whether this influence produced conservative or fashionable, frivolous or intellectual results would have depended upon the individual patron, who might have been from one of Delft's most distinguished families, or might have been a newly rich merchant keen to make his own kind of princely display.

Of course, this presumed milieu of sophisticated patrons in Delft and The Hague must be placed in a broader context. There were plenty of cheap pictures produced and sold in Delft. Montias found that about half of the attributed paintings in Delft inventories between 1610 and 1680 were by masters who never worked there, and he cites numerous examples of Delft paintings being sent some distance away.[90] The number of unattributed paintings in Delft inventories is also significant. For the most part, the present study focuses upon the upper levels of the art market. But this in itself is meaningful. In a discussion of the Haarlem school one would be concerned with a higher percentage of comparatively inexpensive pictures; the most representative artists include the tonal landscapists, painters of peasant scenes, portraitists such as Frans Hals and Johannes Verspronk, and so on. The most representative works of the Delft School were by artists who commanded higher prices, such as Van Miereveld, Van der Ast, Van Couwenbergh, and Houckgeest.

The differences in value are reflected in those of style. A three-quarter-length portrait by Van Miereveld cost considerably more to produce than one by Hals or Verspronk, and brought more than a proportionately higher price. The dominant styles of still-life and architectural painting, and even of landscape in Delft, were labor-intensive as well as fashionable. Van Geel and Van den Bundel, as discussed above, and more obscure landscapists such as Pieter Stael and Simon Jordaens, worked almost exclusively in a Flemish manner similar to that of Roelant Savery and Alexander Keirincx, both of whom were collected at court. Pieter Groenewegen's style was compared above with Poelenburch's. Similarly, still-life painters in Delft, from the obscure

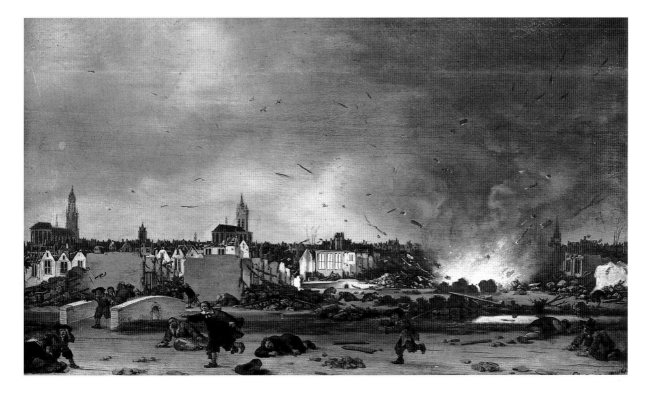

27
Egbert van der Poel,
*The Explosion of the Powder
Magazine in Delft,
12 October 1654*, inscribed
12 oct. 1654.
Oil on panel, 37 x 62 cm.
Amsterdam, Rijksmuseum

Elias Verhulst (d. 1601) to Jacob Vosmaer, Van der Ast, and the Van Aelsts, may be associated with court favorites such as Savery, Bosschaert, De Gheyn, and Jan Baptist van Fornenburgh.[91] Very little resembling Haarlem landscape and still-life painting was produced in Delft before mid-century, when the minor artist Pieter van Asch responded to Haarlemmers such as Cornelis Vroom and Salomon van Ruysdael and to the Rotterdammer Simon de Vlieger (who lived in Delft from 1634 until 1637 or 1638). And nothing like Jacob van Ruisdael's dramatic style of the 1650s ever took root in Delft, where the view of nature remained mostly Arcadian throughout the century.

The genre of architectural painting is discussed in Chapter Three. The main representatives, Houckgeest and Bartholomeus van Bassen, were also "high genre" painters in a manner distinctive of South Holland (see figs. 120, 191). Their scenes set in grand salons and imposing courtyards are quite unlike what came out of Haarlem and Amsterdam (except when Dirck Hals provided figures for the Middelburg architectural painter Dirck van Delen; see fig. 196). In my view, the "court style" of architectural painting (as represented by Van Bassen, Van Delen, Houckgeest, and Hendrick van Steenwyck II) was important for Palamedesz, De Hooch, Vermeer, De Man, and others (as discussed in Chapter Four), whose pictures of the 1660s in particular could be said to represent a gentrification of middle-class genre scenes.[92]

The decline of court patronage and influence after the deaths of Frederick Hendrick (1647) and Willem II (1650) and perhaps some changes in Delft society must be partly responsible for transformations in Delft painting during the 1650s and 1660s. In earlier decades the older noble and patrician families of Delft tended to remain aloof from newly arrived manufacturers and merchants. The latter became more important in the stadholderless period, taking over civic offices and playing a greater rôle in the arts.[93] Reliance upon dealers, public sales, and the export of pictures to other cities (including Antwerp and others in neighboring countries) evidently increased after mid-century. As mentioned above, the much more active art market in Amsterdam proved irresistible for a number of Delft painters.

Painters in Delft and The Hague could be described as even more outward-looking during the third quarter of the century than they were before. Van Dyck, not Van Miereveld, was the model of Hanneman, Jan Mijtens, and Jan de Baen. Abraham van Beyeren (who lived in Delft from 1657 to 1663, but worked mostly in The Hague from 1640 to 1669) and a few other still-life painters working in a modern manner, as well as Ter Borch's former pupil Caspar Netscher (from 1662), also worked in The Hague. The most innovative artists in Delft during the 1650s – Houckgeest, De Witte, Fabritius, De Hooch, and Vermeer – could very broadly be said to have combined qualities that had previously distinguished painting in Delft with new trends in subject matter and style that had earlier been more at home in Haarlem and Amsterdam. Of course, this is a drastic simplification, and what developed in Delft was part of a larger picture in the Netherlands and Northern Europe. No city in the United Provinces had previously been so influential as Amsterdam became in the 1650s, and Holland as a whole was becoming more cosmopolitan in this period of

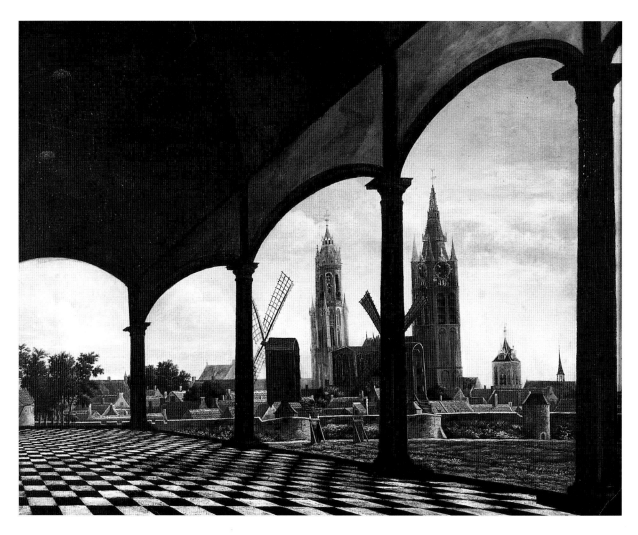

DANIEL VOSMAER,
*A View of Delft Through
an Imaginary Loggia*, 1663.
Oil on canvas,
90.5 x 113 cm.
Instituut Collectie
Nederland (on loan to
Delft, Stedelijk Museum
"Het Prinsenhof")

comparative peace and prosperity, exploration and trade.

Thus the Delft school as it is usually conceived (a small circle of artists active there at some time during the 1650s) could almost be said to have become less coherent and less distinguishable from schools elsewhere than it had been during the first half of the century. But this is not quite correct. Not only did characteristics of the earlier Delft school persist after 1650, but the most remarkable Delft artists of the 1650s and 1660s do reveal common interests in certain subjects and formal qualities: the use of artificial perspective to depict actual environments (most often restricted spaces, whether in churches or houses, courtyards or streets); the realistic description of light effects, including candlelight, moonlight, and firelight (to give Bramer and Van der Poel their due), but especially daylight as experienced out of doors and in various kinds of interiors; other optical concerns, such as color values, the actual appearance of contours and modelling, the impression of mass and volume, the relative scale of things; and the suggestion, through painterly means, of sensations other than those that are visual, such as the experience of textures, dampness and dryness, coolness and warmth. But what may be most remarkable in the rendering of these qualities, which were observed variously by such artists as De Witte, Fabritius, De Hooch, and Vermeer, is the subjective element, the apparent response to what the individual painter considered visually absorbing or beautiful. For Fabritius and Vermeer this was occasionally the appearance of people, the way a living and thinking figure appears in a mirror, or to the eye, and possibly in paint.

Much of this was new in Delft. Fabritius's *Self-Portrait* in Rotterdam (fig. 30) departs stylistically from the South Holland tradition and recalls Rembrandt at his most visually evocative (for example, in the faces of the Vienna and Kenwood self-portraits).[94] Similarly, De Witte's early church interiors (pls. IX, X), while they owe a considerable debt to Houckgeest's contemporary examples in terms of composition, bear little resemblance in their execution and suggestion of light and space to Van Bassen's and Houckgeest's architectural views of the 1630s. It hardly needs saying that Vermeer's technique and most distinctive stylistic qualities likewise have few precedents in Delft before 1650. But one must be careful to distinguish what was of interest to artists and patrons from what was possible at a given time and place. Vermeer himself would never have become the Vermeer we know if he had worked in Delft a generation earlier. Neither would

he have become the same artist – and this is one of the conclusions of this book – if his career had run its course during the same years (ca. 1653 to 1675) not in Delft but in Haarlem, Amsterdam, or Utrecht.

In subject matter as well as style there were changes in the Delft school after 1650 that were part of developments extending well beyond the city walls. Any worthwhile study of De Hooch or Vermeer will mention the related interests of artists such as Ludolf de Jongh in Rotterdam, Gerard Dou, Frans van Mieris, and others in Leiden, Gerbrand van den Eeckhout and Jacob van Loo in Amsterdam, Gabriël Metsu in Leiden and Amsterdam, and of course Gerard ter Borch in Amsterdam, The Hague, Deventer, and elsewhere. A large proportion of the so-called "high genre" paintings that flourished in the 1650s and 1660s consists of scenes of middle-class or patrician life that differ in tone and to some extent in meaning from what had been depicted before. In the South Holland area alone, one could trace an evolution from Esaias van de Velde (who often collaborated with Van Bassen at The Hague) to Palamedesz's scenes of polite company set in gardens (fig. 223), and from his and Van Velsen's paintings of the 1630s and 1640s (figs. 3, 4, 186) to De Jongh's and De Hooch's pictures of cavaliers and young women socializing. But this was part of a much larger "development" (the academic term for changes in fashion) in Holland and Flanders. De Hooch's more domestic subjects (see figs. 234-36, etc.), by contrast, may be considered a Dutch phenomenon with fewer precedents in the first half of the century. His tender scenes of home life, regarded by some writers as quintessential examples of the Delft school, are actually less typical of taste in his adopted city than are De Hooch's and Vermeer's paintings of fashionable couples acting (or pretending to be) refined. It is true that De Hooch's apparent affection for mothers and children, laundry and polished floors was shared with painters such as Hendrick van der Burch, Esaias Boursse, Pieter Janssens Elinga, and Jacobus Vrel, who have collectively been called "the School of Pieter de Hooch."[95] But virtually none of the similar images by those artists was painted in Delft, and only Van der Burch (De Hooch's brother-in-law) was closely connected with the town.

Townscape painting was also something new in Holland during the 1650s, although its sources in printed and painted profiles of cities and other earlier images are numerous and include the pendant profiles of Delft that were painted by Hendrick Vroom in 1615.[96] The various views of Delft that were painted by Van der Poel, Daniel Vosmaer, Fabritius, and Vermeer (figs. 27-29; pls. I, III) have been discussed by some historians as if they comprised a coherent genre, but Van der Poel's and

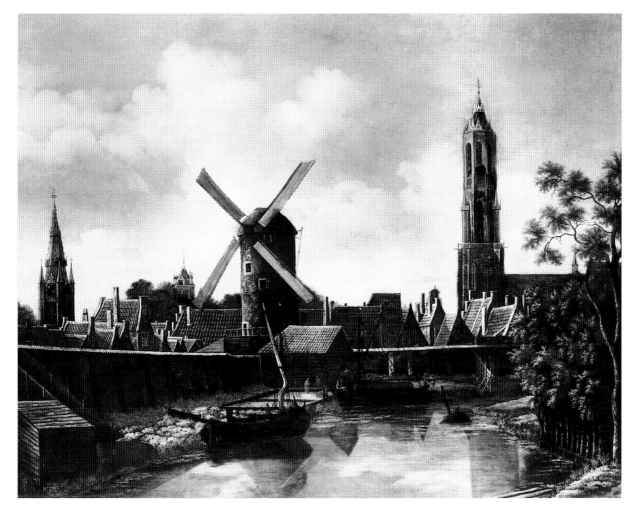

29
DANIEL VOSMAER,
A View of Delft from the South, ca. 1660?
Oil on canvas,
85.5 x 101 cm.
Ponce, Puerto Rico,
Museo de Arte de Ponce,
The Luis A. Ferré
Foundation

Vosmaer's souvenirs of the Delft "Thunderclap" and its aftermath are not townscapes in the usual sense (which concern civic pride, not disaster), and Fabritius's small *View in Delft* is also something quite unlike the large paintings of Delft from outside the city by Vosmaer and Vermeer. Of all the nominally architectural views, the one most comparable to the "perspectives" painted earlier in The Hague and Delft by Van Bassen, Houckgeest, Van Steenwyck, and others is the most eccentric example of townscape painting to date from after 1650, Vosmaer's *View of Delft Through an Imaginary Loggia* (fig. 28).

Like the architectural painters, the townscapists in Delft were connected by personal relationships. This aspect of the Delft school can hardly be overestimated. Every artist in the city, which took about fifteen minutes to walk across, either knew or had some clear idea of almost every other member of the painters' guild, and many of them were related, neighbors, or professionally associated in some way. Fabritius was a neighbor of Egbert van der Poel,[97] whose family knew the Vermeers,[98] and it may be assumed that the sons of Jacob Vosmaer, Nicolaes and Daniel, were well known at least as members of the guild (which they joined in 1645 and 1650, respectively; Daniel was inscribed three days before Van der Poel).[99]

Fabritius is said to have contributed some sketching in chalk (perhaps corrective, not preparatory) and retouching to a "large" painting by Daniel and Nicolaes Vosmaer that was moved from the Town Hall to the Prinsenhof (the same picture appears to have been "hanging in the Town Hall" in February 1653).[100] Brown reports that the subject is "described simply as a 'marine,'" but the documents state that the painting was a "landscape" by Daniel Vosmaer with a "sea- or ship-part" by his brother Nicolaes, and that the landscape was the much better part of the picture (*dat het landtschap in 't selvige groote stuck schilderije gestelt ongelijck beter ende konstiger is gemaeckt, als de zee ofte het scheepstuck is*) and the part that Fabritius mainly retouched.[101] The apparent non sequitur of a prominent "landscape" which features some kind of "scheepstuck" (the notary was taking down oral testimony, without seeing the picture) suggests that the painting depicted one of Daniel Vosmaer's usual subjects, a townscape with water and boats in the foreground, as in his *View of Delft* in Ponce, Puerto Rico (fig. 29). Indeed, one might wonder whether the Ponce canvas is in fact the painting in question: the subject is appropriate to the Town Hall; the size is large enough to be so described by a Delft notary; and the picture reveals pentimenti in its architectural parts.[102] However, the painting appears to date from somewhat later, and another work by the Vosmaers may well have been meant.

Carel Fabritius

Fabritius's importance to the Delft school, as noted above and elsewhere in this volume, has been the subject of considerable conjecture. Historians of art have aped early anthropologists in assuming that missing evidence, the gap in a sequence from master to master or from monkeys to mankind, must have been the most crucial material for our understanding of an evolving species, subject, or style. The same sense of loss has been expressed in connection with Delft church interiors (how else can one explain Houckgeest's unexpected achievement in 1650?; pl. II); with respect to the history of Dutch genre painting (Koedijck's best works lost at sea!); and with regard to Vermeer's early career (did he train in Utrecht or Amsterdam? with Bramer? did he know Fabritius?). The problem, in part, appears to be that works of exceptional quality, as well as the kind of genius that quickly comprehends the essence of an artistic convention or style, are not factors easily grasped or explained by means of a historical outline or narrative.

The missing evidence in Fabritius's oeuvre consists, in so far as is known, of some portraits and easel pictures of other kinds, and illusionistic works of art, especially murals. It is likely that only the last-named paintings would tell us substantially more about the artist's achievement, although even here we have Van Hoogstraten's report that they involved linear perspective, the related evidence of *A View in Delft* (pl. III), the context of contemporary architectural and townscape painting, what is known of Bramer's murals (figs. 19, 20), and the precedent of murals painted in Italy and at the Dutch court.

As for Fabritius's work in relation to De Hooch and Vermeer, enough evidence survives to make a reasonable assessment. Brown notes that two aspects of Fabritius's oeuvre, perspective and genre painting (with particular attention to illusionism in the first case and the immediate environment in the second), have been discussed in connection with his younger colleagues (in 1650 Fabritius was twenty-eight, De Hooch twenty-one, and Vermeer eighteen).[103] These comparisons are convincingly dismissed by Brown, who cites the many other painters involved in the same pursuits.

On balance, the most interesting aspects of Fabritius's style for De Hooch and especially for Vermeer are found in his palette and in his application of paint. More than such artists as De Witte or Potter, Fabritius developed a technique for describing forms in space that anticipated Vermeer's. Visible drawing, in the usual sense of employing line to articulate contours and details, is minimized in favor of thin, fluid, fairly bright strokes and areas of paint. The bird in *The Goldfinch* (fig. 32; pl. V) illustrates this handling in condensed form, while

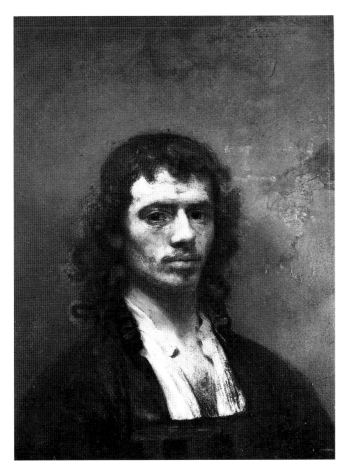

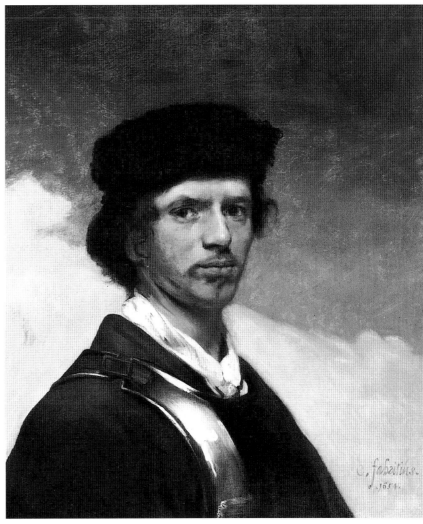

The Sentry (fig. 34, pl. VI) demonstrates its application to the hard edges of architecture seen at close range. In the latter canvas Fabritius seems sympathetic to De Witte in Delft (between 1650 and 1652) and relevant to De Hooch's courtyard views of about 1657-60. But the work by Fabritius of greatest interest for Vermeer as a painter of figures and objects is the London *Self-Portrait* of 1654 (fig. 31). The planes of the face are described by thinly applied layers of color which for the most part suggest the surfaces' reflection or absorption of light. The shadows are transparent, the hair almost textureless, while the torso and even the cuirass are rendered in shifting values of closely related tones. Contours are softened by what look like pentimenti, not revisions but blendings and overlappings of colors which suggest naturalistic effects of light, atmosphere, and focus. The technique evades what the eye, particularly a pair of eyes, cannot apprehend, which is a clear line in nature, comparable to one drawn or engraved.

There are signs of other optical interests in paintings by Fabritius, especially in *A View in Delft*. The illusionistic space of that picture (in my reconstruction) is complemented or enhanced by juxtapositions of color, shifts in focus and scale, and an overall luminosity. The famous goldfinch, for its part, seems to twitch in response to the viewer's intrusion; the sense of motion strikes one as an optical, not a narrative, effect. We might compare the glove in Rembrandt's *Portrait of Jan Six* (Six

Collection, Amsterdam), which also dates from 1654, but it is the head in that painting and also the hands and clothes (the cloak, with its shifting reflections) that most deserve comparison with Fabritius's *Goldfinch* and *Self-Portrait*. The claim that Fabritius served as some kind of link between Rembrandt and Vermeer has often been made, always ambiguously. The value of it, apart from offering a shorthand description of a generational shift, lies in its tribute to three artists with an interest in optical effects and the painterly means to suggest them.

A writer like Lawrence Gowing might be able to describe in a reasonable number of evocative words how Fabritius's technique developed with an eye to naturalistic representation. Ideally this would be done in a gallery with the Rotterdam and London self-portraits set side-by-side (figs. 30, 31). The former is close in technique to Rembrandt, who in the course of his extraordinary evolution never abandoned the suggestion of tactile sensations and the use of tonal contrasts to describe three-dimensional forms. Fabritius's use in the later self-portrait of lighter colors more thinly applied, and in some passages "a more delicate and precise definition of detail," has been noted by Brown, who suggests that "these changes of palette and technique came

30
CAREL FABRITIUS,
Self-Portrait, ca. 1648-49.
Oil on panel, 65 x 49 cm.
Rotterdam, Museum
Boijmans Van Beuningen

31
CAREL FABRITIUS,
Self-Portrait, 1654.
Oil on canvas,
70.5 x 61.5 cm.
London, The National
Gallery

32
Carel Fabritius,
*The Goldfinch ("Het
Puttertje"),* 1654.
Oil on panel,
33.5 x 22.8 cm.
The Hague, Koninklijk
Kabinet van Schilderijen
"Mauritshuis."
See also plate v.

Rembrandt, in suggesting human character or describing moral dilemmas would not have hindered his progress toward a more exclusively optical approach.

Fabritius moved to Delft in about 1649 or 1650 (his soon-to-be second wife, Agatha van Pruyssen, and the painter were described as "both living in Delft" when their betrothal was announced on August 20, 1650).[106] This brought him into an artistic milieu very different from the one in which he had trained. As mentioned above, the South Holland tradition of describing visual experience placed greater emphasis upon precise description, traditional craftsmanship, and drawing, including linear perspective. In *A View in Delft* and presumably in his lost murals Fabritius made his largest adjustments to local taste. It would be interesting to know where the Rotterdam *Self-Portrait* (fig. 30), which probably dates from about 1648-49, was painted. The date on the portrait of Abraham de Potter (Rijksmuseum, Amsterdam), who was an Amsterdam silk merchant, may be read as either 1648 or 1649.[107] In any case, Fabritius's direction is already indicated in paintings of the 1640s, and in Delft Rembrandt was never completely out of mind.

No painting by Fabritius relates him more closely to his younger colleagues in Delft than his small townscape of 1652 (see Chapter Two). However, *The Goldfinch* (fig. 32; pl. v) is intriguing for its manner of execution, its optical qualities, and its illusionism. The term "optical" is used rather indiscriminately by art historians but seems justified here in its secondary meaning of "relating to vision" rather than "to the science of optics." Other artists of the period achieved realistic effects in this very motif (within the context of genre painting) and in still lifes of dead birds. However, one rarely has the sense that the behavior of light and shadows on various surfaces and the projection of forms from a flat surface and into the viewer's space (the wall is identified with the painting's surface over most of its area) are the essential concerns of the artist, as they seem to be here. The painting is far more complex and subtle than it first appears, although the first impression must have been given considerable thought. The description of the ring and chain, for example, seems to dwell upon how these thin metal objects appeared under certain conditions, not how they were made. The two round wooden perches cast differing shadows on the box and the wall, as do the bird's tail and body. The various shadows cast by the box itself could illustrate a page in one of Leonardo's notebooks, except that one takes it all in at a glance. The double shadow cast by the bracket to the lower right, one nearly opaque and the other quite transparent, is an effect often described by Vermeer. When seen from a certain distance (especially if the frame is

about as a result of his contact with other painters in Delft and were themselves to influence painting there after his death."[104] The only drawback to this analysis is its traditional underestimation of Rembrandt's interest in visual experience for its own sake,[105] which appears to have made an impression upon Fabritius and to a lesser extent Van Hoogstraten and other Rembrandt pupils of the 1640s and early 1650s.

Fabritius's development of a technique different from Rembrandt's in a fairly brief span of time is not surprising. He was an artist of a younger generation, and perception as well as representation depends greatly upon personality, especially in the case of an individual with such independent ideas. The fact that Fabritius had little interest, compared with

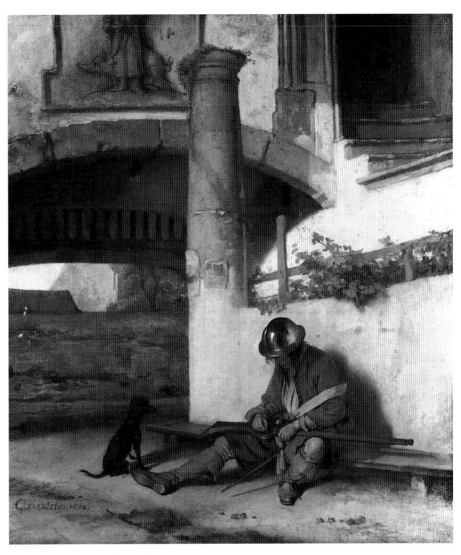

masked from view) the bird's displacement from the ground plane appears more pronounced; the paint strokes blend together, the bird's body seems more oblique, and the stronger colors on the wing and head, wedges of black and yellow, contrast with the duller, less well defined feathers in a way that enhances the impression of a soft, rounded form. Viewing distance is also crucial in most paintings by De Witte and in some by Vermeer.

Brown reviews the iconographic interpretations of *The Goldfinch*, which he properly downplays in favor of its appeal as an illusionistic work of art.[108] His reference to Cornelis Lelienbergh's *Still Life of Finches* in the Philadelphia Museum of Art seems especially appropriate, since the work was painted at about the same time in The Hague.[109] Brown also considers the conjectural reconstructions of how *The Goldfinch* might have been mounted as part of a wall cupboard or piece of furniture. He stresses the trompe-l'oeil aspect of the picture, regardless of how it was originally seen, and cites Jacopo de' Barbari's *Sparrowhawk* of the early 1500s (National Gallery, London) as an analogous work.[110] Both paintings recall even earlier motifs, such as the caged parrot revealed inside a partially open cupboard in the intarsia decorations (finished 1476) in the Duke of Urbino's *studiolo* in his palace at Gubbio (fig. 33).[111] Perhaps Fabritius was aware, through Bramer or some other local figure, of the tradition of illusionistic decoration at the Italian courts, although there is no reason to suppose he had any visual evidence.

The Sentry (fig. 34, pl. VI) shares with *The Goldfinch* its placement of the main motif against a

brightly lit wall; the young soldier's heavy shadow indicates the intensity of (early morning?) light. An old column, now useless except for posting notices, lifts the eye from the slumped figure to that of Saint Anthony Abbot and his pig. The holy man's companion draws attention to the dog, who looks alert and loyal. Outside the gateway, in which the portcullis is raised, there appears to be a narrow roadway, and a wall behind which one sees a rooftop, a tree, and the sail of a boat. In the foreground, there is unobtrusive evidence (at least by Potter's standards) of cows and horses in the neighborhood.

Brown states firmly that "the soldier is not sleeping," although his posture, the slipped sword-belt, and the situation – a solitary soldier sitting in the sun – suggest that he is not wide awake.[112] The sentry is not holding a powder charge (unless it is glued to his fingertip), and he would not prime the pan of the musket with the gun lying on its side.[113] Brown's proposal that the soldier's behavior "may possess no more symbolic significance than the instrument seller in the *View in Delft*" may be accidentally on the mark, since the latter figure (who is not selling anything) is nearly as idle as the soldier. The relief of Anthony Abbot is hard to explain except

33
A caged parrot in a cupboard (detail of the intarsia decorations in the Gubbio Studiolo, completed in 1476). New York, The Metropolitan Museum of Art

34
CAREL FABRITIUS, *The Sentry*, 1654. Oil on canvas, 68 x 58 cm. Schwerin, Staatliches Museum Schwerin (photo: Elke Walford, Fotowerkstatt Hamburger Kunsthalle). See also plate VI.

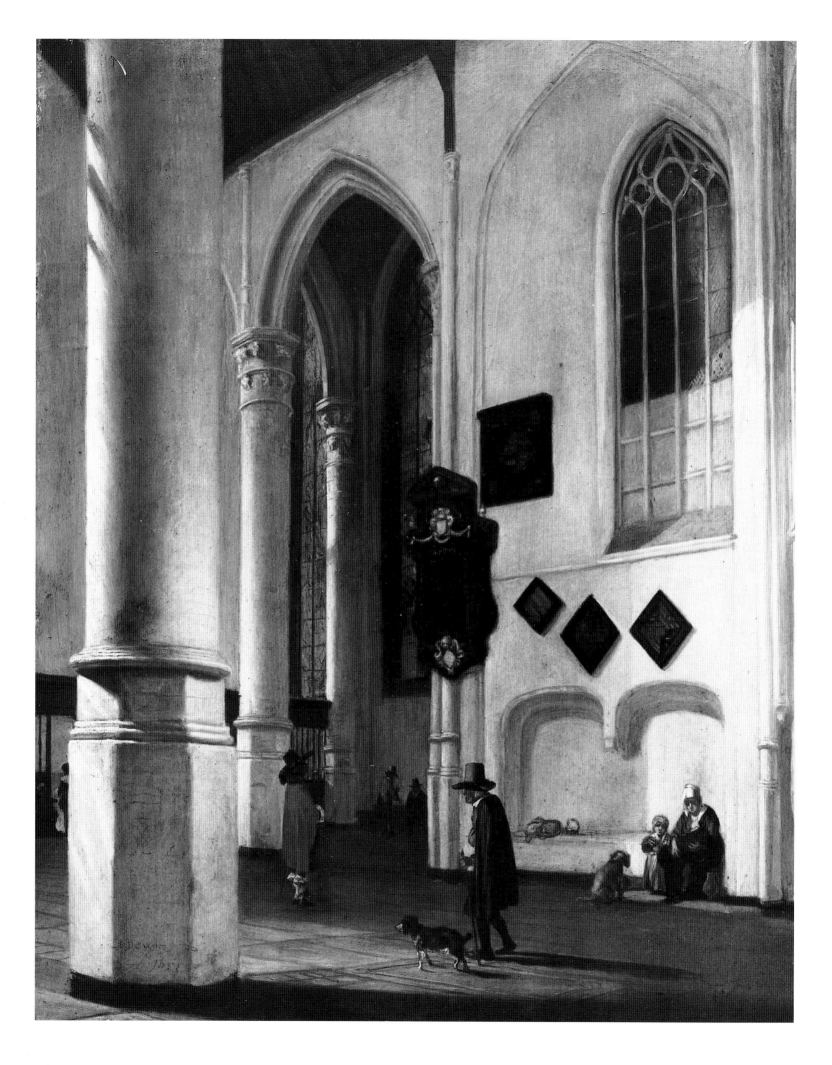

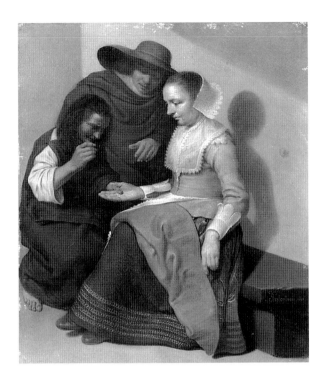

as a reference to diligence: the hermit monk was famous for overcoming temptation through hard work and will power.[114]

That the painting may have a conventional meaning, which is consistent with that of Barent Fabritius's *Seated Soldier with a Pipe* (Galleria Nazionale d'Arte Antica, Rome),[115] does not diminish its descriptive and aesthetic qualities. The composition recalls, oddly enough, Van Velsen's *Fortune Teller* (fig. 35), and several of De Witte's luminous church interiors, in which a column anchors gently oblique recessions, and a figure seated against a sunlit wall is sometimes found (as in fig. 36, where a dog also occurs). Even the idea of an edifying relief or monument overhead could have been inspired by one of De Witte's Delft church interiors. Fabritius's memories of Amsterdam might also have stimulated his imagination, since there was a real "Saint Anthony's Gate" at the end of the Jodenbreestraat, where he studied with Rembrandt.

Fabritius's paintings of 1652-54 appear to have made an impression on his brother Barent, who lived in Leiden, and there is no reason to doubt the widespread assumption that they also influenced De Hooch and Vermeer. *The Sentry* is perhaps the most interesting picture for De Hooch. He probably would have appreciated the handling of the architecture, with its attractive textures and tones, the nice balance of different shapes, the view through an archway, and a stairway leading into a shadowy room. The palette overall, the daylight shining from walls and searching into the deepest shadows, and the effect of a figure set against a background much brighter than itself are devices adopted by De Hooch three or four years later. Fabritius was not their inventor. He simply painted some of the finest

examples of ideas that were in broader circulation, as comparisons with De Witte, Houckgeest, Vermeer, and other painters of the 1650s reveal.

Fabritius and Vermeer

Vermeer's style is our main concern in Chapter Five. He had such an eye for the value of formal ideas, whether new or traditional, that the most perceptive borrowings by De Witte and Fabritius may seem prosaic by comparison. The pleasure of observation has more to do with a painting like *The Sentry* than does clever invention. Nonetheless, there are passages in Vermeer that might have been inspired by such a work by Fabritius, like the receding wall, the transparent shadows, and the highlight on the arm of the chair in *Christ in the House of Mary and Martha* (pl. XVIII), the luminous floor in the background of *A Maid Asleep* (pl. XX), and the worn wood and stone textures in *The Little Street* (pl. XXV).

Vermeer's borrowings from other artists are often difficult to trace, because of his adroit transformations and his practice of judging conventions against reality. Fabritius precedes Vermeer in this; their similarities are mostly a matter of sympathetic interests rather than influence. But Vermeer must have admired Fabritius's technique, which had a greater range than that of any earlier artist in Delft. The manner employed in *The Goldfinch* and *The Sentry* would have encouraged an astute young painter working within the local tradition of close observation to see forms and space more in terms of light and color, of visual incident rather than of tangible detail. Whether this development was characteristic of the Delft school, rather than of a few artists who happened to work there during the 1650s, is uncertain. The question comes up frequently in the following chapters, but the answer is less interesting than the evidence.

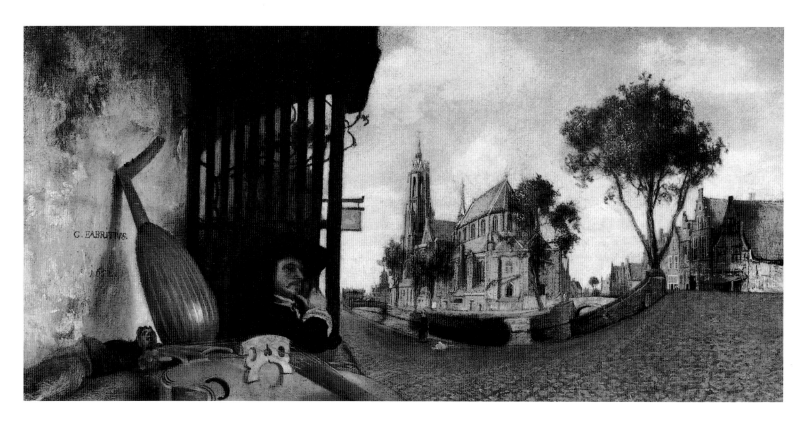

37
CAREL FABRITIUS,
A View in Delft, 1652.
Oil on canvas,
15.5 x 31.6 cm.
London, The National
Gallery. Photograph after
cleaning in 1993.
See also plate III.

38
Photograph of the Nieuwe
Kerk in Delft from
Fabritius's vantage point

39
Postcard photograph
of the Nieuwe Kerk in
Delft, ca. 1900.
Delft, Gemeentelijke
Archiefdienst

Chapter Two

A View in Delft by Carel Fabritius

A View in Delft (fig. 37, pl. III) represents a man sitting at a table on a street corner in the center of Holland's third oldest city. The Nieuwe Kerk (New Church), known throughout the Netherlands as the burial place of William the Silent (Willem I) and, by 1651, of three other Princes of Orange (Maurits, Frederick Hendrick, and Willem II), is seen from the southeast and as strongly receding, so that the choir plays a large part in the architectural view. A similar effect is found in photographs of the site (figs. 38, 39), which has not changed in its broad outlines, except that the canals of the Oude Langendijk on the left and of the Vrouwenrecht on the right have been filled in, the first house on the right has not survived, and a taller steeple was added to the church tower in 1872.[1]

Houckgeest's example

The same choir is featured prominently in Gerard Houckgeest's broad interior view of the Nieuwe Kerk dating from the previous year (fig. 41, pl. VIII). In that sweeping and doubly receding design, which is oddly analogous to Fabritius's composition, Houckgeest surveyed as much of the church interior as is possible from a vantage point at the exterior wall in the southeast turn of the ambulatory. His essential subject is the famous tomb of William the Silent in its place of honor, the choir, but the entire length of the church is shown on the left, where the westward view to the southern aisle in the distance runs parallel to the Oude Langendijk in *A View in Delft*. Thus it may be said, if only figuratively, that Fabritius, in order to record the Nieuwe Kerk and its surroundings, stepped back about one hundred meters from Houckgeest's vantage point (see fig. 42).

The impression that Fabritius, who was Houckgeest's junior by twenty-two years, admired his colleague's composition is enhanced by various points of correspondence between the townscape and the church interior. Some of the similarities are obvious, while others are vague and unexpected, as in cases of unconscious adaptation, coincidence, or artistic affinity. For example, when Fabritius placed his careful rendering of the Nieuwe Kerk in a position comparable to that of Houckgeest's tomb, he seems also to have substituted a row of gabled houses for the ambulatory windows that extend (and tend to flatten) to the right, a pattern of cobblestones (which diminish in size with distance) for the fanning floor of tiles, and trees for columns with leafy capitals. The last comparison in particular is far-fetched, of course. It is simply interesting that Fabritius placed such a prominent tree to the right and that its diagonal relationship with the trees close to the church has a spatial effect similar to that of Houckgeest's columns.

Dutch artists, despite their reputation for describing actual appearances, were so adept at adopting compositional patterns and absorbing visual cues that it is often more appropriate to speak of a common language and common interests than to cite examples of influence. Thus, the way in which Fabritius's pavement and distinctly drawn canal – one writer mistook the waterline on the opposite quayside for a railing running along the Oude Langendijk[2] – resemble the tiles, the baseline (formed by stone slabs between the columns), and the long curve of the column bases in Houckgeest's composition is essentially the result of artists with like goals responding to similar situations.[3] A comparison of other details in the two paintings leads one to the same unsurprising conclusion. Fabritius seems to have used the backlit bridge over the canal on the left to pace the recession, which resembles the way that Houckgeest's open choir screen on the left stops the eye and at the same time allows it to continue on. To the right in both pictures, strolling men clarify distance and scale.

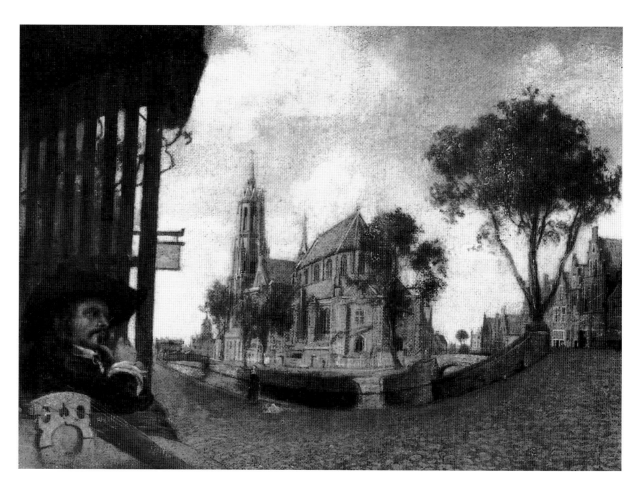

Similar staffage was employed frequently in both genres. However, the woman in the center of the townscape is noteworthy. She has set down some material (perhaps linen, or a covered basket) and apparently looks toward the church. One recalls the paintings by Houckgeest in which figures contemplate William the Silent's tomb (see figs. 98, 142, 145) and church interiors by other artists in which one or two figures direct the viewer's attention to some significant motif (as in fig. 144). Of course, the seated man himself looks toward the church and raises his thumb to his chin in a thoughtful gesture. Virtually the same pose is assumed by Ferdinand Bol's philosophical astronomer in a canvas also dated 1652 (National Gallery, London).

It is not any motif, but the broadest aspects of Houckgeest's panoramic design (fig. 41), that seem important for Fabritius's picture. Perhaps the older artist's invention, which among other things is a virtuoso demonstration of linear perspective applied to the particular problem of a wide-angle view, suggested to Fabritius how he might record the same building from the exterior. He would have observed (as one does when studying Houckgeest's panel in the original) that the Tomb of William the Silent, despite its small scale, attracts notice with its detailed pattern and mass, and also because of its strategic placement as a cornerstone within the perspective scheme (like a building at the intersection of two streets). The way the eye is then drawn into the left background of

Houckgeest's design could have made Fabritius aware that the Town Hall in the distance of *A View in Delft*, although hardly conspicuous, might become a focal point within the composition. The trellis in the townscape, which supports some kind of roof (the area is abraded) over the seated man's head, bears some resemblance in its spatial effect to Houckgeest's choir screen, but this is probably coincidental (more likely sources are suggested below). An artist, especially a perspectivist, might also have noted an analogy between the rectangular tombstones to the lower left in the church interior and Fabritius's viol and table top, which helpfully interrupt the repetitive patterns of the ground planes as they stretch toward the limits of view. An artist might also have been inclined to compare the shop sign in the townscape with the flags in Houckgeest's choir, since these motifs serve to link zones of space and to articulate voids. But artists do not appreciate paintings in quite the same manner as art historians, and visual ideas, which depend so much upon experience, personality, and so on, resist translation into words.

How the painting was viewed

The Support

The similarities between Houckgeest's panel of 1651 and Fabritius's canvas of 1652 are most evident, in my view, when one sees the paintings firsthand.[4] If

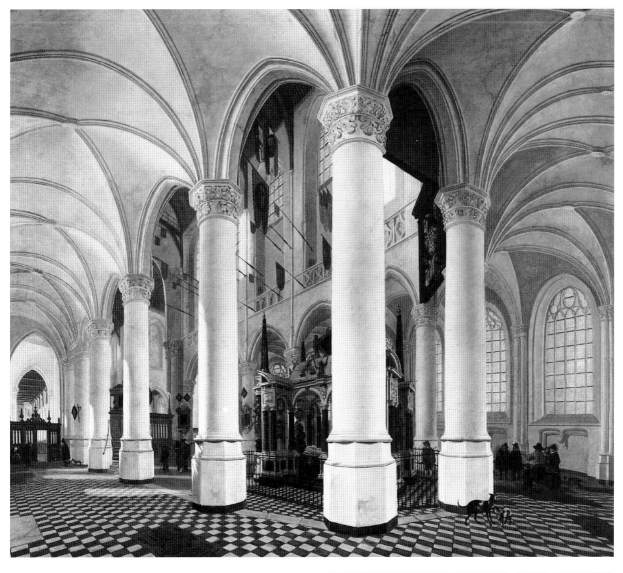

41
GERARD HOUCKGEEST,
*The Ambulatory of the
Nieuwe Kerk in Delft with
the Tomb of William the
Silent*, 1651.
Oil on panel,
65.5 x 77.5 cm.
The Hague, Koninklijk
Kabinet van Schilderijen
"Mauritshuis."
See also plate VIII.

the two pictures were set side by side, however, one difference would be more apparent than any of the similarities: Houckgeest's painting is on a panel of conventional size (65.5 x 77.5 cm); *A View in Delft*, by contrast, was painted on a finely woven piece of fabric that is remarkably small (15.5 x 31.6 cm; 6 1/16 x 12 7/16 in.) even by the standards of small townscape pictures. Egbert van der Poel's many modest-sized panels depicting the powder magazine explosion in which Fabritius died (see fig. 27) – as "souvenirs" of the disaster they bear its date, October 12 , 1654, next to Van der Poel's signature – are generally twice the height of Fabritius's canvas and at least fifteen centimeters wider.[5] Esaias van de Velde's *View of Zierikzee* (Staatliche Museen Berlin), the impressionistic little canvas (27 x 40 cm) that is routinely compared with Vermeer's *View of Delft*, Gerrit Berckheyde's small townscapes, such as his views of the Weigh House and landing place on the Spaarne in Haarlem, and Jan van der Heyden's numerous descriptions of urban scenery are all distinctly larger than *A View in Delft*, with one or two exceptions. Indeed, a broad survey of Dutch townscape paintings indicates that they are very

42
Detail of D. F. de Wit's
plan of Delft (Amsterdam,
1670?). "X" indicates the
artist's vantage point.

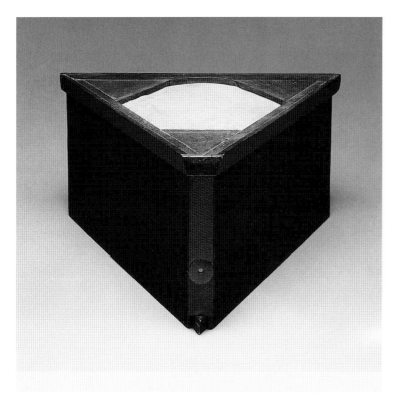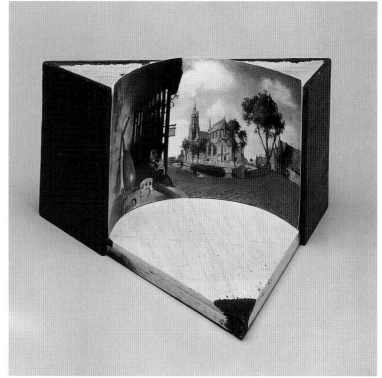

43
Exterior of a
reconstruction of a
triangular perspective box,
with a peephole at the near
corner and translucent
paper glued into the top
(photo: The Metropolitan
Museum of Art, New York)

44
Interior of the
reconstructed perspective
box (see fig. 43). The
photograph is
approximately the same
size as the original
painting (see fig. 37 and
plate III). (photo: The
Metropolitan Museum of
Art, New York)

rarely smaller than about 24 x 32 cm (just a few of Van der Heyden's pictures are that small), that they are almost never on canvas when the shorter dimension is less than 32 cm, and that wood panels were also much preferred for detailed representations of architecture, whatever the scale.[6]

Despite the many questions that have been asked and debated during the past quarter-century of writing about *A View in Delft*, one or two points of the most "elementary" sort have been hitherto neglected (like the dog that did not bark in the Sherlock Holmes story "The Silver Blaze").[7] For example, why did Fabritius paint this exquisite little townscape, with its minute architectural detail, on such a small scale, and, given that decision, why did the artist cut a short strip of canvas to serve as the support? To the writer's knowledge, every Dutch painting that is reasonably comparable in subject, size, and technique (which recent cleaning reveals to be "more [that] of a *fijnschilder* … than had been apparent earlier") was executed on the more sympathetic surface of a smooth hardwood panel or, in a few cases, on copper or another metal support.[8] In fact, one very rarely encounters a seventeenth-century Dutch or Flemish painting of any kind that is this small and not on wood or copper.

Earlier opinions

Many readers will be aware that the manner in which *A View in Delft* was originally meant to be displayed has been debated by scholars for some decades, with the most detailed and differing arguments coming in the mid-1970s from the present writer and from my colleague, Arthur Wheelock. The first three salvos

in our increasingly cordial exchange – Wheelock's article of 1973, my article of 1976, and Wheelock's reply in the preface to the 1977 edition of his 1973 dissertation[9] – formed grist for the mill of a master's thesis completed at California State University in 1978, which added little to the discussion apart from a summary and various misrepresentations of what was said.[10] More mature assessments of the debate have generally reflected the critics' own interests, so that historians of optical and other scientific questions find Wheelock's lens-laden hypothesis somewhat seductive,[11] while conservators and art historians tend to endorse my own version of the majority opinion, which is that the small canvas must originally have been curved and mounted in some kind of viewing or "perspective" box (see figs. 43, 44).[12]

Wheelock proposed that the painting was always meant to be mounted on a flat surface and that the apparent distortions of distance and the flattening effects in the townscape proper were created by the artist's use of a double-concave lens to record the site (fig. 60). Thus the painter expressed his awareness of wide-angle vision, as opposed to the restrictive assumptions of artificial perspective. In defense of these notions, Wheelock underscored the variations of scholars who adopted the perspective-box theme. Like a seasoned debater, Wheelock managed to cite his opponents' "difficulties," "disagreements," "uncertainty," and lack of "consensus" within a few lines.[13]

A more balanced review of the literature would concede that it represents remarkable agreement, to a degree rarely encountered in conjectural

reconstructions of works of art. Over a period of forty years, several scholars examined *A View in Delft* empirically and concluded that it must have been curved or bent in some way (fig. 45). The precise nature of their reconstructions (such as the shape of the curve and the proper viewing position) has depended not so much upon the painting itself as upon external evidence. For example, Richardson's original suggestion that the canvas must have been mounted on the V-shaped back of a perspective box was inspired by his main point of interest, the box of that design in the Detroit Institute of Arts (fig. 93).[14] Richardson also cited John Evelyn's diary entry dated February 5, 1656, which deserves quotation again:

"5. was shew'd me a prety Perspective & well represented in an <u>tri</u>angular Box, the great Church at <u>Harlem</u> in Holland, to be scene thro a small hole at one of the Corners, & contrived into an hansone [*sic*] Cabinet. It was so rarely don[e], that all the Artists & Painters in Towne, came flocking to see & admire it."[15]

Richardson never compared *A View in Delft* to the actual site or worried about creasing the canvas vertically in the center, but simply maintained that "its striking peculiarities" could be reconciled with "strict naturalness of appearance" in no way other than by bending it.[16]

In 1944 Martin (evidently in response to Richardson) modified his earlier idea that the canvas was probably a *modello* for a wall mural by suggesting that it may have been "a perspective study for a half-round wall alcove, as the perspective relationships become immediately correct when the photograph is bent into a semi-circular, concave shape."[17] Schuurman synthesized these views in his monograph on Fabritius, concluding on the basis of a discussion with Martin that the canvas was originally bent backward in the middle and installed within a perspective box, with light admitted from above and a peephole placed centrally opposite (see fig. 45, A). In this reconstruction, Martin and Schuurman maintain, the composition's distortions (the oddly constructed pavement to the right, the underscaled church, and the too-distant view to the market) are corrected, and the image also becomes "an unprecedented and surprising illusion of space."[18]

In 1960 Plietzsch invited his readers to bend a reproduction of *A View in Delft* into a semicircular shape in order to see that Martin's hypothesis was "very probably right."[19] Roosen-Runge, in a lecture given six years later, refined this reconstruction by referring to maps of Delft and suggesting that the picture should be bent a bit more strongly (with a "parabolic groundline") and viewed in a perspective box that permitted an approximately eighty-degree

45
Plans of four suggested reconstructions of a perspective box in which *A View in Delft* would have been mounted.
A = Martin and Schuurman
B = Roosen-Runge
C = Liedtke
D = Williams and Kemp

angle of view (see fig. 45, B). The latter was clearly not calculated in any way but simply corresponds to the close viewing distance that Roosen-Runge arrived at empirically. His main concern was that the viewer's gaze "must rove from left to right as in an actual visual experience" ("wie im Naturraum").[20]

In 1975 G. Q. Williams and P. Kemp, who at the time were lecturers in art and navigation, respectively, at Brunel Technical College, Bristol (UK), wrote an unpublished paper on the "distorted perspective" of *A View in Delft*. They concluded that the picture must have been curved in a line that is slightly flatter than a circular arc in the center but bent more strongly forward, as in Roosen-Runge's and (presumably) Richardson's schemes (see fig. 45, D).[21] According to Elkins, the Bristol reconstruction (which materialized as a perspective box with an unusually large aperture) constitutes "definitive proof that the painting as we have it is in curvilinear perspective," meaning either a perspective construction with no fixed vantage point or one in which "the [single vantage] point can be restored by bending the picture into a continuous curve."[22]

The present writer's reconstruction
My own reconstruction, arrived at independently of Williams and Kemp's,[23] places the canvas on a semicircular curve – that is, a hemicylindrical support, such as a half-round wood panel or sheet of copper – within a perspective box (figs. 43, 44, 46; pl. IV). The peephole is located centrally opposite the painting, at a distance established empirically (where it seemed to work best).[24] The triangular shape of the box, with the peephole at one corner, corresponds with Evelyn's description in 1656 of a "<u>tri</u>angular Box" with "a small hole at one of the Corners"; three of the six surviving Dutch perspective boxes also

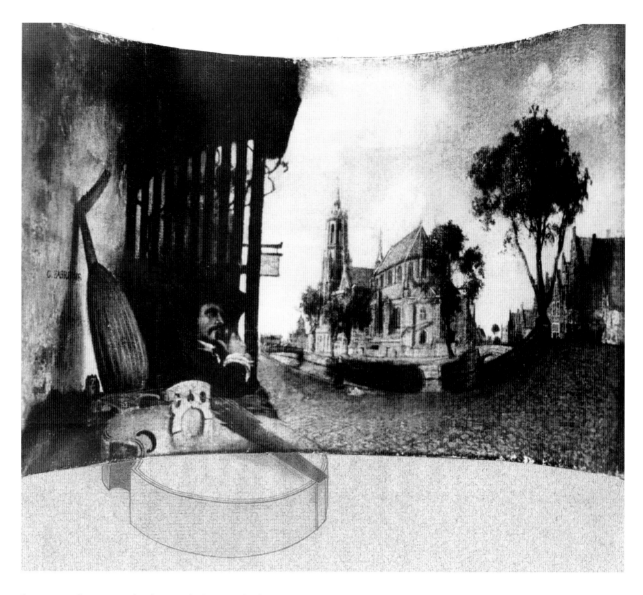

46
Photograph of *A View in Delft* mounted inside the reconstructed perspective box, with a drawing of the viola da gamba as it would appear from the peephole. See also plate IV.

happen to be triangular but with the peephole central in one of the sides.[25] Constructing a model requires one to arrive at a particular form, but it should be noted that the exact shape of the curved mounting, the form of the box (triangular, rectangular, circular, etc.), the distance from the painting to the peephole, and the angle of view allowed by the latter (which in reality depends on the hole's diameter and depth) are all variables within an hypothesis that is entirely consistent with those of Martin and Schuurman, Roosen-Runge, and Williams and Kemp, and with the impressions of other scholars such as Gerson, Brown, Slatkes, Brusati, and Sutton.[26]

A comparison of *A View in Delft* as it is mounted today (fig. 37, pl. III) with the picture as it would appear on a hemicylindrical support (fig. 46 gives an approximate idea; see also pl. IV and figs. 47-49) reveals a complex and consistent pattern of changes, transformations that Fabritius must have methodically planned and then occasionally corrected in the course of execution. Anamorphic images (like the skull in Holbein's *Ambassadors*; fig. 89) are often more obviously distorted than, for example, the tree on the right and the viola da gamba

(fig. 50), but both appear to have been stretched laterally.[27] When the tree is viewed on the curved surface through the peephole (fig. 49), its unnaturally divergent trunks come closer together, and the leaves form a rounder mass, with volume strongly suggested by sunlight falling from the west, shadows on the eastern (near right) side of the tree, and Cuyp-like highlights in the middle (the use of red and green in the leaves seems to enhance the rounding effect). The eye perceives the more expected shape without adjusting to the fact that it actually spreads over a receding surface; the tree is detached from any apparent plane and seems to be a three-dimensional form with actual space between it and the houses. The shaded house on the right, which in the modern mounting of the picture looks like a flat cutout waiting to be folded on the appropriate lines, takes on a more volumetric appearance, and its façade swings into line with the other house fronts on the Vrouwenrecht (fig. 46).[28]

The most impressive transformations on the right side are in the apparent width of the Vrouwenrecht and the angle at which it meets the Oude Langendijk (compare figs. 39, 42) and in the shape of the bridge

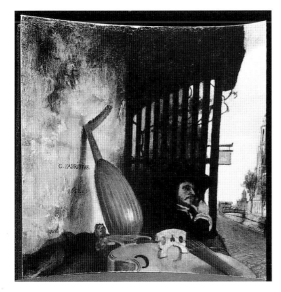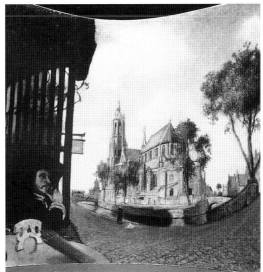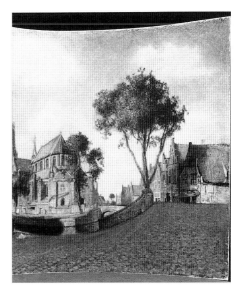

(which blocks our view of the pavement in front of the houses and the lower parts of two pedestrians). The map shows that the bridge goes over the Oude Langendijk at nearly a right angle, so that the water running parallel to the side of the church continues directly to the lower right in Fabritius's composition. On the curved surface the corrected bridge (figs. 46, 49), which previously appeared to be as flat and stretched as the floor tiles in Houckgeest's ambulatory (fig. 41), clearly arches over the canal, while the second bridge on the right, to the rear of the church (see the map, fig. 42), becomes a smaller and rounder span with a realistic spatial relationship to the bridge in the foreground. All of this clarifies the location of the tree to the right, which is planted beyond the bridge, not on it (see the map, though this does not mean that the tree actually existed), and it also makes sense of the two rather geometric shadows on the opposite quay and on the surface of the water, which in the curved projection appear to be cast by the trees behind and on the side of the church.[29] The sun is high in the sky, to judge from the shadows on the tower and on the roofs of the church and houses, and thus may be identified with actual light entering the perspective box from above.

The church is at the back of the curve and changes only slightly in my reconstruction: the "corrected" church has somewhat taller proportions, which are apparently closer to those of the actual church (see figs. 38, 39, 48). More extensive changes to the view occur to the left on the receding surface of the canvas. In the curved mounting, the wall effectively recedes in a direction leading down the Oude Langendijk. The table and trellis appear to stand perpendicularly against the wall, while the viewer assumes a position *by* the wall, *before* the table, and *beneath* the covering overhead. The man's body becomes slimmer and yet rounder, his ear moves into place, he occupies space and gains his proper scale (it should be noted that in the perspective box he is

actually closer to the viewer than is the church). The signature, "C. FABRITIVS," inscribed on the textured surface of the wall, clarifies the receding plane and leads the eye through the illusionistic space between the lute and its shadow. Finally, the viola da gamba regains its symmetrical form and projects forward, almost as if it were right under the viewer's nose (see figs. 46, 47; fig. 50 reconstructs the bottom of the instrument as it would appear extended below the composition on a flat surface). The completed form of the viol would give it a dominant position in the foreground below the church, so that the essential contrast between worldly and spiritual realms literally leaps out at the beholder (see fig. 53, pl. IV).

These and other important qualities of the curved image can only be appreciated fully when they are perceived within a perspective box. The peephole permits the viewer to look in essentially three different directions: to the left, to the right, and to the dominant view in the center (figs. 47-49). The church is isolated within a visual tunnel that leads over the lower half of the viola da gamba, past the woman by the side of the canal, and over to the tower of the church. The eye roams freely from side to side but the depicted and actual surfaces, and the framing effect of the peephole, bring the beholder back to the Nieuwe Kerk again and again. In its position directly opposite the peephole, the church (which seems close and properly scaled) dominates the initial impression and remains a constant reference point as the eye explores (fig. 53).

The illusionistic effect of shadows may likewise be appreciated only in the perspective box, where they appear to be projected in straight lines from the apparent position of the sun (behind the left side of the cloud above the tower). The shadow on the house to the right is now cast by the large tree, the shadow on the quayside opposite the woman is cast by the trees to the side of the church, and of course the shadow of the lute is now cast by rays of the sun

47-49
"Roving-eye" views of Fabritius's townscape as it would appear from the peephole of a perspective box (photographs: The Metropolitan Museum of Art, New York)

47
Left side

48
Center

49
Right side

50
Detail of *A View in Delft*
mounted on a flat surface,
with a sketch completing
the viola da gamba (photo:
author)

51
Detail of *A View in Delft*
mounted on a hemi-
cylindrical surface, with
a sketch completing the
viola da gamba (photo:
author)

52
Detail of Vermeer's
painting, *The Concert*
(see fig. 304), with a
foreshortened view of a
viola da gamba

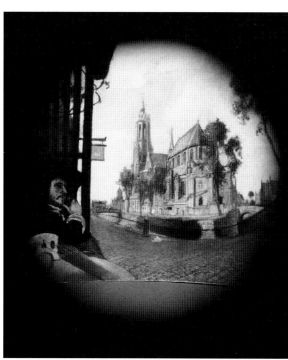

53
Centralized view through
the peephole of the
reconstructed perspective
box (photo: The
Metropolitan Museum of
Art, New York)

that do not curve around corners. (The lute to the
left and the tree to the right enter into a pendant
relationship as illusionistic devices, as each one casts
a shadow forward, toward the lateral margins of
view.) Only in the perspective box do these and other
shadows assume spatially logical positions which are
further from the sun (at the back of the curve) and
closer to the viewer than are their respective objects.
Fabritius may have employed strings and a fixed
point of view to locate shadows properly on the
curved surface. Whatever the method, the result is
pictorial sunlight which seems to fall through the
actual space of the box's interior, and as in Baroque
chapels and Van Hoogstraten's perspective box in
London (figs. 54, 55), the depicted light tends to
correspond with the real illumination. Viewers "can't
believe it's painted until they assure themselves by
touch," observes Van Hoogstraten, who prefaces the
usual list of ancients (Apelles, Zeuxis et al.) with an
appreciation of Fabritius.[30] He might have added that
detecting the deception by means of touch is
impossible when the image is presented in a
"wonderful perspective box."[31]

Samuel van Hoogstraten

That Van Hoogstraten and his patrons – his courtly
patrons in particular – had a high regard for
illusionistic pictures is demonstrated admirably by
Celeste Brusati in her recent monograph.[32] Fabritius
appears to have shared this enthusiasm, to judge from
his known and recorded works of the early 1650s. He
may also have shared briefly in the sort of patronage
that Van Hoogstraten enjoyed: it will be recalled that
in February 1655 Fabritius's widow, Agatha van
Pruyssen, claimed that he had been "in his lifetime
painter to His Highness the Prince of Orange."[33]
This deposition was made before a Delft notary
(who himself composed the words just quoted) in
the course of acknowledging a substantial debt to
Agatha's sister. She or the official or one of the two
signing witnesses would probably have been
prepared to question the unnecessary description of
the artist if it had had no basis in fact.

Van Hoogstraten himself, as it happens, would
not have been directly familiar with Fabritius's
fortunes or his work on perspective boxes and
illusionistic murals, since the Dordrecht painter was
mostly in Vienna (as well as Rome and Regensburg)
at the time.[34] In these years (mid-1651 until early
1656) he, too, painted his first known illusionistic
pictures,[35] one of which secured him the patronage
of the Emperor Ferdinand III, and a gold chain and
imperial medallion which the artist featured proudly
in subsequent self-portraits and a self-referential still
life.[36] After residing again in Dordrecht between
1656 and 1662 (the period in which the perspective
box in the National Gallery, London, was probably
made; see figs. 54, 55), Van Hoogstraten went with
his wife to London for five or six years. In England
he painted some stylish portraits and the illusionistic
murals (fig. 97) that were esteemed by his patron,
Thomas Povey (treasurer to the Duke of York) and
by the diarists John Evelyn and Samuel Pepys.[37]
Knowledge of Fabritius's own illusionistic murals was
probably gained by Van Hoogstraten during his later
residence at The Hague (1668-71); he died two years
before Van Bleyswijck's account of Fabritius was
published for the first time (1680).[38]

This distance between the two artists encourages one to consider the importance of taste and patronage for their production of illusionistic pictures. The example of Van Hoogstraten (other artists are discussed below) suggests that cultivated gentlemen, often with some connection to the courts of The Hague, London, Vienna, or elsewhere, were the most likely clients for illusionistic inventions, especially when some question of science was involved. Wheelock's analysis of *A View in Delft* relates it to contemporary treatises on optics and perspective but fails to explain how the picture might have been appreciated as a work of art. His hypothesis that the painting was made to be viewed as it is now, with its "subjective" distortions due to the artist having recorded the site while looking through a double-concave lens (fig. 60), reminds one of Parmigianino's self-portrait reflected in a convex mirror and of other images in which forms, distances, and the comparative prominence of motifs are abnormally altered, essentially for reasons of stylistic and expressive effect.[39] The question remains, is this interpretation consistent with the aesthetic context of painting in Delft during the 1650s or with illusion-istic works made in a number of European cities during the middle decades of the seventeenth century?

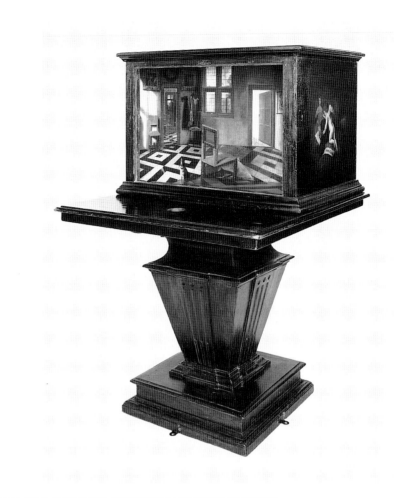

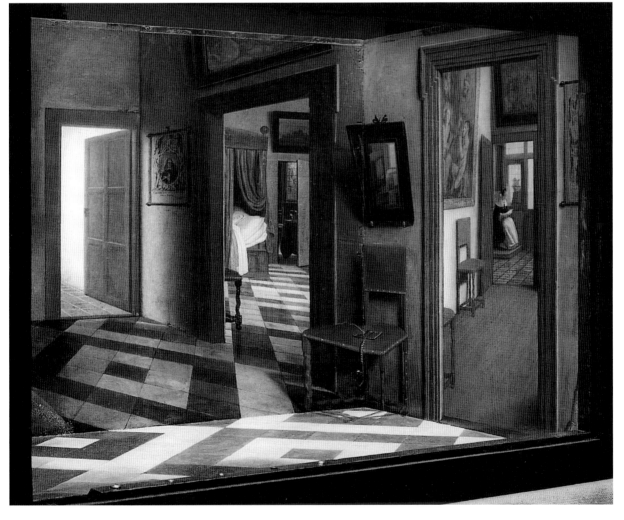

54
SAMUEL VAN
HOOGSTRATEN,
*Perspective Box with Views
of the Interior of a Dutch
House*, ca. 1658-62 (?).
Oil on several panels,
overall exterior
dimensions: 58 cm high,
88 cm wide, 60.5 cm deep.
London, The National
Gallery

55
Interior view of Van
Hoogstraten's perspective
box in London (see fig. 54),
not from either of the
peepholes

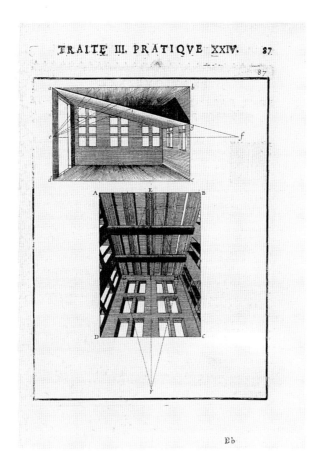

To be sure, artists such as Van Hoogstraten and like-minded *amateurs* were diverted by mirrors, lenses, and various kinds of optical devices; the procedure described by Wheelock would have intrigued them. But whether or not they would have considered the simple transcription of optical distortions to constitute a commentary on the limits of perspective practice, the nature of vision, and the more ambiguous baggage ("distinctive psychological implications" and "emotional impact")[40] that Wheelock assigns to Fabritius may be be judged from Van Hoogstraten's remarks on the artist and on the issues at hand:

"I shall skip over discussing the methods by which one can give anamorphically distorted shapes [*door kaetslijnien mismaekte gedaentens*] their upright [i.e., proper] form in spherical, angular, and cylindrical mirrors, for these are more artifice than necessary science. But nevertheless a master should understand the fundamentals [*wortels*, or roots] of these amusements in order not to be confused in the event that an obliquely angled, round, or other unusually shaped building or vault is to be painted: for however angular the vaults or walls may be, one can always break them down by means of this art [as demonstrated in contemporary treatises; see figs. 56, 57], so that they seem to have an entirely different form, and one can paint the corners and foreshortened walls [to appear] as if they were not there;[41] and even if one adds figures or histories it will all be

surprisingly upright, although it is anything but a readily comprehensible image. With this knowledge one can also make a little room seem very large: *Giulio Romano* showed this at Mantua, in the Palazzo del Te, where he beautifully depicted the Battle of the Gods and Giants, in a vaulted chamber, in which, by receding perspectives [*wegwijkende doorsigten*], the building, which was only fifteen feet wide, was transformed into an extensive field. *Fabritius* has also made such wonders here, as are still to be seen at Delft in the house of the art-loving late *Dr. Valentius* and elsewhere. But it is regrettable that his works were never placed in a large royal building or church, for this kind of painting depends enormously on the place in which it is applied. What another [artist, namely, Van Hoogstraten himself] has likewise achieved with this art for the Emperor in Vienna, and also in England, is not for me to mention. Through the knowledge of this science one also makes the wonderful perspective box [fig. 55] which, if it is painted with understanding, shows a finger-sized figure as [if it were] life-size."

The text continues with praise of Raphael, Goltzius, and especially Jan (Hans) Vredeman de Vries, who is described as a muralist, an author on perspective, and an example of how "perspectives [*perspectiven en doorzichten*] have always and everywhere been held in high esteem." Finally, the chapter ends with Van Hoogstraten's recommendation of five treatises on perspective, namely, the time-tested tomes of Dürer,

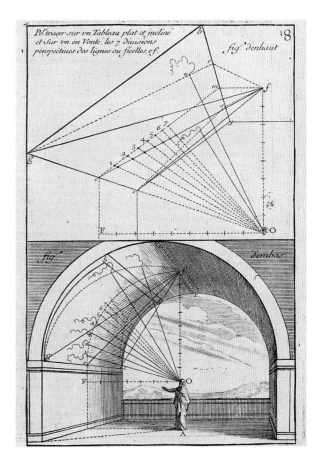

Vredeman de Vries, Marolois, and Guidobaldo, and the latest entry by Desargues (see figs. 57, 68, 73, etc.).[42]

In these and other lines of the *Inleyding* Van Hoogstraten is representative of his period and, with regard to painting, of his generation. High values are placed upon "necessary science," such as artificial perspective, and upon the marvelous results of such expertise: illusionism, wonder, understanding, the status of art, and the appreciation of distinguished patrons and connoisseurs.[43] Painting, according to Van Hoogstraten, "is a science for representing all the ideas and concepts that the visible world can offer, and of fooling the eye with contours and colors. … A perfect painting is like a mirror of nature that makes things that do not exist appear to exist, and deceives in a pleasurable, permissible, and praiseworthy manner."[44]

Similarly, the camera obscura is regarded by Van Hoogstraten as a "picture-making invention [which] can be very illuminating to the young painter's vision, for besides acquiring knowledge of nature, one also sees here the overall aspect which a truly natural painting should have."[45]

In comparing pictorial representation to a "truly natural painting," Van Hoogstraten was hardly calling for distorted images of reality as some sort of expression of how the eye sees, but was advocating

illusionistic pictures of the kind he made: trompe-l'oeil murals, perspective boxes, and works that, like the *View of the Imperial Palace Court in Vienna* of 1652 (fig. 58), resemble images seen in a camera obscura.[46] Van Hoogstraten accordingly maintained that (in Brusati's paraphrase) "the rules of art are found, or have been found, in the attentive observation and imitation of nature."[47]

What, then, would Van Hoogstraten have made of the misshapen (and blurred) image of the Nieuwe Kerk and its surroundings as seen through the large, tilted, double-concave lens (assuming they existed in the seventeenth century) that Wheelock lends to Fabritius (fig. 60), or of *A View in Delft* presented on a flat surface (fig. 37) as an experimental record of "wide-angle vision [which] offered a fascinating alternative to man's normal perception of the visible world"?[48]

Van Hoogstraten answers these questions about wide-angle viewing in his chapter on "How visible nature precisely appears":

"First of all, we may note that we see around us with our eyes, and therefore no straight line can be drawn which is equally close to our eyes at all points, but rather a curve like the circumference of a circle, of which the center is in our eye: just as you can see, standing before a building or a church, that not only both the ends of the walls, but also the towers run off from us, becoming foreshortened and distant [see fig. 59]. But it would be a mistake to represent it

58
Samuel van
Hoogstraten,
*View of the Imperial Palace
Court in Vienna*, 1652.
Oil on panel, 79 x 84.5 cm.
Vienna, Kunsthistorisches
Museum

59
Pieter Saenredam,
*The Tower of the New
Church in Haarlem (from a
close vantage point to the
southwest)*, July 7, 1650.
Pen and watercolor,
32.7 x 20.3 cm.
Haarlem, Gemeente-
archief

60
The Nieuwe Kerk in Delft as seen through an eighteenth-century double-concave lens held in a tilted position (photograph by J. T. Stolp, for Arthur Wheelock)

thus, unless your work, also seen from a very close [i.e. fixed] vantage point, would require it thus. But if you want to sketch a church or a tower, you should keep stepping back until you can embrace the entire building in a glance ... otherwise you will easily lapse into misrepresentation, without comprehending from whence it arises."

Van Hoogstraten then compares pictures that "foreshorten the head toward the top and the feet toward the bottom; the tiled floors are broader than long, the columns round [in cross-section] like an egg, and the squares become irregular." He concludes with the advice that "the right distance is learned from all kinds of work in the art of perspective," and he recommends as a rule of thumb that "one must not assume a distance somewhat less than the height or breadth of the work."[49]

Wheelock's hypothesis and the issues

Van Hoogstraten's remarks on natural vision and artificial perspective may be placed within a broader tradition of writing on optics and perspective, as Wheelock has shown.[50] In *A View in Delft* (however it is interpreted) Fabritius also reveals an awareness of wide-angle vision and the limitations of orthodox perspective practice, as earlier and contemporary artists – Leonardo, Fouquet, Vredeman de Vries, Saenredam, Houckgeest, Steen, Vermeer, and others – did in a variety of ways.[51] However, one finds a consistent distinction in the art and writings of Van Hoogstraten and his contemporaries between what belongs in a treatise and what might be applied in a painting. As Martin Kemp has observed, Van Hoogstraten was "well aware that scenographic perspective is only a very limited case within the whole science of optical phenomena, but this did not lead him to suggest a fundamental revision to the available means at the painter's disposal." In Van

Hoogstraten's writings and for that matter in "all the Dutch treatises," Kemp discovered "not the slightest glimpse of the new ideas on the mechanism of the eye pioneered by Kepler and extended by Descartes."[52]

Demonstrations of optical effects as the main burden of works by seventeenth-century Dutch artists are extremely rare, and are found, if at all, (outside of book illustration) in comparatively minor drawings and prints.[53] This is not to say that Wheelock's interpretation of *A View in Delft* is impossible, however much it seems to impose the aesthetics (and a lens) of a later period.[54] But so much of Fabritius's achievement and its proper artistic context is lost when one subscribes to Wheelock's hypothesis. It was precisely in this period of about 1651-52 that Van Hoogstraten in Vienna, Houckgeest, Van Vliet, and De Witte in Delft, and Fabritius in his murals (according to contemporary accounts) painted some of their most illusionistic pictures. These were still novelties at the time, an enthusiasm of *amateurs* and an area of rivalry among artists working in court circles and in some major cities. The question of patronage, of paintings appreciated and possessed as objects, not concepts (which is not to say that such pictures did not embody ideas), is anachronistically set aside when one interprets the canvas primarily as the record of an experiment (fig. 60). Finally, both considerations – that of plausible paintings and of plausible patrons – raise the question of Fabritius's subject, the Nieuwe Kerk in Delft, which (as Wheelock has stressed in other contexts) meant a great deal to Fabritius's fellow countrymen.[55] What, really, is the subject of this picture, and can it be reconciled with the work's original form?[56]

Like any work of art, of course, Fabritius's painting is about more than one thing; as Panofsky put it, the work has a subject as well as content, the latter being the broader ideas it embodies, and how these concepts reflect a certain cultural milieu.[57] Van Hoogstraten's murals and perspective boxes have various subjects but consistent content, which involves illusionism, perspective, knowledge, and so on – as Brusati describes it (with a modern academic reader in mind), Van Hoogstraten demonstrates "his own artistry of praiseworthy deceptions and ... an ideology of painting as a universal science and an art of peaceful conquest."[58] Similarly, the mature works of Vermeer treat a number of themes which are also found in genre paintings by very different artists, but the Phoenix who rose out of Fabritius's fire (according to the Delft poet Arnold Bon)[59] was absorbed by questions of how we see and of the limits of mimesis in painting. The latter is a more complicated subject than Van Hoogstraten's illusionism, and both interests would appear to have inspired *A View in Delft*.[60]

To continue, for the moment, in a simplistic vein, Fabritius's subject in his only known townscape is the Nieuwe Kerk in Delft, with a faithful description of the actual site and evidently some commentary – supplied by the motifs of an onlooker and musical instruments – on the subject's significance. The work's content, in my view, is Fabritius's own artistry and knowledge: specifically, in this case (or *kast*, as it were), his ability to transcribe accurately the architectural site; his mastery of linear perspective; his knowledge of related issues, such as wide-angle vision, the projection of shadows, and the optical effects of color (for example, red on green leaves in the tree, reddish instruments on a blue tablecloth, and the blue sky as a foil to and reflection in the objects); and the illusionism of the finished ensemble, which would have given it a sense of wonder, like some sort of revelation or insight into deeper things. This is not far from Van Hoogstraten's "ideology," as embodied in his illusionistic paintings and as articulated in the *Inleyding*. However, one could say that Van Hoogstraten's ideology was never stated so concisely or effectively as it was in the original form of *A View in Delft* (figs. 43, 44, 46; pl. IV).

Wheelock's view of the painting considers some of its content (optical effects and concepts) but fails to focus on many other aspects of the work, such as its subject, its fidelity to the site when the image is curved (which would be an extraordinary coincidence if the artist had used a distorting lens), its relationship to architectural painting in Delft about 1652, and its likely reception within the cultural milieu of Fabritius's colleagues in Delft, his former co-pupil Van Hoogstraten, and their patrons. After four chapters on sixteenth- and seventeenth-century optical ideas and on the "limitations of perspective theory," Wheelock's frame of reference in his dissertation was that of a scholar with monuments in search of a document, or documents in search of a monument, depending on which hat (that of an art historian or a student of science) he had on. The subject of optical aids in Delft, which had recently been raised by Seymour (1964), by Schwarz (1966), and most excitedly by Fink (1971),[61] was approached more cautiously and convincingly by Wheelock, but he threw his hats in the same ring when he suggested the use of a mirror or lens to account for compositional devices in Vermeer's *A Maid Asleep* (pl. XX) and in his other works of about 1656-57, and also in Rembrandt's very early *Artist in his Studio* (Museum of Fine Arts, Boston).[62] In another publication of 1977 Wheelock relates the composition of Esaias van de Velde's little *View of Zierikzee* dated 1618 (Staatliche Museen Berlin; mentioned above) to the camera obscura, and concludes that the instrument's "tonal effects" – which will surprise readers who recall the "heightened colors, contrasts

of light and dark, and halations of highlights" attributed to the same device by Wheelock in other essays[63] – "must have given a new impetus to Van de Velde's search for a realistic genre of landscape painting."[64] By contrast, scholars such as Stechow, Schama, and Montias have attempted to explain the rise of tonal landscape painting in Haarlem in terms of style, taste, and the art market.[65]

The importance of these factors makes one wonder whether *A View in Delft* in its flat and distorted form could ever have been appreciated by a patron of the time in a manner that did justice to its "optical" implications. Nothing is found in the accounts of contemporary diarists or of interested parties such as Van Hoogstraten and his Dordrecht associate Dr. Van Beverwijck,[66] or in the known evidence for such figures as Dr. Valentius in Delft (see p. 64), Thomas Povey (a member of the Royal Society) in London, or even Constantijn Huygens at The Hague, to suggest that Fabritius's townscape with its "spherical" distortion (fig. 37), as Wheelock describes it,[67] would have been valued any differently than the street scenes that are reflected by convex mirrors in the foreground of Petrus Christus's *Saint Eligius* of 1449 (Metropolitan Museum of Art, New York) or Quentin Massys's *Moneychanger and his Wife* (Louvre, Paris),[68] or than the curved reflections of windows that carry Jan van Eyck's famous conceit (the Arnolfini mirror) into the much later world of Abraham van Beyeren, Pieter Claesz (fig. 61), and Gerrit Dou.[69] One wonders, for that matter, if Vermeer's probable patron, Pieter van Ruijven, to say nothing of *amateurs* such as Pieter Teding van Berckhout or Balthasar de Monconys, had any sense of the artist's visual acuity or particular optical effects, apart from the general impression that some of his pictures looked like life itself. On his second visit to Vermeer's studio, in June 1669, Teding van Berckhout observed that "la partie la plus

61
PIETER CLAESZ,
Vanitas Still Life, ca. 1635.
Oil on panel, 36 x 59 cm.
Nürnberg, Germanisches
Nationalmuseum

62

Infrared reflectogram
mosaic of *A View in Delft*
by Carel Fabritius (photo:
The National Gallery,
London)

63

Raking-light photograph
of *A View in Delft* by
Carel Fabritius (photo:
The National Gallery,
London). Vertical ridges
occur throughout, but in
this photograph are most
visible below the choir of
the church and at the
bottom of the lute.

extraordinaijre et de la plus curieux consist dans la
perspective," which is essentially the same thing that
Van Bleyswijck (1667-80) said about Van Vliet.[70] A
similar level of appreciation is found in the world of
science: John Wren, for example, maintained in 1663
that experiments staged by the Royal Society for the
benefit of the king (Willem III) should "surprise with
some unexpected effect and be commendable for the
ingenuity of the contrivance" and should not require
a lecture.[71]

The technical evidence

One's frame of reference conditions not only what is
seen in a painting but also one's reading of technical
evidence, such as x-ray and infrared photographs and
microscopic inspection of the paint layer. The
scientific examination of paintings can make a deep
impression on the layman, but curators such as
Wheelock and myself have learned from sobering
experience that even specialists are easily deceived.

As Brown cautioned with respect to *A View in Delft*,
which was in his care for more than a quarter of a
century, "the interpretation of evidence presented by
infrared (and, for that matter, x-ray photographs) is
extremely difficult and must be approached with
more circumspection" than is evident in Wheelock's
analysis.[72]

The wisdom of this advice is borne out by Brown's
own rejection of an observation made by Wheelock:
that Fabritius initially painted a standing man in the
area of the trellis.[73] A recently published infrared
reflectogram mosaic (fig. 62) reveals that Wheelock
saw the standing man correctly in an ordinary
infrared photograph.[74] However, Wheelock was
less successful in interpreting the seated man: his
"melancholic gaze" and "his melancholic air" (which
is infused "throughout the composition") have
disappeared with cleaning, since the figure had been
retouched extensively at later dates (compare figs. 37
and 40).[75]

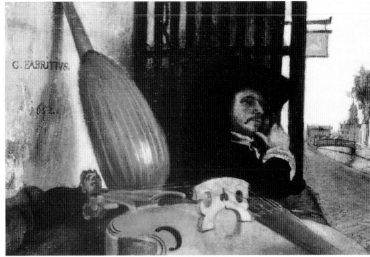

With the perspective box hypothesis in mind, Wheelock paid meticulous attention to any physical evidence that suggests the canvas was once curved. "One might expect to find pronounced craquelure patterns or characteristic paint losses. A microscopic examination of the paint surface, however, has detected no evidence" indicating a curve.[76] Additional evidence that "the *View in Delft* was once bigger" is found by Wheelock in the wide gaps "between the tacks" along the top edge of the canvas.[77] He also wondered whether "any remnants of a strong seventeenth-century glue can be detected on the verso of the canvas,"[78] without noting that the use of adhesive (and, perhaps, widely spaced tacks) could indicate that the canvas was never tacked to a stretcher in the first place.[79]

Cleaning, conservation, and technical examination of *A View in Delft* carried out by Larry Keith and his colleagues at The National Gallery, London, in 1992-93, have now resolved many of these questions. The painting has become richer and subtler in its chromatic range (see pl. III), with a bright blue sky, a vividly blue tablecloth, and many small blue reflections in the cobblestones and on the plaster wall to the left. Visible for the first time in decades are "a pale blue highlight, painted on the belly of the lute as a reflection of the sky [and] surface textures like the gloss of the viola da gamba soundboard." Keith stresses that "the illusion of spatial depth implied by the subtle diminution of the receding cobblestones, and the fine details of figures and architecture on the distant canal were all heightened as a result of cleaning, with the result that, in this picture, Fabritius emerges as more of a *fijnschilder* (fine painter), in the general sense of the degree and sophistication of finish, than had been apparent earlier."[80]

The infrared videcon system "reveals a clear underdrawing of a more or less consistent level of finish throughout, most clearly visible in the lute and its shadow, the viola da gamba, and the distant architecture" (fig. 62).[81] This speaks against Wheelock's notion that the left side of the composition was something of an afterthought,[82] and suggests to Keith that the design (in particular the outlines of the musical instruments, the houses, the bridges and quay, and the main parts of the church) "must have been more or less finalized in some sort of preliminary stage."[83] Obviously, a penultimate cartoon could have been larger and its design reduced by means of some simple drawing device (as discussed below).

More conclusive evidence for the original form of *A View in Delft* is found in Keith's raking-light photograph (fig. 63), which "clearly shows a series of raised parallel vertical ridges, which are the high points of a pattern of concave scalloping of paint and canvas … . The sum of the individual deformations would produce a general curve of the canvas and paint with the lateral edges pushed toward the viewer in a manner suggested by Liedtke's reconstruction."[84] Keith also overrules Wheelock on the question of whether the original paint layer extended all the way to the remaining sides of the canvas: "removal of repaint during restoration showed it to have been painted completely only up to the bottom border, which itself would be in keeping with Liedtke's hypothesis that the foreground would have been continued on the base of the box in an extreme anamorphic projection."[85]

Keith considers the question of anamorphic projection in several aspects of his analysis. He counters Wheelock's complaint that the present writer did not "comment on the very real distortion in the shape of the lute that occurs in the painting when it is curved" by referring to seventeenth-century lutes of diverse shape and size, "with several quite shallow-bowled instruments." (Compare also a lute and its shadow as painted by the young Jan de Heem with Fabritius's "very real distortions"; figs. 64, 65.) Keith – in his text, a note, and the caption beneath my borrowed photograph of the painting as

64
Jan Davidsz de Heem,
Still Life with Books,
ca. 1628.
Oil on panel,
26.5 x 41.5 cm.
Amsterdam, Rijksmuseum

65
Detail of fig. 47 ("roving-eye" view of Fabritius's townscape on the curved surface inside the perspective box, as seen from the peephole)

it would appear on a curved surface (see fig. 46) – repeatedly cautions the reader that flat reproductions of the curved image exaggerate the "anamorphic distortion of the outer sections of the image," which are meant to be seen not by a camera (that is, with a fixed, centralized view) but by a roving eye looking through a peephole (as approximated in figs. 47-49).[86]

According to Keith, the present writer is also "correct in maintaining that, seen with one eye at the close distance dictated by the confines of the box, the church dominates the vista to a surprising degree" (see fig. 53), so that it seems as near to the viewer as it does at the actual site (see fig. 38). The shape of the viola da gamba and "the exaggerated distance between the figure's ear and chin are [likewise] resolved into convincing, naturalistic representation." One wonders whether the man's anamorphic anatomy was partly the reason that he was revised by Fabritius. Keith discovered that "the breadth of the lute's cast shadow [was] reduced from its drawn shape – perhaps an example of an intuitive adjustment of a more mathematically correct but visually awkward anamorphic projection."[87] The present writer sees the possibility of a similar correction in the pentimento of the blue tablecloth where it meets the wall. (The very fact that the material is unexpectedly piled up at the back edge of the table suggests that the artist found a straight line in that marginal area of view uncomfortable.)

With these adjustments made, Keith concludes: "the left wall recedes along, not across, the Oude Langendijk, and the trellis projects in a clear right angle to form a coherent space in which the figure sits and before whom the lute now functions as an effective three-dimensional repoussoir. Furthermore, the lack of binocular depth perception afforded by the single eyepiece intensifies the illusionism of the constructed space, a deception that is difficult to appreciate to full effect without a three-dimensional model."[88]

Had Keith not been so conversant with the issues, he might have been puzzled to find any late revisions in such a minutely planned and executed picture. However, if these minor modifications were known to have been made *in situ*, after the nearly finished canvas was moved from a flat to a curved mounting, then the conservator would have found them as natural as the "major alterations" that were made by Van Hoogstraten as final corrections to his perspective box in The National Gallery, London (fig. 54).[89]

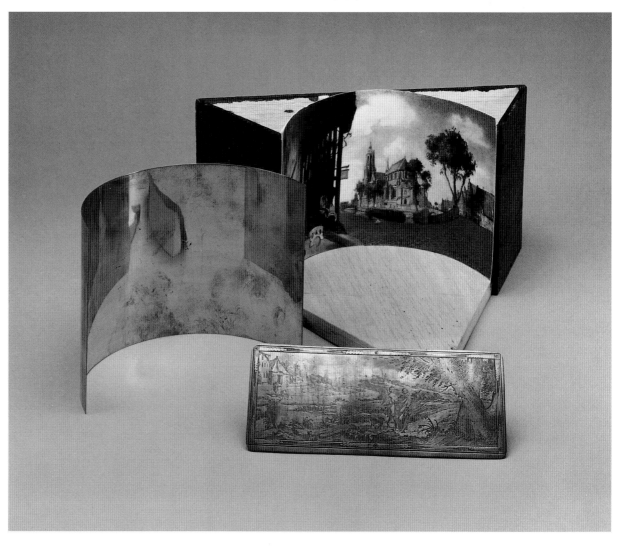

66
The interior of the reconstructed perspective box, seen together with a hemicylindrical sheet of copper, and a 17th-century copperplate engraved with a landscape view. Fabritius could have used a copper-plate of the common "landscape" format to support his small canvas inside a perspective box (photo: The Metropolitan Museum of Art, New York)

In addition to the "raised parallel vertical ridges" in the paint layer, cited above, three different kinds of physical evidence indicate that the canvas was originally mounted on a special support. First, the back of the fabric is now known to be "quite unusually unsoiled and well preserved," suggesting that "it must have been well protected from the environment since shortly after the picture's completion."[90] Second, "two distinct layers of animal glue" are on the back of the canvas, the upper one being the glue used to attach the canvas to a walnut panel at a later date.[91] Third, the lower layer of glue is "easily distinguishable by its unusual green colour (pl. 3 in Keith's article). Analysis showed this to be a copper-protein complex, the result of long-term contact between animal glue and copper, most plausibly explained by the picture's having been glued to a copper panel." Keith observes that "the use of canvas would allow the best combination of flexibility and strength necessary for the curved configuration," while "copper would be a good choice of material since it is easily bent or hammered into the desired shape [see fig. 66] and certainly would have been readily obtainable in this size at the time of painting."[92] This is something of an understatement, since many Dutch landscape prints are almost identical in size to *A View in Delft* (for example, each of Jan van de Velde the Younger's thirty-six engravings titled *Playsante lantschappen ende vermakelijcke gesichten*, or "Pleasant landscapes and enjoyable views," measures 15.8 x 30.5 cm).[93] Perhaps the copperplate used by Fabritius to mount his canvas on a curve was already cut, polished, and engraved with a worn but "enjoyable view."

In summary, the physical evidence alone, independent of all the supporting evidence that has been found by various scholars in the image and at the site, virtually proves that "the painting was mounted on a hemicylindrical copper plate at the back of a peepshow." In choosing these words to describe "the most popular hypothesis," Jørgen Wadum,[94] chief conservator at the Mauritshuis, was perhaps exaggerating slightly or assuming hastily that all interested parties were familiar with the results of Keith's conservation and analysis. Or perhaps Wadum meant that the physical evidence – the painting's small size, its fine execution, the unexpected choice of support, the vertical ridges in the paint layer, the continuation of the paint layer at the bottom edge only, the clean back of the canvas, the two layers of glue, and the chemical evidence that the canvas was fixed to a copper surface – that all this could only be explained by the reconstruction that had been "the most popular hypothesis" for fifty years.

Making the box

When Carel and Barent Fabritius became members of the Reformed Church in Midden-Beemster in 1641 they were each described as *Timmerman*, meaning carpenter or builder.[95] One need not have professional skills to build a box like the one reconstructed here (figs. 43, 44), but it is worth noting that Fabritius started out in a relevant trade. Whatever the exterior form of the box in which *A View in Delft* was mounted, it would have had a translucent light source in the top (probably oiled or very thin paper).[96] The curved copper plate that Fabritius evidently used to mount the canvas would have had some simple wooden supports. If, as seems likely, the composition continued onto the floor of the box, extending the viola da gamba, the cobblestones, and perhaps the tablecloth to the left, this may also have been painted on canvas glued into place. Using the same material would have enhanced the consistency of the illusionistic image, and it might have permitted a fairly inconspicuous join at the base line of the curved support (we recall that the surviving canvas was painted to the bottom edge only). Of circumstantial interest is the fact that adhered canvas was the usual support for illusionistic murals in the Netherlands, for example, Bramer's in Delft (see fig. 19).[97]

The composition

Paintings are not made like dissertations, with the whole divided into parts and one point leading to the next. Fabritius's unexpected insertion of two stringed instruments into the immediate foreground of a topographical view must reflect a moment of inspiration, perhaps arrived at when perusing a perspective treatise or recalling works of art in which artificial perspective played an essential part. Buildings set out in city squares and foreshortened views of musical instruments had one thing in common: they were both familiar as set pieces in perspective treatises and had been featured often in perspectival works of art since the early Renaissance.

Fabritius may also have realized (indeed, this was the more likely connection in Dutch art) that the motifs of musical instruments and the Nieuwe Kerk could be combined in a concise comparison between the mundane world of temporal temptations and the promise of salvation. To link the two realms the artist placed a table outside an inn, which was an arrangement so familiar from everyday life and from contemporary paintings and prints that such an image may well have inspired Fabritius's subject in the first place. Jan Steen and other Netherlandish

painters since the time of Pieter Bruegel the Elder, including Hans Jordaens in Delft (fig. 14), juxtaposed inns and churches, in Steen's case with inn signs (usually "The Swan") and arbors or trellises assisting as visual links (see fig. 67). To this setting Fabritius brought musical instruments that were usually found indoors,[98] and of course he reduced the number of figures at the inn to one.

The actual labor of producing the townscape's design must have been comparatively methodical, and may be conveniently described as four different operations involving linear perspective:

1. recording the townscape;
2. recording the musical instruments;
3. combining the two images, with suitable additions (for example, the trellis and the tree) into a single cartoon;
4. projecting the cartoon anamorphically onto another surface, in this case the curved wall and flat floor of a perspective box.

The last operation would have been tedious but hardly unusual for an artist like Fabritius, Houckgeest, or Van Hoogstraten, and would probably have been facilitated by secondary cartoons on a scale larger than that of the painting itself. One of the cartoons would have corresponded with the underdrawing of *A View in Delft* (to judge from the evidence of infrared reflectography; fig. 62), while another would have shown the lower part of the viola da gamba in anamorphic projection (see fig. 46).

Drawing aids
Despite its small scale, the church in Fabritius's painting corresponds closely with the Nieuwe Kerk

as it may be photographed (figs. 38, 39): relative proportions and overlappings, such as the juxtaposition of the choir's roof with the transept's, and of that roof with the tower, and details throughout are accurately transcribed. If the church had been sketched freehand, no matter how carefully, and then redrawn in an orthodox perspective scheme (as in Saenredam's usual procedure), the building's proportions and overlappings would have been unavoidably modified to a degree not evident here. This is why Ruurs, perhaps following my suggestion, concludes that Fabritius may have "used a drawing frame, of the type described by Alberti, Leonardo, Dürer, and many later authors."[99] The artist would have favored the latest models, since the "drawing frames" or perspective frames published by writers such as Marolois (1629; see fig. 68), Dubreuil (1642), Niceron (1646), and other seventeenth-century authors of perspective treatises were more compact and generally more efficient than Vignola's tall device of 1583 and earlier instruments.[100]

Fabritius may not have needed to consult any treatise on this subject, since Houckgeest almost certainly employed a perspective frame to achieve his remarkably accurate transcriptions of particular views within the Delft churches in 1650 and 1651.[101] The portable device would have allowed Fabritius to record faithfully the Nieuwe Kerk, the distant Town Hall, and the canal in one perspective projection. Vertical recession of the architecture ("the towers run off from us," as Van Hoogstraten observed; see p. 49 and fig. 59), which occurs because the draftsman or photographer lifts his line of sight (so that the picture plane is no longer, like the building, perpendicular to the ground), is one of the drawing problems that the perspective frame was designed to correct. Fabritius would probably have recorded the houses on the right separately, maintaining the same vantage point and horizon line.

The use of perspective frames to draw townscapes was a traditional practice by the mid-seventeenth century. Kemp describes the close connection between the device and surveying in both Renaissance Italy

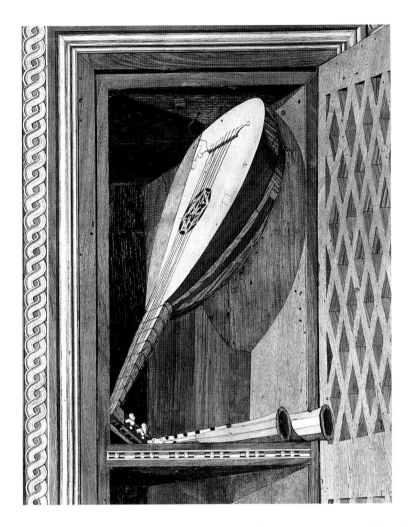

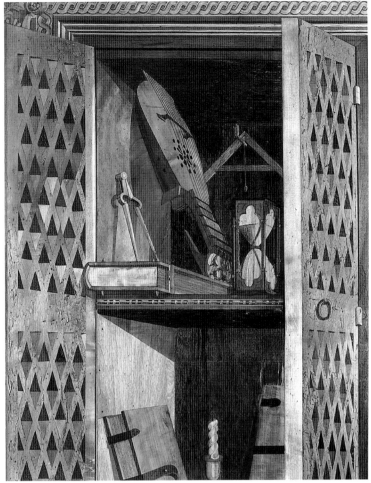

and sixteenth-century treatises. He quotes Gemma Frisius (1545), whose *radio astronomico* was intended primarily for astronomical and geographical measurements. "I shall, however, not discuss how some painter … might delineate by optical principles either an entire fort or a sacred building or even a town (should he wish to) with the aid of our *radius*… and yet I cannot pass over in silence the very great ease and advantage of our instrument which some architect or painter might attain if … he wished to depict the entire face of a building opposite him graphically in a picture and in accordance with the symmetry of the parts."[102]

In seventeenth-century treatises such as Marolois's *La Perspective* (Amsterdam, 1629), the perspective frame is also closely linked with surveying and is treated as an object of intellectual curiosity.[103] Marolois addresses himself to *amateurs*, as had Vredeman de Vries on his title page, and likely readers such as Constantijn Huygens and Samuel Pepys describe perspective frames and other drawing aids in their diaries (discussed later in this chapter). This is interesting for contemporary appreciation of the perspective box because – like the perspective frame, the camera obscura, the cross-staff, and other devices – it was an object one might expect to find in the study of a connoisseur of art and science. For non-professionals these items were not means to

practical ends but embodiments of modern technology, status symbols, and highbrow entertainment used to demonstrate knowledge in some striking or clever way.[104]

Musical instruments

Musical instruments belonged in the same collection of personal attributes (as illustrated by the fore-shortened lute in Holbein's *Ambassadors*; fig. 89), and their aura of polite learning was associated with perspective in a particular way. As mentioned above, stringed instruments had long been favorite subjects in demonstrations of perspective virtuosity. Among the most telling examples are the intarsia decorations dating from the 1470s in the ducal *studioli* of Urbino and Gubbio (see figs. 69, 70). Here, single motifs combine different areas of learning, such as music and perspective, and may relate (if some drawing device was used to record the image) to more than one real object in the gentleman's study.[105] Dürer's illustration of a perspective frame employed to trace a foreshortened lute (fig. 73) was probably the most widely known representation of a drawing device for about a century after its publication in 1525.[106] Later writers on perspective, such as Daniele Barbaro (1568), Salomon de Caus (1612), and Pietro Accolti (1625), pay close attention to the motif of a foreshortened lute (De Caus assigns it a chapter; see

69
A lute and pipes in a cupboard (detail of the intarsia decorations in the Gubbio Studiolo, completed in 1476). New York, The Metropolitan Museum of Art

70
Attributes of learning, an hourglass and a candle in a cupboard (detail of the intarsia decorations in the Gubbio Studiolo, completed in 1476). New York, The Metropolitan Museum of Art

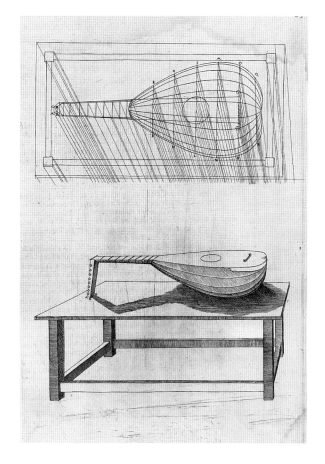

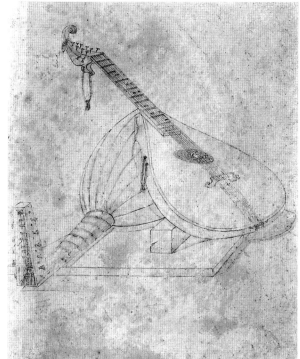

fig. 71),[107] and inevitably anonymous draftsmen took
up the suggestion of tracing a lute or a similar
instrument with a perspective frame (as in fig. 72?).[108]

Lutes and viols were ideal subjects for perspective
demonstrations and drawing devices. Like armillary
spheres, the *mazzocchio*, Uccello's chalice, and, for
that matter, Houckgeest's choir (fig. 41), these
stringed instruments are geometric but unusually
complex forms.[109] They were also described by some
authors – De Caus, for example – as symbols of
proportion and harmony, the common denominators
of mathematics, music, astronomy, and branches of
geometry such as perspective.[110] One is not tempted
to interpret Fabritius's lute and viol in this vein, but it
should be recognized that anyone with a special
interest in perspective at the time would have
realized that stringed instruments were variously

associated with perspective in learned treatises and in
some memorable works of art.

Combining motifs
Having drawn the musical instruments and the
townscape, Fabritius would probably have combined
them in a single perspective cartoon. The scale of the
lute and viol would have been determined arbitrarily;
perhaps the artist sketched a few alternative
combinations of foreground and background to
judge which worked best compositionally, with
particular regard to the impression of rapid recession
over the table top and into the townscape. Although
it is misleading to compare this sophisticated
construction with any surviving perspective box
except Van Hoogstraten's in London (fig. 54),[111] it is
noteworthy that five of the six known examples
feature a chair or table supporting objects as a
repoussoir in the immediate foreground (figs. 92, 93),
thus foiling the architectural view as it is perceived
through the peephole.[112]

The trellis is such an effective formal device that
its insertion into the view hardly requires discussion.
The motif was mentioned above in connection with
Houckgeest's choir screen (fig. 41), but it also may
be compared with the columned porticos of palaces
painted by Hans and Paul Vredeman de Vries,
Hendrick van Steenwyck the Younger, and other
architectural painters (fig. 74). The nearest columns
in those compositions are often interspersed with
narrow views of distant scenery, which effect a
gradual transition from the structure in the
foreground to the open vista without any sense of
interruption in the space as a whole. Of course, the
trellis also supports a small roof overhead, which

74
PAUL VREDEMAN DE
VRIES,
*The Doric Order and the
Sense of Hearing*, from
Hans and Paul Vredeman
de Vries, *Architectur Oder
Baumeisterschafft ...* ,
Amsterdam, 1628.
New York, The
Metropolitan Museum
of Art. Hondius published
Dutch, French, and
German editions of the
book in The Hague in
1606; this plate is based on
a drawing dated 1604.

strengthens the impression of sudden recession through the foreground. At the peephole, one feels like a companion of the seated figure, with a view of the townscape from a vantage point at the nearest corner of the table.

The tree on the right was probably brought in at the cartoon stage or even later, in order to balance

the trellis and lute and to enhance the illusion of actual space on the right. As with the lute, the tree's apparent detachment from the picture surface and from a bright background (compare *The Goldfinch*, fig. 32) gives it a presence such as few trees in Dutch landscapes had been granted previously.

In making one cartoon from two or three perspective drawings, Fabritius simply needed to maintain a common horizon line. Vredeman de Vries, Hondius, and Marolois offer many examples of this practice. In one plate by Hondius (fig. 75), for example, a chair and a set of shelves recede demonstratively through doorways (thus reminding the novice of the horizon in nature), while a building outside to the right recedes to a central vanishing point coincident with the rear wall of the interior. Objects in the room could recede to any point on the horizon, but for simplicity's sake Hondius aligns his furniture with the floor tiles, so that the chair and shelves recede to the distance points.[113]

Perspective and sight

Hondius explains in the same publication of 1622 that the geometry employed to make anamorphic murals may also be applied to the design of a perspective box.[114] Fabritius seems to have made the same connection. His own lost murals, or at least the one in Dr. Valentius's house in Delft, were not only illusionistic but anamorphic, to judge from Van Hoogstraten's account.

75
Perspective projection of
furniture in a room, in
Hendrick Hondius,
Institutio artis perspectivae,
The Hague, 1622.
The Hague, Koninklijke
Bibliotheek

As a topographical draftsman and perspectivist, Hendrick Hondius (1573-1650) – the publisher of Vredeman de Vries and Marolois[115] – would have been admired by Fabritius. Hondius lived on the Buitenhof in The Hague, in a neighborhood occupied by the Orange and Bohemian households, foreign diplomats, court figures such as Constantijn Huygens, and only one other artist, the wealthy *amateur* Jacques de Gheyn II. (Simon Frisius's etching after Hondius, *View of the Court in The Hague*, of 1621 [fig. 76], is thought to have been recorded from the large house that Hondius occupied from 1614.)[116] When De Gheyn was asked by Huygens's father to give his children drawing lessons, the artist recommended Hondius, who taught Constantijn in 1611.[117] In later years his expertise in "perspective and other sciences" brought Hondius to the attention of "kings, great princes and nobles," according to Cornelis de Bie.[118] Hondius must have been well known to Bartholomeus van Bassen, the city architect of The Hague, and to Van Bassen's pupil Houckgeest (discussed in the following chapter).

The geometrical aspects of *A View in Delft* would have interested these gentlemen rather more than the modern reader (who may wish to skip the remainder of this section). However, to understand how the composition relates to contemporary perspective treatises, perspective boxes, and architectural paintings, it is necessary to consider a few technical points.

Once again, Houckgeest's panoramic picture of 1651 (figs. 41, 107) provides a helpful comparison. Both paintings depict very wide-angle views, an unavoidable consequence of which is the apparently diminished size of objects or areas in the central part of the image.[119] If Fabritius saw Houckgeest's composition he may have noted the problem and realized that a peephole could restore the spatial impression gained at the actual site.

There is a more specific similarity between the design of Fabritius's townscape and Houckgeest's perspective cartoon (see figs. 62, 108). The latter includes the entire width of a three-point projection, which by definition encompasses a ninety-degree angle of view. (To put it simply, the side of William the Silent's tomb recedes to the west, while the rear recedes to the north.) On the right, Houckgeest pushed his panorama to an extreme by extending it about fifteen degrees beyond the right-hand distance point.[120] Fabritius extended his panorama to the left in a similar fashion. In his painting, the townscape proper corresponds with a ninety-degree angle of view at the site (see map, fig. 42). The Oude Langendijk on the left recedes directly west, to the left-hand distance point, which is located at the edge of the trellis near the man's hand. Fabritius added the inn scene to the townscape simply by making the edge of the table and the roof line overhead recede approximately to the same point. Someone like Hondius or Houckgeest could have deduced from all this that the wall on the left must (if the table is rectangular) be parallel to the east-west axis of the church – that is, in line with the other buildings on the Oude Langendijk. These relationships seem plausible when one views the painting in a perspective box (figs. 46, 47) but seem much less so in a flat mounting of the image (fig. 37).

Presenting the picture on a curved surface could be said to have served two purposes at once: the "panoramic" (suggesting one's experience at the actual site) and the "illusionistic" (minimizing one's awareness of the picture plane).[121] As a means to "cheat the eye" the curved mounting must have been quite effective. For one thing, the image probably did not correspond in shape with the box's exterior. Other known perspective boxes suggest to the viewer how the painted surfaces are configured inside (see fig. 54). Authors like Dubreuil show different constructions (see fig. 56), so that assumptions about the shape of an interior might be turned to advantage.

The illusionism of other perspective boxes is also diminished by the obvious joins between flat planes and the way the angled surfaces catch the light differently. On a curved surface, by contrast, the light changes only very gradually – hardly at all, in

fact – when the real light source is above or behind the viewer (see fig. 43) rather than off to the side. A vertical seam through the image, as in the Copenhagen boxes (see figs. 91, 92), would have been hard to hide in the case of a landscape or townscape painting. The curved join with the floor (see fig. 46; pl. IV) is also less conspicuous than the usual angular construction; the challenge was avoided in the Copenhagen boxes by dropping the floors completely out of sight.

Of course, even in Fabritius's invention one would have had some awareness of the picture surface. This is part of the pleasure of trompe-l'oeil pictures: their failure to deceive the eye entirely draws attention to the artist's ingenuity. In the present reconstruction, the painted surface also has the expressive function, mentioned above, of leading the eye continuously from one side to another, as in natural vision. "We see around us with our eyes," as Van Hoogstraten reminded his readers.[122]

This point had been made by other authors using visual aids. For example, the first plate of Vredeman de Vries's *Perspective* (fig. 77) gives a bird's-eye view of the ground and the horizon, with the viewer assumed to be in the central square.[123] Each quarter of the circle (ninety degrees) corresponds with a three-point perspective projection, examples of which are shown in the subsequent plates. Thus the book begins with an introductory explanation of how artificial perspective selects from natural vision a single view.

In Vignola's treatise the concept of a roving eye is conveyed by an illustration of Baldassare Lanci's drawing device (fig. 78). A moveable pin in the lower arm pricks a sheet of paper inside the hemicylinder, in correspondence with key points sighted in the actual environment. Vignola's editor, Egnatio Danti, warns the reader that the drawing should not be laid flat for viewing, which would distort the image. Lanci himself used a conventional perspective scheme to depict an idealized view of central Florence as stage scenery (1569). Like other drawing devices,

including Dürer's version of a perspective frame with an eye-point fixed on a wall, Lanci's instrument appears to have had a didactic – not a practical – purpose.[124]

The curved mounting of *A View in Delft* bears a superficial resemblance to Lanci's device, but the designs differ in principle. For the commentator Danti, it would suffice to note that the assumed vantage point is not at the center of Fabritius's half-circle but further back. The townscape reminds one of natural vision, but it remains an orthodox perspective construction, like Lanci's stage scene and the architectural views of Vredeman de Vries. The only difference is that Fabritius's composition was, in a secondary operation, transferred from a flat to a curved surface (which could have taken another form).

What the Delft painter needed was not Lanci or Danti but someone like Marolois, whose treatise of 1628 demonstrates how to project conventional perspective cartoons onto one's choice of angular or hemicylindrical surfaces (fig. 79). His step-by-step

80
Salomon de Caus,
*La Perspective, avec la raison
des ombres et miroirs,*
London, 1612, Book 2,
"On Shadows," a plate
demonstrating how to
paint an illusionistic mural
("continuation of a room
on the wall of said room")
and how to project the
shadows properly.
New York, The
Metropolitan Museum
of Art

81
Salomon de Caus,
*La Perspective, avec la raison
des ombres et miroirs,*
London, 1612, Book 2,
"On Shadows," a plate
showing the lines of sight
in fig. 80. New York,
The Metropolitan
Museum of Art

explanation of how to transfer an image from one intersection of the visual pyramid (the familiar "picture plane") to another (for example, the walls or vault of a building, or the interior of a perspective box) is what Van Hoogstraten had in mind when he wrote, "for however angular the vaults or walls may be, one can always break them down by means of this art, so that they seem to have an entirely different form" (see p. 48 and figs. 55, 56 above).

Reducing the design

Fabritius would have found it much easier to make such an anamorphic projection on a larger scale than that of his painting. He could then reduce the image by a simple system of squares or, more likely (given the townscape's meticulous detail), by employing some kind of mechanical drawing device. Marolois illustates an instrument that functions variously, in one configuration as a perspective frame and in another to reduce or enlarge scale (fig. 68).[125] The latter operation was also performed by the pentograph, which was published by Christopher Scheiner in 1631 and was soon available in efficient models.[126] (A finely calibrated pentograph in brass, dating from the second half of the seventeenth century, is in the Museum Boerhave, Leiden.)[127]

The anamorphic design need not have been reduced and transferred directly onto the primed canvas. Like Saenredam, Fabritius could have made another cartoon on the scale of the painting. This would have allowed any awkward results of the whole process to be mitigated before final transfer to the priming.[128] Saenredam, it will be recalled, blackened the versos of his perspective cartoons and traced them lightly onto primed panels.[129]

Cast shadows

Some general scheme of cast shadows may have been planned during the cartoon stage. The rather precise plotting of the shadows on the quay below the church, and the fact that the width of the lute's

shadow was reduced *in situ*, would seem to support this hypothesis. The use of canvas would have allowed the artist to curve, judge, flatten, and modify, which would have been a less tedious process than the assembly and disassembly required by a perspective box constructed of painted wood panels.[130] Fabritius may also have drawn the broad outlines of shadows by placing his eye at the assumed vantage point (a simple post could stand in for the box with peephole), attaching a string at the location of the sun and pulling it taut in front of the curved image, so that it represented a ray of sunlight passing over certain points on objects such as the lute. One need not make too much of this, since there are only a few distinct shadows. The important point is that the painted shadows make no sense in the flat mounting (pl. III) – the sun would be in several places – but they read logically and illusionistically in the present reconstruction (see figs. 46-49; pl. IV).

The cast shadows in *A View in Delft* not only enhance its illusionism but also underscore the artist's perspective expertise. From the late sixteenth century onward, treatises on artificial perspective included the projection of shadows as a standard subject (see figs. 80, 81).[131] Common sources in books by such authors as Marolois and Dubreuil probably account for the similarity between the cast shadows in Fabritius's townscape and in an illustration like Van Hoogstraten's landscape print (fig. 82), where lines and letters indicate that the shadows should converge to a point on the horizon directly below the sun and that the sun's height determines how long the shadows should be.[132]

Reflection

In its transparency, the shadow of Fabritius's lute demonstrates (as do many shadows in Vermeer) that the apparent density of shadows depends upon the light around them, as well as other factors. This is one example of reflected light, and others are found in the same area of *A View in Delft*, now that it has

ZESTE HOOFTDEEL.

Van de schaduwen der Zonne, en haere streekvallen.

been cleaned: the highlights on the wall and its overall luminosity, the sky's reflection in the belly of the lute, and the reflection of the viol's bridge in its soundboard. Less obvious examples of reflection, which was another standard subject for writers from Lomazzo to Van Hoogstraten, are found in the water, on the church, and in various highlights (for example, on the leaves of the nearest tree). The reflection of the viol's bridge is actually an example of refraction, which is also discussed in contemporary treatises.[133]

Artistry

Observations of this kind were appreciated in Fabritius's day as signs of learning, of an artist's (or a patron's) interest in optics, perspective, and various aspects of the natural world.[134] But the townscape bears no resemblance to an academic exercise; the lasting impression is one of marvelous invention, of cleverness, artifice, and consummate skill. The weathered wall on the left reinforces this reading, not only through its rapid recession but as a painterly passage, a *schilderachtig* motif.[135] With its rough strokes and dabs, like those on a painter's palette, the wall foils the fine definition of forms found in the more central parts of the picture. Perhaps the artist alludes also to peripheral vision, but he more certainly draws attention to the artistic process, and to the powers of conception (or "imagination") which make

a coherent image out of raw materials.[136] All this would have been more evident in the work's original form of presentation. To viewers of the time, *A View in Delft* must have seemed at once wonderfully contrived and completely natural, an achievement rarely seen on a comparable level before the mature works of Vermeer.

83
A detail of fig. 76 (Frisius after Hondius, 1621)

84
ATTRIBUTED TO CLAES JANSZ VISSCHER,
The Court of Holland, 1636.
Engraved vignette made for the border of his *Illustrated Map of the Netherlands*.
The Hague, Gemeente-archief

(Perspective boxes and illusionistic murals by Carel Fabritius)

Documentary evidence of Fabritius's work on murals and perspective boxes has been published before, by Wijnman (1931), Liedtke (1976), and Brown (1981). However, it would be helpful to gather the records in one place and to offer some further observations.

1. The painting itself may be considered a document dating from 1652.

2. Illusionistic murals in Delft, house of Dr. Valentius, etc. (ca. 1652-54).

In his chapter on perspective (*Deurzigtkunde*), Van Hoogstraten (1678) compares Giulio Romano's illusionistic murals in the Palazzo del Te, Mantua, with those that Fabritius made "at Delft in the house of the art-loving late Dr. Valentius and elsewhere." Van Hoogstraten then mentions his own illusionistic pictures painted in Vienna and London, as well as "the wonderful perspective box" (see p. 48 above). Presumably, Fabritius's murals in Delft would have been made between 1652, when he joined the local painters' guild (on October 29), and his death in October 1654.

Brown's suggestion that Dr. Valentius might have been Dr. Theodorus Vallensis (1612-1673), dean of the surgeons' guild in Delft, is certainly correct.[137] His father, Jacob van Dalen (1570-1644), professionally known by the Latinized form of his name, Vallensis, was the personal physician of the Stadholders Prince Maurits (d. 1625) and Prince Frederick Hendrick (d. 1647). The elder Vallensis and his wife are the subject of pendant panels by Michiel van Miereveld, dated 1640 and 1639, respectively (Metropolitan Museum of Art, New York),[138] and the distinguished doctor appears prominently in a group portrait, *The Anatomy Lesson of Dr. Willem van der Meer*, painted twenty-three years earlier in 1617, which was executed in good part by Pieter van Miereveld following his father's design (Stedelijk Museum Het Prinsenhof, Delft).[139] Van Dalen's son and heir, Theodoor Vallensis, graduated from the University of Leiden as doctor of medicine in 1634. His marriage to a burgomaster's daughter, Agatha van Beresteyn (1625-1702), brought him into the regent class of Delft, where he himself served as burgomaster and held other civic offices. He lived on the Oude Delft, which is one of the most likely addresses in the city for a house decorated with a mural,[140] and his death in 1673

matches well with the "late" employed in Van Hoogstraten's publication of 1678. No work by Fabritius is mentioned in Vallensis's estate (a mural might not have been listed among movable goods), but his son, Jacob Vallensis (d. 1725), counsellor at the Court of Holland, owned two "tronies" (paintings of heads or bust-length figures) by Fabritius.[141]

3. "A perspective of the Court of Holland made by the late Fabritius" (*Een perspectyf van 't Hoff van Hollandt, gemaect bij Fabritius za:*) was cited in the inventory of Catharina Tachoen, widow of Salomon van Delmanhorst, on the occasion of her marriage to the notary Jacob van Someren, in Dordrecht, September 9, 1669.[142]

Van Delmanhorst was very probably an artist (listed in the Leiden guild from 1648 until the 1660s) and the son of Hendrick van Delmanhorst, a poet and professor of medicine in Leiden (traceable through 1631; known to Theodoor Vallensis?). Hendrick's father, Salomon, was a surveyor who wrote a poem published in Van Mander's *Schilder-boeck*.[143]

The term "perspective" was often employed for architectural paintings, but could also refer to a cityscape. The work was probably not mounted on a wall or in a box, and it was not necessarily illusionistic. The "Court of Holland" could refer either to a view of the Binnenhof or the Hofvijver, that is, the interior (courtyard) or exterior of the court buildings in The Hague. Both subjects, but especially Hofvijver views, had been represented since the late sixteenth century.[144] Simon Frisius's etching after Hondius's broad view of the Hofvijver from the Buitenhof (fig. 76), dated 1621, became the inspiration or model for many painted and engraved views dating from the 1620s through the 1650s.[145]

Hondius's composition, in particular the central and right-hand sheet (see fig. 83), reveals intriguing similarities to *A View in Delft*, including a shop with a trellis-like fence to the left, the prominent tree to the right, the receding architecture in the center and on the right, and the exaggerated depth of the area of water and of the pavement nearest to the viewer. While Fabritius must have known the print, there is no need to see a direct influence, or influence uninflected by that of other images. Several artists who depicted this view of the Hofvijver in the years between 1635 and 1650 used the same two-thirds of Hondius's view as a model, whereas painters and printmakers of the 1620s and the early 1630s (for example, Hendrik Ambrosius Pacx and Pauwels van

Hillegaert in their "Nassau cavalcades") usually adopted the wider view.[146] The development from about 1635 onward in favor of closer, taller, and more concentrated compositions is consistent with broad trends in Dutch landscape and townscape painting.

A print attributed to Claes Jansz Visscher (fig. 84) was made in 1636 as one of the vignettes around the border of his *Illustrated Map of the Netherlands*, which appears in the background of Vermeer's *Art of Painting*.[147] The designer apparently curved the foreground toward the viewer (in contrast to Hondius) in order to make the mounted dignitaries more prominent. This is not unexpected of Visscher, who handled wide-angle views similarly in a number of drawings and prints.[148] In any case, it is an artistic not an optical effect.

Whether or not these considerations are relevant to Fabritius's lost "perspective of the Court of Holland" can only be conjectured. The subject, like that of *A View in Delft*, concerns the House of Orange, for which Fabritius supposedly worked.[149] One wonders whether his view in The Hague resembled Visscher's composition and whether it preceded the Delft view. It is not hard to imagine that the two townscapes by Fabritius may have been related not only in subject and composition but also by patronage.[150]

4. Fabritius's mural in the Delft brewery called "The World Upside Down."

On April 10, 1660, the owner, Maria Duijnvelt, widow of Nicolaes Dichter, made it a condition of the brewery's sale that she be allowed to remove at her own expense "the painting by Carel Fabritius" which was "nailed fast" to a wall. The mural must have been painted on wood or canvas, not plaster.[151]

It may be recalled that in 1677 the owner of a Leiden brewery, "The World," owned "a painting done by Fabritius, depicting a hunter."[152] The picture may have been by Barent Fabritius. Some brewing families in Leiden and Delft were related, Jan Steen's family being an example.[153]

5. "A small case by Fabritius" in the estate of a Leiden collector (1683).

The list of paintings owned by Aernout Eelbrecht in Leiden was compiled on March 4, 1683, by the well-connected painter Carel de Moor.[154] In addition to works by Jan van Goyen and his son-in-law Jan Steen, there are no less than eight "tronies" by Fabritius; "a piece by Fabritius, in which Van Aelst painted the sword [or dagger]"; and *een casje van*

Fabritius, which could have been a perspective box or a case with doors (of the kind painted by Dou, and made by De Witte for his *Interior of the Oude Kerk in Delft*, dated 1651, in the Wallace Collection, London; see figs. 90, 156).[155]

6. "The piece by Fabritius being a case [or box]" cited in the will of Gerrit Jansz Treurniet, Delft, May 2, 1661.

Treurniet was from Rotterdam, but he was confined by illness to the Delft residence of Doe Arentsz 's-Gravesande, to whom he left 500 guilders plus a fruit still life by "Moliers," a fire scene and a seascape by Egbert van der Poel, and the "case" by Fabritius. Brown described the document incorrectly as unpublished.[156] However, he added significant details, including the idea that Treurniet probably bought the case from Cornelis de Helt, an innkeeper who at the time of his death in 1661 owned a painting by Vermeer.

7. "A large optical piece standing on a pedestal made by a distinguished Master Fabricio of Delft" is cited in the 1690 inventory of the Danish Royal Collection.

The document may relate to the *View of a Voorhuis*, a Dutch perspective box of about 1670 in the Nationalmuseum, Copenhagen.[157] If so, the attribution might reflect some circumstances of acquisition, confusion on the part of the compiler of the inventory, or Fabritius's reputation as a maker of perspective boxes.[158] However, an attribution of the *View of a Voorhuis* to Fabritius is so implausible that another object may have been meant. Any reference to a work by Fabritius in a princely collection is interesting because of his wife's claim that he was painter to the Prince of Orange (see p. 46 above).

8. Dirck van Bleyswijck begins his life of Fabritius (1667-80) with the remark that he "was so quick and sure in the use of perspective as well as natural coloring and execution that (in the judgment of many connoisseurs) he has never had an equal."[159]

9. Van Hoogstraten (1678) mentions the perspective box immediately after his account of Fabritius's illusionistic murals (see no. 2 above and p. 48 for the passage), and on another page compares the latter to frescoes by Baldassare Peruzzi.[160]

The subject

The first scholar to mention *A View in Delft* in print, Hofstede de Groot (1907), called the canvas *A Musical Instrument Dealer at his Booth in the Open Air*. His catalogue entry identifies the actual site but gives equal space to the woman by the canal and to the seated man who is "deep in thought, under a tent set before a wall; some musical instruments lie near him."[161] Readers familiar with Hofstede de Groot's many articles and reviews will know that he had a fondness for reading folkways from pictures. He may have introduced the idea of a musical instrument seller in a temporary stall, or the idea may date from the eighteenth century when itinerant vendors existed.

Holmes, in 1923, added to Hofstede de Groot's description of the site the names of the streets, and suggested that "the shorter title of *A View in Delft* seems more appropriate and convenient."[162] However sage, this opinion proved less influential than Hofstede de Groot's familiar catalogue.

The description of the figure in the foreground as a dealer of musical instruments was uncritically accepted by almost all writers from Jantzen in 1910 to Brown in the 1991 edition of the National Gallery's catalogue of Dutch paintings.[163] However, Wheelock judged the traditional title "certainly inadequate," and in my article of 1976 the man was considered nothing more specific than "the passive agent of a conventional contrast between the church and worldly vanities."[164] A few scholars have endorsed this simple reading of the main motifs,[165] but no one has ever explained why the notion of a "musical instrument seller's stall" should be retained or dismissed.

The Market for Musical Instruments

Market stalls and street vendors of many kinds were depicted frequently by Dutch and Flemish artists, but no illustration of an outdoor musical instrument shop or stall dates from the period. Hans Sachs and Joost Amman's *Ständebuch* (*Book of Trades*) of 1568 includes one seller of musical instruments, a lute maker who sits in craftsman's clothing at his workbench in a shop.[166] Jan Luyken's representation resembles Amman's in that his musical instrument maker-merchants are dressed as craftsmen, they work in a shop where instruments hang on the walls (lutes, viols, and violins in Luyken's illustration), and the interior is accessible to customers by door and window.[167] No other pictorial images of a musical instrument maker or seller are known from the seventeenth century, to judge from the literature. (Some makers sold imported instruments, such as lutes from northern Italy, but there were no gentlemen dealers.)[168] However, the scant evidence is consistent with images and accounts of other trades in that customers went into the workshop, where they were more likely to find a busy craftsman than a man in bourgeois dress idly waiting for some passer-by to purchase one of his last two expensive instruments.

Pepys, for example, in 1668, "called upon one Hayward that makes virginalls, and did there like of a little Espinettes and will have him finish them for me."[169] In 1660, Pepys was at home when he received "Mr. Hill the instrument maker, and I consulted with him about the altering of my lute and viall."[170] Apart from professional musicians, it was gentlemen such as Pepys, Evelyn, and Huygens, and wealthy merchants such as Gaspar Duarte in Antwerp, who bought instruments like lutes and viols.[171] The pride of ownership evident in Pepys's remarks about his own instruments (in his diary, where he is essentially congratulating himself) and in Huygens's comment to a French singer, that in his house she would find as many "lutes, theorboes, viols, virginals, harpsichords, and organs" as she was about to encounter at the Swedish court,[172] is understandable given the cost of these luxury goods (which of course varied greatly: Huygens claimed to own the best lute in the world), and the social polish that possession implied. Huygens and other owners of musical instruments took lessons, practiced often, and played appropriate instruments in polite company. As is well known, Huygens also composed extensively for the lute. Recent studies of inventories, although not far advanced, add statistical support to the impression one gains from letters and diaries, which is that lutes, viols, and keyboard instruments were to be found mostly in professional and in privileged homes, viols were less common than lutes and especially violins, and wind instruments were generally associated with a lower level of society (as in Hans Jordaens's inn scene; fig. 14).[173]

Dutch genre scenes and portraits usually show stringed instruments in fashionable company and in fine homes (or palaces, in paintings and prints of the type designed by Paul Vredeman de Vries; fig. 74).[174] A representative example is Caspar Netscher's *Viol Lesson* (Musée du Louvre, Paris), in which an elegant young lady receives the undivided attention of a handsome music instructor, while a well-dressed boy, presumably her younger brother, and his violin are ignored.

Scholars of Dutch genre painting occasionally advise their readers to note that certain subjects were never depicted, thereby underscoring the point that art is selective. As for selling lutes and viols like fish and cheese on the street, the subject was never depicted because it never happened. Laurence Libin, the Metropolitan Museum's Research Curator of Musical Instruments, cannot recall any illustration,

account, or other evidence of "costly instruments like these being sold from stalls and exposed to the weather – especially not in the Netherlands."[175]

Of course, it is conceivable that on certain market or feast days some musical instruments were sold at stalls, as were paintings (not, however, pictures as costly as lutes and viols). One of the earliest known images of such a stall is a print after the German painter and illustrator Daniel Chodowiecki, dating from 1774.[176] Like shop windows in Dutch paintings and prints, the stall has a sales counter behind which the proprietor stands. The temporary shop is wedged in among others selling meat, garments, toys, and other items in front of a church. Similar markets are still held in Delft today, but on the market square, not on a deserted corner of the Oude Langendijk.

Tavern Scenes

Fabritius's setting differs from market stalls in that a trellis, which is not a feature of stalls, a table (not a portable counter), and the roof are placed against a solid wall. Some permanence is suggested by the vine. Every aspect of this arrangement – the trellis, vine, covered table, musical instruments, and idle gentleman – would be associated immediately by contemporary viewers with an inn even if the sign bearing a swan were not hanging there like a label (as in fig. 14). Taverns called "The Swan" seem to outnumber all others in images dating from the time of Bosch (for example, in *The Wayfarer* in Rotterdam) to that of Jan Steen.[177]

While no historian of art or musical instruments would be able to defend the title we have inherited from Hofstede de Groot, it would require a chapter to review the number of seventeenth-century images that support a reading of the seated man's location as at a table in front of a tavern or inn. One of the better examples is Willem van Mieris's *The Trumpeter* (Stedelijk Museum De Lakenhal, Leiden), where the bacchic motif of a vine and the sign "in de Swaan" serve as visual shorthand for an inn.[178] Tavern exteriors embellished by vines growing on arbors or trellises are found in numerous sixteenth-century paintings and prints.[179] In the title print (after David Vinckboons) of the songbook *Den Nieuwen Lust-hof*, 1602 (fig. 85), an elegant wedding party plays lutes and even a virginal at a table surrounded by a vine-covered arbor.[180] A more common kind of arbor is found in Johann Liss's canvas at Kassel, whose more common patrons play *morra*, music, and *amore*.[181] Steen invented, and probably observed, numerous versions of vine-covered canopies, porticos, and arbors in front of taverns, and in many paintings these quintessentially secular settings are juxtaposed with churches (as in figs. 14, 67). Thus he continued the commentary on wine, women, and song that may be traced back to antiquity, but for our purposes from

Beham via Bruegel to Vinckboons and Steen, to mention only some of the most obvious names.[182]

Had Fabritius given his gentleman a glass it would have saved historians some time, but it would have added almost nothing for the contemporary viewer. Perhaps the artist preferred to concentrate upon the musical instruments as iconographic and perspectival counterpoints to the view of a church. In any case, the swan, the trellis with a vine, and the instruments suffice to identify the setting, making the less resonant motif of a glass unnecessary.

Lutes and viols (although owned by ladies and gentlemen) were made available to patrons of some Dutch inns, or were played for them by hired musicians.[183] In many seventeenth-century tavern and bordello scenes a lute hangs on the wall, as in Willem Buytewech's *Merry Company* of about 1620 in Budapest and Frans van Mieris's sexy *Inn Scene* of 1658 (Mauritshuis, The Hague).[184] Viols were the more occasional attraction, to judge from many images, and from the notice posted in 1670 by Richard Hancock at his inn on the Rokin in Amsterdam. Two of its twenty lines about music, drink, and the other features of a forthcoming "Parnassian Friendship" read as follows:

De Musijk sal geschien, na noen van vier tot tien.
Men sal op hallef acht viejool de gamba hooren.[185]

Organ concerts, by contrast, were funded by the city government in order to "keep people out of inns and taverns," according to a Leiden record of 1593.[186] In the following century Protestant clerics and city officials frequently condemned taverns and so-called

85
Anonymous engraver after David Vinckboons, title plate of *Den Nieuwen Lust-hof*, Amsterdam, 1602. The Hague, Koninklijke Bibliotheek

VV. D. HOOFTS
Heden-daeghsche
VERLOOREN SOON.
Ghespeeld' op de
AMSTERDAMSCHE
ACADEMI.
Op den 3. Februario, Anno 1630.

t'AMSTERDAM,
Door Cornelis VVillemsz Blaeu-laecken; Boeckverkooper inde
Sint Ians-straet, int vergulde ABC. Anno 1630.

86
The title page of
W. D. Hooft, *Heden-daeghsche Verlooren Soon*,
Amsterdam, 1630.
The Hague, Koninklijke
Bibliotheek

muziekherbergen, judging music to be one of the intoxicants that led to worse sins.[187] Among the many mostly earlier paintings and prints that relate to this topical issue are those depicting the Prodigal Son, or a young man quite like him, wasting his time, money, and youth at an inn.[188] A large amount of moralizing literature and undoubtedly a great number of sermons addressed the same theme, which Barent Fabritius painted with other parables for the Lutheran Church in Leiden in 1661.[189]

These details go beyond the subject of our painting, but they stress the point that the image of an inn with musical instruments, especially when juxtaposed with a church, would have brought to mind a host of traditional associations and contemporary concerns. The concise understatement with which Fabritius conveys these ideas speaks for their currency and at the same time sets his approach apart. Perhaps his patron would have appreciated the picture as more contemplative and evocative than

most contemporary paintings with the same or similar motifs. In this respect *A View in Delft* anticipates mature works by Vermeer, as it does in more obvious ways as well.

Meaning

In these pages on the picture's subject it is important not to lose sight of the fact that Fabritius's essential goal was to depict an actual place with extraordinary verisimilitude. Of course, many images of the period concentrate upon the faithful, even illusionistic representation of the immediate environment and at the same time offer ethical asides. The weight assigned to a particular motif must depend upon the context and some familiarity with the artist, as well as a review of traditional interpretations.

In my view, the swan in this painting functioned primarily as an unmistakable sign that the man sits at an inn.[190] When another writer maintains that a swan, even on a shop sign, is "always an attribute of the love-goddess Venus," this is clearly a case of poetic license.[191] It is true that the swan identifies inns of ill-repute in earlier Dutch and Flemish images, that the bird embellishes the title pages of P. C. Hooft's *Emblemata Amatoria* (Amsterdam, 1611) and Crispijn van de Passe's *Thronus Cupidinis* (Amsterdam, 1616), and that Joost van den Vondel, in a poem celebrating a marriage in 1656 ("Ter Bruilofte van Joan Huidekopper"), wrote emphatically about the swan's lust (a rumor presumably started by Leda). But it is impossible to say whether this amorous reputation or the perfectly temporal example of a "swan song" were intended as grace notes to the meaning of the musical instruments in Fabritius's picture, which were far more familiar to contemporary viewers as reminders of sensual pleasure and the passage of time.

Lutes, viols, and other stringed instruments are such common accessories of courtship and dalliance in Dutch art that one need only mention inn scenes and domestic interiors by painters such as Willem Buytewech, Dirck Hals, Pieter Codde, Jacob Duck, Gabriël Metsu, and, in Delft, Anthonie Palamedesz (fig. 3). When the setting is certainly an inn, the playing of musical instruments may be described unequivocally as one pursuit of pleasure among many. An unusually explicit example occurs on the title page of W. D. Hooft's comedy of manners, *Heden-daeghsche Verlooren Soon* ("Modern-day Prodigal Son"; fig. 86), where the well-dressed wastrel and his impromtu paramour are serenaded by a female trio playing viol, violin, and flute.[192]

Of course, Fabritius's "musical company" is nothing of the sort, only a solitary figure. In many genre paintings of the period a couple is provided with a viol and a lute, or viol and violin, forming a combination of two or, with voice, three parts.

Images of this kind and the actual parts played by the instruments – a viol for the base line, a lute or virginal for chords, and a violin or voice for the melody[193] – were sufficiently familiar to contemporaries that many of them would have imagined the missing figures in other scenes, such as the man who would play the unattended viol in Vermeer's *Woman with a Lute* (fig. 288) or in his *Young Woman Seated at a Virginal* (National Gallery, London; fig. 314),[194] and the woman who would play either instrument, but more likely the lute, in *A View in Delft*. In this picture the instruments have been set down only for the moment and remain close at hand. They imply expected company, or at least point out the absence of someone with whom music might be made.

The prominent church, of course, casts another light on the lute and viol, which is that all sensual pleasures are short-lived. More explicit examples of this message are found in prints like Dirck Matham's engraving labelled VANITAS (fig. 87), where a viol, a lute, two other instruments, a songbook, a tankard, and glassware are piled on a table in the foreground, before a window revealing carousing couples in another room. A cheerless poem by the musical prelate Johan Ban accompanies the image and informs the viewer that all human life "hangs by a thread," that music and other pleasures do not produce happiness, and that "time and eternity, these are our sole things of value. This, one must contemplate – the rest is condemned to death."[195]

Matham's print, which has been described impetuously as "the first musical 'Vanitas',"[196] anticipates countless painted allegories, genres scenes, and still lifes in which musical instruments are mixed with skulls, mirrors, candles, bubbles or glass spheres, timepieces, and so on (see fig. 61).[197] The most interesting examples for Fabritius's picture are those in which a few stringed instruments stand alone or with other objects of worldly interest, and are contrasted with some reminder of Salvation. For example, in a painting by Simon Luttichuys of about 1650 (private collection, The Hague), a lute, viol, and songbook sit on a table together with a skull and a plaster head of Christ.[198] The simplicity of the arrangement compares well with Fabritius's image, and contrasts with the many more elaborate compilations of earthly treasure that are depicted in works dating from the middle decades of the century.[199]

Their essential message could be conveyed by a single instrument, for example, the lute that serves as a sign of worldly pleasure in the 1550 edition of Alciati's *Emblematum liber* (a songbook was added in the edition of 1561).[200] On the title page of an actual lute book for which Alciati seems to be the source, Fuhrmann's *Testudo Gallo-Germanica* of 1615 (fig. 88),

cut flowers and a skull-shaped vase join the lute and songbook, above which a hand in the sky points out to slow-witted viewers the well-worn Latin line, "Vanitas vanitatum, omnis vanitas."[201]

Despite their relentlessly consistent content, vanitas still lifes and what might be called "vanitas genre scenes" include some remarkably original compositions. Jan Miense Molenaer's *Lady World* of 1633 (Toledo Museum of Art, Toledo, Ohio), with its catalogue of stringed and wind instruments and other time-tested motifs, is such a vivid invention that in the 1940s, when the skull was still overpainted, the picture was called "The Preparation for the Wedding" (which is just as good a title as "A Musical Instrument Seller's Stall").[202] An equally memorable painting in the same museum is Jan de Heem's lavish still life of comestibles on a table by a window, through which one spies a ship in a storm-tossed sea and finds hope of salvation in the form of a church on the coast.[203]

Some artist other than Fabritius – Edwaert Collier, for example – might have placed an edifying inscription instead of his name on the wall to the left

87
Dirck Matham,
Vanitas Still Life with Musical Instruments, 1622.
Engraving.
New York, The Metropolitan Museum of Art

88
The engraved frontispiece to Georg Leopold Fuhrmann, *Testudo Gallo-Germanica*, Nürnberg, 1615.
Munich, Bayerische Staatsbibliothek

89
Hans Holbein the
Younger,
*Jean de Dinteville and
George de Selve
(The Ambassadors)*, 1533.
Oil on panel,
207 x 209.5 cm.
London, The National
Gallery

of the instruments (or on the outside of the perspective box). A nice choice at a slightly later date would have been the following lines from Jan van der Veen's *Zinne-Beelden oft Adams Appel* (Amsterdam, 1659, no. 32):

De VEDEL of FIOOL die wert God betert, meer Gebruyckt tot ydelheyt, als tot Godts lof en eer (The Fiddle or Viol which would better serve God is used more for vanity than for God's praise and honor).[204]

But all this would have gone without saying for the comparatively few sophisticated viewers who were likely to have known *A View in Delft*. Their thoughts, unfettered by inscriptions or conspicuous symbols, could have flowed freely to other aspects of the work, such as the comparison of music and perspective as two forms of harmony, or the similarity between music and illusions, both of which stir the senses and then are gone.

Of course, the idea of revelation, of perceiving an illusion or discovering meaning, was what made many anamorphic images appealing on an intellectual level.[205] The classic example is Holbein's *Ambassadors* of 1533 (fig. 89), where the cultivated Frenchmen (the envoy Jean de Dinteville and Bishop Georges de Selve), with their musical instruments and other signs of worldly knowledge, stand behind a radically distorted skull which becomes approximately normal in shape and seemingly three-dimensional when seen from a point near the right-hand side of the panel. From that position the mortals and their riches are a disembodied blur; their world was an illusion, and only death remains. But eternal life is offered by a half-hidden crucifix to the upper left, which is revealed behind the curtain. There are, in a sense, three viewing points implied by the painting, which afford images of life, death, and salvation.[206]

In the later, less ethereal world of learning that is embodied in Dutch perspective boxes and illusionistic paintings such as Van Hoogstraten's

murals and still lifes, *A View in Delft* may be the only work that bears comparison with Holbein's: the man at a table with instruments, the church in the background, and in the foreground not a skull but a viol that seems tangible and yet is also perceived as an illusion. The motif introduces the entire scene as an illusion, a little world held in the hands, which leads to the revelation that the real world it depicts, the world in which the artist lived and (as it happens) suddenly died, was to be but a brief experience.

However, there is also the revelation of the church in front of one's eyes. Unlike Holbein's crucifix, the Nieuwe Kerk completely dominates the view when perceived from the peephole by even the most wayward eye (fig. 53). Emanuel de Witte, in the previous year, achieved an analogous effect in his *Oude Kerk in Delft* (fig. 156), which was encased by the artist in a frame with shutters that represented a fruit still life when closed (see fig. 90).[207] The ensemble illusionistically intensifies the scheme of De Heem's *Still Life with a View of the Sea* (and a church) in Toledo, which De Witte most likely did not know. Nor did he have to, since the idea of comparing sensual delights in the foreground with almost hidden religious motifs in the background had numerous precedents, including views of market stalls (none with lutes or viols) by Pieter Aertsen and Joachim Beuckelaer, as well as many still lifes of De Heem's generation.[208] The shuttered frame devised by De Witte also recalls older triptychs, in which the idea of revelation was sometimes illusionistically enhanced,[209] and shuttered panels by Gerard Dou, who also depicted still lifes on the exteriors.[210] In De Witte's version, however, the mundane image is drawn aside to reveal not a generic reminder of faith but a view in a local church during a sermon. The great arch of the Mariakoor (Mary's Choir) and the famous pulpit of the Oude Kerk were as immediately recognizable to De Witte's contemporaries as was the Nieuwe Kerk in *A View in Delft*.

Illusionistic motifs are also painted on the exteriors of surviving Dutch perspective boxes. The two pendant boxes in Copenhagen, which reveal centralized views of Protestant and Catholic church interiors, both have objects painted near the peephole.[211] The only motifs that remain legible are on the Protestant box (fig. 91): illusionistic drawers contain coins, a coral necklace, and a quill pen. Quills and other objects (now unclear) are held in a band below the drawers, as in "letter-rack" still lifes by Collier, Van Hoogstraten, and Wallerant Vaillant.[212] Thus a trompe-l'oeil still life invites close inspection and questioning of its reality, and in the process the peephole and vision of a church interior are revealed (fig. 92). As in De Witte's ensemble, the interior view was surely intended to be perceived as representing a higher order of truth. This impression is enhanced

90
Detail of Jacob Mauer, *Ploos van Amstel and Fellow Connoisseurs in his Cabinet*, ca. 1760. The Petworth Collection (photo: Witt Library, Courtauld Institute of Art, London). Emanuel de Witte's *Interior of the Oude Kerk, Delft* of 1651 (see fig. 156) is seen in its original frame with doors.

by repoussoir elements in the foreground of each anamorphic image: a chair (*kerkstoeltje*) supporting only a Bible in the Protestant church interior, where a preacher reads to a few listeners in the nave; and a crucifix, rosary, and other Popish props on a table in the Catholic interior, which shows numerous signs of idolatry.

Even the secular interior of the perspective box in Detroit (fig. 93), which is attributed to Van Hoogstraten and dated 1663, follows the program of offering earthly delights (in this case food) in the foreground and food for thought in the deeper view. In this palatial setting the painting of the Annunciation (revelation) to the Shepherds on the rear wall and the inscription "Memento Mori" over the main door do not reflect contemporary decorating ideas but an iconographic convention of perspective boxes and related works of art in the Netherlands.[213]

One last variation on the theme of illusionistic revelation may be mentioned in connection with Fabritius and Delft views of church interiors (for example, fig. 162), and that is the motif of a curtain drawn aside to reveal sacred space. Cloth coverings for religious images and relics had a long history in Northern Europe,[214] but Fabritius would have been more familiar with the illusionistic curtain painted by Rembrandt in *The Holy Family* of 1646 (Gemäldegalerie, Kassel). The panel has been compared with Hugo van der Goes's *Adoration of the Shepherds* (Staatliche Museen Berlin), where the angel appears to the shepherds in a distant scene, and

half-length prophets in the immediate foreground pull curtains aside.[215]

Curtains in Delft church interiors date from as early as 1651-52. In some cases it is clear that the artist emulates Parrhasios: the illusion of a real curtain in front of the painting is the point.[216] But Hugo's (and Bronzino's) idea of truth revealed is probably intended in some Delft views of church interiors with curtains in the foreground. The curtain almost certainly suggests revelation in an anonymous painting of about 1660 depicting the Nieuwezijdskapel in Amsterdam (Museum Catharijneconvent, Utrecht), where a sermon is in progress and a Bible has been placed in the immediate foreground (as in the "Reformed" perspective box in Copenhagen), lying open on the shelf of the viewer's pew.[217] This is interesting for the tapestry that hangs like a curtain in the foreground of Vermeer's *Allegory of the Faith* (fig. 315). As discussed in Chapter Six, the intent is not the same as in *The Art of Painting* (fig. 305).

The painting in perspective

The local perspective

This chapter attempts to place *A View in Delft* in the context of Dutch art during the middle decades of the seventeenth century and painting in Delft during the 1650s. Even the most successful effort along these lines would not diminish the impression that the painting is in many ways extraordinary, in its cleverness and craft, for example, but above all in its directness, apparent simplicity, and naturalness of representation. Modern critics have paid tribute to this quality by comparing the composition to images

produced with the aid of a camera obscura, an eighteenth-century lens, and surveying instruments, thus echoing the artist's contemporaries who praised illusionistic pictures and scenes projected in a camera obscura as looking "like life itself."[218]

It was indeed the painter's intention to reproduce the site with apparent objectivity and to create a remarkable illusion. The familiarity of the actual view in Delft must have contributed to the work's lifelikeness in the eyes of its early witnesses. It would have seemed as if the kind of image seen in a camera obscura had somehow been fixed on canvas, or as if a fragment of ordinary experience, the kind of view one has almost every day but rarely stops to consider, had somehow been preserved in a box. The simple pleasure of recognition was probably important to many contemporary viewers of realistic townscape paintings (such as Vermeer's *View of Delft*), church interiors, and landscapes, and was actually not so simple when the subject was one's own church or community or homeland.

The same viewers, even those with less aesthetic distance than Fabritius's fellow artists and connoisseurs, would have understood the meaning of the musical instruments and would have recognized immediately that the man next to them was idling at an inn, perhaps seeking companionship. For writers who have discussed the painting almost exclusively as an example of empirical or "optical" interests – that is, as a monument of the "early-modern" period – the slice of life in the foreground has been a "problem,"

perhaps to be explained as an addition or an afterthought.[219] But the seventeenth-century observer would have understood the comparison of the inn scene with the townscape as an essential aspect of the picture, a layer of meaning made plain after a moment's reflection, or after several moments in the case of such a visually enthralling work.

This note of homespun (or churchspun) philosophy, the vanitas theme interpreted with unusual freshness and force (Fabritius literally brought the message home), was one of several aspects of the work that would have impressed early viewers with the artist's inventiveness. The modern mind may find this notion slightly more difficult than the painter's colleagues (such as Van Hoogstraten) would have. For us, the insertion of the inn scene may seem to undermine what we consider to have been the artist's essential goal: faithful transcription of an actual site. However, Fabritius and Van Hoogstraten would not have seen it that way. For them, realistic description, and especially illusionism, were artistic qualities; quite as much as brilliant brushwork, they expressed virtuoso ability. The performer's rôle is routinely pointed out, for example, by including his monogram or signature in a conspicuous place, often in one of the most illusionistic passages. In Dou's *Self-Portrait* in the Metropolitan Museum and in Van Hoogstraten's *Head of a Bearded Man at a Window* (fig. 94), the artist has chiseled his name into a stone ledge in the foreground. Signs of wear, serious expressions, and in the Dou a cracked flowerpot suggest transience, which art overcomes.[220] Thus form and content, deception and truth revealed, are both addressed in Fabritius's painting by the vanitas meaning of the musical instruments. Life is short; music fades away. The church – and art – offer immortality.

In our eagerness to appreciate Dutch artists such as Saenredam, Fabritius, and Vermeer as the artistic counterparts of Simon Stevin, Johannes Kepler, and Anthony van Leeuwenhoek, it is easy to neglect ideas more specific to the painters' profession, such as the notion of *aemulatio*, the act of emulation through which a master is approached and honored in his own area of expertise. As a former disciple of Rembrandt and co-pupil of Van Hoogstraten, Fabritius would have appreciated the connection between artifice and fame.[221]

Modern distinctions between art and describing, making and "mapping," seem simplistic compared with the questions of representation that are posed in paintings by such artists as Dou and Van Hoogstraten.[222] The example of *A View in Delft* is even more complicated. In so far as it transcribes an actual place and objects "from life" it fails to illustrate Wöfflin's law (which Gombrich quoted approvingly) that "all paintings … owe more to other paintings

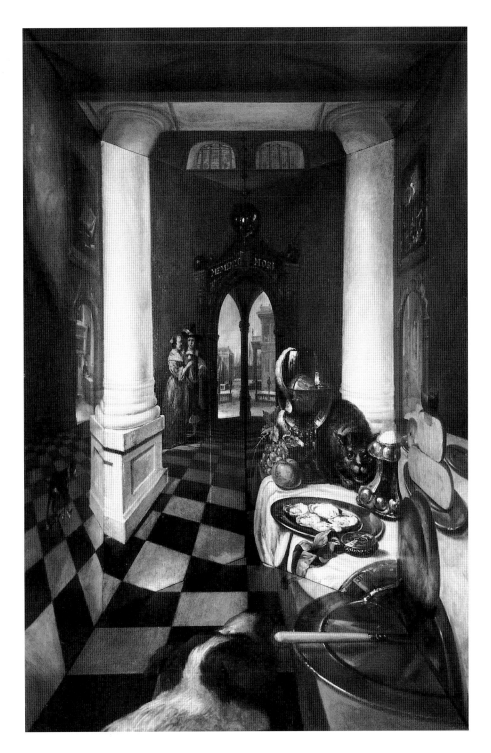

than they owe to direct observation."[223] And yet the more closely one considers the picture in its proper context the more one sees evidence of the maker's hand and understands Van Hoogstraten's lesson that naturalism is "selective."[224]

However the view was recorded, making it into a work of art involved the conscious and often unconscious use of artistic conventions, which in topographical pictures (and many church interiors) began not in the studio but at the site. It was observed above that the approach to the church taken by Fabritius was favored by draftsmen, since the diagonal recession from choir to tower conveys volume and adjusts the building's proportions to the format of a picture or page (fig. 48).[225] Fabritius

93
Attributed to Samuel van Hoogstraten, *Perspective Box with Views of a Vaulted Vestibule*, 1663.
Oil on panels,
41.9 cm high.
Detroit, Detroit Institute of Arts

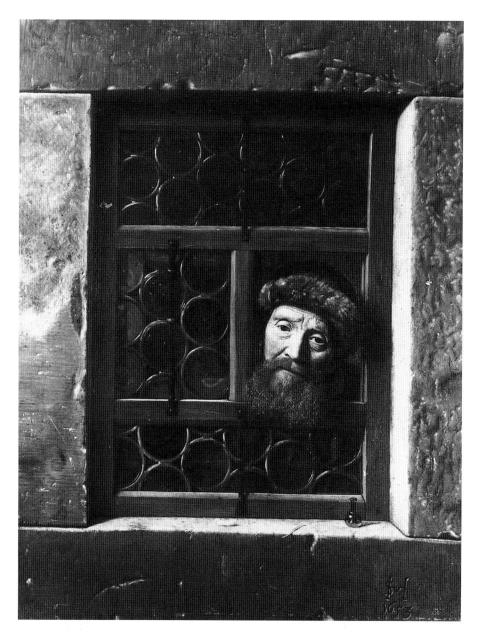

94
SAMUEL VAN
HOOGSTRATEN,
*Head of a Bearded Man at
a Window*, 1653.
Oil on canvas,
112 x 88 cm.
Vienna, Kunsthistorisches
Museum

painting, the canal, the step-gabled house on the left, and the distant tower of the Jacobskerk are approximately true to a view from the Spui, but the church (which differs somewhat from this design) had probably not been built beyond its foundation in 1650, and almost everything else in the scene is invented.

All townscape pictures are arbitrarily composed to some degree, and *A View in Delft* is no exception. Visscher's print, Van Bassen's painting, and a number of similar works (including Fabritius's own "perspectyf van 't Hoff van Hollandt"?; see p. 64 above, no. 3) could have suggested how the site in Delft might be depicted. In both views of The Hague, architecture recedes diagonally to distant buildings, and houses on the right (at about the same distance from the viewer as the main subject) provide a sense of scale. The overall impression of space depends greatly upon the depth and breadth of the foreground, as is evident from Visscher's transformation of Hondius's view (figs. 76, 84). In the process, the house on the left and tree on the right became more prominent repoussoirs. Perhaps Visscher's print served as a source for *A View in Delft* or Fabritius's "perspective of the Court of Holland." The effect of the trellis and roof in the townscape could have been inspired by Van Bassen's shadowy portico (fig. 95, on the left). But many other townscapes (quite a few of The Hague) and architectural paintings could be brought into the discussion of Fabritius's composition and motifs. In the end, one arrives at the unsurprising conclusion that he made well-informed use of stylistic conventions that were current in the area of South Holland and elsewhere during the preceding quarter-century.

The motif of the man seated behind a table is familiar from another tradition, that of genre scenes set in taverns and occasionally in studios. A similar arrangement of about the same time in Delft is known from Bramer's drawing after a lost painting by Adam Pick.[227] A man in a hat sits at the far end of a strongly foreshortened table, upon which musical instruments, smoking requisites, and an oversized *roemer* and tankard enhance the viewer's impression of being very close by. But as with the townscape proper in *A View in Delft*, Pick's composition is only one of many possible sources, or, more precisely, parallels. Fabritius's man with a lute and viol brings to mind many pictures, for example, "music in the studio" scenes by Leiden artists (which usually had vanitas overtones).[228]

We should not infer from these comparisons that Fabritius's picture is filled with borrowed ideas. The point is that the artist's extraordinary success in depicting an actual site and incorporating other elements was not a happy accident or a question of

would not have discovered this by rambling about the center of Delft. Having had little or no previous experience in recording topographical subjects, he would have taken an interest in pictorial precedents. The genre itself, and especially this kind of restricted view (as opposed to city "profiles"), was a recent development, which suggests that the very idea of depicting the Nieuwe Kerk and its immediate surroundings might have been inspired by one or several images.

The compositions Fabritius might have known include Visscher's view of the Hofvijver dating from 1636 (fig. 84) and Van Bassen's *Design for the Nieuwe Kerk in The Hague* of 1650 (fig. 95).[226] The print attributed to Visscher is derived from Frisius's engraving after Hondius (fig. 76), but the view is closer and incorporates recent additions to the architectural landscape, such as the Mauritshuis. The foreground has some basis in reality, but its inclusion and its panoramic effect were artistic decisions informed by various precedents. In Van Bassen's

95
BARTHOLOMEUS
VAN BASSEN,
*Design for the Nieuwe Kerk
in The Hague*, 1650.
Oil on panel,
82.5 x 112 cm.
The Hague, Gemeente-
museum

finding just the right lens to record the view. On the contrary, Fabritius brought extensive artistic experience to bear upon a new representational problem: depicting a familiar view with both fidelity and dramatic force. This is what the artist has most in common with Houckgeest in a painting like the Hamburg view of the New Church (pl. 11) and with Vermeer in a number of paintings, including the *View of Delft* (pl. 1). The "innocent eye" does not see with such style and imagination.

The broader perspective:
Leonardo, Huygens et al.
Before turning to other developments in Delft during the 1650s it would be helpful to widen the scope of discussion one more time. Artists and *amateurs* in other places shared some of the preoccupations that have been identified with Fabritius and Vermeer, such as the virtues and limitations of artificial perspective, and more broadly the relationship between what one sees and what one can paint.

During the same period in Paris, about 1648 until the early 1660s, a small group of artists fought the so-called "perspective wars." The orthodox position, maintained by Abraham Bosse (see fig. 57), was assailed in part by referring selectively to Leonardo's *Treatise on Painting* (*Trattato della Pittura*), which was first published in Paris in 1651.[229]

Manuscript copies of the *Trattato* (about twenty still survive) may have been known not only in

France but also in the Netherlands and elsewhere. Lord Clark maintains that Rembrandt must have consulted the treatise, perhaps the manuscript owned by Joachim von Sandrart who was in Amsterdam from 1637 until 1641.[230] Rembrandt's *Adoration of the Shepherds* of 1646 (National Gallery, London) is considered by Clark to "come near to illustrating" Leonardo's description in the *Trattato* of how to paint a night scene, where he offers advice on values of light and color.[231]

Paintings by Fabritius are also recalled by passages in the *Trattato*. In the chapter "On objects placed against a light background and why this practice is useful in painting," Leonardo observes that a dark form appears detached from a bright wall, especially when the nearest part is in the light and the sides recede back to dark contours.[232] Similar observations are found in *A View in Delft*, as well as in *The Goldfinch* and *The Sentry* (figs. 32, 34), which does not mean that Fabritius read Leonardo or that he intended to demonstrate scientific points.

The *Self-Portrait* in Rotterdam (fig. 30) recalls Leonardo's advice about using a mirror to study light values and foreshortening.[233] In his discussion of the camera obscura as an aid to studying color and colored shadows Leonardo seems to anticipate passages in Van Hoogstraten's treatise and in paintings by Vermeer,[234] while his description of the perspective frame and his persistent concern with the problem of binocular vision would have intrigued

Fabritius.[235] In two chapters of the published treatise Leonardo describes the anamorphic projection of a figure on the wall and vault of a hall. He insists upon a fixed vantage point and recommends a curved surface ("because there are no angles there").[236]

As the very model of the artist as natural scientist Leonardo may be compared with many Dutch painters and draftsmen.[237] However, there is little evidence that his writings were known, not even to Van Hoogstraten, who would readily have cited the *Trattato* at length on subjects such as the perspective of shadows.[238] In general, artists consulted more accessible texts, which perhaps depended upon Leonardo or upon writers he influenced, such as Carlo Urbino, Egnatio Danti, and Daniele Barbaro.[239]

And yet there are striking similarities between some of Leonardo's observations and passages in Dutch paintings. The reason, in a broad view, is that by about 1650 the optical interests that Leonardo, Fabritius, and Vermeer seem to have had in common were being adopted in artistic and intellectual circles throughout Europe. Within this context, the Delft painters still stand out, essentially because like Leonardo they were painters who placed particular emphasis upon empirical observation. That they did so to such a remarkable extent is impressive precisely because of the constant tug of established conventions, both in art and in the physical sciences.[240]

Some light is shed on the subject by returning to Constantijn Huygens, who has been valued as a likely intermediary between artists with optical interests and scientists (or technicians) who had the appropriate expertise.[241] Huygens was preoccupied with optical instruments from an early age. His interest was magnified by contacts with the Dutch scientist and engineer Cornelis Drebbel (1572-1634), who was in service to James I when Huygens was secretary to the Dutch mission in London (1621-24). In England Huygens became familiar with telescopes, microscopes, and the camera obscura, which he praised in a now widely-quoted letter (April 13, 1622) as so compelling in its projection of reality that "all painting is dead by comparison, for this is life itself, or something more *relevé* [vivid?], if that word will do."[242] Huygens later corresponded with Descartes and Van Leeuwenhoek on optical questions, making occasional references to Galileo and to Christopher Scheiner, the astronomer who published illustrated comparisons between the camera obscura and the eye (*Rosa Ursina*, Bracciano, 1630).[243] One of Huygens's more memorable remarks to Descartes was that "the charlatan Kircher" was an exception among Jesuit scholars of optics and perspective (for example, d'Aguilon and Scheiner).[244] Huygens's correspondence may make him appear

au courant with the latest developments in optics: indeed, this was his intention in the letters to Descartes. According to Wheelock, an appreciation similar to Huygens's of recent research on optics "may have suggested alternative means of portraying visual impressions" to Fabritius and may have encouraged his "freedom from the restraints of perspective theory."[245] However, nothing in Huygens's correspondence suggests that his understanding of optics and perspective ever progressed beyond an early reading of d'Aguilon (Aguilonius, Huygens's "primum praeceptorem"), whose treatise has been described as a "highly lucid and fundamentally conservative synthesis of various threads in classical, medieval, and Renaissance science."[246] In his diary Huygens dismissed Kepler's *Dioptrice* as "vague speculation," and found "little satisfaction" in the writings of Guidobaldo and Galileo, who (he unwisely informed Descartes) envelop themselves in "obscure superfluities."[247]

In other words, the pioneering essays on optics were over Huygens's head or were too much in conflict with his acceptance, in several areas of science, of traditional authority. (We might compare his attachment to Vitruvius in matters of architecture.) One would not expect otherwise, given the extraordinary demands on the dilettante's time, his many other interests (music, poetry, and politics were among the most significant), and the fact that

"the actual optical ideas in all the Dutch treatises [including that of Huygens's friend, Hondius] were deeply conservative. Hoogstraten, like Marolois, still advanced an extramission theory of sight, and there is not the slightest glimpse of the new ideas on the mechanism of the eye pioneered by Kepler and extended by Descartes."[248]

To imagine something more sophisticated in the case of artists such as Van Hoogstraten, Fabritius, and Vermeer is completely anachronistic. The latest concepts of vision did not circulate in weekly news magazines; one needed an education comparable to Huygens's, a good library, and the leisure to pursue scientific questions for their own sake.[249] Correspondence with learned figures was essential but could lead to doubt or dismissal of ideas based on sound empirical investigation. Huygens, for example, was aware of William Harvey's demonstration that blood circulated in the body, but he clung to Galen's theory of the humors (one of which, melancholy, he fashionably favored, partly in response to the poetry of John Donne).[250]

Academic artists like Bosse and perspectivists like Hondius exercised an influence comparable to Galen's but with more immediate consequences, since their treatises were employed as how-to books.

Painters interested in different ways of describing space did not need to study Kepler's or Scheiner's pages on the retina when the problems inherent in applying perspective to sketches from life plainly appeared on their sheets of paper (fig. 59) and were concisely stated by authors such as Vredeman de Vries (fig. 77). The Dutch artist sent searching for snippets from Descartes's desk is ironically underestimated. Others with no obvious connection to contemporary science are overlooked. Aert van der Neer, for example, was no Saenredam or Stevin but his gently curved horizons, celestial light effects, shadows, and reflections are, in his best paintings, noteworthy examples of observation, which may seem as significant as any diagram in a treatise when compared with a work such as *A View in Delft*.

Conversations among artists and *amateurs* must have played an important part in disseminating ideas about perception and representation. Much of Van Hoogstraten's writing has the flavor of oral advice, not unlike his "quotes" of Rembrandt imparting wisdom to the author during his student years. Practical demonstrations – for example, in the use of the perspective frame or the camera obscura – could make a lasting impression. Huygens, predicting the De Gheyns' reaction to the camera, said that they would be "marvelously entertained."[251]

A commonsensical view of how Dutch artists thought and worked does not diminish the value of Alpers's notion that they shared a "visual culture" with figures in other fields.[252] But ten pages on Francis Bacon seems somewhat excessive when "bringing home the bacon" was the typical Dutch painter's main concern.[253] In this economic context Huygens's importance for artists such as Fabritius and Vermeer would have been self-evident. His interest in a variety of arts and sciences made him precisely the sort of patron who would have appreciated their powers of observation, their demonstrations of knowledge, and their displays of artifice. He must have been marvelously entertained.

Patrons at or connected with a number of European courts were the focal points at which the parallel concerns of artists, scientists, and philosophers (including Jesuit scholars of optics) ultimately converged. Huygens's interests may be compared broadly with those of Rudolf II, who was the patron of the astronomer Tycho Brahe and his assistant Kepler, artist-naturalists such as Joris Hoefnagel and Roelant Savery, and the perspectivist and illusionistic muralist Vredeman de Vries.[254] Van Hoogstraten's later Habsburg patron, Ferdinand III, not only awarded him for his illusionistic still lifes and other trompe-l'oeil pictures painted in Vienna (figs. 58, 94), but also commissioned Kircher's optical magnum opus, *Ars Magnis Lucis et Umbrae* (Rome, 1646).[255] We have already mentioned the court in

96

97
Samuel van Hoogstraten, *View down a Corridor*, 1662. Oil on canvas, 264 x 136.5 cm. Gloucester, Dyrham Park, The National Trust

London, where Huygens was introduced to optical devices and where anamorphic images (see fig. 96) went back to Holbein's day (fig. 89).[256] Hendrick van Steenwyck the Younger was court painter of "Prosspectives" in London from the 1620s until about the late 1630s, when he evidently moved to The Hague.[257] The English enthusiasm for "perspectives" and optical curiosities makes one wonder whether Huygens was thinking back to London when he wrote in his diary that the camera obscura was one of the devices with which princes amuse themselves.[258]

The one Dutch artist who deserves close comparison with Fabritius as a painter of illusionistic murals and the perspective box must have hoped that these attractions would continue to find favor at the court of Charles II.[259] As it happens, Van Hoogstraten's most prestigious patrons turned out to be minor aristocrats like Thomas Povey (see p. 51 above). Povey's friend Pepys, who was enthralled by Van Hoogstraten's *View down a Corridor* (fig. 97), was similarly diverted by Lord Brouncker's account of

"the art of drawing pictures by Prince Robert's [Prince Rupert, first cousin of Charles II] rule and machine, and another of Dr. Wren's; but he says nothing doth like Squares [the perspective frame], or, which is the best in the world, like a dark roome – which pleased me mightily."

Later in the same year, 1666, Pepys had two prominent makers of optical instruments, Richard Reeve and John Sprong, to his house for a meal and then "to our business of my Microscope … and then down to my office to look in a dark room with my glasses and Tube, and most excellently things appeared indeed, beyond imagination." After another visit from Reeve during which Jupiter was studied with Pepys's "12-foot glass," the diarist lamented that he had learned nothing from his guest about the principles of optics, because the latter, although lens

maker to the king, himself understood "the acting part but not one bit of the theory … which is a strange dullness methinks."[260]

In a self-serving line of the *Inleyding*, Van Hoogstraten regrets that Fabritius never painted an illusionistic mural for a princely or public building. This is followed immediately by a mention of the perspective box as a similar kind of work (see p. 65 above, no. 9). It seems reasonable to associate *A View in Delft* with the world of courtly patrons and to speculate that, if Fabritius really was "in his lifetime painter to His Highness the Prince of Orange," it would have been in recognition of such an achievement. The documents listed above suggest the existence of other "cases" by Fabritius; it will be recalled that an "optical piece" was attributed to him in the inventory of the Danish royal collection. Fabritius's "perspective of the Court of Holland" has been mentioned several times (see p. 64, no. 3). If he made anything comparable for a prince of Orange, as opposed to Huygens or another courtier, it would have to have been before Willem II's death in November 1650. An appointment at court might explain why the artist did not join the Delft guild until October 29, 1652, but there may be some other explanation.

What is clear is that this little painting was part of the most sophisticated perspective box known to have been made in the Netherlands. In its conception and execution it surpasses all other Dutch examples of illusionism, unless one finds that term acceptable for *The Night Watch* or another work in which skillful deception is merely one aspect of the painter's accomplishment.

Illusionism is also but one aspect of *A View in Delft*. In its embodiment of many interests and blending of different truths, the picture is a mature work by an unusually gifted young man (he was thirty in 1652). We may lament what has been lost of Fabritius's oeuvre and be grateful that this fragment survives.

Color Plates

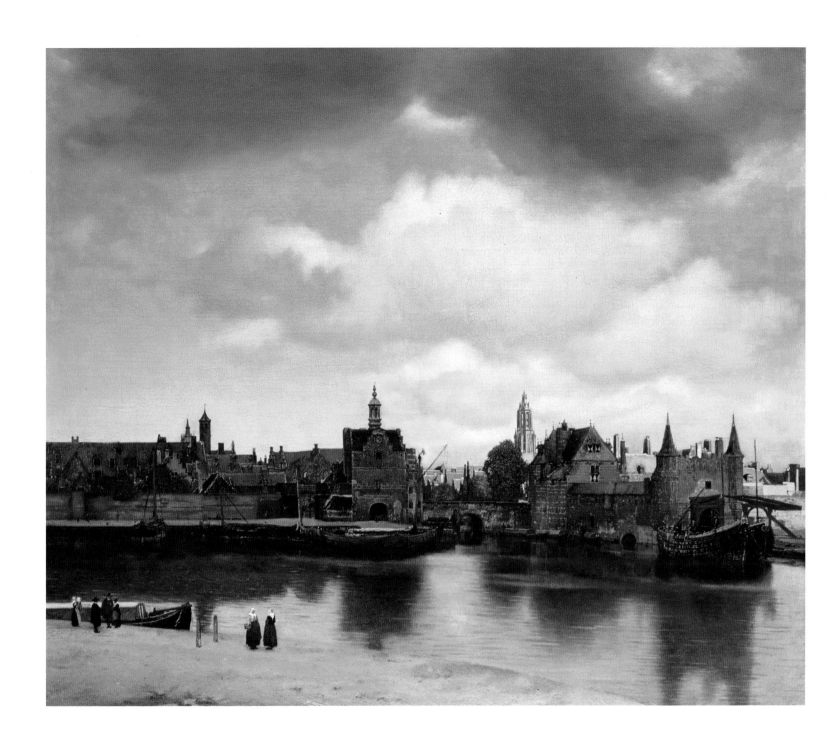

1 JOHANNES VERMEER,
 A View of Delft, ca. 1661. Oil on canvas, 96.5 x 117.5 cm. The Hague, Koninklijk Kabinet van Schilderijen "Mauritshuis"

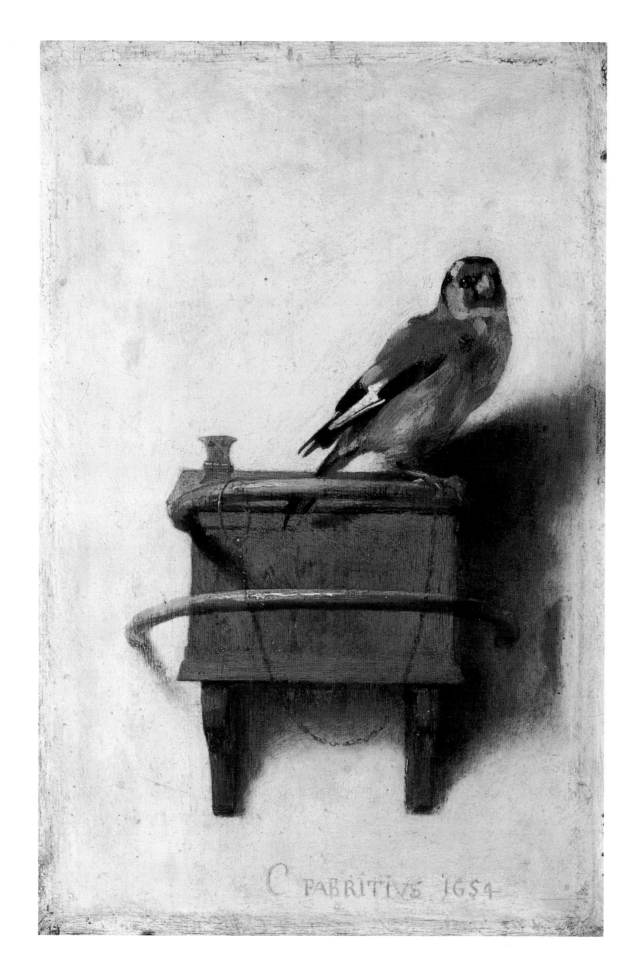

V CAREL FABRITIUS,
 The Goldfinch ("Het Puttertje"), 1654. Oil on panel, 33.5 x 22.8 cm. The Hague, Koninklijk Kabinet van
 Schilderijen "Mauritshuis"

III Carel Fabritius,
 A View in Delft, 1652. Oil on canvas, 15.4 x 31.6 cm.
 (This illustration shows the actual size).
 London, The National Gallery

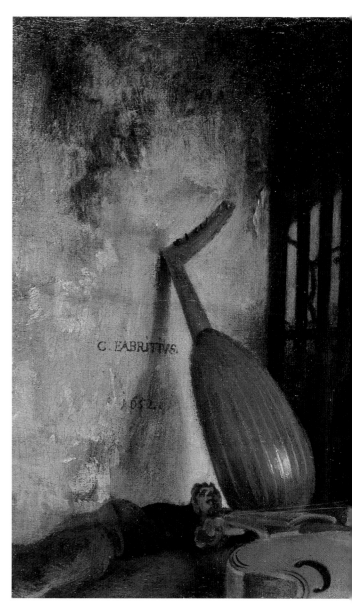

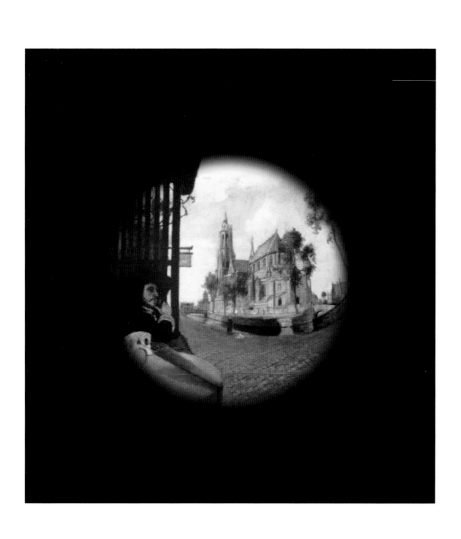

IIIA The painting as seen through the peephole of the reconstructed
 perspective box (see pl. IV and figs. 43, 44)

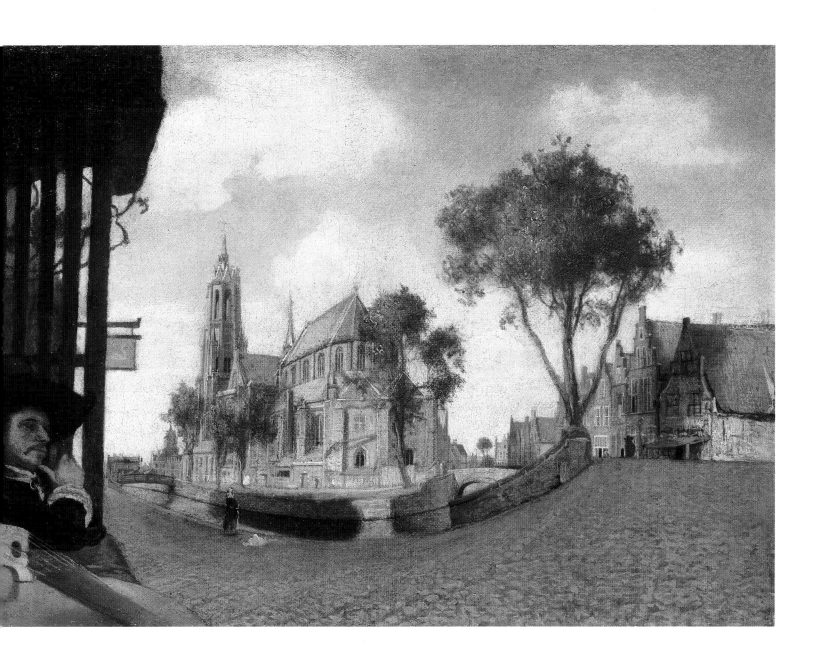

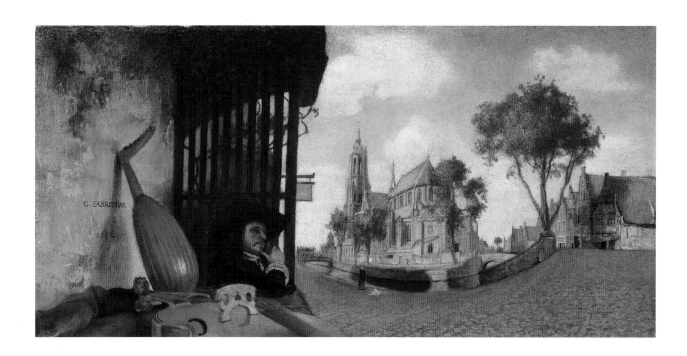

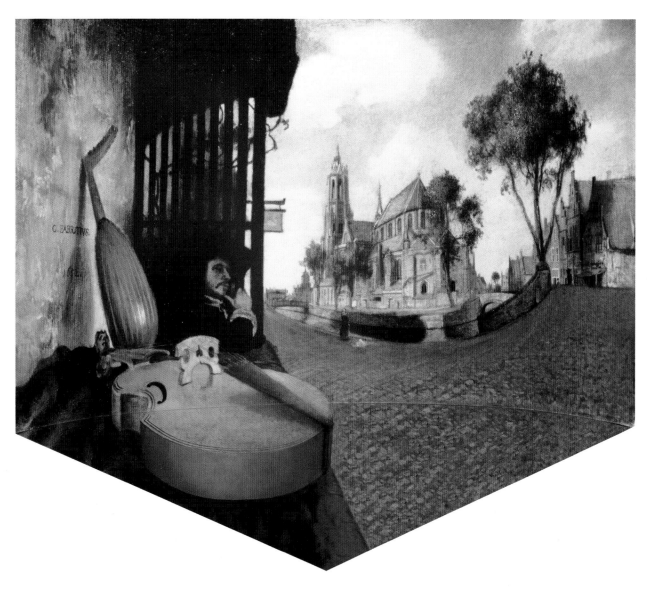

IV RECONSTRUCTION OF *A View in Delft* BY CAREL FABRITIUS,
 as it would have been mounted on a curved surface inside a perspective box, with the floor painted
 (computer simulation of the floor by Christine Hiebert, Metropolitan Museum of Art)

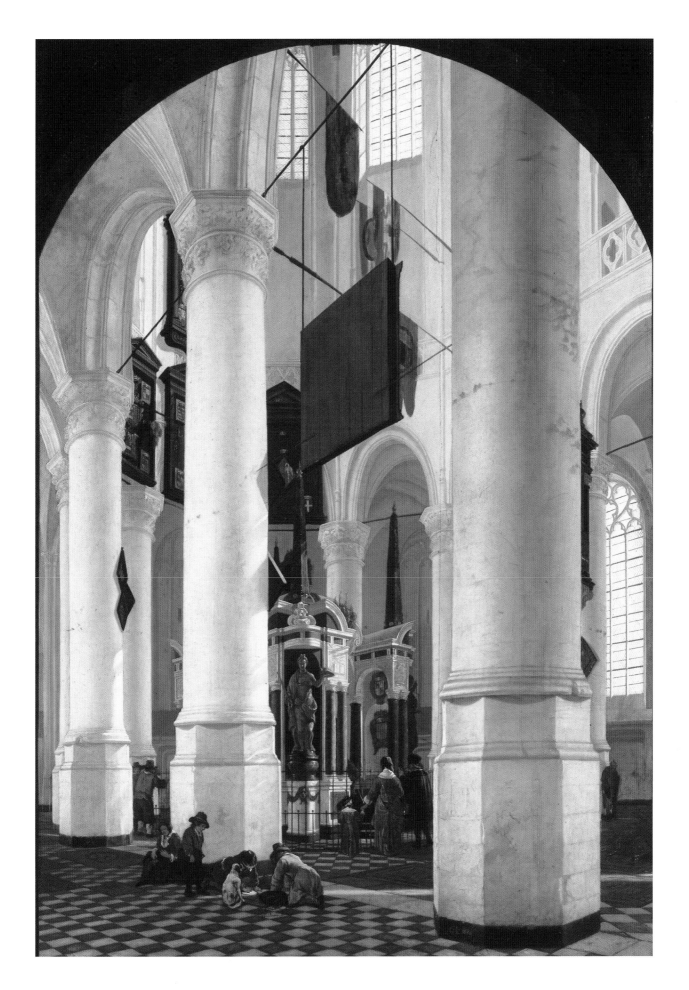

11 Gerard Houckgeest,
 Nieuwe Kerk in Delft with the Tomb of William the Silent, 1650. Oil on panel, 125.7 x 89 cm. Hamburg, Kunsthalle

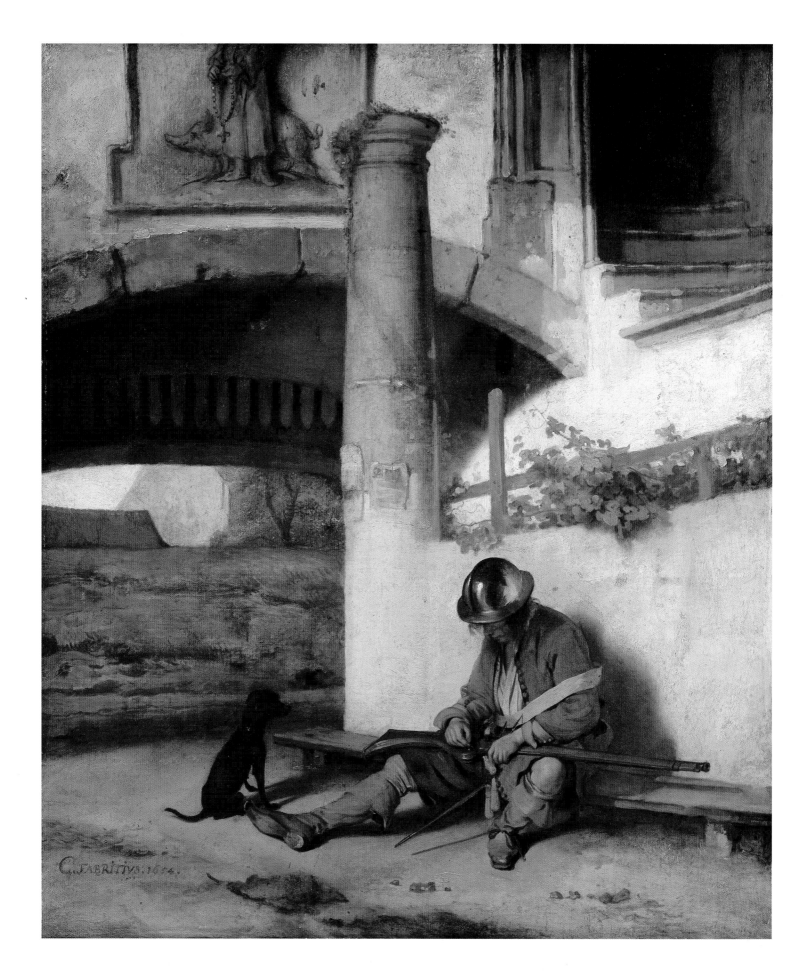

VI CAREL FABRITIUS,
 The Sentry, 1654. Oil on canvas, 68 x 58 cm. Schwerin, Staatliches Museum Schwerin (photo: Elke Walford, Fotowerkstatt Hamburger
 Kunsthalle)

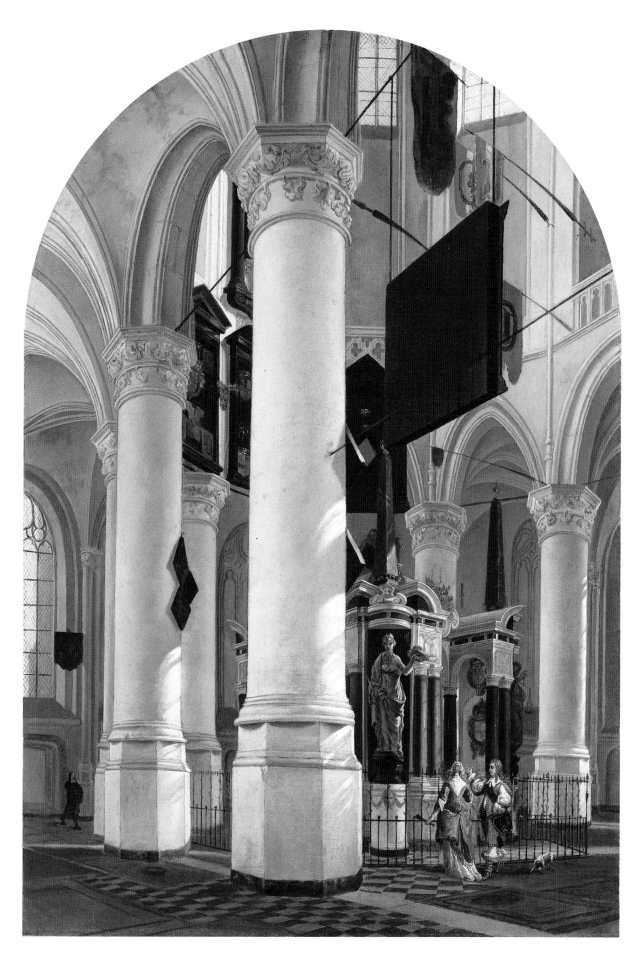

VII GERARD HOUCKGEEST,
Nieuwe Kerk in Delft with the Tomb of William the Silent, about 1651-52 (with somewhat later figures).
Oil on panel, 60 x 41 cm. Private Collection

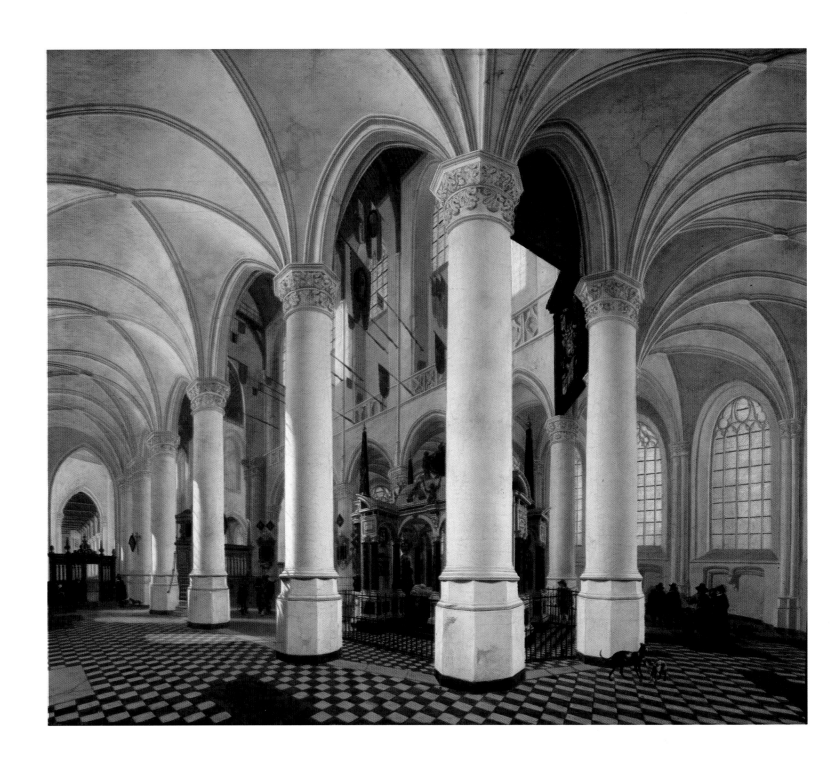

VIII GERARD HOUCKGEEST,
The Ambulatory of the Nieuwe Kerk in Delft with the Tomb of William the Silent, 1651. Oil on panel, 65.5 x 75.5 cm. The Hague, Koninklijk Kabinet van Schilderijen "Mauritshuis"

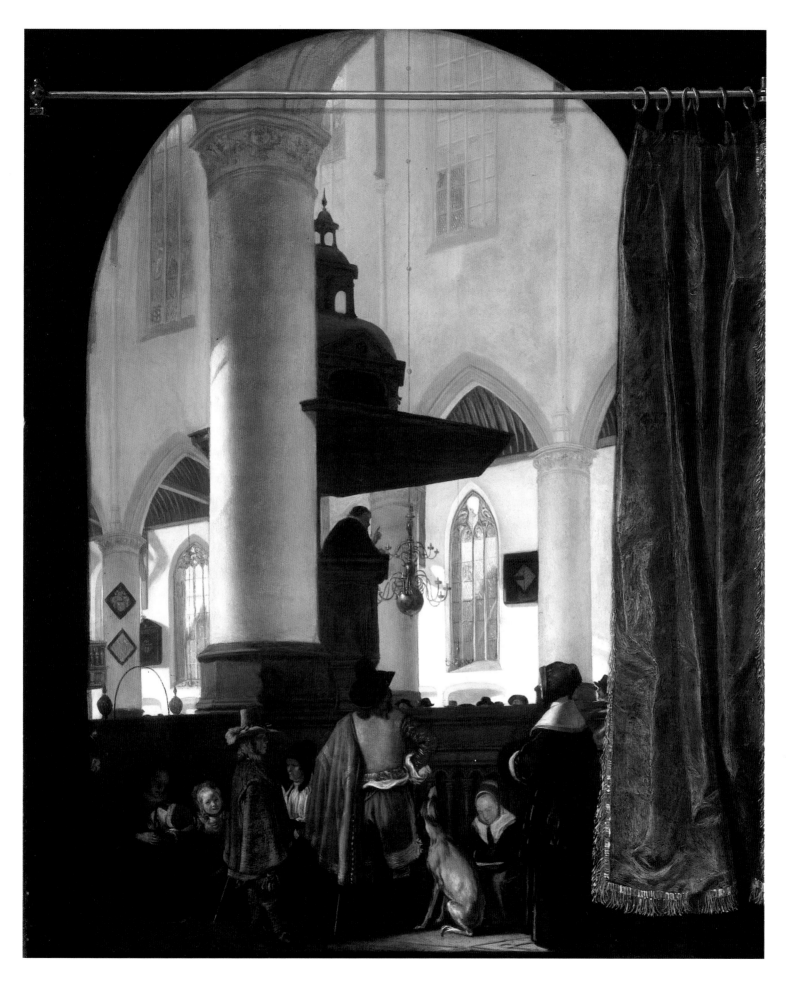

IX EMANUEL DE WITTE,
A Sermon in the Oude Kerk in Delft, about 1651. Oil on panel, 73.2 x 59.5 cm. Ottawa, The National Gallery of Canada

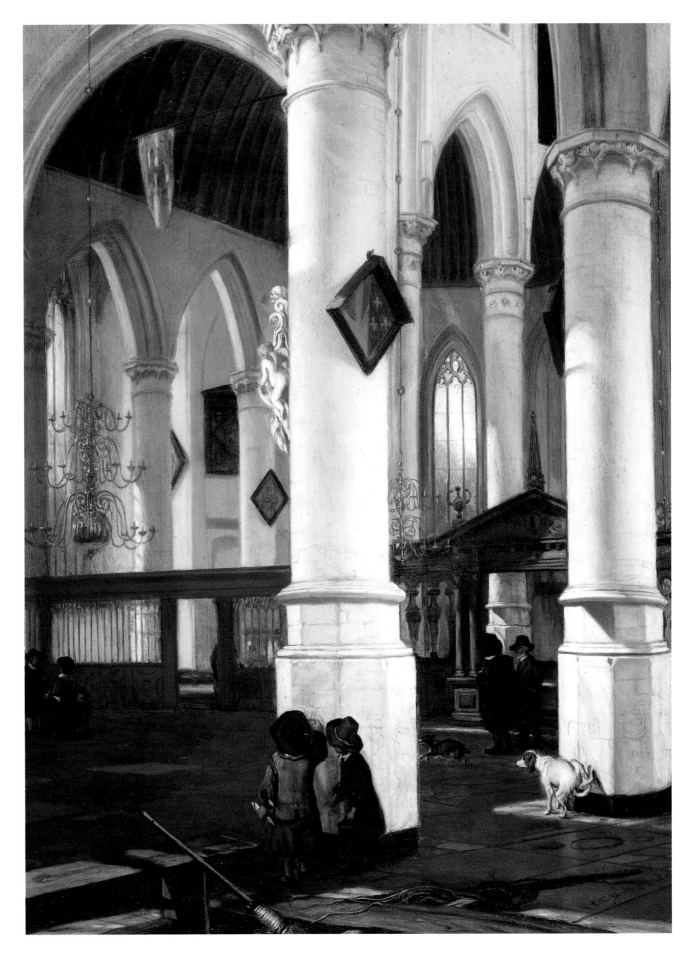

X EMANUEL DE WITTE,
Oude Kerk in Delft (view from the southern aisle to the northeast), 1650. Oil on panel, 48.3 x 34.5 cm. Montreal, Mr. and Mrs. Michal
Hornstein

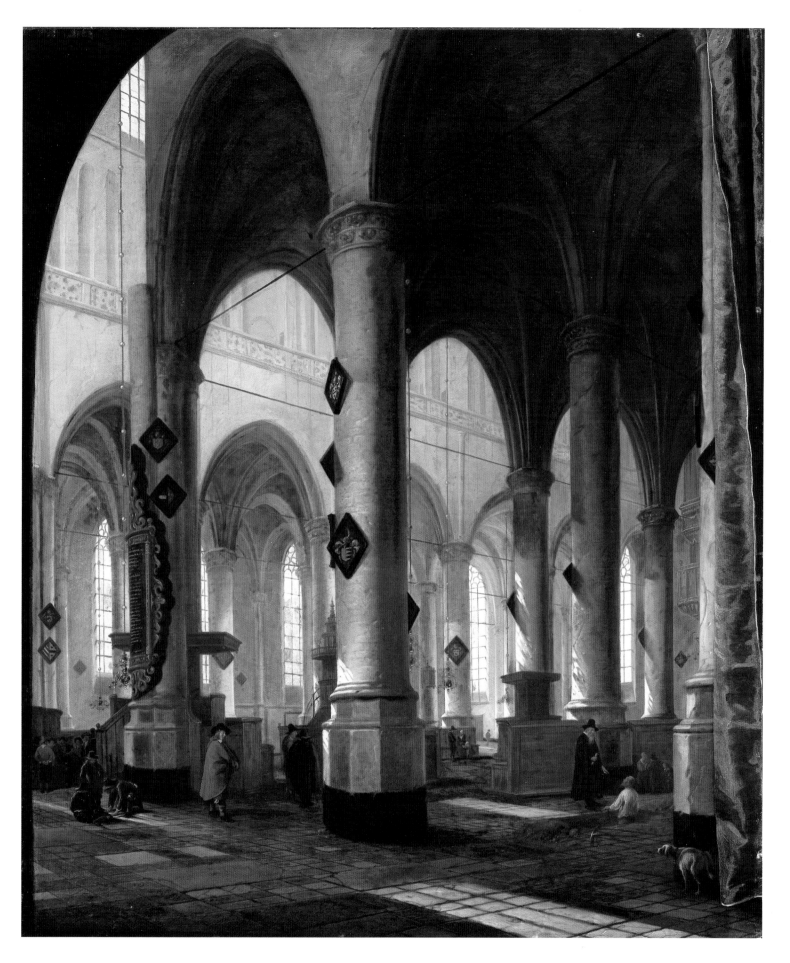

XI HENDRICK VAN VLIET,
The Pieterskerk in Leiden (view from the northern transept to the southwest), 1652. Oil on panel, 97.5 x 82 cm. Braunschweig, Germany, Herzog Anton
Ulrich-Museum

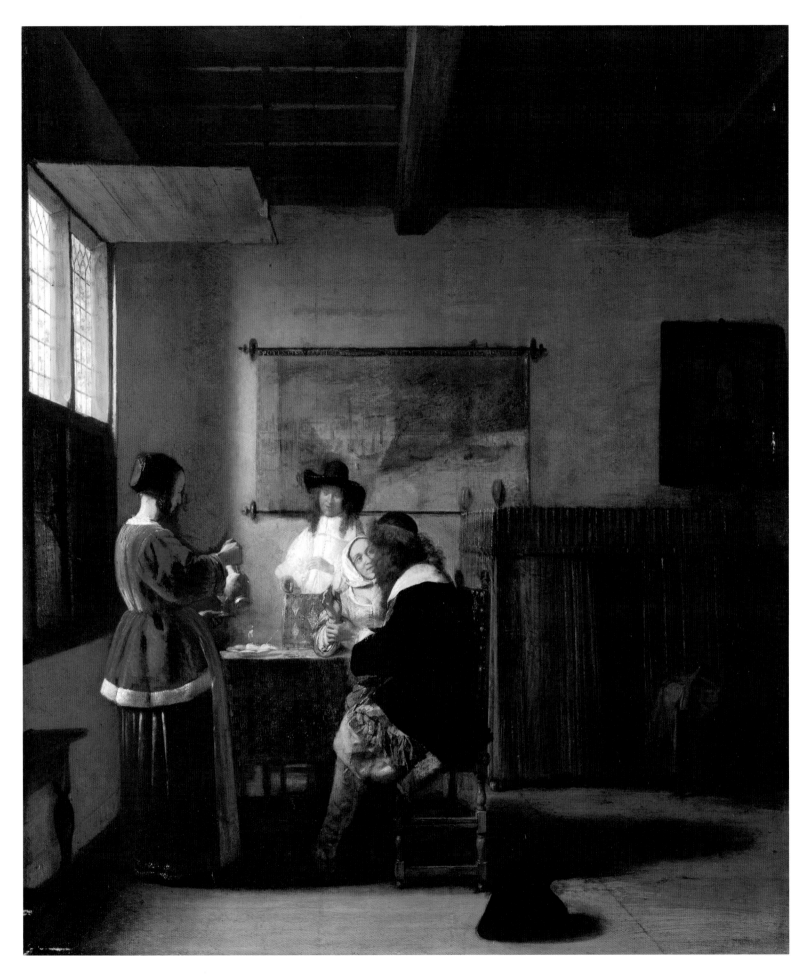

XII Pieter de Hooch,
The Visit, ca. 1657. Oil on panel, 67.9 x 58.4 cm. New York, The Metropolitan Museum of Art, H.O. Havemeyer Collection

XIII PIETER DE HOOCH,

An Interior, with a Woman Drinking with Two Men, and a Maidservant, ca. 1658. Oil on canvas, 73.7 x 64.6 cm. London, The National Gallery

XIV PIETER DE HOOCH,
A Courtyard in Delft with a Woman and Child, 1658. Oil on canvas, 73.5 x 60 cm. London, The National Gallery

XV PIETER DE HOOCH,
 Figures in a Courtyard, 1658. Oil on canvas (mounted on panel), 67.6 x 57.5 cm. Private collection (photo: courtesy of Rob Noortman, Maastricht)

XVI CORNELIS DE MAN,
The Goldweigher, ca. 1670. Oil on canvas, 81.5 x 67.5 cm. U.S.A., Private collection (photo: courtesy of Otto Naumann Ltd., New York)

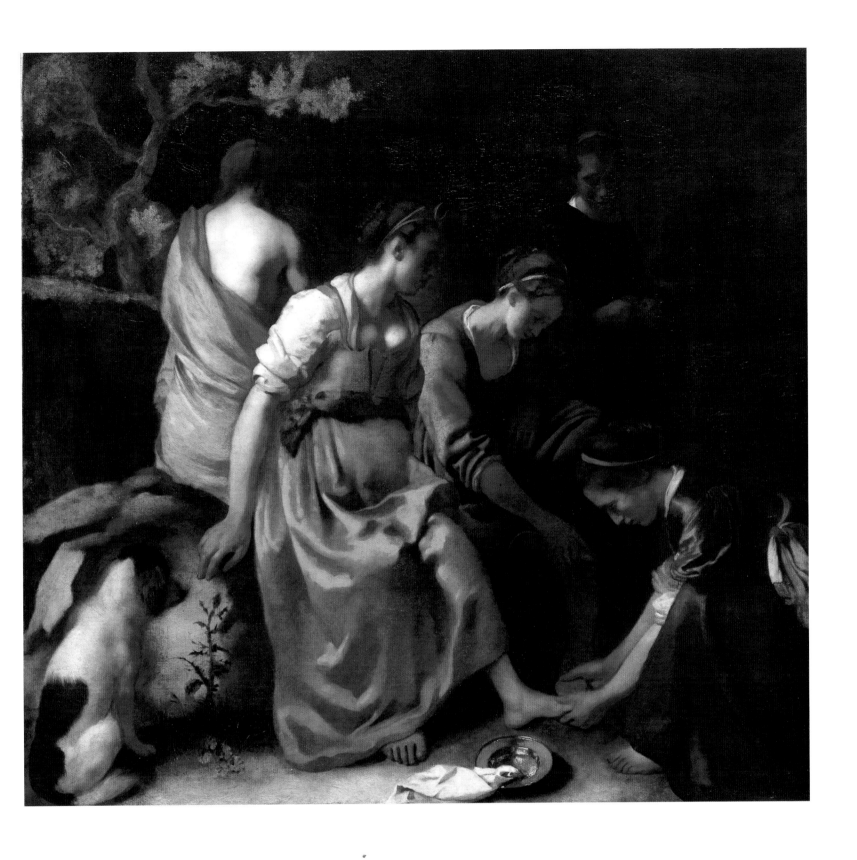

XVII JOHANNES VERMEER,
Diana and her Companions, ca. 1654. Oil on canvas, 97.8 x 104.6 cm. The Hague, Koninklijk Kabinet van Schilderijen "Mauritshuis" (photo of the painting after conservation in 1999-2000)

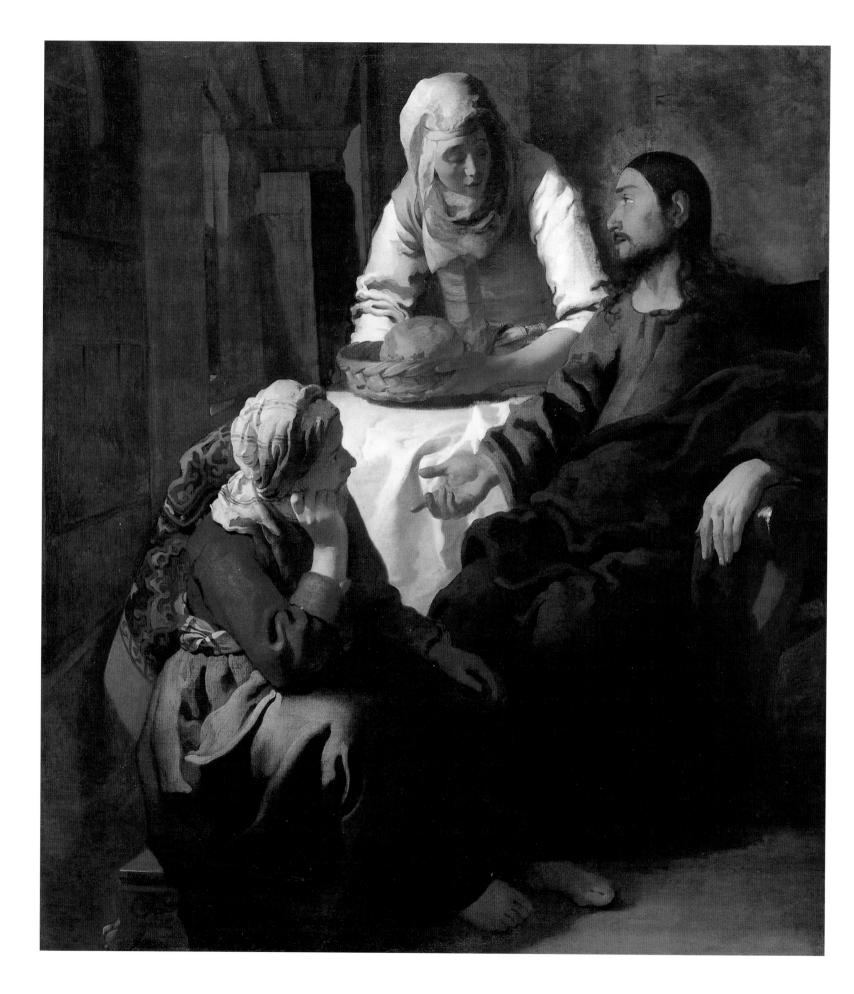

XVIII JOHANNES VERMEER,
Christ in the House of Mary and Martha, ca. 1655. Oil on canvas, 160 x 142 cm. Edinburgh, The National Gallery of Scotland

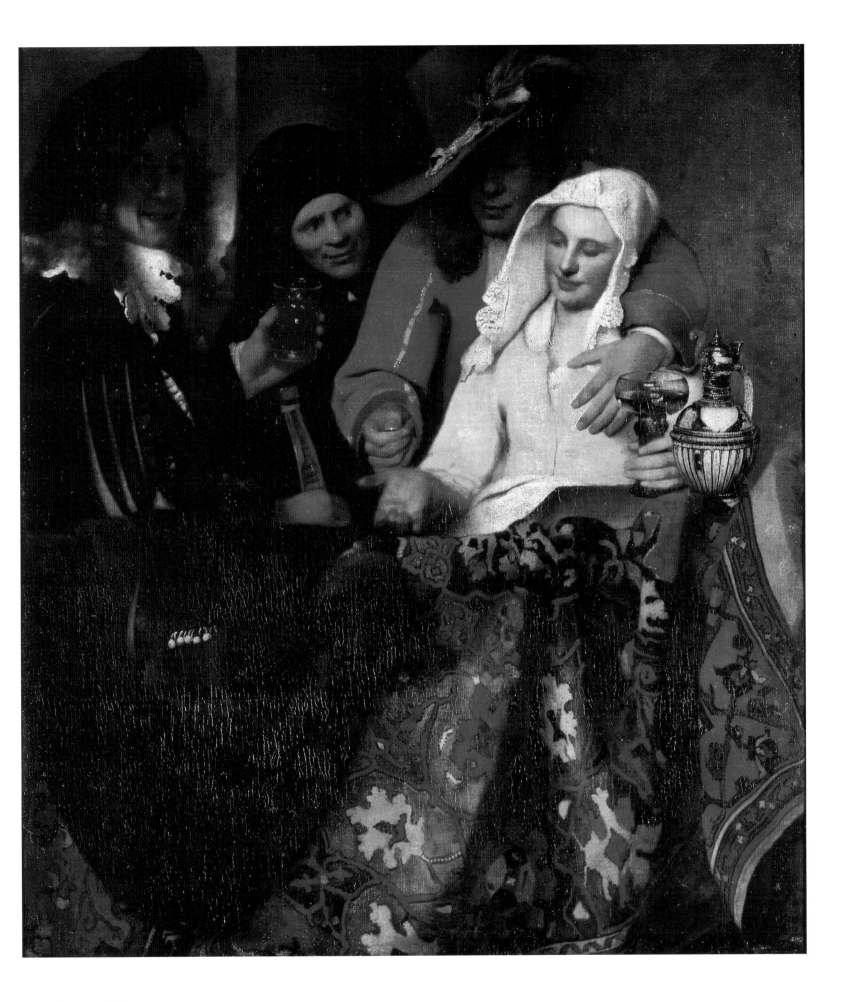

XIX JOHANNES VERMEER,
 The Procuress, 1656. Oil on canvas, 143 x 130 cm. Dresden, Gemäldegalerie Alte Meister, Staatliche Kunstsammlungen

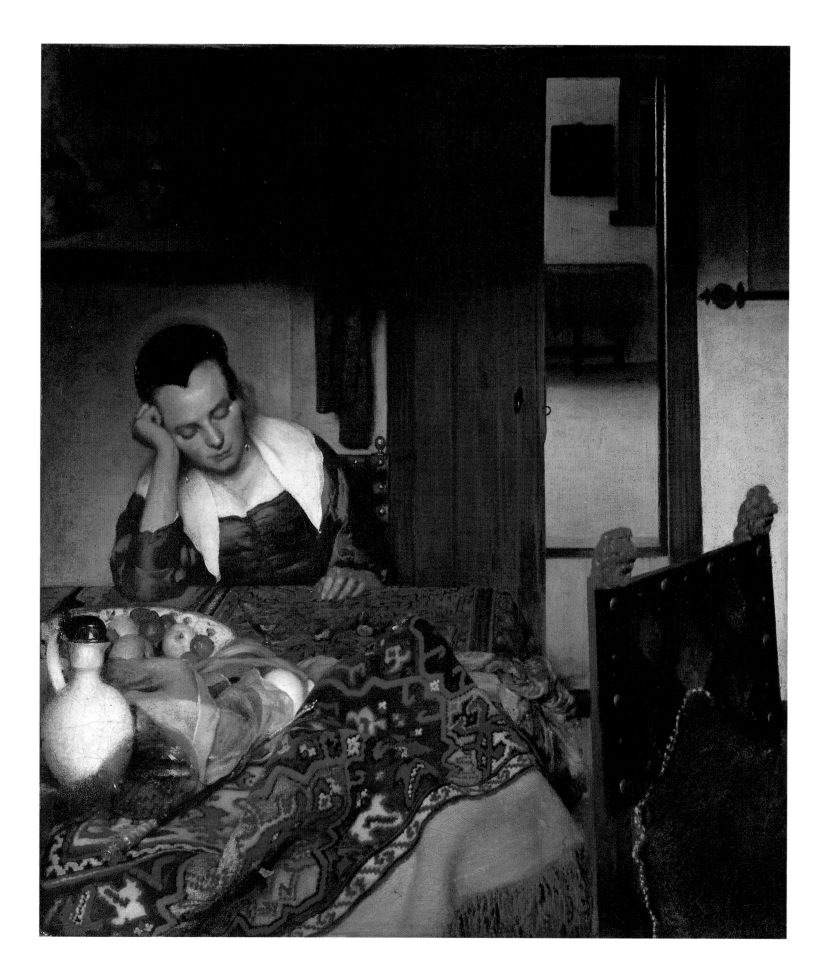

XX JOHANNES VERMEER,
 A Maid Asleep, ca. 1657. Oil on canvas, 87.6 x 76.5 cm. New York, The Metropolitan Museum of Art, Bequest of Benjamin Altman, 1913

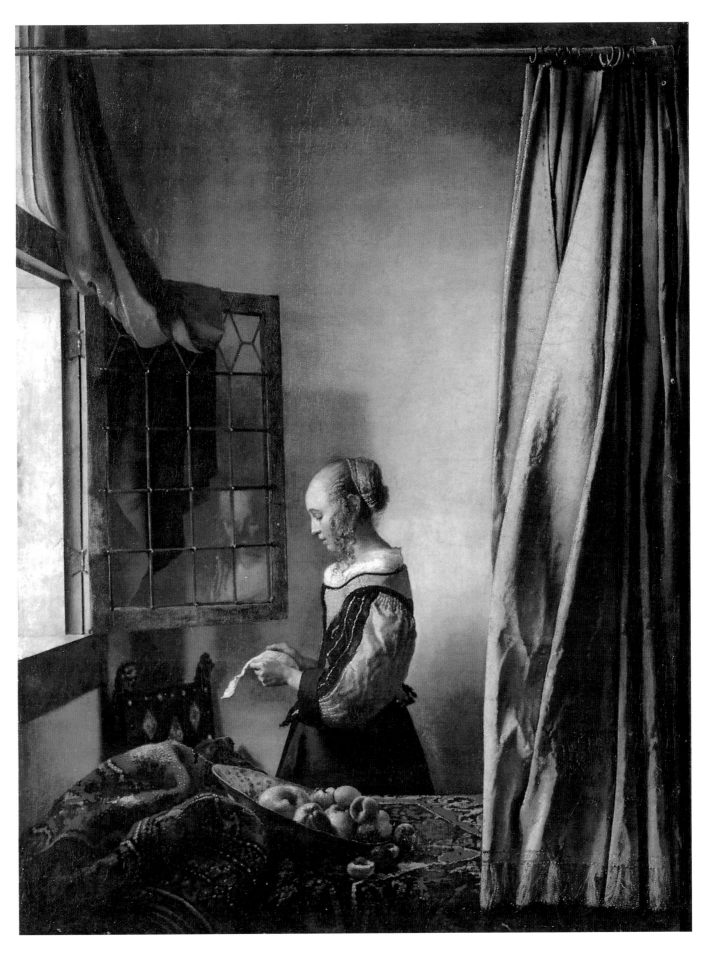

XXI JOHANNES VERMEER,
 The Letter Reader (Young Woman Reading a Letter), ca. 1657. Oil on canvas, 83 x 64.5 cm. Dresden, Gemäldegalerie, Staatliche
Kunstsammlungen

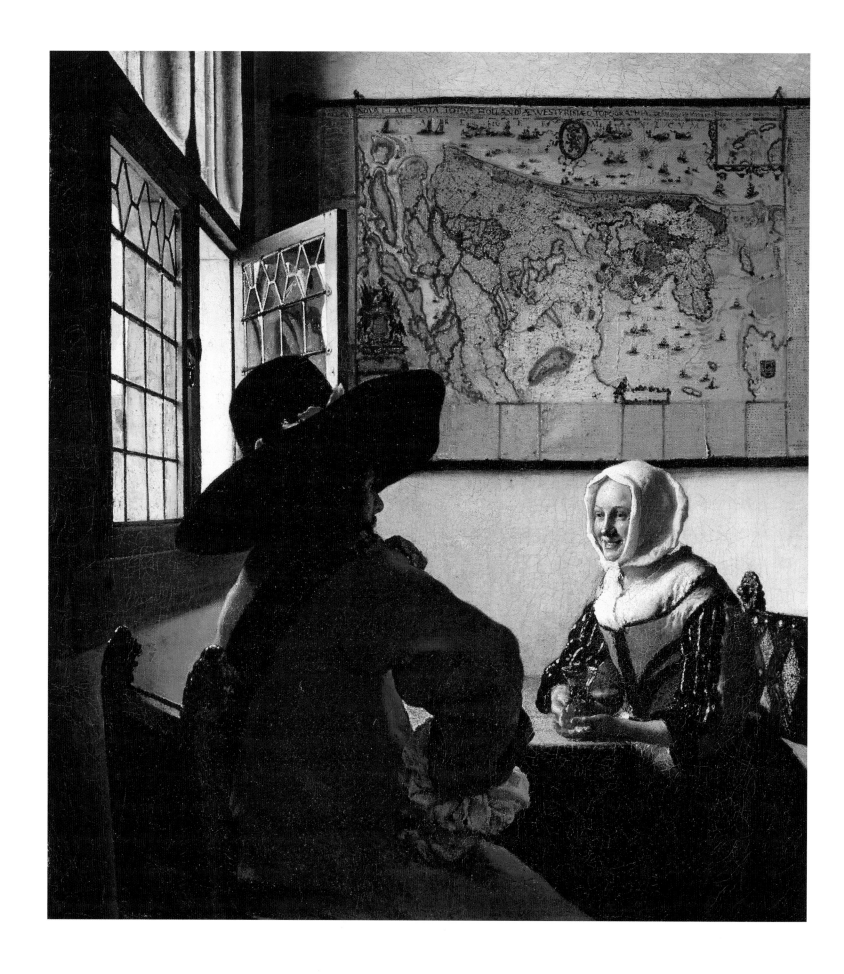

XXII JOHANNES VERMEER,
 Cavalier and Young Woman, ca. 1657. Oil on canvas, 50.5 x 46 cm. New York, The Frick Collection

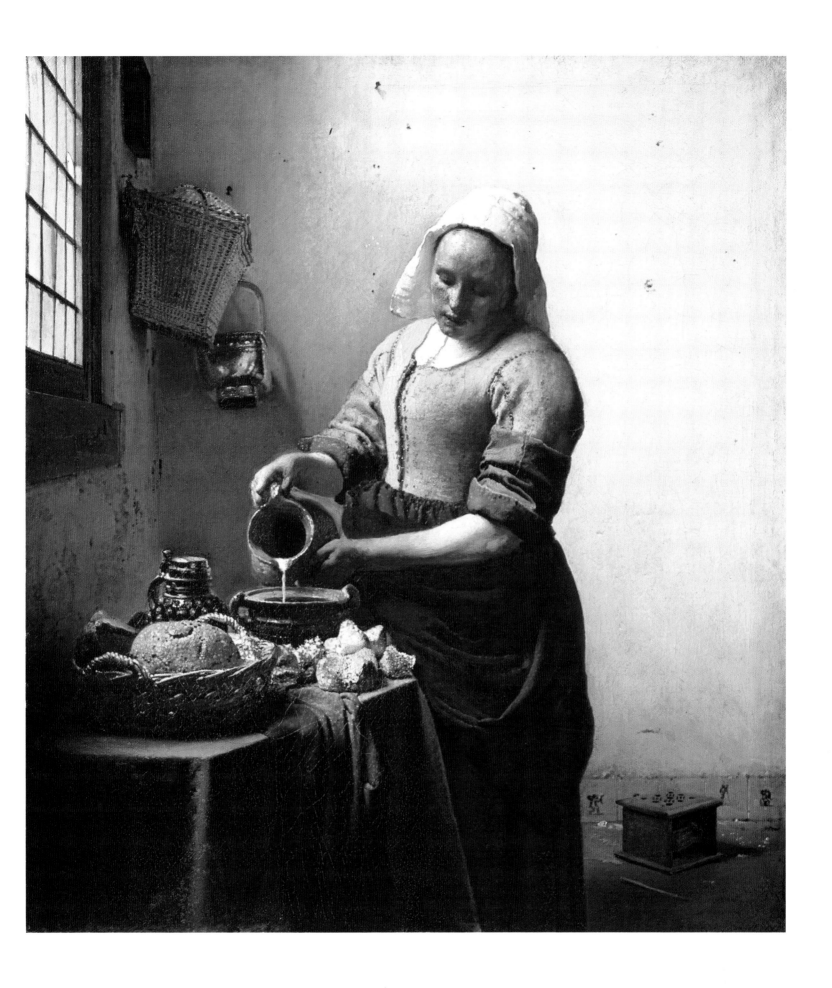

XXIII JOHANNES VERMEER,
The Milkmaid, ca. 1658. Oil on canvas, 45.5 x 41 cm. Amsterdam, Rijksmuseum

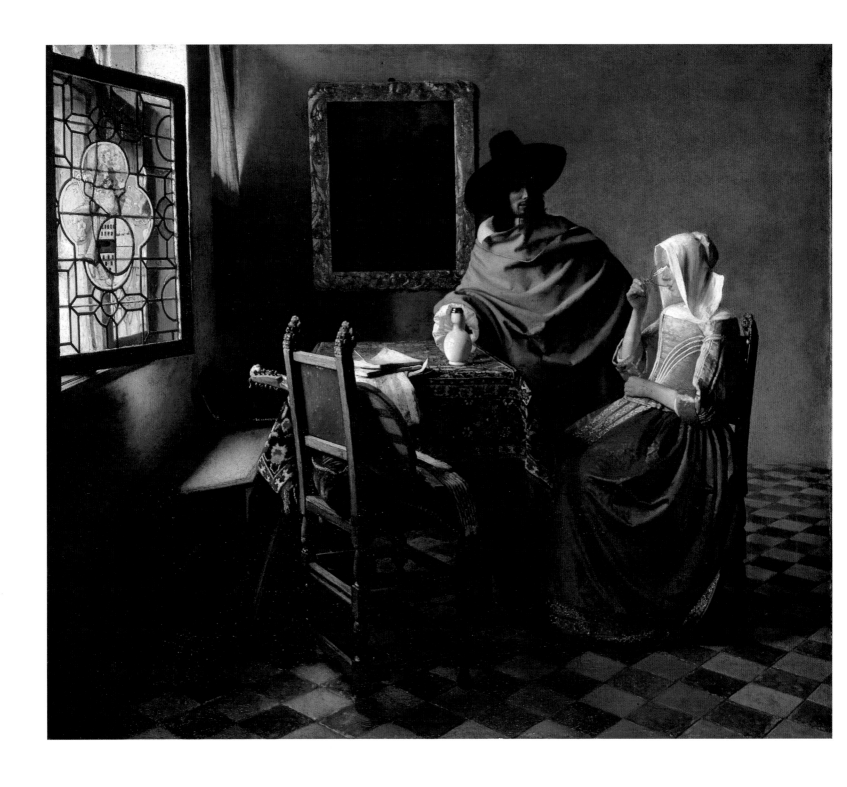

XXIV JOHANNES VERMEER,
The Glass of Wine, ca. 1658-59. Oil on canvas, 65 x 77 cm. Berlin, Gemäldegalerie, Staatliche Museen zu Berlin

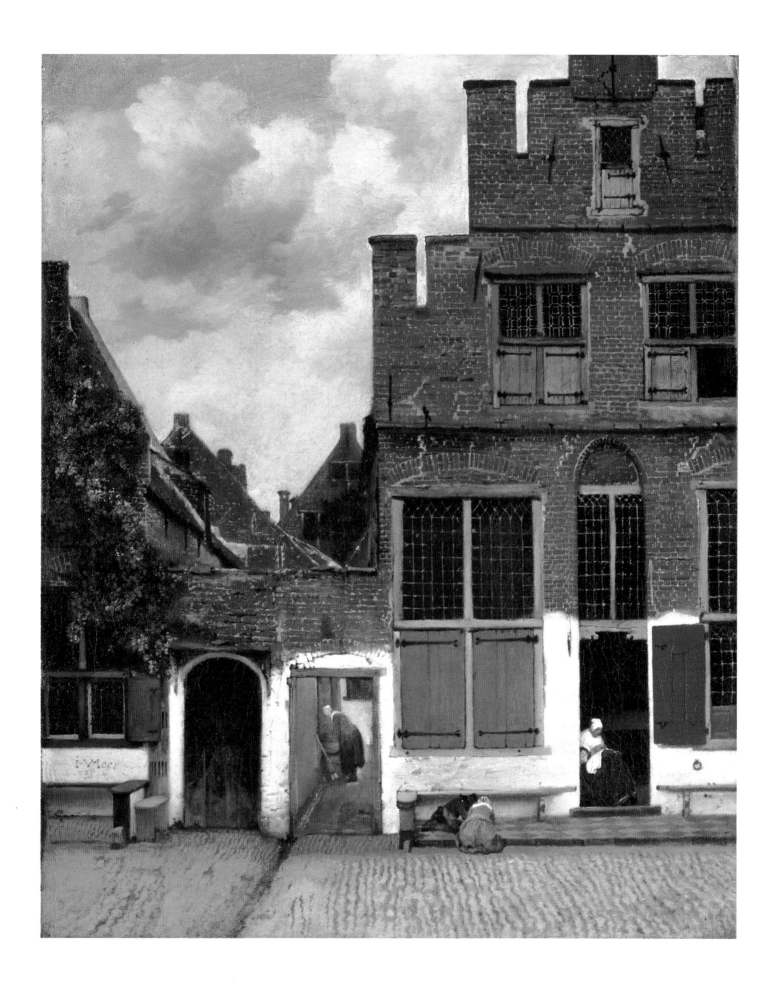

XXV JOHANNES VERMEER,
The Little Street (Het Straatje), ca. 1658-60. Oil on canvas, 53.5 x 43.5 cm. Amsterdam, Rijksmuseum

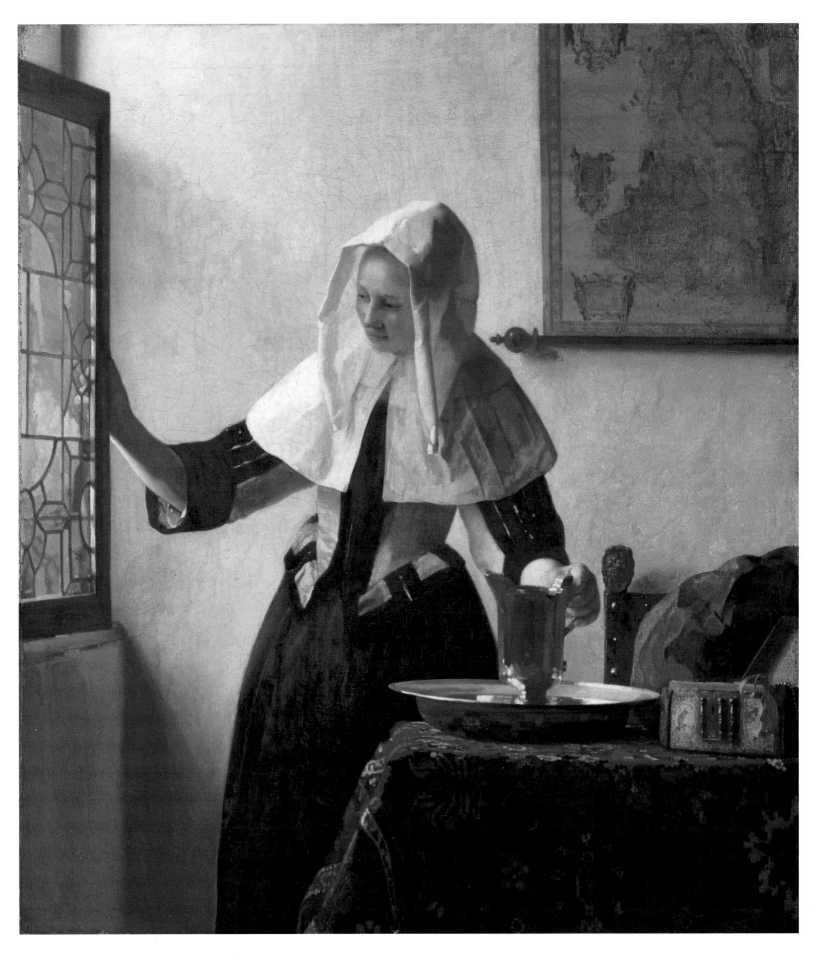

XXVI JOHANNES VERMEER,
Young Woman with a Water Pitcher, ca. 1662. Oil on canvas, 45.7 x 40.6 cm. New York, The Metropolitan Museum of Art, Marquand Collection, Gift of Henry G. Marquand, 1889

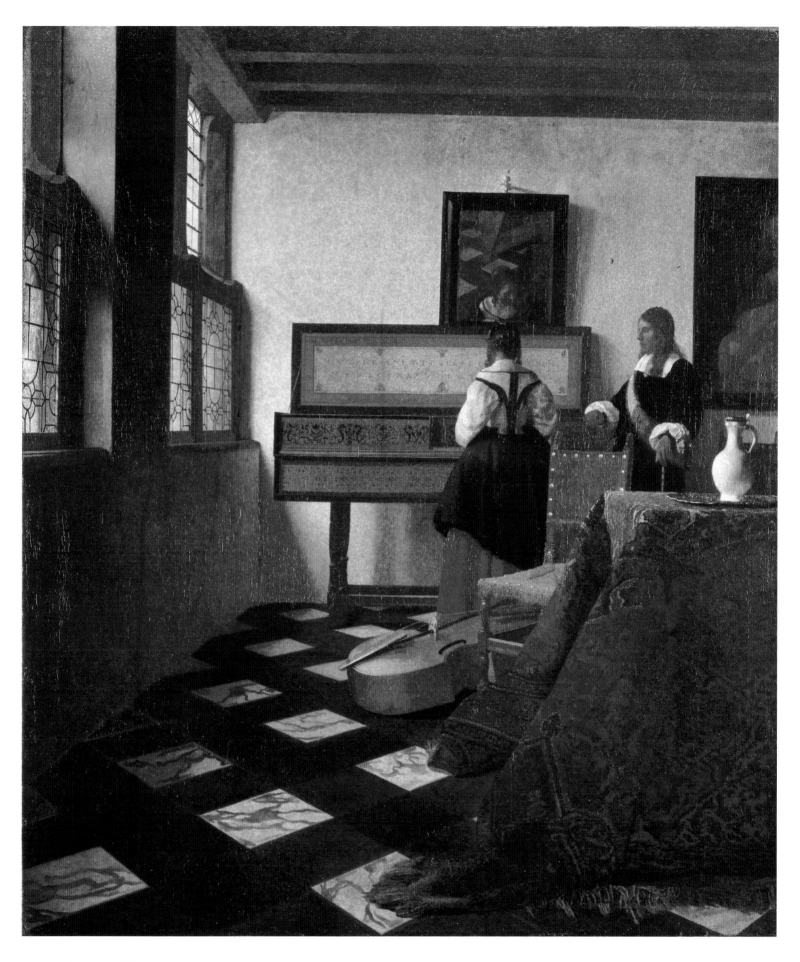

XXVII JOHANNES VERMEER,
The Music Lesson (A Woman at a Virginal with a Gentleman), ca. 1662-63. Oil on canvas, 74 x 64.5 cm. London, Buckingham Palace, Her Majesty
Queen Elizabeth II

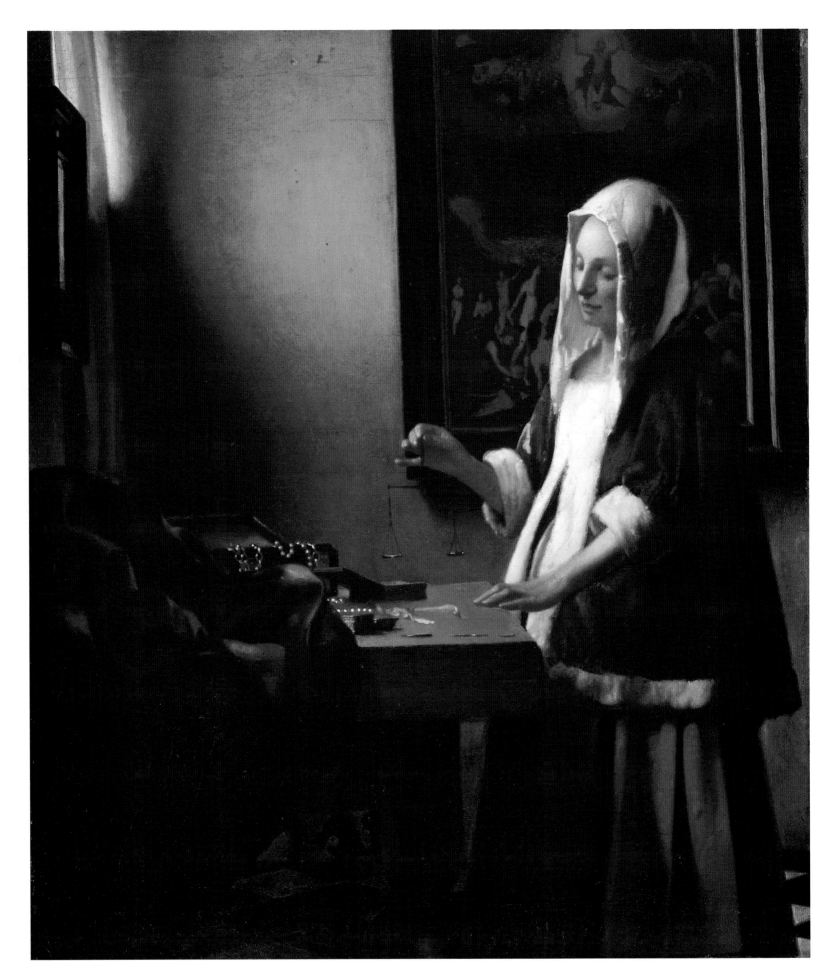

XXVIII JOHANNES VERMEER,
Woman Holding a Balance, ca. 1663-64. Oil on canvas, 40.3 x 35.6 cm. Washington, National Gallery of Art, Widener Collection

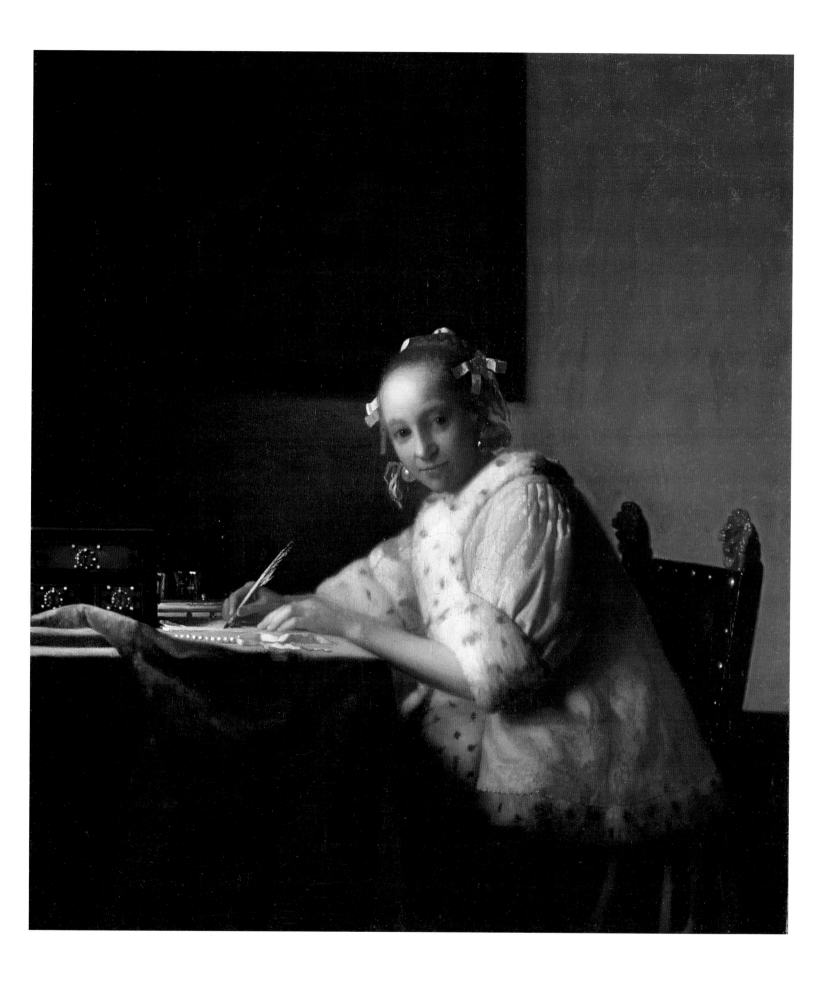

XXIX JOHANNES VERMEER,
 A Lady Writing, ca. 1665. Oil on canvas, 45 x 39.9 cm. Washington, National Gallery of Art, Gift of Harry Waldron Havemeyer and Horace
 Havemeyer, Jr., in memory of their father, Horace Havemeyer

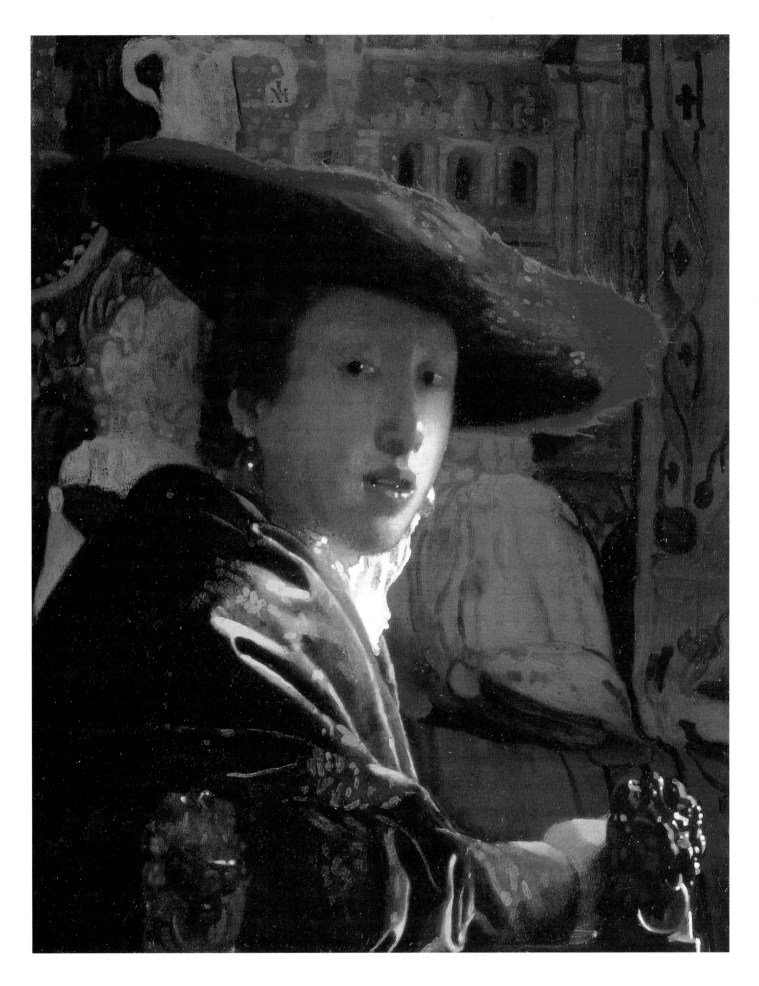

XXX JOHANNES VERMEER,
 Girl with a Red Hat, ca. 1665. Oil on panel, 23.2 x 18.1 cm. Washington, National Gallery of Art, Andrew W. Mellon Collection, 1937

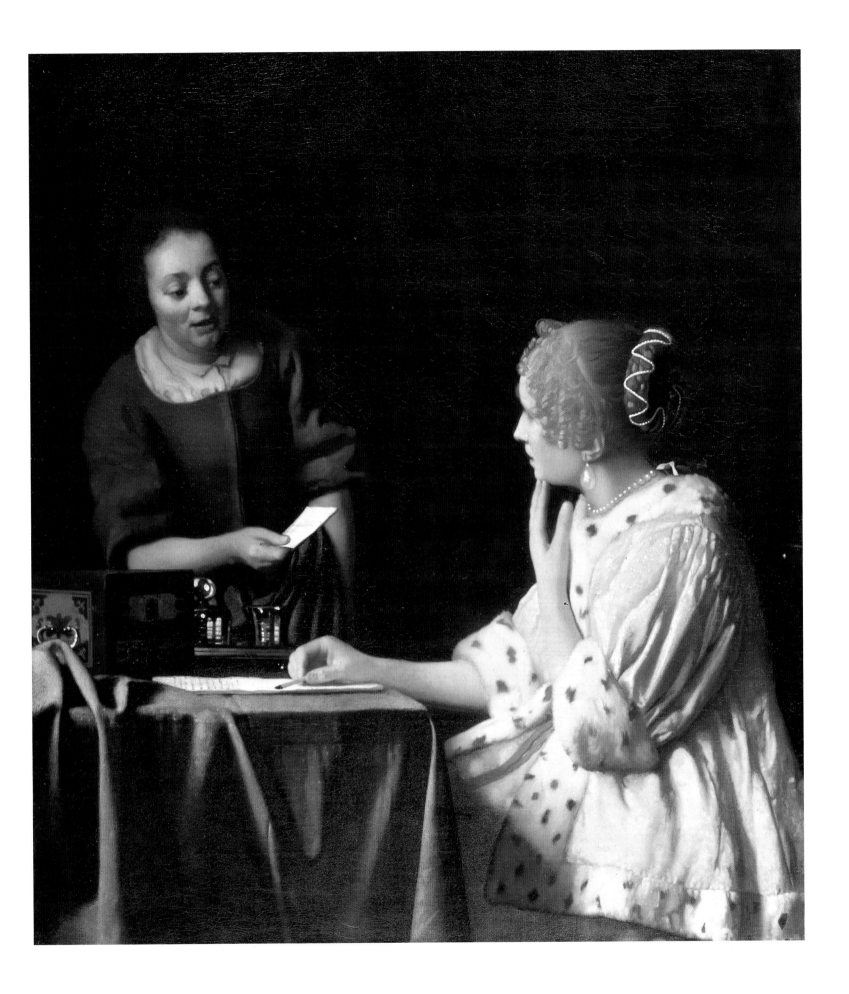

XXXI JOHANNES VERMEER,
Mistress and Maid, ca. 1666-67. Oil on canvas, 90.2 x 78.7 cm. New York, The Frick Collection

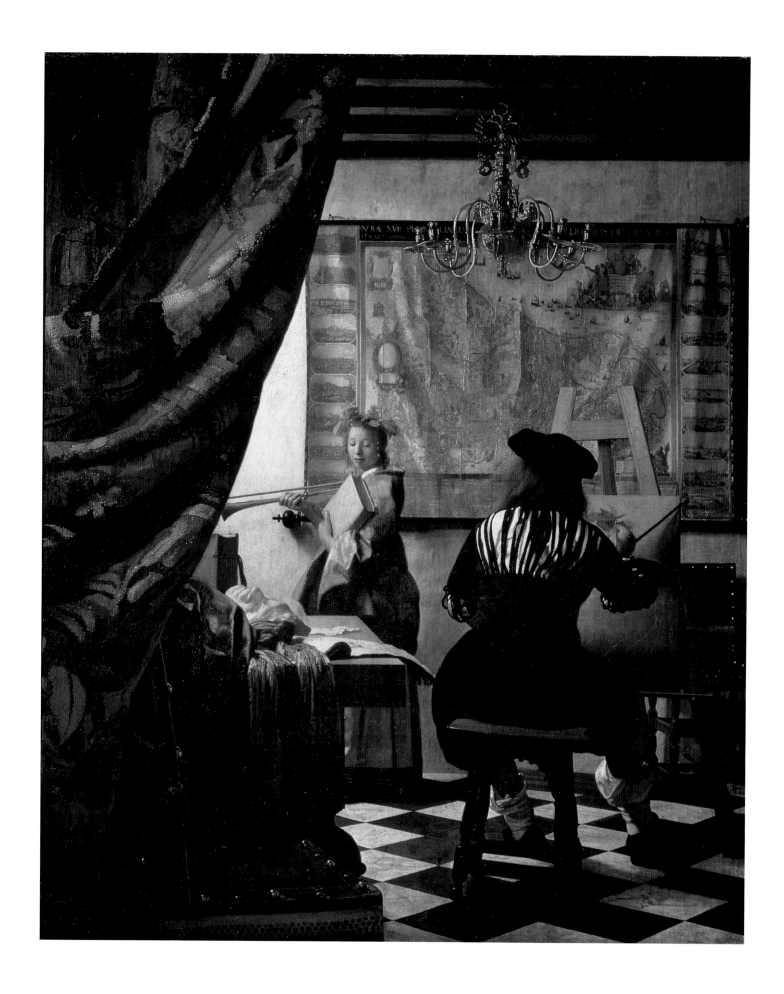

XXXII JOHANNES VERMEER,
 The Art of Painting, ca. 1666-68. Oil on canvas, 120 x 100 cm. Vienna, Kunsthistorisches Museum

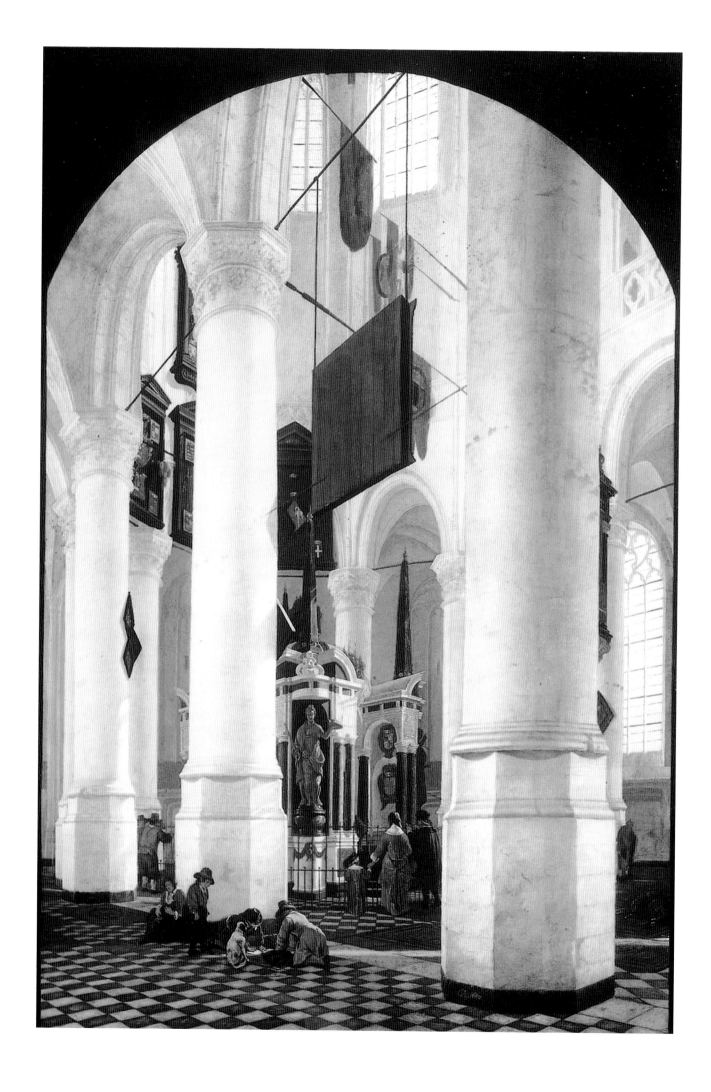

Chapter Three
The Architectural Painters

The most important view of a church interior ever painted in Delft and one of the greatest architectural paintings of the seventeenth century is the large panel of 1650 in the Kunsthalle, Hamburg (fig. 98; pl. II) by Gerard Houckgeest (ca. 1600-1661). Like many painters in Delft he was frequently involved with the neighboring court city of The Hague, where he was probably born and spent his first thirty-five years. He joined the painters' guild in The Hague in 1625 and again in 1639, but in the latter year he was mentioned also as a member of the Guild of St. Luke in Delft, where he had lived for about four years and where he married in 1636.

In 1650 and 1651 Houckgeest turned from the subject of imaginary architectural views to largely – and, in the Hamburg painting, unusually – faithful views in the Nieuwe Kerk (New Church) and Oude Kerk (Old Church) in Delft. This effectively established a new specialty in Delft, which became one of the city's most distinctive artistic developments of the 1650s and 1660s. The careers of Hendrick van Vliet (ca. 1611 – 1675) and Emanuel de Witte (ca. 1616 – 1691/92) as they are remembered today – both had been figure painters in the 1640s – were set in motion by Houckgeest, and the architectural painters must also have influenced Carel Fabritius, Pieter de Hooch, and Johannes Vermeer, as well as less well known Delft artists such as the occasional painters of church interiors, Johannes Coesermans (active 1660s) and Cornelis de Man (1621-1706).[1] It may be that no other picture painted in Delft was as consequential as the Nieuwe Kerk view of 1650, which can be considered (like its central subject) a national monument of the Netherlands.

The subject and its audience

The subject has often been described, although historians have occasionally been less faithful than Houckgeest to particular details (fig. 99). The tomb of "William of Nassau, Prince of Orange, father of the fatherland," to quote from the long Latin inscription cut into the stone tablet crowning the monument (see fig. 100), is seen in its place of honor in the choir of the Nieuwe Kerk in Delft. Commissioned by the States General from Hendrick de Keyser in 1614 and completed shortly after the sculptor's death in 1621, the complex construction consists of Dinant stone, black and white Italian marble, six bronze sculptures (the four female allegories at the corners, the seated prince in armor at the front, and the superb figure of winged Fame on the rear side, at the foot of the marble effigy), as well as sixteen painted escutcheons representing the

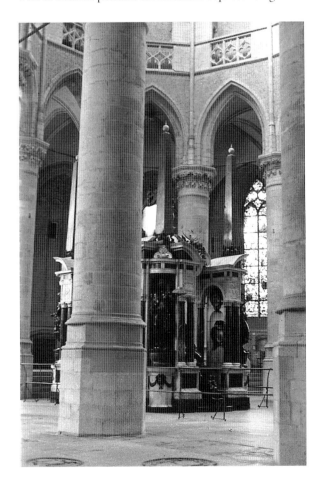

98
GERARD HOUCKGEEST,
Nieuwe Kerk in Delft with the Tomb of William the Silent, 1650.
Oil on panel,
125.7 x 89 cm.
Hamburg, Kunsthalle.
See also plate II.

99
Photograph in the Nieuwe Kerk, Delft (with the Tomb of William the Silent)

four quarters of William the Silent's coat of arms
(Nassau, Stolberg, Hessen, and Königstein). The
tomb was erected in the optimistic years of the
Twelve Years' Truce and became the frequent subject
of three Delft painters – Houckgeest, Van Vliet, and
De Witte – shortly after the Treaty of Münster (May
15, 1648) recognized the United Provinces'
independence from Spain.[2]

It is now generally recognized that the exceptional
size, quality, and fidelity of the picture in Hamburg,
the fact that no painting of the same site is known to
date earlier (compare figs. 101, 102), and of course

the commemorative nature of the subject suggest
that the work was commissioned. This probably
explains why Houckgeest, who at about the age of
fifty was a leading specialist in architectural views,
turned from imaginary compositions to the task of
carefully recording an actual view in a church interior.
In 1640 the prosperous painter was cited as the
designer of tapestries for the States General.[3] The
same body may have commissioned Houckgeest's
first painting of the Tomb of William the Silent,
but potential patrons in the period immediately
following Prince Frederick Hendrick's burial in the
crypt beneath the monument (May 10, 1647) and
the Treaty of Münster one year later would have
included anyone of means who wished to honor the
new nation, the "father of the fatherland," or the
House of Orange-Nassau.[4]

Expressions of loyalty to the Orange line in the
years around 1648-50 were often made out of keen
personal and political interest. A broad review of the
circumstances would consider the faction of Amalia
van Solms, widow of Frederick Hendrick, who
promoted the Orange legacy against the ambitions
of her son, Willem II; groups within the province of
Holland that supported or opposed the young prince;
other provinces that opposed Holland; and the rôle
of Willem II as "protector" of the Reformed Church
(meaning that he was less lenient toward Catholics
than his father had been).[5]

Whatever events brought the Hamburg painting

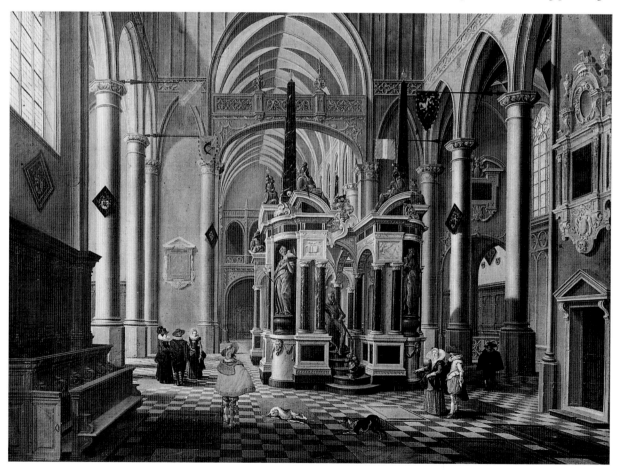

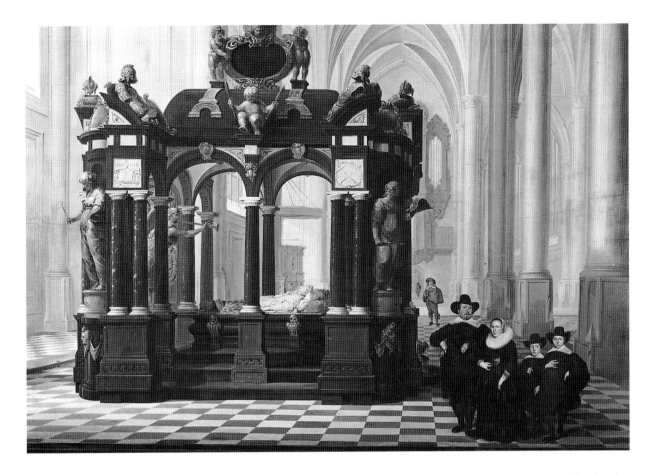

102

DIRCK VAN DELEN,
*The Tomb of William the
Silent in an Imaginary
Church (with a family
portrait)*, 1645.
Oil on panel, 74 x 110 cm.
Amsterdam, Rijksmuseum

into being, other factors deserve consideration: the fact that Houckgeest painted several other pictures of the monument in 1650 and 1651 (figs. 104, 106, 107); De Witte immediately followed his example; De Witte in Amsterdam and Van Vliet in Delft continued to paint views of the tomb from the 1650s through the 1670s (see figs. 160, 175) and also pictures of other national monuments, such as the tombs of Admirals Tromp, Hein, De Ruyter, and Wassenaer. The progeny of Houckgeest's first painting of the tomb suggests that it should be appreciated in rather broad terms, that is, as a celebration of the birth of a nation and as a remembrance of its father-figure, a man (to continue quoting from the tablet surmounting the tomb)

"who valued the welfare of the Netherlands more than his own interests or those of his family; who twice and mostly at his own expense collected powerful armies and led them into the field under the command of the States; who averted the tyranny of Spain; revived and restored the true religion and the ancient laws; who at last left the nearly regained liberty to be attained by his son Prince Maurits, heir to the hero… ."[6]

(Maurits was buried beneath the monument a few years later, on September 26, 1625.)

The same inscription records that the Tomb of William the Silent was erected specifically "as an eternal memorial of his merits," meaning, clearly, the principles for which he and the nation stood. The same convictions are evidently endorsed in Dirck van Delen's portrait of a family at the monument (but not the site), which is dated 1645 and derives partly from a print published by Pieter de Keyser (figs. 100, 102). During the following decades, dozens of paintings (and some Delft tiles) depicted the tomb and were undoubtedly sold to visitors as well as to residents of Delft.[7]

To some critics it may appear that Houckgeest minimized the importance of the tomb by approaching it obliquely from the northern ambulatory, as a stroller in the church might happen upon it almost unexpectedly (fig. 99; compare De Witte, fig. 155). Slive, following Wheelock, convincingly interprets the painter's approach. "Although the best-known monument in the Netherlands is subordinated to the huge pier and is partially obscured by another one, the allegorical sculpted figure of Freedom [or Liberty] on William's tomb gains emphasis by the new scheme."[8]

The point deserves emphasis because the figure of Liberty is not what one might expect, namely, one of "the four cardinal virtues adorning [the monument's] corners."[9] Liberty is not one of the four Cardinal Virtues (Fortitude, Justice, Prudence, Temperance) or one of the three Christian Virtues (Faith, Hope, Charity), which were often represented in the sculptural programs of churches and town halls. The four "Virtues" on William's tomb (the "memorial of

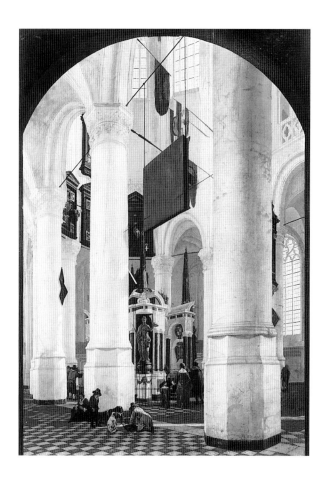

103
GERARD HOUCKGEEST,
*Nieuwe Kerk in Delft with
the Tomb of William the
Silent*, 1650.
Oil on panel,
125.7 x 89 cm.
Hamburg, Kunsthalle.
See also plate II.

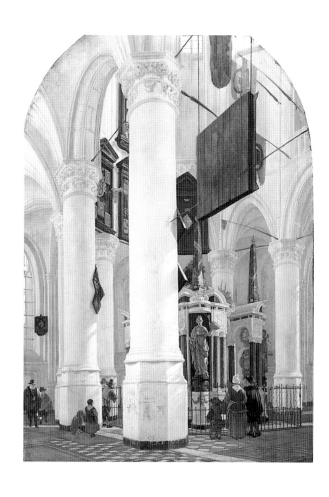

104
GERARD HOUCKGEEST,
*Nieuwe Kerk in Delft with
the Tomb of William the
Silent*, 1651.
Oil on panel, 56 x 38 cm.
The Hague, Koninklijk
Kabinet van Schilderijen
"Mauritshuis"

105
The Houckgeest panel in
Hamburg (fig. 103), with
its basic perspective
scheme indicated and the
Mauritshuis composition
(fig. 104) outlined

106
GERARD HOUCKGEEST,
*Nieuwe Kerk in Delft with
the Tomb of William the
Silent*, 1650.

Oil on panel, 51 x 42 cm.
Private collection
(ex-Crews collection;
photo: courtesy of David
Koetser, Zürich)

107
GERARD HOUCKGEEST,
*The Ambulatory of the
Nieuwe Kerk in Delft with
the Tomb of William the
Silent*, 1651.
Oil on panel,
65.5 x 75.5 cm.
The Hague, Koninklijk
Kabinet van Schilderijen
"Mauritshuis."
See also plate VIII.

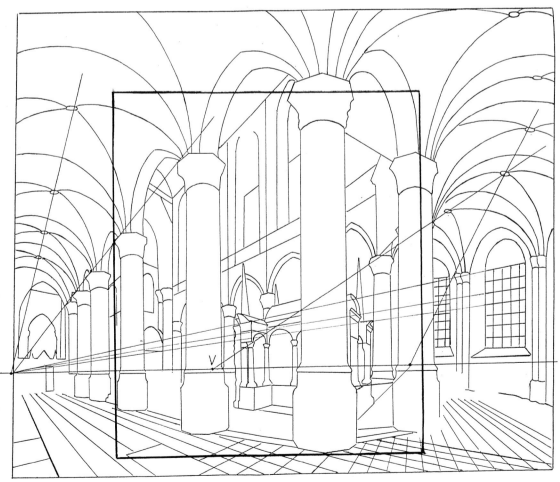

108
Diagram of the broad
Mauritshuis panel by
Houckgeest (fig. 107),
with the ex-Crews
composition (fig. 106)
outlined

85

his merits") are specifically the prince's own, and his legacy as "father of the fatherland": Liberty, Justice, Faith, and Fortitude.

The figure of Liberty is emphasized in the first known painting of the tomb, Van Bassen's panel of 1620 in Budapest (fig. 101), by his approach to the tomb, the flood of light, and the arrangement of the entire composition. The leading rôle assigned to Liberty in the Hamburg painting and the Mauritshuis picture of the following year (fig. 104) is stressed by the placement of what one might describe as representative families (two generations, the present and the future) below the outstretched "Hat of Liberty," which is inscribed on the upturned brim: "AUREA LIBERTAS" (Golden Liberty). In the Maurithuis picture, the family, more modestly dressed than before, has moved from the figure of William to that of Liberty, while the other visitors to the church have become more uniformly focused on the monument. In Van Delen's painting (fig. 102) the family seems to be presented under the protection of Liberty. And in a splendid version of the Mauritshuis composition by Houckgeest's own hand (pl. VII), another artist placed a fashionable couple below Golden Liberty, to which the gentleman gestures instructively.

Houckgeest's approach pays homage not only to the statue of Liberty but also to the choir of the Nieuwe Kerk. Modest though it may seem compared with, for example, the choir of the Abbey Church of St.-Denis in France, this small corner of Delft represents the same sort of hallowed ground in that it is the burial place of the nation's ruling dynasty.[10] Houckgeest's selective view, which embraces much of the choir's space, including almost all of its height, suggests the majesty of the setting, which in 1650 still surpassed that of any other monument in a Dutch church. Contemporary viewers would have been aware of the crypt below the choir, of which the tombstones and escutcheons (or "graveboards") are reminders, and they might have remarked that the placement of a national monument rather than an altar at this location in the choir was made possible by William the Silent, who "restored the true religion." In this light, the "pulpit views" that Houckgeest and De Witte painted in 1651 (figs. 113, 156; Van Vliet's begin a few years later) are related to the paintings that include tombs of heroes (see also fig. 111), for they all bring to mind the new nation's freedom of worship, which for the Protestant public in this period meant freedom from (if not for) the Catholic church and from "the tyranny of Spain."

The dynastic significance of the site is clarified by Houckgeest's careful description of the four large graveboards hung above the tomb on the choir wall (see pls. II, VII). Hanging centrally above the others is the most recently installed graveboard, that of

Frederick Hendrick. The three graveboards in slightly simpler frames, which rest on the column capitals, are those of (from left to right) Prince Maurits, William the Silent, and the latter's fourth wife, Louise de Coligny.[11] The flags hanging in the choir (see also figs. 146-47, 177) have never been identified in print. Of the four flags visible in the Hamburg picture, the one to the lower right bears the crest of Delft (the dark central band on the shield has wavy horizontal lines symbolizing a canal).[12] The other flags require further research, but probably represent guilds, and/or military companies.[13]

Theme and variation

Like other Dutch painters of the time (Pieter Saenredam, for example), Houckgeest exploited his innovation by producing related works. He proceeded in a manner that was at once responsive to actual viewing conditions and distinctive in style.

Following the artist's progress (as outlined in the next paragraph) will require some patience and close study of the illustrations. All of the following appears to have been achieved within a brief period in 1650-51.

(1) The Hamburg panel was painted (fig. 103). (2) The artist found a surprisingly similar view in a different church (fig. 111). (3) He painted a small, delicate version of the Hamburg view (fig. 104). (4) He approached the Nieuwe Kerk's choir in a direction opposite to that taken originally, which nonetheless yielded a similar composition (fig. 106). (5) He then experimented with a much wider angle of view in the broad Mauritshuis picture of 1651 (fig. 107). (6) He found an analogous, if less extreme, wide-angle view in the Oude Kerk (fig. 109); the chapel in the central background was Houckgeest's vantage point in the other Oude Kerk view (fig. 111). (7) From that panoramic composition (fig. 109) Houckgeest extracted the "pulpit views" in the Rijksmuseum (fig. 113; see fig. 110). (8) In a similar operation, a tall view from the southeast corner of the Nieuwe Kerk's ambulatory (fig. 106) was cropped from the panoramic composition of 1651 (fig. 107), that is, from its preparatory material. (9) It appears that Houckgeest recorded a view from a point further back in the ambulatory and that De Witte copied it (fig. 147).[14] (10) Finally, in 1651, Houckgeest painted a view of the Jacobskerk in The Hague (fig. 150), in which he departed from the oblique pattern he had just established in Delft.

In this deliberate but hardly predictable progress from one design to the next, there are many subtle shifts of emphasis, new motifs, and a deft handling of various orthodox but unusual perspective schemes. In the Hamburg painting, for example, the composition

is solemn and stately, despite the diagonal thrust of columns to the left. The design's dignified poise is due in good measure to its centralized perspective scheme (fig. 105). The vanishing point (as is clear from the floor tiles) is just above the well-dressed child, at his parents' eye-level and coincident with William's bronze thigh. The distance points (to which the edges of floor tiles, the sides of the tomb, the column bases and capitals recede) are equidistantly beyond the lateral sides of the composition, by a little less than half its width.[15]

Comparable but slightly off-center perspective schemes were employed in the tall Mauritshuis panel of 1651 (fig. 104) and in the Oude Kerk view with the tomb of Piet Hein (fig. 111). However, in the broad Mauritshuis picture (fig. 107) the scheme is shifted off-center and extended rightward in a highly inventive way (fig. 108). For the wide-angle Oude Kerk view Houckgeest cut the three-point projection in half (figs. 109, 110). One need not be seduced by "la dolce prospettiva" (as Uccello described his preoccupation) to appreciate some of the consequences. The tomb of William the Silent recedes almost symmetrically from Golden Liberty's corner in the Hamburg view (fig. 103), but in the panoramic composition (fig. 107) the rear of the seemingly more distant monument slants sharply to the right. In the Buccleuch panel (fig. 109) the nearest columns are spaced impossibly far apart (compare the same archways in fig. 181). The viewer slowly surveys the interior from left to right, and the distant elevations gently overlap each other, like shuffled cards or pages held apart by pencils in a book. In the illusionistic picture of the pulpit that was cropped from the Buccleuch view (fig. 113), the lateral shift of the perspective scheme almost eliminates the middle ground, so that the eye jumps from foreground to background as in the Jacobskerk view (fig. 150), or as in one of Adam Pynacker's approximately contemporaneous landscapes in which a prominent tree in the foreground is foiled against a distant view.

These geometrical manipulations were more than routine studio exercise. Houckgeest varied his perspective schemes in response to the actual sites. In the east end of the Nieuwe Kerk, a rather restricted space, the artist took advantage of the tight cluster of columns in the tall and narrow choir (see fig. 99). He found a similar arrangement of forms in a corner of the Oude Kerk (figs. 113, 114). But in his panoramic view of the same church, the surprising expansiveness of the interior is effectively conveyed (fig. 109).[16]

All this required experience, more than Houckgeest could have acquired while working on the Hamburg picture. His views of three churches recorded in 1650 and 1651 reveal a mastery of composition and perspective practice. He proceeded

methodically, in a manner reminiscent of Saenredam (for example, in the contemporary series of sketches made in the Nieuwe Kerk at Haarlem).[17] At the same time, Houckgeest responded to the distinctive characteristics of each site. Where, or how, or from whom did the artist learn so much?

Houckgeest, Saenredam, and De Witte (past hypotheses)

No development among artists of the Delft school was so coherent and concentrated as that of the architectural painters, Houckgeest, Van Vliet, and De Witte. To be sure, portraiture in Delft was practiced by a succession of closely interrelated artists (Michiel van Miereveld, Jacob Willemsz Delff, Willem van der Vliet, Hendrick van Vliet, Anthonie Palamedesz) who adhered to a tradition sometimes described as the South Holland School. One of these portraitists, Hendrick van Vliet, produced a steady stream of Oude Kerk and Nieuwe Kerk views during the last twenty-odd years of his career (discussed below). But the comparison between what are occasionally called "portraits" of the two principal churches in Delft and portraits of the people who in many instances worshiped in them (and whose family members were buried in them) serves to underscore how exceptional the break in tradition was, marking the sudden rise of a new kind of architectural painting in Delft. Broadly analogous developments had occurred before. One might, in an introductory book on Dutch art, compare the way in which Houckgeest, Van Vliet, and De Witte shared innovations during the early 1650s to the relationship of the Haarlem landscape painters, Jan van Goyen, Salomon van Ruysdael, and Pieter Molijn a quarter-century earlier. However, the landscapists had many more forerunners and fellow travellers, and their subjects, compared with the Delft painters', were more diverse.

A better comparison might be made – and indeed has been made, though differently than here – with Pieter Saenredam, the honorary "first portraitist of architecture."[18] His earliest architectural painting of any kind is a wide-angle view of Saint Bavo's transept and choir, dated 1628 (fig. 115).[19] Although the Haarlem artist employs a one-point perspective scheme, and the sudden recession from the northern to the southern arm of the transept bears some resemblance to earlier views rushing to a distant choir from the west end of the nave (for example, Hendrick van Steenwyck the Younger's *Interior of a Gothic Church*, 1609, in Dresden),[20] the choice of view and the expansive sense of space in the Getty panel are unprecedented. The panoramic nature of the view is even more evident in Saenredam's drawing

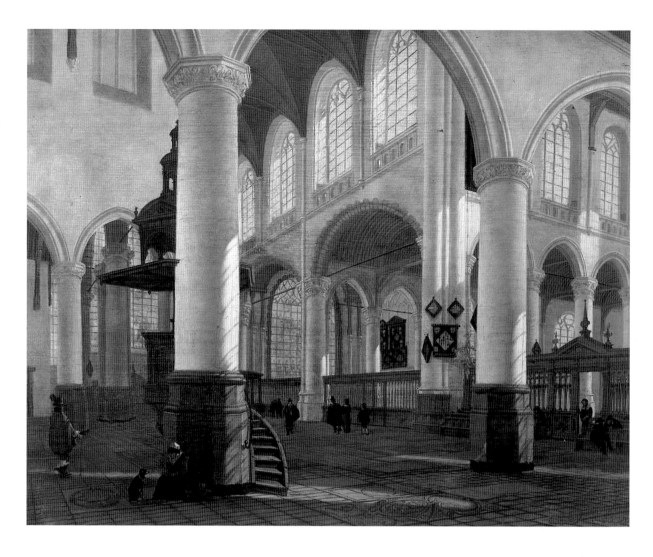

109
GERARD HOUCKGEEST,
Oude Kerk in Delft, *from
the southern aisle to the
northeast*, ca. 1651.
Oil on panel, 41.9 x 56 cm.
Collection of the Duke of
Buccleuch and
Queensberry, K.T.

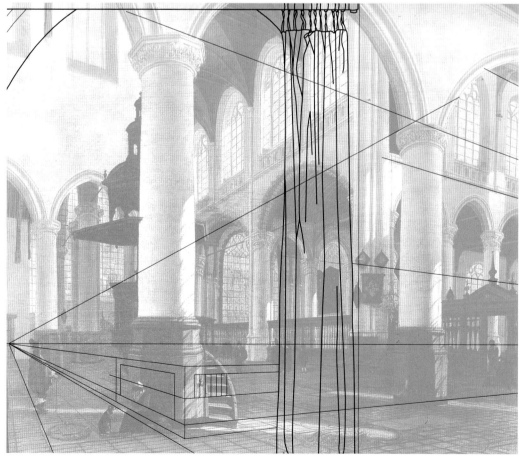

110
Diagram of the Buccleuch
panel (fig. 109), with its
basic perspective scheme
indicated and the
Rijksmuseum Houckgeest
(fig. 113) outlined

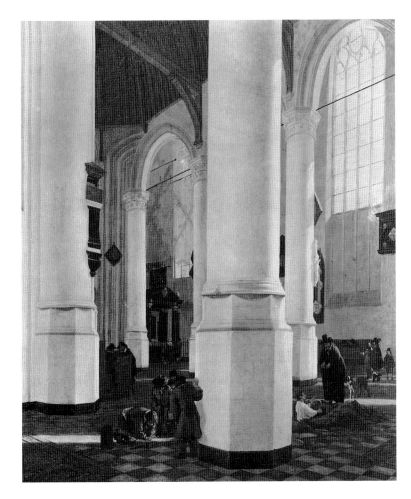

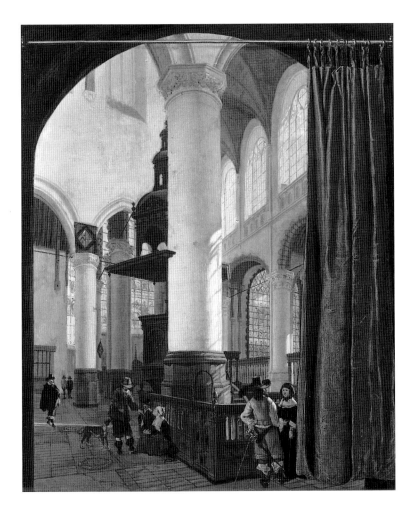

111
GERARD HOUCKGEEST,
*Oude Kerk in Delft with the
Tomb of Piet Hein*, ca. 1650.
Oil on canvas, 68 x 56 cm.
Amsterdam, Rijksmuseum

112
Photograph in the Oude
Kerk, Delft (with the
Tomb of Piet Hein)

113
GERARD HOUCKGEEST,
*Oude Kerk in Delft with a
View of the Pulpit*, 165(1?).
Oil on panel, 49 x 41 cm.
Amsterdam, Rijksmuseum

114
Photograph in the Oude
Kerk, Delft, approximately
from the vantage point
assumed by Houckgeest in
figs. 109 and 113

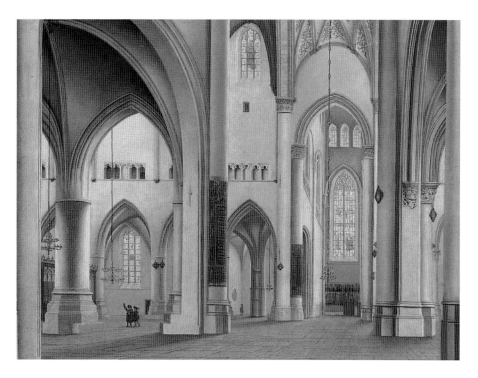

115
PIETER SAENREDAM,
The Interior of St. Bavo's,
Haarlem (view of the
transept to the south), 1628.
Oil on panel,
38.5 x 47.5 cm.
Los Angeles, California,
The J. Paul Getty
Museum

made in the church,[21] from which one would not have anticipated the importance of decorative elements, especially the tapestry-like banner of the weavers' guild that is painted on a crossing pier, in the final work.[22] Perhaps some special interest (the guild's?) or issue (church decoration?) determined Saenredam's unexpected approach to the church interior, just as Houckgeest – whose figure of Liberty in the Hamburg panel (pl. II) is featured discreetly, like the black and gold banner in the St. Bavo view – was compelled by his main point of focus and the spatial limitations at the actual site to approach the architecture in a way not seen before.

One may appreciate how different these two painters are and at the same time learn something from the similarities between their first views of actual architecture. Like Houckgeest, Saenredam had been prepared for his new area of specialization by previous expertise in the use of linear perspective and by some association with professional architects. He was brought to the task of representing his local church by a commission, namely, his meticulous drawings for the engraved plates of St. Bavo's interior and exterior in Samuel Ampzing's *Beschryvinge ende lof der stad Haerlem in Holland*, Haarlem, 1628 (fig. 116). It is possible that the Getty picture (fig. 115) and the painting (1631?; Philadelphia Museum of Art) that repeats the centralized view of St. Bavo's reproduced in Ampzing's book were also commissioned, considering that very few pictures of actual church interiors had ever been painted before (the prime example is Hendrick van Steenwyck the Elder's *Cathedral of Aachen*, 1573, in the Alte Pinakothek, Munich).[23] Townscape views of the early seventeenth century, such as Hendrick Vroom's two views of

Delft dated 1615 (Prinsenhof, Delft), were usually commissioned or at least intended for a particular patron such as the city government.[24]

Saenredam's drawing of 1627 for the engraving in Ampzing's book (fig. 116) makes the comparison of his first dated painting with Houckgeest's Hamburg picture all the more instructive. More than any of Houckgeest's early, imaginary architectural views (figs. 121, 129, 131), the Haarlem artist's first essay in the genre is a textbook exercise in the manner of Vredeman de Vries.[25] The view of St. Bavo's entire nave and choir conforms to the most conventional perspective scheme, as if Saenredam had studied in Pieter Neeffs the Elder's Antwerp shop (even the wide-angle distortions of the nearest arches have precedents, as in Steenwyck the Elder's Aachen view). However, when the same Dutch draftsman, for whatever reason, recorded the more restrictive transept view (fig. 115), he arrived immediately at an eccentric composition which – in its inclusion of columns in the foreground, the wide-angle view to the left, the high-angle view of the vaults, and the rapid recession (to say nothing of the painting's fidelity to the subject and its wonderful luminosity) – responds with startling freshness to the experience of a great architectural space. The perspective scheme, which features a low horizon, off-center vanishing point, and wide-angle distortions, departs from the plates and ignores the advice of contemporary treatises. Houckgeest's oblique projection in the first views of Delft church interiors may have been an innovation in the genre of architectural painting, but his perspective scheme is more conventional than Saenredam's and closer to what may be found (if with higher horizons) among Vredeman de Vries's plates (fig. 148).

The parallels between Saenredam's and Houckgeest's beginnings as painters of actual architectural views are worth considering in some detail, partly because a few authors, viewing the matter in the orthodox perspective of traditional art history, have found Houckgeest's achievement in the Hamburg panel inexplicable without some deus ex machina – either the old hand, Saenredam, or the impulsive newcomer, De Witte – intervening on the Delft painter's behalf.[26] In addition, each of these writers requires some transitional work by Houckgeest, such as the Louisville canvas that later turned out to be by Cornelis de Man (fig. 177),[27] to mark his plodding path from the imaginary architectural views he painted in the 1640s, through a few newish if still largely derivative designs, to his eventual emergence from the one-point perspectivist's tunnel into the clear light of the choir of the Nieuwe Kerk in Delft. Even at that moment, however, Houckgeest, nearly in his dotage ("already fifty," as Wheelock observed twenty-five years ago), could not

fully absorb Saenredam's impact ("it is unlikely that anyone's influence at that stage of his career could have totally eradicated his own artistic heritage").[28] It is true that Houckgeest "limited the field of vision by choosing a vantage point near large columns," and he even placed childlike drawings on one of them,[29] ideas that he and De Witte might have picked up (or clarified, given the date) in an off-moment during Willem II's funeral in the Nieuwe Kerk, since Saenredam was reported to be present at the ceremony in March 1651.[30] However, "it would appear that [Houckgeest] was far less influenced by Saenredam than was De Witte," who may differ from the Haarlem master in his "overall impressions" but reveals "spatial similarities" and, in some vaguely geometric way, "partakes of Saenredam's spirit" in the Wallace Collection painting of 1651 (fig. 156).[31]

The credo that De Witte was present at the creation of realistic church views in Delft has been passed down from the apostle of Netherlandish architectural painting, Hans Jantzen. In his fundamental study of 1910 the German art historian, whose career overlapped that of Monet by thirty years, praised De Witte for his "optical conception," which for Jantzen evoked the light, space, and soul of Gothic architecture.[32] His discussion of De Witte's style suggests persuasively how the former figure painter, with his fluid interplays of light and shadow and his softened contours, transformed the genre from a perspectivist's specialty into an art of describing forms and spaces not unlike that of De Hooch or Vermeer. This revolution was linked in Jantzen's mind, as it was for many artists of his generation, with the belief that one should work from the "living model" rather than in the studio. Thus it was his freedom from the academic discipline of linear perspective that allowed De Witte, followed by the equally innocent but less brilliant Van Vliet, to lead an older and in many ways more experienced artist, Houckgeest, into a new and more modern field, or rather, a rejuvenated version of a field he had been in for about twenty years.

To support this hypothesis Jantzen searched for a suitable "Talisman" (something comparable to Serusier's landscape painting, so named by the Nabis), which could have pointed the way to a new style of depicting architecture. The pioneering picture would introduce the essentials of the "Delfter Bildtypus": an "oblique perspective view," and a close vantage point ("kleiner Augendistanz"). Of course, "we should not be surprised" if the experimental work reveals "all sorts of perspective mistakes, uncertainties, and carelessness." Jantzen had recently come across such a picture in the art trade: an Oude Kerk view inscribed "EDW" in which "the lines of the floor run off from each other and the columns appear deformed." The painting "clarifies for us in a

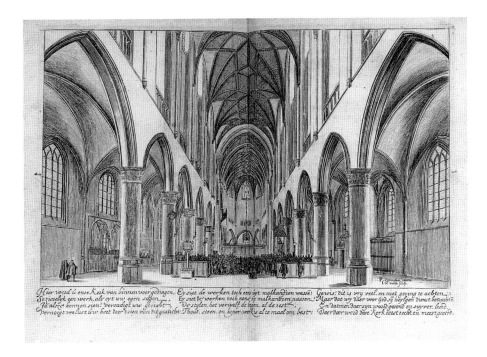

convincing manner how we may think of De Witte's first attempts at architectural painting," which Jantzen dated to about 1647. However, Manke spotted the tomb of Admiral Tromp, erected in 1658, in the background of Jantzen's example, and reasonably assigned the mediocre picture to an unknown artist in the "circle of Hendrick van Vliet."[33]

This is an example of how hypotheses or assumptions which are influenced by the aesthetics of one's own time can cloud the vision of a connoisseur, even one like Jantzen, who for this genre was an exceptionally capable guide.[34] Similarly, his strikingly formalist approach, with its focus on systems of organizing space, proved almost too accessible to scholars of the 1960s and 1970s. The Delft-type of oblique projection, with its wide-angle spreading of space away from a close vantage point and beyond the limits of view, marked a crucial moment of transition, for Jantzen, from the Flemish mode of depicting architecture in strictly tactile terms to the optical mode of De Witte. The clarity and general validity of this analysis have encouraged categorical and often misleading distinctions between architectural views that are imaginary or real, Flemish or Dutch, even "one-point" or "two-point." In a more subtle survey one finds many exceptions, such as real church interiors represented according to textbook schemes (fig. 116) and perspective projections formulated in response to actual viewing conditions but reapplied in paintings of imaginary architecture (fig. 129). The oblique approach was equally useful for views of Delft churches and for architectural fantasies, as Bibiena's *scena per angolo* would soon demonstrate on the Baroque stage. Finally, as Jantzen himself noted with respect to Van Bassen, Jan van Vucht, Hans van Baden, and Anthonie de Lorme in the 1630s and 1640s,

116
JAN VAN DE VELDE AFTER PIETER SAENREDAM, *The Interior of St. Bavo's, Haarlem (view of the nave and choir to the west)*, 1628. Etching and engraving, 13.9 x 23 cm, from Samuel Ampzing, *Beschryvinge ende lof der stad Haerlem in Holland*, Haarlem, 1628. Haarlem, Gemeente-archief (photo: Tom Haartsen)

naturalistic qualities of light, space, and atmosphere were developed by Dutch painters in views of imaginary architecture (Jantzen specifies the province of Holland, and the Zeelanders Dirck van Delen and Daniel de Blieck tend to prove him right).[35]

The "Phantasiekirchen" by Houckgeest, which are discussed below (see figs. 121, 129, 131), also seem in some cases less connected with the Antwerp tradition than with views of actual churches by other Dutch artists (figs. 125, 128, 130). Several contemporary architectural painters moved from one category to another, from realistic products of their imagination to actual scenes, without changing styles or signing up for a new course in linear perspective. Professionals such as Van Bassen and Houckgeest had all the technical and artistic resources at their command from fairly early moments in their careers. The interesting question is how they employed their talents, this being determined less by ability than by personality, experience, and the taste of the time.

Manke would appear to endorse this opinion when she insists that De Witte was a very different artist than Houckgeest, owing him nothing "im künstlerisch-geistigen Sinne."[36] In her view, Houckgeest's example may have provided some exposure to the fundamentals of perspective practice, but for the new subject and new type of composition De Witte was on his own. Thus Jantzen's thesis is adopted and pushed to an extreme. In place of his Oude Kerk view of "about 1647" Manke advances a few early De Wittes of her own, simply by back-dating some of the artist's clumsier works of the early 1650s. Jantzen warned his readers about "good and bad paintings from his hand in a single year, varying in execution, in the suggestion of space and mood."[37] It is entirely typical of De Witte in the early 1650s to paint a superb picture like the one in the Wallace Collection (fig. 156) and to produce, at about the same time, routine or even negligent works like the Oude Kerk view (from nearly the same location) in the Warwick estate, the shadowy image of the same church's choir in a panel formerly in the Van Duyn Collection,[38] and the awkward and derivative view of William the Silent's tomb formerly in Wiesbaden and now in Winterthur (fig. 155).

The latter work was advanced by Manke as a prime example of De Witte's style "about, perhaps still before, 1650."[39] The present writer placed the picture in 1651, relating it rather closely to Houckgeest's painting of that date in which a column is likewise eliminated from the foreground (fig. 104).[40] Russell, following Wheelock, expresses uncertainty about the attribution, and reports that in any case "the costumes belong to a period between 1655 and 1665."[41] Giltaij and Jansen in effect accept the first year of this surprising chronological range, since they associate the composition (especially the

illusionistic curtain) with De Witte's work in the early 1650s (e.g. pl. IX).[42] Costume historians consulted by the present writer consider the couple nearest to the viewer and the man to their right to be quite fashionably dressed, but detect no detail that requires a date later than about 1651.[43]

De Witte's entry into the genre is considered below. Any further discussion of developments in the 1650s should be preceded by a review of Houckgeest's work in earlier years.

Van Bassen and Houckgeest before 1650

Writers from Jantzen to Wheelock have found it rhetorically useful to describe the oeuvres of Van Bassen and Houckgeest before 1650 as old-fashioned, especially if one imagines them in the context of Dutch painting as a whole, and casts Saenredam in the rôle of pacesetter (a sort of Claesz or Van Goyen with a drafting table). The main lines of this historical perspective extend a great distance, from Fromentin, Thoré-Bürger, and Taine to Jantzen, Valentiner, Martin, Swillens, and some pages by Slive.[44]

According to Jantzen, when De Witte fell headlong into the genre, revealing genius and innocence in equal parts, Houckgeest was still turning out "Phantasiearchitektur im Sinne des Bartholomeus van Bassen," such as the *Palace Interior with the Judgment of Solomon* dated 1647 (Schloss, Dessau), and two interior views of Catholic churches, one dated 1648 (Hermitage, St. Petersburg; formerly Semenov Collection) and another in Copenhagen of about the same time (fig. 131).[45] Manke states the same case more emphatically. According to her, De Witte was already painting works like the Winterthur panel (fig. 155) when "Houckgeest noch Phantasiekirchen bei frontal perspektivischer Sicht in der Art des Petersburger Bildes, Jantzen Nr. 166 Abb. 43, in dem altertümlichen, von den südlichen Niederlanden herzuleitenden Stil seines Lehrers Bartholomeus van Bassen malte."[46] Similarly, Wheelock describes the St. Petersburg and Copenhagen pictures as "patterned in the same mold" as works by Van Bassen, who "painted in a style reminiscent of Vredeman de Vries."[47]

None of this is supported by actually looking at pictures by Van Bassen, Houckgeest, and Vredeman de Vries, unless "style" means the use of one or two compositional patterns and a few of the late artist's architectural motifs.[48] A more appropriate comparison with Vredeman de Vries would consider how he, Van Delen, Van Bassen, Houckgeest, and Hendrick van Steenwyck the Younger responded to the architectural tastes of the Dutch and English courts. In a European context the building styles

117
BARTHOLOMEUS VAN
BASSEN, *Interior of a
Catholic Church*, 1622.
Oil on panel, 68 x 103 cm.
With Johnny Van Haeften
Ltd., London, in 1981

favored by the Dutch stadholders were rather conservative.[49] But it seems doubtful that most courtiers in The Hague would have seen it that way, nor would they have considered any of the classicist constructions imagined by Van Bassen (who worked for the court as an architect) or by Houckgeest (fig. 121) as out of date. These painters commanded high prices and, at least at The Hague, depicted settings in which members of the House of Orange and their relatives were pleased to see themselves (figs. 120, 124, 219).[50]

Van Bassen was probably born in The Hague about 1590. His grandfather, Barthold van Bassen of Arnhem, was Clerk (Secretary) of the Court at The Hague, and the painter's son Aernoudt became a counsellor there. Nothing is known, or has been published, about Van Bassen's father, Cornelis. In 1613 the artist joined the Guild of St. Luke in Delft as an outsider, and in 1622 he joined the painters' guild in The Hague. When he married there in 1624 he was described as a resident of The Hague, but in 1625 he still had a house in Delft.[51] He served as dean of the guild in The Hague in 1627. In 1628 Van Bassen, "Mr. perspectijff schilder in 's Gravenhage," signed over a small annuity to Cornelis van Poelenburch and his heirs.[52]

From 1629 until 1631 Van Bassen worked as designer and builder on the palace for the exiled Frederick V at Rhenen (the Elector Palatine, or "Winter King" of Bohemia, was the nephew of the Princes Maurits and Frederick Hendrick and was married to Charles I's sister, Elizabeth Stuart).[53]

From 1630 onward Van Bassen was also working on Frederick Hendrick's new palaces at Honselaarsdijk and Rijswijk (between The Hague and Delft) (figs. 122-23);[54] a payment was made in 1630 to "Barthout van Bassen, painter, for various drawings and models related to the building of Honsholredijck".[55] Constantijn Huygens and Jacob van Campen, the French architect Jacques de la Vallée, and Arent van 's-Gravesande were all active at Honselaarsdijk and Rijswijk, with Frederick Hendrick himself contributing architectural and other ideas.[56] Between 1634 and 1639 Van Bassen worked on the Town Hall, the Catharinakerk, and the Gasthuispoort in Arnhem,[57] and in 1638 he succeeded 's-Gravesande as comptroller of architectural projects for the city of The Hague. He collaborated with Pieter Noorwits (d. 1669) on the Nieuwe Kerk in The Hague until his death in 1652 (see Van Bassen's design in fig. 95).

Houckgeest was born about 1600 in The Hague, where his uncle Joachim Houckgeest (ca. 1580/90-1641/44) was a successful portraitist. We know nothing of his training or activity until 1635, but Houckgeest probably studied with Van Bassen before joining the painters' guild in The Hague in 1625. As mentioned above, Houckgeest moved to Delft by 1635, married there in 1636, and was cited as a member of the Guild of St. Luke in Delft in 1639. But he remained very well connected in the court city. He rejoined the painters' guild there in the same year, 1639. His mother-in-law had recently married her second husband, François Brandijn, who was an advocate at the court of Holland. It will also be

118
BARTHOLOMEUS VAN
BASSEN, *Interior of a
Catholic Church*, 1626.
Oil on canvas, 61 x 83 cm.
The Hague, Koninklijk
Kabinet van Schilderijen
"Mauritshuis"

recalled that Houckgeest designed tapestries for the States General at some time before 1640.[58]

Van Bassen's work as an architect may be more relevant to his and Houckgeest's careers as painters than has hitherto been recognized. The late Renaissance and early Baroque architecture depicted by Van Bassen in paintings dating from the early 1620s onward has comparatively little in common with Vredeman de Vries, apart from a continued interest in Serlio, whose treatises of 1537-47 influenced architects and *amateurs* throughout Europe.[59] In a colorful panel dated 1622 (fig. 117) Van Bassen's vocabulary recalls Vignola (*Regola delli Cinque Ordini d'Architettura*, 1562-63; Dutch, French, and German editions, 1617) and especially Palladio (*I Quattro Libri dell'Architettura*, 1570), although the choir screen (in its motifs and proportions) and the altarpiece frames come closer to Vasari (for example, the Uffizi's façade and the altarpiece frames in Santa Croce, Florence).[60] Palladio was greatly admired by Huygens, Van Campen, and Inigo Jones; the latter accompanied Frederick V and Elizabeth when they travelled through Holland to the Palatinate in 1613. It has been suggested recently that "Van Bassen's serious study of the Banqueting House" in Whitehall by Jones (1619-21, just before Huygens's residence in London) is evident in his designs for Rhenen.[61] This recalls Evelyn's remark, made in 1641, that "the Queene of Bohemia hath a neate, well built Palace,

or Country house, built after the Italian manner, as I remember."[62] Van Bassen's painting of Frederick V and Elizabeth dining in public, dated 1634 (fig. 120; another version is at Hampton Court), and Houckgeest's version of 1635 (Hampton Court), in which the royal figures have become Charles I, Henrietta Maria, and the Prince of Wales (Charles II, who owned the picture), have been described inaccurately but understandably as views of the palace at Rhenen and the Banqueting Hall in Whitehall.[63]

A canvas in Copenhagen, signed "B van Bassen 1623," depicts the terrace of a modern Italian *palazzo* framing a view of the façade of St. Peter's in Rome.[64] The background is, in a sense, as imaginary as the foreground, since Van Bassen approximates Carlo Maderno's unbuilt design as reproduced in a print by Matthäus Greuter.[65] In 1650 Van Bassen painted the crossing of St. Peter's, with invented vaults and decorations, and with the Tomb of Pope Paul III in the niche it occupied until 1628.[66] Houckgeest's painting of a similar church, dated 1642 (Prinsenhof, Delft), may depend upon an earlier work by Van Bassen.[67]

These revisions of actual architecture, examples of early Baroque design, encourage another look at paintings by Van Bassen like the panel of 1622 mentioned above (fig. 117) and works of the same decade, such as the *Interior of a Cathedral*, dated 1626,

in the Mauritshuis (fig. 118). Although the buildings are imaginary, the mass and proportions of the pillars and arches (in the foreground especially) and specific details, such as the windows over archways and the emphatic use of scroll brackets and severely graceful frames (such as the one at the upper right in fig. 118), recall Florentine architecture in the wake of Vasari and Buontalenti, in particular that of Lodovico Cigoli (1559-1613) and Giovanni Antonio Dosio (1533-1609).[68] Curiously, Cigoli also submitted a design for the façade of St. Peter's in Rome, and he was the author of an unpublished but influential treatise on perspective (which includes a chapter on two impressive versions of the perspective frame).[69]

The similarities between recent Florentine architecture and Van Bassen's designs arouse interest in the figure of Costantino de' Servi (1554-1622), the Florentine painter, sculptor, and architect who worked under Jones's supervision (about 1610-12) for Henry, Prince of Wales (d. 1612) and who in 1615 (when Van Bassen was about twenty-five) designed a palace for Prince Maurits to be built at the Binnenhof (on the site of the Stadholder's Quarters, which were rebuilt in the 1620s).[70] De' Servi made designs and wooden *modelli* for the project, a practice Van Bassen adopted later on. "How different the Binnenhof, which is still essentially medieval, would look today if this plan to build an Italian Renaissance palace had been executed!" exclaims one historian of taste at the Dutch court.[71] Just how different is suggested by Van Bassen's vision of a palace that, in better times, might have been constructed next to the Cunerakerk in Rhenen for the exiled King and Queen of Bohemia (fig. 124).

Little is known about de' Servi's activity in London and The Hague. He worked on a great garden at Richmond with the French architect Salomon de Caus (1576-1626), who in April 1613 became the architect and engineer of Frederick V. Van Bassen would have been aware of De Caus as the author of *La Perspective, avec la raison des ombres et miroirs* (fig. 80; London, 1612; dedicated to the Prince of Wales), whereas the Dutch stadholders would have known him mainly as the designer of Frederick V's famous castle garden in Heidelberg (recorded fully in De Caus's book of engravings, *Hortus Palatinus*, Frankfurt am Main, 1620).[72] This clarifies de' Servi's connection with Prince Maurits: the Italian was not an itinerant designer passing through The Hague but a close associate of the major architects who were working at the English and Palatine courts.

Perhaps de' Servi's architectural ideas or at least his sources influenced Van Bassen and possibly also Hendrick van Steenwyck the Younger, who painted architectural views for Charles I during the 1610s and 1620s (fig. 119) and later worked at The Hague.[73]

There are numerous lacunae in our knowledge of this period, not least in the area of relations between architectural painters, architects, and patrons. One would like to know what kept Van Bassen busy in the period around 1615-25, apart from paintings that are now unknown. Could he have been involved with de' Servi's designs for Prince Maurits or with the actual rebuilding, after de' Servi's death (1622), of the Stadholder's Quarters (for which no designer is named)? Might it have been Van Bassen who remodelled the building's interior for Frederick Hendrick, following Maurits's death in 1625? Responsibilities such as these would help to explain how Van Bassen managed to become the designer of Frederick V's palace at Rhenen in 1629, his first known architectural commission.[74]

We know as little about Houckgeest during the first decade of his career (from about 1625 until 1635) in The Hague. The first reliable evidence is the Hampton Court panel dated 1635, in which Houckgeest copies Van Bassen's interior of the previous year (fig. 120) but changes the "sitters."[75] The royal subject of Houckgeest's version and the fact that Charles I owned at least four perspective pieces by Houckgeest are probably not indications of a trip to England (as has been supposed), but may be considered evidence that English agents bought Dutch paintings or that pictures such as Van Bassen's and Houckgeest's banqueting scenes were sent to London by the king's sister or another member of Frederick Hendrick's extended court.[76]

The next indisputable sign of Houckgeest's activity is the *View through an Arcade*, dated 1638 (fig.

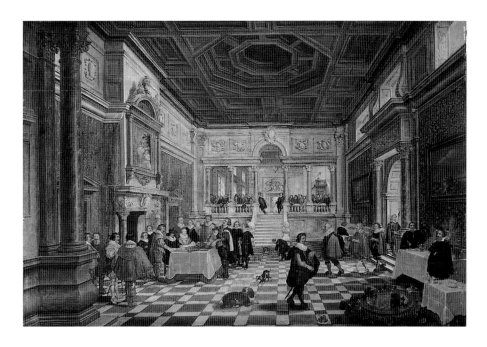

121), after he settled in Delft. The picture has been related plausibly to a plate in Vredeman de Vries's *Scenographiae* of 1560,[77] but the composition and the architecture are derived directly from Van Bassen, to judge from paintings by him dating from at least as early as 1632,[78] including the banqueting scene itself and the doors of a cabinet that Van Bassen decorated

in collaboration with Van Poelenburch (probably 1636).[79] Also reminiscent of Van Bassen in the 1630s is the palette of tans and grays, as well as the zones of skillfully rendered light and shadow. The large canvas in Edinburgh is an impressive achievement which indicates (not least in the drafting of the perspective scheme) that Houckgeest was, at least in terms of execution, as capable as any architectural painter in the Netherlands at that time.[80]

As in the case of Van Bassen, the small number of paintings by Houckgeest that date or may date from the first ten or fifteen years of his activity could suggest that he had other interests. One wonders whether he, too, was concerned with the stadholder's building projects near Delft and The Hague. The Edinburgh painting departs from works by Van Bassen in its spaciousness (Van Bassen's interior views and even his courtyards tend to be claustrophobic) and also in the distant garden, which in its axiality and archway recalls the grounds of Frederick Hendrick's Huis ter Nieuburch (fig. 122). Two related pictures by Houckgeest in the late 1630s are the view of a palace portico in the Louvre,[81] and the *Interior of an Imaginary Catholic Church with Coffered Ceiling* in a private collection.[82] The palace corridor and portico views could also be said to update those

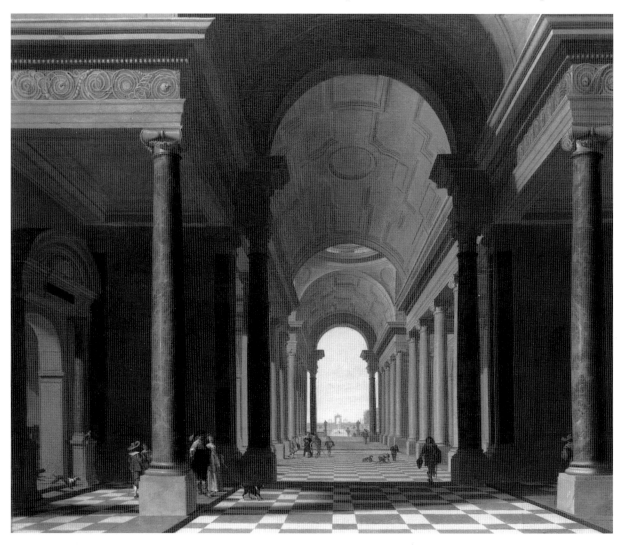

of Van Steenwyck, who probably moved from London to The Hague in about 1638.[83] The subject needs further study, especially with regard to the painters' sources, but in general it appears that the "classical" or Italianate architectural scenes by Van Steenwyck, Van Bassen, and Houckgeest, as well as those by Van Delen and others, may be closely related to the tastes of the court, whether these took the form of actual buildings (see fig. 123) or designs that the princes could only dream about.

Van Bassen's career as an architect and designer bears on the question of "realism" in imaginary architectural views, especially those with classical elements. Jantzen was so impressed by the convincing qualities of light, space, and architectural detail in the Budapest canvas of 1620 (fig. 101) and so struck by Van Bassen's harder, less atmospheric style of the 1620s and early 1630s that the writer proposed a hypothetical stay in Antwerp, as if some kind of "Neeffs disease" might be caught in the Flemish port.[84] But why should Van Bassen's or Houckgeest's imaginary architectural views, in particular those derived from Italian sources, be rendered in a comparatively realistic manner? Their function, in good part, was to illustrate modern architectural forms in inventive combinations, for the pleasure and edification of courtly or at least cosmopolitan connoisseurs. These pictures represent design ideas, architectural concepts, projects that might have been completed in Italy or perhaps even in The Hague or Rhenen (see fig. 124) had Maurits lived longer or had Frederick V (d. 1632) not been dependent upon the hospitality of his princely relatives.

Paintings of imaginary classical architecture are to some extent analogous to mechanical drawings and wooden models of building projects. Temporary architecture – models of buildings (including full-scale mock-ups), triumphal entry decorations, and scenery for plays, operas, and masques – was an international art form.[85] One might also compare Van Bassen's or Houckgeest's views of *palazzi* and Italianate churches with history pictures, which were usually not executed in the same manner as paintings of actual places, people, and things. If one considers the subjects, their conception, the nature of their appeal ("reception"), their courtly and patrician patrons, and the sort of actual interiors that might have been embellished by imaginary architectural views, then it is easier to appreciate their style. For very good reasons, these paintings do not conform to the popular notion of Dutch art as describing subjects "from life."[86]

Van Bassen's interest in realistic effects of light, color, texture, and space varied considerably in paintings of the 1630s and 1640s. The *Interior of a Renaissance Church*, dated 1640, in Prague (fig. 127) and an *Imaginary Catholic Church* of the same date

(private collection) are similar in these qualities to his view of actual Gothic architecture in *The Cunerakerk at Rhenen* of 1638 (fig. 125). The latter departs from the building itself in that the vaults are given rounder profiles and some details are modified or introduced (the church furniture, the patterned floor, the curved molding on the wall).[87] Saenredam's painting of the same interior, dated 1655 (Mauritshuis, The Hague), is more luminous and airy and more true in texture to the whitewashed walls and vaults, but the spatial effect of Van Bassen's view anticipates Houckgeest's paintings of 1650 more clearly than do most earlier works by Saenredam.

Also of interest for Houckgeest's portraits of actual churches is Van Bassen's interior view of the Grote Kerk (Jacobskerk) in The Hague, painted in 1639 (fig. 126).[88] Again, the picture blends fact (the organ) and fiction (compare Houckgeest's painting of 1651, fig. 150), but the general impression is more realistic than many later views of known church

122
PETRUS SCHENK,
Aerial View of the Huis ter Nieuburch at Rijswijk from the north-northwest, with Delft in the distance, 1697.
Etching, 38.4 x 47 cm.
The Hague, Gemeente-archief

123
ATTRIBUTED TO JACOB VAN DER ULFT,
The Huis ter Nieuburch at Rijswijk, seen from the southwest, ca. 1665.
Drawing, size unknown.
Present location unknown (photo: The Hague, Gemeentearchief)

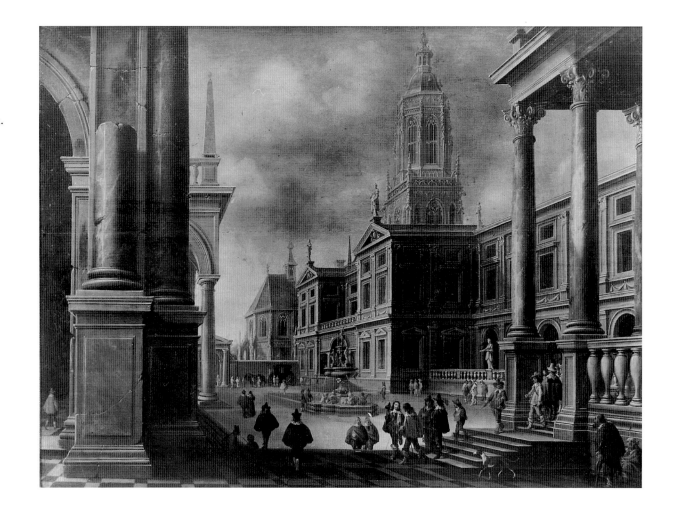

124
BARTHOLOMEUS
VAN BASSEN,
*Imaginary Palace for the
Winter King*, 1639.
Oil on panel, 64 x 86 cm.
Copenhagen, private
collection (photo:
Statens Kunsthistoriske
Fotogradsamling)

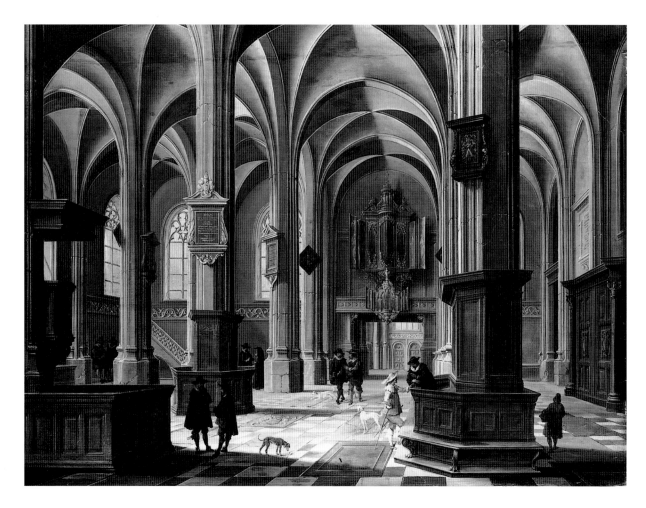

125
BARTHOLOMEUS
VAN BASSEN,
The Cunerakerk at Rhenen,
1638.
Oil on panel,
61.1 x 80.5 cm.
London, The National
Gallery

98

interiors. As in other genres of Dutch painting, one may distinguish between actual and imaginary subjects essentially on the basis of recognizability rather than strict fidelity. By that standard Van Bassen's view of the Jacobskerk may be considered one of the earliest known pictures of an actual church in the South Holland area. A similar approach is found in an exactly contemporaneaous painting by the Rotterdam artist Anthonie de Lorme (fig. 128, discussed below) and in Dirck van Delen's view of the rood screen and choir in the Janskerk, 's-Hertogenbosch, which is dated 1644 and signed by both Van Delen and his Delft staffageur, Anthonie Palamedesz.[89]

Houckgeest's paintings dating from the 1630s and 1640s (see figs. 121, 129, 131), of which only about a dozen are known, exhibit at least as much variety as those by Van Bassen, especially with regard to composition and schemes of illumination.[90] It would appear that Van Bassen was more interested in architectural forms for their own sake, whereas Houckgeest saw the structures more in terms of light and space. His buildings may be partly or mostly modern but they are not essays in architectural ideas. Houckgeest was evidently aware of contemporary works not only by Van Bassen but also by Van Steenwyck, Saenredam, and perhaps De Lorme, who painted imaginary Gothic and classical church interiors (often illuminated by candlelight) before turning in the early 1650s to faithful views of the Laurenskerk in Rotterdam. De Lorme combined his different interests by classicizing the Laurenskerk in a small panel dated 1639 (fig. 128); minor medieval elements (for example, railings in the triforium) are suppressed, the wooden barrel vault has been given shallow coffers, and the proportions of the whole have become broader and heavier. The recession of the transept is tempered by the breadth of view, which embraces more than half of the choir elevation in the left background and two and a half of the four nave archways to the right. If one includes the solid wall on the right, to which De Lorme added stone niches, then the angle of view is about one hundred degrees, or about twenty degrees wider than Saenredam's transept view of 1628 (fig. 115).[91] In its tonal palette, broad and balanced design, and the silhouetted effect of layered elevations, De Lorme's early Laurenskerk view is actually more reminiscent of recent compositions by Saenredam, especially the views across the nave of the Mariakerk in Utrecht, which are dated 1637 and 1638 (in Kassel and Braunschweig, respectively).[92]

Indeed, a number of South Holland pictures of the later 1630s resemble recent works by Saenredam in their palettes, compositions, and tendency to round off Gothic vaults and arches. Another, undated view of the Laurenskerk by De Lorme (Collection of

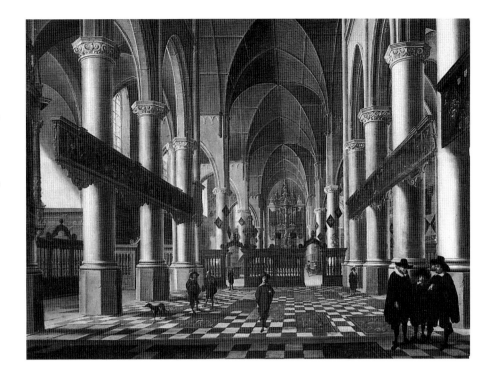

the Countess of Seafield, Kinveachy), showing the nave to the east with classical vaulting, and Van Bassen's *Cunerakerk at Rhenen* (fig. 125) are among the examples.[93] Houckgeest's *Imaginary Catholic Church* of 1640 (fig. 129) may be compared with the center and right side of De Lorme's Laurenskerk interior (fig. 128), but it is almost certainly derived from a different transept view, Saenredam's painting of the Mariakerk, Utrecht, dated 1637 (fig. 130).[94] The latter panel and at least one other view in the Mariakerk, Saenredam's large panel dated January 29, 1641, in the Rijksmuseum, Amsterdam, come from Huygens's house in The Hague and have been connected with his personal interest in the Utrecht church.[95]

Perhaps the Romanesque piers, arches, and groin vaults of the Mariakerk, as recorded by Saenredam, influenced De Lorme's restyling of the Laurenskerk in the late 1630s and Houckgeest's conception of a Catholic cathedral in 1640. The flat-ribbed arches and the receding elevation with one round archway over another in Houckgeest's picture (fig. 129) must

126
BARTHOLOMEUS
VAN BASSEN,
Interior of the Grote Kerk (Jacobskerk) in The Hague, 1639.
Oil on panel,
57.2 x 81.3 cm.
Present location unknown (sold at Christie's, London, October 15, 1987)

127
BARTHOLOMEUS
VAN BASSEN,
Interior of a Renaissance Church, 1640.
Oil on panel, 39 x 50.5 cm.
Prague, Národní Galerie

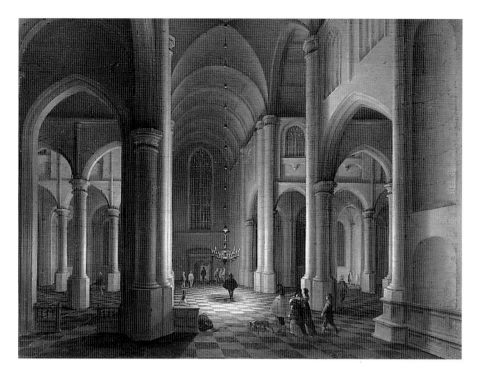

1640 and 1650 (figs. 98, 129) would be more apparent if the earlier view were subjected to some simple redrafting, especially in the floor tiles (which, of course, are invented in both compositions). Similarly, if Houckgeest's piers and archways in the middle ground were replaced by a pair of whitewashed and sunlit columns, such as those he inserted into the Copenhagen panel of about 1648 (fig. 131), then one would begin to appreciate the facility with which the Delft painter – like Van Bassen, Van Delen, and De Lorme – could blend elements from real churches, other artists' views of real and imaginary churches, and arbitrary design ideas (cropping, reversing, redrafting, relighting), according to his goal in a particular work and the nature of the project at hand.

The Copenhagen painting has little to do with the legacy of Vredeman de Vries, apart from the fact that he favored this kind of off-center frontal projection. The scheme was employed to diverse effect by Van Steenwyck, Van Bassen, Van Delen, and Saenredam, whose stylized version of the design in the St. Bavo's transept view of 1628 (fig. 115) is less naturalistic than Houckgeest's composition (fig. 131). In the latter, the space recedes slowly to the choir in the background and spreads laterally into the transept on the left. The sunlit column and pier (where a man begs for charity) interrupt the recession and form the center of attention. The architecture itself is "imaginary" only in the narrow sense that it was never built; it is closely related in style to Baroque churches in the Southern Netherlands,[97] and is rational in plan. In several respects – the daylight

128
ANTHONIE DE LORME,
An Idealized View of the Laurenskerk in Rotterdam, 1639.
Oil on panel, 28 x 37.5 cm.
With Johnny Van Haeften Ltd., London, in the early 1980s

ultimately be derived from the Mariakerk, which in the center of the nave had one great, undivided archway on the upper level.[96] However, the spatial effect of Houckgeest's advancing elevation, with the counter-recession to the right background and the dividing pier (bearing a cartouche with skulls), differs from the impression made by Saenredam's design and anticipates the Nieuwe Kerk view dated 1650 (fig. 98, pl. II). Another promise of things to come is the statue in the background, which is adapted from that of William I on the front of his tomb.

The correspondence of Houckgeest's designs of

128
ANTHONIE DE LORME,
An Idealized View of the Laurenskerk in Rotterdam, 1639.
Oil on panel, 28 x 37.5 cm.
With Johnny Van Haeften Ltd., London, in the early 1980s

129
GERARD HOUCKGEEST,
Imaginary Catholic Church, 1640.
Oil on panel, 50 x 39 cm.
The Hague, Instituut Collectie Nederland (on loan to The Hague, Schilderijenzaal Prins Willem V)

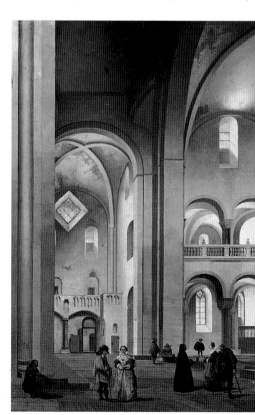

130
PIETER SAENREDAM,
The Transept of the Mariakerk, Utrecht, seen from the northeast, 1637.
Oil on panel, 59 x 45 cm.
Amsterdam, Rijksmuseum

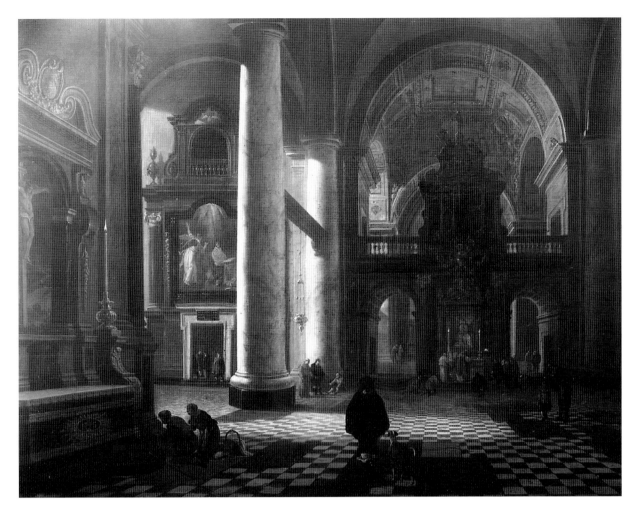

131
GERARD HOUCKGEEST,
Imaginary Catholic Church,
ca. 1648.
Oil on panel, 49 x 65 cm.
Copenhagen, Statens
Museum for Kunst

pouring in from the side, the shadowy areas, the
warm tonality of the whole, and the silhouetted
effects – the Copenhagen panel not only seems
consistent with works in other genres around 1645-
50, but also looks forward to a number of Emanuel
de Witte's early architectural views (figs. 156, 159).
The luminous area on the left, with the column
dividing directions of view, anticipates some aspects
of Houckgeest's work a few years later (compare
fig. 142).

Of course, Houckgeest's paintings of the early
1650s did not develop directly from his earlier work.
Nonetheless, the imaginary views reveal that he had
the experience and the inventiveness to do something
exceptional, and they also remind historians that any
painting, even when it corresponds closely with a
scene as it may be photographed, employs some
compositional ideas previously known to the artist or
used by contemporaries. The same lesson, which has
been taught repeatedly by Gombrich,[98] is learned
from a close study of other Delft artists' most
naturalistic works, which usually date from the
1650s. Houckgeest's approach to actual architecture
in 1650 represents not only a new emphasis on visual
experience but also the imagination of an old hand.

The Hamburg panel again

Houckgeest's large panel in Hamburg (fig. 98, pl. II)
and Fabritius's small canvas in London (pl. III), two
very different views of the Nieuwe Kerk in Delft,
are works that owe their surprising originality to
somewhat similar circumstances. Both artists set
themselves the goal of representing with exceptional
fidelity a wide-angle view of an actual architectural
site. They also both relied upon conventional
perspective practice, which is what one would expect
of both Houckgeest and Fabritius, given
Houckgeest's example (see p. 39 above) and the
younger painter's own reputation for illusionistic
murals (hardly an experimental art form in the
Netherlands). Resolving the rival claims of visual
perception and geometric discipline required creative
solutions. In the Romantic period this might call for
some act of unfettered imagination and a breaking of
rules. In the Baroque period genius served various
forms of orthodoxy and was therefore more widely
esteemed.

Two aspects of Houckgeest's design have often
been described: the bifocal or "two-point"
perspective scheme, with one of the oblique
recessions favored; and the isolation of a discrete
corner of the interior, which allows a close vantage
point and, in a tall format, some suggestion of the

Gerard Houckgeest
after Bartholomeus
van Bassen,
Imaginary Gothic Church.
Engraving.
Amsterdam, Rijksprenten-
kabinet

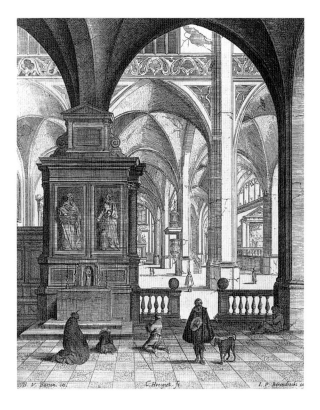

Gothic building's proportions and height (see fig. 99). Oblique recessions had been demonstrated in treatises such as those by Vredeman de Vries and Hondius (figs. 75, 148), but no painted precedent can be directly related to Houckgeest's composition.[99] The genre depended more than others on a particular drawing system, which minor artists (Van Vucht, Van Baden) simply borrowed from printed sources or other painters. In pictures by Van Bassen and Van Delen, orthogonal recessions are skillfully manipulated and seem generally well suited to their idealized views of architecture. Not only their architectural forms but also their perspective schemes might be described as "idealized" or arbitrary, since they generally avoided the wide-angle and high-angle distortions that other artists encountered when recording actual architecture from a close point of view. In choosing real church interiors as his principal subject, Saenredam had the options of arbitrarily increasing the apparent viewing distance (as in Neeffs) or of somehow making the best of the distortions and flattening effects that inevitably resulted from his restricted (back to the wall, in many cases) vantage point in the church. From his first painting (fig. 115) onward, he favored and exploited the second alternative, stretching vaults, archways, and nearby columns laterally, compressing distances between elevations parallel to the picture plane, and swinging receding elevations so far to the side that they seem trapped in a narrow gap between the panel's priming and the picture plane.[100] Saenredam's spare, elegant, tonalist style, in which straight and curved lines play like calligraphy on a page, was not a program that other artists could

follow, especially painters of a younger generation, who witnessed a shift in taste from conspicuous refinement and invention (as in Goltzius, Bloemaert, and Jan Saenredam) to an emphasis upon naturalistic description and illusionism.

The use of a one-point perspective scheme in the work of most architectural painters was linked directly to the goal of representing a large extent of the church interior in a single view. The subject is essentially the architecture itself, whether it is imaginary, inspired by Antwerp Cathedral, or faithful to a real building such as St. Bavo's in Haarlem. More fragmentary or "cropped" views of church interiors usually reveal an interest in some particular section of the church interior, because of its function (baptism, private worship in a chapel, preaching from a pulpit, and so on) or an interest in a meaningful monument or other motif. Thus, in Houckgeest's early engraving after Van Bassen's imaginary view of a Gothic church interior (fig. 132), a woman and two children in the foreground kneel before an altar, above which are large images of Saints Peter and Paul. Saenredam seems to have inspired the composition, but Van Bassen had already depicted a cropped view of a church interior (indeed, it could be one of his broad views cut in half) in a small painting on copper that shows a side chapel with three isolated worshippers and a classical choir screen with statues of saints (1624; Mead Art Museum, Amherst College).[101] Similarly, Saenredam's view of two obliquely receding archways in the Laurenskerk in Alkmaar (1635; Museum Catharijneconvent, Utrecht),[102] which anticipates a design often used by De Blieck in the 1650s, crops the left side of a wide-angle, central projection in order to focus upon an altar and a worshipper in a side chapel, as well as two statues of saints on the nave wall. The behavior of the figures, which were called "filling-in" a few decades ago,[103] is significant in all these pictures and concerns iconolatry. Ambiance, if not idolatry, is established by the large statue of Venus and Cupid above courting figures in one of Van Delen's "palace entrance" views, a panel in Edinburgh dated 1644.[104] The architecture recedes sharply back from the right side to the left and also ascends abruptly above the figures and the triangular plane of the tiled floor.

Each of these cropped views of large buildings, with receding walls, columns, and (in the examples cited) sculptures arranged in compositions taller than they are wide, is to some extent relevant to Houckgeest's designs of 1650-51, and they give the modern viewer some idea of the grammar and vocabulary of forms that were current in his specialized genre. It is also illuminating to cast a brief glance at a few drawings by artists who encountered viewing conditions similar to those Houckgeest found in his first view of the Nieuwe Kerk. One of

these is a drawing of uncertain attribution (Van Steenwyck in the 1630s?) that represents the Jacobskerk in Antwerp (with modified details) during a sermon (fig. 133), a theme favored by De Witte later on.[105] The architecture was sketched with fairly close reference to a single vanishing point at the upper corner of the column base to the lower left. Houckgeest's composition (pl. II) would resemble this one if he had recorded more of the choir (or nave) in the Nieuwe Kerk from further away and used a similar one-point scheme. The comparison clarifies the benefits of the Delft painter's approach: his columns recede less abruptly, the middle ground has more depth, and the eye explores the space more freely than in the Fleming's (?) view. The draftsman evidently wished to emphasize the figures in the foreground rather than the sermon per se, and his perspective scheme and columns serve the purpose effectively. Houckgeest's scheme is better suited to what he wanted to achieve, which had less to do with figures and more to do with how the site actually appeared.

Saenredam drew a number of similar views from vantage points in the aisles of actual churches, as seen in a sketch made in the Catharijnekerk, Utrecht, during his stay in that city in 1636 (fig. 134).[106] He marked an assumed vanishing point on the choir stall in the left background and referred to it approximately as he sketched (the horizontal molding to the upper right would slant more steeply in a proper perspective cartoon). On the basis of drawings like this one, Saenredam could have made paintings quite like those produced in Delft, with truncated columns in the immediate foreground, space receding uniformly in the center and to the sides, and a sense that the environment continues off-stage, around, above, and even behind the viewer. But that was not Saenredam's goal. By sketching wide-angle views with an approximate reference to a single vanishing point, Saenredam anticipated the stretching and flattening effects of his painted designs. The practice became so familiar to him that in drawings of 1650 made in the cubical interior of Jacob van Campen's Nieuwe Kerk in Haarlem he simply drew, freehand, ranks of columns as parallel to the picture plane when oblique recessions were what he actually saw from his vantage point in a corner of the church.[107]

In the Hamburg painting, by contrast, Houckgeest allowed the actual view to determine the perspective scheme. The vanishing point is central, which corresponds with the direction of view implied by the picture plane. The latter is aligned at an angle of forty-five degrees to the main axes of the church, so that the actual architectural forms, such as the sides of the tomb, the octagonal column bases, and the octagonal moldings of the capitals recede to the same vanishing points and distance points as does the

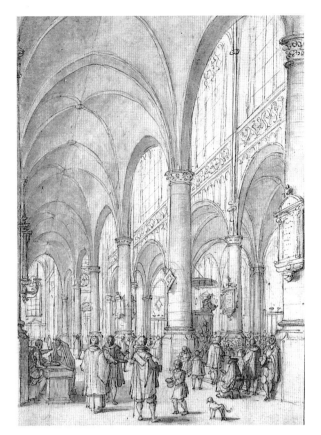

133
ATTRIBUTED TO
HENDRICK VAN
STEENWYCK THE
YOUNGER,
Interior of the Jacobskerk in Antwerp during a Sermon,
1630s?
Pen and ink on paper,
28.2 x 20.2 cm.
Amsterdam, Rijksprenten-kabinet (as by De Blieck)

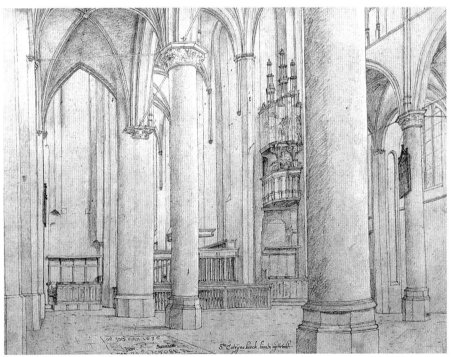

invented pattern of floor tiles (compare Hondius's furniture, fig. 75).

Saenredam has been said to have anticipated Houckgeest's focus upon isolated parts of a church interior. In this he was hardly alone, but the point is that Houckgeest was essentially the first painter to suggest the viewer's immediate proximity to the architecture and at the same time to minimize distortions of form and space. This achievement, a natural impression of interior space, is what made his approach the standard one for some time to come in

134
PIETER SAENREDAM,
The Northern Aisle and Transept of the Catharijne-kerk, Utrecht (view to the southeast), October 20, 1636.
Pen and chalk on paper,
30.3 x 40.1 cm.
Utrecht, Gemeentearchief

Delft. By cropping the centers of oblique projections in his early views of the Delft churches, Houckgeest painted portraits of precisely defined places and at the same time suggested space flowing in all directions beyond the limits of view. His architecture seems to advance toward the viewer as well as to recede, and depth is sensed not so much along lines of recession as through a field of overlapping forms. In the Hamburg picture, the most marginal areas of the perspective construction, those most distant from the vanishing point, are in the upper corners of the composition, which Houckgeest originally completed as part of the view and then masked out with the painted archway. This enhances the sense of three-dimensional space not only by foiling the view at the picture plane but also by hiding the nearest column's exaggerated height (the capital would be completely out of the rectangular composition) and the fanning effect of the ambulatory vaults.[108]

It is important for an appreciation of Houckgeest's approach in 1650 to consider the Hamburg panel and related pictures not only in the context of architectural views but also in that of contemporary Dutch art in general. The same inclination toward meticulous description and illusionism is found in Samuel van Hoogstraten's paintings of figures looking out of Dutch doorways and windows, and in his letter-rack and cupboard-door still lifes of about 1650-55. Fabritius's *View in Delft* and his illusionistic murals of the early 1650s (see pp. 64-65), as well as the first church interiors painted by Van Vliet (with trompe-l'oeil curtains; fig. 162), demonstrate a similar interest in illusionism.

Houckgeest's composition – more broadly considered in terms of its tall format, its dominant diagonal recession, its tight clustering of forms, the way they wedge toward the viewer and even the manner in which they are lit – recalls numerous works in other genres. The tall format becomes common in landscape, still-life, and genre painting about 1650. In still lifes by Willem Kalf and such Delft painters as Willem van Aelst and Harmen Steenwijck, objects are usually grouped closely together on a table top which projects toward the viewer's space. Jacob van Ruisdael sets a tree or group of trees in the foreground against towering clouds and an obliquely receding road (as in the *View of Egmond*, 1648, in the Currier Gallery of Art, Manchester, New Hampshire); Ter Borch places a lovely young woman diagonally between a chair in a near corner and a diminutive maid (see fig. 292); and Dou clusters figures and objects in an arch-shaped window framing a deep domestic interior. Houckgeest's paintings of actual church interiors, although they depend upon specialized expertise, share in a more common language of forms, a style that was current about mid-century. Scholars who

have expressed surprise at Houckgeest's change in direction, which was not so drastic as it might seem, have focused narrowly upon problems of perspective and have paid insufficient attention to matters of taste. There is more to composition, of course, than lining up columns, just as depicting a forest requires more than arranging trees.

Preparatory material

Historians deal with fragmentary evidence and therefore hypotheses. And yet the modern observer with access to photographic archives probably has a more complete record of a Dutch artist's oeuvre than any available in the seventeenth century. This may not have been true for printmakers or for some artists who produced major public works in other countries. But in the case of most Dutch painters, their pictures left the studio destined for diverse locations, including those that were distant, private, or unknown.

A perhaps atypical example is that of Vermeer, who in 1663 had nothing on hand to show the French visitor, Balthasar de Monconys.[109] Until recently, only one painting by Vermeer had been traced in a Delft collection of the seventeenth century.[110] These points tend to support the assumption that Vermeer worked slowly, presumably on one or two pictures at a time, and the hypothesis that he had the support of a special patron rather than a number of local collectors (to say nothing of walk-in trade).[111]

In 1669 Caspar Netscher was visited at The Hague by the Grand Duke Cosimo III of Tuscany. The princely collector bought four paintings, one of which was the artist's portrait of his family dated 1664 (Uffizi, Florence). Given the personal subject and the fact that by 1667 Netscher had turned almost exclusively to portrait commissions, this example does not contradict the impression that even prolific painters (one thinks of Van Goyen) did not hold on to new pictures for very long.

When Dutch painters produced more than one version or close variant of a particular composition, they probably worked in most instances from the original picture, not from preparatory drawings. In the 1641 inventory of Van Miereveld's estate three versions of his portrait of Jacob van Dalen, called Vallensis, and of his wife – the only known versions (Metropolitan Museum of Art, New York) are dated 1640 and 1639, respectively – are recorded as the sitters' property: that is, they were yet to be delivered.[112] However, less literal repetitions in an artist's oeuvre, even in his or her production of one year, more likely indicate the reuse of preparatory material, whether drawings of figures, still-life

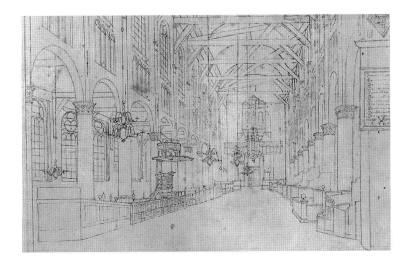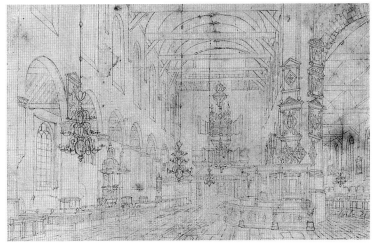

motifs, landscape elements, and so on, or model books, engravings, and similar sources. The great majority of Van Goyen's surviving drawings were intended as ideas for compositions, not records of identifiable sites, although his small books of sketches from life also served as sources for paintings.[113]

In the genre of architectural painting, preparatory material was exceptionally important, even when compared with specialized genres such as flower painting. Architectural treatises provided a catalogue of forms to some painters, and perspective treatises were consulted not only for instruction in geometrical practice but also for motifs and compositional ideas.[114] Sketches of actual architecture (for example, fig. 134) and of motifs such as pulpits must have been kept right at hand. Still-life and genre painters often depicted objects they actually owned, such as chairs, lutes, and porcelain bowls, but architectural painters obviously could not work "from life" in the studio. One might compare landscape painting, especially in the case of De Witte, who, in Amsterdam especially, would invent architectural views using motifs and entire elevations found in more than one of the city's churches. However, when the subject was an approximately faithful or merely recognizable view in a local church, the composition itself, not just motifs, depended upon sketches made at the site. For a painter such as Houckgeest in the early 1650s, and Van Vliet throughout his career in the genre, sketches made in actual churches and construction drawings ("perspective cartoons") based on the sketches were probably the most valuable objects in their studios.

Most of this preparatory material has long since disappeared. No drawings by Houckgeest and no relevant drawings by De Witte are known. A few on-site sketches by Van Vliet survive, as well as two small construction drawings – a view to the west in the Nieuwe Kerk's nave (fig. 135) and a very similar but more detailed view in the Oude Kerk (fig. 136) – which are probably by him as well. Both sheets measure about 18 by 28 cm, which is smaller than

any painting by Van Vliet, and much smaller than his several known paintings of approximately the same subjects. The two drawings are executed mostly in brown ink and are squared in black lead, which suggests that each design was transferred to a larger canvas or panel.

This method differs from Saenredam's in that his meticulous construction drawings were transferred directly to prepared panels by blackening the versos of the sheets and tracing the lines. The majority of Saenredam's on-site sketches and construction drawings survive and correspond with known paintings. Not only the sketches but also many of the construction drawings resemble finished works of art, with shading and watercolor. The care with which Saenredam preserved his preparatory material is indicated, *inter alia*, by their detailed inscriptions, which usually include the date to the day and also the exact date upon which the corresponding painting was finished (sometimes years later).[115] For example, the construction drawing for the painting of the St. Odulphuskerk in Assendelft (Rijksmuseum, Amsterdam), which is signed in full, inscribed with a line describing the subject, and dated October 2, 1649, is itself dated December 9, 1643 (the original on-site sketch is dated July 31, 1634), and is inscribed: "This was painted in the same size as this drawing, on a panel of one piece, and this painting was completed on the 2nd day of the month October in the year 1649 by me Pieter Saenredam" (fig. 137).[116]

Yet another kind of architectural sketch is found in a pocket-size book of line drawings (15.2 x 9.7 cm) that was compiled between about 1652 and 1657 by Daniel de Blieck (fig. 138).[117] The drawings are numbered 1 through 95, but twenty-five sheets have been removed. Many of the remaining drawings (numbers 1 through 82, with twenty-three sheets missing) bear a letter G, perhaps for *geschilderd* ("painted"). On the verso of sheet 82 De Blieck wrote, "I have painted all but eight of the preceding sketches; I have therefore painted seventy-four pieces and drawn these sketches after them."[118]

135
Attributed to
Hendrick van Vliet,
Interior of the Nieuwe Kerk, Delft (view of the nave to the west), 1660s.
Pen on paper,
18.5 x 28.6 cm.
New York, private collection (photo: Metropolitan Museum of Art, New York)

136
Attributed to
Hendrick van Vliet,
Interior of the Oude Kerk, Delft (view of the nave to the west), 1660s.
Pen on paper,
ca. 18 x 28 cm.
New York, private collection (photo: Metropolitan Museum of Art, New York)

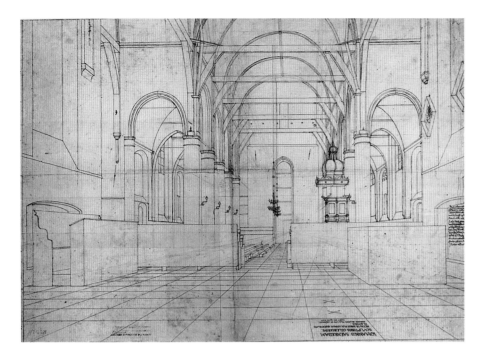

137
PIETER SAENREDAM,
*Interior of the St.
Odulphuskerk, Assendelft
(view to the west)*,
December 9, 1643.
Pencil and pen with brown
ink on paper, 75.5 x 53 cm.
Zeist, Rijksdienst voor de
Monumentenzorg

These *ricordi* recall Saenredam's construction drawings in their second life, that is, as an inventory of finished paintings, and also Claude Lorrain's *Liber veritatis* of the same period. However, De Blieck could not have been concerned about imitations, as Claude had reason to be, and his line drawings differ from Saenredam's construction drawings in that they are summary works without any pretense of aesthetic interest or documentary value with respect to the architecture (one sheet is inscribed "from the old church in Middelburg" and another "from the church in Zierikzee," but the great majority of the views are imaginary). With four slight exceptions the drawings lack wash or any other suggestion of light and shadow, which is remarkable considering that the few known corresponding paintings and many similar pictures by De Blieck feature theatrical repoussoirs and other silhouetting effects, and in many cases nocturnal illumination. The figures in De Blieck's paintings, which are occasionally abundant, are eliminated throughout the book. Thus De Blieck recorded the bare bones of his painted compositions: the view, style of architecture, and essential elements. The sheets look like looser versions of Van Vliet's construction drawings (figs. 135-36), and all together like a pattern book, an inventory of compositions

that had been painted and might be repeated, perhaps with different illumination and staffage.

This last suggestion gains some support from a few comparisons. Giltaij and Jansen identify eight images in the drawing book as copies of paintings by De Blieck that are known today. However, only four of the drawings correspond so closely to the paintings that we may be sure the right pictures are identified.[119] Sheet 29, "copied from the painting now in Vienna," shows five not four bays in the apse, and not one but two chapels to the right, suggesting that the drawing actually follows an otherwise unrecorded variant of the canvas dated 1652 in the Akademie.[120] Similarly, when one compares De Blieck's three paintings of classical porticos to the drawings that supposedly copy them, it would appear that the latter either record missing variants or are themselves variants, that is, drawings that depart willfully from the painted compositions. The *Terrace with a Colonnade* in Copenhagen shows three landscape vistas through a magnificent portico, framed by archways to either side. The so-called "drawing after the Copenhagen painting" (fig. 138, left) omits the central landscape view, a female statue, the right-hand archway, and all the sculptural decoration and the oculus overhead. Because the painting is dated 1658 and the drawing after it 1656, Giltaij and Jansen "assume that De Blieck made the occasional error."[121] Why not assume that the panel dated 1658 is a variant of a composition made in 1656?[122] A comparison of sheets in the drawing book with similar paintings demonstrates what one would have concluded from the evidence of the book or the pictures alone, which is that De Blieck routinely painted versions and variants of his own works.

It follows that the images in De Blieck's drawing book were more than *ricordi*. They comprise a pattern book of possible pictures, compositions that had been painted ("all but eight," as De Blieck reminds himself) and that could also serve for related works. With this pocketful of ideas and one or two small, finished paintings, De Blieck could have given clients a clear notion of what they might buy (size to suit). Of course, artisans (such as cabinetmakers) and architects like De Blieck himself followed this practice, offering a range of options on paper. Other known drawings by De Blieck include a design for a medallion of the cabinetmakers' guild (1655), a design for a tapestry (1664), and three drawings for stonemasons and sculptors.[123] De Blieck's drawing book records past pictures but proposes new ones. It was evidently with a view to a new market that De Blieck wrote on the back of the last drawing in the book: "This was the last piece that I painted before I went to England."[124]

138
DANIEL DE BLIECK,
*A Page from a Drawing
Book*, with pages dated
1655, 1656, and 1657
(this page: 1656). Seventy
pages, 152 x 97 cm.
Zeist, Rijksdienst voor de
Monumentenzorg

Houckgeest ca. 1650-1656

With one exception – a modest painting of the Nieuwe Kerk, dated 1653 (fig. 151) – Houckgeest's several views in Delft churches all date from 1650 and 1651. (However, the date of the panel reproduced in fig. 113 is uncertain.) Until recently, the earliest record of his residence outside of Delft or The Hague was a document of March 1652 placing him in Steenbergen (about 10 km north of Bergen op Zoom, on the North Brabant coast west of Breda). A document published in the Rotterdam exhibition catalogue of 1991 describes Houckgeest as a resident of Steenbergen in May 1651.[125] Houckgeest's mother-in-law was first married to a burgomaster of Steenbergen, and she inherited a house in that town. Houckgeest himself bought a house there in 1651, but from 1653 until his death in August 1661 he and his wife lived in Bergen op Zoom, where they owned a house called "De Grote Valk," other buildings, some land, and horses.[126]

Giltaij and Jansen conclude that Houckgeest "must therefore have painted several of his views of Delft church interiors in Steenbergen."[127] This may have been so, but one need not imagine the artist as cut off from Delft for the rest of his life. The distance from Delft to Steenbergen is about the same as that between Haarlem and Utrecht, or between The Hague and Utrecht or Amsterdam.

The Nieuwe Kerk view of 1653 (fig. 151) could have been based upon a drawing made in that year or earlier. No work by Houckgeest is known to date from 1652. We are left, then, with about a dozen paintings that are dated or probably date from 1650 and 1651 (see box).

From this evidence it would appear that Houckgeest made between five and seven original views in the two Delft churches and the Jacobskerk in The Hague:

– the Hamburg view (no. 1, also used for no. 5);
– the Oude Kerk choir view (no. 3);
– possibly the rear view of William's tomb (no. 4);
– the Nieuwe Kerk panorama (no. 6, also used for no. 2);
– the Oude Kerk panorama (no. 7, also used for no. 8);
– the Jacobskerk view (no. 9);
– and the Nieuwe Kerk "pulpit view" (no. 10).

At least half and possibly all the preparatory material needed for the pictures dating from 1651 seems to date from 1650.

The emphasis placed here upon preparatory material is appropriate for Houckgeest because so much of

1650

1. Hamburg, *Nieuwe Kerk in Delft with the Tomb of William the Silent* (pl. II; fig. 141): dated 1650.
2. Ex-Crews Collection, *Nieuwe Kerk in Delft with the Tomb of William the Silent* (fig. 145): dated 1650. The Stockholm version (fig. 146) probably dates from 1650 or 1651.
3. Rijksmuseum, *Oude Kerk in Delft with the Tomb of Piet Hein* (fig. 143): probably 1650.
4. Lost view in the Nieuwe Kerk, adopted by De Witte (fig. 147)?; perhaps dating from 1650.

1651

5. "Tall" Mauritshuis *Nieuwe Kerk in Delft* (figs. 104, 142): dated 1651. Repeats the cartoon used for no. 1.
5a. Private collection: autograph version of no. 5, with figures by a slightly later hand (pl. VII).
6. "Broad" Mauritshuis *Nieuwe Kerk in Delft* (fig. 107): dated 1651. The cartoon for this composition includes the design of no. 2 of 1650 (see fig. 108).
7. Buccleuch *Oude Kerk in Delft*, broad view with pulpit (fig. 109): 1651? Preparatory material could date from 1650 or 1651.
8. Rijksmuseum, *Oude Kerk in Delft*, tall view with pulpit (figs. 113, 149): dated 165(?). The last digit of the date is quite uncertain but could be a 1. As discussed below, there is no evidence to support Manke's and Giltaij's reading of the date as 1654.[128] The perspective scheme repeats part of the cartoon used for no. 7 (see fig. 110).
9. Ex-Düsseldorf, *Jacobskerk in The Hague* (fig. 150): dated 1651. Preparatory material could date from 1650 or 1651.

After 1651

10. Brussels, *Nieuwe Kerk in Delft* (fig. 151): dated 1653. The approach resembles that taken in no. 7. Preparatory material could date from 1650-51 or 1652-53.
11. Copenhagen, *Grotekerk in Bergen op Zoom* (fig. 152): not dated; probably from about 1655. Houckgeest's local church. The composition recalls that of no. 9.
12. Cape Town *Grotekerk in Bergen op Zoom*: dated 1656 (see n. 167). The perspective cartoon would have resembled that of nos. 7 and 8 (fig. 110) in reverse.

what makes his work exceptional was achieved during the design stage. This is generally true for painters who depicted actual architecture, especially when their designs responded to viewing conditions at the site. But two artists, Saenredam and Houckgeest, went to lengths not evident in the oeuvres of painters such as Van Vliet, De Witte, De Lorme, De Blieck, and so on, to say nothing of minor figures like Van Baden and Van Vucht.

Jan van Vucht (ca. 1603-1637) and Saenredam could be said to define opposite poles with regard to method. The short-lived Rotterdam painter would lay in orthogonals on a primed panel with the help of a pin and a string, draw in standardized architectural elevations, tone the whole with a monochrome wash, add some local touches of light, shadow, and color (a doorway, a dozen floor tiles), and then add a few figures or send the work to a staffageur such as Anthonie Palamedesz in Delft.[129] The time expended on one of Van Vucht's minor works might have been little more than that required by Saenredam to make one of his sketches in an actual church.

The construction drawing made by Saenredam in the studio modified the recorded image willfully, with an eye to the painting's design (fig. 137). At the same time he would employ a ground plan and elevation, or measurements he had taken at the site, to determine relationships of scale and distance. As Schwartz (following Ruurs) has observed, Saenredam "had visible difficulty with both pointed and round arches, let alone the vaulting of his churches," and he resorted to "stopgap measures" such as "freehand or compass approximations," as well as "large-scale manipulation of the center of the composition by geometrical means" (meaning that he arbitrarily changed the distance measurement and thus the angles between orthogonals).[130] This analysis accurately describes the letter if not the spirit of Saenredam's method, which in Ruur's and Schwartz's sober accounting has little to do with style.[131]

The comparison with Saenredam's method is also relevant to the question of Houckgeest's unprecedented fidelity to the actual architecture in his principal pictures, meaning the ones that directly depend on drawings made at the sites. Lyckle de Vries, in his article of 1975, noted correctly that it is even more difficult to draw curved forms properly (for example, arches and the system of ribs in the vaults) in an oblique projection than in an orthogonal view, and yet Houckgeest seems to have had no trouble getting all the shapes and proportions right. There is no evidence that Houckgeest relied (or even could have relied) on numerous measurements of the actual architecture, so De Vries concluded that the artist must have employed a perspective frame to trace the view from a fixed vantage point (he cites Dürer, fig. 73, and the handy instrument published

by Marolois, fig. 68).[132] In my dissertation of 1974 I came to the same conclusion on the basis of photographic comparisons (see figs. 99, 112) and discussed repetitions in Houckgeest's perspective schemes that might circumstantially support the hypothesis of a mechanical device.[133]

No matter how faithfully Houckgeest drew the architecture at the site, the subsequent drafting of a perspective cartoon would modify proportions throughout as well as the shapes of such complex forms as the tomb, the vaults, and the octagonal column bases and capitals (the latter are problem pieces comparable to Uccello's chalice).[134] Over-lapping forms, such as the moldings of the column bases in the view to Piet Hein's tomb in the Oude Kerk (figs. 111, 139; compare figs. 112, 140), would depart from the view at the site in obedience to any perspective scheme that was introduced in the studio. It is revealing that Houckgeest's floor tiles do not comprise a system from which distances and scale may be calculated: his pattern of tiles is constantly interrupted, changes direction, and on the whole looks inserted with reference to the columns, not vice versa.

In comparing Houckgeest's principal views with corresponding photographs, one tends to concentrate upon discrete areas, such as the contour of a column set against another object or the shapes of geometric forms (higher forms in photographs, like the capitals, do not stretch upward as in Houckgeest's paintings – compare figs. 98, 99 – because the camera was aimed upward, not level with the floor). However, the faithful transcription of proportions in Houckgeest's first paintings of actual architecture is one of their most impressive qualities. One may, for example, compare the width of the first or second column in the Hamburg picture to some horizontal distance in deeper space (such as the distance between Liberty and Justice on the front of the tomb): the ratio is about the same in the painting and in a photograph taken from Houckgeest's assumed vantage point. Of course, the artist would have made adjustments in his painted designs, but they correspond so closely to the actual views that producing them without a mechanical aid seems, as De Vries suggested, "extremely improbable."[135]

The simplest way to achieve Houckgeest's degree of fidelity – in both a painting based upon a drawing of an actual site and in the corresponding perspective cartoon – is to produce the on-site drawing and the cartoon simultaneously, that is, by tracing the view with a perspective frame or another device (like the modern camera) which fixes the vantage point and the picture plane. The use of a fixed sight and a perpendicular plane automatically realigns the upward convergence of the architecture to the vertical lines of the squared picture plane. This

adjustment becomes all the more necessary as the artist assumes closer vantage points (as in fig. 141).

Curved and complex forms in the view are simply traced (or transcribed by means of squares) with a perspective frame, not reconstructed from many measurements in three dimensions. Numerous geometrical demonstrations could be adduced to show that Houckgeest's perspective schemes, even the panoramic view recorded from the southeast corner of the Nieuwe Kerk's ambulatory (fig. 108), correspond closely with plans of the Delft churches.[136] Perhaps the most persuasive argument, however, is that the perspective frame would have been extremely helpful to an artist who, with a knowledge of perspective practices and treatises but no previous experience in recording actual architecture, set himself the task of recording difficult views in local churches with a greater degree of fidelity than any painter had ever achieved before. "Nothing doth like Squares," as Samuel Pepys was told by Lord Brouncker when they discussed various drawing machines in 1666, "or, which is the best in the world, like a dark roome – which pleased me mightily."[137]

The use of a perspective frame would also help to explain (without diminishing the rôle of Houckgeest's imagination) how the artist arrived at such an original approach to isolated areas of the church interior. Before the device was used for transcription it could have served as a viewfinder, demonstrating compositional alternatives that, unlike a freehand sketch, very closely matched the designs of possible paintings. The spatial effect achieved by framing three columns at a particular angle to the picture plane and including a massive form in the immediate foreground were viewable as arrangements on a rectangular plane. The perspective frame would also have given the artist some sense of how different kinds of compositions enhanced or impeded the impression of being in an extensive interior space. Saenredam would often define the limits of views he sketched in a church by drawing everything between two vertical elements, such as columns or piers. Despite his debt to Houckgeest, Van Vliet also favored this sense of containment at the sides, but De Witte followed Houckgeest not only in drafting but also in framing receding elevations so that they produced a strong sense of expansion beyond the limits of view (see figs. 156, 159).

The use of a conventional perspective scheme places considerable limitations on the impression of actual experience, especially in a large interior space. The domestic environments depicted by De Hooch and Vermeer, usually with one wall receding rapidly and another leading off-stage (see figs. 185, 265), succeed so well in suggesting the room's embrace of the viewer partly because of the architecture's intimate scale. One advantage to Houckgeest of using a perspective frame would have been that the limitations of orthodox perspective could be accepted and tested at the site, in a way that runs counter to the natural tendencies of exploring eyes and a free hand. Spatial effects somewhat similar to those discovered by Houckgeest in 1650 are found in photographs of architectural subjects, such as Frederick Evans's evocative views of English church interiors.[138]

Whatever Houckgeest's method, he clearly intended to transcribe the subject accurately in the Hamburg painting (pl. II, fig. 141), with minimal departures from the viewing experience at the actual site. Of course, the last phrase raises various questions, a few of which Fabritius (pl. III) and, in his more impressionistic approach, De Witte seem to have addressed. That Houckgeest subscribed to a more traditional method of achieving visual fidelity

139
Detail of Houckgeest's *Oude Kerk in Delft with the Tomb of Piet Hein* (fig. 143). Amsterdam, Rijksmuseum

140
Photograph in the Oude Kerk, Delft (with the Tomb of Piet Hein)

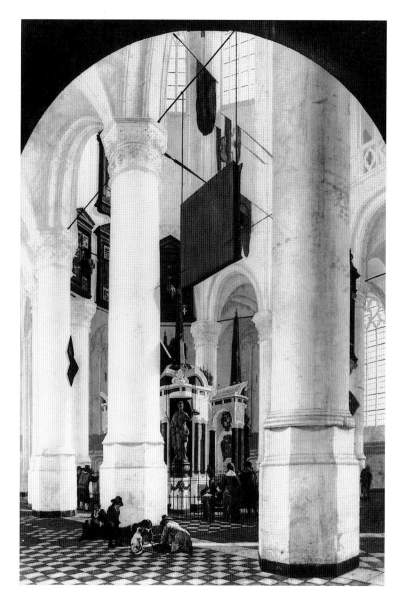

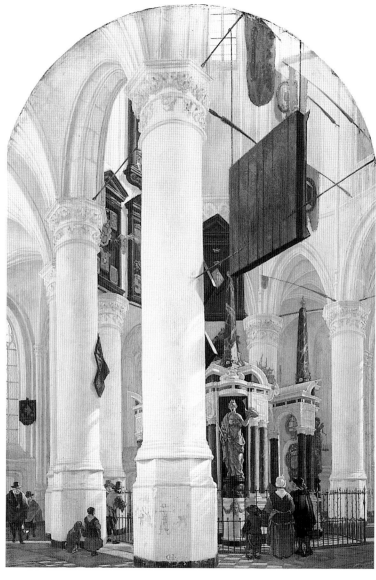

141
GERARD HOUCKGEEST,
*Nieuwe Kerk in Delft with
the Tomb of William the
Silent*, 1650.
Oil on panel,
125.7 x 89 cm.
Hamburg, Kunsthalle.
See also plate II.

142
GERARD HOUCKGEEST,
*Nieuwe Kerk in Delft with
the Tomb of William the
Silent*, 1651.
Oil on panel, 56 x 38 cm.
The Hague, Koninklijk
Kabinet van Schilderijen
"Mauritshuis"

should not diminish one's appreciation of his
remarkable success. A comparison with any one of
Van Hoogstraten's illusionistic murals (see fig. 97)
reveals that the Delft painter's earlier effort is more
illusionistic and more compelling as an evocation of
actual experience. The latter depends upon many
refinements, such as the luminosity of Houckgeest's
palette (the Hamburg panel became much lighter and
cooler when it was cleaned in 1995), the suggestion
of atmosphere, adjustments of drawing with distance
(note the man in the right background), the attention
to textures and stains on the whitewashed columns,
and the consistency with which the fall of sunlight
and shadows are rendered (most of the light
throughout comes from clerestory and ambulatory
windows out of view to the right). The comparison
with Van Hoogstraten's murals also underscores the
effectiveness of Houckgeest's perspective scheme,
with its much lower horizon and expansive space.
The differences between Houckgeest's painted
archway and Van Hoogstraten's porticos, between
their nearby columns and such space-enhancing
devices as Van Hoogstraten's bird cage and

Houckgeest's graveboard seen from behind reveal in
each case how the older painter avoided the
younger's self-referential displays of artifice in favor
of an understated naturalism. The emptiness of
Houckgeest's foreground, his small-scale figures,
each of them absorbed in looking at something, the
artist's own absorption in the study of space, light,
and the surfaces of objects – all these show, in this
first example of Houckgeest's new style, a dedication
to things outside of himself, a kind of discipline
similar to scientific objectivity, and perhaps a
humility that is rarely found in major works of art.

This interest in what the eye sees, in an art form
that seems to make more of experience than of itself,
lends substance to comparisons between Houckgeest's
best paintings and works of the early 1650s by
Fabritius, as well as works of the late 1650s and early
1660s by Vermeer. It cannot be said summarily that
this quality, this concentration upon visual
experience, is characteristic of painting in Delft, only
that it is evident occasionally in the work of a small
circle of Delft artists and that some of the qualities
found elsewhere in the Delft school were conducive

to their interests. An analogous development might sooner have occurred in Haarlem than in Leiden or Utrecht. And for whatever reasons, the decade of the 1650s was a time when visual experience per se appears to have intrigued a number of Dutch painters. In the 1660s conventional displays of artifice were generally more in fashion. Van Hoogstraten's *View down a Corridor* of 1662 seems closer to Vermeer's paintings of that decade, such as the so-called *Music Lesson* in London and *The Love Letter* in Amsterdam (figs. 283, 308) and to genre scenes by De Man (pl. xvi) than to Vermeer's genre interiors of the 1650s and Houckgeest's church interiors of 1650 and 1651.

Houckgeest's second version of the Hamburg view, the small panel of 1651 in the Mauritshuis (fig. 142), makes a very different impression. One writer describes the Hamburg panel as "twice as big,"[139] but the latter's area (as opposed to its height) is 5.3 times greater than that of the small cabinet picture and seems even larger. The same author claims that Houckgeest has shifted his vantage point "a bit to the left," but this description (which really refers to the frame) is not supported by tracing the perspective scheme. The composition precisely repeats a detail of the Hamburg design (see fig. 105), except that the nearest column in that picture should be partly (by about one-third of its width) in the immediate foreground on the right. Recent examination of old radiographs and of infrared photographs at the Kunsthalle in Hamburg has revealed that the southern choir elevation was painted in (not merely drawn) beneath the nearest column, indicating that the latter was to be omitted from Houckgeest's original design. The princely graveboards were once placed in a more central position. Firsthand examination as well as radiographs reveal that the feigned archway (simulating wooden beams) which so effectively frames the view was executed over finished architecture. As noted above, the last repainting, which covered some of the ambulatory's space to the left, was probably introduced mainly to mask the nearest column's exaggerated height. The vertical elements of the choir wall to the upper right would have emphasized the problem, while the ambulatory vaults to the upper left would have diminished the sense of space and also the viewer's concentration on the tomb. Even if Houckgeest had viewed the architecture through a perspective frame at the site, these effects on the panel surface would have been hard to anticipate.

The Mauritshuis picture was painted on a panel cut round above, so that the repoussoir effect is achieved by the painting's actual frame. This suits the intimacy of the view, which has been enhanced considerably by cropping not only the right side but

also the top and bottom of the composition, so that the viewer seems to stand near the spot where the boys made drawings on the floor. The child's drawings on the base of the nearest column in the Mauritshuis painting strike one as a memento of the young draftsmen in the original scene.[140]

Modern viewers, attracted by Houckgeest's seemingly photographic fidelity to the subject, might be tempted to overlook some signs of artistic invention, beginning perhaps with the very choice of view. There are many instances of subtle adjustment in the architecture. In the Hamburg panel especially, the arches have been rounded (compare fig. 99), and at the top of the composition the right-hand window departs from proper perspective to become a more sympathetic pendant to the window on the left. The flags echo colors in the tomb (see pl. ii) and create a sense of volume where it might have been lost. The flagstaffs and tie-rods in the top center of the picture almost seem to visualize the perspective scheme and to criss-cross the center line that drops from the "keystone" of a roof-beam to the child in front of the tomb.

In the Mauritshuis picture (fig. 142) Houckgeest's aesthetic distance from the information gained at the site is more conspicuous than in the Hamburg panel. His goal seems to have shifted somewhat from making an illusionistic image, a kind of surrogate for the actual experience, to making an exquisite cabinet picture, one refinement of which is its illusionism. There are more tangible changes. The pattern of flags and other elements to the upper right in the smaller painting look almost the same as before, but the uppermost flag dips down lower; both the clerestory windows have been brought down as well; all the flagstaffs are stronger and slightly curved; the horizontal molding just above the arch on the right has been rotated down a bit; all the archways have become more pointed again (as they must have been in Houckgeest's perspective cartoon); the tomb's right-rear obelisk has been omitted and the front obelisks are thicker; the decorations on the front of the tomb have been enlarged; the railing has been embellished; the figures of Liberty and Justice have been enhanced; and the floor is not quite the same.

These changes and the more obvious revisions were described as improvements by De Vries.[141] It may appear so on the basis of photographs, but in front of the paintings themselves it is obvious that their very different sizes called for different effects. The nearest column in the Hamburg view serves as a decisive intermediary between the viewer's space and that of the picture, somewhat like a majordomo in the antechamber of a prince's apartment.[142] The same column, if it were included in the Mauritshuis picture, would look trivial as an illusionistic device and awkward in the design. Despite the considerably

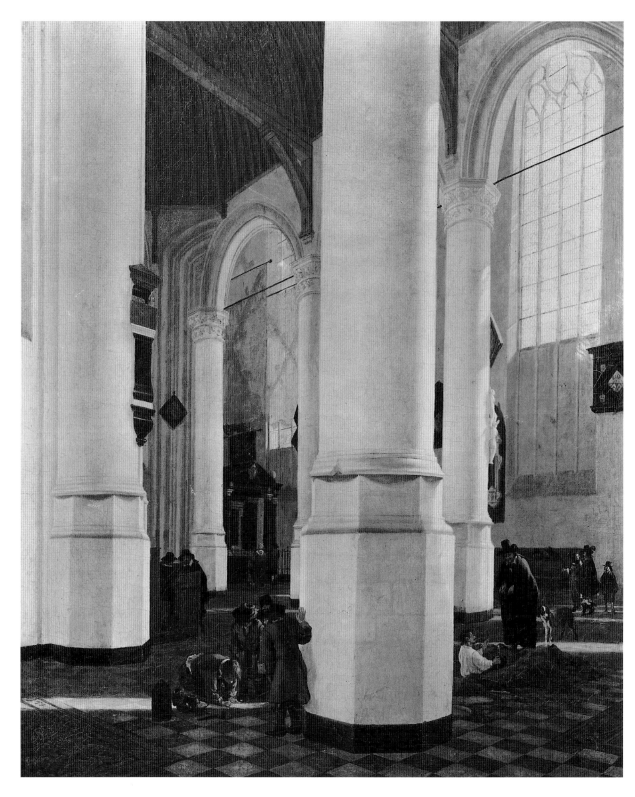

decreased floor area in the smaller work, the space still feels open, and the whole is balanced and restful. If the Hamburg design is heroic, then the Mauritshuis picture is contemplative. The family in front of the tomb, which is brought into focus by the enframement of columns in the larger work, would lose their look of quiet isolation if a column were included on the right in the smaller composition.

Only the author of the Hamburg picture could have created the Oude Kerk view in the Rijksmuseum that, for no particular reason, has been catalogued for decades as an attribution to Van Vliet (fig. 143).

Jantzen, followed by the present writer, Wheelock, and Lokin, have discussed the work as one of Houckgeest's most characteristic inventions, which the figure style alone suffices to confirm (and to distance the picture from Van Vliet's oeuvre).[143] As Wheelock observed, the surprising similarity of the Hamburg panel's overall design ("it is difficult to remember that the paintings depict two different churches") would be even more obvious if the archway had not been added to the large panel. When one visits the site (see figs. 112, 140), where Houckgeest recorded the view with his back nearly to

the wall in the Joriskapel (St. George's Chapel), or when one consults a plan, one comes to appreciate how deliberately the artist repeated the pattern of the Hamburg composition. The choir of the Oude Kerk has no ambulatory, but Houckgeest found three similar zones of diagonally receding space by recording a view from the Joriskapel, which is connected with the Mariakoor (O.L. Vrouwekoor or "Mary's Choir") by two archways to the main choir in the background. The nearest column in the Rijksmuseum canvas overlaps deeper columns almost exactly as in the Hamburg view, with the lower molding of the base tucked between the moldings of the more distant column bases. The Tomb of Piet Hein is much further from the viewer than is the monument in the Hamburg painting, but the figures are rearranged to lead the eye through the allée of archways and over the streaks of light on the floor. To the left in the Amsterdam canvas the view is closed by engaged columns and walls, while to the right the space is open (compare fig. 140). Houckgeest occupies the secondary area of interest with a freshly dug grave and a diagonal line of figures. The floor tiles and nearest gravestones form oblique recessions which enhance the openness and balance of the view as a whole. The tie-beams above help to link foreground and background, left and right, not unlike the flagstaffs in the Nieuwe Kerk choir.

The open grave, the tomb, and other commemorative motifs suggest a vanitas theme, as in many later Delft church interiors and vanitas still lifes (by Pieter Steenwijck, for example) that include a tribute to Admiral Tromp or another hero.[144] But it seems likely that this Oude Kerk view, like Houckgeest's views in the Nieuwe Kerk, was intended primarily as a patriotic picture. The three large flags hanging above the tomb were captured by Hein from the Spanish fleet, and, like the princely graveboards above the Tomb of William the Silent, should be considered as part of an ensemble in the picture's main area of focus.

In about 1651 De Witte painted a frontal view of the Oude Kerk's choir, with figures in front of the tomb (fig. 144).[145] The motifs of a grave digger and a nursing mother in the right foreground add meaning to the spiritual space, but the focus upon Hein's tomb is not disturbed. Houckgeest's oblique approach to the monument has in common with De Witte's direct but equally distant view its embrace of the space as a whole, which is significant, since the tomb's location in the choir of a famous church says as much or more about the hero as any Latin inscription would. Houckgeest also anticipates De Witte in including a fair number of figures (fifteen in Houckgeest's picture), which perhaps lend a sense of community to this civic as well as religious scene. None of the visitors is worshipping, and except for the grave

digger the entire company could be relocated to the market square.

Piet Hein (1578-1629) was a native of Delfshaven and at the end of his life bought a house in Delft, where he hoped to end his days in peace after a daring career at sea. As vice-admiral and then admiral of the fleet of the West India Company, he had captured, sunk, or burned dozens of Spanish and Portuguese ships in the Caribbean and along the coast of South America. His seizure in 1628 of the Mexican silver fleet in a Cuban harbor was a catastrophic blow to the Spanish monarchy and an eleven million guilder windfall for the West India Company and its shareholders. Hein's death the next year in a raid off Dunkirk shocked the nation. The States General arranged a state funeral and commissioned his tomb monument, which was erected about 1637.[146] Joost van den Vondel celebrated Hein in verse, as did the Delft preacher Dionysius Sprankhuizen, who testified that his contemporary never set sail without first entrusting his soul to God in a solemn ceremony.[147]

144
Emanuel de Witte,
The Choir of the Oude Kerk in Delft with the Tomb of Piet Hein, ca. 1651.
Oil on panel, 75 x 60.5 cm.
St. Petersburg, State Hermitage Museum
(as by Houckgeest)

GERARD HOUCKGEEST,
*Nieuwe Kerk in Delft with
the Tomb of William the
Silent*, 1650.
Oil on panel, 51 x 42 cm.
Private collection
(ex-Crews collection;
photo: courtesy of David
Koetser, Zürich)

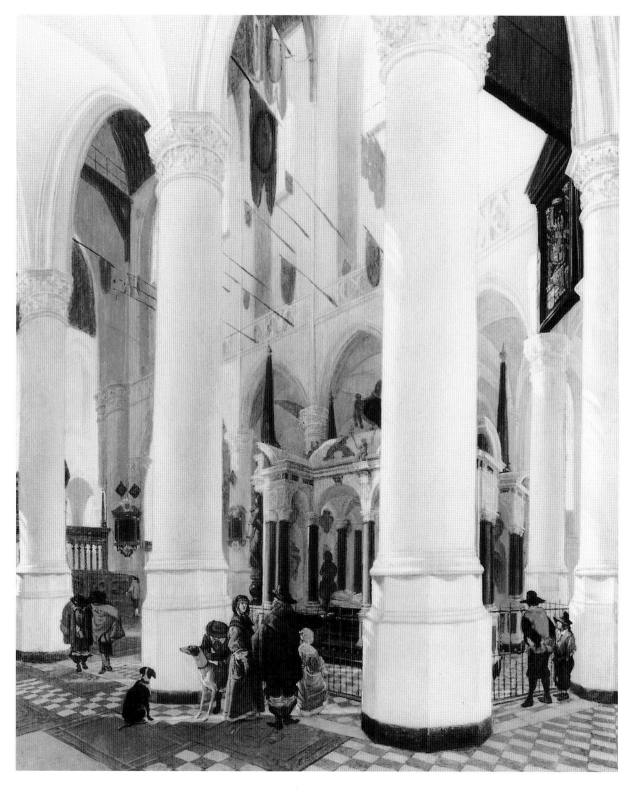

The panel of 1650, formerly in the collection of
Charles Crews (fig. 145), is – like Houckgeest's
church interiors of the following year – very much a
cabinet picture in its scale and fine execution.[148] The
composition impressed De Witte (see the canvas of
1656 in Lille), while the execution and illusionism
– the columns in the foreground are wonderfully set
off against the choir's space – look forward to a
number of small pictures by Van Vliet of about a
decade later.[149]

 As in the Oude Kerk view with the Tomb of
Piet Hein (fig. 143), which could have preceded

or followed this picture, Houckgeest found a
composition strikingly reminiscent of the Hamburg
painting, in this case by recording the subject in a
direction almost exactly opposite to that taken
earlier. Once again, three columns slant to the left
side, where a sliver of space remains; the upper left
corner illustrates how the same area of the Hamburg
panel would have looked had the artist not added the
painted frame. The height of the nearest column in
the ex-Crews picture does not present the same
problem as before, because it is on the curve of the
apse and thus the capital comes into view.

Houckgeest was well aware that marginal distortions of the architecture would become conspicuous beyond the limits of the ex-Crews composition, since it reproduces a large detail of the broad Mauritshuis picture (fig. 107) and was presumably derived from that painting's perspective cartoon (fig. 108).[150] The latter, although employed for a panel dated 1651, was not simply developed from the ex-Crews design, since the panoramic composition faithfully transcribes the architecture as it may be recorded from a single vantage point in the ambulatory of the church.[151] The ex-Crews painting and the corresponding section of the Mauritshuis picture are exactly the same size, which also suggests that they are based on the same preparatory material.

Of course, it would not be surprising to learn that Houckgeest's program of recording views in the Delft churches ran ahead of his production of paintings. Recalling Saenredam's practice, one may imagine a staggered schedule for any artist who draws and then paints topographical views. In Houckgeest's case, there are two other factors to consider: his probable use of a perspective frame, which would have encouraged continuous campaigns at a given site, and his move out of Delft by the spring of 1651.

Despite its compositional similarities the ex-Crews painting offers a very different view of the Nieuwe Kerk than that found in the Hamburg picture. The tomb monument is set within the full length and height of the choir, and parts of the transept and nave in the left background suggest other great spaces just out of sight. From this angle both the bronze statue of a seated William the Silent and the head and upper body of the marble effigy are discernible on the tomb, and Justice is the only visible Virtue. Only Prince Maurits's graveboard can be seen from the front, but a good number of flags are revealed in the choir (the four found in the Hamburg view have kept their proper places). The figures look more inclined to conversation than before.

A version of the ex-Crews composition, on a canvas as wide and almost as high as the Hamburg panel, is in the Nationalmuseum, Stockholm (fig. 146). On the basis of photographs the writer trusted Jantzen's conclusion that the painting is a copy by Van Vliet.[152] Long inaccessible, the canvas finally came to light in the "Delft Masters" exhibition in the Prinsenhof, Delft.[153] A fair number of works by Houckgeest and Van Vliet were available for comparison. The Stockholm picture is difficult to judge because of abrasion, dirt, and varnish. However, it was clear to the writer that the painting is by Houckgeest himself. Except for the considerable change in scale, the autograph repetition recalls that of the Mauritshuis picture in a panel in a private collection (pl. VII).

That Houckgeest was interested in painting more extensive views of church interiors, compositions

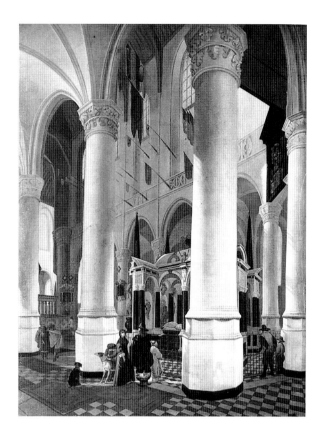

that could be said to combine his early approach to architecture (as in fig. 131) with his new focus upon such important motifs as pulpits and monuments, is demonstrated dramatically by the broad Mauritshuis panel (pl. VIII, fig. 107) and also by nearly all of his work following the first few Nieuwe Kerk and Oude Kerk views. The sweeping view of the Oude Kerk in the small Buccleuch panel (fig. 109) and the generally similar view in the very different interior of the Nieuwe Kerk (fig. 151) are examples in which the artist's oblique recession is taken to greater extremes than in his first views of actual architecture, meaning that one of the distance points in each construction was placed well beyond the limits of view (fig. 110). Another way of approaching an object closely within the context of an extensive view was unpredictably employed by Houckgeest in his view of the Jacobs-kerk in The Hague (fig. 150), where the one-point projection is similar to that found in several paintings by Saenredam.[154]

The writer has suggested elsewhere that De Witte's view of the Nieuwe Kerk interior from the rear of the ambulatory (fig. 147) must record or at least reflect yet another approach by Houckgeest, considering that the composition and the two-point perspective scheme is so characteristic of him and so unlike De Witte's first independent church interiors, not least in that the picture corresponds to the actual architecture as it may be photographed.[155] Apart from a frontal view of the monument, this very asymmetrical, oblique projection was one of the few options left to be explored at the site, after the "Hamburg" and "ex-Crews" approaches to the choir.

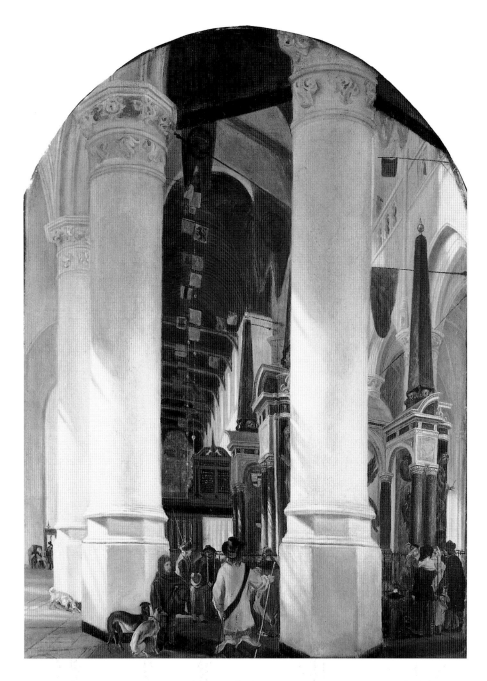

147

sophisticated exercise: whatever "faults" or distortions the artist may have allowed were included in the interest of exploring just how far orthodox perspective practice could be pushed in pursuit of natural vision, the experience of a roving eye. Every one of Houckgeest's paintings dating from 1650 or 1651 deals to a greater or lesser degree with the difficulties of projecting geometric solids onto a picture plane, by cropping, modifying, enhancing, or avoiding the more conspicuous signs of stress. The panoramic picture encompasses a maximum amount of interior space in a manner reminiscent of Saenredam (the fanning vaults recall nearly contemporaneous paintings by him) but with an illusionism that the Haarlem painter eschewed. It is true that Houckgeest's most successful compositions make a more natural impression, but this picture is an artistic triumph on its own terms, which conceivably included advice about or some indication of a proper viewing position. (In my view, a perspective box is out of the question: every known example employs anamorphic projection, and this picture works very well when viewed conventionally.) The painting achieves a precarious balance between its surprising sensation of three-dimensional space (for the sake of which the choir was arbitrarily made dimmer than the well-lit columns and ambulatory vaults) and its striking surface design.

The work has no obvious antecedents, apart from oblique projections in perspective treatises (fig. 148) and the experimentation evident in Houckgeest's immediately preceding designs. The picture, moreover, exercised no obvious influence. However, if Fabritius knew the painting, and one imagines that he did (see pp. 39-40 above), he would have understood it as another solution to the wide-angle viewing problem he considered in *A View in Delft* (pl. III) and probably as an approach more appropriate to Houckgeest's purely architectural subject.

This is not to say that several other considerations, like civic pride and patriotism, played no part in the conception or contemporary appreciation of the panoramic view. But in no other painting of a real church by Houckgeest is content so close to form. The artist presents himself as a perspectivist, as he did in earlier works like the canvas in Edinburgh (fig. 121). In the panoramic view, however, he also seems to be a member of the new generation in Delft. Perhaps a patron or ideas discussed with colleagues encouraged this unusual invention, which is less beguiling than its charming mate in the Mauritshuis (fig. 142) but also more important for the history of Dutch art.

The Oude Kerk and Jacobskerk pictures of 1651 (figs. 109, 149-50) also demonstrate an interest in striking perspective effects, but one would not say that Houckgeest cultivated this enthusiasm at the

The so-called "two-point" projection, with the left distance point coincident with the molding of the column base above the boy's head (left foreground) and the right point far out of the composition, could be seen as evolving from the ex-Crews picture (a similar asymmetrical two-point projection, in reverse) and toward the Buccleuch view (fig. 110). We might also compare the one-point projection that Houckgeest used in the Jacobskerk painting (fig. 150) and the one that De Man later employed (however inaccurately) in approaching the rear of William's monument from the other side (fig. 177).

Of course, there is much more to these paintings than their perspective schemes. However, the survey sheds light on how Houckgeest explored alternatives and on how he arrived at the design of the panoramic view of the Nieuwe Kerk dated 1651 (but based, evidently, on a drawing made in 1650). The broad Mauritshuis picture (pl. VIII, fig. 107) is obviously a

expense of subject matter. On the contrary, his choice of a perspective scheme seems in each case sympathetic to the picture's content. In judging the matter, it is important to remember that the church itself is highly significant even in those paintings that focus on a monument. Motifs and figures develop other themes, such as charity, vanity, or the preaching of Scripture, but the building itself, whether an actual or a typical Dutch church (as in De Witte's imaginary "Amsterdam" views), is always more than a setting for the story. This is clear not only from comparison with works by other artists but also from Houckgeest's almost immediate turn to the representation of local churches when his initial subject was more specifically national monuments.

The small panel owned by the Duke of Buccleuch (fig. 109) was attributed to Houckgeest for the first time in 1985.[156] The view from the southern aisle sweeps from the northern nave wall and the great window at the end of the enormous transept on the left to the central view of the transept's eastern elevation, the entrance to the barrel-vaulted Maria-koor, and the Joriskapel (the column overlapping the graveboards in the chapel is the one foremost in Houckgeest's view from the Joriskapel to the tomb of Piet Hein; fig. 111), and on the right to the main choir's northern arcade and clerestory. The pulpit on the nearest column is an exceptional piece of church furniture dating from 1548, which the Delft painters considered attractive enough to carry around from column to column in other pictures (fig. 144) – if not, as previously thought, from Delft to The Hague (fig. 150).[157] In the Buccleuch painting, however, the pulpit seems less a point of focus than a foil to the central view of the Joriskapel, with its colorful graveboards (replaced by Admiral Tromp's tomb in 1658) and stained-glass windows (blown out by the "Delftsche Donderslag" in 1654).

Houckgeest obviously tried to suggest the great space of the Oude Kerk, with its unusually open plan, a seemingly endless (in his view) choir screen, and distinctive features such as the wide brick arches in the transept and the large windows north and east (facing the ill-fated powder magazine). To achieve this breadth of view the artist essentially reversed the perspective scheme he employed in the Nieuwe Kerk panorama (fig. 108), but he cropped the new view at the distance point on the "short" recession's side (to the left in the Buccleuch picture; see fig. 110), and ran the more gradual recession to a distance point not at the edge of the composition (as on the left in fig. 108) but beyond it by as much as the painting's width. The central vanishing point is hard to locate – Houckgeest normalized the column bases and capitals, and installed a discontinuous floor – but it is in the area of the figures to the far right. This scheme creates a sense of leisurely progress across the view, which in

148
Hans VREDEMAN DE VRIES, *Perspectiva* …, The Hague and Leiden, 1604-05, Part 1, Plate 24. New York, The Metropolitan Museum of Art

this gently oblique alignment to the picture plane leads one slowly to distant spaces. The placement of the figures is sympathetic to the impression of visual ambulation; a figure in the right foreground would have spoiled the effect.

De Witte and Van Vliet appear to have learned a great deal from this subtle scheme (or one quite like it), which offers a moderate approach in between that of Houckgeest's earlier, more impulsive perspectives and the comparatively static alternative of a frontal view. Saenredam used a somewhat similar approach on one occasion, in an oblique view of chapels and a nave wall in the Grotekerk, Alkmaar (1635 panel in the Museum Catharijneconvent, Utrecht),[158] but in his one-point projection the colonnade's exit from the stage is more precipitous and the sense of depth throughout is diminished. The Buccleuch picture, by contrast, seems to be a little world of space and light, with an attention to detail and an illusionism that Houckgeest emphasized to this extent only in 1651. No wonder the painting was attributed to Van Hoogstraten in the 1898 catalogue of pictures in Montagu House, overruling an earlier attribution to "Bleyswijck" (!).[159]

Van Vliet and De Man depicted approximately the same view in the Oude Kerk as more extended to the right (fig. 181).[160] Considering that Houckgeest cut his three-point scheme in half, it seems possible that his original drawing made in the church continued further in that direction. In any case, there is no evidence in the Buccleuch picture to indicate that Houckgeest recorded the view mechanically; the proportions of the architecture, in particular the impossibly wide archways in the foreground, are far from faithful to the view. That this occurs here for the first time within the period 1650-51 seems consistent with Houckgeest's departure from the task of recording monuments and his intention in this picture to suggest the subjective experience of visiting the largest interior space in Delft.

On at least two previous occasions Houckgeest cropped a new composition from a larger one. The Buccleuch composition also has an offspring, in the much admired painting of the Oude Kerk and its

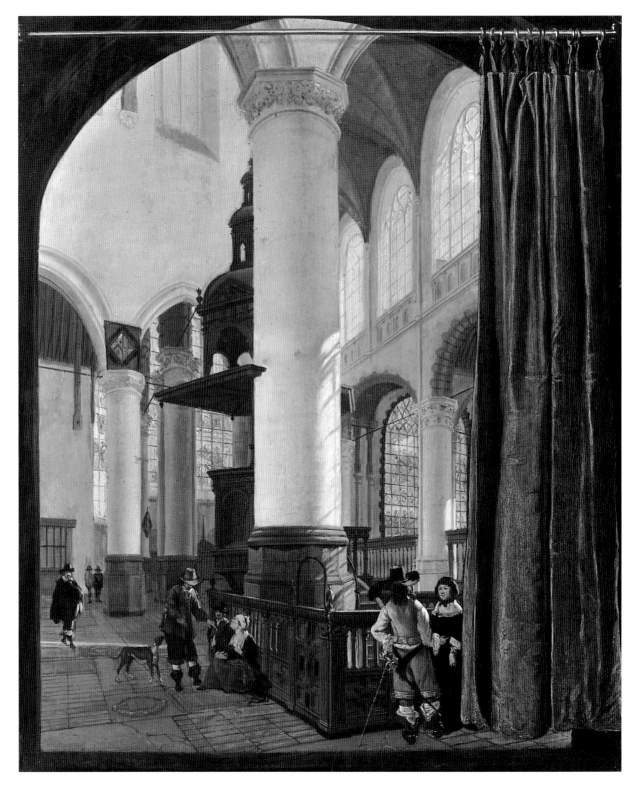

pulpit in the Rijksmuseum (figs. 113, 149). The view
repeats slightly more than half of the Buccleuch
panorama and thus corresponds to a bit less than a
third of Houckgeest's perspective scheme (fig. 110).[161]
Comparison with De Witte's early paintings of the
same pulpit (fig. 156; pl. IX) shows that in the broader
view Houckgeest eliminated the handsome wooden
enclosure around the column that supports the pulpit
and its circular staircase. In the Rijksmuseum panel,
the enclosure is restored to the foreground and
becomes the main means by which the artist creates a
very different impression of space than before. The

result is again illusionistic, but this is achieved here
principally by projecting forms forward and
seemingly into the viewer's space (with the curtain,
on a bar that casts a shadow on the painting within
the painting and on the fictive frame). The sociable
cavalier and young woman appear forward in more
than one sense, and are more prominent than any
figures in Houckgeest's earlier work (compare the
couple, or rather the family, in the foreground of the
ex-Crews picture; fig. 145). An impoverished woman
near the pulpit offers milk to her baby and food for
thought.

Houckgeest's placement of a single column in the center of this arch-shaped composition is an arrangement similar to that found in the tall Mauritshuis panel of 1651 (fig. 142). The two paintings are nearly the same size and are quite consistent in execution. However, in the Oude Kerk view Houckgeest takes an even greater step away from the impression of being at the actual site. The elevations in the background now serve essentially as a uniform foil to the illusionistic forms in the foreground; the nave and transept walls collapse toward the column, rather than suggesting deeper spaces to be explored. Most of the figures and motifs, and the coral color repeated around the pulpit (in the column bases, brick arches, and several figures in the stained-glass windows), serve to bring the eye forward, where the strongly grained wood frame and the intensely green and teasingly tactile curtain complete the impression of a performance at the edge of a stage. One can only admire the ease with which the artist adopted motifs from Leiden-like genre scenes but then regret the qualities he abandoned in this rather conventional picture. The sensation of being right there, in one of Delft's most evocative spaces, is exchanged for that of being "out here," amused by a delightful deception and the poise with which the young woman smiles at the conversation of an attentive cavalier (compare Vermeer's *Cavalier and Young Woman*; fig. 265).[162]

Evidently unaware of the Buccleuch painting, Giltaij revived Manke's reading of the miniature monogram and date on the Rijksmuseum panel as "GH 1654."[163] Having examined the date under a microscope, Giltaij was "satisfied that the date could be read as 1654." Microscopic examination in 1997 and after cleaning in 2000 indicates that the date is "extremely vague and can be a 3, 4, or 5."[164] The last digit is quite indistinct, slanted to suggest recession like the inscription as a whole, and surrounded by random marks suggesting the wood grain of the illusionistic frame. In my view, the "4" may be a "1" with a strongly barbed top. But the date cannot be deciphered with confidence.

All the other evidence, such as the painting's illusionistic style, its distance from Houckgeest's pictures of 1653 and about 1655 (fig. 151, 152), its close relationship with the tall Mauritshuis and Buccleuch compositions, and its apparent influence on De Witte (fig. 156) and Johannes Coesermans (see p. 138), suggests that a dating of about 1651 is more plausible than any other. Given the derivative nature of the panel's design (that is, from the Buccleuch picture's perspective cartoon), its date is not crucial for an understanding of Houckgeest's development. The more intriguing question is the painting's possible influence – with regard to its composition, the curtain, the pulpit, the courting

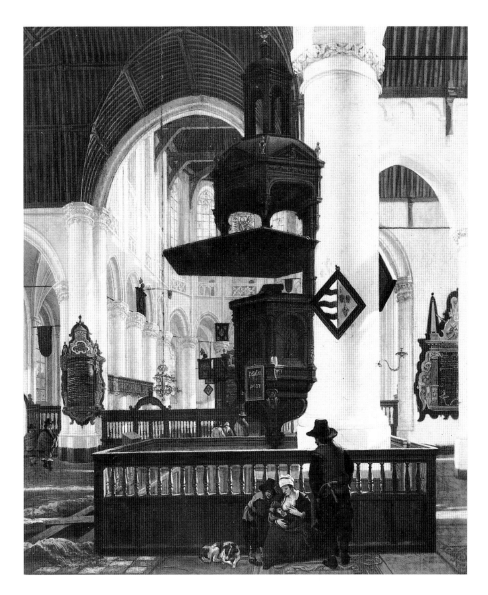

couple, or the nursing mother and boy – on other artists in Delft, namely, De Witte (fig. 156; pl. ix), Van Vliet (fig. 165), De Man (Fig. 181), Coesermans, and Vermeer.

If Houckgeest had approached the Oude Kerk's pulpit from the west instead of the south, he would have seen it set against a view of the choir, somewhat as in his approximately contemporaneous painting of the main church in The Hague (fig. 150).[165] The nursing mother, man, boy, and dog seem to have set themselves up in the same location in the Jacobskerk that they favored in Delft. An open grave and various graveboards remind one in this context not so much of mortality as of the endless cycle of life, while the Psalm (19) indicated on the pulpit speaks of the glory of God, of faith and innocence, and of the heavens as "a tabernacle for the sun."[166] De Vries notes that the focus upon the pulpit and reference to the Psalm's "song of praise" is unsurprising in this Protestant picture. The Psalm's celebration of the Lord's statutes, judgments, testimony, and so on brings to mind the preachers who occupy the Delft pulpit in other pictures, especially a few by De Witte, such as the early panel in Ottawa (pl. ix).

150
GERARD HOUCKGEEST,
The Jacobskerk in The Hague (view of the pulpit, crossing, and choir from the nave), 1651.
Oil on panel, 53 x 43.4 cm.
Düsseldorf, Kunstmuseum (missing since 1946)

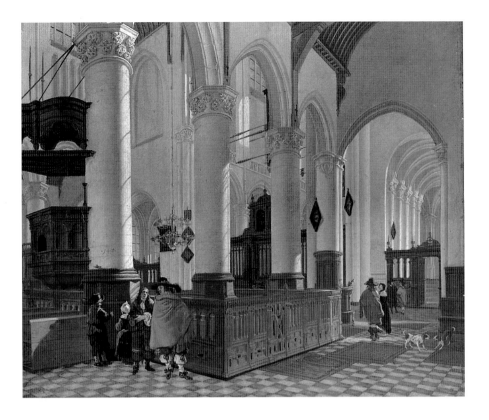

The small panel in Brussels (fig. 151), which is signed and dated "GH [in monogram] . fecit 1653" on the bottom of the pew to the left, depicts various glimpses of the nave (upper left), transept, and choir of the Nieuwe Kerk in Delft from a vantage point deep under the vaulting of the southern aisle. The overall execution and a few special effects, such as the fall of sunlight around the nearest figures, are very fine though not as impressive as in works dating from 1651. The long recession to the right recalls that of the Buccleuch picture and that of the Nieuwe Kerk panorama (fig. 107) to the other side. The chandelier

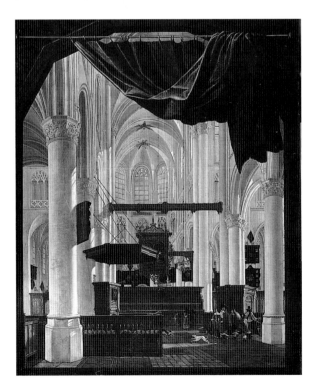

above the red-cloaked man in the foreground seems to mark a pivotal point in the view, where one's attention turns from the pulpit and figures to the receding choir. Like the Oude Kerk panorama (fig. 109), the Brussels picture is devoted to the physical qualities of the church itself, with the figures (and floor tiles) inserted strategically. On the right a door opens to the ambulatory where – one almost needs the reminder – Houckgeest recorded his first views in the church about three years earlier.

At least since his marriage in 1635, and especially after moving to Steenbergen (1651?), Houckgeest was a gentleman artist. His knowledge of architecture and his command of perspective were personal enthusiasms, and, in a sense, attributes. One might compare the artistic pursuits of an admittedly very different person, Jan de Bisschop (1628-1671), the lawyer and friend of the Huygens family at The Hague, whose earliest dated drawing (1648) records the classical ossuary (1560) of the Nieuwe Kerk in Amsterdam in a manner that coincidentally resembles Houckgeest's approach to tomb monuments.[167]

A close consideration of subject matter might help one appreciate the fluctuations in Houckgeest's oeuvre between ambitious or remarkable pictures and more conventional works. His most important paintings were either commissioned or at least represented subjects of great significance to many viewers. One does not find this sense of a special occasion in small cabinet pictures such as the Buccleuch and Brussels paintings, but rather – as in many of De Bisschop's drawings – a felicitous blend of topographical and aesthetic concerns.

The last known paintings by Houckgeest of actual church interiors support the same argument, at the usual risk of forcing fragmentary evidence (one assumes) into a historical mold. The modest panel in South Africa, which is said to be signed in monogram and dated 1656,[168] is an original view of the crossing and choir of the Grotekerk (St. Geertrudiskerk, destroyed in 1747 and restored in different form) in Bergen op Zoom, but seems an uninspired spin-off from older material (the composition resembles the left and central sections of the Buccleuch picture). Signs of wear are obvious even in a small photograph, and one assumes that not all of the weaknesses evident in the drawing are Houckgeest's own.

The much larger canvas in Copenhagen (fig. 152), by contrast, is a meticulous and imposing portrait of the same church. The inscription on the lower left has been read as "GH f55" but appears to be a more plausible "GH fec."[169] The picture could date from as early as 1653 but more likely precedes the Cape Town panel of 1656 by a shorter span of time. The composition recalls paintings dating from 1651: the Jacobskerk view in reverse and from a greater

distance, and a new twist on the motif of a curtain hanging in front of a wooden frame (compare fig. 149). The silvery whites and the grays of the floor and curtain (hung with brass rings on an iron bar) create a splendidly luminous though not atmospheric effect. The recession of the columns and especially the floor leads the eye to a group of frontal graveboards. These all represent members of the Bacx family, which was prominent in Steenbergen and Bergen op Zoom.[170] Similar graveboards in other church interiors by Houckgeest suggest that the matter should be more widely explored. It seems likely that the artist's last important painting of an actual church, as well as his first, was commissioned by – or intended for – someone he knew.

Emanuel de Witte in Delft

In 1650, when Houckgeest painted his first views of the churches in Delft, Emanuel de Witte was about thirty-four years old and had been a figure painter for perhaps a decade. The son of a schoolmaster in Alkmaar, he was born in either 1616 or 1617 (he gave his age as twenty-three in July 1639 and as "about forty" in August 1656).[171] After four decades of work and a hard life in Amsterdam, De Witte died in the winter of 1691-92 at the age of seventy-five. His Amsterdam oeuvre has been discussed in detail by both Manke and the present writer.[172] This brief section is concerned almost exclusively with De Witte's work in Delft in the late 1640s and about 1650-51.

According to Houbraken, De Witte "learned the art [of painting] from *Evert van Aelst Willemsz.*"[173] This first period in Delft would have been during the early 1630s or in any case before De Witte entered the Guild of St. Luke in Alkmaar in 1636. In the summers of 1639 and 1640 he was cited as a witness in Rotterdam. However, his daughter Jaquemyntgen was baptized in the Oude Kerk, Delft, on October 28, 1641. Nearly a year later (September 26, 1642), "Jacomijntje Marijnus van der Beck, widow of Mr. Pieter de Wit, declared herself [to a notary in Alkmaar] in favor of the intended marriage of her son Emanuel with [Jaquemyntgen's mother] Geertgen Arents." When the marriage was recorded on October 4, 1642, the couple was living rent-free in an upstairs room and attic of a house in the Choorstraat, which is just behind the Oude Kerk. On September 17, 1641, De Witte had signed a contract to lease this living and (presumably) studio space from All Soul's Day (probably November 2) 1641, until the same date in 1642. In exchange, he agreed to "instruct Pieter Leendertsz van der Vin, the lessor's nephew, in the art of painting without concealing any knowledge or science understood or known to him in this art but

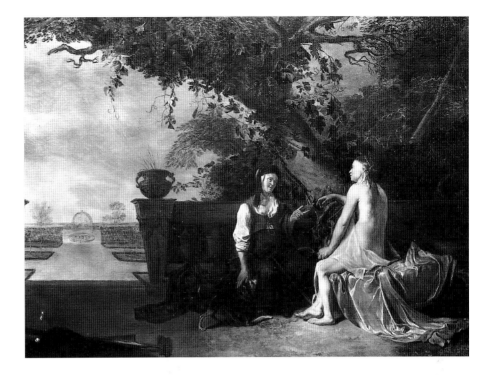

to reveal and inform him about everything as if the forenamed Pieter Leendertsz were his own child." Furthermore, anything painted by the fifteen-year-old pupil would become the property of the homeowner, the brewery foreman Rocus Rocusz van der Vin. As noted by Montias, who published this document, De Witte joined the painters' guild in Delft only nine months later, on June 23, 1642. Pieter van der Vin entered the guild in November 1645 and died at the age of twenty-nine in May 1655. A portrait of Van der Vin and his wife by Carel Fabritius was sold from Van der Vin's bankrupt estate for the respectable sum of forty-five guilders.[174]

A few documents record De Witte's life in Delft during the next decade. He was called a "Painter in Delft" when he served as a witness in 1644. A second daughter, Lysbeth, was baptized in the Oude Kerk on February 20, 1646. In February 1647, De Witte arranged to rent a house on the market square in Delft from May 1647 to May 1648. In November 1649, De Witte was obliged to sell two paintings, each worth about fl. 100, to the Delft painter, art dealer, and innkeeper Adam Pick, for fl. 50 each in order to settle a gambling debt. In March 1650 De Witte took a house on the Nieuwe Langendijk for one year, at a rent of fl. 140.[175]

In accordance with her hypothesis that De Witte inspired Houckgeest to depict the local church interiors, and not vice versa, Manke claims that the inscription *vertrokken* ("departed") next to De Witte's name in the register of the Delft guild can be dated, on the basis of its placement among other entries, to "about 1650."[176] She also cites the declaration of two Amsterdam residents, made in that city on January 24, 1652, to the effect that they would guarantee one Jacob Broen's debt to "Emanuel de With, schilder,"

153
EMANUEL DE WITTE,
Vertumnus and Pomona,
1644.
Oil on panel,
45.8 x 62.8 cm.
Rotterdam, Museum
Boijmans Van Beuningen

EMANUEL DE WITTE,
*Jupiter and Mercury in the
Hut of Philemon and Baucis,*
1647.
Oil on panel, 54 x 62 cm.
Instituut Collectie
Nederland (on loan to
Delft, Stedelijk Museum
"Het Prinsenhof")

as evidence that the painter was living in Amsterdam at the time.[177] When Bredius published the same document he wrote "(in Amsterdam?)" after De Witte's name,[178] as well he might, since De Witte's debt to Pick was attested to a Rotterdam notary on November 19, 1649, by two residents of that city who were recalling an encounter on the market square in Delft of about three months earlier. Furthermore, Delft dealers routinely sold paintings on behalf of Delft artists in other cities. For example, in October 1652 the important Delft dealer Abraham de Cooge gave his Antwerp correspondent power of attorney to collect fl. 690 owed to him for the sale of paintings, and in July 1653 he signed an agreement with the Antwerp dealer Matthijs Musson to share equally anything above fl. 800 that Mussen could get for an altarpiece by Anthonie Blocklandt owned by the Delft businessman. Two months later (September 1653) De Cooge was in Amsterdam where the dealer Hendrick Uylenburgh, two other connoisseurs, and a few prominent painters authenticated a landscape by Paulus Bril at De Cooge's request.[179] The wealthy Amsterdam art dealer Johannes de Renialme joined the Delft guild in August 1644 in order to do business in the city, where he also owned a house. When De Renialme died in Amsterdam in the summer of 1657, he owned eight paintings by Bramer and seven by other Delft artists, including one by Van Vliet and a "Visit of the Holy Women to the Tomb" by "Van der Meer."[180] Delft painters are also known to have sold or consigned pictures directly to dealers in other cities, including Antwerp, Rotterdam, and Amsterdam.[181]

Apart from the debt cited in February 1652, De Witte is not documented at any specific date between March 1650 (rents a house in Delft for one year) and April 1655, when he appraised paintings in Haarlem together with Caesar and Allart van Everdingen, Jan Miense Molenaer, and Petrus Soutman.[182] When he married Lysbeth Lodewycx van der Plass in Amsterdam in September 1655, the painter was

described as "Emanuel de Wit from Alkmaar, painter, widower of Geertje Adriaens van de Velde, living on the Blommarckt" together with the bride ("ouders doot, won. als voren"). In December 1658 De Witte's second wife was banned from Amsterdam for six years for compelling her stepdaughter Jacomijntje to rob money and valuables from their neighbor's house on several occasions.[183]

No painting by De Witte is known to be dated 1652. His earliest known representation of an Amsterdam subject is the *Courtyard of the Amsterdam Exchange,* dated 1653.[184] Amsterdam church interiors date from the following year.[185] The Carter panel depicting the rear of William the Silent's tomb and an illusionistic curtain (fig. 160) is dated 1653, and other paintings of about 1653-56 represent Delft subjects (works in Brussels, Oberlin, and Lille; see fig. 36). One can only say that De Witte probably moved from Delft to Amsterdam – possibly with an interim period in Alkmaar – between 1651 and 1653.

The only dated church interior by De Witte before 1653 is the Oude Kerk view of 1651 in the Wallace Collection (fig. 156). All the other architectural pictures that the artist appears to have painted in Delft can be placed chronologically only on the basis of comparisons with the Wallace picture and with works by Houckgeest that appear to have influenced De Witte (none of Van Vliet's paintings indisputably qualify).

It would be useful to cast a glance at De Witte's work in the 1640s. The earliest unquestionable date on a painting by him is found in the *Vertumnus and Pomona* of 1644 (fig. 153). As in the *Danaë* of 164(7?) in a private collection, Amsterdam,[186] and the Ovidian domestic scene dated 1647 (fig. 154),[187] De Witte establishes a shallow foreground with the help of a few objects, throws strong light onto the figures in the middle ground, and treats the background like stage scenery dropped down immediately behind the protagonists. Pictorial space is created mostly by overlapping planes of light and shadow or of dark and light forms. This approach causes formal difficulties in the firelight of Philemon and Baucis's hut, where shadows flow like tent flaps in a breeze. It may say something for Evert van Aelst's tutelage that De Witte, in his early work, was more adept at using light for describing fabrics and focusing attention than for suggesting depth.[188]

The mythological pictures and *The Holy Family* of 1650 (?) on loan to the Prinsenhof, Delft, reveal a talent for observing people but not for composing narrative. De Witte's history paintings appeal to the viewer as genre scenes: Pomona sunbathes while visiting her aunt; Philemon and Baucis have just opened a Bed and Breakfast to see themselves through retirement. In *The Holy Family* De Witte shows us a hard-working couple tenderly watching

their nursing baby in the candlelight of their crowded little home and carpentry shop. These early pictures could just as well have been painted in Alkmaar or Amsterdam, although one does sense some slight debt to Bramer. However, De Witte's pair of small portraits dated 1648 (Museum Boijmans Van Beuningen, Rotterdam) are consistent in style with portraits painted in Delft by Jacob Willemsz Delff II, Anthonie Palamedesz, and Hendrick van Vliet.[189]

A few early architectural paintings of exceptional quality by De Witte, such as the Wallace Collection's panel dated 1651 and the Ottawa picture of a similar subject and about the same date (fig. 156; pl. IX), suggest that he mastered his own distinctive style in the genre within a year or so. The main virtues of his mature manner are already evident, while qualities recalling the figural paintings remain. In the Ottawa, Wallace, and Winterthur compositions (pl. IX; figs. 155-56), for example, the artist establishes a shallow foreground occupied by figures, a middle zone in which the main motifs are emphasized by highlights and silhouettes, and a background which may be nearly frontal or recede obliquely but nonetheless falls like a curtain behind center stage. In later years this layered, coulisse-like effect would be employed throughout the picture, so that the space resembles a visual field or pattern of impressions, without clear divisions into zones of depth (see fig. 161). But in his early church interiors De Witte was learning methods of composition he had not considered before.

How carefully he did so depended upon his patience (which Houbraken describes as limited) and his priorities in a given picture. In the Winterthur panel (fig. 155) the tomb of William the Silent almost seems subordinate to the fashionable figures, as if it were comparable to a canopied bed or a fireplace in one of Ter Borch's elegant interiors or to the balustrade and foliage in *Vertumnus and Pomona* (fig. 153). The figure types and their prominence in the composition are De Witte's innovations, just as the congregations in his "Sermon" pictures may be considered an important contribution to the genre in Delft. Comparison with De Witte's point of departure, Houckgeest's Mauritshuis painting of the same view (fig. 142), clarifies his different interests. The man and boy on the left and a couple and child in front of the tomb were adopted from Houckgeest but are now less distant and isolated. The figures in the center have become a second family with a young servant and greyhounds, one of which wonderfully catches the light.

The architectural motifs are more obviously derived from Houckgeest. De Witte's main source of inspiration was evidently the tall Mauritshuis picture, where a column is dropped from view. However, the subject, as De Witte conceived it, is a visit to the famous monument, rather than a record of the site.

He includes the choir wall up to the clerestory and yet the height of the space has been reduced by half (that two clerestory windows are partly visible in the top center of the composition may indicate that De Witte referred to the Hamburg panel as well; pl. II). The two nearest columns in Houckgeest's Mauritshuis picture have been shoved together on the left in order to show more of the monument, which sits in the choir like a boat bobbing at a pier. With four obelisks rising and a view through the center of the tomb, it would appear that De Witte consulted other sources, such as his own drawings or a print (see fig. 100). However, the curtain and arched frame (and the shadow cast on the fictive painting by the curtain rod) were probably borrowed here and in the Ottawa panel (pl. IX) from Houckgeest's view of the pulpit in the Oude Kerk (fig. 149), which in my view dates from 1651. In the loose rendering of the Winterthur panel these motifs have lost most of their illusionistic effect.

If one were dealing with almost any other Dutch artist it would be tempting to say that the painting in Winterthur must date earlier than De Witte's Oude Kerk views in London and Ottawa (fig. 156, pl. IX)

155
Emanuel de Witte,
Nieuwe Kerk in Delft with the Tomb of William the Silent, ca. 1651.
Oil on panel,
107.5 x 90.5 cm.
Winterthur, Museum Briner und Kern (Stiftung Jakob Briner)

because it is awkwardly composed, less carefully painted, and more obviously dependent upon another artist's work. However, the most meticulous attempt to place De Witte's church interiors of the Delft period in chronological order will (or should) lead one to the conclusion that it cannot be done and that they should all be dated to 1651 or "about

1651." Not one of them offers a substantial reason to tip the balance toward 1650 or 1652, although De Witte may have painted church interiors in the former year and one supposes that he must have in the latter.

In contrast to the Winterthur panel, where De Witte ignored the main virtues of the works by

Houckgeest to which he referred, in the Wallace picture (fig. 156) he appears to have learned enough from the older artist to arrive independently at something similar yet distinctive and well composed. The shape of the panel seems to have determined the placement of the columns and rhythms of the archways, although Houckgeest's tall view of the Oude Kerk's pulpit (fig. 149), the Mauritshuis picture (fig. 142), and even the view to the tomb of Piet Hein (fig. 143) could have influenced De Witte's design. However, photographs (fig. 157) reveal how De Witte realigned elevations and in general departed from Houckgeest's approach. The more distant architectural forms now recede gently, gracefully filling in the picture field. This counterpoise of sympathetic shapes, the stillness of the figures (which flow together, almost every one slurring into another), and the fall of warm sunlight evoke a sense of peace and solemnity. The emphasis placed upon the preacher and pulpit is balanced by the visual weight given to the columnar woman in the foreground (who looks forward to figures by Ter Borch, De Hooch, and Vermeer) and to the blond boy behind her. The recession to the left is not only offset by the recession to the right but is also tempered by the sideward fall of sunlight and by motifs that weave a pattern across the view: the archways, the figures, and especially the choir screen and church furniture, which act in concert to form a continuous, nearly horizontal barrier.

The very elements that Houckgeest would have used to emphasize and measure progress into depth (including figures) are used by De Witte to bring the background closer to the picture plane. For him, architecture seems less a logical system of geometrical forms than a sequence of images, like landscape vistas or scenes in stained glass. Light and shadow, closely valued tonalities, softer drawing, and looser brushwork than any artist in this specialized genre had used before all contribute to the general impression, which is remarkably coherent and "optical" (if by that one means a pattern of light, color, and tonal values, as opposed to more tactile indications of three-dimensional space). Looking ahead, De Witte was clearly the painter of church interiors who would have been of greatest interest to De Hooch and Vermeer. His space is defined by architecture but animated by light, atmosphere, and humanity.

De Witte's own inclinations are more consistently evident in the pictures he painted in Amsterdam. In the Delft works he could be said to have ignored the genre's traditional interests, as in the immature compositions in Winterthur and St. Petersburg (figs. 144, 155), or to have asserted his own values against those of a borrowed composition. Few early church interiors by De Witte are as successful in this

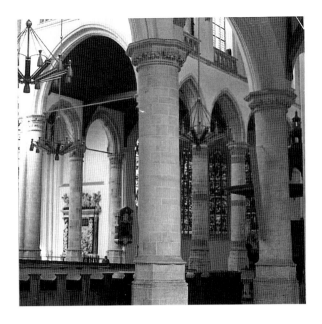

regard as is the painting in the Wallace Collection. Approximately contemporaneous pictures in Worms (formerly in Rotterdam, Van Duyn Collection) and New York (fig. 158) adopt Houckgeest's designs to cross-purposes: distances are compressed, surfaces blended (floor tiles disappear), and motifs are emphasized so that they tend to float in space ambiguously, like family crests in portraiture.

De Witte's figure paintings of the 1640s reveal his tendency to compose pictures largely in terms of surface design. When he turned his attention from illustrated editions of Ovid and other pictorial sources to actual environments or even paintings of

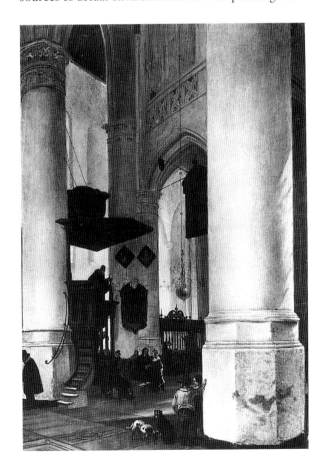

158
EMANUEL DE WITTE, *Nieuwe Kerk in Delft (view from the southern ambulatory to the northwest)*, ca. 1651. Oil on panel, 60 x 40.6 cm. New York, private collection (photo: RKD, The Hague)

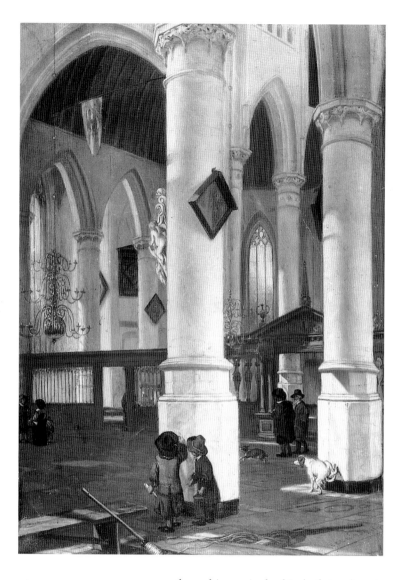

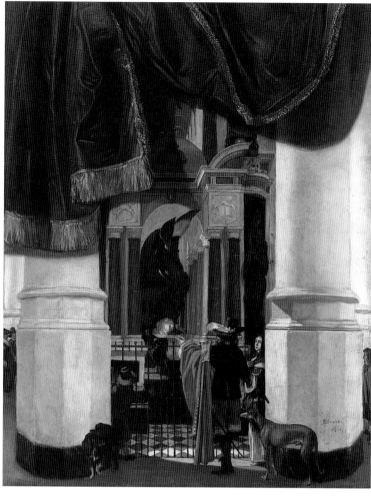

159
EMANUEL DE WITTE,
*Oude Kerk in Delft (view
from the southern aisle to
the northeast)*, 1650 (?).
Oil on panel,
48.3 x 34.5 cm.
Montreal, Mr. and Mrs.
Michal Hornstein.
See also plate x.

160
EMANUEL DE WITTE,
*Nieuwe Kerk in Delft with
the Tomb of William the
Silent (view from the rear)*,
1653.
Oil on panel, 82.3 x 65 cm.
Los Angeles, Collection of
Mr. and Mrs. Edward
William Carter (photo:
Los Angeles County
Museum)

them, his particular kind of visual acuity was not always well suited to the task. If he based himself directly on a Houckgeest composition, as in his first views of William's tomb (figs. 147, 155) or employed a strong oblique recession in another subject (fig. 158), then De Witte usually produced a picture that is to some extent unresolved, with qualities reminiscent neither of Houckgeest nor of his own more independent work. However, when he proceeded on his own, creating compositions which may have benefited from his exposure to Houckgeest but which represent views he had discovered himself (pl. IX), then De Witte was in his element. He appears to have sensed this, since his most successful early designs are usually the most carefully observed and executed. Among the finest pictures of the Delft period are the Ottawa panel (pl. IX), the Wallace picture (fig. 156), and the former Van Aelst painting in Montreal (fig. 159, pl. X). The latter remarkably transforms the view that is more faithfully rendered in the Wallace picture. Perhaps the slightly different vantage point was encouraged by Houckgeest's view to the tomb of Piet Hein (fig. 143).[190] De Witte could just as well have arrived at a similar composition on his own, but the young draftsmen in the foreground,

the newly opened grave, and the unexpected epitaph with putti (which is found at its proper location in the right background of Houckgeest's view) suggest a direct relationship.[191] The resemblance between the choir screen's doorway in De Witte's view (which, to judge from other pictures, had flat pilasters not colonnettes) and Houckgeest's tomb is the kind of correspondence one grows accustomed to in studying the younger artist.

In De Witte's different view of the Oude Kerk, the rôle of windows and other light-filled openings is greatly increased. The space depends less upon the arrangement of columns and more upon the use of light, as well as abrupt juxtapositions of near and distant forms. In Houckgeest's painting two ranks of columns divide three zones of obliquely receding space. De Witte avoids solid forms that lead through (rather than across) the middle ground, which, predictably, in the Montreal panel is a shadowy expanse of floor. The dog on the right not only points to the left, thereby turning the main recession back on itself, but it also slurs the column to the pair of men and the column beyond them (the dog on the left in the Winterthur picture, fig. 155, is just beginning to learn this trick). The flag to the upper

left was once on the end of a longer staff. Like Vermeer, De Witte often modifies a motif to effect a subtle shift in balance.[192]

Discreet adjustments were also made to the Oude Kerk view in Ottawa (pl. IX), in the figures near the base of the column in the foreground and in the window to the upper right. Of all the Delft works by De Witte this one might (hypothetically) be placed last, in 1651 or 1652. The subject and composition recall Houckgeest's view of the same pulpit in the Rijksmuseum picture (fig. 149) and De Witte's panel in the Wallace Collection (fig. 156). His vividly green curtain (with gold fringe) and fictive frame (which, like the curtain rod, casts a shadow suggesting a real light source to the upper left) strike one as responses to Houckgeest. In both the Ottawa and Rijksmuseum pictures a bit of the church's floor is visible below the curtain (which is not evident in most photographs), and the woman next to this pregnant passage attracts particular attention. De Witte's woman, however, reminds one of the self-sufficient figure in the Wallace picture and perhaps of a woman in Van Vliet's view of the Oude Kerk dating from a few years later (fig. 165).

At a normal viewing distance the Ottawa panel is impressively illusionistic. The curtain and the arrangement of architectural forms with respect to the picture plane anticipate the design of the extraordinary Carter painting dated 1653 (fig. 160). The latter goes beyond the contemporary picture of the Amsterdam Exchange (Rotterdam, Museum Boijmans Van Beuningen) in restricting the viewer's attention to the immediate foreground.[193] But it is the Ottawa panel that leads to De Witte's mature work in Amsterdam. There are a few forms and several figures gathered in the foreground and a view of architecture in the distance, with little but shadowy space in between. The veil-like nave wall

and the lighting (not only the highlight) on the nearest column are crucial to the effect. Windows framed in archways, a few graveboards, and the stark shadows on the wall of the aisle in the left background are among the devices that pull the eye forward and backward at the same time.

De Witte's essential goal was to represent the space, light, and emotional effect of Gothic church interiors, and also what sacred space meant to ordinary people of his time. Some of the most memorable pictures painted in Delft during the 1650s interpret architectural space as subjective experience. The impression is comforting, as if the thoughts and values emanating from the figures were safely contained in their immediate surroundings.

The intangible qualities that are so important in De Witte's work were achieved more fully in Amsterdam. Already in paintings of the mid-1650s, such as the *Nieuwe Kerk in Amsterdam* (fig. 161), the architecture beyond the foreground looks visionary. De Witte softens contours, treats shadows like curtains, and lends the light cast from clerestories as much substance as he grants to the radiant columns and nebulous vaults. The architectural forms fill the space like words flowing from the pulpit, like reflections of faith. One can imagine that De Witte's revolutionary style would have attracted sympathetic viewers in Amsterdam, with its sophisticated patrons, profound religious paintings, and four great churches. What cannot be imagined is that De Witte would have found his mature manner, or even his subject, had he not started in Delft.

Hendrick van Vliet[194]

For twenty years Hendrick van Vliet (ca. 1611-1675) was the leading painter of architectural views in Delft. Van Bleyswijck, in his *Beschryvinge der Stadt Delft*, names no other, but reserves for the nephew of Willem van Vliet some qualified praise.

"His brother's son *Hendric van der Vliet* first studied with him and then with the famous Miereveld. He has now become a good portraitist as well, and is also not unlucky in mythologies and histories, both in day and night lighting. He understands perspective well, which may be seen in his modern or contemporary temples. When he has made them at his best they are very well foreshortened and illusionistic, as well as colored naturally."[195]

Most of Van Vliet's architectural views represent the Oude Kerk or the Nieuwe Kerk in Delft with varying degrees of fidelity. (The two reproduced by engravings in Van Bleyswijck's book are among the most faithful and conventional; see figs. 170-73.)

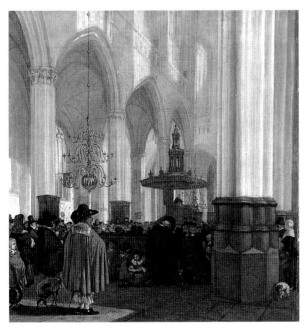

161
EMANUEL DE WITTE,
*Nieuwe Kerk in Amsterdam
(view of the nave to the
northeast)*, 1656 (?).
Oil on canvas,
34.5 x 33.5 cm.
Rotterdam, Museum
Boijmans Van Beuningen

However, Van Vliet also travelled in order to depict important churches in other cities, beginning with his earliest known dated church interior, *The Pieterskerk in Leiden* of 1652 (fig. 162), and including paintings of St. Bavo's in Haarlem (1654, 1666, etc.), the choir of the Jacobskerk at The Hague (1661), the Janskerk in Gouda (1662; fig. 168), and the Mariakerk in Utrecht (1672).[196]

The abundance and variety of Van Vliet's work in the genre goes well beyond what is found in the entire ouevre of Houckgeest and is something different from the kind of fecundity De Witte demonstrates. Van Vliet's representations of churches in cities where he did not reside and the nature of his production in Delft suggest a commercial enterprise sensitive to fluctuations in demand. A few of his pictures – perhaps even a few dozen – were probably commissioned,[197] but his persistent search for new views in the churches of Delft, his repetition of particular compositions, and his wide range of quality would indicate work for the open market. A number of paintings dating from the 1660s and early 1670s appear to have been turned out with studio assistance, especially in the more mechanical passages of architecture and in the sometimes decal-like application of staffage. Van Vliet continued to paint portraits occasionally (as he had since at least 1636; see fig. 24), and even his autograph church interiors generally declined in quality as they increased in number during the last decade of his life.[198] By contrast, the quality and originality of his architectural views dating from about 1652-1662 may be taken as signs of prosperity or at least solvency. A "perspectieff" in the 1657 estate of the Amsterdam art dealer Johannes de Renialme was valued at fl. 190, quite a high price.[199]

Van Vliet's reputation as a perspectivist in Delft is interesting for Pieter de Hooch and other genre painters, who in the mid-1650s at the earliest were just beginning to describe domestic interiors and courtyards in Delft with the help of carefully drafted perspective cartoons (see fig. 242). Of course, one should not assign the architectural painter too crucial a rôle. As discussed in Chapter Four, the Delft type of domestic interior may be placed within a broader context of genre scenes, which the writer has described as a South Holland tradition also represented by painters of elegant companies such as Van Delen and Van Bassen (see fig. 191). Furthermore, other Delft artists, such as Bramer, were familiar with perspective practice (see fig. 21). The projection of rooms as seen in the oeuvres of De Hooch, Vermeer, and even the more eccentric De Man (pl. xvi) did not require expertise on the level demonstrated by Houckgeest or Fabritius. Finally, numerous perspective manuals were available, and some of them represented ordinary rooms (figs. 75, 80). Once an artist like De Hooch mastered the basics of (in his case) frontal projection, he would have been able to solve most problems on his own.

But there is more to it than that. One can describe parallels between genre painters in Delft and artists elsewhere until the cows come home and yet few of the possible prototypes have the realistic sense of space one finds in De Hooch and Vermeer from about 1657 onward (for example, figs. 242, 263) or in church interiors by Houckgeest, De Witte, and Van Vliet beginning in the early 1650s. The three architectural painters, not least Van Vliet, are also remarkable for the attention they devoted to ordinary people walking, standing, and sitting about in various corners of the two Delft churches. It is not difficult to discover compositions that resemble Delft genre scenes by cropping details (some of them large) from paintings such as Houckgeest's "pulpit view" in the Rijksmuseum (fig. 149), De Witte's views of the same subject in London and Ottawa (fig. 156; pl. ix), or Van Vliet's early Oude Kerk pictures with the tomb of Piet Hein (fig. 165). These interior views – with their white walls, cool colors, and rectangular zones of daylight; their illusionistic description of spaces near at hand; their geometric ordering of the view; and their strong sense of continuity with spaces outside the windows and in front of the picture plane – these pictures of familiar places in Delft must have been admired by De Hooch, Vermeer, and De Man (who actually worked in both genres). A few examples of possible influence will be discussed below.

Van Vliet's contribution deserves a brief review. The many questions of authorship, chronology, and his relationship with other artists which were considered in my earlier study need not detain us here.[200] What does require emphasis are the qualities that distinguish Van Vliet from Houckgeest and De Witte. Although he could be considered a lesser artist, he was not merely their follower. It is remarkable that even in this specialized area, where techniques, compositional patterns, and specific subjects and motifs were shared by a few artists in a single location, different ways of seeing emerged immediately.

One of the minor mysteries of this development in Delft is why Van Vliet's earliest known architectural view depicts a church in Leiden (fig. 162). There were a great number of artistic, commercial, and social connections between the two cities, so that it is quite possible that the work was commissioned, for example, by a Leiden patron who had seen recent church interiors from Delft or by a Delft resident who had some personal or family ties to Leiden and the Pieterskerk. However, the vanitas theme treated in the picture was commonplace,[201] and no motif (such as a particular graveboard) is

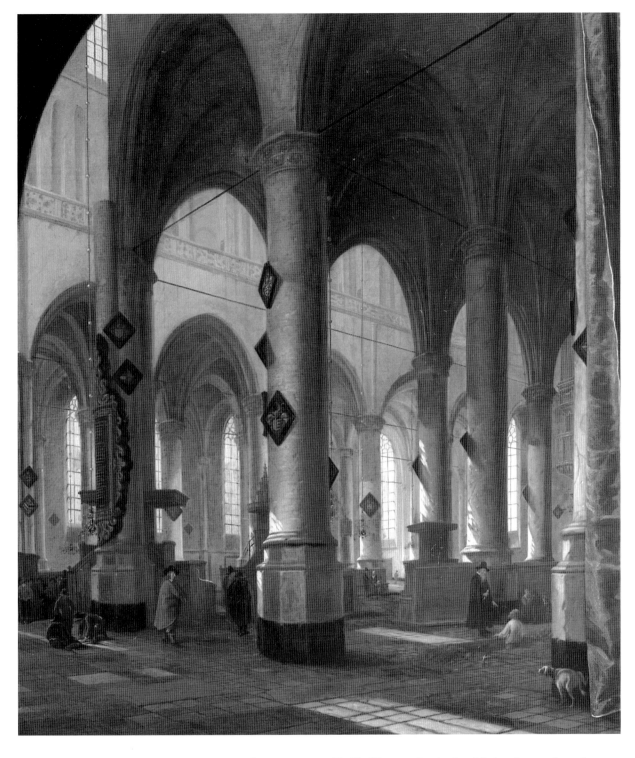

162
HENDRICK VAN VLIET,
The Pieterskerk in Leiden
(view from the northern
transept to the southwest),
1652.
Oil on panel, 97.5 x 82 cm.
Braunschweig, Germany,
Herzog Anton Ulrich-
Museum. See also plate XI.

isolated in a way that suggests private significance.

In any case, one would expect that Van Vliet had painted a Delft church interior before the panel in Braunschweig, in 1651 or early in 1652. The fact that he did not employ linear perspective in his oeuvre before about 1652 does not mean that he knew nothing about it (one does not find De Man's sort of errors, nor De Witte's indifference, in Van Vliet's first architectural pictures). It is also possible that he sketched the site in Leiden and was assisted in preparing a perspective cartoon by another artist. But all this is conjectural, and no missing evidence, if suddenly brought to light, can be expected substantially to alter our view of Van Vliet's rôle in

Delft. He was clearly the third artist to adopt the new subject, and from the first he was a very different painter from Houckgeest and De Witte.

Van Vliet was never so engaged as his colleagues were by representational problems, the way interior space, light effects, and so on actually appear. His earliest architectural views and many later examples are conventionally illusionistic, in a manner that recalls Houckgeest's Oude Kerk panorama (fig. 109) but not his Hamburg panel, nor do they recall De Witte even in the Delft pictures that achieve an illusionistic effect. It is true that Van Vliet's first dated church interior is marvelously evocative of a visit to the Pieterskerk. But this is a trick of memory

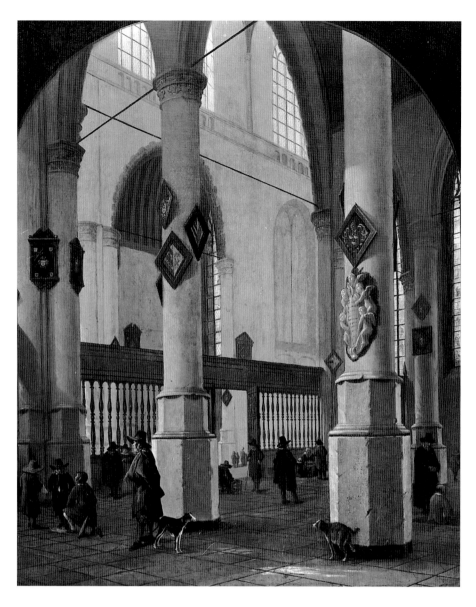

163
HENDRICK VAN VLIET,
*Oude Kerk in Delft (view
from the choir to the
northwest)*, 1654.
Oil on panel, 74 x 60 cm.
Amsterdam, Rijksmuseum

The artist frequently favored a forest of columns rather than the sensation of one or two close at hand. To this end, he cut across corners between the great spaces of choir, transept, and nave, and slimmed the shafts as he stretched the architecture to invisible heights. The apparent distances of the viewer from the foreground and from there to the background (where the brightly lit baptistry of the Pieterskerk appears) are exaggerated by Van Vliet's use of distance points well outside the composition. A different kind of infidelity to the subject is found in Van Vliet's frequent splicing of motifs, which is more radical than Houckgeest's dropping of a column (Van Vliet dropped two or three at a time) or De Witte's moving of an epitaph. In Van Vliet's first dated painting, the Pieterskerk in Leiden is embellished by the triforium of the Nieuwe Kerk in Delft. The nave wall recovers its proper design in a version of the composition dating from the following year (Ringling Museum of Art, Sarasota, Florida).[202]

Van Vliet must have been inspired by the illusionistic and tactile qualities of Houckgeest's style, which are most evident in paintings dating from 1651. The younger artist continued in this direction for the next several years. He dwells on sculptural details and surface textures in the Pieterskerk and various Delft views of the mid-1650s. On the central column in the Leiden church interior of 1652 one can almost count the bricks beneath the worn coats of whitewash and feel the cracks and chips in the porous stone. Van Vliet seems to have been drawn to the cold, decayed look of medieval masonry and the cave-like gloom of large churches in northern climes. The vaults are murky, the shadows long, and light penetrates at a low angle, finding one space and missing others, except for a few streaks of sunlight here and there.

Some of Van Vliet's effects are reminiscent of De Witte's church interiors in Delft. The indirect light on the nave wall of the Pieterskerk and in the transept of an Oude Kerk interior dated 1654 (fig. 163), which is revealed through shadowy columns in the foreground, recalls De Witte's early "Sermons" observed from deep in the Oude Kerk's aisle (fig. 156). One of Van Vliet's most attractive qualities is his range of tones, with pale greens, bluish beige, and transparent yellows lending diffused light and atmosphere to whitewashed walls and slate-gray stones. His palette differs from De Witte's, but the use of tonal contrasts comes closer to his younger colleague's than to Houckgeest's (whose church interiors are more evenly luminous) or to that of any earlier painter in the genre. This is true despite the fact that Van Vliet's most frequent approach to the architecture, with two or three columns obliquely receding in the foreground, is ultimately derived from Houckgeest's designs. In some cases, however,

and of the artist's attention to stone surfaces and damp atmosphere. One does not have that peculiar sensation, as in Houckgeest's most impressive pictures, of seeing precisely the view one has experienced elsewhere, nor is there anything like De Witte's suggestion of a late afternoon hour on a sunny day. Van Vliet's style is more reminiscent of Leiden: it seems as if one could touch the objects if they were not so far away.

In their oblique recessions, framing devices, and illusionistic curtains, Van Vliet's early church interiors are indebted to Houckgeest in obvious ways. The Pieterskerk picture (fig. 162) resembles Houckgeest's Hamburg design but with the oblique recessions stretched out further to the sides, as if Van Vliet had revised the model to resemble more closely the Buccleuch composition (fig. 109) and then borrowed the curtain from Houckgeest's Oude Kerk "pulpit view" (fig. 113). But this kind of analysis does not do justice to Van Vliet's inventiveness. Just as in the case of De Witte, Houckgeest's compositions were sources of inspiration for pictures that one immediately recognizes as typical of Van Vliet.

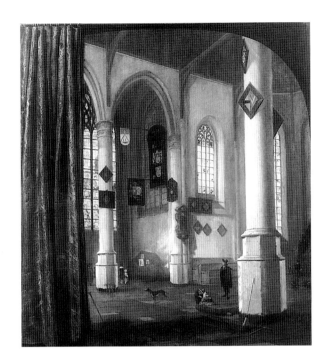

the composition also goes back to De Witte, as in a small picture dating from about 1658-59 of a sermon in the Oude Kerk, (fig. 167). The panel of 1657 representing a funeral procession winding into the Oude Kerk under the organ loft, with a grave for another burgher being dug in the foreground (fig. 166), is hard to imagine in Van Vliet's oeuvre without the influence of De Witte's Ottawa picture of the same space (pl. IX) or of some similar work by the same artist.

Comparing Van Vliet with De Witte and Houckgeest raises interesting questions about naturalistic representation. In so many examples one finds a fairly rapid development from innovations based upon direct observation and a sophisticated knowledge of precedents to the establishment of new forms as stylistic conventions, devices that may be employed or manipulated without further reference to the subject itself. Vermeer's pointillé passages of brilliant daylight, once discovered on gilt leather or the piping of a satin dress (figs. 263, 265), was his to sprinkle on loaves of bread or splash on the side of a boat (fig. 267, 277). A way of describing always becomes a style. In the case of large-scale productions, like architectural painting in Delft, the use of standard patterns and devices was also economical, a marketing strategy.

Even within the narrow range of Houckgeest's work in 1650 and 1651 and De Witte's during the 1650s, one finds pictures that appear like revelations and others that elaborate upon previous ideas. Repetition is avoided by introducing new motifs and formal devices, some of them drawn "from life." But the best inventions lasted for a long time.

These remarks are pertinent to a discussion of Van Vliet because his church interiors are generally one step further removed from the source than are

the paintings of the early 1650s by his predecessors. It is true that Van Vliet often returned to the Delft churches and visited others to record new views, and that many of his effects, his descriptions of light, space, atmosphere, textures, and also human behavior benefited from repeated observation. But even in his first known paintings, which represent a church that Houckgeest and De Witte never depicted, Van Vliet's interest in the new realism introduced by his colleagues was more conventionally that of an artist adopting a current style. His light effects, his palette, and his rough and smooth surfaces are picturesque. Van Vliet's illusionism recalls that of Van Hoogstraten and Willem van Aelst in the early 1650s (figs. 25, 58) as much as that of Houckgeest in 1651. He used the curtain and arch motifs more frequently than almost any other Dutch painter. The curtain is sometimes assigned a principal rôle (figs. 164-65). Distant, diaphanous elevations are set against columns in the foreground with a keen eye to contrasting qualities, like the vistas beyond Potter's bull or Pynacker's peeling tree.

In the later 1650s Van Vliet developed a smoother, thinner execution overall and an emphasis upon light and color rather than texture and form.

164
HENDRICK VAN VLIET,
*Oude Kerk in Delft
(view from the choir to the
northeast across the
Mariakoor)*, 165(4).
Oil on panel,
66.5 x 59.5 cm.
Leipzig, Museum der
bildenden Künste

165
HENDRICK VAN VLIET,
*Oude Kerk in Delft with
the Tomb of Piet Hein*,
ca. 1652-54.
Oil on panel,
76.2 x 65.1 cm.
New York, private
collection (photo: Toledo
Museum of Art)

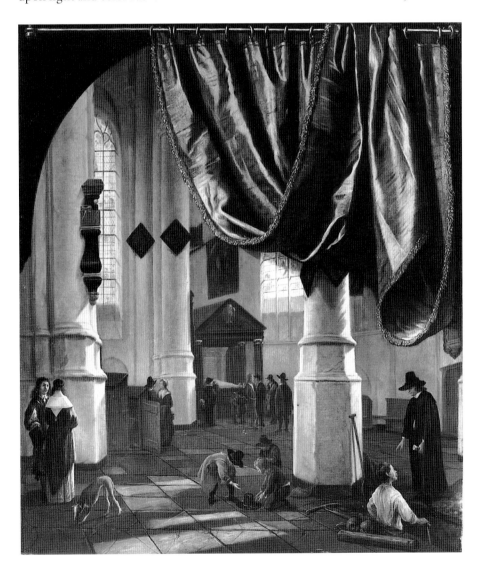

The shift in style resembles that of Vermeer as he progressed from works of about 1657-59, such as the *Young Woman Reading a Letter* in Dresden and *The Milkmaid* in Amsterdam (figs. 263, 267), to paintings of the early 1660s like the *Woman in Blue Reading a Letter* in Amsterdam and the *Young Woman with a Water Pitcher* in New York (figs. 282, 294). A more conspicuous parallel to Vermeer is found in Van Vliet's new emphasis, between about 1657 and 1662 (figs. 169-174), upon deep perspective recessions, which anticipates Vermeer's departure from comparatively intimate scenes to those of figures placed a room's width away (as in figs. 283, 304). These changes are usually discussed within the context of a single oeuvre or genre, but they occurred widely within and outside the Delft school (compare fig. 97).

In several paintings of about 1653-55 Van Vliet moves in closer to the architecture than in his Pieterskerk views and shows other signs of responding to De Witte and especially to Houckgeest. The Rijksmuseum panel of 1654 (fig. 163) recalls Houckgeest's approach in the ex-Crews composition (fig. 145) and adds to the human interest.[203] Houckgeest worked with a small cast of characters,

while De Witte favored either isolated individuals or closely gathered congregations. Van Vliet often employs a large troupe of extras spread throughout the space.

In the Leipzig panel of 1654 (fig. 164) the artist isolates one column in the foreground and covers a pier with the curtain. The arrangement and the subject itself remind one of several early pictures by De Witte.[204] However, the painting's relationship to contemporaneous compositions by Van Vliet himself, such as the panel formerly in Toledo (fig. 165), and the latter picture's connection to Houckgeest (fig. 143) reveal how inventive Van Vliet could be when it came to the placement of columns, the proportions of the architecture, apparent distances (compare the tombs of Piet Hein), and so on. Three columns have been excluded from the ex-Toledo picture: one that should stand between the couple and the dog to the left and two that should block our view of the tomb. The central space of the Mariakoor has been drastically compressed, and the illogical results in the vaults are covered up by the curtain. Of course, the scenery was shoved around for the benefit of the unusually prominent figures (no "extras" here), who recall Houckgeest and Ter Borch, as well as sermons about behavior in church, the brevity of life (the boys play a game of chance), and the lasting virtues of a good reputation (such as Piet Hein's) and a life of faith.[205]

Van Vliet continued to paint restricted spaces from comparatively close points of view in paintings dating from the mid-1650s to the early 1660s. The funeral scene of 1657 (fig. 166), the "pulpit view" in Vienna (fig. 167), and the painting in Toledo with the tomb of Admiral Tromp are among the many pictures that demonstrate the artist's ability to

create new compositions based on a few standard schemes.[206] In the same period, and possibly earlier, he also revised Houckgeest's strongly oblique approach but from a greater distance, as in the canvas of 1658 in Baltimore.[207] One of the most effective examples of this compositional type is the panoramic picture of the Janskerk in Gouda (fig. 168), dated 1662, where four of the stained-glass windows by Dirck and Wouter Crabeth (1552-72) are included in the view.[208]

In later years Van Vliet often referred back to Houckgeest's designs, as in the canvas dated 1671 in Puerto Rico (fig. 175), which represents the choir of the Nieuwe Kerk from nearly the same direction as in the Hamburg panel of 1650. All of the southern elevation and half the vault are included, which would suggest that Van Vliet recorded the architecture from a much closer vantage point than Houckgeest did. But the foreground is deeper, the entire choir seems further away, and peculiar adjustments have been allowed in the shape of the clerestory windows, the height of the ambulatory on the left, and Frederick Hendrick's graveboard, which now reaches up to the rafters. The tomb itself looks like a provincial copy of De Keyser's design. The staffage, flags, and escutcheons have been placed in the picture with decorative intent and hopes of relieving ennui.

No picture like this one or any literal copy by Van Vliet supports the remark made recently that "from 1660 onward … he began copying the paintings of Gerard Houckgeest for no apparent reason."[209] The Stockholm canvas which the present writer published as a Van Vliet of about 1660 (fig. 146) appears to be an earlier replica by Houckgeest, and no hard evidence indicates that Van Vliet made copies of another artist's work. The "engraving after Van Vliet" in Lebrun's *Galerie* (1792), where the original was called De Witte, may now be assigned more plausibly to De Man on the basis of the very similar composition in Louisville (figs. 177-78).[210]

Contrary to the notion of Van Vliet as plagiarist, from about 1660 onward he painted a number of deep orthogonal views of church interiors which were virtually unprecedented in Delft (figs. 169-71, 174). It would be mistaken to regard this as a revival of the Antwerp manner (which lived on, with Van Delen and others, in the 1660s). Somewhat similar compositions are found among Houckgeest's early, imaginary architectural pictures and in Saenredam's work from the mid-1630s onward.[211] But the effect in Van Vliet's most impressive painting of the type, the "Teding van Berkhout" canvas of 1661 (fig. 169), remains distinctive of Delft. The design resembles Houckgeest's Jacobskerk picture of 1651 (fig. 150) but with a broader format and deeper foreground. As in that painting, Van Vliet sets the shaded foreground and a wooden barrier against a deeper

168
HENDRICK VAN VLIET,
*The Janskerk in Gouda
(view from the southern aisle
to the northeast)*, 1662.
Oil on canvas,
110.8 x 128.7 cm.
Melbourne, National
Gallery of Victoria,
Felton Bequest

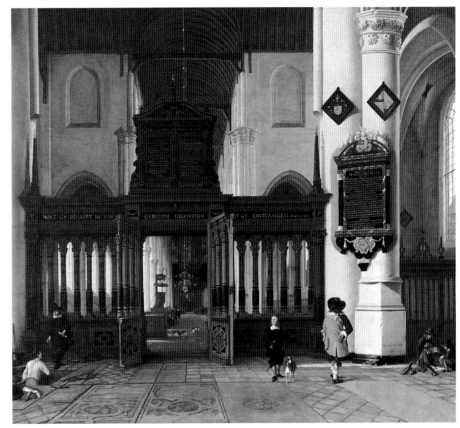

zone of sunlight and connects a crowning element (the tablet on the choir screen; compare Houckgeest's pulpit) with the wooden vaults. In both pictures, memorial tablets are featured prominently, with the one dedicated to Adriaen Teding van Berkhout (1571-1620) – on the right in Van Vliet's painting – acting as a gathering point for figures who have clear precedents in pictures by De Witte and Houckgeest.

The juxtaposition of a strong recession and forms massed in the foreground is a scheme that can be traced back either to the early Renaissance, to Van Steenwyck and Van Bassen (see fig. 101), or to Houckgeest and De Witte (figs. 147, 150), depending upon how narrowly one defines the type. But the inclination to discern traditions should not spoil one's

169
HENDRICK VAN VLIET,
*Nieuwe Kerk in Delft with
the Memorial Tablet of
Adriaen Teding van
Berkhout*, 1661.
Oil on canvas,
100 x 112 cm.
Delft, Stedelijk Museum
"Het Prinsenhof," on
loan from the Teding van
Berkhout Foundation
(photo: Tom Haartsen)

133

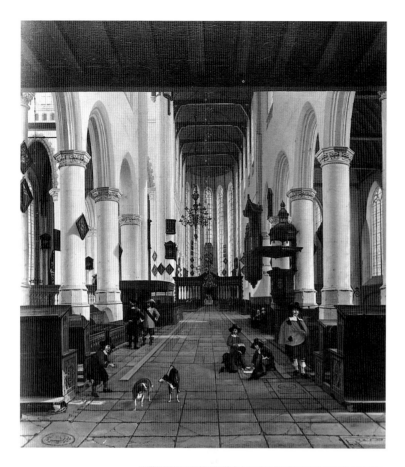

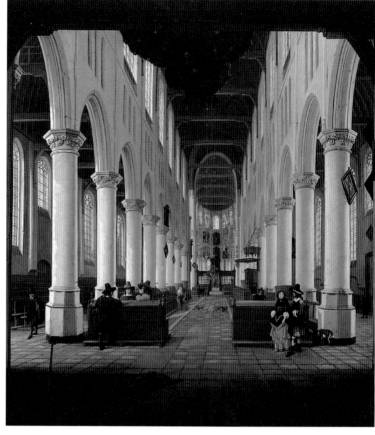

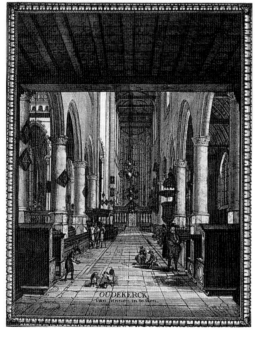

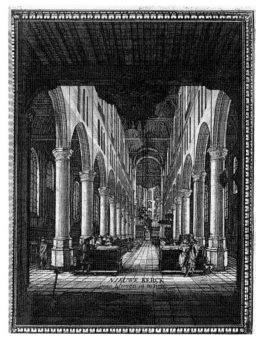

170
HENDRICK VAN VLIET,
*Oude Kerk in Delft (view
from the west entrance to the
east)*, 1662.
Oil on canvas, 95 x 85 cm.
Present location unknown
(formerly Amsterdam,
Houthakker Gallery;
photo: Utrecht, Centraal
Museum)

172
*Oude Kerk in Delft (view
from the west entrance to the
east)*, an engraved plate in
Dirck van Bleyswijck,
Beschryvinge der Stadt Delft,
Delft, 1667 (1680 edition)
(photo: Metropolitan
Museum of Art, New York)

173
*Nieuwe Kerk in Delft (view
from the west entrance to the
east)*, an engraved plate in
Dirck van Bleyswijck,
Beschryvinge der Stadt Delft,
Delft, 1667 (1680 edition)
(photo: Metropolitan
Museum of Art, New York)

171
HENDRICK VAN VLIET,
*Nieuwe Kerk in Delft (view
from the west entrance to the
east)*, 1662.
Oil on canvas, 95 x 85 cm.
St. Petersburg, Florida,
The Gilbert Collection

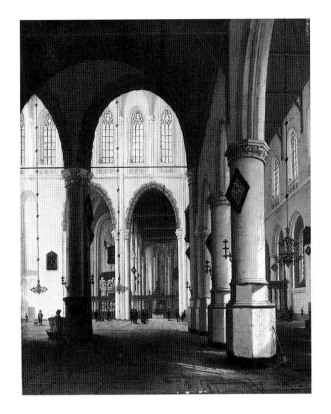

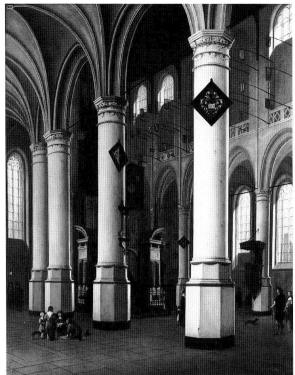

appreciation of how well Van Vliet himself has arranged the scene. The choir screen's doorways, open halfway, link the silhouetted colonnettes on either side to the backlit columns in the distant nave. Their recession is complemented by that of the northern nave elevation seen to the upper right of the open doorway (the whole composition would have become static if the artist had taken two steps to the left). The artist plays with positive and negative spaces: tablets and blind windows as opposed to the framed view of the nave (a miniature Van Vliet) and the archways of the transept resting like pediments on the choir screen. These and similar subtleties make the picture worthy of comparison with some of the finest architectural views by Van Vliet's fellow townsmen. It is easy to believe the family lore that the painting was commissioned by Adriaen Teding van Berkhout's oldest son, Paulus. And Paulus's oldest son, Pieter Teding van Berkhout, must have admired the picture, given what he liked about Vermeer in 1669: "la partie la plus extraordinaijre et de la plus curieux consiste dans la perspective."[212]

A few more conventional one-point views of the nave and/or choir of the Oude Kerk and the Nieuwe Kerk date from 1662 or about the same time. In Van Vliet's inventory of the Oude Kerk from the western doorway (fig. 170), the organ loft overhead and the nearest pews foil the railway-like recession. A pendant view of the Nieuwe Kerk is also dated 1662 (fig. 171).[213] The two pictures were reproduced by Van Bleyswijck (figs. 172-73) and were possibly commissioned by him.

Van Vliet reapplied the same scheme in an impossibly distant view to the Mariakoor (fig. 174).[214]

The artist's vantage point under the shadowy vaults of the northern aisle results in a composition filled with striking effects and diverting vistas; staffage is scattered in remote areas, inviting the eye to explore. The figures in the pendant perspectives of 1662 (see figs. 170-71), by contrast, are placed in the foreground and relate to the viewer like fish in a tank.

The construction drawings by Van Vliet that were discussed above (figs. 135-36) may be placed close to these paintings of the early 1660s. A few less accomplished pictures of similar composition would appear to be by an artist in Van Vliet's employ.[215]

The late works of Van Vliet, from the mid-1660s onward, rarely rise to the level of his earlier years. There are almost no new compositional ideas but some wonderful effects of light and atmosphere, as in a tranquil view of the Oude Kerk dated 1669 (Museum Briner und Kern, Winterthur).[216] The tomb of William the Silent (fig. 175) is approached from many angles, often showing only one corner or side.[217] It may be relevant that the period from about 1667 until 1672 was one of increasing sentiment in favor of the House of Orange (immediately preceding the stadholderate of Willem III).[218] But then, Van Vliet's subjects were always more significant to his contemporaries than they appear to modern eyes. Each one of the several hundred church interiors that were painted in Delft between 1650 and Van Vliet's death in 1675 went to individual households and were appreciated, presumably, in a variety of ways. Whether the church, the prince, the perspective, or something else was most important depended upon the artist, the owner, and the particular work.

CORNELIS DE MAN,
The Goldweigher, ca. 1670.
Oil on canvas,
81.5 x 67.5 cm.
United States, private
collection (photo: courtesy
of Otto Naumann Ltd.,
New York). See also
plate XVI.

CORNELIS DE MAN,
*Nieuwe Kerk in Delft with
the Tomb of William the
Silent (view from the rear)*,
1660s.
Oil on canvas,
121 x 102.5 cm.
Louisville, Kentucky, The
J. B. Speed Art Museum

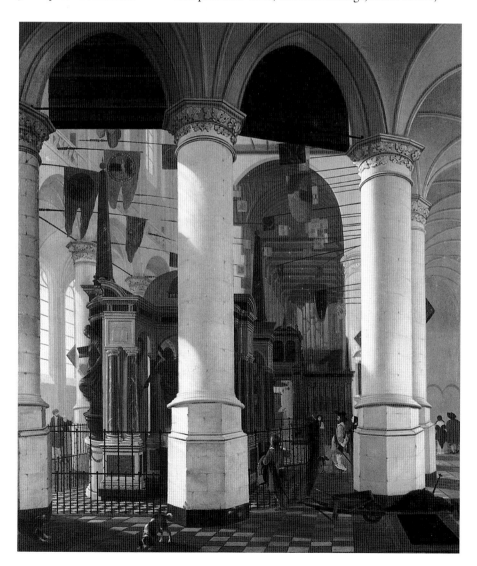

Cornelis de Man

In 1669, the year in which Pieter Teding van Berkhout praised Vermeer and Bisschop for their use of perspective, Jan Sysmus wrote that Cornelis de Man (1621-1706) "florissait dans la perspective."[219] This geometric fecundity is evident from the genre paintings alone. Several of them resemble approximately contemporaneous works by De Hooch, Van der Burch, and Vermeer (see fig. 283) in their clear articulation of cubical spaces, with rapidly receding ceilings, walls, and starkly patterned floors. In *The Goldweigher* of about 1670 (fig. 176; pl. XVI), De Man departs from his usual approach by using an oblique projection, which was rare in genre painting except for more naturalistic examples by Adriaen van Ostade, Ter Borch, and Steen. The latter achieved an intimate, almost accidental look in his interior views, particularly those in which walls recede at acute angles from the sides. One has the impression that Steen sat on a stool in the only corner of a bustling household where he could find enough elbow-room and distance to sketch the scene.

This impression is not what De Man was after. His panelled walls, beamed ceilings, stone floors,

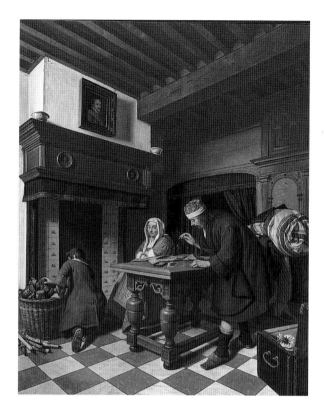

tiled fireplaces, and striped bed linen betray an enthusiasm for patterns per se. In the wide- and high-angle view of the goldweigher's tidy domicile, the floor and ceiling stretch to the four corners of the composition, and the fireplace, the table, the bowl near the upper left corner, and even the shadows eagerly obey the rules of the game. What inspired these demonstrative delineations? Was Abraham Bosse, that pedantic perspectivist from Paris, seeking shelter from his academic persecutors in a quiet corner of Delft?

The answer, of course, is – more simply – the current fashion, as well as De Man's regular practice of borrowing perspective schemes from Van Vliet. In the 1660s and 1670s De Man unexpectedly became Delft's fourth architectural painter of any consequence. Eight church interiors by De Man (five of them signed), five attributed to him, and ten from the "circle of De Man" were catalogued in my survey of 1982.[220] These categories reflect the fact that De Man was previously almost unknown as an architectural painter,[221] and that several works could not be seen firsthand. In recent years a few of the unlocated pictures have come to light, as have several church interiors by De Man that were known only to their owners and then usually under different names.

One of the former pictures is the canvas acquired in 1985 by the J. B. Speed Art Museum in Louisville (fig. 177). In its figure style, crisp contours, and local coloring, this rather festive record of the Nieuwe Kerk's choir is completely consistent in style with De Man's most typical genre scenes and his signed church interiors. In the latter and in unsigned but similar works (figs. 179-181), De Man all but

concedes that his knowledge of perspective was limited to drawing straight lines from rectilinear objects to the vanishing and distance points. Curved and polygonal forms, such as column bases, moldings, and capitals, appear tilted or lopsided, as do De Man's archways in other works.

Wheelock and De Vries observed some twenty years ago that the Louisville canvas is either a copy or version of a painting that is recorded by an engraving in Lebrun's *Galerie* (fig. 178). Wheelock accepted Lebrun's attribution: *Tableau Original peint sur bois par Em. de Witt*. De Vries, by contrast, saw the Lebrun picture as a transitional work by Houckgeest leading from Saenredam's one-point designs to the oblique projections of 1650.[222]

A composition that was evidently used by both Houckgeest and De Witte (fig. 147) seems to have influenced the Louisville painting and related works.[223] In the process, the original "two-point" perspective scheme was simplified to a one-point projection. (Thus, the rear of the tomb is frontal – parallel to the picture plane – whereas it recedes to the side in the earlier paintings and in photographs taken from the actual vantage point.) This redrafting of the design once seemed to the writer so consistent with Van Vliet's orthogonal views of the 1660s (see fig. 170) that he was tentatively considered the inventor. However, "the odd perspective of the column bases and the capitals [in the Louisville picture] is characteristic of Cornelis de Man, and so is the bright, white coloring of the architecture."[224]

Two more works by De Man that strongly recall Van Vliet's one-point designs of the 1660s are the

signed panel in Darmstadt, which represents the entire nave and choir of the Nieuwe Kerk in an off-center view to the east,[225] and a canvas (location unknown) in which the artist takes a similar but much closer approach to the choir of the Oude Kerk (fig. 179).[226] Both paintings feature De Man's characteristically coral-colored column bases, schematic foliage in the capitals, and moldings somewhat askew.

Another painting of the Oude Kerk by De Man, which surfaced in Paris in 1992 (fig. 180),[227] is a broader version of a composition known from a signed panel in a private collection in Germany.[228] The approach to the architecture ultimately goes back to Houckgeest's "pulpit view" in the Rijksmuseum (fig. 149), but numerous Van Vliets intervene. The palette is white, warm tan, and light gray, with eye-catching local colors in the costumes of the figures in the foreground. The man in the center recalls the ingratiating character on the right in the Columbus picture (fig. 181), which also features a young couple with a dog. The German version of this view includes one of De Man's more appealing figure groups, two boys watching a man digging a grave, just above the artist's signature (*CDMan fecit*).[229]

178
Engraving after Cornelis de Man (?), *Nieuwe Kerk in Delft with the Tomb of William the Silent (view from the rear)*, in J. B. P. Lebrun, *Galerie des peintres flamands, hollandais et allemands*, Paris and Amsterdam, 1792, II, no. 31 (as after Emanuel de Witte) (photo: author)

179
Cornelis de Man, *Oude Kerk in Delft (view from the nave to the choir)*, 1660s. Oil on canvas, 67.7 x 81.2 cm. Present location unknown (sold at Christie's, London, December 15, 1989)

180
Cornelis de Man, *Oude Kerk in Delft (view from the southern aisle to the north*, 1660s. Oil on canvas, 104 x 121 cm. Present location unknown (sold at Hôtel Drouot, Paris, December 14, 1992)

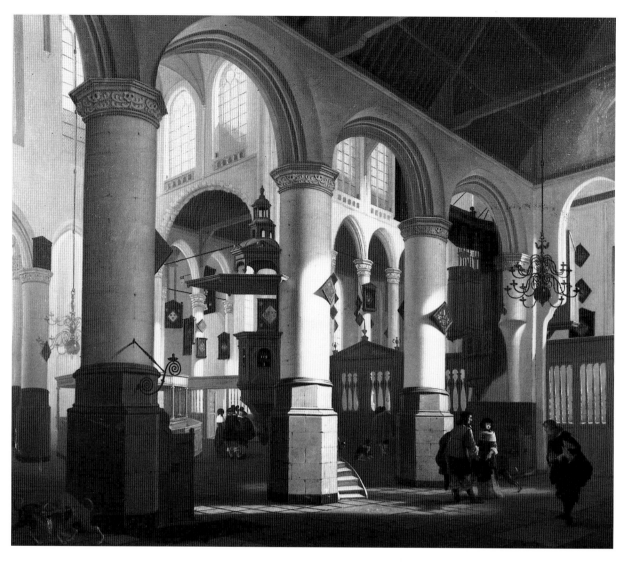

181
CORNELIS DE MAN,
*Oude Kerk in Delft (view
from the southern aisle to the
northeast)*, 1660s.
Oil on canvas,
101.5 x 121 cm.
Columbus, Ohio,
Columbus Museum of Art

De Man's style and his various views of the Delft churches (and in one picture in the Mauritshuis, the Laurenskerk in Rotterdam) do not require extensive discussion here.[230] His most common type of composition is found in about a dozen oblique views out of aisles, all of which are inspired by Van Vliet. Five were illustrated in my study of 1982.[231] Two more have since appeared, a deep prospect in the Nieuwe Kerk and a nicely balanced view toward the Oude Kerk's pulpit, with a distracting checkerboard floor.[232]

What is most interesting, in retrospect, is that De Man's views of Delft churches were painted in the first place. After a long trip to Italy he painted portraits in Delft during the 1650s, then turning to genre scenes and church interiors in the 1660s and 1670s. De Man was forty in 1661. He was related by marriage to a pastor and made several portraits of clergymen,[233] but this probably had less to do with his church interiors than did market demand and the artist's enthusiasm for perspective as a means of stylish design.

However, this does not explain the appeal of De Man's church interiors to every purchaser. In this period when Gothic architecture was disparaged by dilettantes,[234] the Delft churches were the main subjects of an extraordinary artistic development. Any native of the city would have understood why. Nothing in the small center of Delft suggests its long history and sense of community so much as the Oude Kerk and the Nieuwe Kerk. Paintings of Delft church interiors might have more particular meanings, but they were almost always expressions of religious conviction and civic pride.

Johannes Coesermans

Another part-time architectural painter of the 1660s in Delft was Johannes Coesermans, who joined the guild as an outsider on August 22, 1661.[235] His references to Van Vliet are so reminiscent of De Man in a few pictures that the latter may have influenced him. Also known, however, are a signed oil painting derived (directly?) from Houckgeest's "pulpit picture" in the Rijksmuseum (fig. 149), a Van Vliet-like painting of nearly the same subject, and a pen painting in grisaille of 1664 based on De Witte's *Nieuwe Kerk in Amsterdam* (fig. 161).[236]

Coesermans's pen painting of an imaginary Gothic church with a Baroque choir screen, formerly

in Orléans (fig. 182), is dated 1660 and bears some resemblance to Van Vliet's Teding van Berkhout view of the Nieuwe Kerk dating from the following year (fig. 169). The transept wall on the right, with a tripartite window over a blind archway, is adopted from forms in the same church's aisle (see fig. 183, far right). Perhaps another painting by Van Vliet, now unknown, inspired the composition (although similar designs were employed by De Lorme and De Blieck in the early 1650s). However, Coesermans's architecture and choir screen are invented, and the inscription above the tablets on the screen ("Godt sprack alle dese woerde"?) is a distinctive idea.

Other works do not convey this kind of message. In his beautiful pen painting of the Nieuwe Kerk dated 1663 (fig. 183), Coesermans carefully describes every part of the church (where has one ever sensed, as here, the vaults as masterworks of carpentry?) and inserts figures that look like the first guests to arrive at the grand opening of a shopping mall. The composition is very like that of De Man's undated but approximately contemporaneous painting of the same subject in Darmstadt,[237] and of works by Van Vliet, Saenredam, and even Houckgeest (fig. 152).

These comparisons place Coesermans's church interiors in the context where one expects to find a newcomer to the genre in Delft. They also reveal his peculiarities. Both the examples illustrated here have strong recessions – a field of tiles rushing away from the observer – and a naturalistic expansion of space to the sides. In each case, a pair of figures is set convincingly right in the foreground, their heads coincident with the area of the vanishing point. They focus our attention and put our feet on the floor, since all the standing figures of the viewer's approximate height have their heads at about the level of the horizon line.

To put it differently, one has not felt quite so "on the spot" in Delft since the early 1650s, when Houckgeest, De Witte, and Van Vliet set figures in the foregrounds of accessible spaces. And yet these orthogonal views by Coesermans are also very much of their moment, to judge from similar prospects painted by Van Vliet and De Man, Van Hoogstraten's *Corridor* of 1662 (fig. 97), and other pictures of sacred and secular spaces. Coesermans's inventions and his pen-painting technique, which he also used in seascapes with listing ships,[238] create the impression of a cleverly eclectic artist, perhaps a dilettante who was interested in draftsmanship, perspective, architecture, and the genre of architectural painting, each for its own sake and probably with no expectation of steady sales.

A technical refinement tends to support this intuition. All of the pen paintings by Coesermans, but most remarkably the one of 1663 (fig. 183), have extensive passages of stippling: areas of minute dots

that model forms, soften contours, and suggest atmosphere. The use of parallel and hatched lines elsewhere, especially in the areas of deeper shadow, would appear to indicate that the stippling technique and Coesermans's fine lines were adopted from engraving. Perhaps the ambiguity of the medium (his small paintings resemble varnished prints mounted on wood) was part of his work's intended appeal, as in the case of Goltzius's celebrated pen paintings.

In view of all this, it is not suprising that the obscure and somewhat eccentric Coesermans should be the one to have left us the least typical view of any location in Delft (fig. 184). Again one is impressed by prominent figures, which recall those in very few townscapes or any kind of architectural view (De Witte's painting of the Amsterdam Exchange comes to mind). The women and children seem to have arrived in the main square of a Dutch town in order to shop in the market, but like travelling cognoscenti they pause to admire the modern architecture. An interest in classical architectural design, which was hinted at by Coesermans's choir screen (fig. 182), is made manifest in this small panel signed and dated 1664.

Only the step-gabled house in the distance is more than a decade out of date. All of the buildings are fine or grand houses in the manner of Philips Vingboons, who employed the same sort of Ionic pilasters, carved swags, and arched doorways as seen in the mansion on the left, and who particularly favored gabled façades with scroll brackets rising to triangular or rounded pediments, oval windows, and urn-shaped or obelisk-like finials. In fact, Coesermans's ideal townscape appears to be informed

182
Johannes Coesermans, *An Imaginary Gothic Church with a Baroque Choir Screen*, 1660. Pen painting in grisaille, on panel (paper glued to panel?), 39 x 46.5 cm. Formerly Orléans, Musée des Beaux-Arts (photo: Lichtbeelden Instituut, Amsterdam)

by a single source: Philip and Joan Vingboons's *Afbeeldsels der voornaemste Gebouwen uyt alle die Philips Vingboons geordineert heeft*, Amsterdam, 1648. Reference to some older treatise, on perspective not architecture, accounts for the mannekin-like stiffness of the woman to the right, the identification of her beady eye with the vanishing point, and perhaps the deserted look of the streets.[239]

As in Vredeman de Vries's plates depicting Renaissance cities and in Van Bassen's views of courtly architecture (see fig. 124), Coesermans's townscape shows an idealization of a Netherlandish city. The site represented in his panel broadly resembles the Market Square in Delft in the section to the right of the Town Hall (leading to the old Fish Market). In Coesermans's concept, the city center is paved in square stones and somehow enlarged as well as remodelled, so that the medieval streets take on a Mediterranean air. This is not Fabritius's view of Delft (pl. III), nor De Hooch's vision of women and children in familiar courtyards and streets. Coesermans isolates a few formal qualities that were favored by Delft painters in the 1650s and enhances them in sympathy with fashionable artists in other cities, such as Van Hoogstraten in London and De Hooch in Amsterdam.

A few domestic scenes painted by Vermeer at about the same time reveal the same tendency. The composition of Coesermans's townscape is surprisingly like that of *The Music Lesson* (fig. 283), with its off-center rush of floor tiles, the receding wall on the left, the tidy plane of rectangles in the background, the figure in profile at the right frame, and the woman seen from the rear. The similarity is surely coincidental, given the currency of these conventions in the 1660s.

The increasing sophistication of Vermeer and his contemporaries might be considered regrettable by some of their admirers. In the pictures just mentioned one misses the sense of immediacy or even innocence that many viewers have discovered in the early scenes of everyday life in Delft. But then, those views were sophisticated in their own way. And the eagerness to appear cosmopolitan was a kind of innocence, too.

184
Johannes Coesermans,
An Ideal Townscape in Dutch Classicist Style, 1664.
Pen painting in grisaille, on panel, 20 x 17.7 cm.
The Netherlands, private collection

183
Johannes Coesermans,
Nieuwe Kerk in Delft (view from the nave to the choir),
1663.
Pen painting in grisaille, on panel, 52.3 x 44.5 cm.
United States, private collection (photo: courtesy of Otto Naumann Ltd., New York)

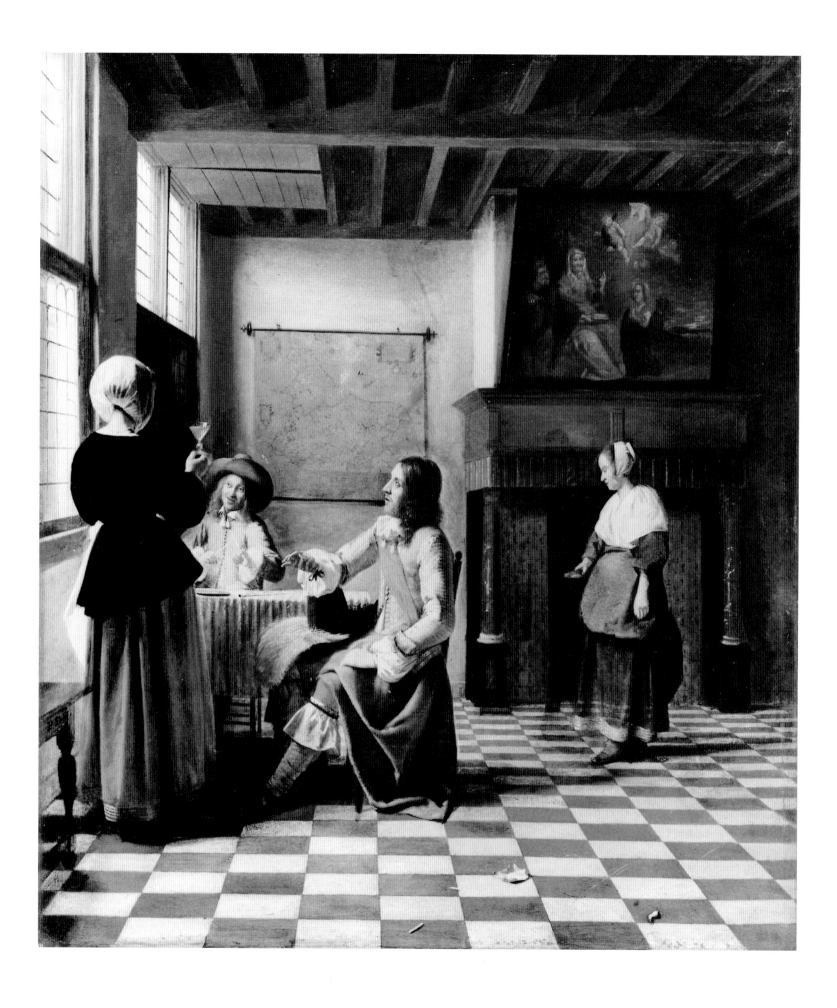

Chapter Four

Pieter de Hooch and the South Holland Tradition of Genre Painting

Pieter de Hooch (1629-1684) is generally regarded as the second most important representative of the Delft school, although this modern judgment would have confounded his contemporaries. He worked in the city but briefly, between about 1654 or 1655 and about 1660. Were the question raised early in that period, before the slightly younger Vermeer (1632-1675) and the somewhat older Cornelis de Man (1621-1706) painted mature works of the same kind, De Hooch's colleagues in the Guild of St. Luke might have been prepared to imagine that he would one day be considered the quintessential genre painter of Delft, although the category would have to be explained.[1] And one artist, Anthonie Palamedesz (1601-1673), would perhaps have been impatient with the whole business of historical hindsight, especially if he were informed that the young upstart from Rotterdam would spend the last twenty-five years of his life not in Delft but in Amsterdam. In 1658, the year in which the twenty-nine-year-old De Hooch painted several of his most admired compositions, Palamedesz was fifty-seven and a *hoofdman* of the guild, which he had joined as a native son eight years before his rival was born. The very artist who had inspired De Hooch's tavern scenes of the early to mid-1650s, the Rotterdammer Ludolf de Jongh (1616-1679), had studied under Palamedesz in the 1630s, painted genre scenes in his manner during the 1630s and 1640s, and still revealed the master's influence in his portraits of the 1650s. Another measure of Palamedesz's importance as a figure painter, which was presumably what *cortegardes*, *bordeeltjes*, *geselschaps*, *conversaties*, and so on mostly involved (see figs. 3, 186), is provided by the number of well-known artists who asked him to practice his specialty in their own pictures: for example, the architectural painters Dirck van Delen in Middelburg and Anthonie de Lorme in De Hooch's own Rotterdam. It seems unlikely that De Hooch was ever approached for the same service.

If historians have been somewhat neglectful of Palamedesz, they have been generous in their estimate of De Hooch. Despite the fact that numerous scholars, following Gowing's remarkable example,[2] have brought artists as diverse as Bartholomeus van Bassen, Quiringh van Brekelenkam, Gerard ter Borch, Dirck van Delen, Gerard Dou, Gerbrand van den Eeckhout, Samuel van Hoogstraten, Gerard Houckgeest, Ludolf de Jongh, Isaack Koedijck, Nicolaes Maes, Frans van Mieris, Anthonie Palamedesz, and Hendrick Sorgh into discussions of how the Delft type of genre interior developed in the 1650s, De Hooch is still credited with an extraordinary breakthrough. One would think that, like many Netherlanders who had worked in Rome, he had just arrived in a comparatively provincial location from some cosmopolitan place.

Blankert, for example, in attempting to explain Vermeer's progress in pictures of about 1658 to 1660, describes De Hooch's paintings of around the same time as the "external impulse" which prodded the junior genius to "develop a perfect synthesis of illusionism and 'classical' composition." The claim is made that "we do not know to what extent De Hooch adopted the new Delft manner [from whom?] in the years before his earliest dated works, 1658," but to judge from his known oeuvre of about 1650-57 (which answers the preceding question well enough) "his artistic career seems to have been a long, arduous trek to a peak." Presumably these years were spent in isolation, for Blankert invites the reader to "imagine what a sensation one of De Hooch's early masterpieces of around 1658 must have caused!" However, the work he illustrates (fig. 185 here) is not some foreign object that the natives would poke with sticks, but a rather static design in which De Hooch fails to focus attention as strongly as several artists had in this type of composition five or ten years earlier, for example, Brekelenkam and Koedijck in Leiden (see figs. 189, 203-4).[3] The

185
PIETER DE HOOCH,
An Interior, with a Woman Drinking with Two Men, and a Maidservant, ca. 1658.
Oil on canvas,
73.7 x 64.6 cm.
London, The National Gallery. See also plate XIII.

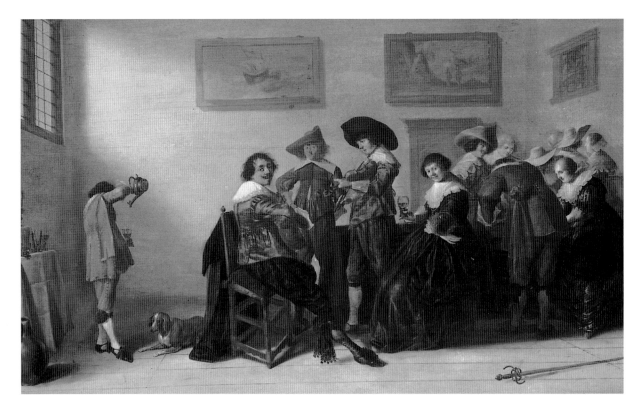

textbook perspective projection (compare the lower left corner of fig. 187) creates a cubical space that is less accessible and immediate than domestic interiors depicted in the early and mid-1650s by Brekelenkam, Ter Borch, Jacob Duck, Van den Eeckhout, Maes, and Vermeer himself (see figs. 199, 200, 217, 232, 241), not to mention church interiors by Houckgeest, Van Vliet, De Witte, and Anthonie de Lorme. Nor does

De Hooch surpass, at least in this picture, about half of the artists just cited in the rendering of daylight and atmosphere. It requires some conceptual leap, a quest for the archetypical, to reach Blankert's level of excitement about the way in which "De Hooch dares to pose his figures in the middle of a large, brightly lit chamber [where] the lines of the ceiling beams, tile floor, and window frames conform exactly to the laws of linear perspective ... We should not underestimate De Hooch's feat," for he was "the first to place figures in interior space with perfect truth to life."[4]

No reasonable assessment of De Hooch's career in Delft would fail to recognize the quality, importance, and even to some extent the originality of his pictures dating from about 1657 to 1660. The "left-corner" scheme which he employed in order to involve the viewer in the close confines of a domestic setting (as in figs. 185, 242) may be described as a counterpart to the "two-point" scheme that Houckgeest, De Witte, and Van Vliet developed about 1650-52. Similarly, De Hooch's rendering of daylight (especially in the *Card Players* of 1658; fig. 246) might be compared with De Witte's in the 1650s (see fig. 156), while his interior spaces, with their comparatively deep recessions and emphasis upon height (ceilings are included more often than not), recall Van Vliet's approach to the Delft church interior, although very similar perspective schemes were used by De Blieck and De Lorme (fig. 188). Moreover, Houckgeest's one-point compositions (compare figs. 150, 152) are hardly irrelevant. But one cannot attribute to the genre painter, as Blankert evidently does, a rôle comparable to that of Houckgeest, for De Hooch did

not record actual interior spaces (however plausible his settings sometimes appear), and he himself did not formulate the Delft type of genre interior.

What De Hooch did accomplish, rather like the architectural painters, was to carefully assimilate and modify well-established conventions, which he must have known not through a few pictures painted by "missing links" like Koedijck, Maes, and Sorgh, but from a large number of compositions dating from the preceding three or four decades. Most of these works were painted by artists active in The Hague, Delft, Leiden, Rotterdam, or Dordrecht. Thus it appears that in the late 1650s De Hooch gradually adopted a regional style. His classic works in Delft are among the best examples of what the present chapter maintains was a "South Holland" tradition of genre painting.[5]

The South Holland Tradition

The notion of a South Holland tradition or style is familiar from studies of seventeenth-century portraiture, where it is represented by painters in Delft and The Hague, such as Michiel van Miereveld, Jan van Ravesteyn, and Willem van Vliet (see figs. 2, 12). Until recently, the concept was not extended to the sort of genre scenes that were known at the time as "companies" or "conversations" ("high life" is one of the inadequate terms employed in modern literature), although Gowing implied that a historical pattern could be discerned. "The convention of form which Vermeer took up [in the Frick *Cavalier and Young Woman*, fig. 241] was of about thirty years' standing … One can trace in Vermeer's clear and rigid rectangle of space another sign of his acute eye for the essence of the varied elements in his tradition."[6]

A few lines earlier Gowing had observed that "the enclosing wall parallel to the plane of the picture and the windows on the left receding obliquely [or rather, orthogonally] toward it make up the unvarying [?] pattern to which he held throughout his work." Gowing refers briefly to interior views by the young Rembrandt "and the style which Dou derived from them," to the "followers of Frans Hals" (Dirck Hals and Hendrick Pot are mentioned), and to "the courtly cabinet pieces of the thirties" (works by Houckgeest and Hendrick van Steenwyck the Younger are cited in a note). With paintings by Vermeer like *The Music Lesson* (fig. 283) in mind, Gowing adds that "the more elaborate of his last works tend toward the pattern propagated by the painters of Leiden." All of these prototypes or sources, Gowing concludes, "share an architecture that is essentially the same and Vermeer adheres to it conservatively."[7]

Gowing undermines his own argument, in my

188
Anthonie de Lorme, *The Laurenskerk in Rotterdam (view from nave to choir)*, 1655. Oil on canvas, 136 x 114 cm. Rotterdam, Historisch Museum

view, when he goes on to maintain that "in the form [meaning composition], as in the figure motif, which he adopts in the *Soldier and Laughing Girl* [fig. 241 here], one origin predominates, the school of Haarlem."[8] In his analysis of that picture the painter-historian concentrates upon the device of silhouetting a male figure in the foreground, which he relates not to Honthorst but to Palamedesz (see fig. 266), Jacob van Velsen (fig. 4), and the early De Hooch, that is, Delft artists whose works were closely related (in Gowing's reasonable view) to genre painting in Haarlem. The latest thing in that vein was De Hooch's *Two Soldiers Playing Cards* in Zürich (fig. 240), which Gowing suggests is slightly earlier than Vermeer's canvas in the Frick Collection (fig. 241).[9] Sutton also compares the two paintings and concludes that De Hooch "seems to have been the more innovative artist at this stage."[10] But if Gowing and the present writer are correct in referring to a well-established convention and in claiming that "Vermeer adheres to it conservatively" in the *Cavalier and Young Woman* (admittedly, Gowing slightly overstates the case), then the question of which picture came first is less interesting than the simple observation that the pictures were painted at nearly the same time.[11]

An old joke in the halls of art history is that two similar objects indicate influence, and three represent a tradition. There are several reasons why the South Holland tradition, which is represented by a few hundred pictures, has not been widely recognized. Even Gowing tends to frame the question in terms of a great artist's "sources" and to provide answers by referring to the works of a few individuals, so that in the case of the Frick painting he overplays the hand

held by De Hooch in *Two Soldiers Playing Cards*. The same academic habits of mind that incline one to focus upon the most familiar artists and schools and a small number of "innovative" pictures (as if our subject were the early Picasso and Cézanne) encourage historians to overlook "conservative" artists (meaning someone like Dirck van Delen [fig. 221], not Gowing's Vermeer), long-lasting conventions, and styles that are essentially regional rather than typical of a particular artist or town.[12]

Another convention of art-historical discourse maintains that surveys of appropriate schools – and the Delft school certainly qualifies – are written principally in terms of advances in naturalistic description. The preceding chapters on architectural painting and on Fabritius's *View in Delft* reveal little hostility to this idea. But long practice (in our discussion of Houckgeest and De Witte we dated it back to the decades of Hans Jantzen and Monet) has conditioned scholars to describe this development as the product of ever more discriminating attention to the actual environment, as if Vermeer's paintings were comparable to Leonardo's notebooks or to the microscopic revelations of Anthony van Leeuwenhoek (the scientist has been associated with Vermeer so frequently that he is often imagined to have modelled for him).[13] Insufficient thought has been given, despite Gowing's and Gombrich's analyses,[14] to the force of stylistic conventions in even the most naturalistic examples of Dutch art.[15]

Thus, De Hooch makes a "long, arduous" effort to render "figures in interior space with perfect truth to life."[16] Even De Hooch's and Vermeer's assimilations of perspective practice have been viewed in this light, no matter how antagonistic "artificial" perspective and "natural" vision seem to us now and seemed to Panofsky a decade before the first essays on interior space in Dutch genre painting were published.[17] For the authors of those studies, types of composition, such as the left-corner scheme, and useful devices like receding windows and door-ways leading to secondary spaces were not learned or invented but simply bumped into as the Delft painters ambled about the house.

Alpers seems to suggest that their palettes were discovered in a similar way, although earlier writers like Eisler had compared the color and light in paintings by De Hooch and Vermeer to the luminous pictures that Houckgeest, Fabritius, De Witte, and Potter painted several years earlier.[18] Like colored drawings by northern artists, which, according to Alpers, "document [?] *what* appears and also render *how* it appears," paintings by "a number of Holland's leading artists – Hals, De Hooch, Vermeer" – in effect draw and color their subjects at the same time. "The notable absence of any drawings [by them] suggests that for such artists – and this is most self-

consciously true of Vermeer – representation takes place directly in color and therefore in paint."[19] As usual with Alpers's wordplay, it is not clear what she means, but it does not appear from this passage that De Hooch spent much time looking at works by other artists to see what they chose to represent, how they organized their compositions, or by what painterly methods they achieved their naturalistic effects. The statement comes much closer to Veldman's concluding remark about the Delft school in general, "a typical feature [of which] is the use of a camera obscura in order to create the most realistic scene possible."[20]

In his discussions of De Hooch's stylistic development Sutton has suggested a number of sources which are for the most part consistent with those Gowing cited in connection with Vermeer.[21] However, Sutton's approach comes closer to that of earlier writers such as Bouchery, who in the 1950s described artists like Ter Borch and Koedijck (fig. 189) as "links in the chain" leading to the light-filled and habitable interiors of the Delft painters.[22] Ter Borch, Van den Eeckhout (fig. 199), De Jongh, Sorgh, Houckgeest, and De Witte in the early 1650s, and even Van Bassen and Van Delen (who represented "an alternative and decidedly minor trend"), are awarded honorable mentions by Sutton, along with Koedijck, Maes, the irrelevant Jacobus Vrel, and some optical instruments ("the unrivalled visual fidelity of the camera obscura surely would have been of interest to an artist with De Hooch's concern for naturalistic appearances"). The pictures composed by these artists up to about 1657 are appraised as sources for the Delft painter, who nonetheless "fashioned his own style." Sutton explains that "by 1658, the year in which his first dated pictures appear, [De Hooch] displays a masterly command of the techniques of space construction, the use of perspective, and the treatment of light and atmosphere."[23] Comparing pictures of domestic interiors by Maes and Vermeer (see figs. 233-34), Sutton concludes that "it was only with De Hooch's painting of ca. 1658 that continuous and perspectively coherent space was fully realized. Within the tradition of interior genre the degree of naturalistic probity in these scenes was unprecedented."[24] More recently, the same scholar stressed that, with all due respect to Vermeer, "De Hooch (who was three years older) was probably the first to master the illusion of space and subtle lighting effects," which makes him "a leading practitioner of the so-called Delft school style, the sources of which are still open to discussion."[25]

Indeed they are, and Sutton deserves credit for recognizing the complexity of the problem. Even Gowing, with his surprising reference to "the school of Haarlem" as Vermeer's touchstone at a crucial

moment in his development, subscribes to the simplistic image of the "North Holland" city as the nesting place of naturalism in Dutch art. This reputation has long linked the Haarlem school of about 1620-40 with the next generation in Delft. The torch of faithful description, empirical observation, and enlightened innovation in the Early Modern Age is passed from one city to the other, but just who carried it remains obscure.

The prime suspects are Fabritius and De Hooch, who were trained in the closely associated art centers of Amsterdam and Haarlem. The older artist, Fabritius, is usually given the lead. De Hooch's seemingly sudden advance of about 1655-58, which (in Slive's survey) "anticipated certain elements of Vermeer's mature period … was perhaps due to contact with the art of Carel Fabritius and other [unnamed but] congenial Dutch painters."[26] How this makes Fabritius the "link between [Vermeer] and Rembrandt" seems to be lost in the rubble of his studio.[27] It does appear that Fabritius and his co-pupil Van Hoogstraten first developed their mutual interest in illusionism and perhaps in linear perspective during the period in which Rembrandt was painting *The Night Watch* (finished 1642) and *The Holy Family* in Kassel (1646),[28] but both artists remained Rembrandtesque figure painters until after they moved to cities in the South Holland region. Van Hoogstraten returned to his native Dordrecht in about 1646-47 and in the next few years painted pictures which share some qualities (illusionism, light, textures, and a fluid technique) with Fabritius's work in Delft. Virtually everything in the latter's oeuvre that may be compared meaningfully with De Hooch and Vermeer was, so far as is known, produced in Delft between 1652 and 1654.

How much De Hooch and his fellow Rotterdammer, Jacob Ochtervelt (1634-1682), owed to their training under Nicolaes Berchem in Haarlem is uncertain, but historians from Houbraken onward emphasize that, as an artist "who was excellent in the painting of interior views," De Hooch followed ("hem volgt") Ludolf de Jongh in Rotterdam (see fig. 209).[29] In any event, De Hooch's strongest ties were in the South Holland area. He and the Delft painter Hendrick van der Burch (active 1649-d. 1678), who was most probably De Hooch's soon-to-be brother-in-law (De Hooch married Jannetje van der Burch of Delft on May 3, 1654), were recorded as residents of Delft when they witnessed the signing of a will on August 5, 1652. Both genre painters also had contacts in Leiden.[30] As is well known, in May 1653, "De Hooch, schilder," was described as being in the service of Justus de la Grange (also known as Justinius de la Oranje), a linen merchant living in both Delft and Leiden who in 1655 owned eleven pictures by the artist.[31]

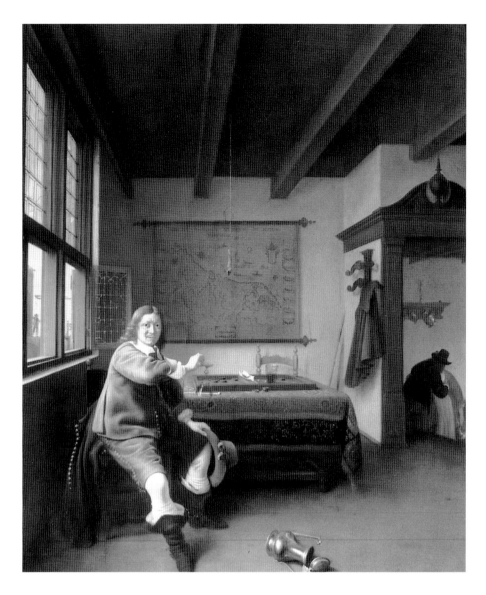

It seems likely, then, that for a time De Hooch went back and forth between cities in the region, between Delft and Leiden and between Delft and Rotterdam (where he was said to reside at the time of his marriage).[32] This lends a little weight to comparisons between De Hooch's most distinctive works in Delft and the similar pictures that De Jongh and Sorgh painted somewhat earlier in Rotterdam (see figs. 207, 209) and between the same De Hoochs and earlier pictures painted by less familiar masters in Leiden, such as Koedijck and Adriaen van Gaesbeeck (see figs. 202-3).[33] However, most scholars have searched for antecedents in Amsterdam, where Nicolaes Maes (Sutton suggests) may have picked up some pointers from Koedijck – the Dordrecht and Leiden painters were both in Amsterdam during the late 1640s – and then somehow passed them on to De Hooch a little later.[34] One fly in the ointment of this hypothesis is that all of Maes's domestic interiors and his interest in linear perspective appear to date from at least two years after his return to Dordrecht in 1653. The "missing-link" theory and its correlate, the "connect-the-dots" approach to a historical sketch of Dutch genre painting, routinely run into

189
Isaack Koedijck,
The Empty Glass, 1648.
Oil on panel, 66 x 55 cm.
Present location unknown
(sold at Sotheby's,
London, July 6, 1994)

problems of chronology and geography. This suggests that a survey based upon dates and locations – decade by decade and region by region – would be less conjectural.[35]

Of course, this approach also presents hazards. Unlike the South Holland portraitists, whose consistent style suited the conservative taste of patrons in the area of Delft and The Hague, genre painters were much less bound to particular places and customers. They almost never worked on order, their pictures were often sent elsewhere, and the artists themselves travelled frequently, absorbing new ideas and perhaps finding new clientele (the rôle of dealers was mentioned above). Genre paintings of both the "low" and "high" variety were sold in many places during the first half of the century. In terms of production, peasant scenes were prevalent in Haarlem, Amsterdam, and Rotterdam; guardroom and brothel pictures were well represented in Amsterdam, Utrecht, and Delft; and paintings of more elegant companies were made by artists in The Hague and Delft, as well as in Haarlem and Amsterdam (not to forget Willem Buytewech in Rotterdam).[36] The last category especially, that of "merry companies" (as depicted by artists such as Buytewech, Dirck Hals, Pieter Codde, Willem Duyster, Esaias van de Velde, David Vinckboons, Jacob Duck, Van Bassen, Van Delen, and Palamedesz), reveals so many inter-relationships between painters active in different places that the search for possible points of contact would seem rather naive (did Maes know Koedijck, did De Hooch know Maes, did Vermeer know Ter Borch – yes! – and so on).[37]

The essential subjects of these "companies" and "conversations" were modern manners and fashions, which must have encouraged a cosmopolitan outlook toward whatever was new in the field. The oeuvre of Ter Borch, and even the drawings and poems that his sister Gesina assembled in albums in Zwolle,[38] show a sophisticated awareness of cultural trends in Amsterdam and other cities, and are probably atypical of the genre only in that the Ter Borchs were active in more provincial places than any of the cities mentioned above.

Both Gerard and Gesina ter Borch could be said to have drawn most of their inspiration from artists and writers in Amsterdam. The increasing influence of the great commercial capital (which became the effective center of political power in the United Provinces in 1653) is another reason why one might exercise caution in speaking of regional styles. When artists moved about after 1650 their destination was more often the same place: Amsterdam, as we have seen with Delft painters such as Willem van Aelst, De Hooch, and De Witte. Others, trained in Amsterdam, reveal strong traces of the experience years after settling in another area. The

predominance of Amsterdam as a social and artistic center in the 1650s and 1660s must have encouraged the exchange of ideas between genre painters in various parts of the Netherlands, to an extent greater than that found in the first half of the century.[39]

While these qualifications are sobering for the argument that genre painters in Delft worked to some extent within a "South Holland tradition," they also lend the hypothesis considerable support. Let us consider the usual question: how important were certain pictures painted in the 1640s and early 1650s by artists such as Koedijck in Leiden, Maes in Dordrecht, and Van den Eeckhout in Amsterdam for De Hooch and Vermeer in the late 1650s?[40] The answer offered in this chapter is: less important than has been supposed. Of course, all the examples usually cited are relevant to the "Delft type" of genre painting in that they represent approximately contemporaneous developments along similar lines, and the apparent influence of Van den Eeckhout, Jacob van Loo, and perhaps even Ter Borch could be considered an illustration of Amsterdam's significance for other schools. It seems likely, however, that none of the artists in question was individually important for the styles of De Hooch and Vermeer. Indeed, one may stand the usual question on its head: given that De Hooch and Vermeer were well aware of Ter Borch, Maes, Koedijck, Van den Eeckhout, Van Loo, Van Mieris, and other inventive artists of the moment, and given that in some works – for example, Vermeer's *Maid Asleep* (fig. 261) and De Hooch's *Visit* (fig. 242) – each Delft painter seems to have responded to one out-of-towner in particular (Maes and Van den Eeckhout, respectively, in these instances), why is it that they promptly went on to paint pictures that really have little to do with the source of influence and that may be described as distinctive of Delft? Of course, independent personalities will always emerge, as in the case of Vermeer. But this does not explain why De Hooch and Vermeer, though they were not birds of a feather, adopted similar schemes at about the same time, nor does it explain why De Jongh, Maes, De Man, Van Mieris, and others active in or not too far from Delft deserve to be included in the body of evidence. In looking for sources, in discerning some instance of one painter's appreciation of another's style, the "missing link" might be what the responding artist demonstrates *despite* the obvious influence: that is, the tug of tradition, the return to type.[41]

Early surveys of Dutch genre painting

In posing these questions one must pay homage to scholars of the past who took on the then nearly impossible task of sketching out a history of Dutch

genre painting. Würtenberger and Von Weiher, working independently of one another and parallel to students of other subjects in Dutch art (for example, architectural painting), described a development leading from origins in Haarlem (ca. 1610-1635) to a culmination in the Delft school. In their Hegelian contrast of local and perhaps regional schools (Amsterdam and Haarlem artists are always discussed together), the Haarlem type of genre interior is seen as essentially a figure painting with a subordinate, stage-like setting or backdrop (see fig. 190). The architecture consists mostly of isolated elements, such as a doorway or fireplace, and is uncertain in structure; the general lack of interest in perspective often makes the position of a figure or piece of furniture, or of the viewer himself, unclear. By contrast, in pictures painted in Delft after the mid-1650s, the figures, furniture, and architecture appear to be placed on equal terms by the artist's use of light and shadow (less of the latter now) and of linear and aerial perspective. De Hooch and Vermeer achieve a convincing continuity between form and space and between the near and far sides of the picture plane.

Like all historians, the scholars of the 1930s who first attempted to trace the development of Dutch genre painting were at pains to make the evidence (which they knew mostly from earlier articles) conform to the logic of language and of cause and effect. Thus they created, and many students still

retain, a mental image of genre scenes progressing through the second quarter of the seventeenth century and down the map, from Haarlem and Amsterdam to Delft, bringing something where there was very little, for example, the early work of Palamedesz (fig. 186), whose style derives (in part) from Haarlem in any case. The southward moves of De Hooch, Ochtervelt, Maes, and Fabritius, the incidence of intriguing pictures seemingly *en route* (that is, in Leiden), and the meeting of Ter Borch and Vermeer in 1653 seem to lend support to the story

190
PIETER CODDE,
A Merry Company,
162(4 or 9?).
Oil on panel, 39.8 x 58 cm.
New York, private
collection

191
BARTHOLOMEUS VAN
BASSEN (figures by
Esaias van de Velde),
A Company in an Interior,
ca. 1620.
Oil on panel, 72 x 100 cm.
Amsterdam, Rijksmuseum

told in similar essays for fifty years, one of which is the chapter on genre painting in the Pelican volume devoted to Dutch art.[42]

Taking a broad view in the present chapter need not lead us back to the simple schemes of yesteryear, since we now have vastly more visual and documentary material and perhaps fewer preconceptions than did scholars of sixty years ago. Their essays fulfilled the function of first efforts, which is to raise questions and, in failing to answer them, to reveal what is unknown. Bouchery, for example, introduces that later staple of the survey course, a comparison between Vermeer's mature genre interiors and the Arnolfini portrait by Van Eyck.[43] He identifies their similar qualities as "northern," and observes that, nonetheless, "it does not seem possible to trace a line of development from Van Eyck to Vermeer and Pieter de Hooch." Plietzsch reached the same conclusion, writing more broadly of a large gap between Early Netherlandish paintings of interiors and those by Vermeer (and, curiously enough, by Ter Borch). De Hooch, by contrast, is compared with Carpaccio: "the ceilings lead back into depth; the checkered floor … the view through an open door … to another room."[44]

Twenty years earlier, Lucy von Weiher, who revealingly managed to anticipate Alpers and follow Wölfflin at the same time, described two kinds of pictorial space in European art, the "southern" or Renaissance conception of space which is rationalized by linear perspective, and the "northern" or empirical approach by which space is described in terms of light and shadow, color, the texture and clarity of objects, and so on.[45] Clearly, Ter Borch is northern and Carpaccio southern (with a touch, as in Leonardo, of the north?), but then what does one say about De Hooch who in the 1660s looks like a Dutch Carpaccio? Von Weiher offers a brief explanation: the Renaissance conception of space arrived in the Netherlands during the sixteenth century, when Antwerp artists (for example, Vredeman de Vries) were profoundly influenced by Italian painting, art theory, and treatises.

The importance of this "Flemish connection" would not be questioned in the case of architectural painters such as Van Bassen and Houckgeest. The idea of a parallel development in genre painting has not been widely entertained, although Schneede and Sutton suggest that the palace views painted by Van Bassen and Van Delen (see figs. 191, 219) may have been of interest to De Hooch.[46] On balance, however, Sutton sees the earlier painters of patrician genre scenes as representing "an alternative and decidedly minor trend." This is a vast improvement upon Plietzsch, who somehow discovered that the same artists' fancy interior views were "disdained by the Dutch little masters as something strange."[47]

Gentrification

Presumably, Plietzsch would also have found it strange that a number of De Hooch's contemporaries – "little masters" like Ter Borch, Potter, Cuyp, Maes, Wouwerman, Van der Heyden, and De Witte – employed a variety of previously patrician forms in their works dating from the 1650s and 1660s. Van Dyck-like portraits, equestrian portraits, hunting and even hawking scenes, views of country houses, and so on flourished in this (on the whole) prosperous period. Ludolf de Jongh placed hunting parties, as well as Diana and her companions, in both northern and southern landscapes dating from 1644 to about 1655. The fashionable couples with greyhounds that appear in De Witte's church interiors of the early 1650s (fig. 155) look like they have come in from fox hunts painted slightly earlier by De Jongh.[48] In this artistic and social climate, which is well known to students of Dutch art (although the focus is usually on either portraiture or painting in Amsterdam after 1650), it is not surprising that artists such as De Jongh, De Hooch, and Vermeer (in works such as *The Glass of Wine* in Berlin; fig. 269) would adopt motifs and compositional conventions from pictures by Van Bassen or, more likely, Van Delen and Gonzales Coques (figs. 219-22), both of whom also worked for courtly clients at The Hague during the 1640s. These painters, and such related figures as Van Steenwyck in London (where he probably painted *The Lute Player*, fig. 289) and Abraham Bosse in Paris, depicted Flemish-style views of polite society in "designer" living rooms. As discussed below, this type of "high genre" scene appears to have made a strong impression in Delft and a little later in Amsterdam, which is hardly unexpected at a time when an upwardly-mobile middle class was adopting forms from their more gentrified contemporaries.

A brisk survey of Dutch genre painters active from about 1655 to 1665, or even from about 1657 to 1662 in the case of De Hooch and Vermeer, reveals a tendency toward greater refinement in dress, interior decoration, and social behavior, with themes like letter writing, sipping wine, playing chamber music, and putting on jewelry becoming more popular. The interior itself, with tasteful appointments, becomes an important part of the picture's content, unlike the interiors that serve as simple settings for "merry companies" and similar figure groups in paintings of the 1620s and 1630s. In this regard, the fancy interior views of the 1660s and 1670s, like those De Hooch painted in Amsterdam, are closely related to other pictures of patrician lifestyle and especially to those that feature luxurious residences. Examples would include scenes with fashionable figures set in formal gardens, often with a grand country house in

view. De Jongh, De Hooch (as in the *Skittles Players in a Garden* of about 1665, in St. Louis), Van der Heyden, and even Jacob van Ruisdael took up the theme.[49] Perhaps because they are considered "architectural" not genre paintings, the villa and "loggia" views that De Blieck (see fig. 138), De Witte (e.g. *Loggia on a Harbor*, 1664, formerly in The Hague), and reportedly Houckgeest painted in the late 1650s and 1660s are not usually mentioned in the same breath, and of course these pictures are less familiar even to specialists.[50] But they probably appealed to the same sort of patron as did Ochtervelt's scenes set in fancy foyers, De Jongh's in courtyards and gardens, and De Hooch's in gardens and marble-floored reception rooms. Not only De Blieck, who was from Van Delen's own Middelburg, but also De Witte derived their loggia and villa views in part from Van Delen, who, it is worth recalling, was still active throughout the 1660s.[51]

In a broader view, Dutch pictures of society gathering in gardens, conversing in courtyards, or tarrying on terraces may be seen as adopting themes that go back to Hans and Paul Vredeman de Vries (see fig. 74) and Lucas van Valckenborch (before 1535-1597) and that were then continued by Van Bassen, Van Delen (fig. 220), and Van Steenwyck (and in family portraits, by Flemings such as Coques).[52] The usual references to Buytewech and Esaias van de Velde are appropriate, of course, but their garden parties usually lack the architectural component that is so conspicuous in terrace scenes by Van den Eeckhout and Van Loo,[53] and in garden, terrace, and courtyard views by later artists such as De Hooch and De Jongh (Van Hoogstraten's palace court, gallery, and garden views are hardly typical but deserve mention also). An exception is found in the terrace scenes with "merry companies" that Van de Velde painted in collaboration with Van Bassen during the 1620s in The Hague.[54]

Sutton makes a similar observation along more formalist lines: De Hooch's Amsterdam interiors, if not those painted in Delft, "call to mind the very De Vriesian tradition [Van Bassen and Van Delen are specified] that the master's work of the late 1650s had done so much to supplant [?]. No doubt the memory of the older spatial formulae was invoked with full knowledge of its associations with the grand and luxurious interiors of an earlier era. Although a number of Dutch genre painters, including Ludolf de Jongh, Hendrick van der Burch, and Vermeer, experimented with more rigidly cubic interiors in the 1660s, De Hooch sustained the greatest interest in these designs and most successfully realized their compatibility with elegant 'high life' themes."[55]

The same connection has been underscored by Keyes. "Van Bassen was a crucial link between the idiom of Hans and Paul Vredeman de Vries and the interiors of Pieter de Hoogh and the architectural paintings of Dirck van Delen, Pieter Saenredam, Gerard Houckgeest, Emanuel de Witte, and others." He draws attention to the many vistas into adjoining rooms or courtyards in Van Bassen's pictures (fig. 191). In contrast to the older Flemish models, "contiguous space is implied," and Van Bassen "is concerned about lighting and the way it is registered on each surface." While it is true that "Dutch art still had a long road to traverse before the exquisite rendering of light infused the atmosphere of Vermeer," Keyes concludes that "Van Bassen's experimentations were a significant step in this direction."[56]

These lines are refreshing though disappointing in their teleological argument that Van Bassen paved a path leading toward De Hooch and Vermeer. Dutch painters worked in different places for different kinds and levels of society. Perhaps the most revealing similarity between Van Bassen and Vermeer was not stylistic but economic. Their painstaking techniques, however different, were both expensive, and required a corresponding level of clientele.

Delft and other 'Schools'

Over the past few decades a great number of prototypes and parallels have been proposed for genre paintings of the "Delft type," of which De Hooch's compositions of the late 1650s may be considered the most representative examples. As Sutton notes, the "De Hooch School" has occasionally been employed as a misnomer of convenience. None of the artists who are commonly associated with the artist, such as Cornelis Bisschop, Hendrick van der Burch, Pieter Janssens Elinga, Cornelis de Man, Jacob Ochtervelt, Jacobus Vrel (who was probably from somewhere north of Amsterdam), and even Esaias Boursse, is known to have studied with De Hooch, and only two of them were from Delft.[57]

A beneficial by-product of this academic harvest has been the realization that the kind of genre interior that earlier writers associated almost exclusively with Delft was represented also by artists active at about the same time or a bit earlier in Amsterdam, Leiden, Rotterdam, and Dordrecht. In a *vogelvlucht* it might be noticed – not that Dutch readers need to be told – that all these cities are in Holland, not in Friesland, Overijssel, Gelderland, or Utrecht. In other words, the mature type of Dutch genre interior was itself a regional product. It will be interesting to see how studies of inventories now underway and yet to be undertaken relate to the subject. How regional was demand?

Of course, it is not always easy to say when a style is no longer local but not yet national in a country

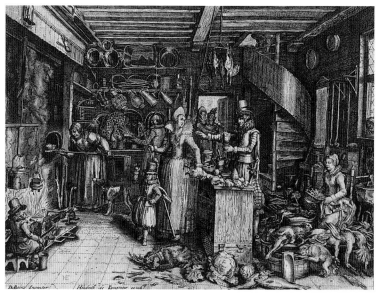

the size of the Netherlands. Local "schools" were not nearly so separated from each other as were Italian cities in the Renaissance.[58] Nonetheless, one may read in recent literature remarks about a painter's reputation spreading beyond the cosy little confines of Delft when a picture turns up about an hour away,[59] and conjectures about two artists having met (as if that were the best way to share pictorial ideas) when barge service between their cities ran five or six times a day. It might almost be more reasonable to assume that each painter of note in all of Holland and the province of Utrecht was generally familiar with the work of every other one, and then focus upon evidence to the contrary: that is, apparent indifference to artists working in the same field. Support for this view comes from the fact that artists often worked as official appraisers of pictures, no matter what their source (as Reindert Falkenburg kindly noted on my manuscript).

In the following review of various cities in the regions (later provinces) of North and South Holland, our main concern is the period from about 1620 to 1660, when the "merry companies" by painters such as Dirck Hals and the guardroom interiors by Codde, Duyster, and others (for example, the Delft native Simon Kick, who also made his career in Amsterdam) were gradually supplanted by scenes of cavaliers and young women by Ter Borch, Van den Eeckhout, and Van Loo; by various kinds of "domestic" interiors, including those of the "Delft type"; by Adriaen van Ostade's polite peasant pubs and cottages;[60] and by Jan Steen's interior views, which, unlike contemporary Delft examples but like his figures, usually look a little loose at the seams. The great diversity of genre scenes dating from the 1640s and 1650s (a period of economic expansion) contrasts with the situation in the previous two decades. The type of interior that Van Bassen painted

in "South Holland" bears little resemblance to the more naturalistic, perhaps more Baroque, and certainly less pretentious interiors that were painted at the same time in Haarlem and Amsterdam.

In the period before about 1620, however, it is not unusual to find drawings and especially prints by "North Holland" artists that reveal the same sixteenth-century Flemish roots as do paintings of Van Bassen's type. Claes Jansz Visscher's engraving of 1609, *Saying Grace* (fig. 192), David Vinckboons's *Kitchen Interior* of about 1616 (fig. 193), and the same artist's *Boerenverdriet (The Peasants' Sorrow)*[61] – which anticipates, in its setting and wide-angle perspective, barn interiors by De Jongh, De Hooch, and Metsu – are Amsterdam examples of the kind of cubical interior one finds frequently in Flemish art from about 1550 to 1600.[62] As in more exclusively architectural subjects, such as Van Bassen's church interior of 1620 (fig. 101), North Netherlandish views of domestic interiors show signs of gradual progress toward a more naturalistic style. Visscher's scene (fig. 192) is more advanced, and perhaps more Dutch, than the contemporaneous paintings and prints of Paul Vredeman de Vries, and, in its conception of space, anticipates compositions by Van Bassen and Van Delen dating from twenty years later. Even the foreshortened Dutch door on the right in *Saying Grace* is assigned such convincing illumination and detail that its similarity to demonstrations in contemporary perspective treatises (fig. 194) seems beside the point.

Haarlem and Amsterdam

That genre interiors like those by Visscher and Vinckboons were well known in Haarlem and Amsterdam, at least through prints and drawings, makes it all the more striking that their equal is rarely found in paintings of about the same time. Drawings

by Buytewech demonstrate that he was quite capable of arranging architectural elements and employing linear perspective; in the case of a few of his sheets dating from about 1617-22, one would think that the interiors painted in the 1650s by Sorgh, Steen, and Brekelenkam were less than a decade away.[63] Similarly, Esaias van de Velde (ca. 1590-1630), who worked in Haarlem from 1610 to 1618 (when he moved to The Hague), made drawings of interiors in the 1620s (fig. 195) which recall the *Kitchen Interior* by Vinckboons (who was possibly his teacher) and Visscher's *Saying Grace*.[64] But these artists never painted interior views comparable with examples of the 1640s onward in Leiden, Delft, or Rotterdam. Haarlem genre paintings, from the time of Frans Hals's so-called *Yonker Ramp and his Sweetheart* of 1623 (Metropolitan Museum, New York) through the 1630s, are often remarkable for their observed qualities, including their descriptions of space, but these compositions are conceived essentially in terms of figure groups, with settings that sometimes seem to have been filled in almost as afterthoughts. Hals's inn scene behind "Yonker Ramp" is a clever backdrop, while Buytewech's usual interior is a shallow stage.[65]

Exceptions to the norm in Haarlem came by way of South Holland and Zeeland. Esaias van de Velde's drawings of interiors composed in approximations of orthodox perspective (fig. 195) date from his last decade, when he worked in The Hague as a figure painter for Van Bassen (figs. 101, 118, 191). This collaboration may have led to the similar partnership of Dirck van Delen and Dirck Hals in four or five known paintings dating from 1628 and 1629 (fig. 196).[66] (Van Delen worked mostly in Middelburg and in the nearby village of Arnemuiden, but he appears to have had clients at The Hague; see figs. 219-20.) Perhaps Van Delen's collaboration with Dirck Hals and a few other North Holland artists – figures in his paintings have been attributed to Jan Olis, Pieter Codde, and others – influenced their independent works, at least when the model of a fashionable interior was relevant to the task at hand.[67]

Interior views by Visscher, Vinckboons, and others were well known through prints, but painted examples would have made a strong impression, especially if they did well on the art market. Two luxurious interior scenes by Van Bassen (with figures by Esaias van de Velde), "A Banquet" and "An Interior including the Parable of Lazarus and the Rich Man," were valued at fl. 150 and fl. 108 by the painters Hans Jordaens and Cornelis Jacobsz Delff for a lottery (including four church interiors by Van Bassen and Van de Velde) organized by the glass painter Cornelis van Leeuwen of Delft in 1626.[68] The large panels produced by Van Delen with Dirck Hals must have been assigned values at least as high.

194
HANS VREDEMAN
DE VRIES,
Perspectiva …, The Hague
and Leiden, 1604-05,
Part 1, Plate 28.
New York, The
Metropolitan Museum
of Art

In any case, a number of Haarlem-style genre scenes – for example, Dirck Hals's *Seated Woman with a Letter* of 1633 (Philadelphia Museum of Art) and the similar painting of 1631 in Mainz (fig. 197), *The Painter's Studio* of 1631 by Molenaer (Staatliche Museen Berlin), and works by Codde and Duyster – reveal a new (for these artists) interest in the domestic interior, the setting itself, including the device of a receding wall with windows to the left.[69] The corner arrangement allowed Hals to hang seascapes on the wall, which are signs of distant lovers or (in the Mainz picture) stormy emotions.[70] The emptiness of the room in the Mainz picture seems to lend the lady's distress a certain poignancy. In this expressive effect, as well as in the everyday type and naturalistic description of the interior, Dirck Hals is so unlike Van Delen that one would not imagine they had just been collaborators.

This is worth bearing in mind when one compares the grand interior views by Van Bassen or Van Delen to the more modest interior views of De Hooch and Vermeer. Had Hals, in the Mainz panel, cropped the right side of the composition, placed a table or chair in the foreground, and perhaps moved the vanishing point to the left so that it would lead the eye to the figure instead of to the seascape on the wall, then his

195
ESAIAS VAN DE VELDE,
Interior of a Tavern, 1629.
Black chalk and brown
wash on paper,
20 x 32.2 cm.
Berlin, Kupferstich-
kabinett, Staatliche
Museen Berlin

painting would resemble a work like De Hooch's
Two Soldiers Playing Cards in Zürich (fig. 240) to a
remarkable degree. These adjustments to an upright
format and more immediate access to the space
would have been made by almost any painter
working about twenty years later than Hals, whether
he was depicting a domestic interior, a still life
(compare compositions by Pieter Claesz and Willem
van Aelst), or another kind of subject. Thus, one does
not need, in a historical outline, a work like Hals's
painting of a middle-class interior as a source for
De Hooch or as a "transitional" work in between
De Hooch and Van Delen. Nor did Hals himself

need help from a third party when he adopted Van
Delen's self-sufficient type of interior space for use
within a more naturalistic tradition of depicting
fashionable society.

When one looks forward from Dirck Hals's boxy
interiors of the early 1630s to De Hooch's domestic
scenes of about 1657-58, the main interest of the
Haarlem pictures is not that they offer precedents
but that they represent a parallel, another instance
of the synthesis of styles that De Hooch achieved in
the mid- to late 1650s. Like Molenaer, Codde, and
Palamedesz in the 1630s, Hals combined
characteristics of two regional types of genre scene to
suit his particular purpose in a small group of works.
In a few examples he was mostly interested in adding
a well-appointed interior to his elegant company's
attributes. In the Mainz picture (fig. 197), however,
the interior contributes more substantially to the
work's meaning and mood. In later paintings, which
are generally less accomplished, Hals usually placed
his pleasure-seekers in the sort of all-purpose, loosely
structured settings that had served him well enough
before.

There was little likelihood that the type of interior
one finds in the "Letter Readers" by Hals and a few
works by Molenaer would have lasted in North
Holland through the second half of the 1630s. In
these years, Amsterdam artists were responding to

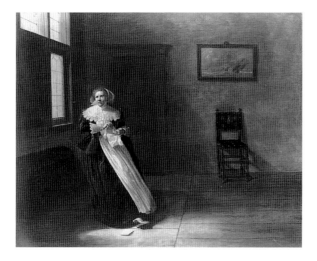

Rubens and other international models. Rembrandt's *Self-Portrait with Saskia (The Prodigal Son)* in Dresden is, while a personal picture, very much of this Baroque moment, with its gesturing figures, theatrical illumination, and a dark background defined by a curtain and a blank wall. There are some exceptions to the North Holland norm of nondescript spaces, like those depicted by Codde and Duyster (fig. 190). In Molenaer's *Woman Playing the Virginal* of about 1635 (Rijksmuseum, Amsterdam) and in portraits by Thomas de Keyser, artificial perspective seems to have been employed with enthusiasm and ignorance in equal parts. These pictures look paradoxically provincial when compared with approximately contemporaneous interior views by Jacob Jordaens or Gonzales Coques (fig. 222), from whose Antwerp perspective this judgment would have been reasonable.

In the 1640s – the decade, according to Clark, of "Rembrandt and the Italian Renaissance" – that master and his pupils made conspicuous use of perspective in some of their most attractive interior scenes.[71] Salomon Koninck and especially Gerbrand van den Eeckhout (fig. 198) set figures in deep domestic spaces which, were they differently lighted, would be cited routinely as antecedents of the "Delft type" of genre scene.[72] These compositions adopt the Leiden kind of interior that is found in Dou, Van Gaesbeeck, Koedijck, and so on, but are enlivened by Rembrandtesque figure groups, brooding shadows, and dramatic effects of light.

In the early 1650s, when Van den Eeckhout painted soldiers playing games of chance (fig. 199), smoking and drinking, or socializing with available young women, he did not describe settings that one would mistake for the South Holland type of interior

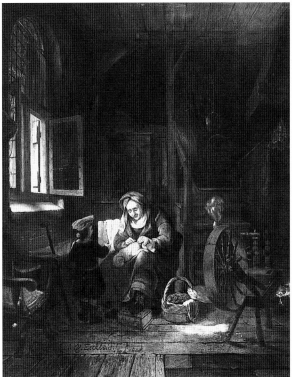

as found in the oeuvres of Van Delen, Koedijck, Sorgh (see fig. 207), or any other artist active in Leiden, Delft, or Rotterdam. His interior scenes of the 1650s remain almost as murky as the ones he painted in the previous decade: corners and curtained windows are employed to focus attention upon the figures and perhaps to suggest their weakness for night life no matter what time it might be.[73] Eclectic painters like Van den Eeckhout and Van Loo, who were working in the most advanced art center of the Netherlands, were accessible to new ideas whether native or not, but they absorbed borrowed conventions into their own tradition. The indigenous

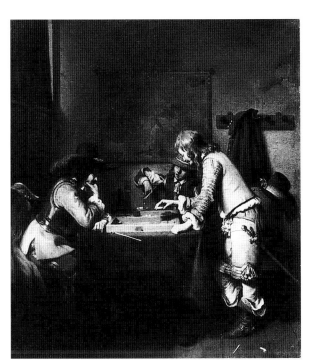

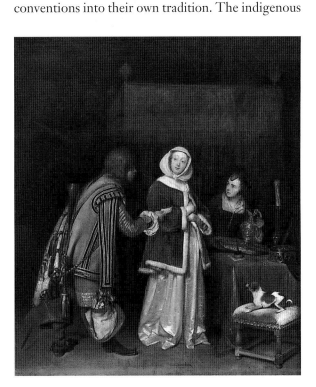

201
Gerard Dou,
A Girl Chopping Onions,
1646.
Oil on panel, 18 x 14.8 cm.
London, Buckingham
Palace, Her Majesty
Queen Elizabeth II

development in the next few years did not lead from Van den Eeckhout to De Hooch (whose early fondness for shadows was revived during the 1660s in Amsterdam) but from Van den Eeckhout, Van Loo, and other artists in Amsterdam to the mature genre paintings of Ter Borch (fig. 200). Even when his settings mattered most, Ter Borch remained essentially a painter of figure groups, with luxurious effects of light and shadow and less interest in space for its own sake than in the tactile sensation of surfaces.

Leiden

Genre painting in Leiden is a special case in many respects, including that of how domestic interiors are described. The city is located about midway as the gull flies between Delft and Haarlem, and the pictures painted there from the 1620s to the 1660s have qualities in common with both the more southern and the more northern Dutch schools. At the same time, conventions dating back to fifteenth- and sixteenth-century Netherlandish art remained traceable in Leiden longer than in any other city in the Northern Netherlands.

Even when Dou used the left-corner scheme in the 1630s (as in *The Young Violinist*, 1637, in the National Gallery of Scotland),[74] or brought the viewer in closer in works of about 1645 (fig. 201),[75] he filled the composition with objects, creating a busy, additive, and occasionally claustrophobic effect that contrasts with the restful and accessible spaces of De Hooch and Vermeer. It is true that Dou's illusionism and what has been mistaken for empirical interests (the impression that his microcosmic

202
Adriaen van Gaesbeeck,
*A Maid Working in a
Kitchen*, 1648.
Oil on panel,
70.8 x 57.8 cm.
Present location unknown
(sold at Christie's,
Amsterdam, November 13,
1995)

environments were based upon studies "from life") anticipate some of the effects found in genre scenes and church interiors painted during the 1650s in Delft. But the use of linear perspective in the Delft type of domestic interior (for example, fig. 246) was fundamental to its realism and its frequent suggestion of tranquility. Dou's use of perspective, by contrast, seems incidental or adjunctive; it keeps objects in their proper places and some orthogonals on target (especially the grid of window panes), but the volume of space still depends upon props and people, as if the approach of Jan van Eyck had been brought up to date by a reference to the young Rembrandt's shadowy corners and floods of light.[76]

Younger artists in Leiden – such as Koedijck, Van Gaesbeeck, and Brekelenkam – painted a significant number of pictures during the 1640s and early 1650s that could be said to modernize the type of interior found in Van Bassen and Van Delen. The latter have served here as a convenient shorthand for the South Holland type of genre scene in the 1620s and 1630s, but one should not conclude that Van Bassen and Van Delen were directly influential for many later pictures with similar compositions. When one compares Van Gaesbeeck's *Kitchen Interior* of 1648 (fig. 202) and his similar, Maes-like painting of about the same date in Karlsruhe (a mother sews by a window, with a baby and two boys nearby) to compositions dating twenty or thirty years earlier by Hendrick van Steenwyck (fig. 289),[77] or when one sets Koedijck's deep interior views (fig. 203) beside those of Van Steenwyck, Hondius, Van Bassen, and Houckgeest (figs. 75, 120, 129), or when one considers Brekelenkam's *Interior of a Tailor's Shop* of 1653 (fig. 204) in relation to Van Delen's *Merry*

Company of 1636 (fig. 221) or Adriaen van de Venne's illustration of an artist's studio in the 1620s (fig. 225), then once again the whole notion of individual influence begins to break down, or to take its proper place within the context of a long and varied tradition of describing middle- and upper-class domestic interiors.

In this tradition Koedijck (who worked mostly in Leiden during the 1640s) is one of the more intriguing figures precisely because he carried the use of linear perspective within the walls of ordinary households to textbook extremes (figs. 189, 203). He is also one of the least interesting artists in most other respects. His high level of craftsmanship and his devotion to petty details must have been inspired by Dou's work of the late 1630s and 1640s, but his rapid recessions (the "shoe-box" construction viewed end to end, as if from the peephole in Van Hoogstraten's London box; fig. 54), with ceiling beams, floor tiles, split-level views to other rooms and, more often than not, a demonstration of how to draw a spiral staircase, resemble the enthusiasms of an *amateur*. Similar motifs, both spatial and figural, suggest that Maes (fig. 215) was impressed by Koedijck, but to go on from these artists to De Hooch, Van der Burch, Vermeer, and that eager perspectivist, Cornelis de Man (fig. 176) is to miss the point that all of these artists had a common interest in perspective treatises, if not always the same books or plates that Van Bassen's generation preferred. In my opinion, Koedijck's interior views

of the late 1640s and the year 1650 (the date on his *Man with a Wineglass*; fig. 203) should be considered symptoms, not a cause, and less relevant to De Hooch and his Delft colleagues than the naturalistic adaptations of the South Holland type one finds in contemporaneous pictures by Brekelenkam (fig. 204), Maes, and Sorgh (in Leiden, Dordrecht, and

205
JAN STEEN,
*The Burgher of Delft and
his Daughter*, 1655.
Oil on canvas,
82.5 x 68.6 cm.
Penrhyn Castle Wales
(photo: Witt Library,
Courtauld Institute of Art,
London)

Rotterdam, respectively).[78] For all we know,
Koedijck's expertise in perspective was less admired
in Delft than in Ahmadabad, where the artist worked
mostly as a merchant for the Dutch East India
Company (VOC) throughout the 1650s. He then
returned to the Netherlands and spent his last years
in obscurity.[79]

Dou in his later decades, his pupil Frans van
Mieris, the less localized Metsu (who had moved
from Leiden to Amsterdam by 1657), and of course
Steen were complexly interrelated with each other
and with artists in other cities. They were all familiar
with the South Holland type of interior by the time
De Hooch made it his own. Steen's so-called *Burgher
of Delft and his Daughter* of 1655 (fig. 205) may be
"far closer in conception to De Hooch's outdoor
scenes" than were the townscapes of Fabritius, Van
der Poel, and Vosmaer,[80] and perhaps one brick on
the path to Vermeer should be inscribed with Steen's
name since the artist, at least in this picture,
"demonstrated how effectively architectural and
figural elements, drawn from daily life, could be fused
to create a new vision of reality."[81] But in a Leiden
context Steen's canal-side vista is simply Koedijck's or

Brekelenkam's corner of space (figs. 189, 204) moved
out of doors, without forsaking a rectangular pattern
of pavement in the foreground, windows to the left
with an open shutter, a place to sit, and even a
secondary view to a lower level (where the rôle of
doorway is assumed by a bridge). The fact that the
painter depicted an approximately faithful view on
the Oude Delft, with trees and the tower of the Oude
Kerk closing the view like a wall with a landscape
painting or some other design, need not obscure the
conventional nature of the composition. Out of all
the possible arrangements Steen might have
discovered in his own neighborhood in Delft, he
chose one that was already common in Leiden, The
Hague, and Rotterdam (see figs. 207, 226, 232) and
one which served his purpose exceedingly well. The
encounter of home life and street life, house and
church, paternal example and Christian duty seems
as consistent with ordinary experience as coming
upon a stoop and a group of people while walking
down the street. But does this constitute "a new
vision of reality" or something closer to Van
Hoogstraten's "selective naturalness"?[82]

In the mid-1650s Van Mieris and, slightly later,
Metsu adopted the left-corner scheme.[83] Van Mieris's
earliest known examples, such as *The Old Chemist*
(location unknown) and *A Connoisseur in the Artist's
Studio* (Gemäldegalerie, Dresden), which Naumann
dates to about 1655 and about 1655-57, respectively,[84]
recall compositions by Brekelenkam and Dou. The
Delft-like designs by Metsu cannot be dated before
about 1659 and remind one of many artists, for
example, Van Mieris, Van den Eeckhout, and Ter
Borch. As with several painters who were mentioned
above, it is remarkable how little Metsu's interior
scenes, although they employ many of the same
devices that are found in works by De Hooch and
Vermeer, actually resemble pictures painted in Delft.
The great exception is the pair of paintings in the
Beit Collection (National Gallery of Ireland), dating
from well into the 1660s, which in theme (letter
writing and reading), design, luminosity, and sheer
quality seem inspired by Vermeer.[85]

For all that may be said about common sources or
a shared tradition in the genre paintings of Leiden
and Delft, one rarely finds in Dou's city an intimate
corner of space used expressively, as it is in De
Hooch and Vermeer. In their mature compositions,
the close vantage points, the receding walls, the open
spaces to the side, the restful balance of rectilinear
elements, the simple, solid shapes, the harmonious
and restricted color schemes, and the serene effects
of pervasive daylight and crystalline atmosphere all
contribute to making the viewer feel physically and
psychologically part of the scene. In Leiden one is
always a spectator; wit, "situation comedy," and moral
enlightenment – just like the "characters" (Steen's are

206
HENDRICK SORGH,
Interior of a Farmhouse,
ca. 1640-42.
Oil on panel, 46.5 x 68 cm.
Rotterdam, Museum
Boijmans Van Beuningen

merely the most familiar), costumes, and props – are presented to the viewer as if he were in a little theater, not in the doorway of a private home. Steen is by far the most remarkable artist in this respect. He could take or leave almost any convention, from Haarlem's shallow stage to Dordrecht's deep spaces, and from the most contrived interior view (as in *A Woman at her Toilet*, 1663, in Buckingham Palace) to the most natural formula (many of his interiors show walls receding obiquely from both sides, with the floor slanting down helpfully, as in wide-angle sketches of ordinary rooms).[86]

Rotterdam

The distance from Delft to the old center of Rotterdam, to the southeast, is only about twice that between Delft and The Hague. Painters from these South Holland cities (and from Middelburg in Zeeland) reveal many connections with artists from Antwerp, as is well known from studies of patronage at the Dutch court and from surveys of still-life painting, portraiture, landscape and history painting.

The closest association between Rotterdam and the Southern Netherlands is found in the circle of artists who have been described as a "Dutch Teniers Group," which was comprised principally of Cornelis Saftleven (1607-1681), Herman Saftleven (1609-1684), and Pieter de Bloot (1601-1658).[87] Like the farmhouse, barn, and inn scenes painted by Brouwer and Teniers, Rotterdam *boerenhuysen* (for example, fig. 206) are remarkably well organized, often on an

L-shaped plan with orthogonals leading from the clear, stage-like space of the foreground to a distant wall. In many pictures of the 1630s and 1640s, roof beams, haylofts, and stalls conform to a frontal projection, as do the plastered brick walls aligned parallel to the picture plane. Compared with these tidy peasant interiors, the dimly-lit hovels and barns painted during the same years in Haarlem by Adriaen van Ostade seem to have collapsed and been reconstructed in the space of an afternoon, hence the dusty air and drunken celebration.[88]

The same orderly approach that one finds in De Bloot and the Saftlevens, a sort of rural counterpart to the design of inn scenes by Flemings such as Joos van Craesbeeck, David Ryckaert, and Willem van Herp,[89] is found in middle-class kitchen interiors painted in the 1640s by the Rotterdam artist Hendrick Sorgh (fig. 207).[90] His *Two Smokers* (formerly art market, Amsterdam) and similar pictures,[91] which derive from Teniers and also strongly resemble tavern scenes of the early 1650s by Ludolf de Jongh (fig. 209),[92] have been associated by Sutton with De Hooch's early subjects set in taverns.[93] As for the Delft painter's domestic scenes, such as the kitchen interior of about 1657 in the Louvre (fig. 208),[94] Sutton again looks for help from "Maes [who], once more, could have provided inspiration for De Hooch's adoption of these themes." There are compositional similarities between the pictures of household chores by De Hooch and Maes, but "despite these resemblances, we encounter a more

atmosphere, and textures. In the mid-1650s Maes painted domestic interiors of considerable interest for De Hooch, but no more so than those by Sorgh, De Jongh, and (in Leiden) Brekelenkam. This was probably not so much a question of Dordrecht being further afield than Rotterdam, Delft, and The Hague, but of the Dordrecht inclination to train with Rembrandt in Amsterdam (as did Maes and Van Hoogstraten, as well as Ferdinand Bol, Abraham van Dijck, Arent de Gelder, and others).[96] In any case, the kitchen and tavern interiors by Sorgh and De Jongh put De Hooch's supposed debt to Maes in perspective and leave Koedijck free to sail the seas. (If Sorgh or De Jongh needed advice about the practice of perspective, Anthony de Lorme was right at hand; see figs. 128, 188.)

De Hooch was about twenty years younger than Sorgh and (it will be recalled) thirteen years younger than De Jongh. The inn scenes of De Jongh and De Hooch are so closely related that until recently two of the Rotterdammer's paintings of the early 1650s were assigned to the more celebrated name.[97] The chronology of De Jongh's genre pictures of about 1645-55 remains uncertain; a number of Fleischer's proposed dates seem too early, in one case (*Gathering at a Table*, of "ca. 1648," in Leipzig) by five or six years.[98] Examples of De Jongh's portraits, tavern interiors, and market scenes have been related to earlier examples by Sorgh,[99] and it would appear appropriate to speak more firmly of the older artist's influence upon De Jongh's inn and stable scenes of the early 1650s.

In a few works, such as the Basel *Hunters in an Inn* (fig. 209), De Jongh employs a deeper and generally more conspicuous perspective scheme than is usually

207
HENDRICK SORGH,
A Maid and a Young Man Offering Fish, 1643.
Oil on panel, 46.3 x 38 cm.
Warsaw, Muzeum Narodowe

208
PIETER DE HOOCH,
A Woman Preparing Vegetables, with a Child,
ca. 1657.
Oil on panel, 60 x 27 cm.
Paris, Musée du Louvre

highly ordered vision of domesticity in De Hooch's art."[95] The question remains, why would a native Rotterdammer like De Hooch have to chase down to Dordrecht for the latest model of kitchen scene, when these orderly interiors had been a Rotterdam tradition since the early 1630s and Sorgh had painted domestic interiors like De Hooch's of about 1657 as much as fourteen years before?

In the background of the abraded panel by Sorgh in Warsaw (fig. 207), a staircase defines a corner of space and connects the three receding planes of architecture. The spiral staircase was soon to be a favorite motif of Koedijck's and was adopted in the mid-fifties by Maes. More importantly, Sorgh's kitchen scenes of the 1640s are another instance of the stylistic synthesis that was mentioned above (in connection with Dirck Hals, Molenaer, and other artists to the north), which to put it too simply combines a Flemish and South Holland sense of order and predilection for linear perspective with a more Haarlem-like emphasis upon daylight,

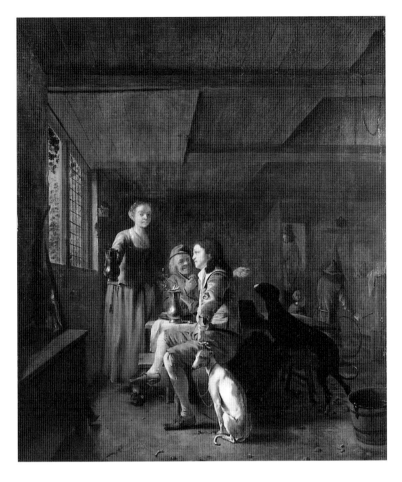

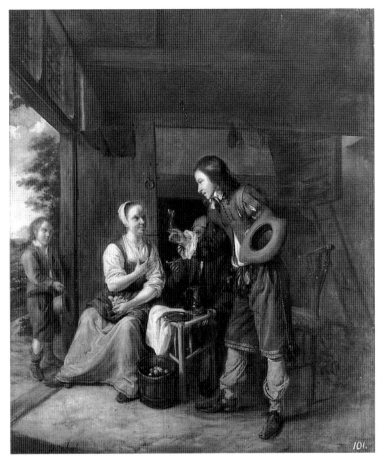

found in Sorgh (not more accurate, however, to judge from the bench in the foreground) and bolder light (which, on the greyhound, brings De Witte to mind). Similar inn scenes by De Hooch (fig. 211) may date from nearly as early (about 1653-55?) but are somewhat less insistent and accomplished than De Jongh's in their construction of space (to say nothing of their drawing and organization of figure groups). On the whole, De Hooch appears to have been even more indebted to De Jongh in the first half of the 1650s than was his Rotterdam colleague Jacob Ochtervelt.[100] This becomes strikingly clear when one compares the architecture, light, and figure types in an early De Hooch like the one in the Hermitage (fig. 210) with an approximately contemporaneous work by De Jongh (fig. 209).[101]

It has been suggested that "by at least the 1660s the general flow of influence from De Jongh to De Hooch had stabilized into a mutual give and take."[102] This may be, but with respect to genre interiors a draw might be declared with the artists' paintings of about 1657. De Jongh's *Message* dating from that year (Mittelrheinisches Museum, Mainz), which "displays an interior with a more clearly defined space than we have noted up to now" (in De Jongh, not Sorgh),[103] is no more interesting for De Hooch's inventions of 1658 than is the Delft painter's own panel, *The Visit* (fig. 242), which probably dates from 1657 as well. One might become more excited about De Jongh's *Hunters in an Inn* of 1658 (fig. 213) until one realizes

that the interior is merely a new model in the line represented by Sorgh's peasant interior of 1645 (fig. 212), now with proper flooring and larger windows. Perhaps of greater significance is the fact that the younger artist's figures now seem the more precisely and securely positioned on the floor (fig. 185). There are numerous signs of responsiveness to visual experience in earlier pictures by De Hooch, but those painted in about 1657-58 are the first in which

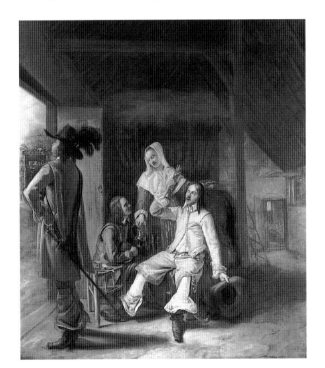

209
LUDOLF DE JONGH,
Hunters in an Inn,
early 1650s.
Oil on panel, 72 x 62.5 cm.
Basel, Öffentliche
Kunstsammlung

210
PIETER DE HOOCH,
A Man Offering a Woman a Glass of Wine, ca. 1653-55.
Oil on panel, 71 x 59 cm.
St. Petersburg, State
Hermitage Museum

211
PIETER DE HOOCH,
Two Soldiers and a Serving Woman with a Trumpeter,
ca. 1653-55.
Oil on panel, 76 x 66 cm.
Zürich, Kunsthaus,
The Betty and David
M. Koetser Foundation

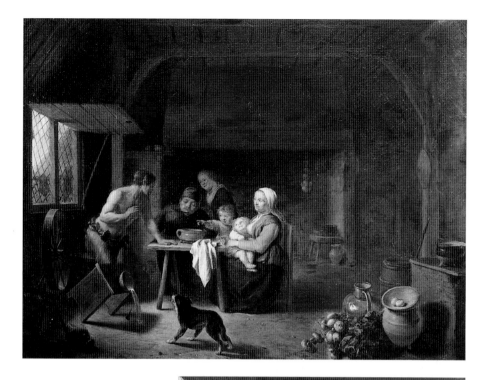

212

HENDRICK SORGH,
Satyr and Peasant Family,
1645.
Oil on panel, 39 x 51 cm.
Leipzig, Museum der
bildenden Künste

213

LUDOLF DE JONGH,
Hunters in an Inn, 1658.
Oil on canvas, 67 x 81 cm.
Groningen, Groninger
Museum voor Stad en
Lande

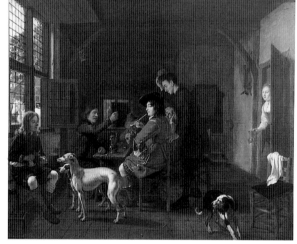

214

NICOLAES MAES,
The Idle Servant (*Interior
with a Sleeping Maid and
her Mistress*), 1655.
Oil on panel, 70 x 53.3 cm.
London, The National
Gallery

one appreciates the importance to him of
independent observation, as well as borrowed ideas.

Dordrecht

The Dordrecht native Nicolaes Maes (1634-1693)
has been mentioned often in connection with Delft.
The kind of interior that is usually compared with
De Hooch's compositions of 1657-58 is not found in
Maes's oeuvre before 1655-56 (figs. 214, 217), and
not until about 1660 in Van Hoogstraten's. Maes's
interest in the strong design qualities of linear
perspective (besides its importance for "illusionism,"
a word one would rarely think of in connection with
Maes) would be more evident were it not for his
persistent use throughout the 1650s of an Amsterdam
palette and Rembrandt School illumination.
Nonetheless, the artist was nearly as intrigued by
perspective demonstrations as was Van Hoogstraten
in the same years (the perspective box in London,
fig. 54, was probably painted in Dordrecht during
the late 1650s). Maes must have referred to an

illustration like those depicting flights of stairs in
Marolois's treatise (fig. 216) when he designed *The
Eavesdropper* of 1657 (fig. 215) and a few similar
pictures, not so much in order to get the projection
right, but for the general idea of showing an interior
with views to spaces upstairs, downstairs, and to the
side. However, when one compares a composition
like that of Maes's *Housewife at Work* (fig. 217) with
Vredeman de Vries's drawing *Wintertime* (fig. 218;
probably a design for stained glass or a print), there
is no need to suppose a direct relationship since
draftsmen such as Vinckboons, Visscher, Esaias van
de Velde, and Adriaen van de Venne made many
images in the same Flemish and South Holland
mode during the first half of the seventeenth century.
The anonymous illustrator of Van der Borcht's
Spiegel (fig. 224) has left us one of the nearly
innumerable interior views that might be compared
with those of Dordrecht and Delft. The figure
groups remind one more of De Hooch than Maes,
except for the man in the foreground who would feel
at home with the lady of the house in *The Idle Servant*
(fig. 214).

Maes's enthusiasm for striking perspectives and
doorkijkjes ("through views") was continued in the
1660s in Dordrecht by Cornelis Bisschop, whose
delightful *Apple Peeler* of 1667 (fig. 309) seems to
improve upon Maes's *Woman Plucking a Duck* of
about 1655 in Philadelphia (see fig. 233) and Van
Hoogstraten's corridor views (fig. 97) of the same
time.[104] The panel also deserves comparison with
Vermeer's *Love Letter*, which appears to date from
two or three years later (fig. 308). The Delft painter
comes in closer to a similar doorway or to the second

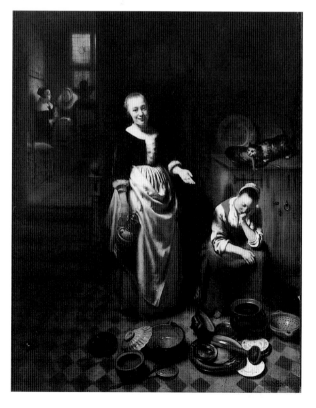

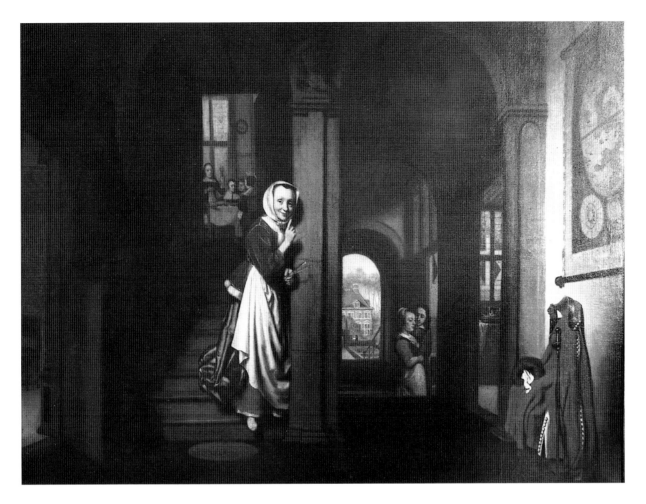

215
NICOLAES MAES,
The Eavesdropper, 1657.
Oil on canvas,
92.5 x 122 cm.
Instituut Collectie
Nederland (on loan to
Dordrecht, Dordrechts
Museum)

one, bringing the chair and the maid's broom and slippers along with him. The usual Dordrecht division of the composition into rectangular planes and openings is enhanced. For some readers, the idea that the "Sphinx of Delft" cropped a design that is typical of Dordrecht might seem insufficiently deferential, but that is literally what he did in his first painting of a comparable subject – *A Maid Asleep* (fig. 261) was cut down on all sides by Vermeer – and in almost every instance of an adaptation one can only marvel at how he makes shared conventions appear uniquely his own. The same comparison with Bisschop, incidentally, helps one appreciate how stylized some of Vermeer's effects became in later works, for example, the shadows cast by the picture frames and the vertical stripe of daylight on the doorjamb (which little resembles the streaks of sunlight in *A Maid Asleep*).

Two other "Dordrecht doorways" come to mind when one considers the composition of Vermeer's *Love Letter*: the well-known canvas in the Louvre called *The Slippers* and the *View down a Corridor with Figures and a Dog* in the Art Gallery of Ontario, Toronto. Both pictures have been attributed to Van Hoogstraten, the Louvre painting with increasing frequency.[105] The Toronto panel is now known to be signed by Metsu.[106] The attribution of the Louvre canvas is complicated by condition problems, but in my view Bisschop may be the painter.

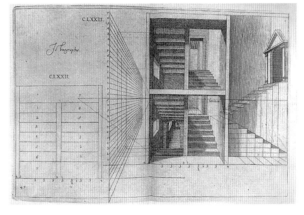

216
SAMUEL MAROLOIS,
Perspective ..., Amsterdam,
1628, plate 47 (figs. CLXXII
and CLXXIII). New York,
The Metropolitan
Museum of Art

The Hague

One of the odder notions in modern studies of Dutch art is that painters such as Van Bassen, Van Delen, and Van Steenwyck represent a minor, peripheral, or atypical trend, as if some accident of birth or unpromising location impaired their development. That these artists appeal to today's viewers less than De Hooch does is an illustration in the history of taste with its own social context, one which makes it hard to imagine contemporary attitudes toward a picture like Van Delen's view of an elegant interior occupied by Elizabeth Stuart, the Earl of Craven, and other members of the Dutch and English nobility (fig. 219). Indeed, it has been difficult since at least the middle of the nineteenth century, when Thoré-Bürger compared seventeenth-century Dutch society

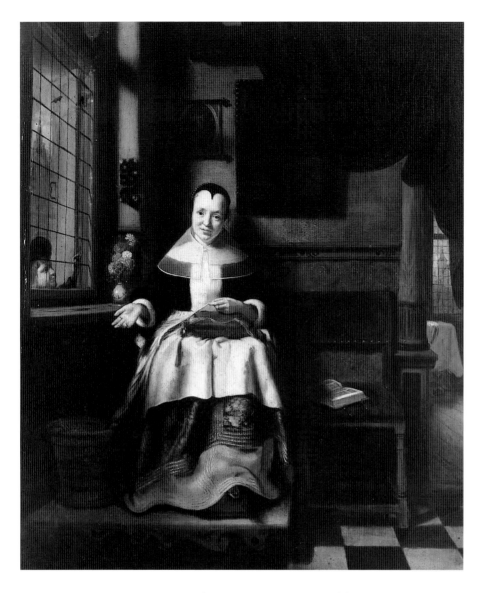

217
Nicolaes Maes,
A Housewife at Work, 1656.
Oil on panel, 75 x 60 cm.
London, The Wallace
Collection

218
Hans Vredeman de
Vries, *Wintertime*, 1585.
Pen drawing,
11.4 cm diam.
Formerly Amsterdam,
Kunsthandel P. de Boer

to "the young, Protestant, and democratic society of America" and categorized Dutch and Flemish artists accordingly: "Rubens belongs with the defeated and slaves, Rembrandt with the victors and free."[107]

We are not so naive about art history and perhaps about politics (at any rate, not so *engagé*) as Thoré-Bürger's writings reveal him to have been. And yet one hesitates to associate Van Delen and Van Bassen with such Haarlem artists as Esaias van de Velde and Dirck Hals – that is, with their own collaborators. Van Delen's murals depicting the sons of William the Silent and their relatives (figs. 219-20), who were the "public servants" of the victors and free, reveal a world in which Rubens and Van Dyck had been welcome and more admired than any other living artists in Europe. Do those masters – along with Jacob Jordaens, Theodoor Willeboirts Bosschaert, Gonzales Coques, Abraham Bloemaert, and all the other Flemish and Dutch artists who worked for the Dutch court at the same time as Van Bassen – represent the same "alternative and decidedly minor trend" as he did or peculiar trends of their own?[108]

To judge from his patrons and prices, Van Bassen's own "side road or byway" was a promising route.[109]

Montias's sample of 407 inventories in Amsterdam suggests that collectors who purchased "church and palace" views were usually "Reformed, wealthy, and socially prominent." Similar, fragmentary records have been found in the archives of other cities: for example, the "perspective with Haman" (a palace view) by Van Bassen that was owned by Sebastian Francken, a counsellor at the Court of Holland.[110] As noted above, paintings by Van Bassen with figures by Van de Velde – a "banquet," an interior with Lazarus and the Rich Man, a temple with Christ and the Adulteress, a view of St. Peter's, Rome – were assigned high values (an average of fl. 140) in 1626 in connection with a proposed lottery in Delft, where two Italianate landscapes by the Delft painter Pieter Groenewegen (also with figures by Esaias van de Velde) were assessed at fl. 32 each.[111] Prices are unknown though hardly necessary to appreciate the importance of the five canvas murals (each about 3.1 meters high) that Van Delen painted for the house of Floris II van Pallandt van Culemborg in The Hague (see figs. 219-20),[112] as well as the three large pictures by Van Bassen (one "painting," one church interior of 1620, and one palace interior with a musical group) that hung in the Koningshuis, Rhenen, in 1633 – that is, in rooms that were designed for Frederick V and Elizabeth Stuart by Van Bassen himself.[113]

This last point is of some interest for our understanding of the so-called "De Vriesian painters."[114] Van Bassen's views of palace interiors (fig. 191) feature deeply coffered ceilings; walls covered to half or two-thirds their height with panelling or gilt leather, above which pictures were hung; doorways, fireplaces, and cabinets embellished by Ionic or Corinthian columns; heavy scroll-brackets, pediments, and crests; and patterned marble floors. The scale of the rooms and the elaborate details are

219

DIRCK VAN DELEN,
*Elizabeth Stuart (The
Winter Queen) and William
Earl of Craven with Other
Noble Figures in an Elegant
Interior*, ca. 1630-32.
Oil on canvas,
230 x 320 cm.
Amsterdam, Rijksmuseum
(on loan to Apeldoorn,
Rijksmuseum Paleis Het
Loo)

220

DIRCK VAN DELEN,
*Members of the House of
Orange and Other Noble
Figures in an Idealized
Architectural Setting*,
ca. 1630-32.
Oil on canvas,
317.5 x 350 cm.
Amsterdam, Rijksmuseum
(on loan to Apeldoorn,
Rijksmuseum Paleis Het
Loo)

exaggerated, but the vocabulary of forms and general effect are of the period, as are the paintings on the walls and the fashionable costumes. Vredeman de Vries never saw rooms like these or painted anything like them (except in the most abstract terms). Van Bassen and Van Delen depict versions of the latest thing, or the next thing, as in a journal like *Architectural Digest* (or *Vogue*, with regard to the costumes) today. There is nothing "conservative" about the subjects of these pictures, nor do the figures in them behave with small-town restraint. As for pioneering effects of space, light, and atmosphere, of the sort Esaias van de Velde introduced into naturalistic landscape painting, these qualities are beside the point here, where the decorative effect of the whole and the appreciation of fine details were primary concerns.

To be sure, there is considerable distance in style and subject between Van Bassen's palatial interiors of the 1620s and 1630s (fig. 120) and De Hooch's genre scenes of the late 1650s onward (fig. 185). These are pictures by very different artists working for different patrons at different times within a long and evolving tradition. Van Delen in the 1630s and 1640s (fig. 221) offers a much closer model for De Hooch's designs in pictures like the one in London of about 1658 (fig. 185), despite the remaining class distinctions, which for that matter separate De Hooch's usual figures from those of Palamedesz (fig. 3). The difference between interiors like Van Delen's and

De Hooch's, which could be described as patrician and upper-middle-class, respectively (whatever one may think of the figures), would hardly have hindered De Hooch in benefiting from Van Delen's example, any more than Houckgeest's early views of invented architecture (fig. 129) prevented him from

hypothesis requires further consideration, but few observers would hesitate to acknowledge the overall tendency toward refinement of manners and settings in Dutch genre paintings during the third quarter of the seventeenth century, which was mostly a flourishing economic period. Perhaps one may speak (as suggested above) of a gradual "gentrification" in scenes of lower- and especially middle-class life and even (as Scholten has) of "aristocratization" in pictures dating from the late 1650s by Ludolf de Jongh (fig. 213) and in his (and De Hooch's) later scenes set in the foyers, courtyards, and gardens of fancy homes.[116] Servants play an important part in these pictures, and they are not the same serving wenches who consort with the customers in De Hooch's and De Jongh's early tavern scenes.[117]

Ter Borch appears to have been quite influential for this development, although one should not lose sight of its essentially social cause. He was well connected at The Hague, probably went there fairly often in the early 1650s, and sold pictures there through Van Goyen and probably others. Ter Borch's pupil Caspar Netscher joined the guild at The Hague in 1662. His paintings of musical companies (for example, the canvas dated 1665 in Berlin) are contemporaneous with pictures of similar subjects by Vermeer, but in style they depend almost entirely on Ter Borch's most elegant genre scenes of the 1650s.[118]

In this respect, Netscher was not a typical representative of The Hague (his fancy portraits are another question). The local artists who depicted

painting restricted corners of the Oude Kerk and Nieuwe Kerk.

In the 1650s and 1660s genre painters like De Hooch and even Van Ostade (who made substantial improvements to his peasant houses in those years) reflected what several art historians, following Norbert Elias, have called "the civilizing process," in which different levels of European society adopted forms of behavior and status-enhancing attributes from their perceived superiors.[115] Much about this

scenes of modern manners included Van Bassen and his collaborator Esaias van de Velde; Hendrick van Steenwyck, who lived in or near The Hague in the 1640s; and Adriaen van de Venne (1589-1662), who moved to The Hague from Middelburg in 1625, the year in which Cats's *Houwelyck* appeared with illustrations by Van de Venne (fig. 225). Also connected with The Hague, if not (or no longer) resident there, were Houckgeest (fig. 121), Van Delen (at least in the Van Pallandt van Culemborg murals; figs. 219-20), and a number of Flemish visitors, such as Jacob Jordaens and Gonzales Coques (see fig. 222). Coques worked for Frederick Hendrick and Amalia van Solms in about 1645-48 (he received a gold chain from the stadholder in 1647), and he acted as agent for the Antwerp art dealer Matthijs Musson.[119] One may also recall that Vredeman de Vries had been in The Hague in about 1601 and his legacy lived on through figures in the court city such as Van Bassen, Hondius, and Van Steenwyck. Finally, many of Palamedesz's pictures of elegant society (see fig. 223) resemble not only those by Buytewech or Esaias van de Velde (who died in 1630) but also "merry companies" that were painted in the 1630s and 1640s by Van de Venne.[120]

The Flemish sources of several South Holland artists have been mentioned above, in this chapter and also with regard to the "court style" of architectural painting. All the artists cited in the previous paragraph (with the possible exception of Palamedesz) were either from the Southern Netherlands or had deep artistic roots in Antwerp. Van Steenwyck's *Lute Player* (fig. 289) looks back to single-figure paintings by Jan Sanders van Hemessen and the Master of the Female Half-lengths, as well as forward to Vermeer's *Woman with a Lute* in New York (fig. 288). The Antwerp sources of architectural paintings by Van Bassen, Van Delen, and Van Steenwyck (who was probably born there) are too well known to require further comment.[121] Flemish conventions were especially long-lived in book illustrations and popular prints; Van de Venne's boxy domestic interiors of the 1620s and 1630s (figs. 225-27) may be placed within a tradition that includes the prints of Visscher and Vinckboons discussed above (figs. 192-93), plates by Vredeman de Vries, illustrations in numerous scientific and technical treatises,[122] and Coques-like interiors such as that found in Flemish books of manners like Willem van der Borcht's *Spiegel* of 1643 (fig. 224).

There was probably no illustrator better known to Dutch artists than Adriaen van de Venne and none more important for genre painting, especially scenes of middle-class life. As a painter he is known for his seasonal landscapes with many figures, similar allegorical and historical pictures (like *Fishing for Souls* in the Rijksmuseum), and grisailles depicting Dutch

223
ANTHONIE PALAMEDESZ,
Elegant Company around a Table in a Garden, 1632.
Oil on panel,
48.3 x 79.4 cm.
Vienna, private collection
(photo: Richard Green
Fine Old Master
Paintings, London)

224
ANONYMOUS ENGRAVER,
an illustration in Willem
van der Borcht, *Spiegel der eygenkennisse*, Brussels,
1643.
The Hague, Koninklijke
Bibliotheek

proverbs and expressions. The latter works earned Van de Venne the designation of low-life painter and nothing else in the most influential survey book on Dutch art;[123] in a more specialized study he is characterized as a *boerse kunstbroeder* of Buytewech and Dirck Hals.[124] The principal illustrator of courtly life at The Hague (in numerous engravings as well as his celebrated album in the British Museum),[125] a frequent *hoofdman* of the guild at The Hague and founding member of *Pictura*, and an artist who had worked for Frederick Hendrick, the King and Queen of Bohemia, and reportedly the King of Denmark,[126] Van de Venne hardly deserves to be characterized as a kind of Brouwer on a bad day. His illustrations for several books by Cats are sophisticated, stylish, witty observations of modish manners, high fashion, and other attributes of gentility.

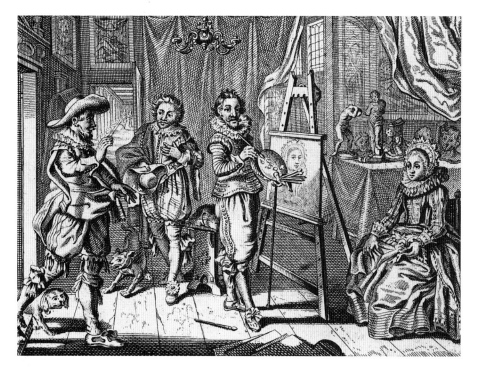

Velde, Abraham Bosse (whose sources were mainly Flemish), Coques in slightly later interior views (fig. 222), as well as many other artists, will demonstrate that Van de Venne is merely one of the most interesting figures in the Flemish and South Holland tradition.

How Van de Venne links the Southern Netherlands and South Holland is not hard to see if one follows the evolution of his style from the 1620s through the 1650s. With regard to interior views specifically, we may compare an early work like *The Painting Shop* of 1623 (which recalls Pieter Bruegel's *Payment of the Tenth Penny*, known from many versions) with illustrations of the 1620s (in Cats's *Self-Stryt* or *Zeeuwsche Nachtgael* of 1622 and *Houwelyck* of 1625) and especially with those of the 1630s onward (see figs. 226-28).[129] In a sense, the difference between Van de Venne and such artists as Van Bassen and Van Delen was determined by Cats and by Van de Venne's own proverbial perceptions of modern society. His figures matter individually, even when they are types (*Vrouwe, Moeder*), so that in every sense the view is closer than in contemporary paintings of "merry companies."[130]

Before leaving The Hague for the leisurely walk or barge ride back to Delft, we might make a few more observations about artists in the court city and the Southern Netherlands. The connection between Dutch and Flemish scenes of middle- and upper-class society is often less obvious than in peasant scenes, in part because of the less similar social contexts. Views of collectors' cabinets, for example, may be considered a distinctly Flemish type of picture, although they resemble Van Bassen's kind of palace interior.[131] Many scholars would consider the latter a Flemish type of picture, but nothing quite like Van Bassen's and Van Delen's palace views were painted in Antwerp (unless Louis de Caullery is considered comparable). However, artists in The Hague invented views of modern life that come as close as one may reasonably expect to interiors painted in the Southern Netherlands by Coques and others and by Bosse in Paris. Once Vermeer and De Man, Van der Burch in Leiden (where works "in his mature Delft style" were actually painted),[132] and De Hooch, Metsu, and others in Amsterdam turned to the level of society that was depicted by Van Bassen and Van Delen and by such Flemings as Coques and Quellinus (see figs. 222, 293), then the similarities were not only those of a stylistic tradition but also a question of treating similar subjects for (broadly speaking) similar patrons. Their interests, in a word, were cosmopolitan, the kind of enthusiasms that linked not only numerous artists but also the social circles of patrons such as Constantijn Huygens and Pieter Teding van Berkhout at The Hague, Diego Duarte in Antwerp, Samuel Pepys in London, and

Van de Venne may appear to tie together many of the other artists who are discussed in this chapter, but this is for the most part a reflection of how traditional their devices were. As a draftsman, however, he often anticipated approaches that were not common in painting until a generation later. Van de Venne grew up in Delft, studied Latin as well as "drawing and illuminating" in Leiden (about 1605), and then followed his father to Middelburg. His brother Jan (who was acquainted with Jacques de Gheyn II) set up a printing business which also sold works of art. Jacob Cats moved to Middelburg at about the same time (1608), then to Dordrecht in 1623 and to Leiden in 1625. After Jan van de Venne died in 1625, Adriaen and his wife went to The Hague. He was an officer in the painter's guild, together with Van Bassen and Van Goyen (with both of whom he produced a large picture and poem praising the guild in 1640), and he was one of the artists in Jean Meyssens's *Images de divers hommes desprit sublime* (Antwerp, 1649).[127]

Van de Venne's illustrations in books by Cats and by Johan de Brune are cited routinely in iconographic studies of Dutch genre painting.[128] A good number of the same images are similar in composition to mostly later paintings by such artists as Brekelenkam, Sorgh, De Jongh, De Hooch, and Vermeer. Some of the illustrations in Cats's *Spiegel* of 1632 (fig. 225) are remarkable for their close points of view and rapid recessions past figures and furniture in the immediate foreground. If one wants a missing link between Vredeman de Vries and Maes (figs. 18, 221), between Van Delen and De Hooch (figs. 221, 185), or between Van Steenwyck and Vermeer (figs. 288, 289), then Van de Venne might be the man, but comparisons with works by Vinckboons, Van de

Balthasar de Monconys and evidently Pieter Claesz van Ruijven in Delft.[133]

Pieter de Hooch in Delft

De Hooch's style and his description of space in particular varied according to the nature of his subject matter. This is unsurprising but cannot be taken for granted, given the many factors that determine an artist's approach: training, influence, tradition, personality, ability, and fashion. When painters treat similar subjects at about the same time, the relative importance of individual and shared qualities becomes clear. Works by Van Delen have been confused with those by Van Bassen, Codde with Quast, Claesz with Heda, De Jongh with De Hooch, and so on. In these examples taste and tradition are common denominators, not least with respect to De Jongh and De Hooch.

An artist's distinctive strengths often emerge in a phase of "early maturity," shortly after a period of training or apprenticeship. This is seen in Rembrandt's strongest pupils, such as Fabritius and Maes. The example of De Witte's early career (see fig. 154) suggests that the opportunities presented by a local market, as well as the factors of training and personality, can be decisive in determining how promptly a painter finds his métier. De Hooch appears to have been a slow starter; he had little of De Jongh's (or Palamedesz's) talent as a portraitist and figure painter, and the artistic community of Delft in the early to mid-1650s hardly needed another portraitist or, for that matter, another architectural painter (which De Hooch could have become as readily as De Witte, to judge from the compositions of 1658-60). What does emerge in De Hooch's early work (fig. 230) is a talent for rendering light effects, which he gradually learned to modulate in order to convey a mood or ambiance. One could cite De Witte again as a precedent in Delft, but there were many in Holland and elsewhere in Europe.

Once more the questions of fashion, personality, ability, and so on are raised. In Nicolaes Maes's most affecting genre scenes, the subject matter, the intimacy of space, the embrace of shadows and atmosphere, the warmth and concentration of light, and the palette's dominant tonalities all seem harmoniously interrelated. Maes learned much of this from Rembrandt's domestic images of the 1640s, and that aspect of the master's work was obviously sympathetic to Maes's personality.[134]

In more conventional pictures by Maes, such as *The Idle Servant* of 1655 (fig. 214), the Rembrandtesque illumination seems less appropriate. It contributes to the dramatic effect (even casting the accusing hand's shadow onto the dormant maid), but the subject is no

226
ANDRIES STOCK AFTER ADRIAEN VAN DE VENNE, an engraved illustration in Jacob Cats, *Spiegel vanden ouden ende nieuwen tijdt*, The Hague, 1632. New York, The Metropolitan Museum of Art

227
Anonymous after Adriaen van de Venne in Jacob Cats, *'s Weerelts Begin, Midden, Eynde, Besloten in den Trou-ringh, met den Proef-Steen van den Selven*, The Hague, 1637. New York, The Metropolitan Museum of Art

228
Anonymous after Adriaen van de Venne in Jacob Cats, *Dood-Kiste voor de Levendige …*, The Hague, 1656. New York, The Metropolitan Museum of Art

229
Pieter de Hooch,
The Empty Glass,
ca. 1653-54.
Oil on panel, 44 x 35 cm.
Rotterdam, Museum
Boijmans Van Beuningen

"Night Watch" and could have been treated just as well in the manner of Van Gaesbeeck or Brekelenkam. The precipitous pattern of floor tiles contributes to the sense of disorder in the foreground, contrasting with the tranquil look of the secondary space (which resembles a slightly later interior by De Hooch). The half-baked perspective scheme with which Maes joins the kitchen and entertaining sections of the household ("upstairs-downstairs") was a new element in his work at the time, so much so that MacLaren declared flatly in his catalogue of 1960 that "this is the earliest known dated genre painting of this type with a view to a farther room."[135] The remark now seems as wildly mistaken as it seemed perceptive thirty years ago, although variations on MacLaren's subsequent lines, which refer to Vermeer's *Maid Asleep* (fig. 261) and to Maes dropping into Delft where "he may have seen lost works by Carel Fabritius" and the like, have echoed ever since.[136] The formal and iconographic properties of the picture have made it more appreciated than admired by commentators, which is often true of works that employ conventions in an obvious way. Subtlety and sheer quality would not be the essential factors in

determining whether *The Idle Servant* by Maes or *A Maid Asleep* by Vermeer would have made the stronger impression on De Hooch's work of the time.

In Maes's "lacemaker" paintings, which also date from 1655 and thereabouts (see fig. 217; others are in New York, Ottawa, and a private collection),[137] the effect of the shallow field of floor tiles or receding boards in the foreground is almost the opposite of the diamond pattern in *The Idle Servant*. Maes often eschewed the busy effect in favor of a wooden floor warmed by a pool of sunlight, especially in his tender domestic scenes of the mid-1650s. In Koedijck's work, by contrast, it is not clear why the subject requires his approach to interior space. *The Empty Glass* of 1648 (fig. 189) could be done over in the manner of Maes's *Idle Servant* without any loss of expression (such as it is), as is demonstrated in works by Maes that feature some of the same motifs. It was not a question of Koedijck's character or talent being out of tune with his training, local tradition, or the taste of the moment. On the contrary, he was enthralled by the latest devices, often to the near exclusion of having something to say. At least in *The Foot Operation* of about 1648-50 (private collection, U.S.A.) the meticulous order of the room and the rationality of the one-point perspective scheme lend a reassuring look to the surgeon's office.[138]

Similar criticism could be levelled at De Jongh, though not as strongly. In an interior scene like the early *Hunters in an Inn* (fig. 209) the extended arms and mugging faces of the figures seem intended for the last row in a theater, although the rushed perspective suggests that the viewer sits up front. Of course, De Jongh's tavern scenes were meant as light entertainment, and the striking formal effects, which often include exaggerated contrasts of light and shadow as well as telescoped space, all contribute to the panel's superficial appeal. De Jongh's later use of perspective, as in the *Hunters in an Inn* dated 1658 (fig. 213), is at once more complex and less insistent than in some of his early inn scenes (and in paintings by Koedijck of similar design), and this approach could be considered more appropriate to his later subject matter, which increasingly involved elegant figures and (in other pictures) patrician architecture. De Jongh's preoccupation with fashionable forms (this is the artist who, Houbraken relates, no longer spoke Dutch when he returned from France) found sympathetic subjects in his mature pictures of polite society. In some scenes of life in the Dutch country house dating from about 1665-75, De Jongh looks like the De Lairesse of genre painting.[139]

A critical review of the devices employed by De Jongh and other genre painters in the 1650s helps to explain why they influenced De Hooch's development. In a way Blankert was right about De Hooch's "long, arduous trek" before he arrived at his

own distinctive style in the late 1650s. Like De Witte to some extent, De Hooch had a certain native ability, a sensitivity to qualities of light and space and their suggestion of mood, but he was not quick to see the value of formal ideas. In this he was almost the opposite of Vermeer in the same period, who (as discussed in the next chapter) absorbed stylistic conventions so effortlessly that they looked like products of his own imagination or independent observations of the environment (compare figs. 240-41). De Hooch required someone like De Jongh to guide him in adopting current conventions, rather as De Witte needed Houckgeest's example when he first turned to church interiors. What one most admires in De Hooch are qualities that seem intangible, intuitive, even inarticulate. His stiff figures with heads bowed forward seem to respond wordlessly to the moods of their environments. De Jongh's genre scenes are often more skillful and usually less memorable.

De Hooch's earliest known paintings probably date from about 1653-54, when he was working for the merchant Justus de la Grange. The *Tric-Trac Players* in Dublin and its supposed pendant, *A Seated Soldier with a Standing Serving Woman* (private collection, England), strongly recall tavern interiors by De Jongh such as *The Reprimand* (dated by Fleischer to about 1650), which in any case probably predates the De Hoochs.[140] Closely related paintings by De Hooch include *The Empty Glass* and *The Merry Drinker* of about 1653-54 (figs. 229-30).[141] The tonal palette of browns and yellows with local accents (the "merry drinker" wears red) and to some extent the

chiaroscuro effects remind one of Codde, Duyster, Molenaer, and other North Holland artists. But the subjects and the hyperactive figure types, with limbs thrusting, heads turning, eyes staring, and glasses held high, have been rightly associated with Rotterdam artists, namely, De Bloot, Cornelis Saftleven, Sorgh, and De Jongh.[142] Of these painters, Sorgh and especially Saftleven must have influenced De Jongh and De Hooch; Saftleven's significance for the early paintings of De Hooch has probably been underestimated. *A Soldier Smoking* (Johnson Collection, Philadelphia Museum of Art), which Sutton dates as early as 1650, and the possible *Self-Portrait* in the Rijksmuseum both recall Saftleven's *Self-Portrait* of about 1629-30 (Fondation Custodia, Paris).[143] De Hooch's one attempt at a history picture, the early *Liberation of Saint Peter*, is composed and illuminated like Saftleven's hell scenes and "animal allegories" of twenty years earlier.[144]

Saftleven's stall interiors of about 1635-40 feature tightly grouped but active figures, emphatically modelled in bright light, as well as the kind of frontal, surprisingly rectilinear architecture one finds in Brouwer's inn scenes of the 1630s. Early De Hoochs like the *Soldiers Playing Cards, with a Woman*

230
PIETER DE HOOCH,
The Merry Drinker,
ca. 1653-54.
Oil on panel, 50 x 42 cm.
Berlin, Gemäldegalerie,
Staatliche Museen Berlin

231
ADRIAEN BROUWER,
The Dozing Innkeeper,
ca. 1632.
Oil on copper,
31 x 24.2 cm.
Munich, Bayerische
Pinakotheken

and Two Children from the De Boer Collection,[145] and the stable scene in the National Gallery, London, have antecedents in Saftleven's interiors of the 1630s or about 1640 (*Interior with Peasant Family* in Basel).[146] Many of these "South Holland peasant scenes," as Schulz properly describes them,[147] follow Brouwer and the early Teniers in dwelling upon still-life details and in emphasizing highlights on the edges of furniture and on glasses and metal objects. The L-shaped plan usually employed by De Hooch, in both a tall and a broad format, was favored by Brouwer (fig. 231) and Saftleven. The wooden partition that defines the foreground in De Hooch's inn scenes in Dublin and Berlin is found in Brouwer and Sorgh,[148] but also in Esaias van de Velde (fig. 195) and in everyday life.

De Hooch's early paintings do not look like works of the 1630s, however much they depend upon low genre scenes of the Antwerp and South Holland tradition.[149] As Sutton and others have observed, more contemporary pictures, such as Ter Borch's guardroom and inn scenes of about 1648-52, also appear to have impressed the Delft painter.[150] His *Soldiers with a Serving Woman and a Flute Player*

(Borghese Gallery, Rome) and *A Soldier and a Serving Girl with Card Players* (Wallraf-Richartz-Museum, Cologne), both broad, rather dark tavern interiors with light entering from a window to the upper left, bring to mind Van den Eeckhout's *Tric-Trac Players* (fig. 199) and similar interiors painted in Amsterdam about 1651-54.[151] The influence of these northern models appears to have had a refining effect upon the illumination and perhaps the figure types in De Hooch's early genre interiors.

The new interest in a deeper and more structured space that is found, for example, in the Koetser stable interior (fig. 211) has been convincingly related to slightly earlier or contemporaneous inn scenes by De Jongh like the picture in Basel (fig. 209) and to similar paintings by De Jongh which were once attributed to De Hooch himself: the *Tavern Scene* in Prague and *Paying the Hostess* in a private collection, New York.[152] Of course, the conception of space may also be compared with that found in works of the 1640s by Sorgh (fig. 212), but the more immediate influence of De Jongh's interiors and figures cannot be questioned. It was noted above that De Hooch was reportedly resident in Rotterdam at the time of his marriage in May 1654, and he probably went there occasionally after he settled in Delft (no doubt shortly before or after the ceremony; his first child was baptized in Delft in February 1655).

In recognizing De Hooch's debts to painters in Rotterdam one runs the risk of returning to Bouchery's concept of artistic "links in the chain" leading to a climactic moment in Delft. De Jongh's influence upon De Hooch may be placed in a broader context by acknowledging not only the contributions of Saftleven and Sorgh but also of Koedijck and Brekelenkam in Leiden and of Jacob Duck from Utrecht, who resided in The Hague from about 1656 to 1660. Duck's chronology is uncertain, but his long enthusiasm for striking spatial effects is not. A panel signed and dated 1655 (fig. 232) – dated works are exceedingly rare – is typical of his genre scenes dating from the 1650s in its sharp recession and the strong connection with the viewer's space. It is unclear whether Duck was responding to earlier developments in Leiden and/or Rotterdam (see figs. 189, 209) or picking up and characteristically exaggerating the latest conventions when he moved to The Hague (which could have been somewhat earlier than 1656).[153]

Some of the architectural elements in De Jongh's and De Hooch's early horse-stall and tavern interiors may be based upon actual models, but similar forms are found in a great number of contemporaneous paintings and prints. Divided windows, doorways, beamed ceilings, and shutters swinging this way and that had long been employed to articulate space in perspective treatises (fig. 194) and in works by artists

as various as Visscher, Van Delen, and Coques (figs. 192, 221, 222). The receding elevation on the left in the early painting by De Hooch in the Hermitage (fig. 210) is almost identical to the one in Van de Venne's illustration of death on the doorstep of a wealthy old man in Jacob Cats's *Dood-kiste voor de Levendige* (1656).[154] These and other artists working in the mid-1650s – compare, for example, Metsu's *Interior of a Smithy* (National Gallery, London)[155] – were simply employing motifs of the moment, but Van de Venne's inventions were slightly modified versions of designs he had been drawing for about thirty years (see figs. 225-28).

The sense of proportion and emphasis upon rectilinear elements that are similarly found in works by Maes and De Hooch were considered above in a broader context, that of Hendrick Sorgh (fig. 207) and other South Holland genre painters. This taste flourished in many forms from the late 1640s onward; one could compare actual houses by Philips Vingboons, Jacob van Campen's New Church in Haarlem (built 1646-49), Saenredam's interior views of the same building in the 1650s, some prints by Rembrandt (for example, *The Virgin and Child with a Cat and Snake*, 1654), and a great number of genre

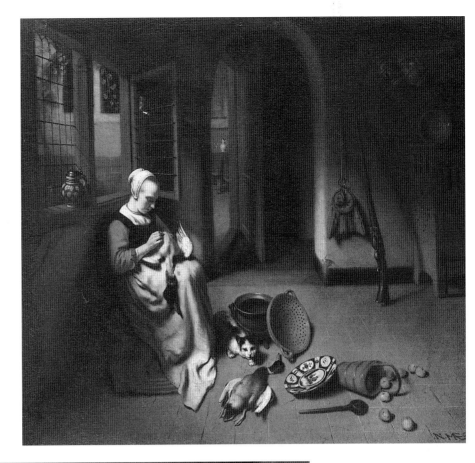

233
NICOLAES MAES,
Woman Plucking a Duck,
ca. 1655.
Oil on canvas,
59.7 x 66 cm.
Philadelphia, Philadelphia
Museum of Art

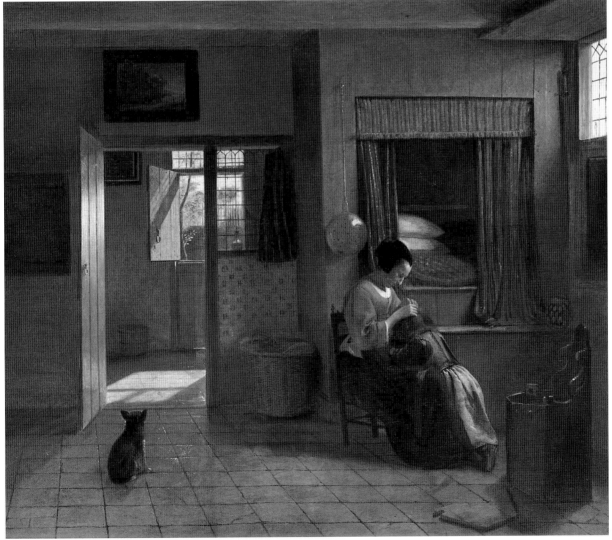

234
PIETER DE HOOCH,
Maternal Duty (A Mother and Child with its Head in her Lap), ca. 1659-60.
Oil on canvas,
52.5 x 61 cm.
Amsterdam, Rijksmuseum, on loan from the City of Amsterdam (A. van der Hoop Bequest) since 1885

 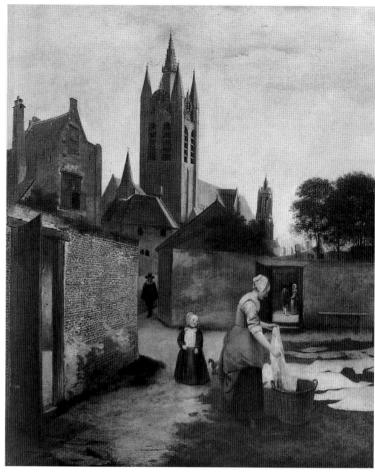

235
PIETER DE HOOCH,
Two Women and a Child in a Courtyard, ca. 1657.
Oil on panel, 68 x 57.5 cm.
Toledo, Ohio, The Toledo Museum of Art

236
PIETER DE HOOCH,
A Woman and Child in a Bleaching Ground,
ca. 1657-59.
Oil on canvas, 73.5 x 63 cm.
Private collection
(Schaeffer Photo Archive, Metropolitan Museum of Art, New York)

scenes. (The Amsterdam native Esaias Boursse and the Amsterdam resident Pieter Janssens Elinga have also been compared with Maes and De Hooch in this regard, but their analogous works all date from the 1660s.)

One may still speak of a particular affinity to Maes in a few paintings by De Hooch dating from about 1657. In the Louvre panel (fig. 208) and in an interior view with similar figures near a fireplace (private collection, Switzerland), the intimacy of the mother and child and the diligent maid recall Maes's scenes of women and children dating from about 1654-55, such as the one in Worms (1654?) and well-known examples in Amsterdam, London, and New York.[156] In these quiet vignettes of home life the young mother and child bring to mind Rembrandt drawings of the 1640s and his seemingly related religious pictures, such as *The Holy Family with Angels* of 1645 (St. Petersburg) and *The Holy Family* of 1646 (Kassel). From works like these Maes learned to huddle figures within velvety shadows and atmosphere, so that they seem nestled in nebulous blankets, safe within the home. A similar feeling is suggested by De Hooch in his shadowy interiors with mothers and children of about 1657, and it continues in the more illuminated interiors of 1658 and slightly later, such as *A Woman with a Baby, and a Small Child with a Puppy* of 1658 (private collection, England), *The Pantry* of about 1658 (fig. 244), *Woman by a Bed and a*

Child at a Door in Washington (version in Karlsruhe), and the canvas known as *Maternal Duty* (fig. 234).[157] In these images De Hooch's emphasis gradually shifts from the home as cosy shelter (which is what one often finds in Maes) to a more open environment, with windows and doors admitting sunlight, breezes, and the familiar noises of the neighborhood. The figures seem more confident in De Hooch's domestic scenes from this point onward, as if the young mother has grown into her rôle, the child feels secure and happy, and the unseen father is proud of his family and their modest prosperity.

The walls, windows, and tidy floors of these households contribute to the impression of intimacy and well-being by their order, small scale, and nearness to the viewer. Maes appears to have been important for De Hooch in this respect also, for he often divided his rooms into small rectangular units, as if he wanted everything private to be measurable by a few steps or a hand. This sensibility is found in *The Old Lacemaker in a Kitchen* (recently acquired by the Mauritshuis) and in all the paintings of young maids and young mothers (see fig. 233), a few of which have small-paned windows to the left or in a rear wall, as in De Hooch's interiors of 1657 onward (where they are handled more beautifully), and walls and a floor plan divided into nicely proportioned sections.[158] If De Hooch did derive this design quality from Maes to some extent, then the debt tends to be

obscured by his superior use of it in both formal and expressive terms. The impression of domestic harmony is extended into the surprisingly soft-edged, mute, and timeless world of geometry. As with De Witte, one finds in De Hooch an artist who had a natural gift for certain kinds of visual language – light, space, proportion – which needed only a brief lesson in grammar to grow eloquent on its own.

In historical perspective De Hooch's shadowy interiors of about 1657 and his more sun-filled rooms of 1658-60 seem separated by the first courtyard views, such as the panel in Toledo, the bleaching scene in a British collection, and *A Family in a Courtyard* in Vienna, all of which date from about 1657 (figs. 235-37).[159] (Each picture features the tower of the Oude Kerk or the Nieuwe Kerk in the background, and in the canvas in England an impressive view of both.) But of course De Hooch developed his remarkable interpretation of bright daylight simultaneously in exterior and interior scenes, and indeed the sense of continuity between indoors and outdoors is one of his most distinctive qualities (Maes's doorstep views, by contrast, look like interiors with one wall fallen away).[160] De Hooch seems to have appreciated the high-walled courtyards of Delft houses as airy rooms, in which brick and plaster surfaces and trees placed as carefully as houseplants catch the light. There is little suggestion in De Hooch's exterior views that his talent for describing space and light would have made him into a landscape painter of even average ability, and the reason appears to be that his way of seeing these properties was so object-bound. (In this the artist was less close to De Witte than to Van Vliet.)

At the same time that De Hooch was inventing interior views which may unequivocally be called "domestic," he was painting "conversations" of a more social kind, bringing the figures from his earlier tavern settings into private rooms and in most cases improving their manners. One of the earliest examples is *The Bearer of Ill Tidings* (fig. 238), which probably dates from about 1657.[161] The figures were evidently inspired by Ter Borch's *Unwelcome News* of 1653 (Mauritshuis, The Hague), while the tilting floor, receding ceiling beams, and open door in the background recall De Jongh and Sorgh (figs. 207, 209). The latter artist occasionally covered the floor with tiles,[162] but not, as here, with a bold checkerboard design. Maes occasionally used a few rows of tiles, but again the effect is not similar. The impulsive rush of the floor (which seems to anticipate the soldiers' departure) and the relationship of the figures to the space is more like that found in Van de Venne's illustrations to Cats's books of the 1620s and 1630s (figs. 225-27), Van Delen's "musical companies" of the 1630s (fig. 221), and some little-known pictures by Palamedesz (also of the 1630s)

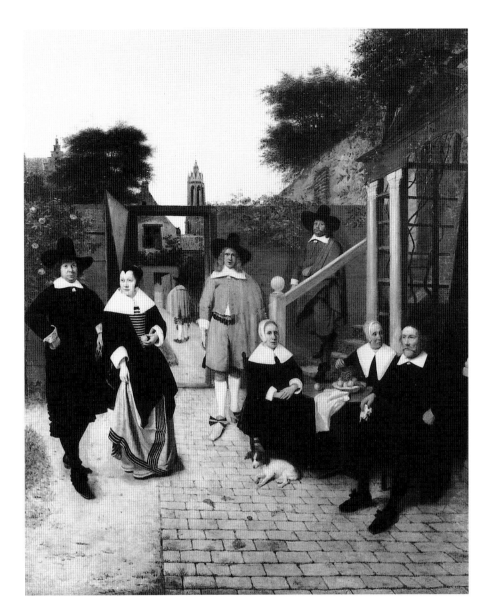

that include wide-angle projections of checkerboard floors (fig. 239).[163]

In 1657 and 1658 De Hooch painted a series of left-corner and a few right-corner interiors which blend together qualities of his and De Jongh's earlier tavern scenes (fig. 209) with the approach attempted in the Barcelona picture (fig. 238). The rooms are now *voorkamers* or similar rooms, that is, the sitting rooms of middle-class or upper-middle-class houses (figs. 242-44, etc.).[164] Gentlemen and soldiers of some authority, their swagger tempered by poise, are entertained by experienced young women, in some pictures with the assistance of a discreet or sullen maid. The change in setting, social behavior, and, to some extent, characters is found also in Ter Borch's work of the early 1650s. In a few pictures he uncharacteristically clarified the type of interior not only by placing a curtained bed, covered table, or grand fireplace in the room, but also by defining a corner, including a receding wall (two, in *The Suitor's Visit* of about 1658 in Washington),[165] and even ceiling beams (as in the *Gallant Conversation* of about 1655 in the Petit Palais, Paris, and the rowdier inn

237
PIETER DE HOOCH,
Portrait of a Family in a Courtyard in Delft,
ca. 1657-60.
Oil on canvas,
112.5 x 97 cm.
Vienna, Gemäldegalerie der Akademie der bildenden Künste

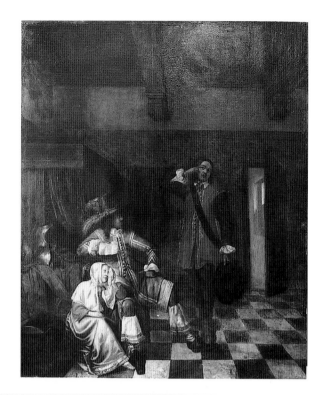

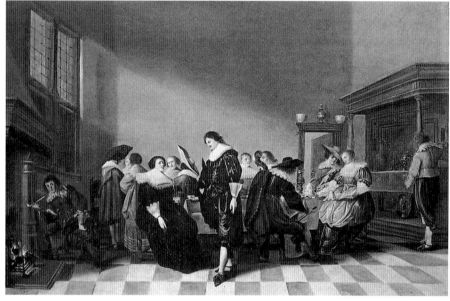

232).[168] These figures are perhaps not the ideal representatives of a supposed process of "gentrification," which Salomon describes in the work of Duck and other artists,[169] and which has been mentioned above with respect to De Jongh's oeuvre about 1654-58. In a broad view, however, De Jongh, De Hooch, and other artists of the 1650s, following Ter Borch, may be seen to have been modifying their various "conversation" scenes in a similar manner, and of course so was Vermeer as he proceeded from *The Procuress* of 1656 to *A Maid Asleep* and to the more expected *Cavalier and Young Woman* in the Frick Collection (figs. 258, 261, 265).

The Visit (fig. 242), which Thoré-Bürger attributed to Vermeer, is one of the first paintings in which De Hooch consistently employs linear perspective to define an architectural environment. If it were not for the underscaled bed and rather sudden shift of scale within the figure group, the space would seem to have been recorded from life. A comparison with De Jongh's panel in Basel (fig. 209) suggests what we have come to expect, namely, that the composition as a whole and devices such as the helpful bench to the lower left and the window shutter have been adopted from another artist. The juxtaposition of the seated figures, whose faces overlap slightly, and the standing woman with a pitcher in the De Hooch could derive from the same picture by De Jongh, or a now unknown, analogous composition, especially if De Hooch had sketched a record of the work rather than carefully copied its particulars.[170]

Some of the many precedents for the type of composition that De Hooch adopts in *The Visit* have been discussed above. The perspective scheme deserves special mention but should not be overemphasized. Orthogonals receding to very nearly the same point define the ceiling, the window and shutter, the bench, and other furniture. The arbitrarily placed seam in the floorboards is helpful not only in suggesting space but also in focusing attention on the figures. The use of perspective in this painting and in the somewhat more complex pictures of 1658 (fig. 185) is not *kinderspel*, but to speak of De Hooch's "mastery" of artificial perspective, as some writers have, is simply nonsense. Apprentices easily acquired De Hooch's level of ability if they had a mind to, as have teenaged boys in drafting classes during the past hundred years. The cartoons of Van Delen's patrician households (fig. 221) and most architectural paintings in Delft are considerably more complicated, in part because they include non-rectilinear elements like capitals, or doors and shutters opened at various angles. Sutton suggests that perspective manuals would not "have satisfied all of De Hooch's demands." It is true that if the artist wanted to master the method (in so far as

scene dated 1658 in the Johnson Collection, Philadelphia Museum of Art).[166] Ter Borch also approaches the scene more closely than in other paintings, such as *A Woman Playing a Theorbo for a Cavalier* of about 1658 (Metropolitan Museum of Art, New York). In this case a corner is added as a background to the kind of figure group he had depicted ten years earlier (knee-length views of women and soldiers, seated at table corners).[167]

In modest essays of the early to mid-1650s Palamedesz appears to have responded to Ter Borch's figure groups, if not to his interiors, as in a very small, mixed-company "toilet" scene (fig. 266) and *A Soldier Pulling on Boots* (art market, Leiden). Similar circumstances are described in De Hooch's panel of about the same date (Pushkin Museum, Moscow) and in Duck's interior with a cocky cavalier of 1655 (fig.

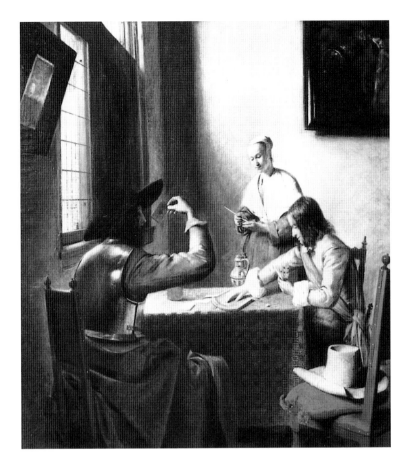
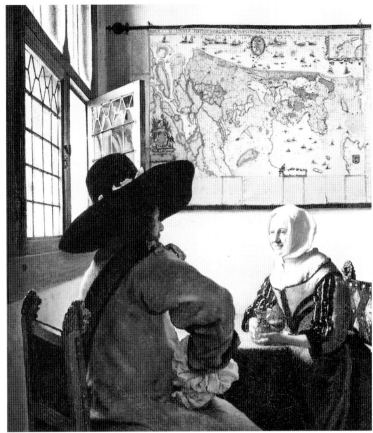

he did) in an afternoon, then he might as well have asked someone like Hendrick van Vliet for instruction, precisely because the available treatises offered more information than he ever needed. As for red herrings like "light, color, and atmosphere [which] are also the determinants of perspective," these cues to distance are another subject (as landscapists would confirm), to which the artist had already given considerable attention before 1658 and which he never used in a methodical manner.[171]

Vermeer's command of perspective practice and his ability to describe interior space by other means were clearly superior to De Hooch's in about 1657, if *The Visit* and the slightly younger artist's *Cavalier and Young Woman* in the Frick Collection and *Young Woman Reading a Letter* in Dresden (figs. 241-42, 263) are approximately contemporaneous. As Wadum has shown, Vermeer used a pin to locate the vanishing point in paintings from the Frick canvas onward, and he determined the horizon's height and the lateral position of the vanishing point with an eye to expressive effect.[172] In the Dresden painting the horizon (which is coincident with the young woman's hairline) could be said to correspond with that of a presumably male viewer; his slightly downward glance adds to the intimacy of the scene. In the Frick painting the horizon is at the young woman's eye level, which with the abrupt recession (coinciding with a 53-degree angle of view) grants the cavalier physical dominance in the scene, as well as immediate proximity to (and a kind of identity with) the viewer.

The woman's focus on her visitor's face is enhanced by the slightly off-center perspective scheme. In both the Frick and Dresden Vermeers an open window and one or two chairs recede at different angles, something that De Hooch generally avoided in paintings of 1657-58. The chairs occupied by the couple in the Frick painting recede to the same distance point – in other words, they are parallel – which intensifies the figures' confrontation. These geometric subtleties are so consistent with the picture's other formal and expressive refinements that two received notions may be considered untenable: that the space in the Frick painting depends upon the use of a camera obscura,[173] or that it derives from De Hooch.[174]

De Hooch's one-point approach to furnishing rooms in the late 1650s is unexpectedly modified in the Bührle painting (fig. 240), where the close viewpoint is also something of a surprise. Except for the chair supporting a hat in the foreground (a motif reminiscent of Ter Borch), the interior, the arrangement of table and chairs, and the three figures seem to combine elements of the Dresden and Frick Vermeers (figs. 241, 263). The light effects on the two soldiers and the table top resemble more schematic versions of Vermeer's extraordinary highlights and shadows in the Frick painting. (It should be noted, however, that *Two Soldiers Playing Cards* is a work of extraordinary quality, in good part because of its passages of light.) The woman's placement behind the table, her pose, and the high expanse of wall

PIETER DE HOOCH,
The Visit, ca. 1657.
Oil on panel,
67.9 x 58.4 cm.
New York, The
Metropolitan Museum
of Art. See also plate XII.

behind her could derive from the Dresden picture, which was originally finished by Vermeer with no curtain, a painting on the wall, and a large *roemer* as a repoussoir in the right foreground.[175] Of course, De Hooch has closed the window in the Bührle picture and slammed the door on psychological interpretation. The painter appears here, as in his early inn scenes, as an observer of flourishing gestures, such as the flinging down of a trump card.

The Visit is more successful in its suggestion of interior space, perhaps the first example by De Hooch in which one can imagine the figures leaving the room (fig. 242). There are signs of struggle,

however. The watercolor view of a Mediterranean seaport and the man's portrait on the wall would not establish its location convincingly if it were not for the bed, which, like the hat and the lifeless shadow on the floor, indicates recession where there might otherwise have been none. If the composition as a whole reminds one of De Jongh (fig. 209) and a dozen other artists, the "Venetian" cityscape (which is probably meant to imply worldly sophistication) and the couple at the corner of the table oddly recall Vermeer's *Cavalier and Young Woman* (fig. 241). The standing woman's radiant red jacket bears some resemblance to the cavalier's red coat, but her

reflection in the window may have been De Hooch's modest answer to Vermeer's mirror-like window in Dresden.

The subject is as conventional as the composition but is more effectively handled than in De Hooch's earlier pictures of merry companies. The ladies, one of whom wears a revealing bodice and a knowing smile, entertain two gentlemen, whose mood is suggested by the discarded hat and coat and by their body language, with hands clutching a clay pipe, the back of a chair, and a woman's wrist. Wine is poured, and some delicacies, probably oysters, are in the shallow bowl on the table. The scene is a pleasant afternoon's outing for a pair of Pepyses, except that the diarist would have favored a bed in another room.[176]

Closely related to *The Visit* are the Louvre's *Young Woman Drinking with Two Soldiers*, dated 1658, and The National Gallery's *Woman Drinking with Two Men*, which must date from the same year (figs. 185, 243). The three figures around the table in the London picture appear to have developed directly (along with the second window and the bench) from three of the four figures in *The Visit*. Perhaps the experience with the bed persuaded De Hooch to bring in floor tiles and to join the floor to the ceiling with a fireplace. An older, bearded man in a hat ("paying the hostess"?) was painted out, and the maid who seems to have confronted him was painted over the finished floor tiles (like "staffage" added to an interior by Van Delen). The orthogonals lead to one well-placed point in the area of Enschede on the map, but De Hooch still has some difficulty coordinating perspective schemes and scale. From the nearest man, whose foot coincides approximately with the width of one square tile, to the rear wall is about seventeen feet. A little geometry indicates that the viewer has just entered a room with street-frontage of about thirty-five feet or eleven meters. Similarly, the horizon is at the servant's eye-level, which means that the men marvel at a young woman who is about seven feet (215 cm) tall.

The Louvre canvas of 1658 (fig. 243) seems transitional between *The Visit* and the London picture, although one may not assume a linear development. Compared with the New York panel, the view is closer, the floor's rise is therefore steeper, and the figures occupy a bit more of the picture field. The secondary recession to the right now begins with a dog and chair and continues through more convincing areas of sunlight and shadow. De Hooch aligns the back of the chair with the open door and then leads the viewer through a hallway to another room by means of rectangles stepping down in size like drawing mats. As if to acknowledge the advance in naturalism, the cityscape on the wall is now of Amsterdam; the harbor helps to continue the sense of

receding space from the floorboards and table top. With these visual and psychological outlets in the rear wall, one might almost have predicted the open window on the left and the generally convincing flow of light and space across the picture. Like columns in a Delft church interior, the figures and nearest chair now seem to advance toward the viewer (as we read from left to right), and the corner of architecture suggests a larger volume of space surrounding the viewer. The bench that De Hooch previously placed in the lower left corner has been carted off, in recognition of its depth-defining mission having been a failure. The cropping of the windows, the ceiling, and the rectangular elements on the right relieves the feeling (which is sensed in the New York and London pictures) that a box of space has been built backward from the picture frame. An understated innovation is the horizontal seam in the floorboards, which the puppy has been told not to cross. One thinks of Houckgeest's and De Witte's framing devices and Vermeer's empty zone of cobblestones in *The Little Street* (pl. xxv).

The Paris picture, despite its numerous signs of progress, is closer in style and quality to the paintings usually dated about 1657 than to De Hooch's other

243
PIETER DE HOOCH,
Young Woman Drinking with Two Soldiers, 1658.
Oil on canvas,
68.6 x 60 cm.
Paris, Musée du Louvre

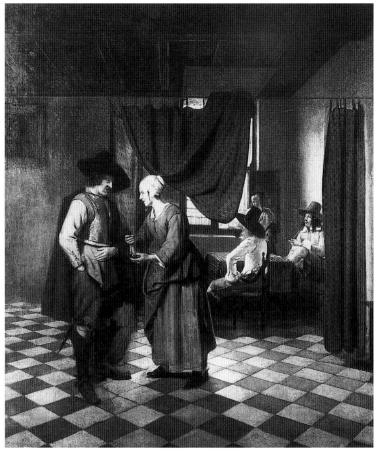

paintings that are actually dated 1658. The most obvious sign of naïveté is the wooden articulation of the figures, which recalls the *Two Soldiers Playing Cards* in Zürich (fig. 240) and earlier works. Of course, the stiffness of the puppet-like woman propped up in her chair was meant to be amusing, but the viewer smiles at the artist's expense.

De Hooch appears to have made a conscious decision to raise his own standard in about 1658, so much finer and so unprecedented in his oeuvre is the level of quality in such works as the Bute *Soldier Paying a Hostess,* the *Card Players* in Buckingham Palace, and the celebrated courtyard scenes in a private collection and in the National Gallery, London (figs. 245-48). In addition to exceedingly fine effects of light and color and a considerably more careful figure style, these works exhibit a persistent exploration of alternatives in composition and motifs. De Hooch may have proceeded by working on pairs of similar compositions: compare, for example, the left-corner interior in Paris with that in London (just discussed); the right-corner interior in the Bute Collection (fig. 245) with the Queen's picture (fig. 246), where a door opens, the only curtains are on the window, and sunlight shimmers over bricks and leaves; *A Woman with a Baby, and a Small Child with a Puppy* of 1658 (private collection, England) with *The Pantry* (fig. 244), where the second composition again seems to elaborate the first;[177] and the two courtyard scenes (figs. 247-48),

which represent the same courtyard with different paving and some new construction on the right.

Each of these hypothetical pairs of pictures may also be compared with another, for example, in their use of doors and vistas in the backgrounds. The secondary spaces in *The Pantry* (fig. 244) and the similar picture in a private collection are reminiscent of those in the kitchen interior of about 1657 in the Louvre (fig. 208) and the kitchen scene in a Swiss collection. The two open doorways in *The Pantry* (and the maid in the Louvre picture) recall the background of the *Card Players* (fig. 246). The *doorkijkje* in the Queen's picture resembles the corridor in the London courtyard view (fig. 247), where a woman is framed in an archway. Figure groups reveal similar relationships: the mother in *The Pantry* and the hostess in the Bute tavern interior (figs. 244-45); the gesturing mother with two children (see Sutton's pl. 28) whose pose resembles the man's in the Louvre drinking scene (where the puppy reappears); and the rearrangement of figures at tables, where the main concern appears to be which two or three characters sit and which one stands.

All of this greatly simplifies what might be described as an artist manipulating many motifs in a seamless process. However, De Hooch never reached the stage of improvisation one finds occasionally in De Witte and in mature works by Vermeer. His natural gifts are far more evident in passages of light, such as those that play over various surfaces

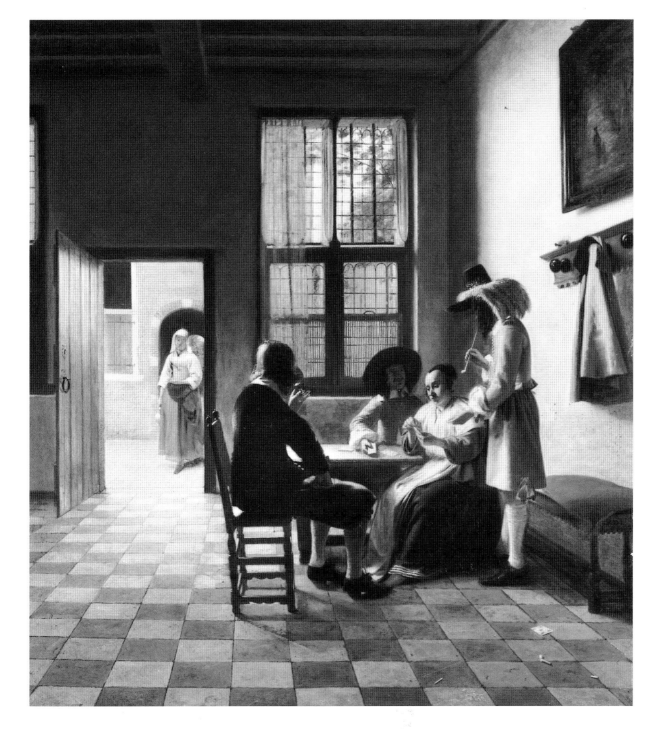

246
PIETER DE HOOCH,
*Card Players in a Sunlit
Room*, 1658.
Oil on canvas,
76.2 x 66.1 cm.
London, Buckingham
Palace, Her Majesty
Queen Elizabeth II

(especially the door) and around the figures in the
Card Players (fig. 246). The picture's design was
conceived with more painstaking deliberation in an
earlier phase of work. In some paintings of the 1650s
these efforts all work together: the rational,
searching adjustments in composition, the more
intuitive handling of descriptive nuances and
painterly effects, the textures, closely valued colors,
and incidents of light. A further effort was needed to
achieve not only this balance but also that between
style and subject, which could be said to distinguish
the two similar courtyard views. De Hooch rarely
surpassed the suggestion of domestic tranquility he
achieved in the courtyard scene in London (fig. 247)
or the idyllic quality that is found, despite the
subject, in the quiet sunlit interior (fig. 246).

There are paintings in which artists appear to be
working for the sheer pleasure of it, but this could
only rarely have been the case. De Hooch must have
had the assurance or expectation of higher prices for
his finer pictures, and this would have made him
attentive to what was successful in the marketplace.
The courtyard pictures (figs. 247-48; pls. XIV, XV)
represent two surprisingly different themes, the
responsibility of motherhood and an idle hour of
drinking and smoking (where the "good mother"
holds a dog).[178] Sutton, following MacLaren, suggests
that the London picture was painted second, because
of the "improved grouping of the figures" and the
fact that the wording of the tablet over the doorway
is less close to that in the original relief.[179]

However, an argument for the primacy of the

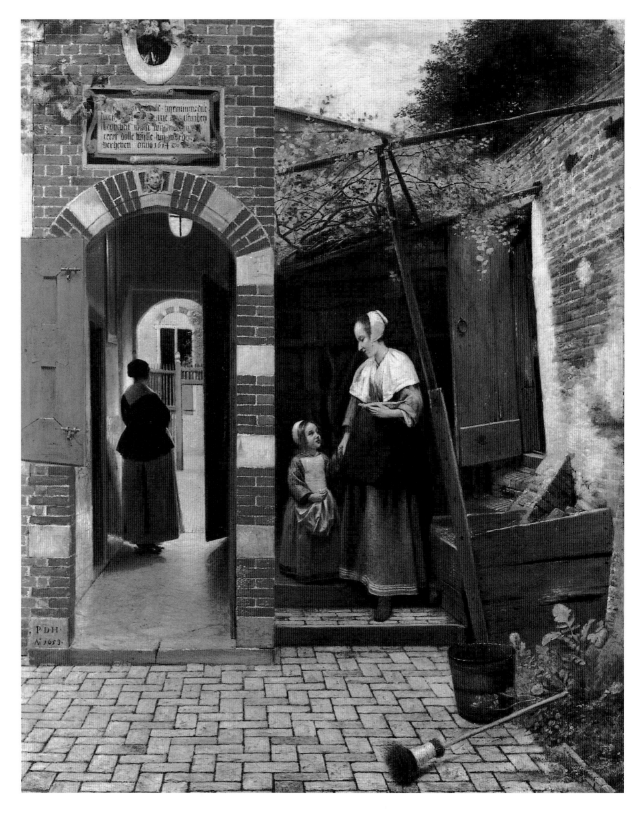

London picture is not difficult to compose. The painting is related to slightly earlier domestic scenes, such as the Louvre kitchen interior (fig. 208) and probably *The Pantry* (fig. 244), perhaps more closely than the other courtyard picture relates to any earlier drinking scene. One cannot assume that second versions usually improve upon already successful designs; the composition in London is so well conceived that it is hard to imagine its derivation from the other work. The wall to the right (which, as will be seen, appears to come from a real source) is joined to the house by a complex arrangement of slanting posts and boards and by a superb passage of foliage. The pavement in the London courtyard is seemingly simpler but subtler in pattern, as are the bricks above the archway. The asymmetrical composition is perfectly poised, with the deeper, more solid, potentially more eye-catching side deferring to the stepped area on the right (the maid has apparently come from the doorway, which may lead into a storage shed). Such motifs as the red shutter, the open door in the corridor, the door to

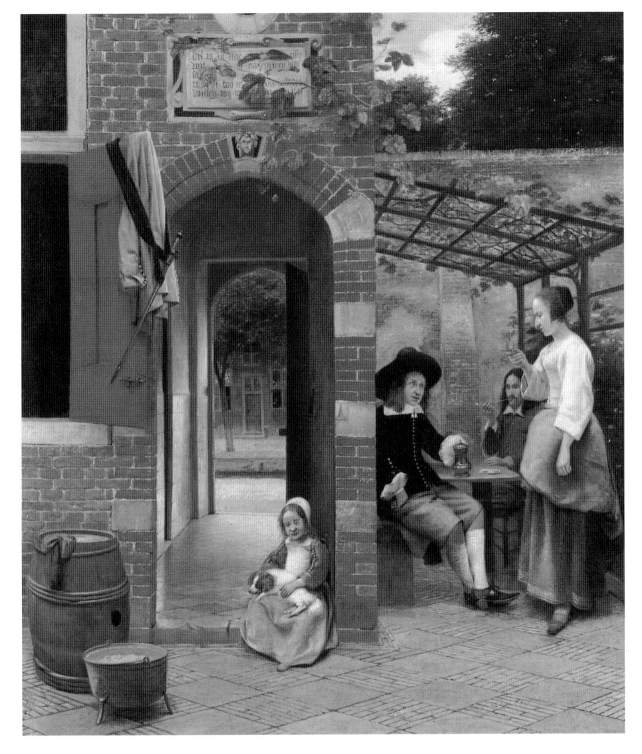

248
PIETER DE HOOCH,
Figures in a Courtyard,
1658.
Oil on canvas (mounted
on panel), 66.5 x 56.5 cm.
Private collection
(photo: courtesy of Rob
Noortman, Maastricht).
See also plate xv.

the right, the trellis and broom, and also the counterpoise of figures (the two women resemble statuettes revolving in a town hall clock) result in a more complex design than in the other painting (fig. 248, pl. xv). Clearly, the London canvas is more than a "close variant of the composition."[180] *Figures in a Courtyard* seems to simplify slightly the London design (the entire recession on the right, with its wonderful textures, has been eliminated) in order to use it for a more fashionable subject, one that is familiar from other courtyard and garden scenes by De Hooch. There is also a greater emphasis upon perspective for its own sake, in both the pavement and the corridor. The latter, formerly the entrance to

a private world, becomes a tour de force as in Van Hoogstraten.

Precedents for the courtyard views of 1658 are not obvious, which is a testament to De Hooch's creativity. Sutton cites the townscape by Fabritius (pl. III), a *Palace Courtyard* by Van Delen, which happens to have an archway to one side, and Steen's *Burgher of Delft*, which is set on one of the city's most fashionable quays (fig. 205). The comparison with Fabritius is meant to support the idea that "De Hooch's first courtyard scenes [of 1658] contributed to the emergence after ca. 1650 of the cityscape as a fully independent genre of painting."[181] The connection with Steen is more plausible, in so far as

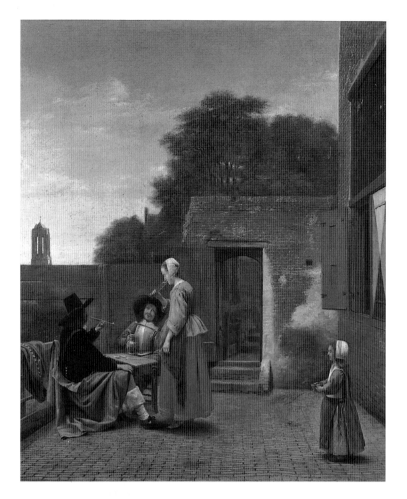 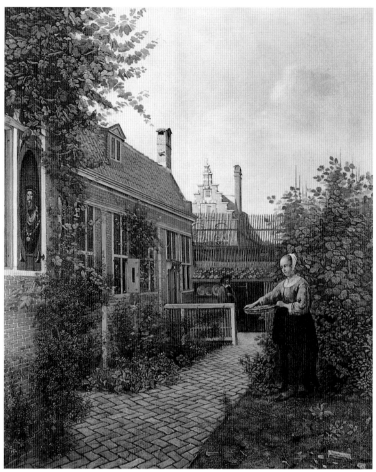

249
PIETER DE HOOCH,
A Dutch Courtyard,
ca. 1658-60.
Oil on canvas,
69.5 x 60 cm.
Washington, National
Gallery of Art, Andrew
W. Mellon Collection

250
PIETER DE HOOCH,
*A Woman with a Basket in
a Garden*, ca. 1661.
Oil on canvas,
69.5 x 59 cm.
Basel, Öffentliche
Kunstsammlung

it reflects common sources in genre interiors, as well as period taste. Other works that describe street scenes (based on actual sites) according to the design sensibilities of the 1650s include *The Grinder's Family* by Ter Borch,[182] *The Amsterdam Exchange*, 1653, by De Witte (Museum Boijmans Van Beuningen, Rotterdam), Maes's exterior views (for example, the *Milkmaid at a House Door* in the Wellington Museum, London),[183] and Vermeer's *The Little Street* (pl. xxv), which must date from slightly later than the De Hoochs. When one compares De Hooch's classic courtyard pictures of 1658 with his own *Family in a Courtyard* (fig. 237; dated by Sutton to about 1657-60), the painting in Toledo (fig. 235), and similar works, it becomes clear that the search for sources leads one back to the same fertility of invention that was discussed above with respect to the interior views dating from 1658.

Between that year and 1660, which is probably when De Hooch moved to Amsterdam, he continued the practice of inserting motifs discovered around Delft into compositions developed from slightly earlier works. A good example is *A Dutch Courtyard* in Washington (fig. 249). Not only the Nieuwe Kerk's tower but also the doorway and the brick wall in the background were apparently drawn from life, since the wall is identical to the one on the right in the London courtyard view (fig. 247).[184] Otherwise, the Washington picture simply takes the painter's

approach to interiors out of doors. In hindsight, the two courtyard views of 1658 (figs. 247-48) seem to define the moment when De Hooch first used the exterior setting not for subjects of household duty but for "merry companies." There was a long tradition of depicting couples in elegant outdoor settings but not in everyday surroundings like the courtyards of Delft.[185]

This attractive subject was short-lived in De Hooch's oeuvre. One exception is *Three Figures at a Table in a Garden* of about 1663-65 (Rijksmuseum, Amsterdam), but in other Amsterdam paintings the artist set patrician couples in splendid gardens or on marble-floored terraces of the Van den Eeckhout type.[186] Before leaving Delft, De Hooch returned the use of courtyards to their usual occupants, mothers with children and maids, notwithstanding the occasional vignette of figures in an arbor.

How De Hooch invented these compositions along lines described above will be clear to the reader: compare, for example, *A Dutch Courtyard* (fig. 249) and *A Woman and Child in a Courtyard* in the National Gallery, Washington, with *A Woman with a Glass of Wine and a Child in a Garden* (private collection; see Sutton's pl. 41);[187] *Two Women* [Maids] *in a Courtyard* (Buckingham Palace) with *A Woman Carrying a Bucket in a Courtyard* in an English private collection;[188] *A Woman and Maid in a Courtyard* in the National Gallery, London, with the Vienna family

portrait and several other courtyard scenes of 1658-60 ("the same piece of wall" and "the identical pump" are seen from different viewpoints in *A Woman and Child in a Courtyard* in Washington);[189] and the wonderful *Woman with a Basket in a Garden* of 1661 (?) in Basel (fig. 250), where the approach taken in *A Woman with a Glass of Wine and a Child in a Garden* has been modified in favor of a long diagonal recession of brick houses, a brick pathway, and abundant foliage.[190]

De Hooch's approach to composition has been emphasized in this chapter because its main concern is his place within the South Holland tradition of genre painting. His mastery of design in the period 1655-60 was crucial for the creation of his finest pictures and for the rest of his career. Of course, De Hooch achieved much more in this period, with regard to other pictorial values, iconography, and observation. Much has been written about the painter's treatment of light and color;[191] an attention to textures is also an impressive aspect of his mature work. These qualities and especially De Hooch's descriptions of space were admired by his contemporaries, to judge from the impression they made upon Hendrick van der Burch (the garden scene in Zürich is one of his best tributes to De Hooch) and from Vermeer's otherwise unexpected picture, *The Little Street* (pl. xxv).[192]

Other artists dwelled intently upon passages of bricks and foliage in the same years, but few ever achieved the naturalistic effects that occur in the best of De Hooch's Delft paintings. Some remarkable examples are found in the backgrounds of a few rarely seen works, such as the view of two houses rising above a fence in *A Woman with a Glass of Wine and a Child in a Garden* (private collection) and the rooftops, chimneys, and towers of the Nieuwe Kerk and the Town Hall of Delft in *Two Women in a Courtyard* (Buckingham Palace).[193] Vermeer's rooftops and foliage on the left in *The Little Street*, with sunlight shimmering over leaves and tiles, may have been inspired by De Hooch, just as Vermeer's bricks, whitewash, views into doorways, and uncharacteristic figures appear to have been. De Hooch favored these motifs from about 1657 onward (for example, in fig. 235), and *The Little Street* is unlikely to date from before 1658.

Many of the strengths De Hooch developed in Delft are also found in Amsterdam paintings of the 1660s (fig. 251). The return of rich shadows in paintings of that decade, as well as their luxuriousness, bring to mind Van den Eeckhout and Ter Borch, Kalf and Van Beyeren, and on occasion Vermeer. De Hooch's career in the great city goes beyond the scope of this essay and is covered admirably in Sutton's monograph and in the catalogue of his recent exhibition.[194]

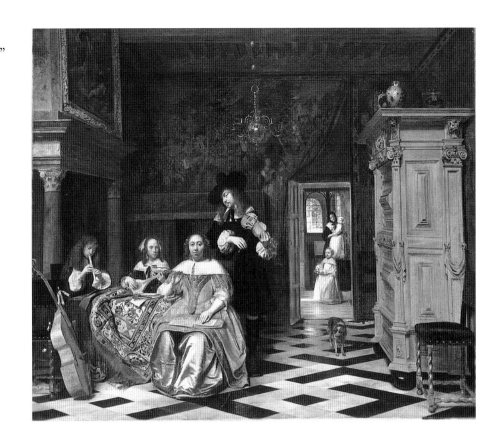

251
PIETER DE HOOCH,
The Music Party, 1663.
Oil on canvas,
100.3 x 119.4 cm.
Cleveland, Ohio, The
Cleveland Museum of Art,
Gift of the Hanna Fund

185

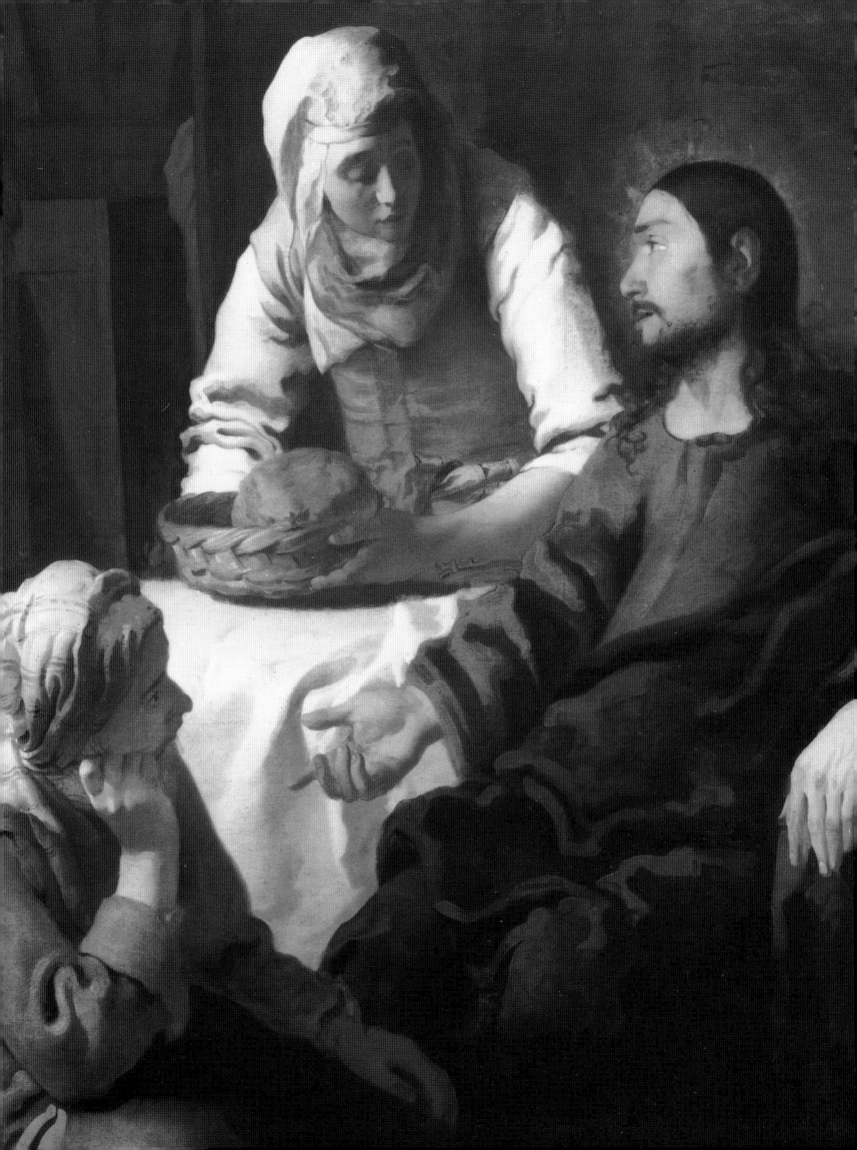

Chapter Five

Vermeer's Early Years

Mystery and hagiography go hand in hand. There seems no other explanation for the tenacity with which rumors of Vermeer's obscurity are still repeated. His biography is now better known than those of most Dutch artists, thanks largely to the archival research and publications of Michael Montias. And yet the sketch of Vermeer's life offered to the public in the catalogue of the monographic exhibition of 1995-96 might be subtitled "The Search for the Sphinx," given its insistence on what is unknown: "the name of his master(s), the nature of his training, the period of his apprenticeship (which must already have begun in the late 1640s), and even the city or cities in which he apprenticed." All this, and also the nature of his "decision to become an artist," his knowledge of art theory, and his interest, if any, in "broad philosophical ideas," his relationships with other painters, his critical reception in the 1650s, and – it is alleged – his patronage, "remain mysteries." Of course, he died the usual death of an isolated genius, "leaving behind a wife, ten minor children, and enormous debts."[1]

The bare facts of Vermeer's life are available in numerous publications, which most readers of this one will already know. Vermeer's father, Reynier Jansz (1591-1652), was a weaver of fine silks and satins, an art dealer, and innkeeper. Johannes, the second child and first son of Reynier Vermeer and Digna Baltens, was christened on October 31, 1632. This took place in the Nieuwe Kerk, steps away from the house and inn called the "Mechelen" that Vermeer inherited in 1670 when his mother and sister both died. On April 20, 1653, he married Catharina Bolnes, the daughter of the wealthy Catholic divorcée Maria Thins. Good relations were gradually established with the mother-in-law, whose home on the Oude Langendijk soon became that of Vermeer's growing family. The couple had as many as fourteen children, of which eleven outlived the artist.

From about 1657 until the late 1660s Vermeer apparently sold the majority of his paintings to a single patron, Pieter van Ruijven (discussed in the next section). The French invasion of 1672 and Van Ruijven's death in 1674 were evidently serious reversals for the artist. In the summer of 1675 he borrowed 1000 guilders from an Amsterdam merchant. He was buried on December 16 of the same year, at the age of forty-three. Two years later his wife testified that in the last few years of his life the artist could not sell his own pictures or those by others which he had on hand. Because of this and "the very great burden of [his] children, having nothing of his own, he had lapsed into such decay and decadence, which he had so taken to heart that, as if he had fallen into a frenzy, in a day and a half he had gone from being healthy to being dead."[2] Here, for those who seek it, is the touch of tragedy. The painter who courted perfection was sent to the grave by real life.

Vermeer and Delft

Everything that defines Vermeer's individuality as an artist may be considered as an objection to the notion of a Delft school. This might be said of any other painter in the city, since shared characteristics make the concept of a school meaningful. The term "Fontainebleau School," which could refer to a French or Italian painter, seems unobjectionable. But is Leonardo an artist of the Florentine School? Genius gets out of school early, or so we imagine in modern times.

Perhaps Vermeer deserves recognition as a representative of the Delft school simply because he never worked anywhere else. However, it was suggested in the first chapter that during the 1650s, when Vermeer's career began and when the Delft

school is said to have "at last come into existence,"[3] the coherence of the city's and the region's artistic traditions began to break down, for numerous reasons, including the collapse of the court as a cultural center, changes in the art market and private patronage in Delft, the rise of Amsterdam as the economic, social, and political center of the United Provinces, and an increasing openness in the South Holland area to developments in Dutch painting elsewhere (as well as continued interest in Flemish art).

Needless to say, when some of Delft's most gifted painters died or departed between about 1650 and 1660 – Houckgeest, De Witte, Fabritius, Potter, Van der Poel, Van der Ast, Van Aelst, De Hooch, and others – the vitality of the local school was considerably diminished. But the most remarkable achievements of an artist – for example, Vermeer's descriptions of daylight, subtleties of design, observations of human behavior (a woman's lips part as she reads a personal letter; fig. 294) – cannot be credited to the local school. From this point of view, one is tempted to perceive the most distinctive paintings by Vermeer, De Hooch, Fabritius, and a few of their colleagues as being not at the center of our focus on the Delft school but closer to the periphery. These works cannot be considered "typical" of Delft, any more than Rembrandt's *Aristotle with a Bust of Homer* is a typical painting of the Amsterdam school between about 1650 and 1655.

And yet, Rembrandt would not have become the same artist had he remained in Leiden or for some unexpected reason moved to Delft (it says something about the nature of the Delft school that this is so difficult to imagine). Moving to Delft from Dutch cities outside the immediate area clearly had consequences for the subjects and styles of such artists as Fabritius, De Witte, and De Hooch. That they were still at formative stages in their artistic lives was important, of course. Van der Ast's well-established style was not transformed during the first few years after he settled in Delft (1632), although one would not expect him to have created certain works of the 1640s – the monumental still life in Douai, with its broken wall and seemingly abandoned palace, or the array of rarities in the panel at Dessau (fig. 10), with a setting resembling Vermeer's corner of space – had he remained in Utrecht or moved to Amsterdam. On the other hand, Van der Ast was carrying something like coals to Newcastle when he moved to the area of Delft and The Hague, where his highly refined type of flower picture had been coveted since the artist's youth. His teacher and brother-in-law in Middelburg, Ambrosius Bosschaert the Elder, died in 1621 while delivering one of his precious still lifes to Prince Maurits.

Like Rembrandt in Amsterdam, Vermeer was one of the least typical artists of the Delft school, but he would not have adopted the same forms or cultivated quite the same preoccupations if his art had matured in another part of the Netherlands. His range of subject matter was restricted in a manner that is at least consistent with earlier art in Delft. His earliest known painting, *Diana and her Companions* (pl. XVII), treats one of the most common mythological themes of artists working for the House of Orange, including Bramer, Van Couwenbergh, Rubens, and François Spiering (whose Diana series of tapestries for Sir Walter Raleigh dates from about 1593 onward).[4] *Christ in the House of Mary and Martha* (pl. XVIII) represents a familiar religious subject on an impressive scale – as in Van Couwenbergh's earlier canvas (fig. 16) – and in a style that appears to take into consideration the Dutch court's interest in Van Dyck (see fig. 256) and other Flemings, as well as in the Utrecht Caravaggisti. Vermeer's first genre scene, *The Procuress* of 1656 (pl. XIX), raised to a new level what Van Couwenbergh and Willem van Vliet had already done, which was to reinterpret Honthorst's type of "merry company" in a more descriptive and somewhat less ill-mannered mode ("the bravo of Utrecht is here exchanged for the humane and domestic characters who people the painting of the school of Delft").[5]

Vermeer turned to a more modern and elegant type of genre scene after he painted *The Procuress*. He absorbed ideas from many artists working along similar lines, such as Maes, De Hooch, and Palamedesz (who was still inventing new if not very significant compositions during the 1650s; see fig. 266). It is revealing, however, to observe how Vermeer tended to borrow motifs and stylistic conventions from these painters without adopting their tone or expressive qualities, such as Maes's tender or lighthearted domesticity, De Hooch's occasional coarseness or cosiness, and Palamedesz's easygoing sociability. Even in the large painting of a dreamy and perhaps tipsy young woman, *A Maid Asleep* (pl. XX), which reminds one of Maes in style and subject, one finds a shift of emphasis toward understatement and sophistication, as in Ter Borch's slightly earlier work. A similar development was discussed in Chapter Four with regard to Ludolf de Jongh and De Hooch, but Vermeer came close to them only briefly, as in the Frick *Cavalier and Young Woman* (pl. XXII). In the approximately contemporaneous *Young Woman Reading a Letter* in Dresden (pl. XXI), the nuances of style and interpretation already anticipate those of his mature work and emulate Ter Borch, Dou, Van Mieris, and others who enjoyed the support of cosmopolitan patrons.

Vermeer and Van Ruijven

The standard of execution and other qualities of the pictures just cited speak for the probability of an understanding with known collectors, the promise of a respectable price. Vermeer's likely Maecenas, Pieter Claesz van Ruijven (1624-1674), later "Lord of Spalant" (from 1669), was related by marriage to the diplomat Pieter Spiering (Spierincx) Silvercroon, son of the celebrated tapestry manufacturer François Spiering, and special patron of one of the most highly paid artists in Holland, Gerard Dou.[6] Montias suggests that "Silvercroon" may have inspired Van Ruijven to support an artist, rather as princes did.[7] However, Van Ruijven's interest in Vermeer seems to have been far more focused and sympathetic than most instances of patronage (in the Netherlands, at least). The arrangement certainly would have been more rewarding than the support enjoyed (or endured) by De Witte and De Hooch.[8]

In any event, Montias's thesis that Van Ruijven bought most of Vermeer's paintings from about 1657 until the early 1670s is supported by both hard and circumstantial evidence and is consistent with contemporary custom. The artist's investment of time, skill and, in some passages, costly materials, and his refinements of form and content (which he could have discussed with the collector) cannot be explained simply in romantic terms as the products of genius, patrons be damned. On the contrary, it is quite possible that Vermeer's most typical subject matter, which commenced with *A Maid Asleep*, the *Young Woman Reading a Letter*, and the *Cavalier and Young Woman*, reflects in good part Van Ruijven's taste.[9]

These paintings date from about 1657, when (on November 30) Van Ruijven lent or advanced two hundred guilders to Vermeer.[10] This may have been the beginning of a sympathetic relationship comparable to that of Silvercroon and Dou, which would have had a liberating not a confining effect on the artist. The visits of the French diarist Balthasar de Monconys and the Dutch *amateur* Pieter Teding van Berckhout to Vermeer's studio in 1663 and 1669, respectively, are also unsurprising in the case of an artist who worked for one or a few well-connected patrons but not for an artist who worked through dealers or for the open market.[11]

Vermeer's tendency to distance himself from his most immediate models (such as Maes and De Hooch) in paintings of about 1657-58, so that the figures seem to rise somewhat above their bourgeois origins, could indicate the influence of a cultivated patron, but it may also be considered typical of painting in Delft. The quietude and reserve, perhaps even the allusiveness of Vermeer, recall the conservative portraits and undramatic history pictures that were painted in Delft during the first half of the century (see figs. 8, 24). At the same time one may cite Ter Borch, with regard to his sensibility, as well as his subjects and style. His concept of polite society was conditioned partly by experience as a court portraitist in Münster and The Hague. When Vermeer met Ter Borch, either in Delft in 1653 or somewhere earlier on,[12] the young man must have been impressed by the painter's polished demeanor and perhaps by news of his patrons, who already included representatives of the national government and senior diplomats. It seems likely that a few of Ter Borch's genre scenes were accessible in Delft, as well as in The Hague and Amsterdam. That his former pupil Caspar Netscher enjoyed a successful career in The Hague from 1662 onward is interesting for Vermeer at a later date, but only with respect to the similarities in subject matter, refined execution, and foreign visitors.

Vermeer's style, rather than his subjects or patrons, allows for the most revealing comparisons with other painters in Delft and The Hague. However, his formal qualities make him exceptional in at least two ways. First, he had an intricate understanding of artistic conventions, which like a linguist's knowledge might be mistaken for mere facility. Second, there is Vermeer's intense study of appearances, of precisely how things appear in reality and how they may be imitated plausibly in paint.

These two aspects of the artist's work reflect his genius but do not explain it. Nothing can, although inspired descriptions of his paintings, like those of Lawrence Gowing and more recently John Nash, contribute greatly to our appreciation of why Vermeer is like no other painter. For the most part, that is not what the present essay is about. The main concerns here are style and observation, which in Vermeer's day were inseparable disciplines. As Van Hoogstraten maintained, even the most innately talented artists had much to learn.

Vermeer his own *leermeester*

Vermeer's development from the last days of 1653, when he became a master in the painters' guild of Delft, to about 1660, when he arrived at his mature style, is an extraordinary example of a great artist teaching himself.[13] Independence from a particular master is not unusual in the career of a precocious painter, and it was more common in those countries with an open art market and freedom from official academies. Rembrandt in Leiden is comparable with the early Vermeer in the balance he achieved between learning willfully from other artists and from direct observation. But Vermeer's temperament was very different from Rembrandt's, which seems to

be reflected in the Delft painter's much narrower range of subjects and expressive qualities, in his even more selective survey of current artistic ideas, and in his fascination with light for its own sake rather than for its usefulness – in an arbitrary manner – as a dramatic device. These inclinations are linked by one aspect of Vermeer's personality, which might be considered reticence or preoccupation but has been described more simply by a conservator who knows his pictures well: few artists were ever so careful.[14]

This is not to say that Vermeer was cautious or overly methodical, which would imply a lack or distrust of imagination. Vermeer's deliberation was rather like Pieter Saenredam's (see fig. 130) in that both painters of light-filled interiors used their sophisticated command of stylistic conventions to transform visual observations into exquisite works of art. The painter of church interiors was more concerned with relationships of space and Vermeer with those of light, but both artists found new ways of recording these two fundamental aspects of visual experience. It may be said, however, that the main element in each painter's program of self-training was the discovery of an effective approach to compositional design.

Rembrandt fills the more familiar rôle of an impetuous prodigy who pores over all the available models and absorbs, with a visual hunger, everything in the environment. Through sheer inventiveness he took risks which occasionally justify Constantijn Huygens's remark that the even younger Jan Lievens had a stronger grasp of composition.[15] Vermeer's compositions, by contrast, are open to criticism only when they are too conventional (for example, fig. 254).

The history paintings with which Vermeer began his career are sometimes seen as signs of misplaced ambition, a prelude to the Vermeer who had found himself. One of the artist's most astute interpreters finds the Edinburgh picture (fig. 255) surprising, its style difficult to explain, and Swillens's rejection of the attribution (and signature) understandable.[16] However, Vermeer's early paintings were clearly important for his later work as exercises in composition, painting techniques, and one essential aspect of his development: he was one of the finest figure painters in Delft. The point is doubly underscored by the fact that a fair number of Delft artists made figure painting their specialty and that no other Delft painter of interiors, whether of churches, inns, or private homes, was particularly talented in this area. The most comparable genre painter, Pieter de Hooch, is often noted for his wooden articulation of drapery and the human form.

In placing an emphasis on Vermeer's program of self-teaching one need not neglect his signs of genius, even the early ones. Like many prodigies (which

Vermeer was not), he often saw great potential in minor works of art. A perhaps related phenomenon is the brilliant beginner's rejection, radical revision, or temperamental appropriation of an established artist's ideas. A broad range of artistic reactions is found among Rembrandt's followers, in Van Dyck's response to Rubens, and perhaps even in Vermeer's constant shifting, in his early paintings, from one model to the next. But the very mention of these relationships, like the search for Vermeer's master,[17] betrays the historian's dependence upon available types and models. We shop in the convenience store of "sources" to explain what is rarely explicable in logical terms: the rise of an individual style from the surf of talent, inspiration, fortuitous opportunities, and the elusive factor of personality.

Vermeer and artistic conventions
Notwithstanding the last remark, conventions of style and meaning must be considered constantly in order to understand how an artist of any talent incorporated them into his own work. This is especially important for an appreciation of Vermeer, because of his bewildering ability to absorb technical and compositional ideas and to renew them substantially, usually by testing the borrowed convention against the evidence of actual appearances. For example, the silhouetted figure in the *Cavalier and Young Woman* (fig. 265) is a device ultimately derived from genre paintings by Honthorst,[18] but "done over from nature" in the light of the studio.[19] Vermeer thereby arrived (as did Rembrandt, when he borrowed the same idea)[20] at unprecedented descriptive and expressive qualities.[21] Similarly, the intimate corner of space found here for the first or second time (compare fig. 263) was by this date (about 1657) routinely employed by genre painters in the South Holland area (see figs. 189, 204, 209), but the closeness of view and the consequently abrupt recession reveal that Vermeer was not content with a standard artistic formula. Scholars have suggested that the use of a camera obscura or even "a wide-angle lens or convex mirror" produced the photographic look of this composition, with its "contrast of scale between the two figures."[22] Vermeer may have learned more about the visual environment from the camera obscura, and some of his stylistic peculiarities could depend upon that experience. However, the rushed recession of space in the Frick picture is similar to that found in a number of Delft paintings dating from the 1650s, such as Fabritius's *View in Delft* (pl. III), Houckgeest's first views inside the Delft churches (pl. II), and works by De Hooch. Vermeer was probably more prepared to see the connections than we are: for example, the resemblance between two receding columns (the near one perhaps in shadow) and the

figures of the cavalier and young woman, or to see her similarity to the goldfinch that Fabritius painted about three years earlier (pl. v). This kind of comparison has nothing to do with artistic sources but with similar interests in observation, so that in some cases it hardly matters – that is, there are reasons one cannot determine – whether Vermeer first saw something in another artist's painting or in reality.

Much of the mystery that has been perceived in Vermeer by writers from Proust to Snow,[23] and by other *amateurs*, comes from their unfamiliarity with the formal and iconographic conventions of Dutch painting at the time, which are made more obscure by Vermeer's discreet steps away from anything commonplace. His profound interest in optical effects compounds the sense of wonder, since his figures, even when conventionally arranged (in the *Young Woman with a Water Pitcher*, pl. xxvi, he adopts the "Aristotle/Flora" pose employed by Rembrandt and a few followers), are treated in terms of light, color, and definition (or "focus"), as if they were still-life objects slowly transferred to canvas by some automatic means. Contemporaneous examples of remarkable verisimilitude, as in figures by Frans van Mieris, may by comparison look like routine passages in the surface layer of seventeenth-century Dutch painting. And yet very little in Vermeer, apart perhaps from some qualities of color and effects of light, can be credited to his possible use of the camera obscura,[24] and in my view nothing is due to convex mirrors or wide-angle lenses other than those he had in his head. When one compares Vermeer's luminous motifs to passages in contemporaneous church interiors by De Witte and in still lifes by Kalf (to name two of several sympathetic painters), one is brought back to the realization that Vermeer's manner of recording visual experience was not a science but a style – and a style of the period, however rare an example it might be.

That sophisticated forms of realism in painting depend upon a mastery of artistic conventions and not upon an innocent eye is one of the main lessons of Gombrich's *Art and Illusion* and related studies.[25] Vermeer's own review of current artistic ideas had much to do, of course, with intangibles like taste and opportunity, but was also conditioned by two practical considerations: his teacher, if any, made no obvious impression on him; and the art market, with its realities of efficient production and popular appeal, was not his main concern. The security provided by his late father and his mother-in-law, and, above all, the support of his sympathetic patron, Van Ruijven, allowed Vermeer to develop differently than most artists of the period, with time for exceptional refinements of style and meaning,

and some assurance that they would be recognized.

A similar level of involvement is required of Vermeer's admirers today. Modern viewers are more prepared for this than were earlier Vermeer enthusiasts, such as Thoré-Bürger, because much has been learned in recent decades about the painter's contemporaries in Delft and his connections with artists in other towns.[26] All this has not discredited the most informed sort of subjective remarks, such as Gowing's,[27] nor does it alleviate the need to give each of Vermeer's paintings, in the original, a great deal of time. Wheelock properly faults the textbook analyses offered by Blankert because he appears to have "neglected close examination of the paintings and analysis of technical information about Vermeer's painting techniques and artistic procedure."[28] But even here one discerns, in the litany of clinical terms, an attempt to objectify more than is warranted. Vermeer painted for connoisseurs.

The early works

The academic approach to Vermeer's stylistic development has dominated recent discussions of his two earliest undisputed works: *Christ in the House of Mary and Martha* and *Diana and her Companions* (figs. 254, 255). Scholars follow each other in placing the religious picture earlier (about 1654), essentially because it seems less Dutch and less Vermeer-like than the other painting. The seemingly Italian or Flemish qualities of color and texture in the *Diana* and the international flavor of Vermeer's supposed models, paintings of the same subject by the Amsterdam artist Jacob van Loo, have not been neglected.[29] Nonetheless, most writers look back from *A Maid Asleep* (fig. 261) and see the Mauritshuis painting as similar in the transparent shadows of the (abraded) faces and in the coppery highlights on the figure to the lower right. Slatkes, by contrast, considers the drapery in the *Diana* reminiscent of Van Dyck (see fig. 256), while both early works remind him of Ter Brugghen (fig. 257) in their treatment of light.[30]

Diana, Callisto, and Company
From whichever viewpoint *Diana and her Companions* is analyzed, its values of light and texture may be considered tentative signs of brilliance in an immature work of art. The suggestions of daylight in both the highlights and shadows are realized with the eagerness of new discovery. Vermeer could not have found these qualities in Jacob van Loo but perhaps saw them in Carel Fabritius, whose *Self-Portrait* in Rotterdam (fig. 30) and some figures in his early history pictures anticipate the handling here.

While the *Diana* has undeniable virtues, they are

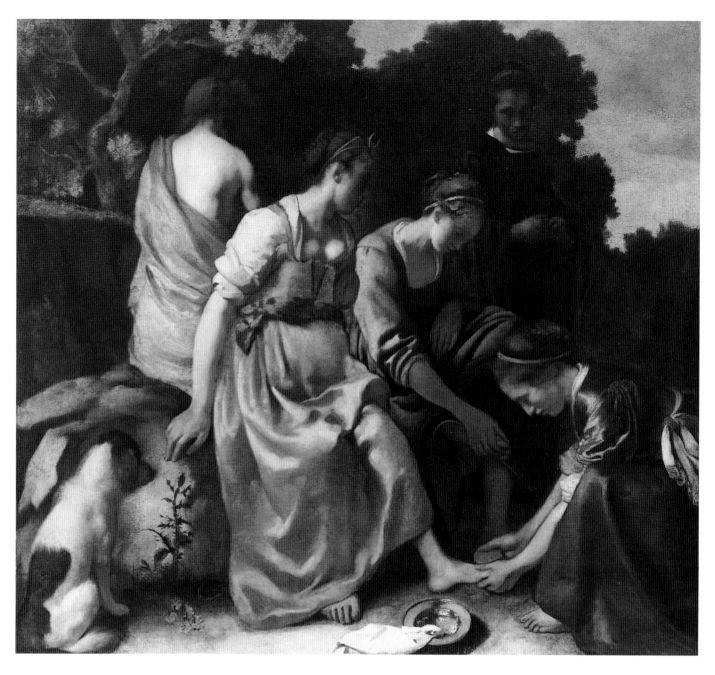

253
JOHANNES VERMEER,
Diana and her Companions,
ca. 1654.
Oil on canvas,
97.8 x 104.6 cm.
The Hague, Koninklijk
Kabinet van Schilderijen
"Mauritshuis." Photo of
the painting before
conservation in 1999-2000

not found mainly in the picture's design. The triangular arrangement in the foreground, which the dog faithfully obeys, is buttressed symmetrically by the two farther figures and then surrounded by landscape elements which convey almost no sense of space. (This description, true enough before, has become more so after conservation of the painting in 1999-2000, which revealed that the sky was a later addition and that the canvas extended further to the right: see figs. 253, 254.) A basin and towel fill the foreground, the dog occupies the corner, and a plant decorates the space in front of him, which is bridged by a rock that looks like a lavender bedspread piled on the floor. The slope to the left and a tree close the space above; the effect on the right must originally have been similar. All this appears to be the work of a beginning artist, who spent his best efforts on the skirt of Diana and the drapery of the figure to the lower right. But other writers have judged the picture more favorably,[31] and, as Gowing cautions, the "Italianate subject and style of the *Diana*" and its "comparatively conventional facture" are not decisive guides to dating, given the eclecticism of Vermeer's early work.[32]

Eclecticism may be the problem with Vermeer's realization of the subject, which has been variously interpreted. The composition recalls Van Couwenbergh's erotic mythological scenes of the 1640s, but the demeanor of the figures resembles that of Diana's companions in paintings by Van Loo.[33] Vermeer's Diana has been compared with Rembrandt's *Bathsheba* of 1654 in the Louvre.[34] This or some similar source is plausible, but surprising, given Ovid's text (*Metamorphoses*, II, lines 442-65). "Worn with the chase and overcome by the fierce heat of sun," Diana dipped her feet into a sylvan stream and bade her companions to join her. "Come, no one is near to see; let us disrobe and bathe in the

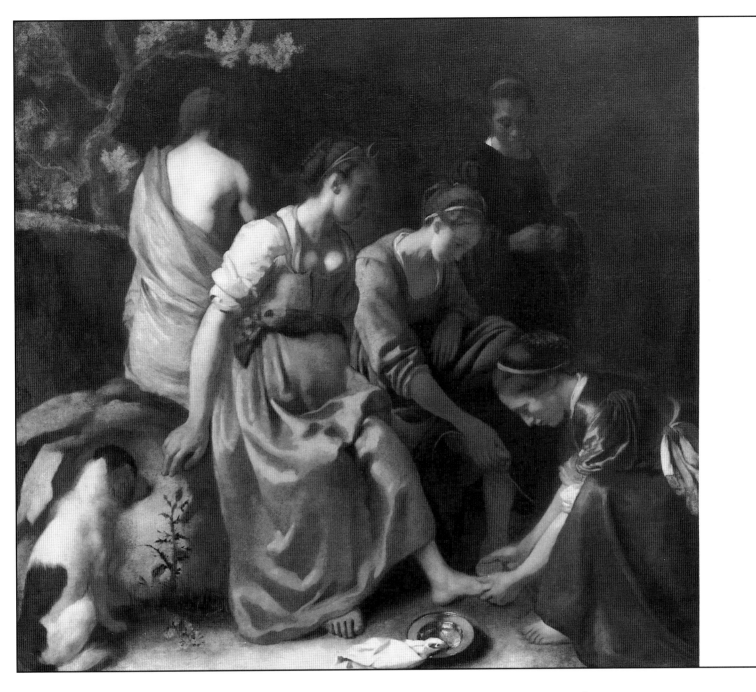

brook." But one maiden, Callisto, who had been keeping to herself and blushing "with downcast eyes," sought excuses for delay, fearing discovery of her pregnancy and expulsion from Diana's merry band. Vermeer's Callisto must be the somber maiden in the right background, with downcast eyes and fists joined protectively in front of her. She shows no intention of removing her buttoned-up dress and robe, which contrast with her companions' loose attire (the "antique" here, as in works by Honthorst and Moreelse, is suggested by Dutch dress with décolletage).[35] Thus, Diana's mood (as described by Ovid) and Callisto's have gone unrecognized, the former reminding Wheelock of religious solemnity, the latter looking suitable to confession in a Catholic chapel or condemnation in a Calvinist church.[36]

Perhaps Diana and her companions are sad about something or other: Wheelock wonders if it might

be the Delft explosion in October 1654.[37] But their demure expressions are similar to those that contemporary Dutchmen (male viewers) found fetching in other paintings of the same time. Gowing found "a precise parallel" to Diana's pose and expression in Jacob van Loo's scene of complicated courtship, the so-called *Wooing* in the Mauritshuis.[38] The comparison would seem nonsensical were it not for the analogous young ladies at their toilets (as Vermeer's Diana and Rembrandt's Bathsheba are) in contemporaneous paintings by Ter Borch and a number of other artists.[39] In the *Diana*, Vermeer was already attracted to young women in private activities, such as performing their ablutions or reading love letters (which Callisto does not expect).

Another figure that has been compared with Vermeer's Diana is found in Peter Lely's so-called *Nymphs Bathing* of 1640 in Nantes. Foucart considers

254
JOHANNES VERMEER, *Diana and her Companions*, ca. 1654. Oil on canvas, 97.8 x 104.6 cm. The Hague, Koninklijk Kabinet van Schilderijen "Mauritshuis." Photo of the painting after conservation in 1999-2000, with an indication of its original size. See also plate XVII.

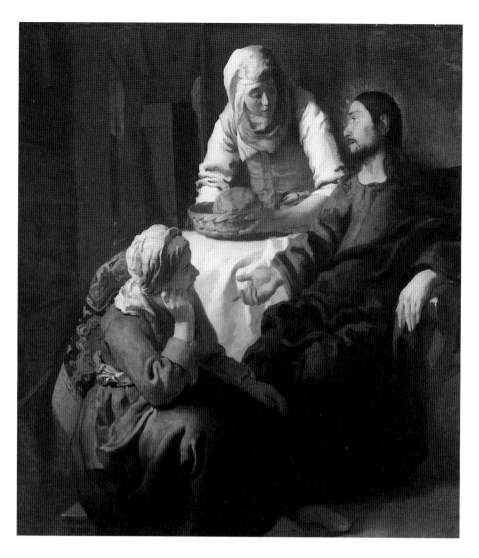

255

JOHANNES VERMEER,
Christ in the House of Mary and Martha, ca. 1655.
Oil on canvas,
160 x 142 cm.
Edinburgh, National
Gallery of Scotland. See
also plate XVIII.

such as that of *A Maid Asleep* (fig. 261), where the closed eyes and dreamy smile recall one of Diana's companions, the clothing recalls another one, and the painting of Cupid on the wall relates real life to mythology.

Christ, Mary and Martha

In Vermeer's first known religious picture, *Christ in the House of Mary and Martha* (fig. 255), there is again a strong sense of domesticity. The subject may have been chosen for its relevance to modern life: Christ admonishes Martha for being absorbed in housework, which was a view of Dutch women entertained by foreign visitors. Genre painters such as the Rotterdammer Pieter de Bloot set the subject in simple Netherlandish interiors,[43] and even Van Couwenbergh suggests a Dutch household in his view to a second room (fig. 16).

The Edinburgh picture resembles *Diana and her Companions* in the coloring of the costumes, the muted background, and the strong, nearly white light. There is also some similiarity in the triangular arrangement of the figures: as in the mythological painting, the religious scene features a seated divinity with a devotee at his feet, and at the top of the triangle a less faithful follower. Martha, serving bread, recalls Callisto's downcast eyes and self-effacing tilt of the head, but her expression understandably betrays a less troublesome sense of shame. She has an even less blameworthy sister in *The Milkmaid* (fig. 267), where the rolled-up sleeves, covered head, bread basket, and almost beatific expression underscore the family resemblance. A distant cousin of both women is found in *A Maid Asleep*.

A prototype for these tilting heads has been discovered by Wheelock in a copy, inscribed "Meer 1655," after a *Saint Praxedis* by Felice Ficherelli.[44] Confrontation with Vermeer's early paintings in the monographic exhibition of 1995-96 convinced the majority of scholars and conservators that the controversial copy or version is not by Vermeer. Not only the figure type and expression but also the palette and brushwork recall Ficherelli's original works. There is some resemblance between the illumination of the drapery in the copy and that on passages of drapery in *Diana and her Companions*. However, the saint's fingers look like limp sausages, thus departing from Ficherelli's example and hands by Vermeer. Whatever resemblances remain between the Italian picture and Vermeer's accepted early works simply illustrate the international flavor of their style.

This quality would have been encouraged by the examples of Honthorst, Bramer, and other artists who were highly regarded in Delft and The Hague. Wheelock suggests that Vermeer, following Bramer's advice, might have travelled to Italy, since Ficherelli's

the resemblance between that canvas and Vermeer's, and also the occurrence of a *Finding of Moses*, "in all likelihood a work by Lely," in the backgrounds of the Beit picture and *The Astronomer* (figs. 316, 317), an indication of the older Dutch artist's importance for Vermeer's development.[40] What these comparisons actually reveal is that the young Delft painter was already conversant with common forms and meanings, which must have been in much wider circulation than the usual references to Van Loo and Rembrandt would suggest.

Vermeer's interpretation of an extremely popular mythological theme is remarkable not for its mood or some "age-old reference to death,"[41] but for the way in which he bridges the gap between history painting and genre scenes. The deliberate blurring of the lines between ancient and modern life is familiar from many works by Rembrandt, Jan Steen, and other artists of the period, but it had a special resonance in the kind of Arcadian images that were admired at the Dutch court.[42] The contemporary viewer's ability to imagine Vermeer's Diana and her companions as young Dutch women *en déshabillé* must have added to the picture's appeal. Perhaps the painter was already more inclined than he has sometimes seemed toward the treatment of subjects

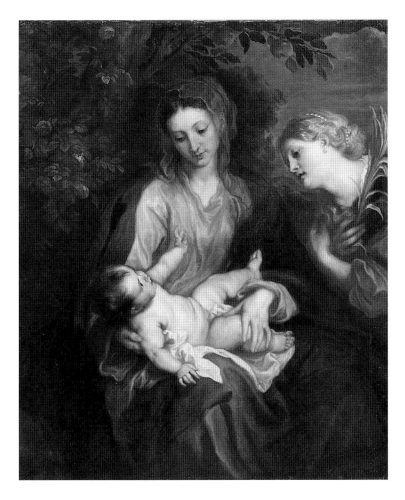

Saint Praxedis (now in Ferrara) cannot be traced elsewhere. But the expense was probably prohibitive, and the artist would have had less time for things in which he was actually interested.[45]

One such subject was modern life. Vermeer's two earliest pictures involve personal relationships, a sense of duty, or deference to someone else. Diana and her companions look forward to Vermeer's mistresses and maids. Christ has no counterpart, but Christian virtues are an issue for some of Vermeer's later female figures in domestic interiors. The usual view of Vermeer's "two 'un-Dutch' history paintings" deserves some revision.[46] It was not unusual for Dutch painters to begin their careers with a few history pictures, as De Hooch and Metsu did at about the same time. The unusual aspect of Vermeer's examples, as suggested above, is how his interpretations lead into the scenes of everyday life, which most often concern some question of domestic (that is, womanly) virtue.

One would not expect anything else of the artist, given his sensibility. To see Vermeer as finding himself (and his household situation) in his domestic images and still searching for himself in his early paintings is a romanticized view of the artist which overlooks the fact that his history pictures were already revisionary. They forsake courtly and erotic

intimations (Quellinus's Christ, Mary and Martha resemble, by contrast, a Flemish count and his eager mistresses) for the kind of intimacy one encounters in everyday life. Vermeer takes his subjects seriously, diminishing the aesthetic distance that was part of the Flemish decorative painters' appeal (as in Jacob Jordaens's mythologies). In this regard Vermeer resembles Ter Brugghen, whose *Saint Sebastian Tended by Saint Irene and her Maid* of 1625 (fig. 257) is similar to the Edinburgh painting in expressive as well as in formal terms.[47]

A domestic quality has also been discovered in Vermeer's two later allegorical pictures, *The Art of Painting* and the *Allegory of the Faith* (figs. 305, 315). (The latter was probably intended for the home of a prominent Catholic family, not for an institution of any kind.)[48] *The Little Street* (pl. xxv), one of Vermeer's most De Hooch-like pictures, features a woman making lace, two children playing or drawing, and a maid at work. Even the *View of Delft* (pl. 1), when compared with other profile views of the city, makes the architecture appear more residential than grand, an impression enhanced by the six figures (one with a baby) conversing in the foreground.

One would be left with a false impression if it were concluded on the basis of these observations

256
ANTHONY VAN DYCK,
Virgin and Child with Saint Catherine of Alexandria,
ca. 1630.
Oil on canvas,
109.2 x 90.8 cm.
New York, The
Metropolitan Museum
of Art, Bequest of Lillian
S. Timken, 1959

257
HENDRICK TER
BRUGGHEN,
Saint Sebastian Tended by Saint Irene and her Maid,
1625. Oil on canvas,
150.2 x 120 cm (originally about 162 x 127 cm).
Oberlin, Ohio, The Allen
Memorial Art Museum,
Oberlin College

that Vermeer was a painter of ordinary domestic life and that this interest led him to interpret his few history pictures in a prosaic manner (like Steen's *Bathsheba Receiving King David's Letter* in a private collection).[49] On the contrary, his allegorical and history pictures have in common with the domestic scenes their suppression of narrative. Diana and her companions, Christ and his, the mistresses and maids, the men and women together, the men and women alone, and the objects they touch or contemplate seem suspended in space and time, as if the artist presents us with a vision of a human situation or relationship, not an explanation of it. This is essentially what is meant when writers describe Vermeer's approach as poetic rather than literal.

The artist's preoccupation with light contributes greatly to the expressive effect of his images. It is clear from his first two known paintings that he surveyed various kinds of illumination in the works of other artists. For example, the transparent shadows in the faces of Diana and her companions recall Carel Fabritius, while the strong contrast of light and shadow on Martha's face (which is idealized and sculptural) and the silhouetted treatment of Mary in the Edinburgh picture are Utrecht-like effects.

In *Christ in the House of Mary and Martha*, the bright colors, including comparatively large areas of white drapery, the interplay of arms and hands, the close viewpoint – which has one looking downward, upward, and abruptly past the figures – and even the brownish background washed by various effects of light appear to be Vermeer's interpretation of Ter Brugghen's formal ideas. The approach to space complements the monumentality of the pyramidal figure group, as in Ter Brugghen's canvas in Oberlin (fig. 257). Quite unlike Ter Brugghen, however, is the painterly agitation of the drapery, which is very Flemish, and probably the Delft painter's somewhat schematic response to Van Dyck (fig. 256). The Antwerp artist's manner of rippling highlights over broad areas of dark drapery seems adopted and simplified here in a way that is not found in Thomas Willeboirts Bosschaert or the other Flemings who had just worked for the Dutch court. Even the more precisely descriptive highlights on the satin blouse of the kneeling woman in *Diana and her Companions*, as well as the orange bolt of drapery on the bare back to the left in that picture, could have been derived from paintings that Van Dyck had supplied to the Dutch court (such as the *Amaryllis and Mirtillo* at Pommersfelden).[50] Vermeer's early admiration of Van Dyck (which would not have been a novel idea in Delft and The Hague at the time) might also account for the surprising hands in the Edinburgh canvas (fig. 252), except for the more substantial one supporting Mary's head (Ter Brugghen lends a hand). The handsome type of Christ with his long, straight

nose and smooth brow, his elegant gesture (which makes the same hand in Quellinus's rendition of the subject at Valenciennes look like a gardening tool), and the cascade of tapering fingers falling from the chair's armrest come as close to Van Dyck's idea of the Saviour as might be imagined in the case of the young Vermeer.[51] Van Dyck also favored this kind of fluid, triangular arrangement of figures in religious compositions, with a figure leading in from one corner of the foreground.[52] The pose of Martha, leaning forward with her head tilted forward and to the side, may reflect such a source: for example, one of Van Dyck's Virgins with the Christ Child (fig. 256), recalled here by Martha's tender cradling of the bread basket.[53] If Vermeer did refer to such a painting, he transferred the Virgin's usual red and blue garment from Martha to Mary.

Even with regard to Vermeer's earliest works the search for sources in the usual manner is frustrated by a number of factors. On the one side, there is a common language of pictorial motifs, the visual equivalents of catch phrases, figures of speech, rhetorical strategies. On the other side is a painter whose ability to learn, inflect, and reinvent artistic forms seems to have been extraordinary in an age when middling talents were fairly competent in the same practice.

Thus, in *Diana and her Companions* (fig. 254), the figures remind one of Rembrandt, Fabritius, Ter Brugghen, Maes, and others, while the composition recalls Van Couwenbergh, Van Loo, Lely, and Jan van Bronchorst.[54] For *Christ in the House of Mary and Martha*, artists as widely scattered as Bramer, Fetti, and Erasmus Quellinus have been named, perhaps even the last unnecessarily, since the poses, gestures, and grouping of the figures were ideas in wide circulation and ultimately represent the influence of Italian art in the Southern and Northern Netherlands over the course of a century. A more reliable measure of Vermeer's ambition and precociousness in the Edinburgh canvas is that it achieves a stylistic synthesis of two great artists, Van Dyck and Ter Brugghen, an essentially unstable mixture of emotionalism and contemplation, of movement and stillness, which is tenuously held together not so much by force as by sincerity. The figure types, although similar to those Vermeer admired in other artists, are already his own. Martha, with her lips slightly parted and head half in sunlight, anticipates the letter readers, the milkmaid, and the woman with a balance in later paintings; Mary looks ahead to the thoughtful heads in profile which occur variously in the *Cavalier and Young Woman*, the *Mistress and Maid*, and *The Astronomer* (figs. 265, 296, 316); Christ bears some resemblance to Vermeer's geographer and the man in *The Music Lesson* (figs. 283, 317). These are neither logical nor

surprising correspondences. As in Rubens and Rembrandt, the figures' faces and dispositions reflect the painter's own personality. In the same way, passages of light in *Christ in the House of Mary and Martha* recall Ter Brugghen or Van Dyck and at the same time seem typical of Vermeer.

The early paintings by Vermeer are dated by Wheelock as follows: the inscription "Meer 1655" on the *Saint Praxedis* is taken at face value; *Christ in the House of Mary and Martha* is placed in the same year because it is "so different in appearance from the images generally associated with Vermeer"; *Diana and her Companions* is dated "ca. 1655-56," since its sources and *Stimmung* seem more Dutch. The last picture recalls "Rembrandt's philosophy," although its "quiet pensiveness" is also "not far removed [from the] emotional character" found in Fabritius (for example, *A View in Delft* before it was cleaned). Wheelock's association of the Mauritshuis painting with "the memory of the tragic gunpowder house explosion" of October 1654 may also have influenced his chronology.[55]

In my view, the *Saint Praxedis* is not by Vermeer; the *Diana* is probably his earliest known work, dating from about 1654 (he joined the painters' guild on December 29, 1653);[56] and the Edinburgh picture dates from about 1655. The last painting, when encountered for the first time, "comes as a shock" to some viewers; according to Wheelock, this is because the paint is "applied fluidly and in broad planes of color" and because the canvas is "so large."[57] However, Vermeer's earliest known dated work, *The Procuress* of 1656 (fig. 258), is almost exactly the same size in one dimension and less than a foot shorter (20 cm) in the other. The two large, Utrecht-influenced pictures are also more consistent in execution than has generally been allowed.

Christ in the House of Mary and Martha, when viewed in the original and especially (as in 1995-96) in the company of the Mauritshuis picture, is clearly a more accomplished work of art. The kind of historical logic that has Vermeer proceeding from foreign (or rather, Flemish) to domestic sources, and from bolder, broader brushwork to a more deliberate (or more timid) technique immediately seems inadequate when the paintings are seen together or in prompt succession. Most analyses also simplify the stylistic roots of both pictures. Like many Delft paintings discussed in the preceding chapters, the early Vermeers have a background in both Dutch and Flemish artistic traditions, although not the same ones in each work.

In glossy reproductions the space of the Edinburgh painting looks disjunctive, and its areas of uniform color tend to go flat.[58] Before the canvas itself the sense of space is compelling, especially on the left where the downward view of Mary seated on

a low stool foils the rapid recession past a foreshortened door and into another room (where the view ends at another door, which is half open, casting a strong shadow onto a reddish-brown curtain or similar form).[59] This arrangement of the background, which of course suggests a kitchen or larder, has been traced to the large canvas by Erasmus Quellinus in Valenciennes that features Christ in a pose similar to that found here.[60] However, the same sort of recession and architecture (in contrast to Quellinus's Baroque town house with a pretentious kitchen) – with a simple wall and window on the left, ceiling beams or boards receding sharply, a dirt floor and doors ajar, all rendered in shades of brown – are featured by Ludolf de Jongh and Pieter de Hooch in their inn scenes of the early 1650s (see figs. 209-11, 229-30). The figures are often presented full-length in the foreground, in poses reminiscent of Flemish history pictures (compare De Hooch's *Empty Glass*, fig. 229, to Vermeer's religious picture).

In the Edinburgh canvas, the three figures and the table almost fill the nearest space, which is practically equal in depth and width. The recession of the door on the left is answered by that of the wall on the right, where Martha casts a shadow, and a rectangular form, perhaps meant as a print, clarifies the receding plane (Christ's chair could not be pushed back any further).[61] The corner of Mary's stool, with a bright highlight on the edge just above Vermeer's signature, and the arm of Christ's chair project the furniture forward, but the space remains uncertain in plan. The table carpet behind Mary masks an awkward transition from the foreground to the door and corridor.

The emphatic modelling of the figures (which is not evident in photographs) makes the closeness of view, the sense of volume, and the projection of space intensely felt at a normal viewing distance. The drapery throughout is beautifully rendered, with thick, fluid highlights contrasting with the deep, absorbent shadows in the folds. A superb passage is the colorful carpet which adds greatly to the visual weight of Mary; the pattern continues in her scarf like base and treble lines of music, blending effortlessly into the sash at her waist. The rhythms in Mary's drapery lend emphasis to the focus on Christ, whose gesture and voice seem to animate his robe and sleeve and the cascading folds in the white tablecloth. Martha leans well forward; the space under her forearm and the basket (which casts a strong shadow) suggests the rapid recession of the table top toward her. She seems to serve and bow at once, her lovely features responding to Christ's rebuke. Radiographs reveal that his profile was modified to turn the head more obliquely. All three faces, but especially Mary's, recall the evocatively

258
JOHANNES VERMEER,
The Procuress, 1656.
Oil on canvas,
143 x 130 cm.
Dresden, Gemäldegalerie,
Staatliche Kunst-
sammlungen. See also
plate XIX.

259
JAN VAN BRONCHORST,
*Musical Company at a
Balcony*, ca. 1652-56.
Oil on canvas,
106 x 177 cm.
Present location unknown
(Zürich, art market, in
1944)

turned and shaded faces in Ter Brugghen's oeuvre.[62]

It is a measure of Vermeer's progress in this painting that, while its formal qualities are skillfully resolved, the subject is effectively realized. The interplay between the three figures never comes to rest: Christ seems to speak to Mary, and she reflects on his words, even as he answers Martha's complaint.

Montias suggests that Vermeer may have studied not in Delft but in Utrecht, because of family ties there, which through marriage extended to the famous teacher of Honthorst and Ter Brugghen, Abraham Bloemaert, and to his son Hendrick.[63] Amsterdam connections might be deduced from the apparent influence of Jacob van Loo and perhaps of Quellinus, who worked on the new Town Hall's decorations about 1655-56.[64] A lost painting by

Vermeer, *The Holy Women at the Sepulchre*, was cited
in the 1657 estate of the Amsterdam dealer and
collector Johannes de Renialme, who was earlier in
Delft and probably in contact with both Vermeer's
art-dealing father and Vermeer himself.[65] Wheelock
sees similarities in style between the early Vermeer
and Rembrandt, but more persuasively recalls that
Carel Fabritius and Nicolaes Maes were Rembrandt
pupils and that several Delft artists, for example, De
Witte (three of whose church interiors were in Van
Ruijven's collection), moved to or had business in the
big city during the early 1650s.[66] Another painter of
some interest for Vermeer's early compositions, from
Diana to *The Procuress*, is Jan van Bronchorst (ca.
1603-1661; see fig. 259), who was from Utrecht but
worked in Amsterdam from about 1650 to 1661.[67]

The Procuress
If Vermeer's early history paintings appear
naturalized by their costumes, settings, and styles,
so that they forecast his genre scenes, *The Procuress*
(fig. 258; pl. XIX) seems to cross into the latter
category on the path taken previously by Frans Hals,
Rembrandt, Van Couwenbergh (fig. 15), and the
many other Dutch artists who took the Parable of
the Prodigal Son as a point of departure. Van
Couwenbergh's anticipation of Vermeer bears out
Gowing's axiom that "wherever [his] sources can be
traced beyond doubt it is clear that they were

common knowledge among the artists of his
school."[68]

In its execution *The Procuress* recalls both of
Vermeer's earlier paintings, but it also departs from
them in accordance with different goals. Wheelock
draws attention to the increasing emphasis upon
textures, as in the carpet in the foreground (the
similar carpet in the Edinburgh canvas differs in
distance and function within the composition),[69]
and in the costume details and objects on the right.
(In the 1650s, Vermeer often used textures to draw
attention to key motifs.) Other parts of the painting
recall realistic passages in the earlier works, such as
the satin jacket of Diana's kneeling companion and
the figure of Mary (except for her left arm) in the
Edinburgh canvas. The latter's overall design and
some motifs also reveal illogical resemblances to
The Procuress, the kind that occur when a painter
treats unrelated themes in immediate succession.
For example, the man and woman on the right in
The Procuress correspond approximately in pose and
to some extent in gesture with Martha and Christ,
and they are likewise wedged between a wall and
table. Moreover, the black-scarfed procuress slightly
recalls Martha in the tilt of her head, but serves more
obviously to lead the eye from the man on the left to
the main focus of the composition. As in the
Edinburgh painting, hands, arms, and "still-life"
motifs interconnect the characters, who are

260
ATTRIBUTED TO PIETER
DE GREBBER,
*The 'Surrounding Gallery'
in the Great Hall at
Honselaarsdijk* (detail),
ca. 1637.
Ten drawings in all,
20.9 x 580 cm.
Amsterdam, Rijksprenten-
kabinet

presented from the side, frontally, and obliquely on an arc-shaped plan. The man's overcoat draped over the table carpet in *The Procuress* serves as a repoussoir, as does the figure and especially the blue skirt of Mary in the religious picture. She is also, like the man, a kind of witness at the side, who in one way or another reflects upon the exchange (of words, of money) at the center of the story. Such figures in Baroque art and theater serve as associates of the viewer, signalling appropriate responses.

Vermeer's canvas in Dresden is more obviously related to Caravaggesque painting in Utrecht. Baburen's *Procuress* of 1622 (Museum of Fine Arts, Boston) was owned by Vermeer's mother-in-law, Maria Thins,[70] and appears in the background of *The Concert* (fig. 304) and *A Young Woman Seated at a Virginal* (fig. 314). In both of those later works, Baburen's picture is muted, like an off-color remark whispered in mixed company. Baburen's *Prodigal Son* in Mainz is closer to Vermeer's *Procuress* in subject and in its four-figure arrangement.[71] But the buoyant mood and some aspects of Vermeer's design are closer to works by Honthorst, who must have influenced Van Couwenbergh's bordello scene of 1626 (fig. 15) and other intermediate designs. The spatial device of the table carpet, which presumably covers some sort of partition or balustrade, may have been adapted (hence its strangeness here?) from the carpets that fall from balconies in "musical companies" by Jan van Bronchorst (fig. 259) or from the similar foils in front of the half-length figures that animate the "Surrounding Gallery" of the Great Hall at Honselaarsdijk (attributed to Pieter de Grebber; see fig. 260).[72]

Like other motifs in *The Procuress*, the young man with the lute looks spliced in from another context. He recalls the figure in Van Couwenbergh's panel of 1626 (fig. 15) and the sly self-portraits and cameo appearances by fellow artists in numerous genre paintings, including Jan de Heem and Adriaen Brouwer in the latter's in-joking tavern scene, *The Smokers*, of about 1636-37 (Metropolitan Museum of Art, New York).[73] Variations on the idea are found in Rembrandt's portrait of himself and his wife (*The Prodigal Son*), about 1636 (Dresden); Metsu's *The Artist and his Wife in a Tavern* of 1661 (Dresden); Frans van Mieris's *Charlatan* of the early 1650s (Florence) and the *Doctor's Visit* of 1657 (Vienna); as well as in many works by Steen.[74]

The pose, the glance, the fancy costume (as discussed below), and even the placement of the figure on the left in *The Procuress* make it likely that this is the only self-portrait (or any painter's portrait) of Vermeer, who was twenty-four at the time. Artists frequently placed themselves at the margin of group portraits, as Ter Borch did in *The Swearing of the Oath of Ratification of the Treaty of Münster*, 1648 (National

Gallery, London).[75] But the convention Vermeer mainly follows here is that of artists assuming the rôle of the Prodigal Son or a modern-day version of him in tavern and bordello scenes. No one depended upon this tradition so much as Steen, who lived in Delft in 1655 and 1656.[76] However, there is no sign of Steen's direct influence in *The Procuress*, and his example would merely have reminded Vermeer of the many artists (including Palamedesz) who had acted similar parts.[77]

Among the most familiar attributes of the Prodigal Son, or the *Heden-daeghsche Verlooren Soon* (to borrow Hooft's title of 1630; fig. 86), in Dutch paintings and prints are a raised glass, a lute (a female lutenist was painted out of Rembrandt's *Prodigal Son* in Dresden), and a large hat with a feather, or a floppy beret. The latter is a sixteenth-century fashion adopted by Rembrandt, Dou, and their many followers, especially when the artist assumes a rôle (including that of "the artist"). Outdated clothing, such as Vermeer's slashed doublet, was also standard for artists playing comic parts, such as a wastrel or quack.[78]

In *The Procuress*, an essential part of the humor, and the reason for the young fop's grinning glance, is the obscene significance of the lute's erect neck in combination with the glass. Far less obvious references to sexual intercourse are routinely discovered in works by Steen, but to my knowledge the rake's sign language in this picture has never been described. This says something, if only in a footnote (handnote?), about the "reception and interpretation" of the Sphinx of Delft, who in the Dresden canvas hardly seems enigmatic.[79]

And yet he is, in expression if not in gesture. John Nash, in the best discussion of this painting available, describes it as frank in its sensuality but "subtle in its portrayal of character and mood." The figure of the procuress herself, because of "her leering absorption in the activity of the lovers provides an unsettling reflection of the fascination they hold for the viewer."[80] For Nash, the figure to the left, while possibly a self-portrait, is like a "first-person narrator in a novel who speaks directly to the reader yet is a fiction embedded in the events of the narrative and not the actual voice of the author." He, too, "discomfits us, exposes us as voyeurs."[81] There is indeed something strained about the young man's smile (in contrast to the expressions of the other figures) and the searching, not smiling, look in his eyes.

The ambivalent expression is hardly uncharacteristic of Vermeer. The other figures similarly slip personas: the procuress is friendly and evil, the man in red a dupe and protector, the whore a predator nestled comfortably in his embrace. There are mixed signals in the earlier pictures, too: the

alleged melancholy of Diana's faintly smiling companions; and Martha, the rebuked mistress of the household, who seems poised for a kiss (Mary, the plain sister, might wonder what the visitor's intentions are).[82] But more revealing analogies are found in slightly later paintings, such as the seemingly innocent siren in *A Maid Asleep* (fig. 261) and the lady in the *Cavalier and Young Woman* (fig. 265), whose body language and beaming smile look almost professional.

The fixed smile and steady gaze of Vermeer's interlocutor on the left in *The Procuress* may, in addition to suiting the occasion, reflect the artist's study of himself in a mirror. The angle of the head, the raised left (that is, right) hand, and the more arbitrary arrangement of the other arm are consistent with this reading. But more striking still is the handling of light in this area, which differs from that on the other figures and, as a result, makes it seem as if a mirror or mirror-like image has been inserted into a painting by one of Honthorst's Amsterdam or Delft admirers.

The figure also recalls several of Rembrandt's earlier self-portraits, either in the costume, pose, and flowing locks,[83] or in the shadowy face, with daylight streaming over the shoulder, catching the cheek and the tip of the nose, shining off the hair and costume, and seeming to starch the collar with parchment-like tactility. Rembrandt's *Self-Portrait* of 1629 (Alte Pinakothek, Munich) is one of the closest antecedents, but there are a good number,[84] a few of which must have influenced Fabritius in his own self-portraits. Most of these pictures feature a brightly illuminated wall immediately behind the bust-length or half-length figure, whose shadow measures space and the intensity of light. (A similar arrangement is found in Fabritius's *Goldfinch*, pl. v, which strangely anticipates the self-conscious figure in Vermeer's bordello scene.)

Whether or not the "self-portrait" in *The Procuress* is Vermeer's own image, it may be considered the first figure in which he appears not only to use light naturalistically but also to study how it looks on a live model. And yet he almost certainly saw similar effects in other portraits or *tronies*. This is one of the essential characteristics of Vermeer: not to borrow what another artist had done earlier, but to see in a painting what effects might be studied afresh in the studio.

Scholars have supposed that the painter appears in *The Procuress* because the artist in *The Art of Painting* (fig. 305) wears similar attire.[85] Van Gelder considered the costume in the later picture "Burgundian," but it was recently described by a costume historian as stylish dress of Vermeer's own time.[86] The slashed sleeves and standing collar of the types seen in *The Procuress* were fashionable in the 1630s.[87] As in Rembrandt, Vermeer's use of older costume is theatrical and dandified, recalling Honthorst's cavaliers and Van Dyck's dapper princes, as in *Le Roi à la ciasse* (Louvre, Paris). By contrast, the man and woman on the right in *The Procuress* wear everyday dress. Thus the costumes clarify rôles: the figure on the left is a "first-person narrator" from another time and place, where it is possible to be in and out of the picture at the same time.

Quite a bit has been written (for the most part following Gowing) about Vermeer's practice of setting up barriers in the foreground, thereby distancing his attractive characters from the observer. For Gowing especially, this has psychological significance. Vermeer's women are approached cautiously, tentatively. Beginning with the *Young Woman Reading a Letter* in Dresden (called *The Letter Reader* below; fig. 263), Vermeer sought a "definite, impersonal solution" through purity of color ("an orderly coolness that nothing will disturb") and an idealized space ("the utter certainty of spatial interval"). The barrier effect and Vermeer's "perhaps even more elusive invention, the inverted use of trompe-l'oeil," by which Gowing means illusionistic space that seems intangible (unlike Dou's interiors), place his women in protective environments: if not on pedestals, then in a kind of viewing case. This description is useful, in so far as it suggests that Vermeer's realism does not resemble an illusionistic reconstruction of the environment but images perceived in purely visual terms, such as those projected in a camera obscura or in the human eye. Gowing, however, takes another tack. "We gather from her [the prototypical letter reader in Dresden] and the immutable terms of her confinement an impression of the forces that move but stay the painter, and discover a tension of feeling that is in essence poetic."[88]

In these lines about desire, discretion, and voyeurism Gowing goes rather far, but his profoundly thoughtful pages help one appreciate how deliberately Vermeer adopted and modified formal devices, often transforming their expressive effect. The carpets in "musical companies" by Van Bronchorst and in wall decorations by De Grebber, mentioned above, are placed in front of figures seen as if from below (figs. 259-60). In *The Procuress*, Vermeer has us (and the figures) looking sharply downward onto what should be a table top, so that the uncouth company seems uncomfortably close, as if the viewer were one of Honthorst's figures seated in the foreground. This disconcerting spatial effect is enhanced by the carpet's and coat's immediate juxtaposition with two hands in the center of the composition and with the hand and jug on the right. There is no escaping this ensemble, making vulgar gestures under the viewer's nose.

The deeply undulating layers of cloth in the foreground function somewhat like De Witte's and Van Vliet's illusionistic curtains (see figs. 160, 165), locating and crumpling the picture plane. Here, however, the deeper space is claustrophobically filled.[89] The two forearms extending backward from the gleaming edge of the coin are radically fore-shortened; the white cloth spilling into the young lady's lap tapes together pieces of the picture puzzle that threaten to pop apart. The vessels to the right, especially the jug, undergo stresses similar to those suffered by column bases and capitals in Houckgeest (see fig. 98), because of the closeness of view.

In this, Vermeer's first painting of an "everyday" subject, his tailoring of the image shows at the seams. As in *Diana and her Companions*, where a rock and dog look like two more pieces in the pile of clothing, and as on the left in the Edinburgh canvas (fig. 255), the artist strains to fill in the lower corners of the composition and to relate the whole ensemble of drapery and figures to the background (to the right of the jug in *The Procuress* he simply throws in the towel). But with each early painting these devices become more convincing as things observed: the table, carpet, and chair in *A Maid Asleep* (could chairs be under the table carpet in *The Procuress*?); the carpeted table and curtain in *The Letter Reader* (fig. 263). And Vermeer becomes more adept at arranging the parts. The boxing-in of the figure, which is complicated in *A Maid Asleep* and still an obvious effort in *The Letter Reader* (in both, the right side and bottom are blocked off), is almost second nature to Vermeer in the *Young Woman with a Water Pitcher* (pl. XXVI). But *The Procuress*, despite its awkward moments, is hardly unsophisticated in design. The slanting rhythms across the canvas – seen in the men's hats and the white bonnet, in arms and folds – and the countercurrent from the border of the carpet on the right through the red lines in its pattern to the slashed sleeve suggest that Vermeer could have gone on to paint bigger, busier pictures than he did. In general, he abandoned the use of rhythms and strong colors when, after *The Procuress*, he started working on a smaller scale and composed pictures more in terms of proportions, contours, and closely related tonalities. Movement was almost forsaken, which suited the painter's study of figures as objects and of light and space as independent entities.

The first domestic interiors

The first two paintings by Vermeer after *The Procuress* of 1656 are probably *A Maid Asleep* of about 1656-57 and *The Letter Reader* of about 1657 (figs. 261, 263). These canvases, each about 85 centimeters high, are larger than Vermeer's later genre interiors. The scale,

as in earlier works, may reflect that of their models. Maes's *Old Woman Sleeping* in Brussels is considerably larger, although most of his interior scenes are small. At first it would appear that the Dresden *Letter Reader* is an exception, since the exquisite figure is reminiscent of Ter Borch and the illusionistic interior recalls those by Dou and other *fijnschilders* who worked on a smaller scale. But other paintings may have come into play, including Delft church interiors and possibly that notorious attribution problem in Chicago, *The Terrace*, a large canvas (107 cm high) which Fleischer attributes to De Jongh and dates to the period 1657-60.[90] Houckgeest and Van Vliet have often been mentioned (see figs. 113, 165); the expanse of bare wall in *The Letter Reader* – which originally bore a large version of the painting of Cupid [91] – next to the unusually tall window, is also the kind of visual idea (both solid surfaces seem translucent) that an artist of Vermeer's acuity would have appreciated in works by the architectural painters, especially De Witte.

"A drunken sleeping Maid"

A Maid Asleep recalls *The Procuress* in the figure, table, and piled-up carpet, and perhaps in the wineglass and jug. The placement of the figure in a narrow gap between the table and the wall (which appears to step back) is also similar. The brown coat with gold buttons in the foreground of the bawdier scene comes from the same shop as the brown pillow with gold trim leaning against the brass-buttoned back of the chair. The maid's pose is surprisingly like Mary's in the Edinburgh picture (as if Vermeer, like Rembrandt and his pupils, studied poses from different vantage points), but her expression seems to have evolved from Martha's and from the whore's in *The Procuress*. The view to a second room, past a chair, table, and open door, is like a distant memory of Mary and Martha's household, here remodelled on the rectilinear, neatly compartmentalized pattern of Maes.[92]

Many writers have suggested that in *A Maid Asleep* Vermeer was mainly inspired by Maes. There is still speculation about how the artists might have met, like Abstract Expressionists in a bar, or like Vermeer in Thoré-Bürger's imagination, painting *The Procuress* "in Amsterdam, close to Rembrandt."[93] In any event, Maes is recalled by the composition, coloring, use of shadows, and to some extent the technique of *A Maid Asleep*, Vermeer's first "genre interior."[94] It will be remembered that Maes was back in his native Dordrecht by the end of 1653 and painted all of his domestic scenes there in the mid- to late 1650s (figs. 214, 215, 217).

The similarities between Vermeer's and Maes's designs are evident at a glance and tend to dissipate upon closer study. This is the first painting by

261
JOHANNES VERMEER,
A Maid Asleep, ca. 1657.
Oil on canvas,
87.6 x 76.5 cm.

New York, The
Metropolitan Museum
of Art, Bequest of
Benjamin Altman, 1913.
See also plate xx.

262
Detail of fig. 261

patterned carpet in the foreground to the blurred plane of the table top (where the woman's wineglass nearly disappears).

Vermeer might have noticed effects of this kind not in works by Maes but in still lifes or architectural paintings. The gleaming floor and wall on the right, with the silhouetted chair, recall passages in Fabritius (for example, *The Goldfinch* again), while other qualities relating both to vision and design are anticipated in *The Procuress*. Although indebted to Maes, *A Maid Asleep* is a more complex picture than that artist ever painted, in part because Vermeer was incorporating, to a degree he had not attempted before, effects studied in the actual environment. That some of the same effects were also found in works by other artists is, in a way, beside the point. Vermeer would have considered not only what his colleagues had described but also what they must have observed.

The subject of *A Maid Asleep* ("Een dronke slapende Meyd" in the Dissius sale of 1696) also takes Maes as a point of departure for something less direct, more nuanced, and evocative of real experience. Evidently for the first time, Vermeer treats the subject of feelings between people by depicting only one figure, a maid dressed up for company.[96] As is now well known, Vermeer arrived at this interpretation only after painting out the figure of a man standing in the second room (his head and hat were replaced by the mirror) and also a dog standing in the doorway, facing the man.[97] The chair in the foreground was added; grape leaves were removed from the bowl of fruit; the canvas appears to have been trimmed by the artist on all four sides; and the corner of the painting on the wall above the maid was enlarged, perhaps to include the mask (compare the painting of Cupid in fig. 313).[98]

Vermeer has been said to have solved in this picture "the most vexing problem that he posed for himself: how to convey the melancholic moods of his history paintings in scenes drawn from daily life."[99] This seems completely off the mark, given that the woman's eyes are closed.[100] Melancholy is a fitful state, and the person here dozes pleasantly. Like a fallen mask, sleep reveals the lady's feelings, which are written on her lips. Nash (following Kahr) cites a verse accompanied by an image of Cupid in Otto van Veen's *Amorum Emblemata* of 1608: "Love in what eer hee doth, doth not disguise his face." The same writer wonders pragmatically if the flashes of daylight on the door frames indicate that the departed suitor forgot to close the front door.[101] The light throughout suggests that the encounter and its dreamy aftermath, warmed by sunlight, love, and wine, transpired during the day, when a maid might have better things to do. Like her expression and her collar, the door next to her is open; a key is partly

Vermeer in which he employs geometric shapes as well as other forms to suggest distance through sudden shifts in scale, and, at the same time, in order to structure the composition expressively. Perhaps Vermeer saw the latter possibility in Maes, but the counterpoise of axial elements that Vermeer introduces in *A Maid Asleep* and refines in the late 1650s was a fashion shared with De Hooch and other genre painters, with such architectural painters as De Lorme and Saenredam, and with architects, too.

The exceptional aspect of this approach in Vermeer is its link to his interest in perception. In the New York canvas, space shifts in between parallel lines and along shared contours. Details of the design – such as the arrangement of the mirror, window, and table in the background, and the seesaw of finials (like weights in a scale) on the back of the nearest chair – would escape actual vision with the slightest movement. To Nash, these relationships suggest contemplation: "the stilling of the flux of appearances into so resolved a pattern imparts a monumental stillness to the momentary, the incidental."[95] Nash also describes the "almost stereoscopic" quality of Vermeer's sudden changes in focus, for example, from the peak of the precisely

visible on the other side.[102] This attribute of domestic duty has been forgotten, allowing access to the woman's private domain.[103]

A mirror, seen through the doorway in a more orderly room (a contrast familiar from Maes; fig. 214), quietly reminds the viewer of Vanity. Much has been made of the fact that the mirror shows no reflection. A tilting mirror would have reflected the featureless floor, but in any case it is a symbol not an object drawn from life. The disorder of the still life (fig. 262), which hints at forbidden fruit, and perhaps the pillow in the foreground allude obliquely to idleness (Sloth), which with the encouragement of wine (Intemperance) may lead to illicit love (Lust).[104] But Vermeer is no Maes, no preacher, not even a Calvinist. The woman's artless humanity is part of her appeal.

The first letter reader
The Letter Reader in Dresden (fig. 263) probably followed *A Maid Asleep*, but from about 1657 onward Vermeer's pictures became more complexly interrelated and a linear development cannot be defined. (The two paintings may have progressed simultaneously.) Again there is a piled-up table carpet and a bowl of fruit. Initially, a large *roemer* stood in the lower right corner, and another version of the painting of Cupid occupied a fair amount of the composition to the upper right.[105] (With or without the open window, the painting on the wall would have added considerably to the rectilinear division of the design.) The chair and pillow, still at an angle, have been moved to the background. The rôle of mirror is now played by the window, which reveals the woman's face from the vantage point Vermeer had favored in the past (Callisto, Martha, prostitute, maid). The letter reader originally turned her head somewhat toward the window. Thus our view of the woman, like her type, pose, attire, and absorbed expression, would have recalled Ter Borch.[106]

In his elimination of message-laden motifs Vermeer may have benefited from knowing his patron, Pieter van Ruijven. But one would not credit the collector with making the artist subtler in his interpretation of familiar themes. There is much in contemporary poetry and in the oeuvres of such artists as Rembrandt, Ter Borch, Fabritius, and others, to suggest that Vermeer's language, if not common, was current (as the vogues of emblem books, Petrarchan literature, and love letters make clear).[107] It is also evident from Vermeer's early paintings that he became fluent in this mode of discourse largely on his own, either through the study of well-chosen models or the practice of revising himself.

Vermeer's editing of motifs is perhaps best seen in

relation to his sources. Ideas were carried over into his work and distilled or discarded. The consideration this required could be compared with the artist's assessment of stylistic conventions in the light of visual experience. In the realm of meaning the experience was emotional and intellectual: what people really felt in certain situations, and how knowledgeable viewers responded to works of art.

Gowing maintains that Vermeer's "early borrowings are not only foreign to him but inconsistent with one another."[108] This is an exaggeration on both counts. Vermeer learned a great deal about composition, technique, and expression in his early years. One is lured by his precociousness into forgetting that in 1654 he was still only twenty-two years old and impressionable.

What is more convincing in Gowing's account is that *The Letter Reader* marks a moment in Vermeer's career when he discovered a specialty that was well suited to his artistic interests and temperament. Themes of domestic and social life were fashionable, but Gowing is right to emphasize that "Vermeer's own vein of genre is a very personal one."[109] Women, without children, preoccupy Vermeer's comparatively few male figures (apart from the astronomer and the geographer) and his male viewers, starting with the painter himself and Van Ruijven or a similar patron. Even when the subject is essentially domestic, the woman seems admired for her beauty and character, not as a cog in the wheel of family life. Her absorption in a particular task is appreciated for the focus outside of herself, rather than as a duty performed. Pouring milk, lifting a water pitcher, making lace, making music, reading a letter are in Vermeer's "own vein of genre" similar acts of concentration, signs of a particular disposition. When preoccupied with pearls, a love letter, or a male companion, the woman may appear more concerned with her own interests, but there is still a sense of self-effacement, of desire or surrender. Vermeer's women do not assume rôles in the manner of Maes's mistresses and maids or De Hooch's young mothers, serving girls, and coquettes. In similar situations Vermeer's young women look uncomfortable: the stiff pose in *The Glass of Wine* (fig. 269), the embarrassed grin in *Young Woman with a Wineglass* (fig. 272).

When Vermeer first focused on female figures in isolation, his survey of artistic prototypes focused, too. His earlier approximations of interior space had not prepared him for the task of reconstructing domestic environments, which soon developed into one of the artist's main interests, comparable to his more intuitive attention to light. The dependence upon a Maes-like system of overlapping and diminishing rectangles in *A Maid Asleep* (there is no perspective scheme to speak of) and the rather

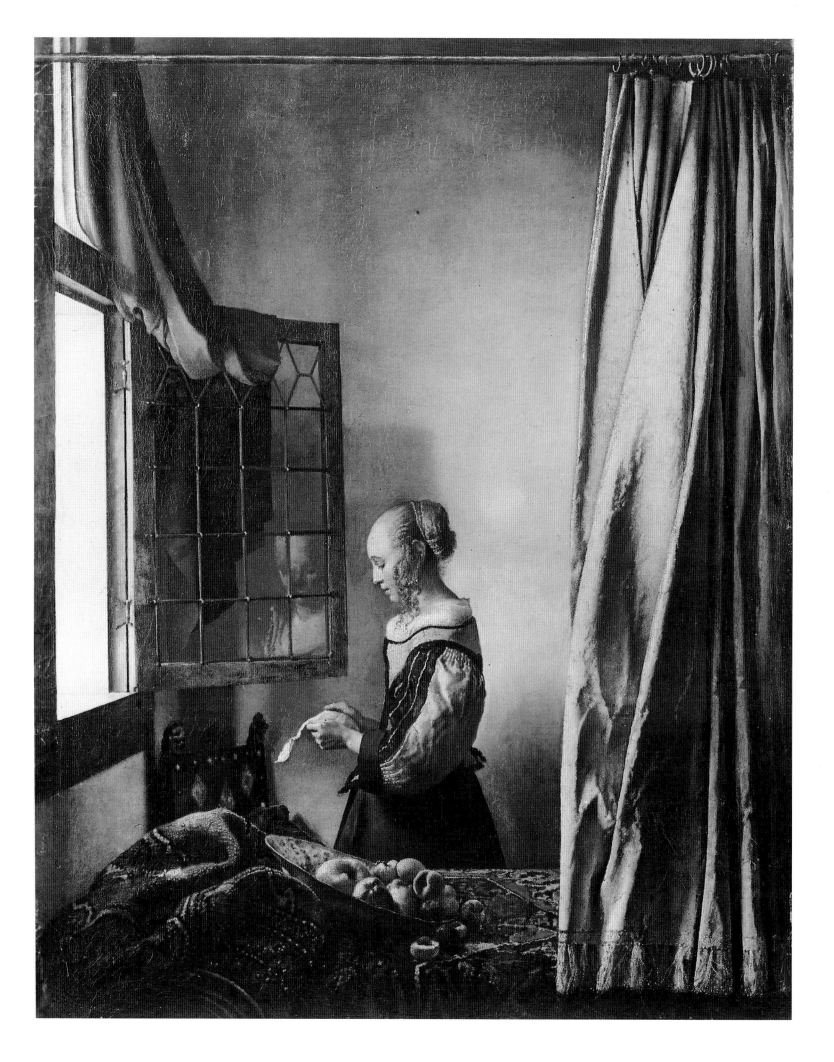

awkward insertion of a window into *The Letter Reader* reveal how new these devices were to Vermeer at the time. The window in the latter picture seems surprisingly large and close to the viewer; without the figure, it would appear to extend no deeper in space than the table. The red curtain,[110] the woman's reflection, the chair, and the window's shadow on the wall compensate for its ambiguous placement and perspective (the panes do not converge properly) and help define the uncertain space between the table and the rear wall (the fourth such in the painter's oeuvre).

The process of adopting and distilling ideas, which has often been described with regard to Vermeer's composition and iconography, is also evident in his technique. In *The Letter Reader* he intensifies illusionistic qualities throughout, in a manner that broadly recalls genre painting in Leiden and architectural painting in Delft. In the actual application of paint, however, Vermeer is more reminiscent of Fabritius in his works dated 1654 (figs. 31, 32, 34; pls. V, VI). ("A painting" and two *tronies* by Fabritius were listed in Vermeer's estate.)[111] Impressionistic descriptions of detail in the Dresden picture bring to mind passages in Fabritius's *Self-Portrait* of 1654 (curls and blurred contours) and in *The Goldfinch*. The white wall in *The Sentry* is interesting not only for the simplified setting in *The Letter Reader* but also for the textured treatment of light on the lady's face and dress.[112]

Wheelock and Nash have written illuminating lines on Vermeer's abbreviated suggestions of form in motifs such as the young woman's face, hair, hands, and sleeves, as well as the letter. Nash describes the "crumbs of crystallized light that form textures of stone, wood, glass, porcelain, fabric, fruit, hair, and skin," which Wheelock convincingly considers to be Vermeer's elaboration of "a technique he first used in *The Procuress* for accenting the textures of materials." Of particular interest in that painting (fig. 258) is the whore's lace-bordered headscarf, the front edges of which look like the sugary crust of crumbcake, while the rest is more like a film of milk.[113] At a certain distance these contrasting textures read as lace and linen and also suggest recession, just as the textured carpets in the foregrounds of Vermeer's first genre paintings set off the more thinly or broadly brushed forms at greater distances.[114] In *The Procuress* as well, one finds thick, beaded highlights on the gold piping of the red jacket and thin, blurred dots of light on the silky ribbon of the man's hat. Other small highlights, which look like those in later paintings less surely described, are seen in the glass and especially on the neck and lid of the jug. The beaded rendering of the moldings around the foot, body, and neck of the vessel forecasts the optical carpentry of the boats in *A View of Delft* (pl. I).

While Vermeer independently developed these highly efficient, shorthand notations of visual incident, other artists of the time occasionally employed similar schemes. Willem van Aelst stippled little fields and streams of light onto the gold silk borders and fringes of his luxurious tablecloths, in still lifes dating from as early as about 1650 (fig. 25).[115] (Compare the fringe on the curtain in *The Letter Reader*.) Vermeer's famous bread in *The Milkmaid* (fig. 267) resembles the somewhat magnified skin of a lemon or orange by Willem Kalf. Kalf's early type of kitchen or farmyard scene must have been known to Egbert van der Poel (Kalf worked in Rotterdam from about 1646 to around 1652), while his Amsterdam still lifes of the 1650s were undoubtedly well known to Van Beyeren and other artists active in The Hague and Delft. His soft-focus rendering of table carpets, porcelain, and fruit, as well as reflections in silver and glassware, deserve comparison with Vermeer's description of similar objects, which is not to say that they look quite the same. Kalf's optical effects have no exact equivalents either. Vermeer developed his own precise techniques, his personal conventions, and pushed them in some passages further than most painters of the time.

That these effects are found in an early stage of development in the two paintings in Dresden (figs. 258, 263) encourages closer examination of the idea that Vermeer made use of the camera obscura. The so-called "discs of confusion," beaded ribbons of light, and similar effects defining various surfaces (for example, on and around the female figure in the *Cavalier and Young Woman*; fig. 265) are found in embryo in *The Procuress*, which no one has associated with an optical device. The effects become more pronounced in *The Letter Reader* and in the smaller works that follow. Similar origins may be traced for other qualities that have been connected with the camera obscura, such as blurred contours, the halation of highlights, sudden shifts in scale, and intensified relationships of tone and color.

It is quite possible that Vermeer noticed a few of these effects in a camera obscura, especially the broader qualities of color and light. (The raised forearm in the *Young Woman with a Water Pitcher* [pl. XXVI], for example, is strikingly like what one occasionally sees in a photograph.) But less extreme forms of these "optical" effects are found in earlier paintings, and Vermeer appears to have refined them from picture to picture. In some passages they are employed in a remarkably arbitrary manner. For example, in *The Milkmaid* (fig. 267), the highlights sprayed like cream onto every piece of bread and the handle of the basket are artistic analogies to texture and to the brilliance of sunlight at the same time. It is not a photographic, not even a naturalistic effect, but an illusionistic device that works splendidly in this

264
Detail of lion-head finial

265
JOHANNES VERMEER,
Cavalier and Young Woman,
ca. 1657.

Oil on canvas,
50.5 x 46 cm.
New York, The Frick
Collection. See also plate
XXII.

small, intensely colored picture. Similarly, in rendering blurred highlights on the lion-head finial of a chair (of the kind seen in fig. 264), Vermeer achieved an effect similar to that seen in a camera obscura (or in photographic reconstructions of how they work), but he was also enhancing effects of light that had been described by Dutch artists decades before. (The detail reproduced here is from Hals's *Portrait of Cornelia Vooght Claesdr*, 1631, in the Frans Halsmuseum, Haarlem.)

Among *The Letter Reader*'s many virtues, its range of various light effects is perhaps the most impressive and original. The daylight falling on the red curtain differs from that on the green curtain, in accordance with their different materials, distances from the viewer, and proximity to a visible or assumed source of light. The red curtain and the woman are visually transformed by the window panes. In the lower left corner, two large folds in the table carpet reflect direct and indirect light, forming one of several two-part optical essays in the picture. Some of the finer notations of light occur in the letter's recto and verso (which is lit through the paper), in the top and bottom of the porcelain bowl, and in the cornucopian spill of fruit, which has tipped over a now nearly invisible glass and ends with a cut peach.[116] Perhaps the large *roemer* formerly in the right foreground was intended partly as another study of reflections in glass.

There are similar refinements of composition. The woman's face is framed twice, by the glass and by the window's shadow behind her. The chair's finials, as well as a shadow of one, lead the eye through measured alternations of light and dark to the letter, which forms an arch that echoes and continues the line of the piled-up carpet. The lady's forearm and the fruit bowl descend together, but then the eye is lifted by the yellow panel of the sleeve. The wrinkled, curving fabric seems to answer the long curve in the green curtain, while the figure's left contour follows the window frame. The visible part of the woman and the open window are equal in height, so that a proportional relationship is sensed between the figure and the curtain in the foreground, the open window, and the picture plane.

The time one devotes to discerning Vermeer's refinements is nothing compared with the care he exercised in painting each passage. His approach resembles, but mostly surpasses, what one finds in contemporaneous still lifes, especially Van Aelst's and Kalf's. *The Letter Reader* recalls Kalf's type of composition in its haunting stillness and in several motifs, such as the shelf-like table in the foreground, the porcelain bowl, and at one time a *roemer*. The woman stands like an elegant beaker, her curls catching the light like bumps of glass.[117]

A cavalier and a young woman

Close study of the Dresden picture prepares one to apprehend how calculated the handling of light is in the *Cavalier and Young Woman* (fig. 265). The canvas is less than half the size (area) of *The Letter Reader* and is more concentrated in composition. For the first time, a perspective scheme determines the arrangement of forms in space.[118] The male figure is at once strikingly realistic and as arbitrary as any element in the artist's first five or six years of work (comparisons with works by Honthorst, Van Couwenbergh, De Hooch, and others were drawn in Chapters One and Four; see figs. 240-41).

The main motifs of the composition lock together like sections of stained glass. As in *A Maid Asleep* (fig. 261), the woman in the Frick painting is framed on three sides by rectangular elements. The man and his chair (which again cuts a corner in the foreground) bear the visual weight of the angled carpet, the chair, and (with the help of the open window) the open door and view to another space in *A Maid Asleep*.

The Frick canvas is complexly related to *The Procuress* and *The Letter Reader* as well. As in the former picture, a smiling woman dressed in yellow and white holds a glass in one hand, holding the other open above the table top.[119] The soldier reacts like an older, more reserved colleague of the men in the earlier composition. But the *Cavalier and Young Woman* bears less resemblance to *The Procuress* and to De Hooch's most comparable inn scenes (see fig. 240) than to *The Letter Reader*. Again, a woman in a yellow dress (the same one this time) is, at a certain

266
ANTHONIE PALAMEDESZ,
An Interior with a Woman Combing her Hair and Two Men Looking On, ca. 1655.
Oil on panel,
13.3 x 15.5 cm.
With Rafael Valls Ltd., London, in 1997

distance, the center of attention. The suitor, silhouetted like a dummy-board figure, serves as the viewer's surrogate.[120] A strong diagonal recession leads, as before, from the repoussoir across an illuminated table top to the woman, whose position seems fixed in relation to the wall. In the bottom border of the map, three brownish rectangles pace off the distance between the two figures and help measure the angles at which they lean. (The rectangle just above the woman's head is crowned by a cartouche, on which a miniature male figure rests his elbow.) The map reminds one that a painting (of Cupid) was originally intended for *The Letter Reader*, which more obviously resembles the *Cavalier and Young Woman* in the use of the open window, the illusionistic space, and various light effects. The flare of light at the left contour of the man's red coat seems to intensify the effect Vermeer sought in the red drapery to the upper left in the Dresden picture. The shadows on the table carpet to the lower left in *The Letter Reader* may be compared with those on the man's coat overall, which is set against the sunlight on the table top rather like the carpet in Dresden is suddenly punctuated by brilliant pieces of fruit.

Various details in the Frick picture recall Kalf, De Heem, and other still-life painters who turned simple motifs into tours de force: the chair finials, the leaves in the man's hat, the faceted glass, the two nails holding up the "New and Accurate Map of All Holland and West Friesland," and of course Vermeer's description of the map itself, a miniature replica that goes beyond any comparable passage in contemporaneous still lifes, such as Van Hoogstraten's "letter racks."[121]

The modern attempt to explain Vermeer's achievement or even his "philosophy" by referring to images formed in a camera obscura may be justified in that the artist combined close observation with a sense of wonder.[122] But the quasi-scientific analysis of his effects tends to miss their point, which was to astonish the contemporary viewer with virtuoso displays of artifice. Vermeer's image, like his map, is painted (one's sense of this is greatly enhanced by the Frick Collection's new picture lights). The work of art is not, like an actual map or images formed by optical instruments, a way of exploring the world methodically, but an aesthetic exercise and a miracle of craftsmanship. Of course, a patron such as Pieter van Ruijven (who appears to have owned this picture of "een soldaet met een laggent Meysje, zeer fraei") would probably have appreciated some parallel to scientific investigation in a realistic painting, but he was, above all, a collector of beautiful objects, not a student of nature.[123]

If Vermeer did observe effects of light and color in a camera obscura, he would most likely have treated them as he did realistic passages in paintings by other artists: as fragments of visual experience or memory, which he would re-create arbitrarily in his work. The hypothesis that Vermeer regularly referred to a camera obscura underestimates his exceptional powers of assimilation and imagination. In particular, the claim that "Vermeer probably used the camera obscura as a compositional aid in other paintings," as well as in (according to Wheelock) *A View of Delft*, *The Girl with the Red Hat*, *The Art of Painting*, and *The Lacemaker*, is implausible given the many sources of his designs in works by other artists and the intricate formal connections between Vermeer's own pictures.[124]

Gowing noted that silhouetted figures in the foreground had been employed in Delft by Palamedesz and Van Velsen (see figs. 4, 266). He also cites Dirck Hals and De Hooch as artists who arranged figures at a table similarly (as did Brekelenkam, Duck, and others).[125] Some of the many precedents for the setting in the *Cavalier and Young Woman* were discussed in Chapter Four. The window is based on the same model as the one in *The Letter Reader*, but here the scale is normal and the perspective accurate. The map also appears elsewhere in Vermeer's oeuvre on a radically different scale (fig. 294), as if it were available in various sizes, like paintings of Cupid.

The milkmaid, discreet object of desire
In *The Milkmaid* (fig. 267), which may be dated to about 1658, the process of paring down to little more than the essentials of the subject – Vermeer's revisions of two (probably) earlier single-figure pictures will be recalled (figs. 261, 263) – continued with the removal of a rectangular object – a map or painting, which was high on the wall above the woman – and a basket of linen where the foot warmer appears.[126] A low horizon (just above half-height), unexpectedly sculptural form, and the composition's simplicity lend the painting exceptional monumentality, notwithstanding the fact that it is even smaller than the *Cavalier and Young Woman*. The table, still life, and the bending figure are built backward and upward from the lower left corner, in a manner somewhat like that in *Christ in the House of Mary and Martha* (without Christ but with the bread basket; fig. 255; pl. XVIII).

"For such a simple composition, *The Milkmaid* has virtually no precedents in Dutch art."[127] It is true that the most similar antecedents are Leiden works which crowd the setting with objects, as seen in Dou's *La Cuisinière hollandaise* of about 1650 (Louvre, Paris)[128] and Van Mieris's *Young Woman Gathering Water from a Well* of the early 1650s (present location unknown; the composition may also be original with Dou).[129] In the 1640s Jacob Backer drew single-figure studies of domestic servants with a pail or jug.[130] The exquisite example in the Abrams Collection (fig. 268)

is typical except for the pretty maid's unrevealing bodice.[131]

In the Leiden paintings (including Dou's *Girl Chopping Onions*, fig. 201) and even in Backer's drawing, the jugs are suggestive, although the women seem almost innocent. This is not inconsistent, since the notion of protecting virtue is common in images and literature of the time.[132] A jug held by a comely woman, especially when combined with a foot warmer (which anticipates Duchamp's explanation of the Mona Lisa's smile, "L.H.O.O.Q."), refers to her private parts.[133] Between the milkmaid and the foot warmer, Vermeer painted a Delft tile depicting Cupid with a bow and arrow, which on this scale is at least as discreet as the Cupid in *A Maid Asleep* (where a white jug rests open-mouthed on the table, partly obscured by cloth). Could the cracked window pane be another hint of the threat to feminine virtue, as well as a clever bit of illusionism? The "peephole" in the window might also bring to mind the man looking through the window in Van Hoogstraten's London perspective box (see fig. 55), who, like the viewer, is a voyeur.[134] These thoughts take us a long way from Wheelock's protective interpretation of *The Milkmaid*, which "is not a genre scene" but an allegory "conceived to convey an abstract concept... . The milkmaid, at the very least, embodies an ideal of human dignity."[135] The composition is based, according to Wheelock, upon a painting of Artemesia by an obscure Italian Baroque painter, not Ficherelli this time but Fiasella. "Each figure projects enormous moral authority." In this anachronistic and hagiographic account (one would think that the artist was Jean-François Millet), "the kitchen maid conveys a physical and moral presence unequalled by any other figure in Dutch art."[136]

The milkmaid's fortitude, while reminiscent of the hefty females in Ripa, more likely follows the Netherlandish tradition of depicting peasant women and kitchenmaids as muscular beauties of earthy mien. An early example is found in Lucas van Leyden's engraving of 1510, *The Milkmaid*, which has been interpreted as an allegory of lust and free will based upon a contemporary connotation of *melken* (to milk), meaning to attract or lure.[137] A similar meaning seems intended in a well-known engraving after Jacques de Gheyn II, *The Archer and the Milkmaid*, where a stout and sexy farm girl holds the bowman's elbows, guiding his aim. The couple might be compared with Venus and Cupid, though the man looks more like Mars, especially with his bulging codpiece. The milkmaid's smile, like the weapon, is aimed point-blank at the viewer, thus "milking" him.[138] In the distance, the same two figures kiss and fondle on a river bank. The detail offers clarification for viewers who need it, like the Cupid in Vermeer's row of blue and white tiles.

More immediate models for Vermeer's physical type of kitchen maid are found in single- and multi-figure paintings by Pieter Aertsen, Joachim Beuckelaer, and their many emulators, including Joachim and Pieter Wtewael in Utrecht, and Pieter van Rijck, Cornelis Delff, and Willem van Odekerken in Delft (see the latter's undated *Woman Scouring a Vessel* in the Rijksmuseum, Amsterdam). In many paintings of this type, a chicken on a spit or a similar motif refers to copulation, but subtler signs, like jugs and various foodstuffs, also convey the idea.[139] A relevant work in this tradition is the very Snyders-like *Kitchenmaid* attributed to Samuel Hofmann in the Musées Royaux, Brussels, where the woman pours milk into a pot on the food-covered table in front of her and greets the viewer with a friendly smile.[140]

Vermeer's milkmaid was not intended to be such a temptress. But the male viewer is attracted and intrigued, as even "proper" gentlemen were by maids and serving women in the real world before Courbet. Samuel Pepys, for example, confided to his diary during a visit to Delft (May 19, 1660) that a friend took him "to a Duch house where there was an exceedingly pretty lass and right for the sport; but it being Saturday [meaning a big lunch crowd, presumably], we could not have much of her company." The next day Pepys was in Scheveningen, where the weather was too bad for his intended sail. He naps at an inn, "where in another bed there was a pretty Duch woman in bed alone." He chats with her ("as much as I could") and ventures to kiss her hand, "but had not the face to offer her anything more."[141]

The Milkmaid was evidently owned by another respectable gentleman, Pieter van Ruijven, who appears to have had a number of pictures of "pretty Duch women" on his walls. In his home, the small canvas would have served not as an allegory "conceived to convey an abstract concept" but as an exquisite work of art, depicting a corner of everyday reality in some ways comparable to cabinet paintings by Dou. However, Vermeer's interpretation is more suggestive of actual experience than works of the Leiden type, both visually and psychologically. Vermeer's woman does not look at the viewer, although it is easy to imagine that she is aware of him. The painter often gives the impression of sympathy with his female subjects (which is something one finds in contemporary poetry and occasionally even in Pepys) but this is not the case with Dou's kitchen maids or Steen's "oyster girls." Vermeer appears to have considered the circumstances he describes from the woman's point of view as well as his own or a likely patron's. Other artists, such as Maes and Metsu, painted young women preparing food; as they work diligently, private thoughts and slight smiles play over their features.[142] Vermeer treats the theme more

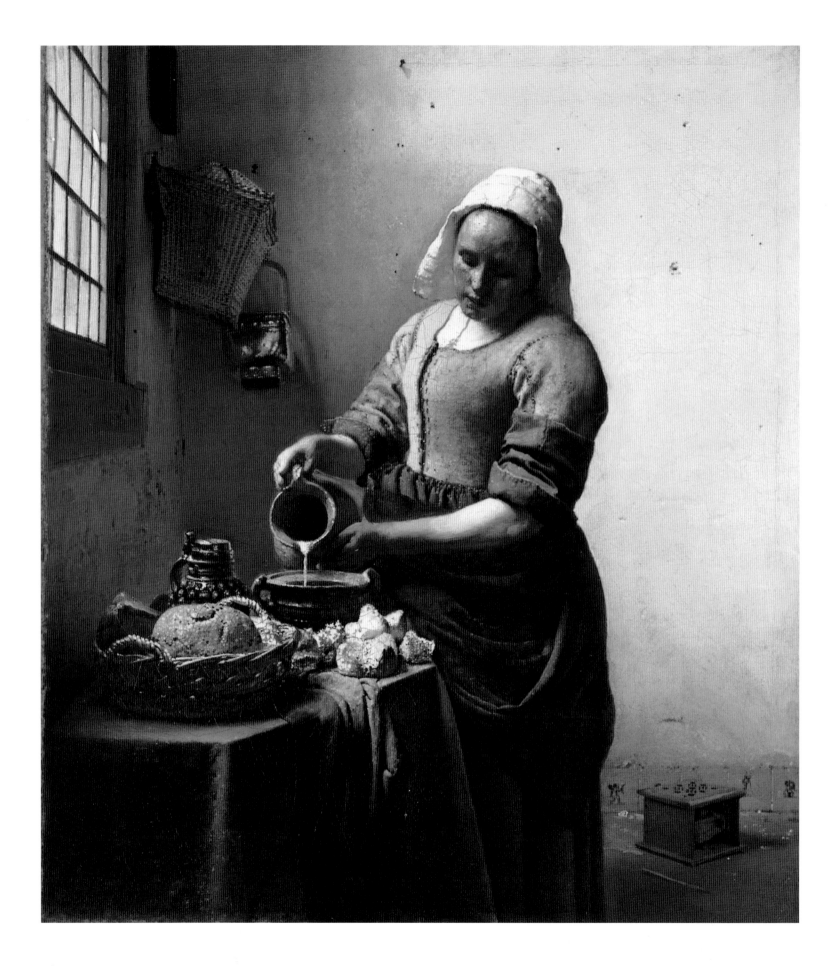

267

JOHANNES VERMEER, Oil on canvas, 45.5 x 41 cm.
The Milkmaid, ca. 1658. Amsterdam, Rijksmuseum.
 See also plate XXIII.

elliptically and evocatively (Gowing's "evasive"
is modern and perhaps rather English). His
appreciation of poetic understatement was
apparently instinctive but also something learned, to
judge from the way in which he refined this mode of
expression from picture to picture, omitting telling
details and leaving situations unresolved.

The figure of the milkmaid has also been
described as Vermeer's "sole excursion into the
depiction of 'the commonfolk'."[143] To be sure, the
woman is not a *juffer*, an elegant young lady like the
artist's letter readers, but her type recalls Mary and
Martha, the working girl in *The Procuress*, and the
distant maid in *The Little Street*. A few of Vermeer's
earlier female figures are also of interest for the way
in which the milkmaid is painted, with an emphasis
on local color, volume, and texture, in strong contrast
to his later technique.[144] This may have been
encouraged to some extent by Vermeer's sources, the
Aertsen-Snyders tradition of kitchen maids, and the
insistence on surface in Dou. The plastered wall in
the background, with its illusionistic nails and nail
holes, also resembles surfaces in the *Cavalier and
Young Woman* and *The Letter Reader*, while the light
on the bread exaggerates the technique of rendering
optical effects found in parts of those pictures.

Again Vermeer employs a diagonal recession
leading from the immediate foreground. However,
the woman's location is more clearly specified by the
table than in earlier works.[145] She is also the focus of
forms converging in her direction, the pyramid of
objects ascending to her right hand, and the triangular
wedge of the window, basket and pail, and a small
black frame (not a mirror, given its height). The
arrangement is more successful than in analogous
passages of earlier pictures and more natural in
effect. And yet each element is assigned a precise
place and value, for example, the foot warmer: its
shadow, its angle to the tiles, the straw in front of it.
The basket and pail are so artfully suspended on the
two walls (where they cast curious shadows) that
their antecedents in rustic kitchen scenes by Delft
and Rotterdam artists – Sorgh, De Bloot, the
Saftlevens, Van der Poel – would not normally come
to mind.[146] The flaking wall and worn window, the
littered floor, the ceramic vessels, the basket and pail
are Vermeer's versions of motifs in those pictures,
reinvented as beautiful objects and essays in optical
incident.

In retrospect, *The Milkmaid* deserves its
reputation as the most mature of Vermeer's
"transitional" works, which may be dated to 1657 and
1658. In this and the Metropolitan Museum, Frick,
and Dresden pictures, Vermeer experiments with
various ways of describing forms in light, and he
progressively masters the representation of interior
space. In the future he would achieve both goals with

268
JACOB BACKER,
A Woman with a Jug,
ca. 1645.
Black and white chalk on
blue paper, 36.6 x 25.2 cm.
Cambridge, Mass. The
Harvard University Art
Museums, Maida and
George Abrams
Collection

extraordinary efficiency and consistency, for example,
in the *Young Woman with a Water Pitcher* (pl. XXVI),
which has often been compared with *The Milkmaid* in
order to measure the distance from it to Vermeer's
mature style.[147] The comparison reveals how much
he left behind in order to create coherent visions of
the environment, comparable to the generalized
impressions De Witte painted after his first few years
of depicting architecture. *The Milkmaid*, by contrast,
draws the eye to many places, despite its concentration
upon one monumental form. Vision serves virtuosity
in this painting: illusionism, diversion, unusual
effects, surprising skill, and inventiveness, within a
context that, for sophisticated viewers, would
probably have emphasized how original the picture
was at the time. In most of Vermeer's later paintings
this virtuosity was placed in service to his interest in
visual experience. The shift of focus from artifice to
observation resulted in works that look effortless,
almost inevitable, as if the artist automatically
recorded images he had actually seen. In creating this
illusion Vermeer abandoned ordinary naturalism and
illusionism. His mature paintings are more like
visions, intangible and remote, a version of reality
based upon immediate experience but formed in the
imagination.

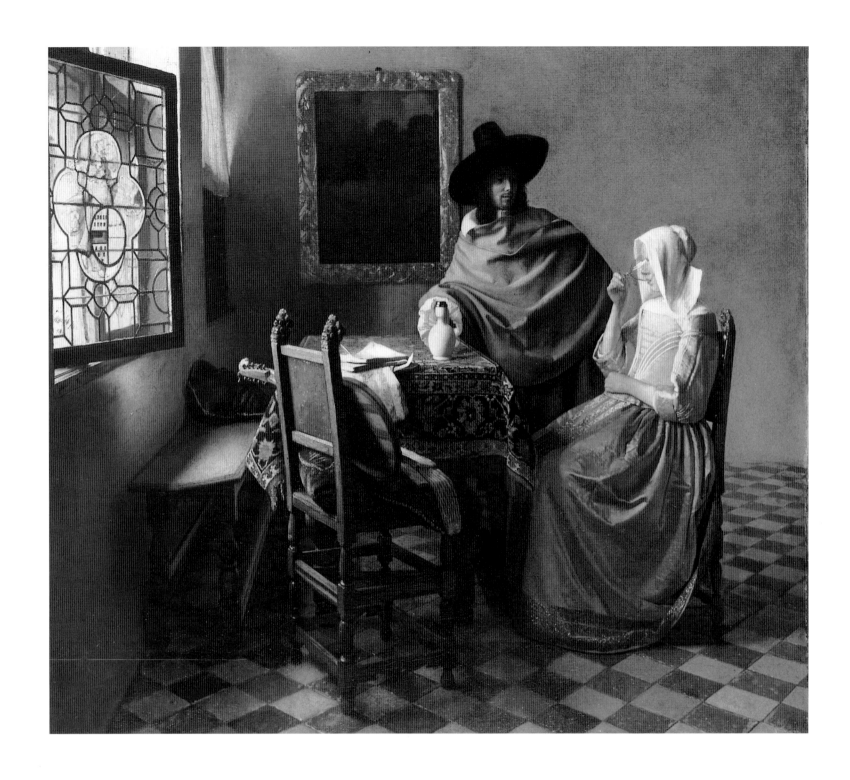

269
JOHANNES VERMEER,
The Glass of Wine,
ca. 1658-59.
Oil on canvas, 65 x 77 cm.
Berlin, Gemäldegalerie,
Staatliche Museen Berlin.
See also plate XXIV.

Chapter Six
Vermeer's Maturity

Three scenes of modern manners

In about 1658 or 1659 Vermeer turned to a new type of composition, which is found in the *Young Woman Interrupted at Music* in the Frick Collection, the *Young Woman with a Wineglass* in Braunschweig and *The Glass of Wine* in Berlin (figs. 269, 271-72). In earlier views of domestic interiors the artist created space mostly by building back in depth with objects and figures (as in fig. 267). A window and one or two pieces of furniture recede in perspective, but the space depends primarily upon overlapping forms leading to the principal motif. In the Berlin and Braunschweig pictures, by contrast, the figures and furniture occupy the middle ground of a deep space which, with its tiled floor and more complex arrangement of windows and other elements, depends much less upon the presence of figures for its suggestion of a three-dimensional environment.

The glass of wine
The most successful design in this regard is the Berlin picture (fig. 269), where the strong recession is tempered by a number of obliquely aligned elements, for example, the floor tiles, the chair and cittern, the window, and the progression from the woman via the man to the Ruisdael-like landscape on the wall. Both chairs introduce a more gradual diagonal recession to the right; before the canvas itself, the naturalistic impression of expanding space is enhanced by some sense of recession through the window to the outside. In the center of the composition the objects recede abruptly: the landscape is placed beyond the bench and table like a choir at the end of an aisle and nave. Relationships of this kind reveal a great deal of pictorial learning, both from perspective treatises (fig. 270) and from other painters, such as Houckgeest and De Hooch.

Vermeer's approach in this painting is similar to De Hooch's in 1658 (fig. 185),[1] but it is more sophisticated in that the vantage point is closer, the space more complex, and the view more effectively focused upon the figures. The window with its image of Temperance directs attention to the seated woman; the chair and cittern face her, suggesting the suitor's advance from another flank. As with Houckgeest's view in the Nieuwe Kerk (pl. II), the observer's first impression is of realistically receding space, while the second impression is of carefully considered design. The latter quality becomes more apparent as the eye follows such forms as the chair's legs and stretcher bars, the tiles beneath the table,

270
Jean Dubreuil,
La perspective pratique nécessaire à tous peintres, graveurs, sculpteurs, architectes, etc., Paris 1642-49 (treatise III, lesson LXVIII and LXIX).
New York, Metropolitan Museum of Art

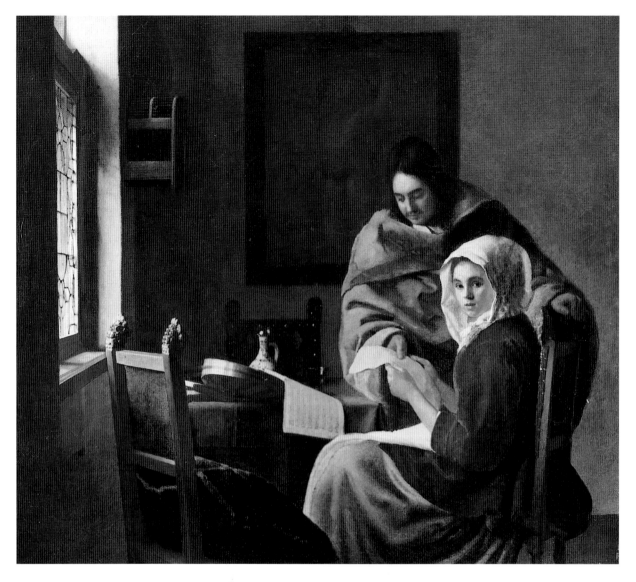

271
JOHANNES VERMEER,
*Young Woman Interrupted
at Music*, ca. 1659.
Oil on canvas,
39.3 x 44.4 cm.
New York, The Frick
Collection

and the cittern leading to the left (assisted by its contrasting strips of wood), where the instrument's neck overlaps a pillow and the bench is slotted between the table carpet and the wall. The cittern's neck and the chair finials turn the eye clockwise toward the songbooks on the table, where the wine jug functions like the pivot of a carousel on which figures, seats, and walls go round. To some extent the composition recalls Delft church interiors in which perspective is used not to define a cube but to dramatize a corner of space. However, Vermeer's sources are manifold. He has mastered a visual language, which despite slips in syntax (as in the distance to the wall on the right) is employed with confidence and without literal quotations from other works.[2]

There are other signs of maturity in the Berlin picture. The palette, warmer and richer than before, seems to bring the more local coloring of De Hooch's contemporaneous pictures into the light of day. A superb interplay of tonalities and of patterned strips and bands begins with the tiles and continues in the bars of the chair, the back of the cittern, the border of the carpet, and the trim of the woman's dress. The

handling of light is more harmonious and consistent than before; one is less inclined to describe its "behavior" in certain passages (as in *The Milkmaid*) than its effect throughout the space. There are noteworthy incidents, to be sure: the flash on the window frame, set beside a slash of light on the wall; the curtain in the corner; the sideward illumination of the figures and the back of the chair ("an object of lyric beauty, angled as it is both to catch and reflect the light bestowed on it by the open window and to rhyme with and respond to the silhouette of the window frame itself").[3] Vermeer's light has become less deferential to details and textured surfaces and more of a common denominator. The green cloak, the orange dress, and the woman's forearms are generalized and subjected to quite arbitrary transitions from intense brightness to deep shadow (hence the man's dummy-board detachment from the space behind him). Modelling has given way to modulation, and the massing of objects in space to its graduated measure by light.

In general, it may be said that in the later 1650s Vermeer began to conceive his images more broadly in terms of space and light, which required a

sublimation of tactile and sculptural qualities. This reminds one of the evolution of architectural painting in Delft as first described by Jantzen, from haptic to optical values, as seen in the early, illusionistic church interiors by Houckgeest and Van Vliet, as opposed to the mature manner of De Witte. The contrast underscores the importance of personal experience – and ultimately of personality – for visual perception and its transcription into art. Signs of Vermeer's interest in optical qualities are evident in his earliest works. But transforming this predisposition into a coherent style of painting, with its formal reductions and syntheses, required considerable experience, both as an artist adopting conventions and techniques and as an individual responding to the visual environment.

The Berlin canvas is also a mature work of art in that its style suits the painter's interpretation of the subject. The act of drinking wine, which tempers emotion through social ritual, is a page out of Ter Borch, whose silent pauses are exceeded in stillness only in works by Vermeer.[4] The delicate balance of the composition, with the figures and furniture forming a triangle in a rectilinear realm, is fine-tuned by the artist's handling of light. Forms and movement seem suspended, or at least restrained, by intervals of shape, tone, and time.[5] However, a memory of motion is found in the folds of the man's cloak, which flow from the decanter to the lady's stiffly steadied glass. A remarkable conceit is the linen nimbus around the white jug.

The Glass of Wine was first recorded in the 1736 sale of Jan van Loon in Delft. The *Young Woman Interrupted at Music* (fig. 271) came to light in 1810, but the Braunschweig canvas (fig. 272) is probably the "merry company in a room" listed in the Dissius sale of 1696 (and later described more fully).[6] This suggests, though it hardly proves, that only one of the three pictures under discussion was acquired by Vermeer's patron, Pieter van Ruijven. One might speculate that Vermeer's adoption of a comparatively popular type of composition is consistent with this, but it is only one of several possible explanations of his interest in the more conventional form.

It served his purpose, in any case. The deeper space, defined by a more developed perspective cartoon, allowed the artist to place figures and objects at a certain distance from the viewer and thus to describe them more summarily as components in a visual field. The approach is similar to De Witte's synthesis of architectural elements in the middle ground and his tendency to present elevations frontally, so that near and far motifs combine in a uniform, softly-focused pattern. The greater rôle of architectural and other geometrical elements in Vermeer's work from about 1658 onward, their frequent frontality, his simplification of contours in

figures and figure groups (for example, the conical shapes in the *Young Woman with a Water Pitcher* and the *Woman in Blue Reading a Letter*; figs. 282, 294), and his attention to "negative" shapes within the composition (sections of bare wall advance visually, like De Witte's windows) suggest that the artist appreciated the value of these formal ideas wherever he encountered them.

Young woman interrupted

If Vermeer's stylistic development was at all consistent, then the Braunschweig canvas (fig. 272), with its more thinly painted and more generalized forms, would date from a little later (about 1659-60) than *The Glass of Wine*.[7] The *Young Woman Interrupted at Music* (fig. 271) is harder to judge because of severe overcleaning in the past. However, the execution of less abraded details, such as the chair back, the cittern, and silver-mounted pitcher, as well as the composition (assuming it is not, or not much, cut down), suggest proximity to the Braunschweig picture rather than the slightly later date (about 1660-61) proposed by Wheelock. The arrangement of furniture resembles that in both the Berlin painting (fig. 269) and the Frick *Cavalier and Young Woman* (fig. 265), where the closeness of view is comparable. The cittern and the pillow on the chair lead the eye to the woman in a manner unexpectedly analogous to the cavalier's arm and leg. The painting of Cupid returns, as if recovered (partially) from a lower layer of *The Letter Reader* in Dresden. The sheet of music in the woman's hands, the glass of wine on the table, the cittern, again (tilted like the bowl in Dresden), and, more obviously, the continuous progression of objects from the left foreground back to the right – all these suggest an evolution directly from paintings datable to about 1657-58. The lady's glance brings to mind the young woman in the Braunschweig picture, but her frankness also recalls figures in earlier works (figs. 258, 265).[8]

Young woman embarrassed

These comparisons place the Braunschweig canvas in its proper context, that of genre scenes dating from about 1657-60 in which the painter surveys quite a variety of contemporary artistic ideas. In a search for the essential Vermeer one might compare the Dresden *Letter Reader* with the Amsterdam *Woman in Blue Reading a Letter*, or *The Milkmaid* with the *Young Woman with a Water Pitcher*, and conclude that the artist was a circumspect observer of young women alone with their thoughts and private preoccupations. The Braunschweig man and woman, with their forced smiles and angular movements, strike a false note on this imaginary stage. But Vermeer had not yet settled into the reticent manner that is associated, simplistically, with his mature work. Just

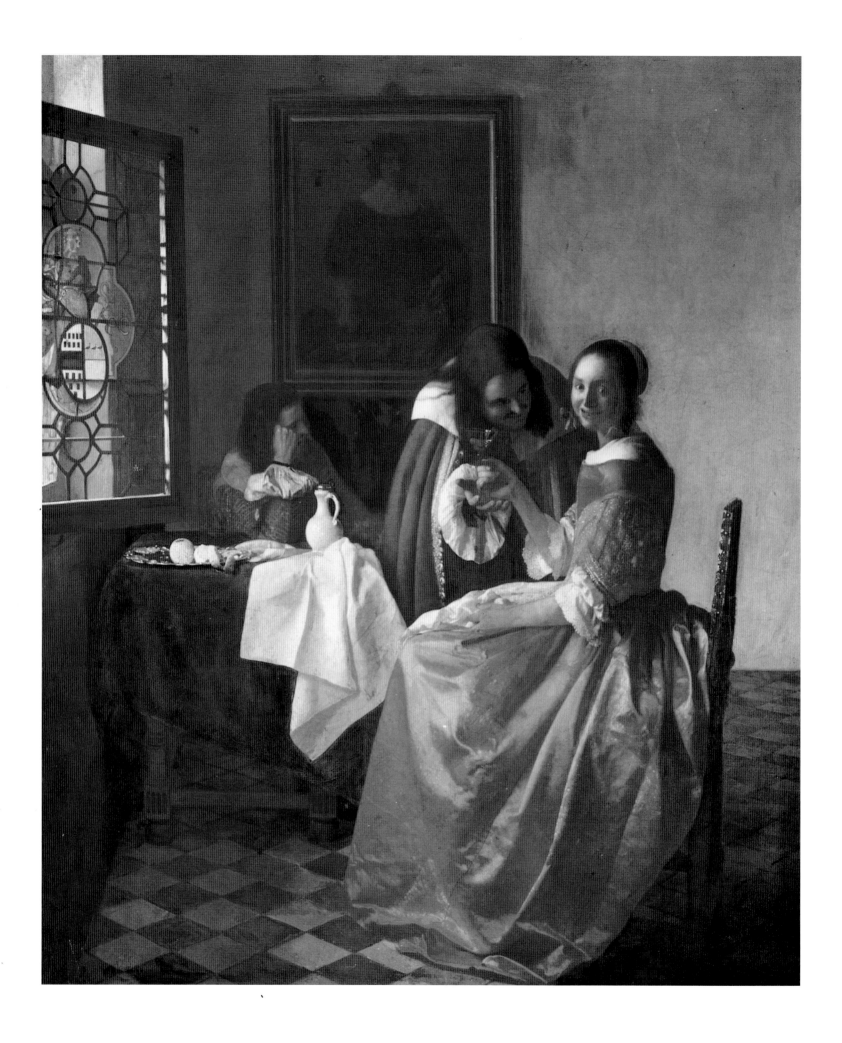

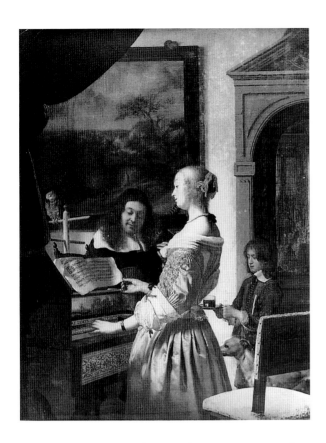

as the letter reader in the Dresden picture responds to Ter Borch, the couple in Berlin to Ter Borch and De Hooch, and each genre scene of the 1650s to several artists at once, the *Young Woman with a Wineglass* borrows characters typical of Frans van Mieris in a setting that recalls De Hooch, De Jongh, and other painters active in the South Holland area.[9]

Van Mieris's *Oyster Meal* of 1661 (Mauritshuis, The Hague) has been cited in connection with the possibly earlier painting by Vermeer in Braunschweig.[10] Several works by Van Mieris dating from 1658 to 1660 might also be compared: *The Duet* of 1658 (fig. 273); the *Inn Scene* of 1658 in the Mauritshuis (with a man slumped over the table); the *Oyster Meal*, 1659, in the Hermitage; and *The Cloth Shop*, 1660, with its loathsome Lothario (fig. 274).[11] The Leiden master is well known for his grimacing and sometimes nefarious smiles, versions of which are tried on by Vermeer in this colorful canvas. The arrangement of the figures in the foreground also comes close to that in another Mauritshuis Van Mieris, *Teasing the Pet*, dated 1660.[12]

The more general correspondences between Vermeer's style from about 1660 onward and Van Mieris's manner partly reflect their mutual awareness of Ter Borch and other artists. Van Mieris's masterly descriptions of silk and satin, Turkish carpets and still-life details (such as silver-gilt tableware) must have been admired by Vermeer. In the years about 1660 Van Mieris usually placed three-quarter-length or full-length figures in the middle distance, sometimes with shadowy backgrounds resembling the corner in the Braunschweig picture. The

composition is in some respects more reminiscent of Van Mieris (figs. 273, 274) than of De Hooch, although one must allow for Leiden *horror vacui* and Vermeer's usual process of distillation.[13] Of course, in the *Young Woman with a Wineglass* the floor tiles, the open window, and the slightly off-center placement of the picture on the rear wall (counterbalancing the figures in the foreground) evolve from *The Glass of Wine* (fig. 269) and from compositions by De Hooch. But the eccentricity of the Braunschweig canvas within Vermeer's oeuvre and perhaps as a painting from Delft can be explained partly in terms of his interest in an artist of very different temperament: Van Mieris.

As one might expect when Vermeer focused on current fashions, the *Young Woman with a Wineglass* is fairly straightforward in its iconography. The figure in the window, with a skirt that seems cued in color to the lady's dress, clearly holds a bridle and recommends temperance.[14] The man in the background has nodded off. As in *A Maid Asleep* (fig. 261), this has nothing to do with melancholy,[15] but suggests that idleness leads to temptation, whether carnal or comestible like the wine in the silver-mounted jug, the imported oranges on the silver tray, or the tobacco (?) in the paper between them. Wheelock's conclusion that the man "has succumbed to the narcotic effects of tobacco" is too literal for Vermeer, requiring that one see a clay pipe "just evident" on the table when there is none.[16] The seated man is comparable with the upright figure above him (with a slashed doublet of the 1630s), rather like the woman is with Temperance.[17] The suitor in the foreground has been identified as a

272
JOHANNES VERMEER,
Young Woman with a Wineglass, ca. 1659-60.
Oil on canvas,
77.5 x 66.7 cm.
Braunschweig, Germany,
Herzog Anton Ulrich-Museum

273
FRANS VAN MIERIS,
The Duet, 1658.
Oil on panel,
31.5 x 24.6 cm.
Schwerin, Staatliches
Museum Schwerin

274
FRANS VAN MIERIS,
The Cloth Shop, 1660.
Oil on panel, 55 x 43 cm.
Vienna, Kunsthistorisches
Museum

lecherous instructor in social graces,[18] which would explain the girl's awkward grin, the emphasis upon holding the wineglass, and even the particular usefulness here of Van Mieris (compare, for example, *The Cloth Shop* [fig. 274], where a predator of conspicuous refinement strings the young lady along).

Gowing's tendency to overwrite was not restrained by this picture. He drew astute comparisons with the works of other artists, especially Metsu, but exaggerated the differences in technique between the paintings in Braunschweig and Berlin (figs. 269, 272). The former "must belong in its final form to a time several years later."[19] The economy of definition in the figures, above all, in the woman's lower arm, must be due in part to overcleaning and repainting in the past.[20] But only in part: in execution the *Young Woman with a Wineglass* goes beyond the Berlin picture in the direction of the *Young Woman with a Water Pitcher* and the *Woman in Blue Reading a Letter* (figs. 282, 294). This becomes somewhat clearer when the New York canvas is properly dated, in my view (which accords with Blankert's and Gowing's) to about 1661-62, not a few years later as has been proposed.[21]

275

JOHANNES VERMEER, *The Little Street (Het Straatje)*, ca. 1658-60. Oil on canvas, 53.5 x 43.5 cm. Amsterdam, Rijksmuseum. See also plate xxv.

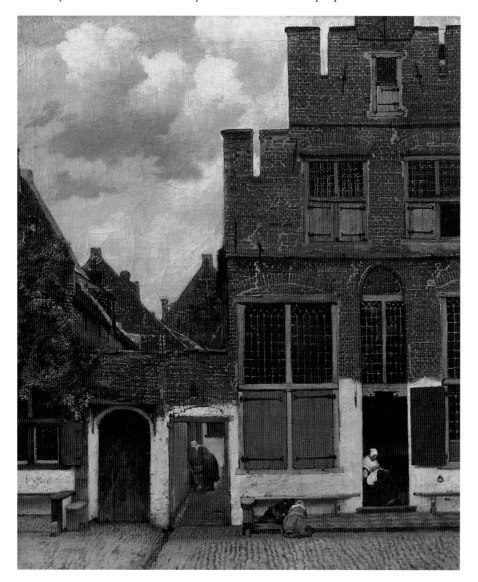

The two exterior views

A house in Delft

The Little Street (Het Straatje) (fig. 275) was probably painted about 1658-60, during the period in which Vermeer first turned to De Hooch's type of genre interior.[22] The variety of technique in the painting, with its emphasis upon different textures and light effects, appears consistent with Vermeer's approach in *The Milkmaid* (fig. 267): baked bricks assume the rôle of baked bread. But the sense of form and space found in that picture and, differently, in the contemporary courtyard views by De Hooch (figs. 247-49) has vanished in Vermeer's street scene. Despite the prospect through a doorway and the recession of houses, back to back, to a façade on another street, all the architecture appears compressed into a shallow zone of space in the middle ground. The pavement in the foreground insists upon the viewer's distance, not so much by its depth as by its blurred definition, as if it were seen from across a canal. The sky, filled with unthreatening clouds, comes forward, like one of Vermeer's white interior walls. In its overall impression of space, *The Little Street* looks ahead to interior views like the *Young Woman with a Water Pitcher* (fig. 282), where the compositional pattern is surprisingly similar (the map, woman, and table form a frontal elevation; the raised arm, like the roof lines, links the main motifs to the left frame).

Too much has been made of Vermeer's entry into a new genre, as if Dutch artists subscribed to our categories. Despite the resemblance to townscapes by Jan van der Heyden (and Pynacker; fig. 7), *The Little Street* is much closer to De Hooch's courtyard scenes of 1658 and the slightly later *Dutch Courtyard* in Washington (fig. 249).[23] Other pictures that may be compared with De Hooch's exterior views of about 1658-60 include Hendrick van der Burch's *Graduation Ceremony at the University of Leiden* (Rijksmuseum, Amsterdam) and Daniel Vosmaer's so-called *View of a Dutch Town* (fig. 276). The worn brick walls which the Delft artists favor were evidently appreciated as *schilderachtig* motifs; each painter compares them with whitewashed areas, tile roofs, clouds, and clusters of foliage, to picturesque effect.[24]

But of course there is more to these compositions than the various surfaces of reality. Vosmaer's broken walls and vacant plots of land recall the Delft explosion and remind one of the fragility of life. *The Little Street*, while not topical, concerns the treasured things that such a tragedy takes away. As always, Vermeer is not as literal as De Hooch, who tends to be so both in his narrative of everyday life and in his description of the material world. However, there are wonderful instances of observation in Vermeer's

façade; the green shutters alone, and the way they are set into the window casement, testify to his respectful study of ordinary objects. And for once Vermeer adopts a De Hooch-like theme: a family home, long cared for; the timeless routines of household work; and the blessing of children, who will hopefully grow to maturity and pass the house on to children of their own.[25]

Vermeer appears to have combined and modified motifs taken from different houses in Delft, as De Hooch did in his courtyard views.[26] The connection with those compositions is underscored (however faintly) by the pentimento of a woman sitting in the doorway of the alley;[27] the motif recalls De Hooch's little girl in the doorway of one of the two closely related courtyard views dated 1658 (fig. 248), while the other one in London (fig. 247) could have suggested to Vermeer the deeper placement of the maid. Both paintings by De Hooch include several motifs that Vermeer might have adopted, though he treats them more summarily, just as he interprets the theme of domestic virtue in a broader vein.

The London De Hooch is the more comparable to *The Little Street* in composition (figs. 247, 275). One side is rectilinear, the other sliced by angular lines and garnished with a vine.[28] The foreground is emptier and less regularly defined than in the similar composition by De Hooch (fig. 248); the broom and bucket might be waiting for Vermeer's maid. The old wooden door, the metal ring, and the steps have counterparts in Vermeer's canvas, where the red shutter placed beside a doorway seems indebted to De Hooch's designs. In a more general way Vermeer's composition recalls De Witte, whose views through elevations of architecture concentrate upon such motifs as windows, archways, doorways, monuments, and graveboards. The latter elements function in his designs like Vermeer's shutters and dark windows; simple shapes and strong colors accent the field of blending layers and tones. The device of running a long orthogonal through an opening (which in the Vermeer represents water draining into the street) was employed by De Witte in the early 1650s to draw attention to deeper spaces and distant figures.[29] In the same years he depicted exterior views of architecture, presented frontally and from a close point of view.[30]

The Little Street may be compared with other paintings of the 1650s, for example, Ter Borch's *Grinder's Family* in Berlin.[31] But Vermeer's wide knowledge of current conventions and his sources in actual architecture cannot be combined in some simple equation to explain how his painting came about. He creates the impression, at once false and true, that he surveyed all the latest pictorial ideas and then put them aside, turning to a view out the window.

A view of Delft

The *View of Delft* (fig. 277, pl. 1) is a true cityscape painting; the term "townscape," which is often justified by the subject, seems too modest for this quietly monumental composition. Wheelock dates the canvas convincingly to 1660-61, which for the present writer means not long after *The Little Street*. Circumstantial evidence favors 1661.

A good essay could be devoted to the picture's critical history.[32] Gowing had little to say about it, apart from calling it "our most memorable image of the remoteness which is the essence of Vermeer's world."[33] Not much more has been offered by the majority of recent writers, who, like Gowing, appear to feel more at home with Vermeer's interior views and silent figures.[34] The main exception is Wheelock, whose strong suit is the sort of objective analysis this picture requires: painting technique, compositional adjustments, effects of color and light and how they might relate to the possible use of a camera obscura, comparison with the actual site, and so on. The following lines depend heavily upon Wheelock's several publications but offer a few fresh remarks.[35]

276
Daniel Vosmaer,
View of a Dutch Town,
ca. 1662.
Oil on panel, 66 x 53 cm.
Poughkeepsie, New York,
The Frances Lehman
Loeb Art Center, Vassar
College, Purchase, Agnes
Rindge Claflin Fund

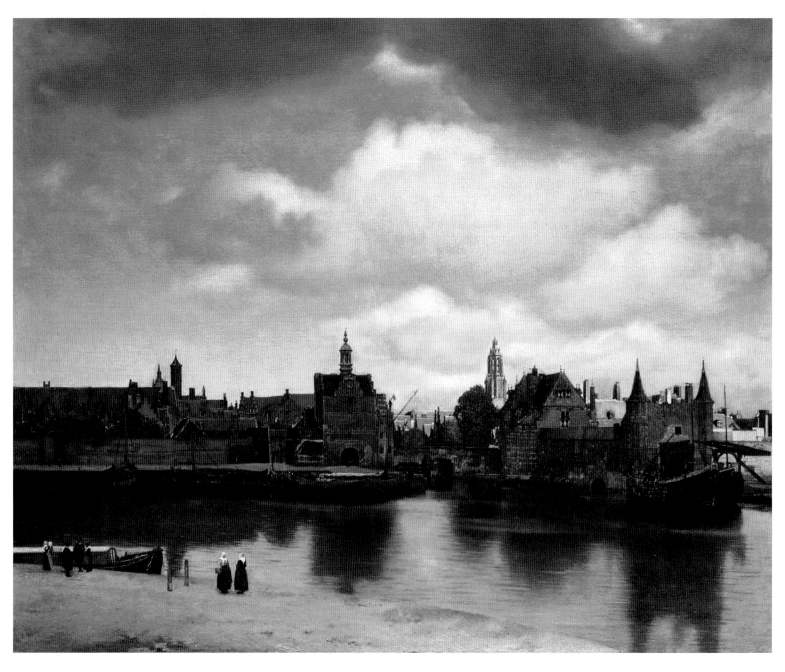

277
JOHANNES VERMEER,
A View of Delft, ca. 1661.
Oil on canvas,
96.5 x 115.7 cm.
The Hague, Koninklijk
Kabinet van Schilderijen
"Mauritshuis." See also
plate 1.

The painting is a comparatively faithful view of Delft from the south, which was the principal approach to the city from Rotterdam, Schiedam, and Delft's own outlet to the mouth of the Rhine at Delfshaven. The blocky building with a clock, in the center of the view, is the Schiedam Gate; to the right is the Rotterdam Gate (both were demolished in the nineteenth century). The two structures, linked by the bridge, were nearly parallel to each other and not nearly so far apart as they seem in the painting. The actual alignment of the Rotterdam Gate would have been rendered more accurately if Vermeer had extended it from the bridge (which he broadened) toward the lower right corner of the composition. The true course of the quay to the far right is suggested by the nearest boat on that side – or was, before the artist extended its stern.[36]

These and many other adjustments to the composition are detailed by Wheelock. The description of the architecture, which admits arbitrary passages such as the long red roof on the left, uniformly emphasizes the cityscape's horizontal continuity and elevations that were or appear to be parallel to the picture plane. Shorter vertical motifs pace the panorama from left to right. To the lower left, the red cabin of the barge echoes the red roofs across the water. In front of the barge, the reflection of a distant tower is arbitrarily thickened and tucked in between two posts. The maids nearby stand almost as stiffly and are carefully placed within a patch of reflected sky.

Technical examinations have shown that Vermeer initially painted the front of the Rotterdam Gate in bright sunlight, not shadow, and that the reflections of its towers to the lower right were extended downward considerably.[37] The reflections of the two gate towers in the water reinforce the rectilinear structure and the frontality of the whole design.

Once again, the interplay of frontal forms, shining voids, and softly geometric shadows is reminiscent of Emanuel de Witte, for example, in church interiors viewed directly across great spaces and into shimmering sheets of glass.[38] Other artists reveal a similar sense of proportion, but few of them, not even De Hooch and Van Vliet, compare as closely with Vermeer as does De Witte in the general effect of space. Three-dimensional motifs are merged together at a certain distance, so that areas of light and shadow, not receding forms, create the illusion of depth. The forms look flat upon close inspection, but are surprisingly suggestive of actual space when the image is seen from several steps away.

As in large passages of De Witte's contemporaneous paintings (the examples reproduced here are earlier), there is little use of linear perspective in the *View of Delft*. The horizon coincides with the center of the long, low roof of the Rotterdam Gate, which appears to recede to a point near the top of the city wall at the left edge of the composition. The wide-angle stretching of the Rotterdam Gate to the right, which recalls De Witte more than Saenredam, allows the blue-roofed buildings to balance those roofed in red. The brightly lit buildings in the right background respond likewise to the tan-colored strips of the near bank and distant quay.

Three barges with red cabins are moored where the Rotterdam Gate joins the bridge.[39] Before the canvas itself their forms are readily understood, despite the artist's impressionistic rendering. However, the barges barely function as cues to distance; they serve mainly as echoes of the red rectangles to the left. In the same area, red bricks, stippled lines of mortar, and cloud-like patches of stone and lime rise above the water's slick surface and are reflected in it, amplifying their effect in the design.

All of these refinements speak against the hypothesis that Vermeer used a camera obscura to record the site. However, Wheelock maintains that "distinctive effects of light, color, atmosphere, as well as the diffusion of highlights associated with the camera obscura are found in this painting."[40] This does not mean that the artist's tapestry of reds, blues, browns, and so on is the condensed record of a beautiful day. One can walk about in bright sunshine with any model of nineteenth-century view camera and never find effects as clear and brilliant as those in *A View of Delft*. If Vermeer did benefit from observing the image formed in a camera obscura, it was likely the "dark-room" not the portable type, and it probably provided him with no more than memories of optical effects.[41] Wheelock himself notes that the striking use of pointillé highlights on the boats to the right is arbitrary, since the effect would not occur in an area of shadow whether

viewed with a camera obscura or the naked eye.[42] Kemp makes the same observation with regard to the artist's domestic motifs, such as table carpets and drapery. "Vermeer scatters globules of light across relatively matt surfaces which would not exhibit circles of confusion in a camera. In his later works the luminous dabs are exploited as a form of painterly shorthand which is optical in origin and artificially contrived in application."[43]

Wheelock has much more to say about this great work. For example, he describes the painter's wide range of techniques employed to create textures in the architecture (such as sand mixed with lead white).[44] Two aspects of the picture that have not received much attention recently are the formal means by which Vermeer achieved its illusionistic effect and the composition's derivation from landscape painting in Amsterdam, namely, the majestic vistas with high skies depicted by Philips Koninck and Jacob van Ruisdael. Perhaps these questions were clouded over by discolored varnish,[45] and by the different interests of art historians during the past twenty years.[46]

The high view over the foreground, the tall sky, and the focus upon motifs coincident with the horizon are features developed by Koninck in the late 1640s (fig. 278). He employs two means to enhance recession over flat terrain: alternating zones of light and dark leading back from an elevation in the lower left corner and receding ranges of cumulus clouds. Vermeer uses similar devices with essentially the same effect in *A View of Delft*. Both the clouds and the ground plane recede on a gentle diagonal toward the tower of the Nieuwe Kerk. The deeply

278
PHILIPS KONINCK,
Landscape, ca. 1649.
Oil on canvas,
143.2 x 173.4 cm.
New York, The
Metropolitan Museum
of Art

shadowed base of the nearest cloud is a powerful repoussoir, like one of Honthorst's foregrounds inverted. Together with the shaded zone of architecture, the nearest cloud suggests that the sun is high behind the viewer, which it usually is in the middle hours of the day. The tower of the Nieuwe Kerk often stands out in sunlight, as here. Nonetheless, this accent, like the composition in general, reveals its origin in contemporary landscape painting. A similar arrangement of flat terrain, with a church tower in the right background and high clouds pinwheeling up from the spire to a shadowy mass seemingly over the viewer's head, is found in Van Ruisdael's *View of Ootmarsum* of about 1661 (Bayerische Pinakotheken, Munich). His *Haarlempjes* likewise offer many points of comparison.[47]

Vermeer's formal refinements transformed a detailed topographical view of a conventional type into a majestic and illusionistic composition. The individual buildings are immediately recognizable but hardly documented: every motif contributes to the impression made by the whole. The receding surface of water and layer of clouds, the persistent silhouetting effects, and the brilliant highlights, stroked and dotted over darkened forms, all enhance the primary impressions of depth and luminosity. In its own time the canvas was never seen in interior light comparable to that of a modern gallery, and it was probably hung higher than it usually is now. Thus the artistic means by which Vermeer achieved his effects were less evident, and the look of life itself all the more remarkable.[48]

Where the painting hung in the seventeenth century is not known. However, its size, format, and composition would have made it suitable as an overmantel. Aspects of the design, such as the firm base, the architectonic accents, and the swag-like curves of the uppermost cloud, encourage the hypothesis.

Less conjectural is the suggestion that the painting was intended for Pieter van Ruijven's home on the Oude Delft, which begins at the Schiedam Gate. As has been noted often, *A View of Delft* (called "De Stad Delft in perspectief, te sien van de Zuyd-zy") was sold in the Dissius auction of 1696 for 200 guilders. Other paintings by Vermeer in the same sale went for between fl. 17 and fl. 175 (*The Milkmaid*).[49] The cityscape is one of the least likely pictures by the artist to have entered Dissius's collection from a source other than the Van Ruijven inheritance. The painting's size and subject were unexpected of Vermeer in the early 1660s, and its planning and execution, involving a great amount of time and some unusual materials, indicate a special order. The format and approach to the site, which is more picturesque than topographical, speak against a civic or otherwise official commission. If such a

commission had been awarded, the painting's appearance in the Dissius sale would be hard to explain. For that matter, no owner in Delft, such as another private purchaser of this expensive picture, would have been inclined to let it go (this is not just another luxury item, like a painting of some fashionable figures). The fact that the Dissius sale also included four paintings of church interiors (three of them listed as by Emanuel de Witte) and *The Little Street* might suggest that Van Ruijven was interested in having views of various sites in Delft.[50]

Reactions to Van Ruijven's rôle in Vermeer's life as an artist have not been entirely objective. Alan Chong, in his *Palet Serie* book on the Mauritshuis painting, maintains that "the recent discovery of the original patron of Vermeer's *View of Delft* profoundly affects our understanding of the meaning of the picture."[51] Not so for Wheelock, who three years later reports that "just why Vermeer came to paint this cityscape is not known; neither a commission for the work nor a description of the painting [dating] from the artist's lifetime has survived."[52] This suits Wheelock's hypothesis that the Nieuwe Kerk's tower is illuminated in *A View of Delft* to serve "as a constant reminder [to senile citizens?] of the intimate connections that existed between Delft and the House of Orange, an emphasis made all the more emphatic because the tower of the other great church, the Oude Kerk, is largely obscured."[53] In fact, the painting "can only be understood as a celebration of that long and distinguished history" of relations between Delft and the Dutch court.[54]

Here and in Chong's discussion of Charles II's visit to Delft (and many other cities) in 1660,[55] the likely owner of the painting is swept aside in the name, oddly enough, of social context. Van Ruijven was a Remonstrant who was excluded from any public office worthy of such a prominent citizen, although later on he served as a regent of the Camer van Charitate (1668-72). The Oude Kerk, where the Van Ruijvens owned a family grave, is "largely obscured" in Vermeer's painting not because of any artistic decision but because one can barely see the top of the tower from the actual vantage point.[56] In my view, the tower of the Nieuwe Kerk and quite a few buildings around it are brightly illuminated for pictorial reasons that Philips Koninck or Jacob van Ruisdael, and probably Van Ruijven, could have explained. Of course, the tower was a point of civic pride, rich in historical associations. (In the 1680 version of Van Bleyswijck's book the towers of the Oude Kerk and the Nieuwe Kerk are illustrated on fold-out plates.) But the tower is also picturesque, and a clear sign that we are indeed looking at "the City of Delft in perspective, as seen from the south side."

The term "picturesque" may seem improper for Vermeer's approach, which has been described more reverently as "realism... of a most profound type."[57] However, one would not hesitate to characterize several contemporaneous works – Jan de Bisschop's impressionistic sketch of the Schiedam Gate

(ca. 1660-61), Jan van Kessel's drawing of the Rotterdam Gate (mid-1660s), Van Kessel's painting of the East Gate in Delft (1667?), Jan van Goyen's painting of the East Gate dated 1644, or, for that matter, Daniel Vosmaer's *View of Delft* in Ponce (fig. 29) – as picturesque views, which in their focus upon old city gates and walls, windmills, and Gothic towers are reminiscent of many other Dutch drawings and paintings (by Van Goyen, Van Ruisdael, Van Kessel, Lambert Doomer, Gerbrand van den Eeckhout, Roelant Roghman, Herman Saftleven, Simon de Vlieger, Rembrandt, and so on).[58] It seems likely that Vermeer's vantage point was chosen not because of a convenient window or any symbolic theme, but because this view of Delft across the small harbor on the south side (the largest area of water along the city walls) was one of the most attractive views available.[59]

The principal difference between Vermeer's view of Delft and cityscapes by other artists – with the exception of Fabritius's *View in Delft* – is the importance here of illusionism and optical effects, as has been remarked by commentators since at least the time of Thoré-Bürger. Most of the uncommon qualities of light and color in Vermeer's canvas are similar to those found in his interior views of about the same time. However, the reflections in the water were something new for Vermeer, and his handling of them, and of the light, ripples, and even traces of a breeze on the surface of the water are extraordinary examples of observation. The density of the reflections of the buildings recalls Rubens's well-known "Aguilonian annotation" on a drawing of

trees (British Museum, London) that "the reflection of the trees in the water is darker and more perfect than the trees themselves."[60]

The Parisian perspectivists Dubreuil and Bosse had naturally seen the subject of reflections in water as within their province (figs. 279-81).[61] Similarly, their demonstrations of perspective applied to interior views dealt not only with open doors and windows and variously tiled floors (see fig. 270) but also with the projection of complex shadows (fig. 287; compare Vermeer, fig. 283) and questions such as how light from a window will fall on a floor and from there reflect to illuminate slightly an area of the ceiling (as in fig. 287). Van Hoogstraten, following these writers (and De Caus; figs. 80-81), also illustrates shadow projections and demonstrates the need to distinguish various kinds of *Kamerlicht*.

Vermeer was probably more aware of these publications than were most artists in Holland. He may have benefited from their explanations, especially with regard to shadows like those to the right of the mirror and virginal in *The Music Lesson* (fig. 283). But as a painter Vermeer was almost the antithesis of Bosse, favoring experience over book learning. Professional perspectivists and painters such as Fabritius and Vermeer had parallel interests, nothing more. For Vermeer, a demonstration in a treatise was like the example set by another painter or by an optical device. The evidence was judged afresh through direct observation and, during the course of work, revised at will in accordance with an aesthetic program. Vermeer's realism is profound because it is beautiful.

The "pearl pictures" and related works

From this point onward we are mostly concerned with questions of style, not problems of representation. Vermeer's genre interiors and single-figure pictures of the 1660s are, if anything, more remarkable for their naturalistic qualities than the paintings of the late 1650s, in good part because even his most noteworthy passages of observation are generally subordinated to the impression made by the whole. Crucial to this achievement is the tendency to place figures and objects at a greater distance, as well as the more pervasive use of shadows in Vermeer's mature work, as in the *Woman Holding a Balance* and *A Lady Writing*, both in Washington (figs. 290, 295).

These considerations bear upon the difficult problems of chronology in the period from about 1662 to 1668, the date on *The Astronomer* (fig. 316). Of course, Vermeer may have worked on two pictures in somewhat different manners at about the same time. But he was such a deliberate artist that scholars have been encouraged to pursue rather narrow questions of stylistic development.

A small group of pictures with similar compositions – the *Woman in Blue Reading a Letter*, the *Woman Holding a Balance*, the *Woman with a Pearl Necklace*, and the *Woman with a Lute* (figs. 288, 290, 291, 294) – has been placed convincingly in the period 1662-64. Whether or not the *Young Woman with a Water Pitcher* (fig. 282) and *The Music Lesson* (fig. 283) should be placed before, with, or just after the works of about 1662-64 is difficult to decide, as Wheelock's dating of the last picture to 1662-65 suggests.[62]

Young woman with a water pitcher

Gowing dates the *Young Woman with a Water Pitcher* comparatively early, about 1661-62.[63] This seems more plausible than Wheelock's dating of about 1664-65. The two authors differ strongly in their subjective responses to the work. Gowing considers it "the most primitive of its type," which he finds in more mature form in the *Woman in Blue Reading a Letter* (fig. 294). Wheelock, by contrast, considers the Metropolitan Museum's canvas such a distinctive example of Vermeer's mature style that he may be said to have moved beyond the mundane concerns of contemporary genre painters. "In a Neoplatonic fashion, the artist found that beneath the accidents of nature there exists a realm infused with harmony and order."[64] For De Vries, this "attempt to upgrade Vermeer" to a seat in Poussin's section is based upon "an untenable definition of genre." The "association of Vermeer's transition from the middle to his later style with a change from Neoplatonism to classicism [is also] completely unfounded," in De Vries's view.[65]

It does seem odd to suggest that Vermeer's vision or his camera obscura came with Neoplatonic attachments, since the geometric organization of the *Young Woman with a Water Pitcher* (a cone and three rectangles) is obviously a distillation of designs that De Hooch and Vermeer favored about 1660. Similarly, the figure's pose resembles that found in slightly earlier Dutch paintings of well-balanced individuals, such as Vermeer's own *Milkmaid* and Rembrandt's *Aristotle*.[66] These consistencies support Gowing's placement of the New York picture close to the wine-drinking scenes in Berlin and Braunschweig, as does the recurrence of an open window, again with a wonderful description of sunlight on the frame. The table carpet is given a shape and space-defining function quite like those of the woman's angular skirt in the Braunschweig canvas, where her lap forms a base for the conical shape of the bowing man. Formal similarities of this kind have been seen in earlier works by Vermeer and usually reflect closeness in time, like patterns of speech one might fall into for a brief period and then just as unconsciously leave behind.

As in the Berlin and Frick paintings (figs. 269, 271), a chair once stood at an angle in the left foreground of the *Young Woman with a Water Pitcher*.[67] Its elimination may have coincided with the shifting of the map, which had extended further to the left, behind the figure. The composition became much less cluttered with Vermeer's editing, and the sense of space less dependent upon overlapping objects (an approach that was not completely successful in the *Young Woman with a Wineglass*). This suited the artist's more generalized description of forms in light, which is seen especially in the woman's forearms and her face, with its mask-like serenity. However, the painting still recalls those in Berlin and Braunschweig in its strong local coloring. Assertive areas of red, blue, yellow, and white are balanced rather than blended, which they become in the more muted images of the next few years.

There remains, in the New York canvas, some sense of constructing space from foreground to background, in contrast to the more natural impression of depth in pictures like the *Woman in Blue Reading a Letter* and the *Woman with a Pearl Necklace* (figs. 291, 294). Over time the often admired negative shapes and the interplay of outlines in the *Young Woman with a Water Pitcher* – for example, the pitcher's rise into the yellow part of the sleeve, and the way the map bar fills the angle between the head and shoulder – become recognized as clever calculations. By comparison, the "pearl pictures" (Gowing's name for the group gathered about the *Woman with a Pearl Necklace*) seem subtler, less "primitive," by which Gowing meant less obviously composed.

The astonishing ensemble of basin and pitcher, forearm and hand, is a study of reflections and apparent movement such as Vermeer's contemporaries had rarely if ever seen.[68] The blurred hand and pitcher handle are immediately juxtaposed with the chair finial, which despite the play of light over leonine features seems inanimate by comparison. Vermeer also compares the black sleeve to the leather chair back, each with gold embellishments; the blue skirt with the material draped over the chair; and the yellow satin on the jacket with the gold face of the jewelry box. The central theme of black, blue, and yellow is more complexly developed on the red base tone of the table carpet.

The carpet pattern is magnified and blurred in the bottom of the basin, while the red and blue strokes on the right side of the pitcher echo the angle that the lid of the jewelry box, with its red lining, cuts against the blue drapery on the chair. This still-life passage is an instance of both Vermeer's fascination with visual experience and his virtuoso response to a colleague's example, such as the rendering of the basin and pitcher in Van Mieris's *Woman Stringing Pearls* of 1658 (Musée Fabre, Montpellier).[69] This

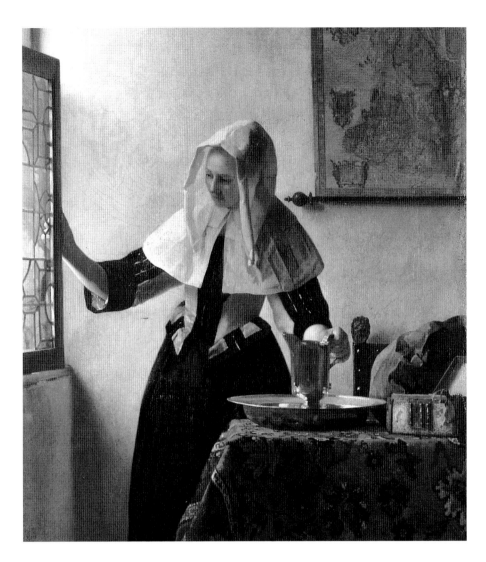

paragone of pots and pans complements that of textures and light on table carpets and of veil-like linen wrapped around shoulders and partly revealing the garment underneath – motifs also shared, however differently described, with the Van Mieris in Montpellier.

The frozen movement in the *Young Woman with a Water Pitcher* also takes Leiden compositions as a point of departure. Dou, for instance, painted pictures of older women, their heads covered less elegantly, watering plants outside their windows. Vermeer appears to recall that type of picture and also a similar one that Dou painted about 1660-62, in which an attractive young woman opens a window or pushes a window curtain aside.[70] The point is not that Vermeer's painting has a commonplace narrative after all, but that the suspension of narrative which modern viewers admire and occasionally describe as timeless would have been understood by discerning observers of the period as a moment of real experience artfully transformed. The basin and pitcher, relieved of their practical purpose, become symbols of purity, seemingly consistent with the woman's modest attire (which significantly restyles the dress of the Dresden *Letter Reader*) and unselfconscious concentration. A few writers have

282
Johannes Vermeer,
Young Woman with a Water Pitcher, ca. 1662.
Oil on canvas,
45.7 x 40.6 cm.
New York, The
Metropolitan Museum
of Art, Marquand
Collection, Gift of Henry
G. Marquand, 1889.
See also plate XXVI.

noted that she turns her back on the jewelry box and the map, symbols of vanity and worldliness.[71] Perhaps the woman simply takes these objects for granted; the jewelry box, at least, and the string of pearls with ribbon ties (as in fig. 291) are there for the viewer to notice. The already antique jewelry box is only the most obvious sign of luxury in this corner of a private world. The basin and pitcher, the map, the table carpet, the dress, and the leaded window are all indications of tasteful and comfortable living, which for many contemporaries was itself evidence of virtue.

The "music lesson"

It is not hard to imagine that compositions like the *Woman with a Lute* and the *Woman in Blue Reading a Letter* (figs. 288, 294) might follow immediately after the *Young Woman with a Water Pitcher*. The two paintings in the Metropolitan Museum (figs. 282, 288) both represent a figure confined by a pattern of rectangles – the window, the table, the chair in the right background, the map with its pointing bar – and they also once shared a silhouetted chair in the foreground. It is less certain, but in my view likely, that *The Music Lesson* (fig. 283) also dates from about 1662-63, rather than the middle of the decade. A similar display of marble floor tiles is found in the Gardner *Concert* (fig. 304) and other later paintings, but closer comparisons suggest that *The Music Lesson* comes from an earlier moment when Vermeer's pictures had brighter palettes, with local colors and fewer shadows, rectilinear designs and somewhat forced recessions. (The relationship of the Gardner painting to the one in Buckingham Palace is considered below.)

The queue of forms on the right in the Queen's picture – table, chair, viol, woman, virginal, mirror, woman, table, and easel – may be compared with the recession on the right in the Braunschweig composition (fig. 272). As in the Berlin (fig. 269) and Braunschweig interiors, the recession on the left is abrupt, suggesting cell-like enclosure and the viewer's distance rather than freedom to move about. Some relief is provided by oblique views to the right (compare Van Vliet in 1662-63, figs. 170-74). In *The Music Lesson* the viewer's eye is drawn by the gleaming white pitcher to the scene of *Roman Charity*, where Cimon's bound arms and dependence upon Pero suggest the suitor's captivity. He is bound by bars of music, which he evidently sings as well as hears, and by beauty and desire. From his point of view the young woman appears in profile, looking slightly downward, rather like the figure in the Dresden *Letter Reader* appears to the viewer. In both paintings a reflection also tempts one to succumb to the exquisite, frustrating pleasures of sight.

Wheelock wonders about the gentleman's identity. He resembles the man who appears in *The Astronomer* and *The Geographer* (figs. 316-17), but the model for that figure, in Wheelock's opinion, is the Delft microscopist Anthony van Leeuwenhoek.[72] On the other hand, "it is possible that the owner of the virginal is the gentleman represented in the painting. Unfortunately nothing certain is known about the painting's provenance prior to its appearance in the Dissius sale of 1696."[73] What Wheelock appears to be hinting at here is that Vermeer's patron, Pieter van Ruijven, may be the man in *The Music Lesson*, that he may have owned a virginal of this design, and that he may have borne a surprising resemblance to Van Leeuwenhoek. My own view is that the man is a type, a vehicle for the artist's fantasies and for those of his fellow men.

While *The Music Lesson* seems to follow the Braunschweig picture in aspects of design (and the pitcher), its sudden recession to comparatively distant figures is something new. In 1662 Van Vliet, as noted parenthetically above, and Van Hoogstraten (fig. 97) began to favor deep, one-point recessions. The trend continued in Van Vliet's oeuvre and also that of Coesermans (figs. 183-84) during the next few years. Perhaps Van Vliet also inspired the short-distance construction of Vermeer's perspective scheme (which Wadum has helpfully diagrammed), although he surely could have arrived at it on his own.[74]

The geometry of the Queen's picture and the calculated design of each remotely similar composition by Vermeer suffice to dismiss Kemp's suggestion, following a "reconstruction" by Steadman, that the artist arranged people and props in an actual room and then recorded these *tableaux vivants* (*The Music Lesson* is one of six specified) with a camera obscura.[75] Wheelock gets somewhat closer to the truth when he suggests that "Vermeer used a sharply receding perspective to make the room look larger than it probably was in reality." What room? What reality?[76]

When one compares this small canvas to views of church interiors, such as those Van Vliet painted in 1661 and 1662 (see figs. 169-71), to Vosmaer's curious cityscape of 1663 (fig. 28), and to genre interiors of the 1660s by Van Hoogstraten, Cornelis Bisschop, Ludolf de Jongh, De Man, and Vermeer himself, then it is clear that the artful design of *The Music Lesson* does not relate as closely to actual architectural interiors as it does to current modes of imagining them. As discussed in Chapter Four, this practice had a long history, which included many long and short trends favoring different approaches (for example, here, a deeper recession than any visible in the average house) and various motifs (for example, marble-tiled floors, which were almost as rare in homes as they were in Gothic churches).

In other genre paintings of this general type, a courting couple is placed in the middle ground or background, with a window, terrace, corridor, or simply an expanse of tiled floor keeping the viewer at a distance, like Maes's *Eavesdropper* spying on lovers in another room (fig. 215). Leiden pictures often create a similar impression of peeping into a private room, but without the show of perspective. As Naumann observes, "Van Mieris's *Cloth Shop* of 1660 [fig. 274 here], with its obvious play of foreground and background elements, surely predates Vermeer's *Concert* in Boston (Gardner Museum); the latter's *Music Lesson* in London (Buckingham Palace) and *The Art of Painting* in Vienna (Kunsthistorisches Museum) also make use of the device."[77]

In Van Hoogstraten's *View down a Corridor* of 1662 (fig. 97) and De Witte's domestic interior of about 1665-67 (fig. 284),[78] the prospect of private rooms includes a mirror reflecting the head of a figure for the viewer's benefit.[79] The motif assists our reading of the subject (as in toilet scenes by Ter Borch) and enhances our appreciation of the artist's perspective expertise (compare the mirror in fig. 55). By reflecting a glimpse of the woman's face, Vermeer also heightens our sense of voyeurism. No one discovers the viewer, in contrast to Van Hoogstraten's dog and pop-eyed parrot or the man in De Witte's bed. But then, Vermeer's observer sits behind an easel, in the world of art.[80]

Vermeer's allusiveness allows various readings, or responses, to the circumstances he describes.[81] His omission of obvious symbols and the apparent objectivity with which he describes a scene encourage viewers to interpret it as if it had not been interpreted already. It has been suggested recently that the viol on the floor recalls the metaphor of sympathetic heartstrings (as in Cats's emblem, where an absent lover is specified); that as a mirror reflects light so love responds to love (as in an emblem by Hooft); and that therefore the painting is essentially about "abstract concepts... joy, harmony in love, healing, and solace." In this reading, the *Roman Charity* on the wall is thought to reinforce "the theme of healing and solace" and the pitcher on the table forsakes its earlier rôle in pictures by Vermeer to take on "an almost sacramental character, reminiscent of the ewer and basin found in early Netherlandish scenes of the Annunciation."[82] If so, why not depict a ewer and basin and include a section of *Roman Charity* or another image that could conceivably suggest "healing and solace" instead of erotic captivity?

The artist's patron would have found it hard to stray this far from familiar readings. Again and again, in interpretations borrowed from emblem books, individual paintings are imagined as addressed to a broad audience, rather than to the actual or likely owner of the work. Would Van Ruijven have looked

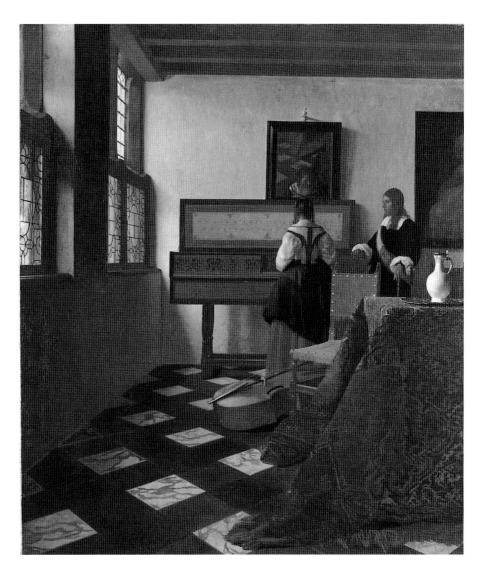

to this picture for information on healing and solace or reminders of the Annunciation, as if the canvas were some kind of self-help brochure? Vermeer's evocative approach assumes privacy.

When *The Music Lesson* is compared with works by contemporary painters (for example, fig. 273), it appears as a finely nuanced treatment of a fashionable theme.[83] It concerns emotions, not circumstances, in contrast to De Witte's "morning-after" or "later-that-day" staging of a similar situation (fig. 284). Once again, there is a woman at a virginal below a mirror, a pitcher on the table, and a man with a sword (which rests with his clothes on the chair in the foreground). The stylish weapon and baldric suggest that Vermeer's man is not a music master.[84]

De Witte's example incidentally bears upon the question of the virginal's height in *The Music Lesson*. Wheelock describes Vermeer's fine-tuned adjustments to the composition and considers it "remarkable that the virginal is so high."[85] Curators in the department of Musical Instruments at the Metropolitan Museum find its position unsurprising.[86] It has also been suggested that the painter might have seen a Ruckers virginal in Huygens's house at The Hague, but two similar Ruckers instruments were owned in the 1660s

283
JOHANNES VERMEER,
The Music Lesson (*A Woman at a Virginal with a Gentleman*), ca. 1662-63.
Oil on canvas,
74 x 64.5 cm.
London, Buckingham Palace, Her Majesty Queen Elizabeth II.
See also plate XXVII.

229

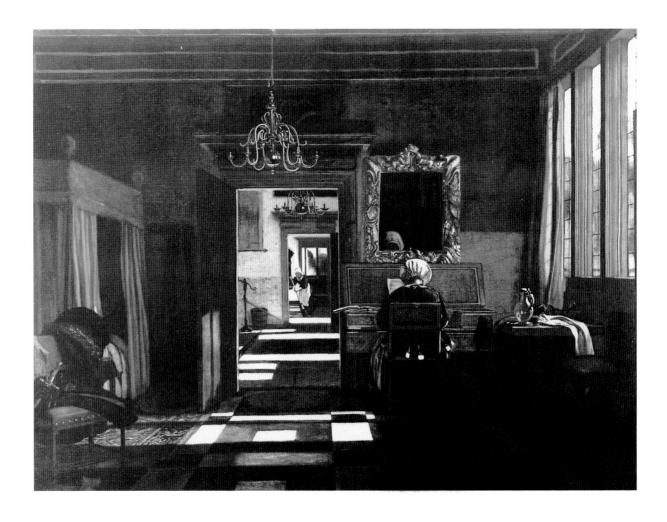

284
EMANUEL DE WITTE,
*Interior with a Woman
Playing a Virginal*,
ca. 1665-67.
Oil on canvas,
77.5 x 104.5 cm.
Rotterdam, Museum
Boijmans Van Beuningen

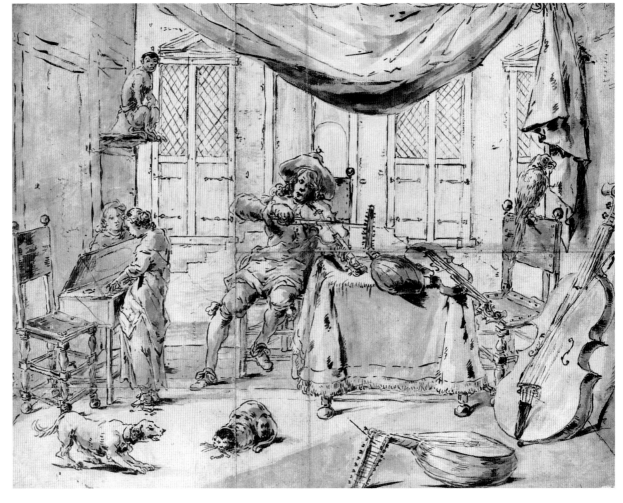

285
LEONAERT BRAMER,
Musicians in an Interior
(recto of *Musicians in a
Loggia*, fig. 22), ca. 1660.
Brush and gray ink, with
gray wash, 37.2 x 46.3 cm
(three pieces of paper
stuck together).
Amsterdam, Rijksprenten-
kabinet, Rijksmuseum

by the Delft organist Dirck Scholl, who lived (like Van Ruijven) on the Oude Delft.[87]

Bramer drew a woman playing a virginal on both the recto and the verso of a sheet in the Rijksprentenkabinet, Amsterdam (figs. 22, 285). In the scene with Italianate architecture the woman is joined by gentlemen playing a lute and viol with the brio of a mariachi band. In the Dutch interior, which resembles the setting of *The Music Lesson* seen from the side, a man stands by the virginal and watches the woman, while a violinist at the table saws away. The lute in the foreground and the foreshortened instruments on the table remind one of the lute and viol in Fabritius's *View in Delft* (pl. III).

It has been proposed that the Amsterdam drawings are designs for a mural in a private house.[88] The inconsistent scale of the figures and furniture and the fact that the drawings were made on a pieced-together sheet of paper support the conclusion that this is preparatory work, which the present writer would date to about 1660, not earlier. The two sides of the sheet appear to offer alternative ideas for a single project and are more interrelated than they first appear: compare the receding walls and chair on the left; the central musician and foreshortened instruments on the table; the woman at a virginal, in each case with a male figure looking on (extreme right on the verso); a musical motif (a lute, or songbooks on a stool) in the right foreground; and a barking dog, dashing hopes of harmony.

A drawing by Bramer in Düsseldorf (fig. 286) of about the same size (and again on a pieced-together support) shows some informally attired figures peeping through the large keyhole of someone's front door. It seems likely that this is Bramer's design for the exterior of a perspective box. Perhaps, then, the Amsterdam drawings are alternative ideas for the inside of a perspective box, rather than for a mural. The arrangement of furniture around the walls (where a chair or viol could be projected on two or three surfaces; compare figs. 54, 55), the foreshortened instruments, the placement of isolated objects on the floor, and the importance of architecture in both designs speak in favor of the hypothesis. A curtain in one drawing and an arcade in the other seem like deliberate complications in the deeper zones of space. A monkey in what might be considered the more successful design smiles at the viewer (or peephole) and refers, *inter alia*, to the notion of "aping," or similitude.

From the parrot's perch in the Dutch interior (fig. 285, right) one would have a view like Vermeer's in *The Music Lesson* but with more distractions in the middle of the room. As in Van Hoogstraten's canvas mural of 1662 (fig. 97), the parrot, cat, and dog add to the music hour's erotic charge.[89] The chained

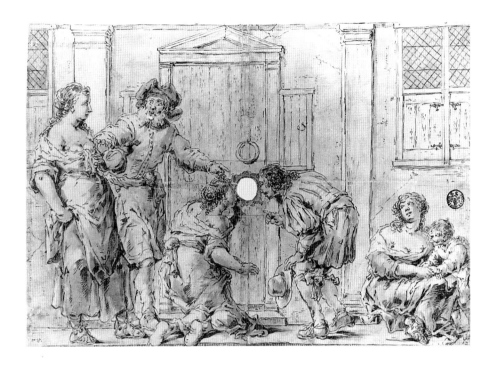

monkey, of course, is also a sign of enslavement to sensual appetites, as in Dirck Hals's *Garden Party* of 1627 (Rijksmuseum, Amsterdam), which likewise features parrots and dogs.[90] As we have seen, Vermeer treats the theme of musical courtship more obliquely by placing a reminder of the imprisoned Cimon next to the enchanted gentleman.

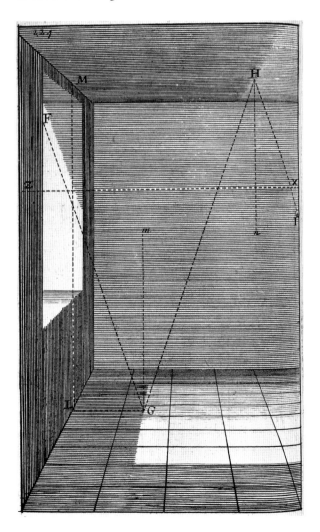

286
Leonaert Bramer,
The Curious Ones,
ca. 1655-60.
Brush and gray ink,
brown and grey washes,
39.1 x 56 cm.
Düsseldorf, Kunstmuseum
Düsseldorf

287
Abraham Bosse,
Manière universelle de M. Desargues pour practicquer la perspective,
Paris, 1647, plate opposite p. 199, indicating the fall of sunlight on a floor and its reflection on a ceiling.
London, The British Library

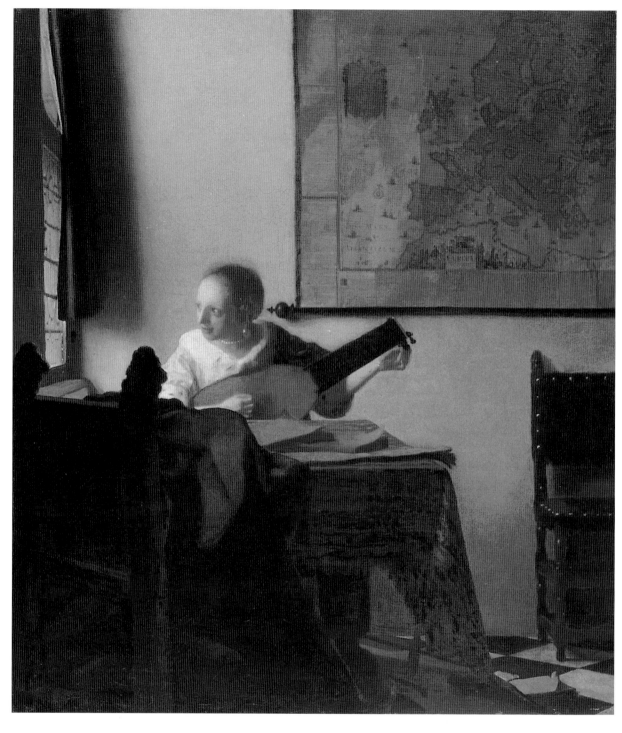

Vermeer's distance from his fellow artists was not the result of intellectual effort but of intuition and involvement, of being intensely absorbed in each aspect of his work. This is also evident in his refinement of painting techniques, as Wheelock has shown in several publications. With regard to *The Music Lesson*, Wheelock places special emphasis upon the artist's various means of describing textures, for example, on the near edge of the table carpet.[91] The tactile quality is another reason for dating the picture to the early 1660s and not to the mid-1660s, when one rarely finds comparable passages. The fall of light and sharp projection of shadows in this canvas are also closely considered by Wheelock in terms of design ("light effects around the virginal are far more

artificially conceived than one would initially suspect").[92] Also calculated, but following different principles, is the gradual lightening of the ceiling beams from left to right (compare De Hooch's ceiling in fig. 242). As mentioned above, this recalls a demonstration in Bosse's treatise (fig. 287), but Vermeer handles the effect as if he discovered it independently.

Woman with a lute

The *Woman with a Lute* in the Metropolitan Museum (fig. 288) is one of the first interiors in which Vermeer employed large areas of shadow and a more generally muted palette than before. The overall impression, with strong contrasts of tone and softened contours,

bears some resemblance to images formed in early cameras.[93] However, similar lighting schemes, with dark forms in the foreground and a curtain shading the corner of the room, occur in the *Woman Holding a Balance* and the *Woman with a Pearl Necklace* (figs. 290-91), and variations of these effects are found in other works of the 1660s by Vermeer. In the same decade a number of Dutch genre painters, such as De Hooch, Metsu, and especially Van Mieris, and of course De Witte in his church interiors, created evocative effects of atmosphere, with broad, blending areas of shadow. Van Mieris is also of interest for Vermeer's use of a very dark background in some pictures, such as the *Girl with a Pearl Earring* (compare the Leiden painter's *Pictura* of 1661 in the J. Paul Getty Museum). Michiel Sweerts has also been mentioned,[94] and is compared with Vermeer below (see figs. 296-97). As with Van Loo and other "sources" discussed in Chapter Five, the similarity reflects a broader development in Dutch and Flemish (and in this case even French) painting than has usually been acknowledged.

A date of about 1662-63 for the *Woman with a Lute* would appear to be supported by comparing its composition with the designs of the *Young Woman with a Water Pitcher* and the two earlier pictures in the Frick Collection (figs. 265, 271). In focusing on the lute player Vermeer placed her head at the intersection of receding orthogonals; the figure's position and even pose seem determined by the table (she completes a triangle) and a reserved area of the wall. The arrangement of the map bar, left arm, and neck of the lute is refined to a degree reminiscent of Saenredam. Dovetailed shapes occur later in Vermeer's oeuvre but are less noticeable. The broader aspects of the picture's design, which may be traced back to works such as Van Steenwyck's *Lute Player* (fig. 289), were discussed in Chapter Four.

The painting's subject also seems somewhat conventional, considering that this is a mature or "early mature" work by Vermeer. (It was not owned by Van Ruijven or Dissius and is traceable only from the nineteenth century.)[95] The woman's eager glance out the window and the viol on the floor tell us that she expects company. The ships at sea on the map (compare fig. 197) could imply long absence, but this is quite uncertain.[96] The large pearl (an attribute of Venus) and the woman's smile suggest thoughts of love.

Woman with a balance

The *Woman Holding a Balance* of about 1663-64 (fig. 290; pl. XXVIII) is a more sophisticated composition. One has the impression that Vermeer combined the strongest aspects of the two interior views in the Metropolitan Museum (figs. 282, 288) and moved beyond their minor shortcomings. Here

and in the *Woman with a Pearl Necklace* (fig. 291), a pregnant expanse of space has been opened in the center of the view. The woman's relation to the mirror and to the light falling from the window is thereby intensified. The emphasis upon shadows, atmosphere, and unoccupied space works in harmony with the resolution of forms in the middle ground. There is no chair in the foreground, no comparable repoussoir. The pair of scales, which coincides closely with the horizontal and vertical center lines of the composition, also seems equidistant from the picture plane and the rear wall.

The naturalistic impression made by the painting is very much enhanced by its light effects. If one covers the right half of the composition there remains one of the most remarkable still lifes of the century, at least with regard to illumination. But the woman's hands and face draw most of our attention. The viewer's concentration is encouraged by a few orthogonals and corresponding colors and by the brilliant light which rather arbitrarily floods over the head, the front of the jacket, the table top and the near side of the skirt. Light falls where it was wanted or needed, as in the much earlier *Last Judgment* on the wall. However, the canvas in the background also illustrates the difference between what paintings usually look like and what we see in Vermeer.

As in the *Young Woman with a Water Pitcher*, the

234

meaning of the *Woman Holding a Balance* is conveyed mainly by one motif and would not have perplexed literate observers of the period. In the opinion of many later viewers the lady is pregnant, but this is doubtful.[97] Costume historians are not surprised by the woman's bulging waistline (also at the back and sides), which is caused mostly by a thick, folded-over skirt. The billowing jacket completes the desired profile. The same specialists, unlike art historians, have surveyed representations of pregnant women by Dutch painters, which are exceedingly rare and bear little resemblance to the lady in Washington.[98]

Like the basin and pitcher in the New York canvas (fig. 282), the object held by the woman in the Washington picture is juxtaposed with a jewelry box. Two strands of pearls (one with ribbons) and one or two gold chains have been pulled from the box. The smaller box on the table held the balance and the weights at the front of the table. The pieces at the corner of the table must be gold coins.[99] In the Dissius sale of 1696 the painting was described as "A young lady weighing gold, in a case by J. vander Meer of Delft, extraordinarily artful and vigorously painted."[100]

The fact that the scales are empty does not speak against the observation that gold is being weighed, but it does shift attention to the scales per se. The woman holds the instrument gingerly, steadies herself against the table, and waits to see if the balance is true. Balance is the theme of the painting – that is, Temperance.

Vermeer had treated the same theme in *The Glass of Wine* and *Young Woman with a Wineglass* (figs. 269, 272). This is noteworthy in part because paintings of figures weighing gold do not always emphasize the idea of moderation. In Willem de Poorter's *Old Woman Weighing Gold* (North Carolina Museum of Art, Raleigh) the pile of precious metal objects indicates avarice, to which the figure's aged face and the crutch on the floor are sufficent responses.[101] In *The Goldweigher* by Cornelis de Man (fig. 176), the woman's pose and the rolled-up bedclothes may suggest the sin of sloth, while the scene as a whole conveys material comfort. Somewhat different lifestyles, and life after death, are brought to mind by the portrait of Prince Maurits and the roundels representing Christ and the Virgin.[102]

In De Hooch's *Woman Weighing Gold* of about 1664-65 (Staatliche Museen Berlin), the interior, with its gilt-leather walls, is even more opulent. There are no jewels, no mirror, no painting on the wall to remind the viewer of the vanity of worldly possessions. In Sutton's opinion, De Hooch "undoubtedly was inspired" by the Washington Vermeer, but Wheelock considers this unlikely, given that De Hooch originally included the figure of a man seated in the chair.[103] The second figure may

have added something to De Hooch's meaning, but probably no more so than the woman in the painting by De Man. De Hooch's interpretation requires nothing other than the impression of luxury and the focus on the scales. A comparable simplicity is already found in the *Girl Weighing Gold* of about 1530-35 attributed to Jan van Hemessen (also in Berlin).[104]

In Vermeer's painting, the *Last Judgment* on the wall amplifies the meaning of the mirror and the scales: worldly things count for nothing in the end, or rather, at the beginning of eternal life. This is a somewhat exceptional case of iconographic elaboration in Vermeer's oeuvre, although it reminds one of the *Roman Charity* in *The Music Lesson*, and perhaps (depending upon the interpretation) *The Finding of Moses* in the *Lady Writing a Letter with Her Maid* (fig. 311).[105] To take it much further – for example, by bringing in Saint Ignatius of Loyola and the artist's "contacts with the Jesuits" – is quite unnecessary, although several scholars have tried.[106]

The usual gambit in their arguments is that all earlier observers have missed one thing: nothing in the scales, something in the womb, something under the table.[107] It might be more instructive to consider what the painting's original owner (almost certainly Van Ruijven) would have noticed immediately. First, the woman with the slightly smiling lips is beautiful, like the girl with the alluring expression in the panel attributed to Van Hemessen and the lady in the Berlin painting by De Hooch (who did not specialize in pretty faces). The patron could not possibly have mistaken the woman's expression for one that is "pensive," to say nothing of interpreting "her act of judgment" as being "as consciously considered as that of the Christ" above her head.[108] On the contrary, she is one of Vermeer's sensuous innocents, like the women in *A Maid Asleep*, *The Milkmaid*, and the *Woman with a Pearl Necklace* (which were evidently owned by Van Ruijven, too). The scales and the *Last Judgment* suggest restraint to the male observer. As in *pronk* still lifes, visual temptation is combined with an appeal to better judgment, to moral sense.

In this reading nothing is swept under the table carpet: a beautiful woman, fashionably dressed, holds a balance, the usual purpose of which was to weigh silver and especially gold.[109] She has gathered before her gold coins, a gold chain, and strings of pearls. The viewer sees the scales differently than she does, with the help of the mirror and the painting on the wall.

Of course, the scales could have been considered, together with the *Last Judgment*, in a more particular way.[110] Just how was a matter of sectarian opinion at the time.[111] In the case of Vermeer (a Catholic) and Van Ruijven (a Remonstrant) there was little cause for controversy. In addition to moderation, the balance, set beside the *Last Judgment*, conveys the

290
JOHANNES VERMEER,
Woman Holding a Balance,
ca. 1663-64.
Oil on canvas,
39.7 x 35.5 cm.
Washington, National
Gallery of Art, Widener
Collection. See also plate
XXVIII.

235

concept of free will. Salvation is not preordained; it is the individual's responsibility.[112] This view would not be inconsistent with the one implied in the other domestic scenes by Vermeer that Van Ruijven appears to have owned. From *A Maid Asleep* onward, thoughts of pleasure and temperance are aroused and left to linger, without tipping the scales either way.[113] The *Woman Holding a Balance* addresses the idea more explicitly, but only by including the religious image in the background. The scene remains as evocative as almost any other in Vermeer's oeuvre, which is a notable achievement in such a potentially didactic work.

The Washington canvas, the similarly composed

Woman with a Pearl Necklace, and the *Woman in Blue Reading a Letter* (figs. 291, 294) are among the finest works of Vermeer's career. As Gowing observes over several pages, the artist frequently recapitulated motifs and compositions, *The Letter Reader* in Dresden being one of his (and Gowing's) favorite sources of inspiration.[114] It is fascinating to consider that the remarkable coherence of Vermeer's oeuvre probably depended not only upon his visual memory but also upon direct access to many of his own, earlier pictures. One may also marvel at the prospect of having several closely related paintings by Vermeer in the same collection, so that his interpretations of themes such as drinking wine,

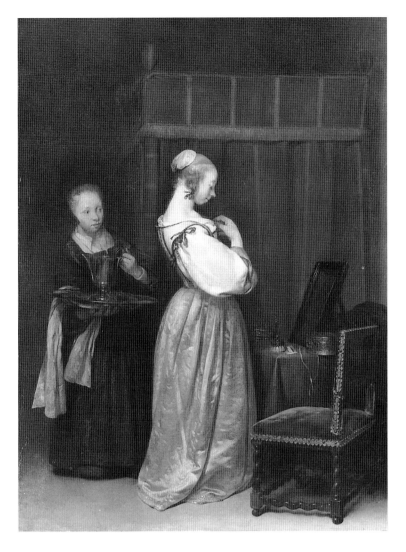

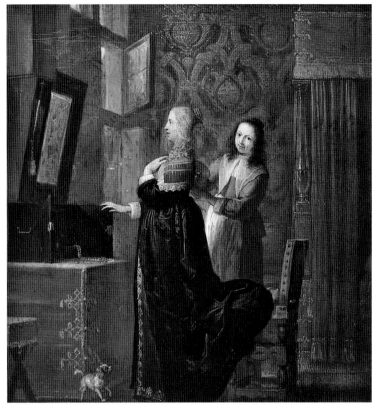

making music, receiving or writing a letter, and so on, could be savored as small ensembles, each image gaining in nuance through proximity to other works. Is it subconscious jealousy that has made the apparent discovery of Vermeer's principal patron disagreeable to one or two critics, or is it still the romantic tenet that genius is seldom appreciated in its own time?

Woman with a pearl necklace

Van Ruijven is thought to have owned the *Woman with a Pearl Necklace* (fig. 291), no. 36 in the Dissius sale ("Een Paleerende dito [Juffrouw] seer fraey van dito").[115] The composition originally included a map on the rear wall and a lute or cittern on the chair in the foreground.[116] These motifs recall the map and viol in the *Woman with a Lute* (fig. 288), while the overall design was once closer to that of the *Woman in Blue Reading a Letter* (fig. 294) as well as the *Woman Holding a Balance* (fig. 290). It is impossible to place these pictures in chronological order, but their close relationships of form and content suggest that they were all painted in the space of two or three years, probably about 1662-64.

According to Wheelock, the woman tying on a pearl necklace "stands transfixed... poised almost as a priest holding the Host during the Eucharist [which] dismisses any possibility that Vermeer conceived this image in a negative light."[117] This would represent quite a departure from the tradition that descends from Bosch to Ter Borch, whose *Toilette* of the early 1650s in New York (fig. 292) is one of the Berlin picture's closest antecedents.[118] For Wheelock, the mirror, a perennial symbol of vanity, also stands for "self-knowledge and truth," while pearls "had numerous metaphorical associations," including "faith, purity, and virginity." But would these chaste notions have been uppermost in a contemporary viewer's mind as he dwelled upon the dreamy-eyed young woman, who wears unpriestly attire, fancy ribbons in her coiffured hair, large pearl earrings, and a pearl necklace?

The subject of a woman absorbed in the pleasant task of self-adornment was well suited to Vermeer's temperament. Like Ter Borch, he was a perceptive invader of privacy, finding in unguarded moments the most appealing aspects of feminine charm. However, the distinctive sensibilities that the two painters brought to bear upon the theme should not obscure its popularity in Dutch, Flemish, French, and English art of the time, nor its similarity to subjects such as Venus at her toilet, Diana bathing,

292
GERARD TER BORCH,
A Young Woman at her Toilette with a Maid,
ca. 1650-51.
Oil on panel,
47.6 x 34.6 cm.
New York, The Metropolitan Museum of Art, Gift of J. Pierpont Morgan, 1917

293
ERASMUS QUELLINUS THE YOUNGER,
A Woman Before a Mirror, with a Maid, ca. 1645.
Oil on panel,
38.5 x 32.5 cm.
Present location unknown (photo: ACL)

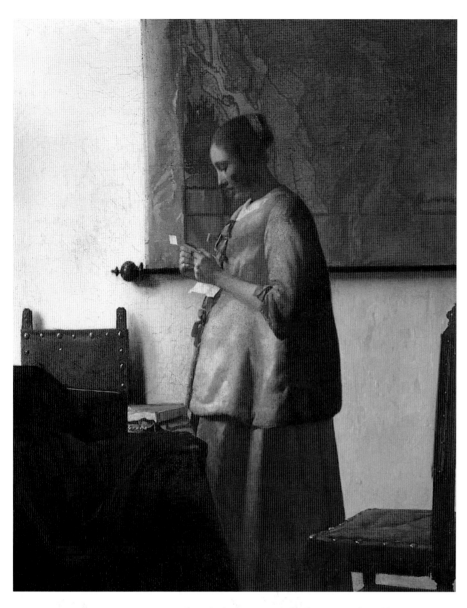

294
<small>JOHANNES VERMEER,</small>
*Woman in Blue Reading a
Letter*, ca. 1663-64.
Oil on canvas,
46.6 x 39.1 cm.
Amsterdam, Rijksmuseum

in Berlin, but a basin, a brush, and on the near corner of the table, a comb. A brush and comb occupy the same position on Ter Borch's table (fig. 292), while a basin and pitcher are held close at hand by the maid. These motifs, together with the focus upon a mirror, stand for purification, the need to curry and cleanse the soul. According to Wheelock, Vermeer flipped the switch from "negative" to "positive" when he eliminated the map and stringed instrument from the composition.[121] Such bipolar iconology is too simplistic for Quellinus, let alone Vermeer. If the latter's use of symbols is less obvious than in other artists' works, it is because of his sympathy for human nature and his practice of subordinating incidentals to the general impression and mood.[122]

Comparisons with such painters as Ter Borch and Quellinus place Vermeer's inventions in a broader stylistic as well as iconographic context. In his orderly designs he followed a Flemish and South Holland tradition, but like De Witte and other artists of the 1650s and 1660s he gave new life to familiar patterns by studying appearances closely. Ter Borch's example must have been helpful to Vermeer in overcoming the more artificial effects of the South Holland style. The prevalence of shadows in Ter Borch makes space less a matter of measure than of ambiance. Vermeer did not simply adopt this approach, which Ter Borch shared with painters in Amsterdam, nor did he follow Ter Borch (to say nothing of Dou and Van Mieris) in describing tactile qualities. Vermeer's mature style was a new synthesis, which reflects his time and place and yet resembles the manner of no other artist.

Woman in blue reading a letter

Ter Borch was Vermeer's most sympathetic source of inspiration in the "pearl pictures," to judge from their spareness and sincerity, their focus on the faces and poses of young women absorbed in personal occupations, and their softening of visual information (which Vermeer, unlike Ter Borch, carries through the main motif). The *Woman in Blue Reading a Letter* (fig. 294) recalls the Dresden *Letter Reader* but also recent works by Ter Borch (for example, *The Letter* in Buckingham Palace and *The Letter Reader* from the Pannwitz Collection),[123] and of course other single-figure compositions painted by Vermeer about 1663-64. In the *Woman in Blue*, forms are defined and tones rendered with remarkable uniformity, although this is exaggerated by some reproductions. Vermeer again plays down recession even in those elements he had employed earlier to opposite effect (for example, the angled chair). There is a sense of moderation, of understatement, even of effortlessness in this exceedingly artful design.[124]

and Bathsheba responding to David's call.[119] For a subject so intimately involving vanity, one finds a remarkable range of interpretations in the seventeenth century. Near to one extreme is the emblem in Cats's *Spiegel* (1632) showing a woman fretfully combing her hair before a mirror, with a *subscriptio* explaining that one must also comb "what is hidden inside" in order to obtain a "pure foundation."[120] For Quellinus in Antwerp, by contrast, the only comment upon the woman trying on jewelry comes, if at all, from the mirror and from the knowing glance of the maid (fig. 293). Vermeer's and Ter Borch's interpretations (figs. 291, 292) fall ambivalently between those of Father Cats and the fashionable Fleming Quellinus, and rather close together, suggesting that Ter Borch's invention might have influenced Vermeer's.

In four paintings of the early to mid-1660s, Vermeer placed a string of pearls on a table next to or spilling out of a jewelry box (figs. 282, 290, 294, 295). In the canvas by Quellinus pearls cascade from an ebony cabinet. Despite the preoccupation with pearls, no jewelry box appears in Vermeer's painting

The theme of love letters was also well suited to the artist's interest in feminine behavior and

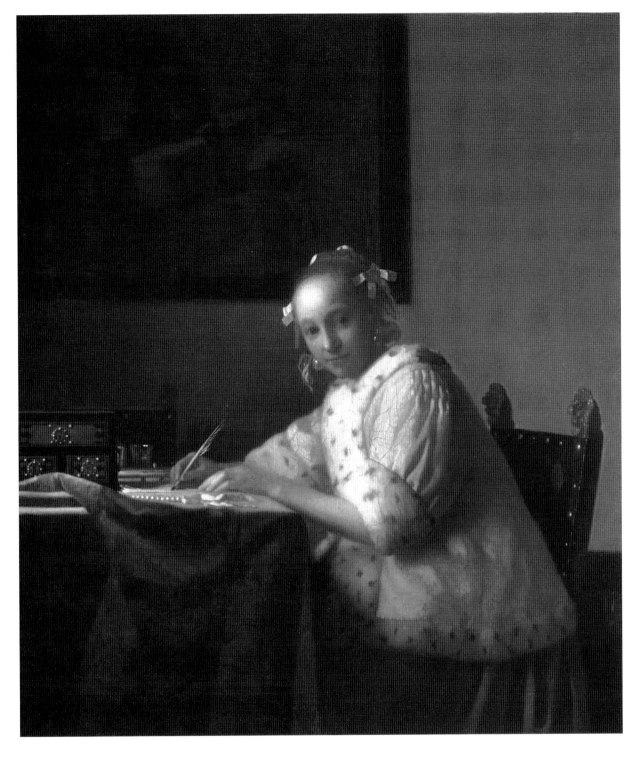

295

JOHANNES VERMEER,
A Lady Writing, ca. 1665.
Oil on canvas,
45 x 39.9 cm.
Washington, National
Gallery of Art, Gift of
Harry Waldron
Havemeyer and Horace
Havemeyer, Jr., in
memory of their father,
Horace Havemeyer. See
also plate XXIX.

emotions.[125] The look of pleasure on the face of the
woman in blue, her tight hold on the sheet of paper,
the roundness of her shoulders, and the bend of her
neck suggest immersion in the missive's message,
more so than in Vermeer's earlier work (fig. 263).
The letter has been said to have come "unexpectedly,"
since the woman "has interrupted her toilet,"
meaning putting on pearls.[126] One might just as well
suppose that the letter, like the pearls, came out of
the box of personal treasures. Either reading is too
literal; the pearls, the map, the parted lips simply hint
that the letter is about love.[127]

Letter writing

There are many signs of empathy in Vermeer's earlier
descriptions of young women. But there seems a finer,
more mature regard for humanity in his paintings of
the mid- to late 1660s. This is found in the women of
the "pearl pictures," including the less lovely, more
intriguing figure in *A Lady Writing* (fig. 295), and in
the surprising appearance of the plain servant in the
Frick *Mistress and Maid* (fig. 296). The same
sentiment seems to have inspired the two *tronies* in
"antique" fashion, the *Girl with a Pearl Earring* and
the Wrightsman *Young Woman* (figs. 301, 302). The
model in the latter, which has been mistaken for a
portrait (while the prettier girl represents an

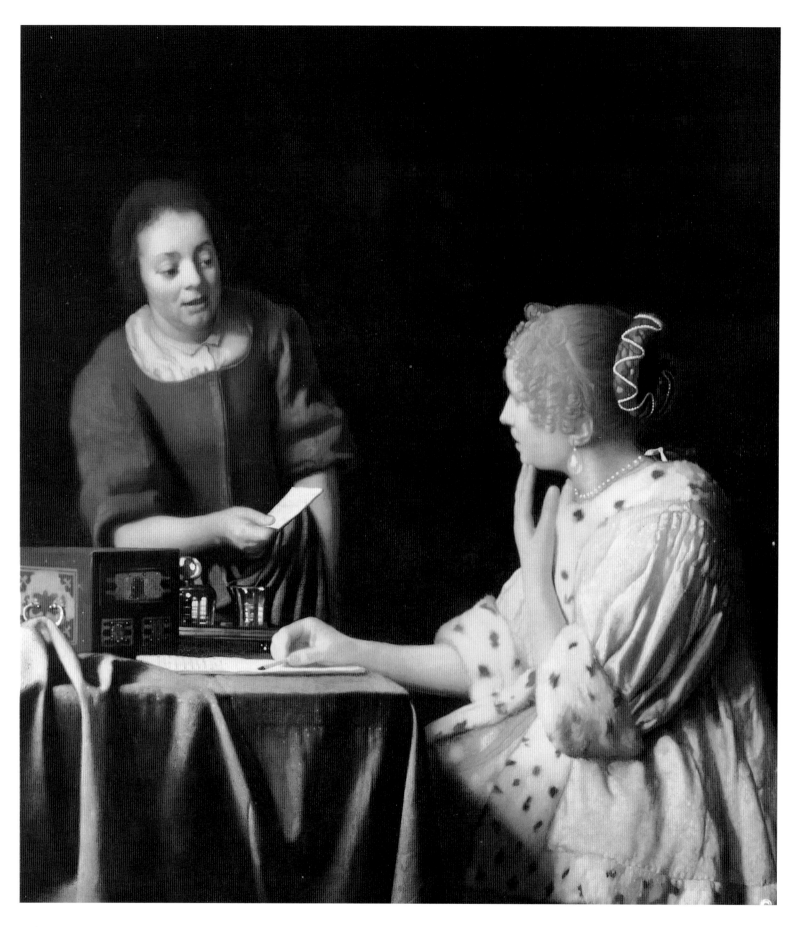

296
JOHANNES VERMEER,
Mistress and Maid,
ca. 1666-67.
Oil on canvas,

90.2 x 78.7 cm.
New York, The Frick
Collection. See also
plate XXXI.

"idealized study"),[128] could be a younger sister of the letter writer in Washington (fig. 295) and has the same engaging sense of character. One wonders whether it was the practice of painting live models or the study of artists who excelled at descriptions of character and expression that encouraged Vermeer, in his early thirties, to explore personas more intimately. In this regard, the *Mistress and Maid* of about 1666-67 (fig. 296) reminds one of paintings by Sweerts (fig. 297), who has also been mentioned in connection with Vermeer's *tronies* of young women.[129] The dark backgrounds that Vermeer unpredictably adopted about 1665-67 and perhaps his broader handling of drapery lend support to the suggestion of Sweerts's (and perhaps Dujardin's) influence. Vermeer does not emulate the intensity that Sweerts, in a few pictures, established between figures.[130] But in the period about 1665-67 and occasionally later he does reveal an interest in individual character and particular types, which were the main concerns of Dutch artists (including Fabritius) when depicting *tronies*. In any case, Gowing's perception of remoteness seems less pertinent to Vermeer's oeuvre from the mid-1660s onward.

A new naturalness may also be discerned in the artist's conception of compositions such as *A Lady Writing* and the *Girl with a Pearl Earring*. The impression of deliberate design – perspective, repoussoirs, counterpoised rectangles, and so on – was gradually diminished in the "pearl pictures" and has largely disappeared in the "letter-writing" paintings in Washington and New York (figs. 295, 296) and in the two *tronies* mentioned above (figs. 301, 302). One sees genius at work in the earlier pictures, whereas in the paintings of about 1663-64 until the end of the decade genius is simply there.

It will not appear paradoxical to sympathetic readers of these pages that Vermeer's development of seemingly less contrived compositions was partly inspired by other artists. Ter Borch remained a touchstone; his *Letter Writer* in the Mauritshuis has been compared with *A Lady Writing* (fig. 295) for its subject but is at least as interesting for its comparatively simple design.[131] Other paintings of the 1650s by Ter Borch feature a woman seated quietly to the side of a table, with light setting her off from a dusky background.[132] The woman does not look out at the viewer in any of these examples, and Vermeer might be expected to have followed suit. Wheelock wonders whether the Washington picture may be a portrait, despite the usual luxuries on the table and the shadowy still life of musical instruments on the wall.[133] But Vermeer never really broke with compositional conventions at any point in his career. Rather, he synthesized borrowed ideas and revised them in accordance with fresh observation. *A Lady Writing* appears to modify Ter Borch's type

of composition by recalling the tradition of scholar portraits, to which Bramer had recently made a small contribution (fig. 298).[134] Vermeer had depicted genre figures looking at the viewer in earlier pictures (figs. 258, 271, 272), and the *tronies* of about the same date as the Washington canvas reveal a closer interest in the convention's psychological effect. Its employment here, with a woman presumably in love (not a man in his office), was a characteristic leap of the imagination for Vermeer.[135] And also, in a sense, for Van Ruijven, the painting's apparent purchaser.[136]

While the general scheme of illumination in *A Lady Writing* may be compared with Ter Borch's and Bramer's (fig. 298), the description of particular light effects is comparable with that found only in other mature works by Vermeer. His virtuosity is demon-

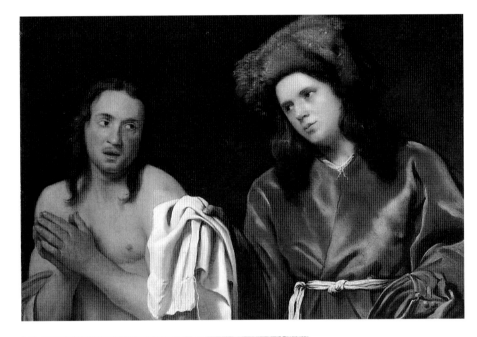

297
MICHIEL SWEERTS,
Clothing the Naked,
ca. 1660-61.
Oil on canvas,
81.9 x 114.3 cm.
New York, The
Metropolitan Museum
of Art, Gift of Mr. and
Mrs. Charles Wrightsman,
1984

298
LEONAERT BRAMER,
*A Man Reading by
Candlelight*, probably
dating from the 1650s.
Black and white chalk
and gray wash on yellow
paper, 19.9 x 16.5 cm.
Düsseldorf, Kunstmuseum

299
C<small>AESAR VAN</small>
E<small>VERDINGEN,</small>
*Trompe-l'oeil with a Bust
of Venus*, 1665.
Oil on canvas,
74 x 60.8 cm.
The Hague, Koninklijk
Kabinet van Schilderijen
"Mauritshuis"

strated mostly within the horizontal zone of the table top, with light reflecting variously from the jewelry box, pearls, inkwell, quill pen, yellow ribbons, and blue cloth. The differences between the jacket's two sleeves, which range in definition from the darts on the near shoulder to the blurred cuff on the right arm, reveal more mastery than a mere decade's preparation could be expected to achieve.[137]

The superb quality of the Washington picture gives some idea of what has been lost in the abraded *Mistress and Maid* (fig. 296).[138] The Frick painting is four times the size (area) of *A Lady Writing* and differs from it in many respects. A figure speaking and a thoughtful response have not been seen since the canvas in Edinburgh (fig. 255), where Martha's entrance from another room remotely anticipates the arrival of the maid.

The expressions and gestures of the mistress and maid bring to mind paintings by Sweerts,[139] while the arrangement of the figures at a table and against a dark background recalls several works by Ter Borch of the 1650s.[140] The composition is structured in Vermeer's usual manner (compare figs. 282, 290, 295, to parts of this design), but the low viewpoint and breadth of description are probably related to the painting's scale. It may have hung higher than smaller works by Vermeer and would have been viewed from a greater distance. Under those conditions the mistress would not seem "disproportionately large."[141] Compared with earlier compositions in which the artist used the relative scale of figures to enhance recession (for example, fig. 265), the occurrence here is hardly noteworthy.

The rendering of the mistress herself somewhat subverts the overall impression of naturalism. Even

allowing for some simplification of form through overcleaning, the head and raised hand are Canova-like. The contrast with the maid's lumpy features and the degree of abstraction evident in the lady's hair (with its calligraphic string of pearls) leave little doubt that the woman's marble-like perfection was an intentional effect. Caesar van Everdingen's *Trompe-l'oeil with a Bust of Venus* (fig. 299), dated 1665, is in some ways a similar synthesis of idealism and illusionism.

The "tronies"

Van Everdingen's canvas could be considered a sophisticated kind of *tronie à la antique*. Vermeer painted at least three pictures that may be so described (figs. 300-302). As Wheelock has observed in connection with the *Girl with a Red Hat*, the artist owned *tronies* by Fabritius, and examples by Vermeer himself were described by contemporaries as in "antique dress" and in "Turkish fashion."[142]

Consideration of the very small panel in Washington within the context of *tronies* by various Dutch painters is essential for an understanding of its subject and style. Blankert rejected the picture; De Vries and Brown have recently questioned it.[143] Even Wheelock, who has defended the painting persuasively on several occasions, draws attention to one or another "major difference" between it and all the other mature works by Vermeer.[144]

As noted above, *tronies* were painted by Dutch artists as studies of character, expression, physiognomy, and figure type, ranging from the girl next door to imaginary foreigners. Some of the most intriguing specimens mix exoticism with naturalism: unfamiliar headgear, silk and fur garments, outsized gold pendants and pearls; Persian soldiers and sultans who speak with a Leiden or Amsterdam accent. "There is, in my Prince's house, a picture of a so-called Turkish potentate, done from the head of some Dutchman;" this is Huygens's well-known description of Lievens's *Oriental* (Gemäldegalerie, Potsdam-Sanssouci), then in Frederick Hendrick's quarters at The Hague.[145] Rembrandt, Lievens, Flinck, Backer, and also artists from Utrecht and other cities (for example, Jan Gerritsz van Bronchorst; fig. 303) painted *tronies* in extraordinary variety. A survey limited to familiar examples would include works ranging in size from several inches (15 or 20 cm) to a few feet high (100 to 150 cm), painterly and meticulously finished studies, works dashed off as decoration and others in which the study of light or the figure's physical and psychological characteristics were given close consideration. One of the few constants in the production of *tronies* is their intangible air of the studio, of being essays meant to be appreciated primarily for their artistry and imagination.

When one sets aside the hermetic view of Vermeer as an artist whose every gesture is rarified ("even *Girl with a Pearl Earring* seems studied and cerebral in comparison"),[146] then the *Girl with a Red Hat* appears unsurprising as a *tronie* from Delft. The choice of support, wood, is only to be expected in a work of this size.[147] The pose and expression, including the parted lips, staring eyes, and seemingly sudden turn of the head in response to the viewer, are conventions found in a number of earlier *tronies*, for instance, Backer's *Boy with a Beret* in Cracow and his *Girl with a Pearl Earring and Gold Chain* in Raleigh.[148]

The presentation of the figure in the Washington picture and in the Wrightsman *Young Woman* (figs. 300, 302) recalls Rembrandt's *Self-Portrait* of 1640 (National Gallery, London) and numerous slightly later paintings, mostly self-portraits in imaginary attire, by Flinck, Bol, and other Rembrandt followers.[149] Most of these pictures show an elbow resting on a horizontal support in the immediate foreground; one hand, also at rest; drapery flowing over the near shoulder in a display of folds, reflections, and fancy material; some kind of loose or high collar (in Flinck's case just below the chin); a large beret tilted at an angle (some with feathers); and in many examples a gold or pearl earring.[150] Of course, Vermeer's optical effects in the *Girl with a Red Hat* and the figure's somewhat androgynous features are exceptional (the latter quality also occurs in Sweerts).[151] The tapestry is slightly surprising, although some kind of drapery covers the entire wall in the background of the *Mistress and Maid* (fig. 296), and the shapes and colors (mostly green and orange) complement those of the figure in a manner typical of Vermeer.

On balance, three small details have disturbed connoisseurs. First, one finial is out of line. It fits in front of the drapery like the dog sits by a rock in *Diana and her Companions* (fig. 253), serving to fill dead space.[152] Second, the sketchy white scarf joins the neck awkwardly, like the white blob in the Wrightsman picture (fig. 301).[153] Finally, the hat itself:[154] in a genre known for fancy hats made from exotic materials, Vermeer's fur or feather beret (his blurred rendering makes the material uncertain) is simply one of the more imaginative models. The hat brings out the lady's lips, and for all we know it existed.[155]

The exceptional aesthetic and technical qualities of Vermeer's simpler *tronies* in The Hague and New York (figs. 301-2) have been discussed at length, especially in the case of the *Girl with a Pearl Earring*.[156] It seems highly probable that both figures were based upon live models and that neither was intended as a portrait. Of the several artists who have been mentioned as having painted similar works earlier (Backer, Ter Brugghen, Van Mieris et al.),

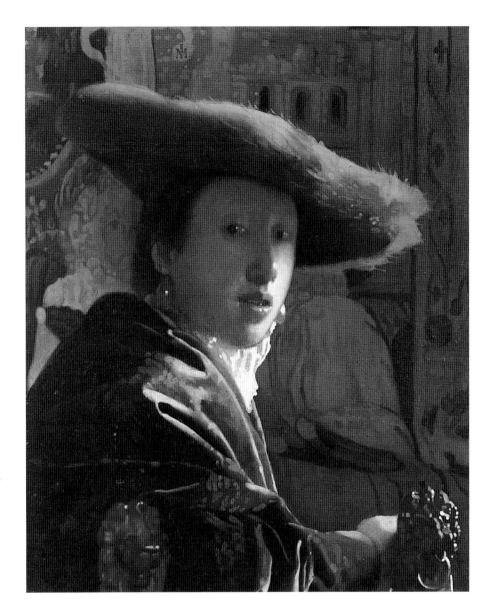

Sweerts is the most interesting, as is evident not so much from the *Boy with a Hat* in Hartford as from less familiar studies of male and female models.[157] In 1656 Sweerts published a series of engravings depicting bust-length figures,[158] a few of which may be said to anticipate Vermeer in their compositions and "antique" costumes (which applies only to the headgear in the Mauritshuis picture).

A date of about 1665-67 seems appropriate for both the Mauritshuis and Wrightsman *tronies*. In 1982 the two works were placed side by side during off-hours of the Mauritshuis exhibition in New York and they appeared more consistent in quality and immediacy than one had imagined. The Mauritshuis picture is more elaborate and beautiful, but the Wrightsman painting is equally impressive in its naturalism and character. To employ terms like "timelessness" and "classicism" with regard to either painting is misleading, in my view; at best, these are subjective tributes that no contemporary of the artist would consider germane.[159] Indeed, when one compares *tronies* of young women by other Dutch painters, such as Backer, Flinck, and Van Bronchorst

300
JOHANNES VERMEER,
Girl with a Red Hat,
ca. 1665.
Oil on panel, 22.8 x 18 cm.
Washington, National
Gallery of Art, Andrew
W. Mellon Collection. See
also plate xxx.

243

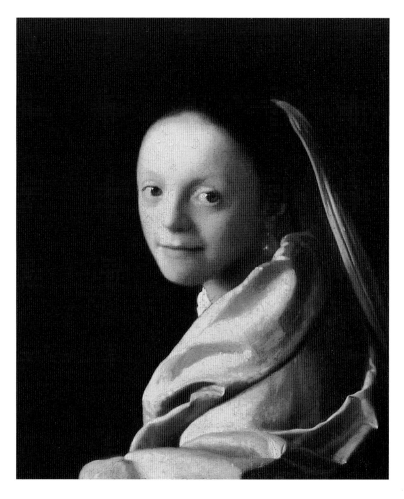

(fig. 303),[160] it appears that Vermeer emulated their spontaneity – turned heads, parted lips, strong light, and so on – in his own way. Thoughts of the classical tradition are of course conveyed by Van Bronchorst's cameo-like arrangement of a young Dutch woman with off-the-shoulder drapery and a fillet-like ribbon in her hair. But Vermeer's *tronies* are so intensified by direct observation that even his undatable poses and props contribute to the sense of a studio session. His "timelessness" is almost the opposite, a moment of visual experience one cannot forget.

Nothing like this impression could be captured in a Daguerrotype, let alone a camera obscura. The expressions, poses, light effects, and spaces in Vermeer's *tronies* are contrived to appear immediate.[161]

These pictures are very much studies of character, expression, and physical qualities. With regard to the latter, Vermeer's concentration upon passages of drapery in his paintings of bust-length figures has been somewhat neglected, or misinterpreted solely as experiments with light. The changing colors and fugitive effects of light and shadow on the surfaces of fine fabrics such as satin, silk, and velvet were considered by artists of the time as among the most difficult tests of ability.[162] Female figures by Ter Borch and the Leiden painters come foremost to mind, but superb passages of silk, fur, and other materials had been a feature of *tronies* for decades (the costume of

Rembrandt's *Noble Slav* being one of the earlier examples of overt display).[163] Vermeer went to considerable lengths in the same vein. In the *Girl with a Pearl Earring*, for example, the blue material was painted with ultramarine mixed with yellow ochre, an organic red, and lead white, while finely ground yellow ochre was mixed with lead white and ultramarine to render the folds and highlights of the yellow jacket.[164] The challenge of depicting various materials might answer a question posed by Brown[165] – why the "exotic costume" in the *Girl with a Red Hat*? – and might also explain why the artist treated the entire background as a tapestry. The wool material mostly absorbs rather than reflects light and thus serves as an effective foil to the unusual ensemble of fabrics, flesh, hair, wood, and pearls in the foreground.

If the description of fine fabrics was a principal concern in Vermeer's *tronies*, then this might be of interest for the disputed *Girl with a Flute* in Washington.[166] Wheelock suggests that the work was left unfinished by Vermeer and was possibly damaged even before it was modified not long after the artist's death. Later abrasions complicate the most cautious analyses, to say nothing of offhand opinions.[167] Some of the obvious weaknesses are not the original painter's: the flute, the finger on top of it, the thumb of the other hand. The white blouse, the shoulders, the left cuff, and other costume details

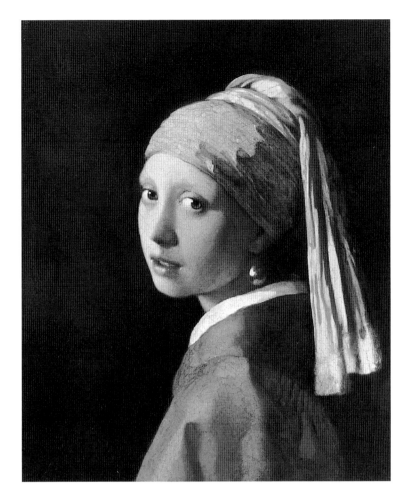

were altered at an early date.[168] All of the flesh parts may be described as unfinished, retouched, or damaged. (Vermeer usually employed glazes at a late stage to modulate flesh tones.) In contrast to the face and forearm, the blue satin jacket, the fur trim, and the hat (which is covered in an imported fabric, probably silk) appear to have been nearly finished when the artist stopped working on the picture.

The expression of the face, in its present state, seems a weaker version of the one in the *Girl with a Red Hat*, and it bears a passing resemblance to the expression in the *Girl with a Pearl Earring*. For some scholars this may suggest adaptation by another artist, but the various expressions, like the passages of draperies, types of headdress, tapestry backgrounds, and so on in Vermeer's *tronies* might also be considered to be closely related ideas within a narrow part of the painter's oeuvre. In any case, doubters of the *Girl with a Flute* or the *Girl with a Red Hat* have generally failed to follow one of the basic principles of connoisseurship, which is to explain the strongest aspects of the work.

The arts of music and painting

The concert
The Concert (fig. 304) probably dates from about 1666-67.[169] This canvas and *The Music Lesson* (fig. 283)

are nearly identical in size and are somewhat similar in composition and subject. Both images suggest moderation, the Gardner painting perhaps more unequivocally than the earlier picture, where a sense of amorous tension is established by various understated means.

Wheelock has observed in some perceptive pages that the viewer's remoteness from the figures in *The Concert* works differently than the safe distance assumed in *The Music Lesson*.[170] Here one has the feeling almost of intruding or of halting in a doorway, not wanting to disturb the company. The perspective construction is less impetuous; the effect of staring is diminished by shifting the center of focus away from the figures and increasing the distance measurement. The stark pattern of floor tiles allows one to locate the vanishing point at the eye-level of the harpsichord player and coincident with the area of bare wall behind her, above the cittern on the table. The viewer is drawn in a blocked direction, that is, urged to remain on this side of the shadowy table and viola da gamba. The silhouetting of these large objects in the foreground, with Vermeer's usual contrast of dark forms against light and (to the left, where the songbooks catch the light) of illuminated motifs against an area of shadow, contributes greatly to the illusion of space.[171]

A male viewer might imagine himself as the lutenist, flanked by the exquisite young woman in

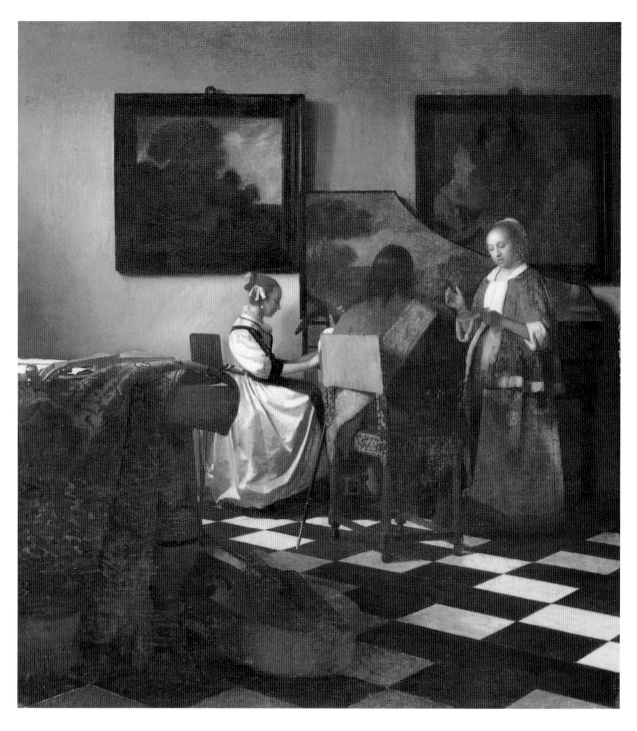

yellow (compare *The Letter Reader*, fig. 263) and by the singer keeping time with her right hand. As Wheelock concludes, the gesture should probably be "understood as a statement of temperance, or a life of moderation," especially given the juxtaposition with Baburen's *Procuress* and the comparison of rugged and idyllic landscapes.[172] The Arcadian scene on the harpsichord provides inspiration for tranquil music and wandering thoughts, while the canvases on the wall serve as rough reminders of the real world outside. Light falls softly from the upper panes of windows offstage to the left; closed shutters cast a shadow and contribute to the sense of privacy. For a few moments this isolated world will remain nearly perfect, harmonious and beautiful.

The Concert and *The Music Lesson* (fig. 283) were probably not intended as pendants, which they could have become even if painted a few years apart.[173] However, each picture is self-sufficient in design and subject, and in technique the works differ considerably. Vermeer downplays textures in *The Concert*, which by contrast were emphasized in the table carpet and other passages of *The Music Lesson*. In the Gardner painting the subtle use of glazes, which have been partly lost through abrasion (especially in the standing woman's attire), contributes to the fine transitions of light and tone. But the overall technique is "less varied and complex than in earlier works," and for the first time Vermeer employs the economic manner of describing drapery ("sharp and crisp") that is characteristic of his later works.[174]

At the same time, *The Concert* could be said to revive a tendency in Vermeer's pictures of about 1660-62, namely, the taste for pattern, perspective, and the counterpoise of rectilinear elements. The furniture and even the figures defer to a system of horizontal and vertical divisions, which is played against the diagonally receding elements. One order speaks for surface, the other depth, and, as usual in Vermeer, each refers respectfully to the other. The man's broad baldric and the curving edge of the harpsichord lid likewise lift and fall in counterpoise, as if extending the movements of the singer's hand.

The Art of Painting and the camera obscura

The Art of Painting (fig. 305; pl. xxxii) has been dated plausibly to about 1666-67 but could date from as late as 1668 or 1669, when *The Astronomer* and *The Geographer* were painted.[175]

Wheelock interprets the allegory in the traditional manner – the Painter, unlike Vermeer, should depict historical subjects and cerebral ideas[176] – and in the course of describing the picture's execution revisits the question of the camera obscura. He detects an apparent change of focus as the viewer turns from a close inspection of the forms in the foreground to the area of the model and the crisp surface of the map. The deeper, sharper zone of space is described as the picture's "depth of field [which] is not evident in normal vision."[177] Analogous effects of focus and illumination occur in Delft architectural paintings and in some still lifes and landscapes (by Kalf, Pynacker et al.), although the sharper forms are usually found in the foreground. The more distant "depth of field" in *The Art of Painting* recalls that seen in *A View of Delft*.

The recession from table to figure to wall in the Vienna canvas might be compared with the composition of *The Lacemaker* (fig. 312) in that blurred objects in the foreground, cascades of cloth and thread, are likewise contrasted with the more sharply defined forms in deeper space. Here, too, Wheelock concludes that the artist employed a camera obscura.[178] The hypothesis is plausible but tends to restrict one's appreciation of the complex creative process that is so distinctive of Vermeer.

The Art of Painting is large, the Louvre picture very small (which Wheelock also associates with the camera obscura); the area of focus is comparatively near to the viewer in one image (around the lace-maker's stand) and quite far in the other. Achieving satisfactory focus at any distance was considered an innovation in the camera obscura's design during the 1680s,[179] but in Vermeer's oeuvre we find a range of focus comparable to that of a zoom lens. Furthermore, it does not appear that all forms in an area of weak focus are blurred (note the corner of the table in *The Art of Painting*) or that all forms in an

area of sharp focus are precisely described. Nor is it clear that any kind of camera is required to observe differences in focus within a particular view, since they are obvious to anyone who experiments with eye glasses, magnifying glasses, or telescopes. Nowhere in Vermeer's work is there consistent (as opposed to cumulative or circumstantial) evidence for his use of the camera obscura or any other optical device, and for good reason: he employed observed effects of light, color, focus, and so on selectively, "enhancing them," as Kemp concludes, "in such a way as to transform them into significant stylistic features in his highly individualistic art."[180]

This assessment restores a sense of balance to discussions of Vermeer and optical devices. The artist was absorbed by the study of light under both normal and peculiar conditions, but he described its behavior willfully in pursuit of his particular artistic goals. For example, his juxtaposition of blurred and sharp passages serves to enhance the impression of receding space, just as more conventional repoussoirs (defined by shape, shadow, or color) suggest a shift in depth. Differences in focus are also used to draw attention to important motifs. In addition, curious effects of light tend to imply keen observation, whether they are faithful to appearances or not. A more commonplace example than Vermeer's lion-head finials and sparkling bread would be a window reflected in a *roemer* painted by a still-life specialist. The motif seems to record actual conditions in the studio but may just as well have been borrowed from another artist's work.

Much of what Wheelock says on the subject of Vermeer and the camera obscura is consistent with these remarks. But he also concludes that "Vermeer would have used the camera obscura as a tool to help him visualize the scene and guide him in conceiving it."[181] This comment on imagination, conception, and composition seems considerably to overstate the usefulness of the optical device and is ill-suited to an artist with such a sophisticated command of current stylistic conventions and such a clear view of his own ideals.

A similar impression is made by Wheelock's reference in the subsequent sentences to Van Hoogstraten on the subject of the camera obscura. Vermeer's contemporary is said to have praised the image formed in a camera obscura as a "truly natural painting,"[182] but what he actually wrote is that "the sight of these reflections in the darkness can be very illuminating to the young painter's vision," for example, by revealing "the overall aspect which a truly natural painting should have."[183] Van Hoogstraten thus recommends the camera obscura as offering a quick course in *houding* for apprentices.[184] Surely the Dordrecht artist, had he known Vermeer, would have recognized in him not a student but a

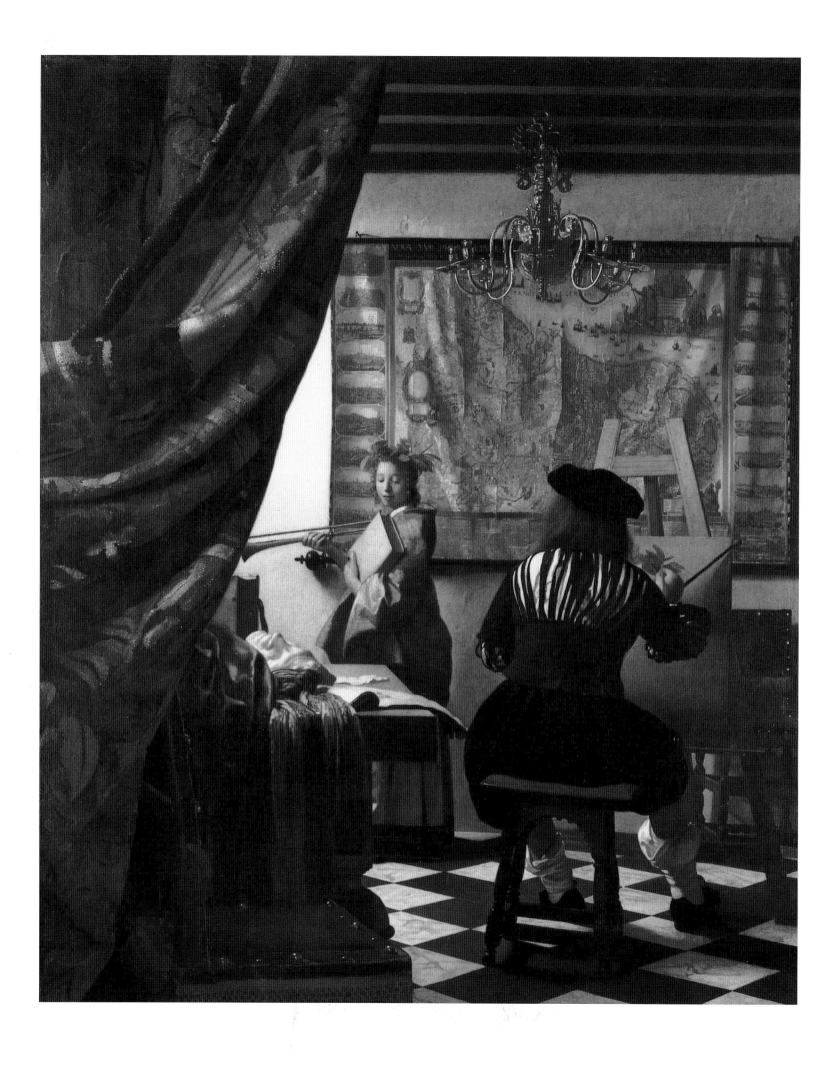

master of illusions, including the illusion that he had rendered scenes and optical incidents exactly as he had perceived them.[185]

The Art of Painting and the art of painting

The last point is especially relevant to the Vienna picture, which may be described as both an allegory and a demonstration of Vermeer's own art of painting (as well as a represention of Painting as a liberal art). It matters enormously, in my view, that Vermeer kept *The Art of Painting* in his own house, where he was more likely to be visited by connoisseurs and customers than by delegations supporting Painting not Sculpture, Dutch art not Italian, or classical rhetoric.[186] The picture was not painted for Huygens, Van Ruijven, a university, the town hall or the headquarters of the painters' guild, but for Vermeer himself, "in order to have an outstanding specimen of his art in his studio."[187] Thus the identification of the painter in the picture with Vermeer himself was meant to be self-evident, and the young woman's pose and expression make it plain that, like any model, she is acting a part (imagine this relaxed, coy creature an an illustration in Ripa, or as the figure of Fame on William the Silent's tomb; fig. 160).

The real presence of the artist is in the paint layer. There is an extraordinary array of materials – fabrics, paper, plaster, etc. – differently described, despite the painter's optical rather than tactile approach in works of this period. The heavy weave of the warmly colored tapestry is seen from both the front and the back; in the upper left corner, above the stippled sunlight on the hanging's black border, the vague pattern of the verso is enlivened by loose threads, reminding one of those soon to appear in *The Lacemaker*. Two unalike silky fabrics spill over the edge of the table top toward the worn seat of the chair, with its dazzling studs and tacks. In the background, the faceted folds of the woman's gown and undulations in the crinkled map (two nails and former folds raise its surface in relief) are revealed by raking sunlight, which at the same time reduces the model's features and her leather volume to elemental shapes (the book recalls the brightly lit chair backs in earlier works).

The coherence of Vermeer's vision is such that it requires close inspection fully to appreciate the diversity of his effects. Throughout the composition, visual analogies and fine distinctions are subtly – almost slyly – drawn. Leaves branch out from the lady's hair, the painter's brush, and the folds of the tapestry. The tones of the map intensify those of the stained plaster wall. The model's face may be compared with the mask on the table, paper with leather, silk with wool. Gray shadows ripple through the artist's white shirt and leggings, articulating folds while picking up the pattern of the veined white

marble underfoot. The two bold confrontations of black and white, in the floor and in the artist's doublet, contribute to a continuous contest of order and accident, geometry and fluid forms. The rectilinear structure of the entire design is similarly subverted by gathered and falling drapery and by the jaunty contrapposto of the protagonists. Everything is carefully crafted to look perfectly natural, as if the studied ease of the courtier (as described by Castiglione) had been transformed into a manner of making art. The approach was not unique to Vermeer, but few painters approached him in being so artful and so natural at the same time.

But how natural are the circumstances described here by the artist as similar to his own? One might compare an audience chamber where a prince expects a peer, or a painter's studio when he receives a prince (as does Velázquez in *Las Meninas*). Or rather, images of those interiors. Like Flemish pictures of collector's cabinets and most seventeenth-century views of artists' studios,[188] this idea of Vermeer's immediate environment derives less from reality than from pictorial precedents. The fact that this painting of the artist's studio was seen by contemporary viewers in the artist's studio must have compounded their appreciation of what he had done.

In Joos van Craesbeeck's picture of a painter's studio (fig. 306), an artist with a feathered beret faces away from the viewer and begins work on a typical Craesbeeck, "The Five Senses" set in a tavern. The models look like neighbors who have agreed to hold appropriate poses for an hour or so. Of course, the figure of the painter contributes to the representation of Sight, turning the genre-like allegory of the Senses into a picture of "The Art of Painting." An artistic still life (including a palette), the impressive description of light, the treatment of surfaces like

306
JOOS VAN CRAESBEECK,
The Five Senses, ca. 1655.
Oil on panel 48.5 x 66 cm.
Paris, Collection Frits
Lugt, Fondation Custodia,
Institut Néerlandais

305
JOHANNES VERMEER,
The Art of Painting,
ca. 1666-68 cm.
Oil on canvas,
120 x 100 cm.
Vienna, Kunsthistorisches
Museum. See also plate
XXXII.

249

those of the pewter tankard and the wooden stool, and the illusionistic repoussoir to the left testify to the painter's abilities, just as the conception of the whole reveals his inventiveness.

It could be said that Vermeer surveys similar territory from a higher point of view. His artist paints a variation on a theme by Vermeer, a beautiful young woman demurely posing in sunlight. The mask may, as Sluijter suggests, contribute to a *paragone* of the arts,[189] but perhaps also to a comparison between the senses of touch and sight (like the bust in Rembrandt's *Aristotle*). The mask may also be counted among the studio props, which, broadly speaking, include the painter's beret and eccentric clothing.[190]

These points add support to Sluijter's closely argued thesis that *The Art of Painting* represents an artist inspired by the prospect of honor and fame, not by the contemplation of history. Vermeer earns his own laurel wreath through invention and execution, which in his artistic milieu were valued largely in terms of illusionism. This is clearly what Teding van Berckhout meant when he described his visit to Vermeer's studio in 1669, observing that the aspect of the artist's work which was "la plus extraordinayre et la plus curieuse consiste dans la perspective."[191] The connoisseur refers to the illusion of three-dimensional space, not to the network of receding lines.

Sluijter's study alters or resolves the interpretation of several motifs. Clio's laurel crown and trumpet refer to honor and fame (*Eere-Roem*, as the Dutch translator of Ripa, Dirck Pietersz Pers, rendered her name); the large book indicates that fame will be recorded for posterity (Clio, in this context, is the muse of future history). Thus art conquers mortality, as claimed by critics such as Philips Angel and by contemporary painters such as Dou.[192]

The map in the Vienna picture appears to suggest that the art of painting has brought glory to the Netherlands, as writers such as Huygens and De Bie maintained.[193] This is not quite the same as saying that Vermeer celebrates "the art of Netherlandish painting,"[194] and it departs entirely from the notion that the artist refers to national history.[195] Earlier suggestions that the chandelier features the Habsburg eagle (which one scholar considers a phoenix, inspired by the poem in Van Bleyswijck by Arnold Bon) can be discounted along with political interpretations of the map.[196]

The main point to make about the map and the chandelier is that they represent the art of painting's extraordinary capacity to describe appearances, including the most intangible qualities and fleeting effects. The complicated masterpiece of metalwork, with its molten reflections and elusive detail (such as the standing figures), is a tour de force with which few motifs in contemporary still-life painting can be compared.[197] The object hangs above the painter like one of the baskets suspended from the rafters in households by Jan Steen,[198] but instead of attributes forecasting future ruin the chandelier offers evidence of astonishing talent and supports the picture's promise of lasting fame.

The tapestry, while reminiscent of Parrhasios's illusionistic veil and feigned curtains hanging in the foregrounds of other Delft pictures (see figs. 149, 162), would have created a more particular illusion for contemporary viewers, that of standing before the threshold of a room. One finds a similar arrangement (if not the same effect) in other Dutch views of interiors: Thomas de Keyser's *Portrait of Constantijn Huygens and His (?) Clerk* (National Gallery, London), where a tapestry is pulled aside to reveal the entrance to the courtier's inner sanctum; Vermeer's

own canvas, *The Love Letter*, in Amsterdam (fig. 308); and De Hooch's family portrait in Cleveland (fig. 251), where the doorway through which we see the maid minding children would usually be covered by the tapestry. In each case, the tapestry limits access to a finely appointed room in which the master or mistress of the house might receive distinguished visitors (and, briefly, servants, children, and dogs).

In *The Art of Painting*, the front of the tapestry faces into the room, one wall of which is approximately at the picture plane. We stand just outside the space of the studio, still unseen by the artist. The situation is comparable to that found in a much earlier Flemish picture attributed to Hendrick van Steenwyck the Elder, *Art Lovers Welcomed by Fame* (fig. 307), where a winged and trumpet-toting Fame conducts the contingent of connoisseurs in the doorway toward the easel of a distinguished painter.[199] The sculptor unexpectedly working right beside him is clearly the painter's social and artistic inferior. To the right, a lute and sculptural fragments, standard studio props, are piled at the feet of a Herculean figure which, whatever its intended meaning, supports the notions of victory and lasting fame.

Above all, this very small image on copper, which the painter might have kept in his studio, celebrates the fact that discriminating gentlemen of the very highest and next highest ranks – Alexander the Great, Charles V, and, in Vermeer's century, Philip IV, Charles I, Cosimo III, Huygens, De Monconys, and Teding van Berckhout – paid homage to great artists by seeking them out in their studios. In this way, the contemporary viewer completed *The Art of Painting*, by being cast in the rôle of a visiting connoisseur.[200]

The later works

Had Vermeer died shortly after painting the Vienna picture, at the age of thirty-five, his fame and our view of his oeuvre would not be very different than they are now. The studio scene summarizes much of what the artist achieved between *The Letter Reader* in Dresden and *The Concert* in Boston; the latter work and the *Woman in Blue Reading a Letter* (fig. 294) are among the earlier pictures that make for illuminating comparisons with *The Art of Painting*. Gowing, in one of his curt accounts of Vermeer's professionalism, observes that "the general pictorial arrangement that Vermeer adopted here, and retained as the staple composition of later works, was a familiar one. Consideration of his immediate sources demonstrates again how little part invention ever played in the development of his style."[201]

More recent writers, by contrast, have offered exacting descriptions of Vermeer's composition, for example, by noting where Clio is located with respect to the map and the vanishing point; how the painter is slightly overscaled to enhance recession; and how the stool is situated in relation to the pattern of floor tiles.[202] Neither the concise nor the precise appreciations of the artist's skillful design are far off the mark; he adopted, distilled, and wonderfully refined current artistic ideas. Gowing refers to "Dou and his followers" and illustrates *The Painter's Studio* of 1659 (now assigned convincingly to Brekelenkam) in the Hermitage, St. Petersburg, to show how Vermeer shared compositional conventions with Leiden and supposedly Haarlem painters (for example, "the elaborate studio scenes which Frans van Mieris devised under the influence of Ter Borch").[203] The comparison also reveals how little the Vienna painting resembles the others, and how extraordinary are Vermeer's particular kind of illusionism and his approach to describing visual experience.

As noted often in the chapters above, both convention and invention enabled Delft painters to create illusions of reality. The rôle of "direct observation" in Vermeer has been celebrated by critics ranging from Thoré-Bürger to the most ardent proponents of the camera obscura (Fink and Schwarz) at some expense to the innocent reader's understanding of how perception is transformed into art. Whether sketching the most general plan of a composition or pulling a thin glaze over the image of a pearl or an eyelid, the painter depended upon schemes and techniques he had for the most part learned from other artists. Of course, Dutch painters as varied as Van Goyen, Hals, Rembrandt, Fabritius, and Vermeer introduced technical and stylistic innovations, which, when successful, immediately became conventions through repetition and borrowing. This was understood, if little verbalized, by artists and critics of the period. For them, realism itself was a style, an aesthetic option, not some sort of resistance movement against style, academic training, or artistic sophistication in general.[204]

The naturalistic manner, when practiced on a level like that of Dou, Van Mieris, or Vermeer, required exceptional amounts of time and concentration, and the promise of (or independence from) patronage. Any relaxation of the standard set in, for instance, *The Art of Painting*, encouraged standardization, the repetition or simplification of schemes employed before, shorthand techniques, commonplace pictorial strategies. There are numerous examples of this tendency in Vermeer's work from the late 1660s onward. Wheelock describes the abbreviations of technique, the more extensive use of opaque paints rather than glazes, a more economical method of rendering drapery, and so on.[205] Distinctive devices such as the pointillé technique of suggesting

308
JOHANNES VERMEER,
The Love Letter,
ca. 1669-70.
Oil on canvas, 44 x 38 cm.
Amsterdam, Rijksmuseum

highlights become abstracted to the extent that they seem more decorative than descriptive (for example, on the tapestry in the *Allegory of the Faith*; fig. 315). The reduction of form found in a face such as the more idealized one in the *Mistress and Maid* (fig. 296) reaches an extreme in Vermeer's oeuvre with the figure in *The Guitar Player* (Kenwood, the Iveagh Bequest).[206] That picture is perhaps the best example of the artist's great distance, in his later work, from paintings made only thirteen or fifteen years earlier, such as *The Letter Reader* in Dresden or even paintings dating from the mid-1660s.

An artist's approach might have been modified for the most practical reasons – less time, less money per picture – as Van Vliet's late manner evidently was. But one must allow that even Vermeer's style was strongly influenced by contemporary taste, not only by his personal interests and circumstances. What would De Lairesse say of the modern judgment that Vermeer's work in the early 1670s represents a falling off? This view fails to account for the contemporary shift in the same direction – away from illusionism and toward abstraction, decoration, or stylization – in the oeuvres of such artists as Van Hoogstraten, Van Mieris, Netscher, Bisschop, and Eglon van der Neer, and De Man and Verkolje in Delft.

Vermeer's "tendency toward abstraction" is discussed by Wheelock in positive terms but is considered some kind of brilliant in-breeding, as if the product were tulips not pictures. "The shift in Vermeer's pictorial emphasis [as seen in *The Guitar Player*] is in many ways a natural outgrowth of his own stylistic evolution." We are cautioned that "Vermeer's own artistic inclinations, and not the demands of a patron, seem to have led him in this stylistic direction, given the fact that this work remained in his possession until his death" (in other words, in his own *salon des refusés*). If there was any external force that influenced the artist, for example, in the Beit picture (fig. 311), then it was the current intellectual climate, which encouraged "a different concept of classicism than that which had guided his previous work, one tinged with the ideas of Neoplatonism." In Vermeer's later works "he began to suppress the incidentals of nature and presented instead a purified vision of the world as he saw and understood it."[207] But if so, then one must admit Van Hoogstraten, De Man, and other Dutch painters of the 1670s into the same philosophy class, since they, too, started suppressing the incidentals of nature in favor of a more idealized and decorative approach.

The Love Letter
A good example of this stylistic tendency is *The Love Letter* of about 1669-70 (fig. 308), which one hesitates to regard as a triumph of the *Poussinistes* over the *fijnschilders*. The illusionistic treatment of

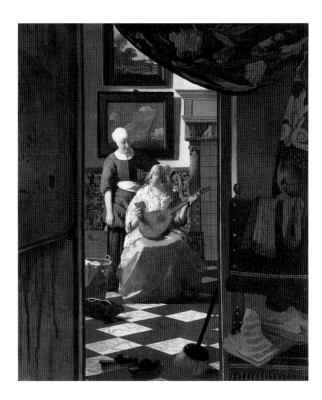

the tapestry and other passages in *The Art of Painting* is not repeated here, where the hanging has become a stylized framing device and a prop for the narrative. Now the tapestry faces the viewer and has been shoved aside in order to pull the normally covered door forward (on the left, with a map). The servant slipped off her shoes and set down the broom only after entering the elegant sitting room, rather than leaving them outside as she might have done in less haste.[208]

The mistress with the familiar ermine-trimmed jacket was evidently distracted even before the maid came in. She holds a cittern – its shape seems suggestive – and has set down her mending chores. It appears, as Franits proposes, that the lady daydreams of love.[209] The rumpled songbook on the chair in the foreground is probably an indication that amorous longings have been suffered before. The landscape with a wandering male figure, the seascape, and perhaps the map which mostly shows ships on the Zuider Zee may suggest the regretted absence of a man.[210]

As he had earlier, Vermeer gives a new twist to an old story, but *The Love Letter* is surprisingly straightforward compared with his other works involving amorous missives. The picture listed in the Dissius sale as "Een Juffrouw die door een Meyd een brief gebragt word" is usually considered to be the Frick canvas (fig. 296), not this one.[211] Ownership of the *Mistress and Maid* would be more consistent with our tentative impression of Van Ruijven's taste, who appears to have preferred evocative understatement to the more prosaic approach found here and in works by the many other painters of modern manners he might have favored.

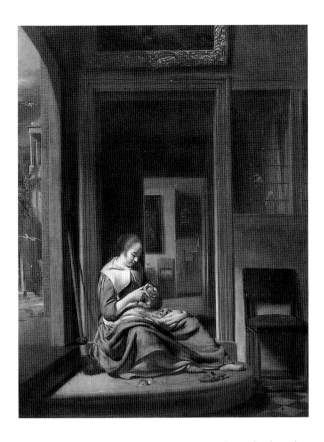

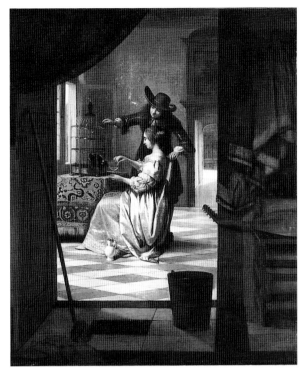

309
CORNELIS BISSCHOP,
Apple Peeler (*Young Woman
Peeling an Apple*), 1667.
Oil on panel, 70 x 57 cm.
Amsterdam, Rijksmuseum

310
PIETER DE HOOCH,
A Couple with a Parrot,
1668.
Oil on canvas, 73 x 62 cm.
Cologne, Wallraf-
Richartz-Museum

A generation ago *The Love Letter* was described as the "culmination of [Vermeer's] interest in portraying those private, unguarded moments in life" that one also finds in such works as the Dresden *Letter Reader* and the Amsterdam *Woman in Blue* (figs. 263, 294). The painter was simply assumed to be a master of sensitive observation, even when he had other, more exclusively artistic goals in mind. In the same passage it is suggested that "prototypes for Vermeer's composition are not known" and that the idea for this one may have come "through his experiences with a camera obscura, since a portable camera obscura is most effective when it is directed toward a sunlit scene from a darkened room." The device evidently helped the Delft artist approach the subject "in a way that anticipates the 'keyhole' realism of Degas in the nineteenth century."[212]

Vermeer's art of describing is discussed from the same angle in Wheelock's recent and illuminating book on the artist's technique. The abbreviations of form found in *The Guitar Player*, which on the whole "demonstrates the remarkable energy of Vermeer's late style," are ascribed to the painter's continued use of the camera obscura. Now, however, the abstractions discovered in the blurry box are developed into an all-purpose manner of execution: "Vermeer did not utilize this effect to suggest an unfocused foreground element, but made it an integral part of his image through the broader abstraction of form that occurs throughout." (The similar development in De Witte's contemporaneous church interiors is not brought into account.) Finally, not only Vermeer's late technique (called "freedom of

expression" in this passage) but also the "remarkably asymmetrical composition" of *The Guitar Player* "can be associated with his experiments with the camera obscura [since] unusual cropping effects are found by viewing through this optical device."[213] But they are also found by leafing through reproductions of Dutch portraits (especially pendants) dating from the same period.

The problem with studying Vermeer's style "in camera," without constant reference to the broader context of Netherlandish art, is that one is led astray by the painter's self-taught skills and powers of observation to conclude that he somehow sailed above the art world of the time (like Nadar in his balloon).[214] Gowing dismissed this Swillensian notion of the Dutch realist as *idiot savant*, which is nearly the exact opposite of the image needed to characterize the later Vermeer.

If anything, the painter was a much less independent person during the early 1670s. In October 1671 he was elected to his second two-year term as a *hoofdman* of the Guild of St. Luke. He appraised Italian paintings at The Hague, together with Johannes Jordaens, in May 1672. That year was disastrous for the Dutch economy, because of the French invasion and the English war. As Vermeer's widow testified in July 1677, he was not only unable to sell his own works during the war with France, "but also, to his great detriment, was left sitting with the paintings of other masters that he was dealing in."[215]

The effect of these circumstances on Vermeer's style is impossible to determine. But it may be said that his tendency to simplify form and technique in works of about 1670 onward was economical in more

than one sense and also consistent with contemporary taste, especially in history painting and portraiture.[216] Of course, Vermeer's later paintings do not make a uniform impression. In *The Astronomer* and *The Geographer*, *The Lacemaker*, and passages of *Lady Writing a Letter with Her Maid*, the overall treatment of forms and space in terms of light and shadow recalls the artist's earlier interest in optical effects (and contemporaneous works by De Witte, such as the *Imaginary Catholic Church* of 1668 in the Mauritshuis).[217] But in *The Love Letter*, the two genre interiors in London (figs. 313-14), and the *Allegory of the Faith* (fig. 315), all of which may be dated to about 1670-72, the distance from Vermeer's style in, for example, the "pearl pictures" seems considerably greater. Abstract patterns, which had always attracted the artist, now make a dominant impression, and the use of light and shadow on figures and especially drapery is schematized in a manner that is comparable to but actually less naturalistic than De Lairesse's at the same time.[218]

The kind of narrative that was described above in connection with *The Love Letter*, which could be summarized in a few lines of stage direction, does not come to mind when one examines the artist's earlier interpretation of essentially the same subject in the *Mistress and Maid* (fig. 296). The Rijksmuseum picture is more conventional in almost every respect. This is most evident in the compositional type, which is a clever variation of the *doorkijkje* used in eavesdropping scenes since the mid-1650s. Closer antecedents of *The Love Letter* – such as Van Hoogstraten's *Corridor* of 1662 (fig. 97), *The Slippers* in the Louvre, Metsu's *View down a Corridor* in Toronto, and Cornelis Bisschop's *Apple Peeler* of 1667 (fig. 309) – were discussed in Chapter Four. The use of doorways to set off perspective views was also well established in Delft architectural painting, even in the work of minor representatives such as Louys Elsevier (his view of the Oude Kerk, 1653, in Lisbon).[219]

Of course, versions of the conceit occur in De Hooch's courtyard views (see fig. 247) and in *The Little Street* by Vermeer (fig. 275), in the latter instance with a sewing mistress and a maid with a broom. However, more appropriate comparisons may be made with Steen's *Woman at her Toilet* of 1663 (Buckingham Palace), where the seductive figure is seen through a doorway,[220] and with De Hooch's *Couple with a Parrot* (fig. 310), which has been assumed to depend directly upon the composition of *The Love Letter* but appears to date from 1668 and was more likely the most immediate of the many precedents for Vermeer's design.[221] Corresponding elements include the shadowy foreground (which no one has associated with the camera obscura), the open doorway, the curtain cutting a corner, the broom and the nearby chair, the tiled floor, and some

purely formal similarities, such as the perspective scheme and the doorway in the background, which resembles Vermeer's fireplace. The comparison also clarifies how deliberately Vermeer avoided the illusionistic potential of this compositional type, filling the foreground (which is much deeper in the De Hooch) with frontal and nearly flat elements and treating the view like a *pietre dure* design, with hard shadows wedged into place, the yellow skirt cut like stone, and a uniformity of texture that no longer reflects an optical approach.

The Beit picture in Dublin

Perhaps the finest work of Vermeer's last years, dating from after *The Astronomer* of 1668 and *The Geographer* of 1669 (which are discussed briefly below), is the Beit *Lady Writing a Letter with Her Maid* of about 1670 or 1671 (fig. 311). Almost every motif in the painting reminds one of an earlier usage,[222] and there are echoes sensed all the way back to the house of Mary and Martha (fig. 255). The diaphanous window curtain, the low view of the table and the large painting on the wall, the subject of writing and, above all, the evocation of mood recall one or another of the "pearl pictures." One would be tempted to place the work in the mid-1660s, were it not for "the unarguable, unfeeling fall of light," which chisels the mistress's sleeves and lies "flatly upon broadly modelled forms."[223] As Wheelock observes, "the window glass seems frosted rather than transparent," the gray veins in the tiles have lost whatever look of marble they had before, and the maid's form and features are rendered with "geometric simplicity."[224]

Here, again, one is reminded of De Lairesse, who codified ideas he shared with Jan de Bisschop and other contemporary critics. Kemmer reveals (since few scholars have read De Lairesse) that the Amsterdam artist advocated not only the emulation of antiquity and the treatment of history subjects but also an elevated kind of genre painting, in which the figures are "cleansed of all imperfections," their poses are "well mannered," and passions play over their features in a way that reveals good breeding as well as the feelings of the moment.[225] Perhaps Vermeer had similar views in mind when he conceived a few of his later pictures. The maid in the Beit painting, for example, appears to control emotion with dignity. Her mood seems to resonate in somber tones throughout the composition, especially in the muted green of her dress, which is carried over to the curtain in the foreground through modulations in the shadowy wall.

On the floor is an open letter, a red wax seal, and, evidently, a stick of sealing wax.[226] Has a letter been written, sealed, and reopened? Is the mistress writing a letter for the maid?[227] The circumstances are

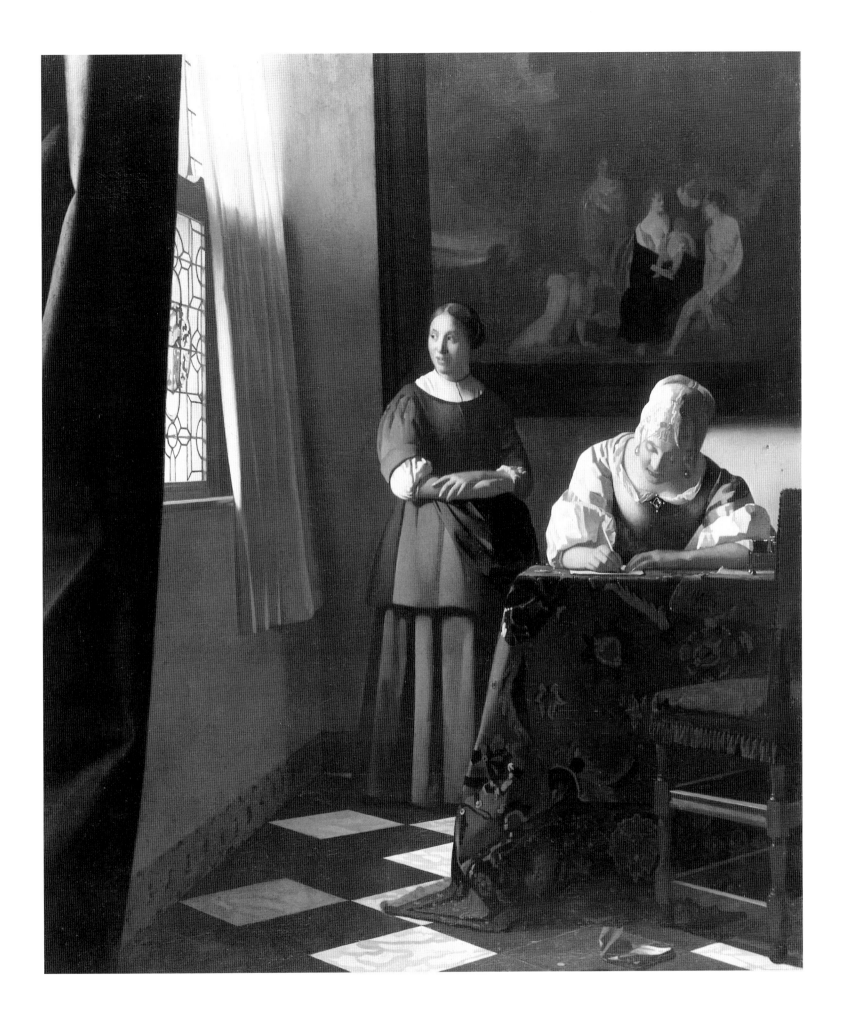

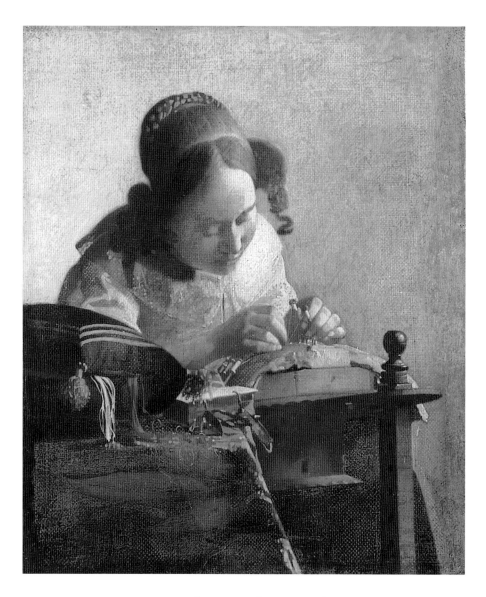

The Lacemaker

The Lacemaker in the Louvre (fig. 312) has been dated plausibly to about 1669-70.[232] The small canvas corresponds fairly closely in scale to the analogous motif of a woman bending over a table in the Beit picture (fig. 311). The manner of execution is similar, especially in the face and hands and in the table carpet, where some points of light are applied in both pictures.[233] The use of pointillé highlights is more extensive in the Louvre painting, which in its blurred highlights (for example, in the hair, on the blue material beneath the hands, and on the wooden knob) and in the softer folds of the jacket and collar recalls the *tronies* of about 1665-67 (figs. 300-302). Only the *Girl with a Red Hat* and the *Girl with a Flute* are as small as *The Lacemaker*, where the figure is deeper in space and not perfectly preserved. Thus the place of the Louvre picture in Vermeer's oeuvre is hard to judge: it comes closest to paintings of about 1669-70 but retains naturalistic effects of light and space that are more familiar from works of the mid-1660s. This is also true of passages in *The Astronomer* and *The Geographer* (figs. 316-17), which are only twice the height of *The Lacemaker*. When one compares the latter to *The Guitar Player*, where the similarly scaled figure is also lit from the right and coifed in curls, the greater degree of abstraction in the Kenwood canvas is remarkable.

Vermeer's possible use of the camera obscura to record the motifs in *The Lacemaker* was considered briefly above in connection with *The Art of Painting*. Effects found in very different compositions have been attributed to the device, but here the intimacy of the view is cited in support of the conviction that, "as with the diffused, almost fragmented finial, the optical effect of the threads certainly derives from a camera obscura image." The more conventional designs of lacemaking scenes by Maes and Netscher are contrasted with "the informality of this tightly framed composition."[234]

It should be remembered, however, that Vermeer was inclined to simplify motifs and settings in order to concentrate upon a figure's pose and expression (as in *The Milkmaid* and the *tronies*). Nor was he alone in this, as Goldscheider's comparison of *The Lacemaker* with the similar design of Velázquez's *Needlewoman* of the 1640s (National Gallery of Art, Washington) illustrated a few decades ago.[235] (Blurred forms and mirror-like effects of light occur in that painting as well, but are described in a different style.) Vermeer's approach to the lacemaker is anticipated also in Rembrandt's intimate sketch of Titia van Uylenburch bent over needlework (Nationalmuseum, Stockholm) and in numerous other figure studies found in drawings and prints by Rembrandt and members of his circle.[236] The comparison with Dutch genre paintings devoted to the same theme is misleading,

312
Johannes Vermeer,
The Lacemaker,
ca. 1669-70.
Oil on canvas,
24.5 x 21 cm.
Paris, Musée du Louvre

ambiguous and resist trivial interpretation.[228] The subject seems to be not so much a social situation as human emotion and character. This may be the key to understanding the inclusion of the Lely-like *Finding of Moses*, a smaller version of which appears in *The Astronomer* (fig. 316). Wheelock works out an oblique reading (God serves as independent arbitrator for "opposing factions"),[229] but the impression gained from the passage in Exodus (2:5-10) is of women behaving admirably when sheer emotion might have steered them on another course. Pharaoh's daughter sent a maid to the Hebrew women, acting in what seemed the best interests of everyone. Does Vermeer draw a comparison between human behavior as it is described in a biblical episode and as it might occur in everyday life? He would not be the first Dutch or Delft painter to do so; the Town Hall, for example, featured the usual model of wise resolution, *The Judgment of Solomon*, where a child's fate is also decided.[230] In any case, Vermeer appears to have conceived the picture independently of a commission or intended patron, for the work passed to his widow and from her to the baker, Hendrick van Buyten, whom she owed over 600 guilders for bread.[231]

because Vermeer never limited himself to the most obvious sources; inspirations for a motif or composition might come from another genre (for example, portraiture) or another medium. In fact, the small canvas in the Louvre seems closely connected with the subgenre of studio views, in which an artist studies a colleague, a model, or (in a mirror) himself absorbed in some exacting task such as drawing, etching, or needlework. The painter in the studio scene attributed to Hendrick van Steenwyck the Elder (fig. 307) appears to be working on such an image. Drawings from life by a great number of Dutch artists also come to mind.[237]

Perhaps Vermeer saw some kinship between the image of an artist at work and the concentrated labor of lacemaking or needlework. An important difference, of course, is that Vermeer's *Lacemaker* and analogous works by other Dutch artists (another example would be Caesar van Everdingen's *Woman with a Pot of Hot Coals* of about 1646 in the Rijksmuseum, Amsterdam) pay homage to the beauty as well as the hard work of young women.[238] Thus the close point of view can be related (as in the case of Vermeer's *tronies*) to the theme of desire rather than to an optical device. And Vermeer's subject, and to some extent his composition, can be connected with a fair number of feminine images, such as Rembrandt's *Girl at a Window* of 1645 (Dulwich Picture Gallery) and the many works it inspired.[239] Often in these pictures a young woman leans forward from behind a window sill or half-door, barriers which broadly resemble the tables that Vermeer employed to place a letter reader, a lacemaker, or another attractive figure at a slight remove. It is an approach that, in Vermeer's discreet handling, his patron appears to have appreciated in earlier works. *The Lacemaker* was evidently one of the last pictures that Van Ruijven acquired directly from the artist.[240]

Perhaps the most persuasive evidence linking the Louvre picture with the camera obscura is found in the red and white threads spilling out of the pillow-like sewing box, although its tassels, the ribbons on the small book (of lace patterns?), and the highlights on the near edge of the table carpet are also impressionistically described.[241] Vermeer may have seen similar effects in a camera obscura, but the entire still-life passage may be regarded as another display of astonishing technique, comparable to that seen in the table top in *The Milkmaid* or in *The Art of Painting*. The red threads recall the loose orange threads on the back of the tapestry in the studio scene, which appear to have been drawn and perhaps partly dribbled with the tip of a loaded brush. The same nearly accidental technique was taken a bit further in *The Lacemaker*, where the intention is not only representation but also the demonstration of unusual skill. The red threads might be described as

linear cousins of Vermeer's pointillé and more distant cousins of the painterly effects achieved (in some cases with unconventional means) by Rembrandt and other contemporaries.[242] Of course, in the seventeenth century there was no contradiction between the goals of naturalistic description and artistic display, as Dou and his followers demonstrated in their attention to light effects and in their deliberate embellishment of subjects with eye-catching accessories ("een rijkdom aan zichtbare dingen").[243]

The pendants (?) in the National Gallery, London
In discussions of Vermeer's style, his formal refinements are often admired as if they were icing on the cake. "Adjustments" are made to the visual evidence, which the artist is supposed to have discovered in his studio or in an optical device. The traditional view that the artist recorded scenes as he saw them (and even as he had arranged them in the studio) is now regarded with skepticism but remains influential, as Kemp makes surprisingly clear.[244]

These observations bear upon the peculiar critical history of the two paintings by Vermeer in the National Gallery, London (figs. 313, 314), which are the late works most reminiscent of the "pearl pictures." For Wheelock, these coolly appealing images represent a progressive sacrifice of visual and psychological observation on the altar of design. Their "restrained, balanced compositions" and the superficial resemblance between the poses of the figures in *A Young Woman Seated at a Virginal* and *A Lady Writing* in Washington (fig. 295) are considered signs of "dependency on earlier models [which suggest] that Vermeer's creative energy had begun to lag."[245]

During this descent into schematization, the artist is assumed to have remained dedicated to the study of optical effects. For example, his "more direct, even bolder technique" (in *A Young Woman Standing at a Virginal* he supposedly defined "the sharp folds of the woman's dress with quickly [?] applied strokes of white paint") is interpreted as a "striving for greater atmospheric clarity."[246] A similar crispness occurs in Van Vliet's late work (ca. 1665-75) and in contemporary Delft pictures by Verkolje and De Man (see figs. 175-77). Again, then, it would appear that Vermeer's development in the direction of harder light, airless space, and stylized passages of drapery can be understood in the broader context of changing taste, which would not exclude a concurrent interest in time-saving techniques.

The two paintings in the National Gallery, London, are usually dated to about 1670 or the early 1670s.[247] However, Wheelock's focus upon descriptive qualities recently led him to separate the pictures by two or three years. He observes that "crisp accents convincingly articulate folds" of the dress in *A Young*

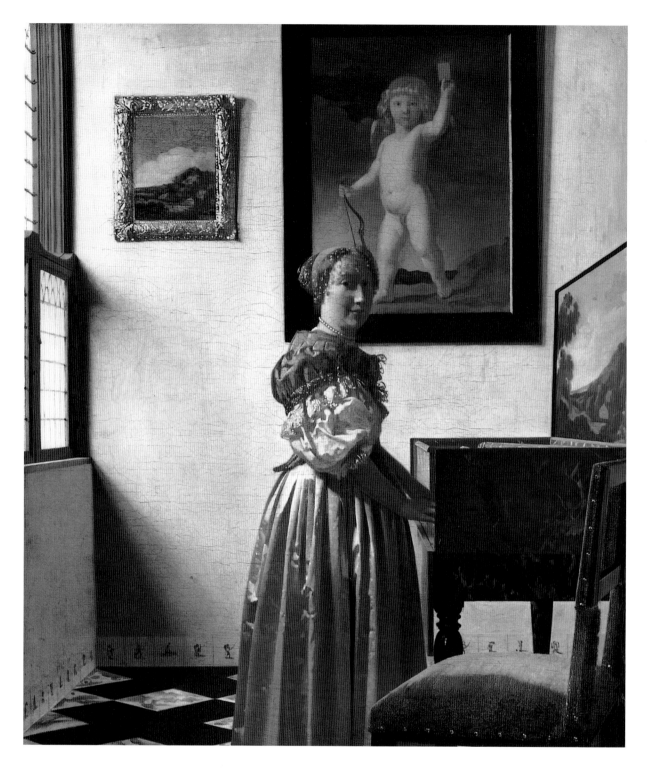

Woman Standing at a Virginal, where Vermeer also "articulates the physical structure of the intricate frame" of the landscape painting on the wall. By contrast, "the light blue accents on the folds of material in *A Lady Seated at the Virginal* create flat patterns of color rather than the semblance of material," and the artist also "summarily renders the frame surrounding Baburen's *Procuress* with broad, flat strokes of yellow paint." Therefore, the lighter picture is dated to about 1672-73, the darker one to about 1675 (Vermeer died in December of that year).[248] But what if "physical structure" and "the semblance of material" were not the painter's main concerns? The figures and objects might be

rendered differently for expressive reasons, or as part of an arbitrary variation of technique which is to some extent rationalized by the very different illumination of the two interiors. From this perspective, the paintings may very well date from about the same time and appear more plausible as pendants.

In any case, the motifs compared by Wheelock are not closely analogous and are assigned rôles peculiar to each stage. The mosaic of gold highlights on the heavy frame of Baburen's *Procuress*, which suggests an Italian style, is balanced by the bold pattern of the tapestry and echoed on the back of the chair. By contrast, the calligraphic relief of the French-style

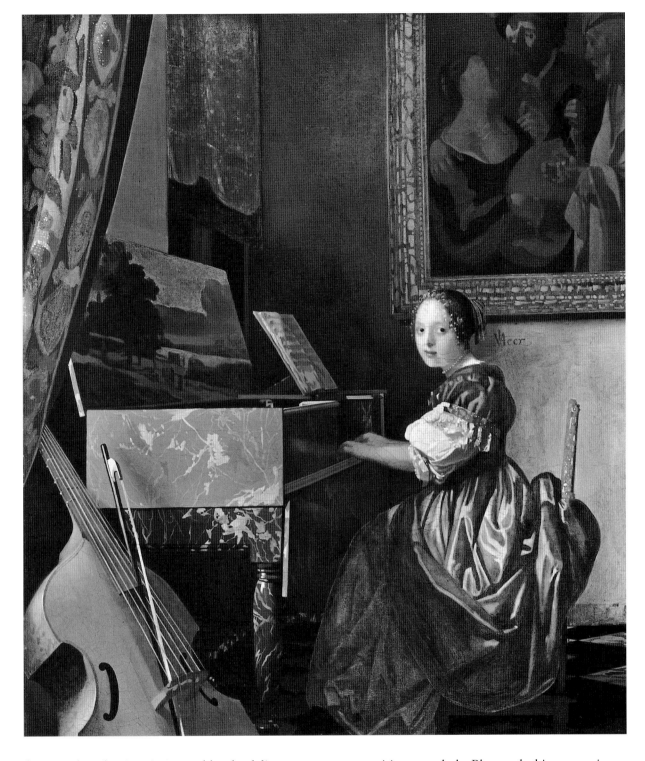

314
JOHANNES VERMEER,
*A Young Woman Seated at
a Virginal*, ca. 1672-73.
Oil on canvas,
51.5 x 45.6 cm.
London, The Trustees of
the National Gallery

frame in the other interior resembles the delicate details of the lady's sleeves, bows, and curls (compared with which the seated figure's curls seem a Morse Code of highlights). The schematic pattern of reflections on the blue drapery of the seated woman plays counterpoint with the faux-marbling on the virginal; one might almost overlook the "optical" effects of the passage in between, where the white skirt and blurred arms (indicating movement?) are mirrored in the front of the instrument. The subtler light on the dress of the standing woman is consistent with the light and shadow on the virginal and chair (the chair's back is lit from both sides) and contributes to the finely nuanced coloring of the composition as a whole. Blues and whites occur in ever-changing combinations, in the dress, the chair, the paintings, the marble patterns on the virginal and on the floor, in the highlight on the ebony frame, and in the shadows cast in the corner of the room and over the woman's features. These and other formal niceties, such as the more frontal and rectilinear arrangement of shapes in one painting and the slurred and angled outlines in the other, seem to suit two different feminine types, one of them forward, entertaining, and probably insincere, the other frank, refined, and reliable.

Most recent writers have resisted the notion that the pictures are pendants.[249] The evidence of

provenance is less conclusive than has been allowed. In the 1682 inventory of nearly two hundred Italian and Northern European paintings owned by Diego Duarte (before 1616-1691), the Antwerp *amateur* of music and collector of musical instruments, "A work with a young woman playing on the virginal with other motifs [*bywerck*] by Vermeer" was valued at 150 guilders.[250] Broos conjectures that Duarte's friend and occasional visitor in the 1670s, Constantijn Huygens the Younger, may have brought one of the paintings to Antwerp.[251] Neither this nor evidence of an early divorce would decide the question of whether or not the pictures were painted as a pair.[252] Vermeer might even have conceived the pictures as optional pendants, to be sold together or separately.[253]

The paintings have also been doubted as pendants on iconographic grounds.[254] But a fairly straight-forward reading supports the suggestion made above, namely, that the pictures compare seduction with lasting love. As is now well known, the painting of Cupid holding up a tablet or card derives from an emblem in Otto van Veen's *Amorum Emblemata* (Antwerp, 1608) signifying fidelity to one person.[255] Quite the opposite idea is conveyed in the other composition, by the young woman's expression and by the painting on the wall. The landscapes on the lids of the virginals suggest a similar message, offering the male viewer the familiar (Herculean) choice between the path of least resistance and the harder way.[256]

Wheelock subscribes to the interpretation of *A Young Woman Standing at a Virginal* as an image of virtuous love. However, he proposes that the allegedly later painting with a seated woman "examines a more complex theme: the choice between ideal and profane love." To this end, the virginal and the viol join forces to symbolize harmony, in contrast to Baburen's lute.[257] This is somewhat surprising, given the frequency with which Vermeer's contemporaries depicted amorous duets, or implied that one was possible with an attractive young woman.[258] In Vermeer's *Woman with a Lute* (fig. 288), for example, the dressed-up young lady and the viol on the floor appear to wait for a musical partner. It seems far more likely that the two instruments (and the lady's look) in the London picture were meant in the same way, rather than as metaphors for sympathetic heart-strings (Wheelock refers to Cats's emblem about resonating strings, but here the viol's cannot vibrate because of the bow).[259] The simpler interpretation of the paintings as pendants is supported by Wheelock's own observation that "the dimly lit interior suggests an intimate and seductive environment." But this is explained away, in favor of the more high-minded analysis.[260]

Taking Vermeer on faith

In several passages above it was suggested that our modern enthusiasm for the image of Vermeer as investigator of the natural world and of the very nature of visual experience results in an incomplete picture of his work, just as the concept of an "art of describing" becomes a "reductive argument for all Dutch picture-making as a mode of knowledge construction."[261] A logical consequence of the conviction that "Vermeer's style of painting [was invariably] built from a rational foundation and fundamentally grounded in creating a semblance of reality" is that the artist "made only one mistake, the painting traditionally known as the *Allegory of the Faith*." The picture (fig. 315) is considered "an impressive tour de force, beautifully painted, with a fascinating iconography, but as a work of art it is a failure."[262]

The failure here is art history's, for not placing the work in its proper context, which is that of Netherlandish allegorical paintings dating from about 1670, not that of young women depicted in Delft living rooms. Vermeer probably painted this large canvas on commission, most likely for a wealthy Catholic individual rather than for a Jesuit or other institution.[263] However, it was maintained recently that no patron would have influenced the conception of this picture, the artist's least characteristic work. As in his genre paintings (according to this view), Vermeer is thought to have assembled objects he happened to have around the house – Jordaens's *Christ on the Cross*, an ebony crucifix, and so on – and, with a little help from Ripa and Jesuit neighbors, painted whatever he pleased.[264]

Hertel compares the *Allegory of the Faith* with works by Rubens, Bernini, Poussin, and Otto van Veen (*Triumph of the Faith*) and reviews critical reactions to Vermeer's allegorical compositions.[265] It would have been helpful to consider Dutch history pictures as well, for example, Adriaen Hanneman's *Allegory of the Peace* dating from about 1664, a huge canvas in which the female figure, derived from Ripa, wears a low-cut white dress, a blue mantel, and pearls in her hair.[266] Compared with that work painted several years earlier at The Hague, Vermeer's picture seems far more compelling and accessible, as would befit a personal expression of faith. The setting itself resembles a room set aside as a chapel in a private house.

Perhaps a Catholic patron knew *The Art of Painting* (fig. 305) and requested a religious work of similar design. Or Vermeer may have made the proposal. However, the sacred subject called for a different approach, one well removed from the self-conscious world of the studio. The result bears little resemblance to religious and historical pictures by such artists as Steen and Van den Eeckhout, where

much of the flavor of their genre scenes is carried over. Vermeer's composition has more in common with works by De Lairesse, Dujardin, and other classicist contemporaries.[267] And his transformation recalls that of fellow South Holland genre painters who, perhaps influenced by Dutch and Flemish artists active at The Hague (Hanneman, Jordaens, Willeboirts Bosschaert et al.), modified their styles when it seemed appropriate to the subject matter. "The artist adapted his technique to suit the larger format, using somewhat broader brushstrokes, although various details in our picture remind one of the refined execution of his cabinet pieces." This strikes one as an adequate description of Vermeer's manner in the *Allegory of the Faith*, although a degree of abstraction was called for by more than just the picture's scale. However, the quote is from Broos's discussion of *The Triumph of Justice* by Metsu (Mauritshuis, The Hague).[268] That histrionic composition, like Hanneman's *Allegory of the Peace*, provides an appropriate frame of reference for assessments of Vermeer's success in the religious allegory. Another might be Huygens's patronage, for example, his rôle in the Oranjezaal of the Huis ten Bosch and his support of Hanneman in the 1660s.[269]

The *Woman Holding a Balance* and *The Art of Painting* have occasionally been considered antecedents of the *Allegory of the Faith*. But despite their symbolic elements, the viewer responds to those earlier pictures in a different way. The most comparable figure in them, "Clio," is clearly under-stood as a flesh-and-blood model who is playing a part. The woman in the later painting is immediately recognized as an allegorical figure, representing not some aspect of human experience (such as love, the sense of sight, etc.) but an abstraction, the Catholic Faith. To be sure, there are motifs in the picture that recall illusionistic elements in other works by Vermeer: the tapestry, the glass sphere, the shiny terrestrial globe. But these do not justify responding to the image as if it were a less visceral version of the *Woman Holding a Balance*. Hertel cites one scholar's description of the allegorical figure's "wild turning" toward the glass sphere as an extreme example of misinterpretation.[270] "Faith" is not moving, or even posing, in the usual sense. Her expression and gesture contribute, as in Ripa, to the clarification of an idea, not to the progess of a narrative.

Hertel observes that a "slow, attentive motion from object to object, from reference to reference, reflected and coordinated by the allegorical figure of Faith, is not only suggested by Vermeer but also enacted by him in the process of their carefully rendered, detailed representation."[271] Her reading has a modern ring, and goes too far in several passages. But aspects of the composition are illuminated for the first time. For example, Hertel suggests that

Saint John the Evangelist, behind the figure of Faith, serves as the viewer's intercessor by gesturing toward Christ and holding a cloaked hand to his breast. Faith repeats the heartfelt gesture, while her yearning pose echoes that of the mourning Virgin. The glass sphere is a symbol of Heaven and the Creator; like the soul compared with the body, the transparent object contrasts with the physical world below.[272]

Vermeer's patron would have recognized, and presumably discussed with the artist, the various relationships between motifs. For example, the globe is Vermeer's visualization of a remark made by Ripa, that Faith has "the world under her feet."[273] The cornerstone of the Church (Christ) crushes a serpent (the Devil), which, together with the apple on the floor, refers to original sin. The serpent also recalls the legend of Saint John the Evangelist, who (it is said) was ordered to drink a cup of poisoned wine by the Emperor Domitian. When John lifted the cup, the wine flowed from it in the form of a snake. The chalice on the table (defined as an altar by the crucifix and Bible) refers to the Eucharist and is, as Ripa specified, a symbol of the Christian faith.[274]

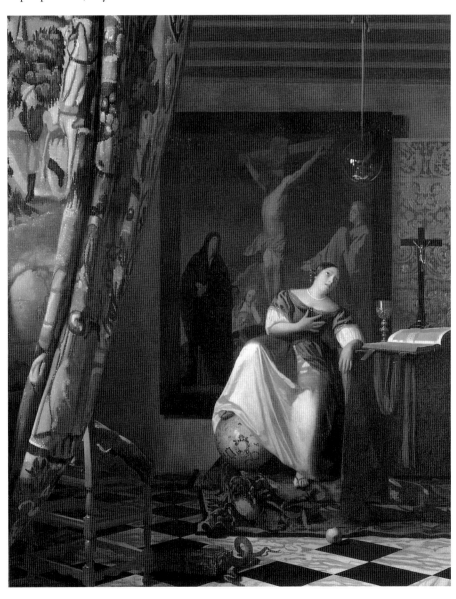

315
JOHANNES VERMEER,
Allegory of the Faith,
ca. 1672-73.
Oil on canvas,
114.3 x 88.9 cm.
New York, The
Metropolitan Museum
of Art, The Friedsam
Collection, Bequest of
Michael Friedsam, 1931

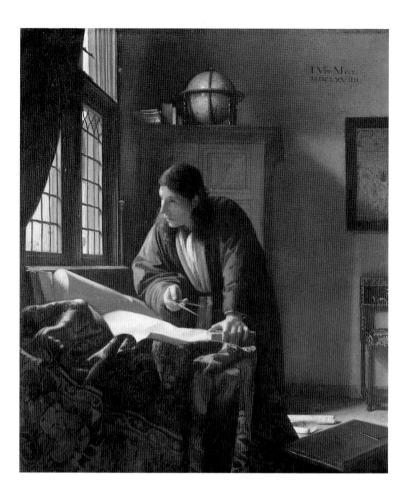

316
JOHANNES VERMEER,
The Geographer, 1669.
Oil on canvas,
52 x 45.5 cm.
Frankfurt am Main,
Städelsches Kunstinstitut

Knauer identifies the subject on the tapestry as Eliezer and Rebecca, and considers this a pre-figuration of the main scene.[275] It seems more likely that the tapestry suggests revelation – of truth, a holy image, and sacred space. The similar use of curtains was discussed in connection with illusionistic pictures in Chapter Two. As noted often, Vermeer was adept at creating psychological barriers. Here the tapestry separates the viewer from a spiritual realm.

Two kinds of knowledge

In contrast to the allegorical painting just discussed, few works evoke the contemporary interest in the physical world quite so vividly as Vermeer's pair of pictures dated 1668 and 1669, *The Astronomer* and *The Geographer* (figs. 316, 317).[276] The same man appears to have served as model for both paintings. Their marvelous air of mystery, of things yet to be discovered, is much deflated by the identification of the model with Anthony van Leeuwenhoek, the Delft *amateur* of science.[277] The similarity to the man in *The Music Lesson* (fig. 283), the lack of resemblance to portraits of Van Leeuwenhoek, and the fact that the physicist's scientific enthusiasms were still embryonic in the late 1660s (when, as a linen merchant, he attended anatomy lessons) encourage one to think of the pictures in broader terms.[278]

The two paintings are generally considered pendants. It seems likely that they were commissioned,[279] but not necessarily, nor can one assume

that the patron resided in Delft. Globes, maps, charts, books, scientific instruments, and other objects indicating an interest in geography or astronomy occur in a great number of Dutch paintings, drawings, and prints. Some are portraits, but the majority are genre scenes by such artists as Bol, Dou, Maes, De Man, Kneller, Salomon Koninck, Jan Olis, and many others.[280] Terrestrial and celestial globes were such common attributes of learned gentlemen,[281] and even learned artists,[282] that it is not at all surprising to find the two paintings by Vermeer described in a Rotterdam sale of 1713 as "A work depicting a Mathematical Artist, by vander Meer," and "A ditto by the same."[283]

Contemplative expressions are the norm in these images. Dou's astronomer (Braunschweig) rolls his eyes skyward; Bol's astronomer (London) stares reflectively into the fall of light. Vermeer distilled two figures from this tradition, which one is tempted to describe as the Faust and Aristotle types (after Rembrandt's etching of 1652 and painting of 1653).[284] But unlike Rembrandt's Aristotle and the figures painted by Bol and Dou, Vermeer's astronomer looks inquiringly at the globe and turns it with his fingers. Compared with the geographer, the seated scholar seems more active, not paused in contemplation, which is one of several complementary relationships to be discovered in the two works.

Some writers have been troubled by the fact that a wall recedes on the left in both pictures. In fact, the

317
JOHANNES VERMEER,
The Astronomer, 1668.
Oil on canvas, 50 x 45 cm.
Paris, Musée du Louvre

dominant recessions differ considerably, with perspective schemes focused in front of the seated figure and behind the standing one.[285] The same cabinet in the corner and essentially the same window and table are seen from different points of view, which strengthens the impression that the astronomer leans forward eagerly, and that daylight, or the light of understanding, streams into the face of the geographer (the cabinet casts different shadows, enhancing these effects). Repoussoirs, nudging the viewer from opposite sides, are established at the extreme left in *The Astronomer* (the wood panelling) and to the right in *The Geographer* (the stool, reminiscent of Ter Borch). In the latter, open floor space, objects and shadows lead the viewer offstage to the right. It is clear that *The Geographer* was intended as the left-hand picture, while the some-what darker scene with the seated figure was placed to the right. One could go on in this vein and then continue with the pair of pictures in London (figs. 313-14).

A similar sense of counterpoise is found in significant objects (to say nothing of different gowns, table carpets, and so on).[286] The globes, of course, are pendants themselves. Other objects, such as the dividers and the cross-staff (hanging in the center of the window) in *The Geographer* would be just as useful in the astronomer's study. The sea chart on the wall behind the geographer reminds one that navigation depends upon a knowledge of the stars.[287]

Finally, a painting of *The Finding of Moses*, the infant sailor who was occasionally described in Vermeer's time as "the oldest geographer," hangs on the wall behind the astronomer. Van Berkel concludes, convincingly in my view, that the Louvre painting represents "two very different types of seventeenth-century knowledge, the new beside the old [Mosaic science], the strictly calculated beside the contemplative, knowledge beside wisdom."[288] *The Geographer* gives the same impression; indeed, the greater emphasis upon contemplation (if not ancient learning) appears to have been placed there. It could be said, in summary, that the two pictures have the same meaning, that the two figures are one and the same. He is the contemporary scholar, who draws upon the wisdom of the ages as well as his own experience.

And so did Vermeer, as an artist. Few painters were ever so resourceful in adopting ideas from others. Few, if any, of his contemporaries placed such faith in their own observations. And yet Vermeer leaves so much to the viewer: all that is invisible, indescribable, beyond understanding. In the end, he lets silence speak.

Notes

Notes to Chapter One

1 P. Sutton on De Hooch, in Turner 1996, xvi, p. 733.

2 De Vries 1985, which does not discuss Delft, but the question of "schools" in Dutch art.

3 E. J. Sluijter in Delft 1981, p. 172.

4 J. Breunesse in Delft 1981, p. 189.

5 Brown 1981, p. 43.

6 Referring to the turn from winter to spring in the story of Delft painting, Eisler 1923, p. 172, forecasts as follows: "Trüb gärt es noch im Werke des Anthonie Palaemdesz, ein Gast aus Amsterdam, der junge Paul Potter reinigt der Weg, aber erst die Kirchenmaler bringen den Umschwung, den Carel Fabritius rhythmisch vollendet." Sections of Eisler 1923 are best read while listening to Vivaldi 1725.

7 Brown 1981, p. 43.

8 Montias 1982, p. 181.

9 Haak 1984, p. 442.

10 The quotes are from Jane Ten Brink Goldsmith's article on Delft in Muller 1997, pp. 101 and 102.

11 As noted in Delft 1981, p. 229, in the article on silversmiths by K. A. Citroen. See pp. 202-9 in the same volume for M. I. E. van Zijl's essay on tapestries.

12 See Eisler 1923, pp. 178-87, and The Hague 1994-95, p. 12 of Amy Walsh's biography of Potter.

13 The quotes are from Michiel Plomp's essay in Delft 1996, p. 39. My colleague (see New York-London 2001) is well aware that these lines slightly simplify the historical situation.

14 The Hague 1994-95, p. 13 and no. 15.

15 See Harwood 1988, pp. 23-24.

16 See The Hague 1998-99a, especially Vermeeren's essay on the art market in The Hague. Several Delft painters are mentioned, including Bramer and Palamedesz (p. 57). Only a few, mostly decorative painters resident in The Hague worked for the court (pp. 75-77).

17 On Volmarijn see Gudlaugsson 1952 and Judson 1955. An especially interesting example based on Honthorst's half-length compositions is the *Supper at Emmaus* of 1632, in the Ferens Art Gallery, Hull. The wealthy Delft *amateur* Willem Verschoor (ca. 1630-1678) may be considered a late follower of Honthorst, but he probably got his few ideas from Van Couwenbergh.

18 See Slatkes's article, "Bramer, Italy and Caravaggism," in Milwaukee 1992-93, pp. 13-18.

19 Amsterdam 1986, nos. 230-31.

20 See Sluijter in Delft 1981, pp. 180-81; Delft 1996, pp. 34-35; Briels 1997, pp. 221-27.

21 On Spiering and Van Mander see Delft 1981, pp. 202-7, and Montias 1982, pp. 286-88. For Van der Houve (or Hoeve) see Sluijter in Delft 1981, p. 173, and Plomp in Delft 1996, p. 21, fig. 8.

22 See Enkhuizen 1990.

23 For a brief review of portraiture in Delft and The Hague, see Haak 1984, pp. 216-19, 323, 327, 332-35. For The Hague, see The Hague 1998-99a.

24 See The Hague 1997-98b, pp. 32-33, and the city maps of 1598 and 1649 in Dumas 1991, pp. 58-61. A map in The Hague 1998-99a, pp. 46-47, shows where artists lived (almost all of them outside the court district).

25 See MacLaren/Brown 1991, p. 475, and, on the sitter, Abels and Wouters 1994, pp. 133, 135-38. The portrait may have been ordered in connection with Purmerent's appointment as archpriest of Delfland in 1631.

26 Van der Ploeg and Vermeeren in The Hague 1997-98a, p. 57.

27 On artists in Middelburg see Amsterdam 1984; Haak 1984, pp. 204-8, 342-43, 424; and the appropriate sections in Briels 1987 and Briels 1997.

28 Montias 1982, p. 139. Briels 1976 does not provide percentages for Amsterdam and Haarlem, but lists all the immigrants on pp. 80-84 and p. 149.

29 Montias 1982, pp. 73, 99-100 (quote from p. 73).

30 Montias 1982, p. 177.

31 Compare Montias 1982, p. 130, and the biography in Briels 1997, p. 344, n. 11.

32 Mander 1994, fol. 258r (211r on the Nassau Genealogy).

33 See Briels 1997, figs. 56, 60, 65, 68, and 149.

34 See the essay by Van der Ploeg and Vermeeren and the relevant catalogue entries in The Hague 1997-98a.

35 See the articles by Brière-Misme (1954) and Van Gelder (1948-49) cited and discussed in Maier-Preusker 1991, pp. 163-64, 230.

36 See The Hague 1997-98a, p. 52, fig. 26.

37 Amsterdam-Jerusalem 1991-92, no. 23; Maier-Preusker 1991, no. A 8, fig. 24.

38 Sluijter in Delft 1981, p. 174. After three sentences broadly comparing Van Couwenbergh with Honthorst, Sluijter reports: "Volgens Van Bleyswijck, was zijn werk zeer geliefd en werkte hij ook voor de prins van Oranje; inderdaad kunnen wij nog werk van hem aanwijzen in de Oranjezaal in het Huis ten Bosch." This is true enough, but creates the impression that Van Couwenbergh's contribution to court decoration was restricted to a little bit at a late moment, which was hardly the case. See

also Plomp in Delft 1996, pp. 21-22, fig. 9, and p. 28, fig. 19.

39 See Montias 1982, pp. 46, 170, 338, on Van Nes, who like Van der Houve was a wealthy brewer's son.

40 Attempts to regulate prostitution in Delft around the turn of the century are discussed in Abels and Wouters 1994, pp. 181-82.

41 For the details in this paragraph see Maier-Preusker 1991, pp. 165-66, and his chronological list on pp. 174-76.

42 Maier-Preusker 1991, pp. 167-69.

43 See Maier-Preusker 1991, figs. 9, 10, 12.

44 See Maier-Preusker 1991, figs. 34, 35, 42, etc. (figs. 24-6 remind one of the background in Rubens, Hendrick Bloemaert, and many other artists of the early seventeenth century).

45 Wheelock 1981, p. 66. Compare Plomp (Delft 1996, p. 25), who suggests that Vermeer saw a small work by Fetti.

46 Sluijter in Delft 1981, p. 174 ("een zeer eigen plaats").

47 Baldinucci 1845-47, IV, p. 527.

48 For the engraving and inscription see Delft 1994, pp. 19-21, fig. 5.

49 De Bie 1661, p. 252, quoted and partially translated in Delft 1994, pp. 27-8.

50 For both records of these lost works see Delft 1994, p. 21, where a drawing in the Rijksprentenkabinet of the Rijksuniversiteit, Leiden, is related to the "Fortuna." If this is a *modello* or *ricordo* of the composition cited in the inventory of 1758, then its subject was somewhat inaccurately described. The drawing appears to show Good Fortune and Bad Fortune on a pedestal, hurling welcome and undesirable objects at a divided multitude (the Last Judgment done over as a balance sheet of life). The figures on the left are miserable, enslaved, or dead; some ruined structure is suggested in the background. To the right a king and other fortunate beings receive the flying gifts in front of palatial architecture.

51 Montias in Delft 1994, p. 43.

52 On Bramer's subjects, which were recherché in the 1630s especially, see Delft 1994, pp. 67-68. Some of them were shared with Van Couwenbergh.

53 For a careful translation of Huygens's comments into English, see Liedtke 1995-96, p. 9.

54 Montias 1982, pp. 79, 207. Michiel Plomp kindly cautions me regarding the hypothesis that Bramer may have painted on slate in the north. My main concern is the automatic use of the support to date paintings by Bramer to his Italian period, as in Milwaukee 1992-93.

55 Delft 1994, p. 43.

56 However, it emerges clearly enough in Utrecht-Braunschweig 1986-97.

57 That is, *Simeon's Hymn of Praise*, 1631, in the Mauritshuis, The Hague (The Hague 1997-98a, no. 22).

58 The last comparison is made in Delft 1994, p. 55, fig. 10 (C. Saftleven's *Trials of Job* of 1631 in Karlsruhe).

59 Brown 1995, which amplifies his review of Delft 1994 in *The Burlington Magazine*, CXXXVII (1994), pp. 862-64.

60 For Van de Venne's biography and De Bie's reference to Van Diest see Royalton-Kisch 1988, p. 38. The "attractive" hypothesis (Brown 1995, p. 46) is rejected by J. W. Noldus in Turner 1996, IV, pp. 656-57.

61 See Delft 1994, p. 53, and Brown 1995 on Farnese and Scaglia.

62 See Brown 1995, fig. 2 (Ottino, in Dulwich). An excellent example is Ottino's *Descent from the Cross*, of which three autograph versions on slate are known (Castelvecchio, Verona; Sotheby's, London, April 8, 1981, no. 125; idem, April 11, 1990, no. 2). A *Virgin and Saint Joseph Adoring the Infant Christ* on slate, convincingly attributed to Bassetti, was sold at Sotheby's, New York, October 10, 1991, no. 116. The *Miracle of Saint Paul* said to be by an unknown Dutch or German painter in the University Art Gallery, State University of New York, Binghampton, is also by Bassetti, according to Everett Fahy. This large canvas looks forward to Bramer's *Denial of Peter* of 1642 (Rijksmuseum, Amsterdam).

63 Delft 1994, no. 9, color pl. on p. 6.

64 Brown 1995, p. 47, and Paul Huys Janssen in Delft 1994, pp. 14-16.

65 MacLaren/Brown 1991, pp. 190-91.

66 See Delft 1994, pp. 21-25, on three fresco projects by Bramer (1653, 1657, 1660). On p. 23 it is claimed that he also painted frescoes at the princely palaces ("see doc. 1649") but one fails to find any evidence specifically of fresco in the relevant documents.

67 Here I concur with Brown 1981, p. 53; see also his Appendix C, pp. 162-63, on decorative murals in Holland. Tassi is of some interest: see San Francisco-Baltimore-London 1997-98, pp. 111-12, fig. 16. On Bor and De Grebber at Honselaarsdijk, see Snoep 1969, and Brown 1981, p. 162, fig. 49; The Hague 1997-98a, pp. 40-44, especially fig. 12 (drawings for Honselaarsdijk attributed to De Grebber; fig. 260). De Grebber never went to Italy, but Bor was in Rome from 1623 until about 1626. One of his roommates there was an artist named Willem Thins (also called Guglielmo Tens; see L. Slatkes in Turner 1996, IV, p. 377). J. M. Montias, in a letter dated June 17, 1998, confirms that this is Vermeer's uncle by marriage: Willem Willemsz Thins, younger brother (born about 1600/05?) of Maria Thins, Vermeer's mother-in-law. Marten Jan Bok brought "Gulielmo Tinzi de Gouda in Hollandia" to Montias's attention, and he incorporated the information into the Dutch edition of his book (Montias 1993, pp. 132-33). This is intriguing in light of the family connection between the Thins family and Abraham Bloemaert (see Montias 1989, pp. 109-10 on this question, and for his earlier mention of W. Thins). The Thins family was from Gouda, as was Bramer's roommate in Rome, Wouter Crabbeth (see Delft 1994, p. 15).

68 See Delft 1994, pp. 63-67; paintings cat. nos. 50 (the triptych), 51 (the Feigen canvas); drawings cat. nos. 19-21 (ceiling sketches), 27, 36, 37; and pp. 199-201, figs. 25 and 26 (quasi-Venetian wall and ceiling designs).

69 See Delft 1994, pp. 22, 63, on the Van Bronchorst document dated February 4, 1653.

70 See text and n. 35 above.

71 Delft 1994, pp. 200, 262-65. The reference to these projects as "stopgaps" in Bramer's production (p. 65) is something one would never encounter in studies of Rubens or Jordaens.

72 Plomp in Delft 1994, pp. 183-84, 311-19 (complete list of known material).

73 Ten Brink Goldsmith 1984, p. 32. The precise wording of this argument is problematic (most of these subjects had never been portrayed before, as Michiel Plomp has noted in conversation). However, it is obvious that Bramer intended the drawings for a sophisticated viewer.

74 Delft 1994, p. 317, no. 30; see also Ten Brink Goldsmith 1984, p. 23.

75 Delft 1994, pp. 314-16, nos. 22-24. Ten Brink Goldsmith 1984, p. 23, refers to the *Aeneid* and *The Life of Alexander the Great* as "listed in the 1691 catalogue of the book collection of Dr. W. Snellonius, who was apparently a famous scholar." According to Van der Aa 1852-78, vol. "S," pp. 251-52, the short-lived Willebrordus Snellius van Royen (1591-1626) was an authority on optics and triangulation and had several major publications to his credit. But this Snellonius cannot be the scholar in question. Perhaps another member of the family was the owner.

76 Van den Brink 1993 on the series of drawings by Bramer; The Hague 1997-98a, nos. 5, 29, for Van Dyck's canvas (the *Amaryllis and Mirtillo* at Pommersfelden) for the Stadholder's Quarters, and for the series of paintings based on *Il Pastor Fido*, made about 1635 for one of Amalia van Solms's rooms at Honselaarsdijk.

77 See Royalton-Kisch 1988 and Bol 1989.

78 As noted by Plomp in Delft 1994, p. 184.

79 On this subject see Brusati 1995, the pages indicated in her index under "drawing."

80 The quotes in this paragraph are from Montias 1982, p. 181.

81 Montias 1982, pp. 105-6; the term "critical mass" reappears on p. 181.

82 Montias 1989, Ch. 13. Van Ruijven is discussed below in Chapter V.

83 Montias 1982, p. 179.

84 Ekkart 1995, p. 161.

85 See Sutton in Turner 1996, XXIII, p. 831, ill.

86 Discussed in Delft 1981, p. 176, fig. 184, and in Ekkart 1995, p. 161.

87 See New York-London 2001.

88 Blankert 1978, p. 31: "De Hooch was the first to place figures in interior space with perfect truth to life."

89 Montias 1982, p. 184.

90 Montias 1982, p. 100.

91 On these artists see Segal 1989; on Verhulst, Montias 1982, p. 56.

92 The "court style" of architectural painting was first defined in Liedtke 1991a.

93 The nature of Delft society, which is touched upon in Eisler 1923, Delft 1981, Montias 1982, and Wijsenbeek-Olthuis 1987, will be discussed more fully by Marten Jan Bok in New York-London 2001.

94 See Van de Wetering 1997, Ch. VIII.

95 Delft 1996, pp. 162-97.

96 Amsterdam 1993-94a, nos. 200-201. On Dutch townscape painting see Amsterdam-Toronto 1977, and Liedtke 1979a.

97 Brown 1981, pp. 150-51, doc. no. 18.

98 Montias 1991a, p. 45.

99 Montias 1982, appendix A, tables A.2 and A.3. It will be recalled that Christiaen van Couwenbergh's mother was the sister of Jacob Vosmaer, so Daniel Vosmaer was Van Couwenbergh's cousin.

100 See Brown 1981, pp. 52, 154-57, doc. nos. 34-37; and (1653) p. 150, doc. no. 17. See also Montias 1982, p. 196.

101 See Brown 1981, pp. 52, 154-55, doc. nos. 34-36, especially the second half of no. 36.

102 See Liedtke 1992a, p. 35, nn. 75 and 76.

103 Brown 1981, pp. 58-60.

104 Brown 1981, p. 60.

105 Which is not a fault of Van de Wetering 1997.

106 See Brown 1981, pp. 22, 148-49, doc. nos. 11, 12.

107 Brown 1981, no. 2. On these and other questions concerning Fabritius's work in Amsterdam, see Liedtke 1995-96, pp. 26-28. On De Potter see also Bikker 1998, p. 292.

108 Brown 1981, pp. 126-27, no. 7. Wurfbain's hypothesis that the painting served as a shop sign for Cornelis de Putter's establishment in The Hague (see Brown 1981, p. 127) is credited to a later author in The Hague 1998-99a, p. 51, n. 5.

109 Brown 1981, p. 47, fig. 37. See the caged bird in the illusionistic *Still Life with Hunting Gear* in the Akademie, Vienna (Trnek 1992, pp. 15-18, no. 6).

110 Brown 1981, pp. 47, 127. See the articles by Boström and Wurfbain listed in his bibliography.

111 See Raggio and Wilmering 1996, pp. 29-30, fig. 38.

112 Brown (1981, p. 48), who has already been doubted by Wheelock in Washington-The Hague 1995-96, p. 28, n. 29, and in Düchting 1996, pp. 13-15. Compare *La Sentinelle endormie* attributed to Willem Duyster in the Musée des Beaux-Arts, Lyons.

113 According to Stuart Pyhrr, Curator in Charge of Arms and Armor, and

Donald LaRocca, Curator of Arms and Armor, at the Metropolitan Museum of Art, New York (in 1998). The only possible operation would appear to be clearing the touch-hole with a pin, but the sentry's right hand is too low on the gun. Loading and priming were normally performed while standing.

114 Düchting 1996, p. 15, suggests that the column signifies uselessness, but this seems far-fetched.

115 Sumowski 1983-[94], II, no. 594. The supposed copy after another painting of a sentry by Carel Fabritius, Sumowski's no. 606, is unknown to me.

Notes to Chapter Two

1 See Brown 1981, cat. no. 5, and MacLaren/Brown 1991, pp. 137-38, no. 3714. On the church itself see Rijkscommissie 1969, pp. 394-96. The small spire or flèche above the crossing of the church in Fabritius's view has not survived either.

2 Elkins 1988, n. 25.

3 As discussed below, Dutch draftsmen and painters (for example, Jan van Goyen) often represented churches from behind the choir. This angle of view offers the most comprehensive and compact view of a church with a western tower (compare photographs of Notre Dame in Paris).

4 They were both seen in Delft 1996. This section of the text on "The Support" concerns the choice of canvas, wood, or copper. Analysis of this particular support, Fabritius's small canvas, is described below within the section on "the technical evidence."

5 On Van der Poel's pictures of the Delft explosion see MacLaren/Brown 1991, pp. 306-9, and Delft 1996, pp. 94-98.

6 This conclusion is based upon reviews of Lawrence 1991 and her unpublished oeuvre list of paintings by Gerrit Berckheyde; Wagner 1971 on Van der Heyden; Van Thiel et al. 1976 for paintings in the Rijksmuseum, Amsterdam; and Amsterdam-Toronto 1977. Three unusually small versions of a view also found in larger pictures by Van der Heyden of Cologne's Cathedral and Square measure only about 12 x 16.5 cm. Two of these examples are on wood while one work in a private collection, Dortmund, is on silver or silver-covered copper (Wagner 1971, no. 47). A case of special interest for this survey is Jacob van der Croos's *View of The Hague with twenty views of surrounding locations*, dated 1663 (Haags Historisch Museum; Dumas 1991, no. 18). The central view is on canvas (60 x 123 cm), while each of the twenty surrounding views is on a panel measuring about 17.5 x 32 cm.

7 By Arthur Conan Doyle (1894). Perhaps a better comparison would be with "The Purloined Letter" by Edgar Allan Poe, since the physical evidence of *A View in Delft* is under the scholar's nose.

8 The quote is from Keith 1994, p. 55, in an article on the painting's treatment and original manner of display (based on new technical evidence gathered during Mr. Keith's conservation of the painting).

9 See Liedtke 1976a, Wheelock 1973 and Wheelock 1977a, pp. 4-11.

10 Cole 1978.

11 Veltman 1979; Kemp 1990, p. 213.

12 See n. 26. The most important support comes from Keith 1994, as discussed below.

13 Wheelock 1973, pp. 65-66, citing "no consensus" twice.

14 On the Detroit perspective box see Richardson 1937; Koslow 1967; and Brusati 1995, p. 364, no. 87, pl. VII.

15 Evelyn 1955, III, p. 165.

16 Richardson 1937, p. 152.

17 Martin 1944, pp. 392-93, modifying Martin 1936, p. 178.

18 Schuurman 1947, p. 53. Schuurman even calls for the painting's prompt restoration to "its first state," so that it would form a "worthy pendant" to Samuel van Hoogstraten's perspective box in The National Gallery, London.

19 Plietzsch 1960, p. 48.

20 Roosen-Runge 1966.

21 G. Q. Williams and P. Kemp, "'The Music Dealer' by Carel Fabritius, an Explanation of Distorted Perspective." I have never been given the opportunity to read the paper, which was submitted to a British journal in 1975. It was described to me in some detail by David Bomford (see n. 22) and by Christopher Brown, who also allowed me to examine the perspective box made by Williams and Kemp.

22 Elkins 1988, pp. 274-75, n. 28, with a diagram showing "some possible curvatures" adapted from Williams and Kemp's analysis. Elkins was provided with a copy of the paper "and copious additional notes" by Williams (see Elkins, n. 27) and concluded that the Bristol findings were consistent with "a nearly semicylindrical shape" and a parabolic shape, "within acceptable limits of error" (n. 30). When David Bomford of the Conservation Department of The National Gallery read the same paper in 1975 he concluded that the curve was determined empirically after the angles between a few buildings had been measured (as reported in Liedtke 1976a, p. 62, n. 2).

23 See n. 21. The box reproduced in figs. 43, 44, was made in 1972 and shown to Arthur Wheelock in that year.

24 This point was stressed in Liedtke 1976a, p. 69, n. 33, but missed by some critics: see n. 26.

25 The pair in Copenhagen (see figs. 91, 92) and the box in the Bredius Museum: see Koslow 1967; Blankert 1991a, no. 57; The Hague 1996a, pp. 24-25; and Bomford 1998. Bomford, in Brown, Bomford, Plesters and Mills 1987, pp. 71-72, makes the point that the rectangular box in London by Van Hoogstraten (figs. 54, 55) resembles two triangular boxes with peepholes at the corners.

26 Horst Gerson, letter to the writer dated 22 June, 1976 ("I think you are completely right in your interpretation"); Slatkes 1981, p. 119; Brown 1981, pp. 44, 123-26, no. 5; MacLaren/Brown 1991, pp. 137-38; Brusati 1995, p. 309, n. 33; Sutton in Dulwich-Hartford 1998-99, p. 23 (citing only Keith 1994). Sutton had a copy of my model mounted on a wall in the didactic section of the De Hooch exhibition at Hartford (1998-99).

A few writers have drawn erroneous conclusions from the simple geometry of my reconstruction. Ruurs 1981-82, pp. 264-65, claims that my model (which he has never seen) "does bring the Nieuwe Kerk slightly closer, but it is still far too small." A brief survey of hotel keyholes would have revealed to Ruurs that the extent of view depends entirely upon the dimensions and especially the depth of the aperture, not the shape of the room. He continues, "nor do I understand how Liedtke thinks that a scene which in reality covers a horizontal angle of more than 90 degrees [see the map, fig. 42] could be presented faithfully and free of distortion within a visual angle (from the eye to the edges of the curved painting) of only 60 degrees" (my box forms an equilateral triangle). In this case one might send the scholar (Ruurs, or Elkins [1988, p. 270], who makes the same mistake) to a "Cinerama" theater, where he may sit in any seat. The perspective box is not a reconstruction of viewing conditions at the actual site, but an anamorphic device designed to make the image (which could have been imaginary) look illusionistic by eliminating or at least minimizing the viewer's awareness of the picture surface. The perspective box also allows a roving eye to view the picture, somewhat as in painted barrel vaults of the seventeenth and eighteenth centuries (see Czymmek 1981); on this point see Hultén 1952, pp. 286-87; Hinks 1955; Koslow 1967; Kemp 1990, pp. 138-39; and Bomford, in Brown, Bomford, Plesters and Mills 1987, p. 68. Veltman 1979, p. 81, and Wheelock 1977a, p. 11, forget this property of perspective boxes when they complain that Fabritius's signature and the lute become distorted when seen in the photograph of my curved reconstruction (fig. 46). As Keith 1994, pp. 59, 63, n. 21, clarifies in the caption to the same photograph and in rebuttal to Wheelock, "the fixed focal point of the camera lens compresses the intended anamorphic distortions of the outer sections of the picture slightly more than would be experienced from the same physical position by the cumulative image produced by the single, scanning human eye." In other words, what one sees in fig. 46, a projection onto a flat picture plane, is not what one sees in the reconstructed perspective box, where the line of sight meets the picture surface at a constantly changing angle. This is true for all known Dutch perspective boxes: they are anamorphic images projected onto surfaces that are meant to be seen (or not seen, when the illusion works) from acute angles. If, by contrast, the viewpoint were placed at the center of the circle described by an image on a hemicylindrical surface, as Ruurs seems to require, then one would view the picture orthogonally in all directions, as in large-scale panoramas of the nineteenth century (see Kemp 1990, pp. 213-15). (The viewing distance in this case would be about 10 cm, impossibly close.) No forms would be distorted anamorphically. If they were distorted (as they are in flat mountings of *A View in Delft*), they would not be corrected.

27 Compare the trees in the landscape painting that is projected anamorphically in the upper left corner of the box in the Bredius Museum (see Blankert 1991, no. 57; The Hague 1996a, p. 24). On anamorphic images see Leeman 1976; Baltrušaitis 1977; Kemp 1990, pp. 208-12, passim (see index).

28 Wheelock 1977a, p. 9, faults my "subjective" judgment of a house that no longer exists, but maps of Delft (fig. 42) make its shape and position clear enough.

29 As discussed below. Compare Houckgeest's geometric areas of sunlight in the panel of 1651 (fig. 41, left).

30 Van Hoogstraten 1678, p. 308, where he discusses the use of shadows in illusionistic pictures.

31 The phrase (quoted in the title of Koslow 1967) is from Van Hoogstraten 1678, p. 274.

32 Brusati 1995, Chs. 3-5.

33 Brown 1981, p. 152, doc. no. 23.

34 See Brusati 1995, pp. 52-78.

35 Brusati 1995, pp. 58-74.

36 See Brusati 1995, pp. 54-55.

37 Brusati 1995, pp. 91-109. For Pepys's response see Liedtke 1991b.

38 For Van Bleyswijck's and Van Hoogstraten's accounts of Fabritius, see Brown 1981, Appendix B.

39 Wheelock 1977a, p. 11, responding to Liedtke 1976a, writes of *A View in Delft*, "its spatial distortions are too subjective to be effectively calculated and measured." The criticism should have been levelled at Roosen-Runge, Williams and Kemp, and Elkins, none of whom Wheelock has answered. On Parmigianino's self-portrait see Freedberg 1950, pp. 201-2.

40 The quotes are from Wheelock 1977a, p. 11, and Wheelock 1981, p. 37.

41 Van Hoogstraten 1678, p. 274. See Liedtke 1976a, p. 62, n. 10, on Wheelock's mistranslation of this passage (acknowledged in Wheelock 1977a, p. 7), so that it seems to suggest that "mirrors could be used as an

aid in mural painting." In his rebuttal, Wheelock adds, "It is inconceivable that Fabritius was not familiar with these optical devices given Van Hoogstraten's enthusiastic recommendation of them." No doubt, but Fabritius died twenty-four years before Van Hoogstraten's praise appeared in print.

42 Van Hoogstraten 1678, pp. 274-76. On this chapter of the *Inleyding* see Brusati 1995, pp. 194-98, and pp. 10-12 on the importance to Van Hoogstraten of Vredeman de Vries. On Jan Saenredam's engraving after Goltzius, *The Sense of Sight*, which is mentioned by Van Hoogstraten on p. 275, see Sluijter 1991-92. On Desargues see Baltrušaitis 1977, pp. 71-78; Descargues 1977, pp. 106-10; and especially Field 1997, pp. 190-226.

43 On the last point see Brusati 1995, pp. 69-70.

44 Van Hoogstraten 1678, pp. 24-25, as translated in Brusati 1995, p. 11, who observes that "in his treatise, Van Hoogstraten gives this tradition of honorable deceits paradigmatic status." Compare the views of Philips Angel, *Lof der Schilderkonst*, Leiden, 1642, as discussed in Brusati 1995, p. 230, and especially in Sluijter 1993.

45 Van Hoogstraten 1678, p. 263, as translated in Brusati 1995, p. 71.

46 See Brusati 1995, pp. 72-73, fig. 43, making this connection convincingly.

47 Brusati 1995, p. 225, quoting Van Hoogstraten's well-known remark that "one must, through the habit of attentive observation, aim to make the eye into a compass."

48 Wheelock 1977a, p. 73, where he continues: "Unhindered by restrictions imposed by traditional perspective theory, Fabritius probably felt free to utilize its [wide-angle vision's?] expressive characteristics without concern for the distortions it created."

49 Van Hoogstraten 1678, p. 34, probably meaning whichever is the greater dimension, which yields a viewing angle of about fifty-three degrees.

50 Wheelock 1977a, reviewed in Liedtke 1979c. Wheelock's hypothesis was first published in Wheelock 1973 and is still maintained in the 1988 edition (pp. 34-35) of Wheelock 1981 (pp. 36-37; "must have used a lens not to ensure an accurate depiction of the site but to exploit its peculiarly distorting effects for their emotional impact").

51 On Leonardo see Kemp 1990, pp. 44-52; on Fouquet and Steen see Elkins 1988; and on Saenredam, Liedtke 1975-76 and Ruurs 1987. On Vermeer see Wheelock 1977a, Ch. 7.

52 Kemp 1990, p. 119.

53 For example, Saenredam's sketch of the tower of the Nieuwe Kerk in Haarlem (fig. 59), as discussed in Liedtke 1975-76; Amsterdam 1993-94b, no. 73 (etching, about 1690 ?). See De Lairesse's remark on concave mirrors, quoted by Wheelock 1977a, p. 6.

54 Crary 1992, p. 32, assails Wheelock 1977b on this score. On the lens of about 1800 that was employed by Wheelock, see Wheelock 1973, n. 42. He cites Peter Kylstra of the Universiteitsmuseum, Utrecht, who attributes the lens to J. M. Kleman, Amsterdam, in the late eighteenth century, and suggests that "the scale and structure of the lens indicates that it was designed for the purpose of making perspective views." In other words, it is an example of the kind of eighteenth-century optical devices that were used in the pursuit of the Picturesque, like the camera obscura featured in Paul Sandby's *Rosslyn Castle* of about 1775 (Yale Center for British Art, New Haven), and like the Claude Glass. The latter device (which was usually slightly convex) was used at about the same time by Thomas Gray at Kirkstall Abbey to capture the landscape, including "the glittering and murmur of the stream, the lofty towers and long perspectives of the church." See Kemp 1990, pp. 198-99, figs. 394-95.

55 Wheelock 1975-76; Wheelock in Washington-The Hague 1995-96, p. 124.

56 As Wheelock 1973, p. 77, observes, "Another question that is difficult to answer is the exact subject of the painting. The present title is certainly inadequate." He sees the left side of the composition as an addition to the original concept, and the composition as a whole as possibly a fragment of a larger design. On the latter point see MacLaren/Brown 1991, pp. 137-38, and Keith 1994, p. 60 ("Wheelock's assertion that the canvas has been trimmed is not consistent with an examination of the canvas cusping").

57 See the celebrated introduction to *Studies in Iconology* (Panofsky 1962, Ch. 1), and Holly 1984, pp. 24-31.

58 Brusati 1995, p. 227.

59 See Brown 1981, p. 160.

60 Vermeer's concern with effects of light, focus, and so on was obviously more sophisticated than Van Hoogstraten's, but Kemp 1990, p. 119, understandably applauds the latter's "wholehearted placing of illusion in the service of natural representation."

61 See also the other articles by Schwarz listed in Wheelock 1977a, p. 342, and his posthumous collection of essays, Schwarz 1985. In the same years the relationship between art and visual perception was studied by many scholars outside the field of Dutch art, for example, Arnheim, Baltrušaitis, Boring, Gibson, Gombrich and Gregory, Parronchi, Pirenne, and White (see the bibliographies in Wheelock 1977a and in Liedtke 1982a, and Hagen 1980).

62 Wheelock 1977a, pp. 209, 274-75.

63 The quote about colors and so on is from Wheelock 1981, p. 38.

64 Wheelock 1977b, p. 101.

65 Stechow 1966 (see also London 1986); Schama in Amsterdam-Boston-Philadelphia 1987-88, pp. 70-71; Montias 1990, pp. 360, 371, on tonalism and cost. Gifford 1995 describes the importance of changing techniques for the new style.

66 See Brusati 1995, pp. 19, 131, 272 (n. 23), 286 (n. 44), and especially Loughman in Dordrecht 1992-93, pp. 59-60, fig. 16 (window-shutter type of camera obscura illustrated in Johan van Beverwijck's *De Schat der Ongesontheyt*, Dordrecht, 1642).

67 See Wheelock 1973, p. 78, n. 9. The distortions are not spherical but cylindrical and are consistent with the curved mounting of the canvas. As Bosse's diagram of a vault (fig. 57) demonstrates, curved lines on a curved surface look straight from the proper vantage point.

68 D'Otrange Mastai 1975, pp. 84-85, fig. 66 and pls. 3, 4. For the panel by Christus, *A Goldsmith in His Shop, Possibly Saint Eligius*, in New York, see Della Sperling's entry in New York 1998-99, no. 22 (p. 153 on the mirror).

69 The Claesz in Nürnberg (fig. 61) is catalogued in Tacke 1995, pp. 69-70, no. 23. Glass spheres and similar objects in Dutch paintings are obviously related to the contemporary interest in anamorphic images which become comprehensible when viewed in a tubular or some other form of shaped mirror (see Leeman 1976). On Dou's possible use of a curved mirror or lens, see Wheelock in Washington 1978, pp. 64-65.

70 Teding van Berckhout is quoted by Wadum in The Hague 1996a, p. 47. For Van Bleyswijck on Van Vliet see p. 127.

71 See Brusati 1995, p. 93, who compares Wren's remark with Pepys's reaction to Van Hoogstraten's *View down a Corridor* (fig. 97).

72 Brown 1981, p. 126. Compare Wheelock 1973, p. 75.

73 Brown 1981, pp. 125-26, and MacLaren/Brown 1991, p. 138.

74 Keith 1994, p. 60, fig. 7, supporting Wheelock 1973, p. 74, fig. 5.

75 The quotes are from Wheelock 1973, p. 74. See Keith 1994, p. 55, and pls. 1, 2, comparing the canvas before and after conservation. In Washington-The Hague 1995-96, pp. 19-20, Wheelock suggests that "the brooding melancholia of Vermeer's *Diana and Her Companions* and

A Woman Asleep, ca. 1657 recalls the mood of Fabritius's *A View in Delft* and *The Sentry*."

76 Wheelock 1973, p. 75, who tempers his statement in n. 43. Brown 1981, p. 125, summarizes: "All of which is to say in effect that there is no evidence one way or the other."

77 Wheelock 1973, p. 76.

78 Wheelock 1973, n. 43.

79 Keith 1994, p. 60, responding to Wheelock's analysis, explains that "canvases were often stretched and primed in large sizes, to be trimmed later to the desired picture size … Examination of the cusping of *A View in Delft*, which is visible in an X-radiograph (fig. 8), indicates only that its canvas was primed in larger size than was later used for the painting, and also that the piece was probably taken from near a corner of the primed fabric, resulting in greater cusping along adjacent sides."

80 All quotes are from Keith 1994, p. 55.

81 Keith 1994, p. 60.

82 Wheelock 1973, p. 74, on the man and the trellis as "later additions," and p. 75 on "the composite nature of this half of the composition." See n. 56 above.

83 Keith 1994, p. 60, responding to Wheelock's assertion (in Wheelock 1977a, p. 200) that "Fabritius composed the picture additively."

84 Keith 1994, p. 61, and fig. 1 on p. 56.

85 Keith 1994, p. 60. The word "extreme" is misleading here since the proposed projection onto the floor of the perspective box (which would depict the bottom of the viola da gamba, a continuation of the cobblestones, and perhaps a bit more of the tablecloth on the left; see pl. 4) would be less distorted than many anamorphic projections within surviving boxes.

86 Keith 1994, pp. 57-59, caption to fig. 4 (quoted in n. 26 above), and n. 21 on p. 63, correcting Wheelock 1977a, p. 11.

87 The last three quotations are from Keith 1994, pp. 59, 57, and 63 (n. 24), respectively. On the eye overruling linear perspective, see Bauer 1982, pp. 141-43.

88 Keith 1994, pp. 57-58.

89 Quoting Keith's colleague, David Bomford, in Brown, Bomford, Plesters and Mills 1987, pp. 69-70, on "peepshow construction." See also Bomford 1998.

90 Quoting from Keith 1994, pp. 62, 57, respectively.

91 Keith 1994, pp. 55, 62, n. 1, and pl. 3, quoting from the caption. The canvas was removed from the later wood support and "relined" (with linen canvas) for the first time (see Keith 1994, p. 57, for a full description of the process).

92 These quotes are all from Keith 1994, p. 62.

93 See De Groot 1979, figs. 75-78, for a few of these prints reproduced in actual size.

94 Wadum in The Hague 1996a, p. 45.

95 Brown 1981, pp. 15, 84, n. 16, and p. 146, doc. no. 2.

96 See Bomford in Brown, Bomford, Plesters and Mills 1987, p. 70, who found traces of paper around the edges of the light apertures in three perspective boxes.

97 See Snoep 1969; Brown 1981, pp. 53, 162; Milwaukee 1992-93, no. 17; Delft 1994, pp. 63-67; and Quentin Buvelot's essay in Amsterdam 1995, Ch. 4.

98 The point needs no support, but see the essays in The Hague-Antwerp 1994, and Buijsen's contribution to The Hague 1996b.

99 Ruurs 1981-82, p. 265, with no reference to Liedtke 1976, p. 72, n. 60. On this "type" of frame (it was frequently modified in the sixteenth and seventeenth centuries) see Kemp 1990, pp. 168-84, which provides a useful background for the following discussion.

100 Kemp 1990, figs. 335, 352, 359-62, 365. See also Simon Stevin's frame and sight on a stand, illustrated in Kemp 1986, p. 243, fig. 11. The terms drawing frame and perspective frame are used interchangeably in modern literature. "Glass frame" is a common but inaccurate term.

101 As discussed in Liedtke 1982a, pp. 52-54, and briefly in the next chapter. De Vries 1975, pp. 39-40, reached the same conclusion independently. Houckgeest may have left Delft by March 1652, but Fabritius could have consulted him about the use of perspective frames before he recorded this or an earlier topographical view.

102 Kemp 1990, p. 169, fig. 324, reproducing the relevant illustration from Gemma Frisius, *De Radio astronomico …* , Antwerp, 1545. On recording exterior views of architecture in the Renaissance, see Kemp 1991-92, pp. 95-100. On the *radius*, which is known as a Jacob's Staff or cross-staff, see The Hague 1996a, p. 51, and Frankfurt 1997, pp. 58-59, no. 3 (eighteenth-century example), comparing the one hanging between the windows in Vermeer's *Geographer* (see Washington-The Hague 1995-96, p. 172 under no. 16). Cross-staffs are seen with globes in Salomon de Bray's drawing of a book and picture shop, 1628 (Rijksmuseum, Amsterdam), and in Gabriël Metsu's *A Young Woman Seated Drawing* (National Gallery, London). Cross-staffs in use are shown in Lieve Verschuier's *The Comet of December 1680 as Seen in Rotterdam* (Historisch Museum, Rotterdam; Washington-The Hague 1995-96, p. 41, fig. 16); the two related drawings in the Gemeentearchief, Rotterdam, are both inscribed: *Staart-ster in W.Z.W. Hoog 13 Lang 54 gra. 26 Des. 1680*.

103 See Kemp 1990, p. 183; The Hague 1996a, pp. 34-36 on drawing frames, p. 51 on land surveying, and pp. 65-69 on cartographers and painters.

104 See Hanover-Raleigh-Houston-Atlanta 1991-93, especially pp. 242-22 on Kircher's museum, pp. 386-88 on "marvels of art," and pp. 433-40 on perspective, anamorphs, and optical aids. On scientific instruments as status symbols see The Hague 1996a, p. 23, and the publications by K. van Berkel cited therein. Still of interest is Ornstein 1928, especially pp. 56-58 in the discussion of individual scientists, and pp. 111-15 on instruments at the Royal Society. On contemporary developments in Italy, see Findlen 1994, Ch. Five ("*Fare Esperienza*"), especially pp. 201-8 on the optical instruments in Antonio Giganti's *studio* in sixteenth-century Bologna, and on the pursuit of "experience"; also Thornton 1997.

105 Kemp 1990, p. 171, suggests that a drawing frame might have been used for images of this kind. See Leeman 1976, pls. 13-17, for views of the *studiolo* in Urbino; Raggio and Wilmering 1996 on the *studiolo* formerly in Gubbio (now in The Metropolitan Museum of Art, New York).

106 Kemp 1990, pp. 172-73; see also the chapter on Dürer and perspective by Joseph Harnest in Strieder 1989, pp. 347-60.

107 See Descargues 1977, pp. 60-62, pl. 38 (Barbaro, after Dürer), 88-89 (Accolti); Baltrušaitis 1977, p. 93, on De Caus and Accolti.

108 See Kemp 1990, pp. 183-84, fig. 364. The Princeton drawing was catalogued in Gibbons 1977, no. 719, as an "intarsia design?" of the "fifteenth century (?)." Its date and function are a subject of debate.

109 Davis 1980, pp. 184-90 on the *mazzocchio*, and p. 196 on the lute ("the representation of Dürer's simple lute has required establishing more than one hundred and eighty points"). See also M. Kemp in Washington 1991-92, nos. 139-40 for the *mazzocchio*, the drawing of a chalice and its attribution to Uccello.

110 See Baltrušaitis 1977, pp. 93, 109-10. See also Kemp 1986, pp. 240, 242, on Kepler's and Stevin's interest in geometrical theories of music, and Kemp 1990, pp. 86-89, on G. B. Benedetti.

111 Wheelock 1977a, p. 8, complains that the surviving boxes are larger, on wood, and depict interiors.

112 See Koslow 1967; Liedtke 1976b; Brown, Bomford, Plesters and Mills 1987, fig. 19 (one of the two peepholes of Van Hoogstraten's box in London allows an oblique view downward of a chair and a letter bearing the artist's name); Blankert 1991, no. 57, and The Hague 1996a, pp. 24-25, for the box in the Bredius Museum. The exception is the amateurish box depicting a domestic interior, in the Nationalmuseum, Copenhagen (Koslow 1967, figs. 16, 17).

113 On this plate and a more complex example in Vredeman de Vries, see Kemp 1990, pp. 110-12, figs. 209, 213.

114 Hondius 1622, p. 17 (as noted in Wheelock 1973, p. 82, n. 39).

115 Orenstein 1994, pp. 197-209, and pp. 188-91 for Hondius's own treatise of 1622.

116 Orenstein 1990; Dumas 1991, p. 649; Orenstein 1996, p. 32. Dumas suggests that the print was made in connection with the rebuilding of the Stadholder's Quarters (the wing on the right, with the archway) in 1621.

117 Orenstein 1996, p. 33. The relationship of Hondius to Huygens about 1637-44 may be judged from four letters from the former to the latter: Unger 1891, pp. 190-93.

118 De Bie 1661, p. 488. He also records that Hondius stayed in London and Paris, where he visited numerous *konst-kamers en Schadt-cabinetten by verscheyde Princen en Heeren.*

119 As noted by Ruurs 1981-82, p. 265.

120 See Liedtke 1982a, pp. 48-49; Kemp 1990, p. 117; and De Boer 1988, pp. 171-72, fig. 15, where the angle of view is said to be 116 degrees.

121 Of course, Fabritius could have used his initial cartoon for different purposes. He might have made a conventional picture or a mural of the same design; an anamorphic mural, like the ones published and painted by Maignan and Niceron in the previous decade (see Baltrušaitis 1977, Ch. 3); or a perspective box with a rectangular, triangular, or other surface inside.

122 See p. 49 above. It might be stressed once more that the hemicylindrical surface placed at an arbitrary distance from the viewer's eye is an artistic analogy, not a replication of the experience at the site. Compare Liedtke 1976, pp. 71-72, with Ruurs 1981-82, p. 264.

123 See Liedtke 1976a, p. 71, and Kemp 1990, pp. 109-10.

124 Kemp 1990, pp. 174-77, on Danti and Lanci, and p. 172 on Dürer. See also Liedtke 1976a, p. 71, especially nn. 51 and 52; Maltese 1980; Frangenberg 1986, pp. 168-71; and Conforti 1993, p. 173, fig. 188 (Lanci's view of Florence).

125 See Kemp 1990, p. 183, fig. 361.

126 Kemp 1990, pp. 180-82, figs. 353-57.

127 See The Hague 1996a, p. 29 (ill.). The device bears the engraved signature of Jacobus de Steur of Leiden.

128 See Keith 1994, p. 60, describing the painting's "clear underdrawing of a more or less consistent level of finish throughout."

129 See Schwartz and Bok 1990, p. 80, fig. 86.

130 See Bomford in Brown, Bomford, Plesters and Mills 1987, pp. 69-70, and Bomford 1998.

131 For example, Lomazzo, in his *Trattato* of 1585, divides perspective into optics, artificial perspective, and the study of reflections, and considers cast shadows in one section of the second category. De Caus (1612) and Marolois (1628) adopted Dürer's two methods of shadow projection; De Caus employed the *näherer Weg* to plot precisely the shadows of objects and people in a contemporary interior (figs. 80, 81). Other writers, such as Aguilon (1613) and Accolti (1625), criticized Dürer and his followers for treating sunlight as if it cast shadows as simply as does candlelight. Dubreuil (1642) and Van Hoogstraten (1678) stuck with the traditional method, although the former pirated and the latter cited Desargues (that is, Bosse's *Manière universelle de M. Desargues* of 1647), who was the first scholar to develop a correct method of solar shadow projection. Van Hoogstraten's chapter on cast shadows immediately precedes the one on linear perspective. See Bomford in Brown, Bomford, Plesters and Mills 1987, p. 66, on the authors cited by Van Hoogstraten, and especially Kaufmann 1993, Ch. 2, on shadow projection in treatises.

132 See Van Hoogstraten 1678, pp. 269-71.

133 See Kemp 1990, p. 133, fig. 256.

134 See Kemp 1990, pp. 25, 55, and 118 on Van Hoogstraten's treatise: "It is organized in nine books, each dedicated to one of the Muses, and is predominantly larded with generous helpings of derivative humanist learning which serve to emphasise the high intellectual and social status of painting." A slightly different spin is found in Brusati 1995. Also of interest: Emmens 1968.

135 On the changing concept of what is *schilderachtig*, see Bakker 1995 (also of interest: Chihaya 1992). Reindert Falkenburg pointed out the idea's relevance here. There are other painterly walls in Fabritius's small oeuvre (and in De Hooch and Vermeer). The placement of the lute against the wall, which bears the artist's signature and date, deserves comparison with *The Goldfinch* of 1654 (pl. v).

136 On "the creation of the pictorial idea" see Van de Wetering 1997, Ch. IV, and Ch. VII on the "rough and smooth manners" and illusionism.

137 Brown 1981, p. 86, n. 31. In a letter of August 28, 1997, R. E. O. Ekkart informed the writer that there were no other candidates in Delft about 1650 for the designation of "Dr. Valentius."

138 Montias 1982, fig. 3; Baetjer 1995, p. 297.

139 See Delft 1981, fig. 125, and The Hague 1998-99b, p. 16, fig. 9. Moes 1897-1905, nos. 1886, 1890, lists the Delft and New York portraits by Van Miereveld.

140 Brown 1981, p. 86, n. 31, found no contemporary account of the house. An unnoticed record of the building's exact location may yet surface at the Gemeentearchief, Delft.

141 Wijnman 1931, p. 140. Two *tronien* and another painting (*een stuckje schildery*) by Fabritius were also listed in Vermeer's estate of 1676 (Wijnman 1931, p. 140; Blankert 1978, p. 150, doc. no. 40; Montias 1989, p. 339, doc. no. 364).

142 Wijnman 1931, p. 137; Brown 1981, p. 157, doc. no. 40.

143 Van Mander 1994, p. 56. See Thieme/Becker 1907-50, IX, p. 28, where the reference to "Salomon D., der 1648 bei deren Begründung in die Delfter Lukasgilde aufgenommen wurde," mistakenly places the "konstryck Schilder" in Delft not Leiden (see Obreen 1877-90, v, p. 201, for the references to Salomon Delmanhorst in the Leiden guildbook). I am grateful to Hessel Miedema for essential help on this question (letter of May 6, 1998).

144 See Dumas 1991, pp. 667-73, for Binnenhof views; pp. 600-59 for the Hofvijver. For Hans Bols's Hofvijver painting of 1586 (Dresden), Hondius's engraving (*Curia Hollandiae*) of 1598, and a panoramic drawing attributed to C. J. Visscher, see Amsterdam-Toronto 1977, p. 67, fig. 1, and nos. 35, 91; also Dumas 1991, pp. 14-19, figs. 4, 6; pp. 649-55. Compare Dumas's nos. 6, 47, and 52.

145 See Dumas 1991, pp. 650-51 under no. 59, with numerous illustrations.

146 See the examples reproduced in Dumas 1991, pp. 650-55.

147 See Dumas 1991, pp. 222, 653, and especially 234, n. 29, citing the relevant literature.

148 For example, the Hofvijver view (from the Mauritshuis end) in a drawing cited above (n. 144) and in his engraving, *The "Arminiaanse Schans" in Leiden*, 1618 (Amsterdam-Toronto 1977, nos. 12, 91); and an etching, *View of Gennep*, 1641 (Amsterdam 1993-94b, no. 12).

149 As discussed above. See Brown 1981, p. 152, doc. no. 23.

150 Here the historian is frustrated by insufficient evidence. It would be interesting to know if Dr. Theodoor Vallensis or Jacob Vallensis (counsellor at the Court of Holland) – see document no. 2 in the text – had any connection with the Van Delmanhorst-Tachoen family in Leiden. Both families were involved with the Hoogeschool, the center of Latin studies in the Netherlands. Constantijn Huygens and Jan de Bisschop also come to mind. However, the number of people who might have admired either view by Fabritius includes a large part of educated society in the South Holland area and beyond. One example that does not leap to mind immediately is Johan Hilersig (Counsellor and Secretary to the Prince of Orange), whose widow, Catherina Hooft of Delft, owned "an unfinished work by Fabritius," the only one of forty paintings in her possession to be assigned an artist's name when they were auctioned on April 15, 1664 (Brown 1981, p. 154, doc. no. 32).

151 For the text see Brown 1981, p. 153, doc. no. 28.

152 Brown 1981, p. 157, doc. nos. 44, 45, where it is suggested that *A Sentry* (pl. VI) might be meant.

153 Washington-Amsterdam 1996-97, pp. 26-29.

154 Brown 1981, pp. 157-58, doc. no. 47.

155 On this point see Brown 1981, p. 124. For Mauer's painting in full see Liedtke 1982a, fig. 74.

156 Brown 1981, p. 154, doc. no. 30; see Liedtke 1976a, p. 65 and n. 11.

157 Koslow 1967, pp. 54-55, no. 5.

158 As noted by Liedtke 1976a, p. 65, and by Brown 1981, p. 124.

159 Van Bleyswijck 1667-80, II, p. 852; see Brown 1981, p. 159.

160 Van Hoogstraten 1678, pp. 274, 308; see Brown 1981, p. 161.

161 Hofstede de Groot 1907-27, I, p. 574, no. 4.

162 Holmes 1923, p. 87.

163 Jantzen 1910, p. 151, uses Hofstede de Groot's title. MacLaren/Brown 1991, p. 137, retains the title used in MacLaren 1960, p. 127: *A View in Delft, with a Musical Instrument Seller's Stall*. Lokin in Delft 1996, p. 91, and other writers simply follow the Gallery's form.

164 Wheelock 1973, p. 77; Liedtke 1976a, p. 61.

165 For example, Slatkes 1981, p. 119, and Düchting 1996, p. 13.

166 Amman 1973, p. 111.

167 Fischer 1975, p. 99 (ill.); Hempstead 1995, no. 55.

168 See Giskes 1994, and Hempstead 1995, p. 138.

169 Pepys 1985, p. 900, in the entry for April 4, 1668.

170 Pepys 1985, p. 17.

171 See the discussion of Huygens in The Hague-Antwerp 1994, pp. 72-74, 82-86; and Buijsen in The Hague 1996b, pp. 110-18 on Huygens and Duarte.

172 See The Hague 1996b, p. 113.

173 See Legêne's article and addendum on inventories in The Hague-Antwerp 1994. Montias found very few viols in seventeenth-century Delft households (mentioned in the Vermeer symposium at the Rijksbureau voor Kunsthistorische Documentatie, The Hague, May 30-31, 1996). The "nobility" of the lute sets it apart from a pile of wind instruments in Roemer Visscher's emblem, "Niet hoe veel, maer hoe eel" (see Peeters in The Hague 1996b, p. 11, with ill.).

174 See the works illustrated by Kryova in The Hague-Antwerp 1994.

175 Memo to the writer dated July 9, 1996.

176 Heyde 1994, p. 191, fig. 28.

177 For two examples by Steen see Washington-Amsterdam 1996-97, no. 22. In an illustration to a legal text of 1549 a sign with a swan serves to indicate an inn (Van Deursen 1991, p. 228, fig. 32). Similarly, in his scene of Saint Agnes being forced into a brothel (Palazzo Reale, Genoa) the Master of the Adoration of the Magi of Turin (ca. 1500) identifies the building simply with the sign of the swan.

178 See Leiden 1988, no. 38, where Sluijter suggests that "De aard van de herberg waar de trompetter voor zit, wordt waarschijnlijk aangeduid door de zwaan op het uithangbord, immers een attribuut van de liefdesgodin Venus."

179 See, for example, Renger 1970, figs. 5, 57, 60; Raupp 1986, figs. 170, 194, 203, 221.

180 See The Hague-Antwerp 1994, pp. 54-55, fig. 22, where Kyrova wonders "whether a fragile and costly instrument such as the lute would have been played at these outdoor pastimes." The serving maid and other motifs make it clear that the setting is the exterior of a public not a private house. See also Claes Jansz Visscher's engraving after Vinckboons, *The Prodigal Son* of 1608 (Antwerp 1994, p. 90, no. 38), for a similar company under an arbor at an inn. In the background the fallen hero is expelled from a bordello bearing the sign of the swan.

181 Augsburg-Cleveland 1975-76, no. A 13, pl. 14 (the woman on the right holds a fiddle not "a lute," as claimed on p. 77); Klessmann 1999, no. 33, pl. 7. For similar arbors with vine leaves above, see Paris-Montpellier 1998, nos. 25 (Dujardin), 52 (Steen); Amsterdam 1997b, no. 30 (Matham).

182 Moxey 1989, Ch. 3, on Beham; Goossens 1977 on Vinckboons (see fig. 36). See the vine-covered porch and inn sign featured by Steen in *A Village Revel* of 1673 in Buckingham Palace (Washington-Amsterdam 1996, no. 46, where Chapman recalls that Steen petitioned to open an inn during the previous year). See also Washington-Amsterdam 1996, p. 113, fig. 1 (etching by Adriaen van Ostade, 1652); p. 144, fig. 2; no. 17 and comparative illustrations; no. 24 (for the vine); p. 219, fig. 1; and no. 48 (*Merry Company on a Terrace*, Metropolitan Museum of Art, New York). The general arrangement of *A Village Revel* may have been borrowed from Jan van de Velde II's engraving, *A Village Festival* of 1630, which also shows a vine-covered portico in front of the tavern (Lawrence-New Haven-Austin 1983-84, no. 30).

183 See Balfoort 1981, pp. 38-41; Hempstead 1995, p. 139, n. 3, citing J. H. Giskes (see Giskes 1994); and Buijsen in The Hague 1996b, p. 110.

184 See Haverkamp Begemann 1959, no. VIII; Philadelphia-Berlin-London 1984, no. 26; The Hague-Antwerp 1994, p. 160. Compare the anonymous drawing, *A Tavern Scene*, in the Institut Néerlandais, Paris, illustrated in New York-Boston-Chicago 1972-73, no. 110. In Joachim Beuckelaer's *The Prodigal Son Among Whores* in Brussels, a lute and glass are offered together by the serving maid (see Renger 1970, p. 136, fig. 87).

185 See Balfoort 1981, p. 40.

186 Cited by Buijsen in The Hague 1996b, p. 110.

187 See Van Deursen 1991, pp. 85-87; Schwartz 1966-67, on the same reservations about organ music.

188 See Haeger 1986.

189 See Liedtke 1977, and Sumowski 1983-[94], II, nos. 563-65.

190 Brown 1981, p. 125, and MacLaren/Brown 1991, p. 138, appear to concede this point. Brown rejects the swan as a *memento mori*, which is not what I had intended to suggest in the subjective last paragraph of Liedtke 1976a.

191 Sluijter in Leiden 1988, p. 158.

192 The play is related to a painting by Duck in Welu 1975b. See also Chapman 1990, pp. 117-18.

193 See The Hague-Antwerp 1994, p. 120.

194 See my entry on the New York picture in Stockholm 1992-93, pp. 316-18, and Moens 1986, p. 55, on the London canvas.

195 Fischer 1975, pp. 63-72.

196 Fischer 1975, p. 86.

197 Many examples will be familiar to the reader from well-known publications. See also Blankert 1991a, p. 164, and The Hague-Antwerp 1994, pp. 58-61, fig. 26, on Hendrick Pot's *Painter in his Studio* in the Bredius Museum, The Hague; Caen-Paris 1990-91, nos. O.25 and O.26; De Mirimonde 1978-79; Destot 1994, pp. 202-3, for an *Allegory of Vanity* attributed to Jürgen Ovens.

198 Caen-Paris 1990-91, no. O.17.

199 See, for example, the encyclopedic collection in Pieter Boel's *Allegory of Worldly Vanity*, 1663 (Musée des Beaux-Arts, Lille), which the writer discussed in New York 1992-93, pp. 79-83.

200 See Veca 1981, p. 58, fig. 65.

201 See my discussion in New York 1992-93, pp. 105-6.

202 See Philadelphia-Berlin-London 1984, no. 78.

203 Bauman and Liedtke 1992, p. 339, no. 262; Auckland 1982, no. 8. The canvas is signed and dated 1646; the view was once thought to represent Antwerp.

204 Cited in Welu 1975b, p. 16, n. 6.

205 See Kemp 1990, pp. 210-12.

206 For the latest analysis of Holbein's picture see London 1997-98. The crucifix covered by a curtain may have been inspired by church custom: see, for example, Smith 1957-59.

207 Manke 1963, no. 12; Liedtke 1982a, p. 82, figs. 73, 74.

208 See Falkenburg's essay on Aertsen and Lowenthal's on Kalf in Lowenthal 1996.

209 See Philippot 1966 and Smith 1957-59.

210 The known examples are later but the form may have been known before its use in Delft. See Sumowski 1983-[94], I, nos. 308, 309, for the examples by Dou in the Gemäldegalerie, Dresden, and in the Louvre.

211 On the Copenhagen boxes see Koslow 1967 and Liedtke 1976b.

212 The most similar example is Van Hoogstraten's illusionistic painting of a cabinet with liturgical vessels and a letter rack holding various objects, in Kroměříž Castle (Brusati 1995, no. 77, fig. 42).

213 On the perspective box in Detroit see Koslow 1967, pp. 53-54, and Brusati 1995, no. 87, pl. VII, figs. 58, 59, and p. 97.

214 See Smith 1957-59.

215 Tümpel 1986, pp. 243 (ills.), 245.

216 For example, in De Witte's painting of the Nieuwe Kerk (1653) in the Carter Collection (fig. 160): see Liedtke 1982a, p. 125, pl. VIII; and Rotterdam 1991, pp. 185-86, which speculates unconvincingly about priority in the use of the motif in Delft.

217 See Van Swigchem, Brouwer and Van Os 1984, pp. 24-25, fig. 1.

218 Wheelock 1977b, p. 93, quotes Huygens on the camera obscura ("here is life itself").

219 As in Wheelock 1973, pp. 75, 77.

220 See Brusati 1995, p. 65. On the Dou, New York 1995-96, no. 45.

221 On *aemulatio* and Rembrandt see Chapman 1990, pp. 65-66, and Van de Wetering 1997, p. 169. See Brusati 1995, pp. 151-53, on Dürer and the artist's "nobility," and on illusionism as self-display.

222 For the former see Alpers 1983. On the latter see Sluijter 1993, Brusati 1995, and Liedtke 1997. The distinction between art and describing was

considered by Bode to explain why Leonardo seemed of little interest to modern artists (Bode 1921, p. 145).

223 Gombrich 1972, p. 268. Gombrich enters the discussion fairly frequently in Van de Wetering 1997, for example, pp. 170-71 ("making comes before matching").

224 See Liedtke 1997, pp. 118, 120.

225 Compare Beck 1972-73, I, nos. 803, 804, 819 (drawings by Van Goyen); Amsterdam-Toronto 1977, no. 54 (Beerstraten); Plomp 1997, no. 69 (Doomer).

226 See Dumas 1991, pp. 653-54, and 95-100, respectively.

227 Blankert 1978, pp. 33-34, fig. 25, comparing the composition to that of Vermeer's *Young Woman Reading a Letter* in Dresden (fig. 263). On Bramer's copies see Plomp 1986 (no. 44 on this one).

228 See Raupp 1984, pp. 266-88.

229 See Kemp 1990, pp. 119-29, and especially McTighe 1998.

230 Clark 1966, pp. 64-67, 213, n. 13; see Klemm 1986, p. 333. On the history of the treatise see Pedretti 1969. Fabritius's townscape was connected with the *Trattato* in Liedtke 1976a, pp. 72-73, which is evidently where Wadum in The Hague 1996a, p. 33, came upon the idea.

231 Clark 1966, p. 64. The painting has been associated with Nicolaes Maes (to whom E. Haverkamp Begemann assigned the work) and with a drawing attributed to Fabritius: see MacLaren/Brown 1991, p. 332, nn. 8 and 9.

232 Evidently because this use of light was essential to "the primary purpose of the painter," Leonardo repeatedly discussed the technique of placing dark figures on a light ground. See, for example, Leonardo 1651, Chs. 159, 160, 288, 342 (= McMahon 1956, Chs. 147, 153, 456, 458; Pedretti 1965, Chs. 35, 42, 53, 38).

233 Leonardo 1651, Ch. 275, which combines McMahon 1956, Chs. 431 and 432.

234 See Pedretti 1965, pp. 146-47, and Gioseffi 1966, col. 764, comparing Leonardo's *sfumatura* to out-of-focus images in the camera obscura.

235 On the perspective frame see Leonardo 1651, Ch. 32 (McMahon 1956, Ch. 118; see also Ch. 119). On binocular vision see Leonardo 1651, Chs. 53 and 341 (McMahon 1956, Chs. 220 and 487), where he considers it impossible to paint an object "to seem in the same relief as the natural world" unless the image is seen with only one eye (diagrams illustrate the geometry). Aguilon (1613) and Descartes (1637) also wrote on the importance of binocular convergence for the perception of distances (see Boring 1942, p. 271).

236 Leonardo 1651, Chs. 300 and 201 (McMahon 1956, Chs. 498 and 497).

237 Alpers 1983, pp. 46-48, copes with Leonardo in the context of her argument about Northern and Southern artists by marginalizing him ("it is finally impossible to fix Leonardo in this scheme"), using some psychoanalysis and a peculiar comparison with Poussin on the question of "simple mirroring" as opposed to "selective or rational mirroring." Leonardo's remarks on selective vision might have been compared with Van Hoogstraten's on "selective naturalness" (which Alpers quotes selectively: see Liedtke 1997, pp. 118, 229, n. 20).

238 On Leonardo's contribution see Kaufmann 1993, pp. 58-65.

239 See Kemp 1990, pp. 74-76. Perhaps the closest comparisons with passages in Leonardo's treatise may be made not with any painting by Rembrandt or by one of his disciples but with Rubens's illustrations for François d'Aguilon's *Opticorum libri sex* (Antwerp, 1613), and with Rubens's use of color in some paintings and in a well-known landscape drawing (see Kemp 1990, pp. 99-104, 274-77).

240 See Grafton 1991 with regard to the sciences.

241 Wheelock 1977b; Kemp 1990, pp. 192, 196.

242 Wheelock 1977b, p. 93, quotes the original French and offers a slightly different translation, as does Kemp 1990, p. 192. See also Tierie 1932, Ch. v, and Wheelock 1977a, p. 156.

243 On Scheiner see Kemp 1990, pp. 180-83 (on the pentograph) and pp. 191-92, fig. 379 (on the eye and the camera with and without lenses).

244 This paragraph and the following owe much to Matthey 1973, pp. 350-57; see his n. 78 for the comment on Athanasius Kircher (on whom see Kemp 1990, pp. 191, 280, and Godwin 1979).

245 Wheelock 1977b, pp. 70, 77.

246 Kemp 1990, p. 101.

247 Matthey 1973, pp. 351, 353.

248 Kemp 1990, p. 119.

249 Kemp 1990, p. 89, makes this point with regard to Guidobaldo.

250 Matthey 1973, p. 359, on circulation; Chapman 1990, pp. 31-32 on Huygens's melancholy.

251 Huygens 1911-17, I, p. 94, quoting from Huygens's letter of April 13, 1622 (see Tierie 1932, pp. 50, 108-9, n. 3).

252 Alpers 1983, p. xxv, on the term, which she credits to Michael Baxandall.

253 Alpers 1983, pp. 99-109, etc. Kemp 1990, p. 251, gets by with one mention of Bacon, as the object of William Blake's scorn.

254 See Kaufmann 1988, pp. 105-15, and Chapman 1997, p. 334, who supports Kaufmann's suggestion "that origins for the illusionistic and scientific aspects of the realism often considered Dutch are to be found in the appreciation for naturalistic artifice in the Prague court of Rudolf II." This is not quite what Kaufmann "recently and more aggressively" stated in his Princeton and New York lectures of 1996 (see Chapman, n. 12). He spoke of numerous courts and artists throughout Europe and seemed aware of the precedents at Italian courts. See also Kaufmann 1995.

255 As noted in Brusati 1995, p. 285, n. 38; see pp. 70-71 on Van Hoogstraten and the camera obscura.

256 See Baltrušaitis 1977, pp. 16, 107, index under anamorphic depictions of royalty.

257 See Liedtke 1991a, p. 33 and n. 17. Charles I owned at least a dozen of Van Steenwyck's architectural pictures and "a little boock of Prospectives" by him.

258 Huygens 1971, p. 120. In the same passage Huygens suggests that the painter Johannes Torrentius did not know as much about such things as he let on.

259 See Brusati 1995, pp. 91, 109.

260 These quotes are repeated from my longer discussion of Povey, Pepys, and their interest in optics and perspective, in Liedtke 1991b, pp. 229-32. See also Brusati 1995, pp. 92-95.

Notes to Chapter Three

1 Biographies and surveys of the careers of Houckgeest, Van Vliet, and De Witte are available in Liedtke 1982a; see also Rotterdam 1991. The church interiors painted by Cornelis de Man were first discussed in Liedtke 1982b, the text of which was also printed in Liedtke 1982a. Everything known about Johannes Coesermans, who also painted architectural views in Delft, was presented in Liedtke 1992c. These artists are discussed more briefly below. Some thoughts on the relationship between architectural and genre painters in Delft were offered in Liedtke 1979b.

2 On the monument see Van Beresteyn 1936; Neurdenburg 1948, pp. 49-54, figs. 16-28; and Jimkes-Verkade 1981. On the Treaty of Münster (Peace of Westphalia), its politics and imagery, see Dane 1998.

3 See De Vries 1975, p. 25 and n. 6; Liedtke 1982a, p. 29. The document dates from 1640, but the designs may have been made earlier.

4 Montias 1982, p. 246, concludes on the basis of inventories that "a large percentage of all the households in Delft, rich and poor, seem to have hung portraits of the reigning *stadhouder* and his family on their walls."

5 For a brief review of these points see Israel 1995, Ch. 25. See also Ruurs in Rotterdam 1991, p. 43, who mentions Willem II's struggle against the Regents of Holland.

6 The inscription was composed about 1620 by Constantijn Huygens, whose Latin lines were chosen over those of Daniel Heinsius and of Hugo de Groot (see Jimkes-Verkade 1981, pp. 216-17 for the text in Latin and Dutch).

7 Israel 1995, p. 894, notes with regard to the "vogue" for views of the Nieuwe Kerk, with "a glimpse of the mausoleum of William the Silent," that the motif was "a sentimental attraction, doubtless, for Orangist buyers." He cites the wrong pages in Wheelock's dissertation; see Wheelock 1977a, pp. 235-46, and Wheelock 1975-76, pp. 179-81, on "the tomb of William the Silent and its significance in 1650-51." Wheelock maintains that, "in light of the contemporary concern over the nature of Willem II's relations to the states of Holland before his death, and over the future of the Republic subsequent to it, Houckgeest's sudden attraction to the tomb of William the Silent is understandable" (p. 180). However, the death of Willem II (November 6, 1650) could not have resulted in the original commission, if there was one. Boer 1988, p. 81, dismisses the idea out of hand, and with a view to his mistaken hypothesis that the painting by De Man in Louisville (fig. 177) is a transitional work by Houckgeest of about 1648-50 (see his p. 152), stresses that the Treaty of Münster made the tomb of William I into "a new symbol ... a national monument" (as if it were not already). By contrast, Giltaij and Jansen, in Rotterdam 1991, p. 170, remark that "it is uncertain whether the [Hamburg] painting has any iconographical meaning, but Houckgeest seems to have been primarily interested in achieving illusionistic perspective effects." This preoccupation would hardly have required Houckgeest's conversion, in this picture, from imaginary to real architectural views.

8 Slive 1995, p. 269. Compare Wheelock 1975-76, p. 180: "From this angular viewpoint, moreover, the allegorical figure of Liberty, perhaps the greatest of William I's gifts to the Netherlands, stands before us, highlighted by bright sunlight."

9 Wheelock 1975-76, p. 179. The slip is understandable, and points out the novelty of the program. See Delft 1996, pp. 64-65, fig. 50.A, for the motto carved on a corner of the tomb: *Te vindice tuta libertas* ("With your protection, liberty is safe").

10 It has been suggested that De Keyser's design was influenced by the Tomb of Henry II and Catherine de Médicis (1559-73) by Primaticcio and Germain Pilon in Saint Denis (Broos in Paris 1986, p. 263, following Neurdenberg 1930, p. 119, and Jimkes-Verkade 1981, p. 215). In this case the four bronze figures at the corners of the marble temple are indeed the Cardinal Virtues.

11 The graveboards were identified by Broos in Paris 1986, p. 262 (also in Broos 1987), who cites a catalogue entry in manuscript by Frits Duparc, and also Hodenpijl 1900, pp. 161-62.

12 Daniëlle Lokin, director of the Gemeentemusea Delft, kindly enlightened me in a recent conversation.

13 My letters to the Koninklijk Nederlands Leger- en Wapenmuseum in Delft have failed to elicit a response, but the matter will be pursued on another occasion.

14 Liedtke 1982a, pp. 49-51 on "a lost composition dating from 1650-51."

15 See Kemp 1990, Appendix I, for a helpful review of perspective practice and terminology. The classic article on the history of artificial perspective remains Carter 1970.

16 Plans of the Oude Kerk are found in Wijbenga 1990 and in various editions of *Kunstreisboek voor Nederland* (e.g., Don 1985).

17 See Liedtke 1975-76.

18 Slive 1995, p. 264. The comparisons to Saenredam made in De Vries 1975 and Wheelock 1975-76 are discussed below.

19 Schwartz and Bok 1990, Ch. 5, no. 55, fig. 67. The painting of St. Bavo's, Haarlem, in the Philadelphia Museum of Art (ibid., no. 29, fig. 63) is possibly dated 1631. The date is faint and uncertain, but there is no evidence for 1628, the date occasionally reported.

20 Jantzen 1979, fig. 9.

21 Schwartz and Bok 1990, no. 57, fig. 64.

22 See Schwartz and Bok 1990, p. 71, and Van Swigchem 1987.

23 Rotterdam 1991, no. 4. See n. 19 above on the Saenredam panel in Philadelphia.

24 For Vroom's views of Delft see Amsterdam 1993-94, nos. 200 and 201; and Delft 1996, pp. 88-90, fig. 71.

25 Compare the illustrations (drawing and print) in Schwartz and Bok 1990, p. 60, or fig. 116 here, to Vredeman de Vries 1604-5, Part 1, pls. 45, 47.

26 For example, Wheelock 1975-76, p. 170: "It appears unlikely that his style shifted without some external influence." Similar notions are found in De Vries 1975 and De Boer 1988.

27 See n. 150 below with regard to De Boer 1988, Ch. VI.

28 Both quotes are from one sentence in Wheelock 1973, p. 233; repeated in Wheelock 1975-76, p. 178.

29 These are "elements in Saenredam's paintings [that are] found in Houckgeest's works," according to Wheelock 1975-76, p. 178.

30 "The three painters may have met upon that occasion," according to Wheelock 1975-76, p. 174.

31 Wheelock 1975-76, quoting from pp. 178 and 176.

32 See Sauerländer 1994 on the relationship between Jantzen's book on Dutch and Flemish architectural painting (1910) and his study of Gothic cathedrals (the title essay in Jantzen 1951).

33 Manke 1963, no. 267, referring to the Sedelmeyer panel discussion by Jantzen 1910, p. 115.

34 Jantzen evidently knew the painting in question only from a photograph, and confused it with another work (Manke 1963, no. 295).

35 See Jantzen 1910, pp. 71-77.

36 Manke 1963, p. 23.

37 Jantzen 1910, p. 118. Manke minimizes this impression in her illustrations. Wheelock 1975-76, p. 170, rejects two of the autograph pictures that Manke accepted but dated too early, the Winterthur panel (fig. 155) and another in a private collection, New York (fig. 158): Manke 1963, no. 24, fig. 11; and no. 23, fig. 5, the latter as "about 1647/48."

38 The Warwick painting was first published as by De Witte in Liedtke 1986. For the Van Duyn painting: Manke 1963, no. 21, no ill.; Liedtke 1982a, p. 115, no. 247, fig. 77; Sotheby's, New York, January 17, 1985, no. 55.

39 Manke 1963, no. 24.

40 Liedtke 1982a, pp. 13-17, 80, no. 250, figs. 2, 3.

41 Wheelock 1975-76, p. 170, n. 14; M. Russell in Oberlin-Allentown-Miami Beach-Sacramento 1989-90, p. 116, no. 44, citing the opinion of Avril Hart of the Victorian and Albert Museum. Cleaning in 1987 revealed the remains of De Witte's signature. I am grateful to Dr. Peter Wegmann at the Museum Briner und Kern, Winterthur, for showing me radiographs and reviewing the work's abraded condition (especially in the upper half).

42 Rotterdam 1991, no. 37. The authors note that Wheelock knew the panel only from a photograph, and suggest that its "rather poor condition" must have influenced his judgment.

43 Costume Institute, Metropolitan Museum of Art; Emilie Gordenker, Institute of Fine Arts, New York University, 1997.

44 See De Vries 1996b (review of Slive 1995).

45 Jantzen 1910, pp. 94-95, 114, fig. 43 (Semenov), and pp. 162-63, nos. 165, 166, 176 (quote from p. 114 on the early De Witte). See also De Vries 1975, pp. 34-36, figs. 8-10, and p. 52, nos. 8-10; Wheelock 1975-76, pp. 169-70, fig. 2 (Copenhagen); Liedtke 1982a, pp. 22, 26, 31-33, fig. 14 (Copenhagen; fig. 131 here).

46 Manke 1963, pp. 21-22.

47 Wheelock 1975-76, p. 169.

48 This was made admirably clear in the "Perspectives" exhibition (see Rotterdam 1991).

49 See Ottenheym's essay in The Hague 1997-98b on Frederick Hendrick and architecture.

50 See my essay on "The Court Style" of architectural painting, Liedtke 1991a. In Rotterdam 1991 (the same catalogue) Montias discusses "Perspectives" in seventeenth-century inventories. Concerning the patrons, he concludes, "a majority of them were Reformed, wealthy, and socially prominent" (p. 25).

51 See Rotterdam 1991, p. 81, and the articles by Bredius cited there.

52 Sluijter-Seijffert 1984, pp. 30, 163, nn. 30 and 32 (Aernout van Bassen married Poelenburch's daughter Adriana in 1651), and p. 250 (the document).

53 See Liedtke 1991a, p. 41, n. 41, for references; also Schwartz and Bok 1990, pp. 192-95; The Hague 1997-98a and The Hague 1997-98b.

54 See Dumas 1991, pp. 521-27, no. 42. Another version of the drawing published by Dumas, p. 524, fig. 6 (fig. 123 here) is in the Kupferstichkabinett, Staatliche Museen Berlin, as by Van der Ulft (called Jan de Bisschop until the 1931 catalogue).

55 Fockema Andreae et al. 1957, p. 123.

56 See (with caution) Kuyper 1994, p. 299; pp. 268-74 on Honselaarsdijk; pp. 295-301 on Rhenen and Rijswijk. Compare Dumas 1991, no. 42, on Rijswijk.

57 B. Vermet in Turner 1996, III, p. 353.

58 See n. 3 above.

59 Dutch translations by Pieter Coecke van Aelst appeared in the 1540s, in 1606, and in 1616.

60 Conforti 1993, figs. 177-79, 198-99, 244-45, etc.

61 Kuyper 1994, p. 298.

62 Evelyn 1955, II, pp. 34-35 (Rhenen, August 10, 1641).

63 See White 1982, pp. 17-18, 63. Houckgeest's version is also illustrated in Liedtke 1982a, fig. 8.

64 The figures are by Esaias van de Velde; Keyes 1984, p. 170, no. III, pl. 362.

65 B. Vermet in Turner 1996, III, p. 353, calls this "the only case in which a direct source [for Van Bassen's architecture] has been identified." Maderno's design was itself somewhat imaginary, according to Cardinal Barberini, who complained that the cupola as shown in Greuter's print could not be seen to a similar extent from anywhere on the ground (See Bauer 1982, p. 142).

66 Berlin 1984, no. 3; Briels 1987, p. 278, fig. 349.

67 De Vries 1975, pp. 32-33, fig. 7; p. 52, no. 7 (as signed); and p. 54, n. 33, on the inscription and the likelihood of a Catholic commission. See also

Lokin in Delft 1996, pp. 47-48, fig. 35. Giltaij's doubts about the authorship, date, and even period of the work (Rotterdam 1991, p. 165, n. 5) are unfounded. The inscription of an architectural painting's date of execution on a tombstone is commonplace in works by Van Bassen, De Blieck, and others.

68 See Florence 1985 and San Miniato 1959.

69 Profumo 1992; see also Kemp et al. (in preparation), cited in Miles Chappell's article on Cigoli in Turner 1996, VII, p. 314. Cigoli is best known today as the leading Florentine painter of his generation, but he was also an architect of considerable reputation and a friend of Galileo.

70 See Dumas 1991, no. 47, on the chronology.

71 Fock 1979, p. 467 (see n. 8 for sources). On de' Servi see Thieme/Becker 1907-50, XXX, pp. 527-28. He is not mentioned (nor is Inigo Jones, except once in passing) in The Hague 1997-98a and The Hague 1997-98b.

72 See R. Zimmermann's article on De Caus in Turner 1996, VI, pp. 95-96, and literature cited there. Also Bezemer Sellers in The Hague 1997-98b.

73 On Van Steenwyck as court artist see Liedtke 1991a, pp. 33-35.

74 Compare Van Bassen's view of the imaginary palace at Rhenen (fig. 124) with Saenredam's drawings of the building (Schwartz and Bok 1990, figs. 203, 205). See Keblusek in The Hague 1997-98b on the Bohemian court at The Hague.

75 See n. 63. This writer is not at all convinced (nor was Lyckle de Vries, with whom I corresponded) by the attribution to Houckgeest of an allegedly earlier painting in Nice, or of one said to be signed and dated 1630 which was with Caretto, Turin, in 1972 (see Foucart 1975). The attribution to Houckgeest of another picture at Hampton Court, the *Palace Interior* (White 1982, pp. 63-64, no. 88, pl. 77), is plausible, but the work would date from about 1638 at the earliest.

76 White 1982, p. XXXIII, and p. 63 under no. 87. For quotations from the Van der Doort inventory of Charles I's collection, see Rotterdam 1991, p. 165.

77 Rotterdam 1991, pp. 165, 167, fig. 2.

78 Van Bassen, *Interior of a Catholic Church*, 1632, canvas, 110 x 139 cm, with Johnny Van Haeften, London, in 1984.

79 Oxford 1985-86, no. 56.

80 See the remarks about the vanishing point and distance points in Rotterdam 1991, p. 165.

81 Foucart 1975, fig. 1; *Catalogue sommaire …*, 1979, p. 73. A version, with figures attributed to Anthonie Palamedesz, was at Christie's, Amsterdam, November 11, 1996, no. 44. See also *Henrietta Maria in an Arcade*, said to be by Houckgeest and Cornelis Jonson van Ceulen I, published in White 1982, p. XXXIII, fig. 20 (sold at Sotheby's, London, March 8, 1989, no. 24). The composition recalls Daniel Mijtens and Hendrick van Steenwyck the Younger's enormous canvas, *Charles I in an Imaginary Palace*, dated 1626 and 1627 (Galleria Sabauda, Turin), and Van Steenwyck's pendant pictures of Charles I and Henrietta Maria in arcades, 1637 (Gemälde-galerie Alte Meister, Dresden); see Liedtke 1991a, p. 33, fig. 1 (Turin). In its scale (307 x 240 cm) the Turin canvas deserves comparison with Samuel van Hoogstraten's illusionistic murals, which were also painted in London.

82 De Vries 1975, pp. 30-31, fig. 4; Liedtke 1991a, pp. 37-38, fig. 8.

83 Liedtke 1991a, pp. 33-35.

84 Jantzen 1910, pp. 59-62. See also Liedtke 1982a, pp. 22, 26-27.

85 The relevant literature need not be cited here, but Bauer 1982 deserves special mention.

86 De Vries 1992, p. 52, suggested that I might explain the relationship between "Realistic Imaginary Churches" (Liedtke 1982a, Ch. 2) and the "Court Style" of architectural painting (Liedtke 1991a). The first term refers principally to style, the second to subject.

87 See MacLaren/Brown 1991, p. 11, which is based on my report in the National Gallery files.

88 Dumas 1991, p. 98, fig. 5, with earlier literature.

89 On the Van Delen: Blade 1976, pp. 59-61, 140-41, 239, no. 72, fig. 64. The same subject was treated by Saenredam in a drawing dated 1632 (British Museum; Schwartz and Bok 1990, p. 87, fig. 91).

90 See De Vries 1975, figs. 1-10.

91 See Schwartz and Bok 1990, p. 257, no. 56 indicated on a plan of St. Bavo's.

92 See Schwartz and Bok 1990, figs. 147, 145.

93 See also Houckgeest's engraving after Van Bassen's *Imaginary Gothic Church* (fig. 132), which probably dates from the late 1630s and is related to Saenredam's view across St. Bavo's choir of 1636 (Rijksmuseum, Amsterdam); Liedtke 1982a, p. 31, figs. 10, 11. A panel of similar design, said to be signed by Houckgeest but not dated, was in the collection of H. Klenk, Mainz (De Vries 1975, pp. 30-31, fig. 5). Compare also Saenredam's view across St. Bavo's choir, 1635, in the Muzeum Narodowe, Warsaw (for both Saenredams cited here: Schwartz and Bok 1990, pp. 124-29, figs. 123, 130). The silhouetted repoussoir recalls the framing effect of the frontal elevation in Vredeman de Vries 1604-5, Part II, pl. 47, and also the Gothic archways used to frame chapels (with a "covered" vanishing point well to one side) in paintings of similar format by Pieter Neeffs the Elder (for example, the nocturnal scene dated 1612 sold at Sotheby's, New York, October 7, 1994, no. 34, to Galerie Sanct Lucas, Vienna).

94 As maintained in Liedtke 1982a, pp. 30, 32, figs. 12, 13, and supported in Schwartz and Bok 1990, p. 142, figs. 158, 159.

95 Schwartz and Bok 1990, pp. 149-54.

96 See Schwartz and Bok 1990, figs. 143-47, 150-51. De Lorme's stone niches in the Laurenskerk view dated 1639 (fig. 128) may also derive from the Mariakerk (Schwartz and Bok 1990, fig. 152).

97 See Van Ackere 1972 for numerous examples.

98 For example, in Gombrich 1972 and Gombrich 1975.

99 See Liedtke 1982a, p. 37, n. 11, on Altdorfer, and pp. 55-56, fig. 38, on Bruegel.

100 See Liedtke 1975-76, and my article in Turner 1996, XXVII, pp. 510-11.

101 See F. Trapp in *Mead Art Museum Monograph*, X (1989), p. 42 (ill.).

102 Schwartz and Bok 1990, no. 4, fig. 114.

103 Utrecht 1961, p. 40, under no. 4.

104 Blade 1976, no. 70, fig. 51; Amsterdam 1997a, p. 28, fig. 8.

105 Published in Bernt 1957-58, I, no. 69, as by De Blieck, for no apparent reason. I am grateful to Peter Schatborn and to Hans Vlieghe for opinions about the authorship and subject.

106 Schwartz and Bok 1990, no. 132, fig. 190.

107 As discussed and illustrated with comparative photographs in Liedtke 1975-76.

108 Radiographs reveal indications of the architecture behind the nearest column, which may suggest that Houckgeest considered omitting it from the view (compare fig. 142).

109 Blankert 1978, p. 147, doc. no. 21.

110 Montias 1982, p. 258. Compare Wheelock in Washington-The Hague 1995-96, p. 16: "Further, the 1664 inventory of The Hague sculptor Johan Larson lists a 'tronie' by Vermeer, an important indication that by the mid-1660s interest in his works had moved beyond Delft."

111 See Montias 1989, pp. 246-51 on Vermeer's presumed patron, Pieter van Ruijven.

112 Bredius 1908, p. 8.

113 As discussed in Buijsen 1993 and Liedtke 1995.

114 See Liedtke 1970.

115 For example, Schwartz and Bok 1990, no. 124, fig. 175, different parts of a drawing of the Buurkerk, Utrecht, dated August 2, 1636 (Gemeente-archief, Utrecht), served for compositions dated 1653 and 1654 (see Schwartz and Bok 1990, figs. 218-21).

116 Rotterdam 1991, p. 307 under no. 68, the construction drawing; nos. 16 and 67 for the painting and the sketch.

117 See Liedtke 1982a, p. 73, and Rotterdam 1991, no. 70.

118 Rotterdam 1991, p. 309, with the Dutch text.

119 Rotterdam 1991, no. 52 and p. 250, fig. 1; no. 54 and 255, fig. 1; p. 310, figs. 1 and 2; p. 311, figs. 3 and 4 (but with a minor change in the vaults). With regard to the first painting, the *Gothic Church Interior* of 1656 in Glasgow, three sheets in the book are fairly close in composition.

120 Rotterdam 1991, pp. 309, 312 (ills.). Compare Trnek 1992, pp. 72-74.

121 Rotterdam 1991, p. 251 under no. 53, with comparative illustrations.

122 The presumed pendant reproduced in the Rotterdam catalogue (art trade, 1920) is dated 1656 and corresponds approximately (but not closely) to the pendant sketch on the sheet dated 1656. It should also be noted that the two portico drawings, if switched left to right, strongly resemble another sheet dated 1656, which corresponds generally (but with significant differences) to a painting of a country house seen through a broad portico (Muzeum Narodowe, Cracow; said to be dated 1656). See Rotterdam 1991, pp. 309, 313 (ills.).

123 Rotterdam 1991, p. 245.

124 Liedtke 1982a, p. 73; Rotterdam 1991, p. 309, reproduced on p. 244.

125 Rotterdam 1991, pp. 163, 315 (document of May 27, 1651, reproduced).

126 Rotterdam 1991, p. 163, following Wichmann 1924, p. 557.

127 Rotterdam 1991, p. 315.

128 See Rotterdam 1991, p. 177.

129 See Rotterdam 1991, no. 48, for one of Van Vucht's more elaborate efforts. In a contract of 1635 Van Vucht agreed to deliver annually a picture with twelve columns, and in the fifth year a painting with forty-eight columns.

130 Schwartz and Bok 1990, p. 80 in Ch. 6, "Technique in Perspective." For the last point more simply put, see Liedtke 1971, pp. 133-34, figs. 11, 12.

131 Schwartz and Bok 1990, p. 81, discusses Saenredam's "priorities," which in Schwartz's view do not include "the elements which have received the most attention from modern scholars – perspective, space, color, technique." Readers interested in the latter might consult Liedtke 1975-76, Liedtke 1988b, my entry in Turner 1996, and Liedtke 1997.

132 De Vries 1975, pp. 39-40; repeated in Delft 1974-75, sec. IV.

133 Liedtke 1974; Liedtke 1982a, p. 52.

134 See Ch. 2, n. 109 above.

135 De Vries 1975, p. 40.

136 For example, see Liedtke 1982a, p. 53, on keystones in the vaults of the broad Mauritshuis picture (indicated in my diagram, fig. 23a). See also De Boer 1988, p. 238, fig. 15.

137 See Liedtke 1991b, p. 230, for the quote from Pepys's diary (February 21, 1666) and a discussion of his interest in optics and perspective. For several reasons, above all, the darkness of the church interior, a camera obscura could not have been used by Houckgeest to transcribe such complicated images.

138 See Liedtke 1982a, p. 74, fig. 69 (ca. 1903).

139 Broos 1987, p. 222.

140 Compare Rotterdam 1991, p. 170, where the boys are said to be "poring over their exercise books."

141 De Vries 1975, p. 40. Disputed in Liedtke 1982a, pp. 42-43; see also Broos in Paris 1986, p. 262, and Lokin in Delft 1996, pp. 54-55.

142 The metaphor is inspired by the description of Frederick Hendrick's *Edelman vande Camer* in The Hague 1997-98b, p. 24.

143 Jantzen 1910, pp. 97, 163, no. 184, fig. 45; Wheelock 1975-76, pp. 181-82, fig. 12; Liedtke 1982a, pp. 35, 40-41, etc.; Lokin in Delft 1996, pp. 53-54. Not considered in De Vries 1975. Van Thiel et al. 1976, p. 582, no. A 1971, as attributed to Van Vliet. The writer examined this painting and the other Rijksmuseum Houckgeest (the "pulpit picture") in the conservation studio with curator Wouter Kloek and conservator Martin Bijl in December 1997. They agreed that the canvas appeared to be by Houckgeest. It is rather worn; there are retouches in some areas, for example, in the base of the nearest column (where the picture might have been signed in monogram). My earlier reading of an "h G" signature to the lower left (see Liedtke 1982a, p. 99 under no. 1) now strikes me as implausible.

144 Pieter Steenwijck's *Vanitas Still Life (Allegory of Admiral Tromp's Death)*, probably painted about 1656, is in the Lakenhal, Leiden (Lakenhal 1983, pp. 320-21, no. 409; Delft 1996, p. 33, fig. 24).

145 Manke 1972, p. 389, fig. 1; Blade 1971, pp. 41, 43-44, fig. 7, mistakenly follows the old Hermitage attribution to Houckgeest.

146 Neurdenburg 1948, p. 137, fig. 107, credits Pieter de Keyser with the execution in 1629. He probably carved the effigy, but the architecture of the tomb has been attributed to Arent van 's-Gravesande and to Van Bassen, as well as to the younger De Keyser (Wijbenga 1990, p. 46, citing Van Beresteyn 1938 and other sources).

147 See Van der Aa 1852-78, VI, p. 127.

148 Liedtke 1982a, pp. 41, 49, 99, no. 3, fig. 24. Sold by David Koetser, Zürich, in 1993, to a private collector in the Netherlands.

149 For example, his Nieuwe Kerk view in the Nationalmuseum, Stockholm, no. 683. On De Witte's painting in Lille see New York 1992-93, no. 16.

150 On the perspective scheme employed for both the broad Mauritshuis and ex-Crews pictures see Liedtke 1982a, p. 49, fig. 23a, and De Boer 1988, pp. 178-85, figs. 15, 20-27. De Boer's conclusion that Houckgeest invented a new projection method is unconvincing. He correctly observes that the artist normalized the shapes of columns (they are not distorted laterally, as in some of Saenredam's works). This may usually be said of the capitals as well.

151 See De Boer 1988, fig. 14, a photo made with a "fish-eye" lens. The same extent of architecture may be seen through each archway.

152 Jantzen 1910, p. 174, no. 583; Liedtke 1982a, p. 104, no. 25, and p. 110, no. 125, fig. 25; De Vries 1975, no. 18, as by Houckgeest (unaware of the ex-Crews picture); Nationalmuseum, Stockholm, *Illustrated Catalogue – European Paintings*, 1990, p. 379, no. NM 464 as by Van Vliet.

153 Delft 1996, p. 75, fig. 60; listed on p. 224.

154 See Liedtke 1982a, pp. 43-44, figs. 26, 27.

155 See the photo in Liedtke 1982a, fig. 51a. The panel in the Detroit Institute of Arts (no. 37.152; Liedtke 1982a, p. 101, no. 11a) was studied afresh with curator George Keyes in May 1998. The execution is entirely typical of De Witte in his comparatively minor works of the early 1650s (for another, see Liedtke 1986).

156 Liedtke 1985b; full discussion in Liedtke 1986. Previously published as by De Witte (Edinburgh 1984, no. 35; not in Manke 1963).

157 See Liedtke 1982a, figs. 26b, 28a, 30a. On the pulpit, Wijbenga 1990, pp. 22-24, figs. 23-28; it was moved to its present location in 1923. In Liedtke 1982a, p. 43, fig. 26, the present writer mistakenly claimed that Houckgeest inserted the pulpit of the Oude Kerk, Delft, into his view of

the Jacobskerk in The Hague (fig. 150). I had not realized at the time that the Jacobskerk's pulpit was closely modelled on Delft's: see Bangs 1997, pp. 35-37, figs. 21-24.

158 Schwartz and Bok 1990, p. 252, no. 4, fig. 114; Utrecht 1961, no. 4.

159 See Edinburgh 1984, no. 35. For Van Bleyswijck see the bibliography.

160 Liedtke 1982a, pp. 64-65, 121, 123 (no. 289), figs. 30, 47, 100.

161 First published in Liedtke 1986.

162 See also Liedtke 1982a, pp. 44-46, on the subject of this picture.

163 Rotterdam 1991, no. 32, where the analysis of the perspective scheme is confused, and there is no reference to the discussion of the Rijksmuseum and Buccleuch pictures in Liedtke 1986. In March 2000, curator Wouter Kloek informed the writer that in the course of cleaning "a small hole in the middle [of the composition, at the height of the horizon] has been found," and that this was the central point of the perspective construction. "The hole that Giltaij found is of a secondary nature" (see Rotterdam 1991, p. 32). The matter may be discussed again in New York-London 2001.

164 Kindly communicated by Wouter Kloek in March 2000. He and I examined the date together in December 1997.

165 As Dumas 1991, pp. 31-33, 55, n. 109, records, this rare view of a church in The Hague was copied in a colored drawing by Abraham Delfos (1776). Houckgeest's painting itself was lost in 1945. See also Liedtke 1982a, pp. 43-44, fig. 26.

166 De Vries 1975, p. 41, and Wheelock 1975-76, p. 184, mention the Psalm. See also Blade 1971.

167 Amsterdam 1992b, p. 24, no. 1. Compare also the drawing by Willem Schellinks of the old Town Hall in Amsterdam, 1640, reproduced in Amsterdam 1997a, p. 8, fig. 2.

168 Bax 1981, p. 27, no. 35 (ill.), misread the monogram as "CH." The inscription is recorded as *G H. 1656 (?)*, and the condition as fair, in Fransen 1997, pp. 114-15. See also Liedtke 1982a, p. 101, no. 10.

169 See the discussion of the inscription and dating in Rotterdam 1991, p. 181. Giltaij's suggested reading of the marks after the monogram as "fec" for "fecit" is supported by direct examination.

170 Schutte 1988, pp. 334-35, fig. 1 (cited in Rotterdam 1991, p. 181, and kindly sent to me by Jeroen Giltaij).

171 See Manke 1963, pp. 63, 65.

172 Manke 1963, pp. 29-58; Liedtke 1982a, pp. 86-94.

173 Houbraken 1718-21, I, p. 283.

174 Montias 1982, pp. 164-65. Obreen 1877-90, I, p. 37, and Manke 1963, p. 63, note that De Witte paid the outsider's fee of fl. 12 when he joined the painters' guild.

175 For these documents and their sources see Bredius 1915-22, V, pp. 1831-32, and Manke 1963, p. 64.

176 Manke 1963, p. 63; first published in Obreen 1877-90, I, p. 44, no. 29. On p. 1 of Manke's text this dating is tempered to "about or a little after 1650."

177 Manke 1963, pp. 1-2, 65.

178 Bredius 1915-22, V, p. 1832.

179 On De Cooge's visits to Antwerp and Amsterdam, see Montias 1982, pp. 210-11.

180 See Montias 1982, pp. 214-15, and Montias 1989, pp. 139-40.

181 Montias 1982, pp. 217-18, citing specific examples and documents.

182 See the documents listed in Manke 1963, p. 65. On Manke's reading of Amsterdam poems dating from 1650 and 1654 as references to De Witte (her "documents" of 1650 and 1654), see Liedtke 1982a, p. 84, n. 24.

183 Manke 1963, pp. 65-66.

184 Willem van der Vorm Foundation, Museum Boijmans Van Beuningen, Rotterdam; Rotterdam 1991, no. 35, with earlier literature.

185 Manke 1963, no. 59, a view of the Oude Kerk in Amsterdam, was said in earlier literature to have been dated 1654. Her no. 84, a view in the Nieuwe Kerk, Amsterdam, is dated 1654 (my reading in 1987; no mention of the date in Manke). De Witte's view in the Janskerk, Utrecht, is dated 1654 (Paris 1983, p. 160, no. 96, pl. 55; Manke 1963, no. 93, as said to be dated 1654).

186 Manke 1963, no. 5, fig. 1, reads the date on the *Danaë* as 1641 and rejects Bode's earlier reading of 1647 as *fälschlich*. It is also too close to De Witte's earliest church interiors for Manke's chronology. Having read the date on the *Danaë* recently, I would say that it is probably 1647. The work is more accomplished than one would imagine from photographs. On De Witte's early mythological paintings see Manke 1963, pp. 7-13, and Liedtke 1982a, pp. 79-80.

187 Michiel Plomp in Delft 1996, pp. 23-25, fig. 11, compares works by Bramer, and a panel by Domenico Fetti that may have provided a model for the figure of Baucis bent over and lit from below.

188 Another, undated painting of Vertumnus and Pomona by De Witte is published in Rijksdienst Beeldende Kunst 1992, p. 321, no. 2859 (ill.), as on panel, 36 x 30 cm. The figure of Pomona is a seated nude seen from the same angle as in the Rotterdam picture, but her pose comes much closer to that of Medusa in De Witte's drawing in the Abrams collection (Amsterdam-Vienna-New York-Cambridge 1991-92, no. 20). Perhaps all three figures derive from the same model (Geertgen Arents?) drawn from life. The reclining nude in the *Danaë* is also drawn from the rear and resembles a studio exercise.

189 Ekkart 1995, p. 218, nos. 78-79, cites Delff and Palamedesz. Compare Van Vliet's *Portrait of a Woman* of 1650 in the Rijksmuseum, Amsterdam.

190 Liedtke 1982a, p. 99, no. 1b, maintains that a copy in Brussels of Houckgeest's view to the tomb of Piet Hein was painted by De Witte. This now seems to me doubtful. One possibility is that the panel (which copies a canvas of nearly the same size) is a second and weaker version by Houckgeest himself (as in the case of the Stockholm picture, fig. 146). However, anonymous copies after Houckgeest's Delft church interiors are not unknown.

191 The small marble monument commemorating Johan van Lodensteyn and his wife, Maria van Bleyswijck, dates from 1644. It was moved around at will by De Witte and Van Vliet but not by Houckgeest. For a photo of the object *in situ* see Worcester 1979, p. 118.

192 The date on the Montreal picture was read as 1650 in 1879 and in 1939, when it was said to be barely legible (see Liedtke 1982a, p. 83). Manke 1963, no. 18, consider the date "bei genauer Prüfung" to read 1654. The same sort of *Prüfung* in The Hague 1982, no. 97, produced a date of "165(0)."

193 See Liedtke 1982a, fig. 78; Rotterdam 1991, no. 35.

194 On Van Vliet's influence on architectural painters outside Delft, such as Anthonie de Lorme and Daniel de Blieck, see Liedtke 1982a, pp. 68-75.

195 Van Bleyswijck 1667-80, p. 852, as translated in Liedtke 1982a, p. 57. Two paintings by Van Vliet are reproduced by engravings in Van Bleyswijck's book (figs. 172-73 here). The prints and the artist's biography were added to the book in 1680, when the second volume (pp. 487-892) appeared.

196 See Liedtke 1982a, pp. 105-14, for an oeuvre list of church interiors by Van Vliet.

197 See Rotterdam 1991, nos. 43, 44.

198 Montias 1982, p. 176, n. ii, suggesting that Van Vliet died poor, refers to the wrong pages in Obreen 1877-90, V, which should be pp. 284-87. The artist's estate was valued at fl. 300.

199 Bredius 1915-22, I, p. 238, cited in Rotterdam 1991, p. 211, n. 5.

200 Liedtke 1982a, Ch. IV and Appendix II for Van Vliet. See the substantial reviews by De Vries 1984 and Wheelock 1986. Lokin's discussion of Van Vliet in Delft 1996, pp. 69-83, is based directly upon my own and is addressed to the general public, but adds several good points and is richly illustrated. See also the section on Van Vliet in Rotterdam 1991, pp. 212-26.

201 See Braunschweig 1978, no. 40, which exhausts this approach to the picture.

202 Liedtke 1982a, p. 61, fig. 42. Reindert Falkenburg noted here the similarity with landscape paintings in which motifs drawn "from life" are relocated.

203 A variant of the Rijksmuseum composition (cropped on the left and above) is dated 1656 and was sold at Christie's, London, June 11, 1937, no. 32 (Jantzen 1910, no. 530). Later variants include the Mauritshuis canvas of about 1658 (Liedtke 1982a, p. 65, fig. 48) and the canvas dated 1659 in the Philadelphia Museum of Art.

204 See Liedtke 1982a, figs. 77 and 80 (Van Duyn and Oberlin views across the Mariakoor into the Joriskapel). On the Leipzig Van Vliet see Rotterdam 1991, no. 42, where the outrageously red color plate is as misleading as the statement that "the painting is entirely true to life."

205 On this picture see Liedtke 1979b and Liedtke 1982a, pp. 62-63.

206 On the Toledo painting (1658) see Rotterdam 1991, no. 43.

207 See Liedtke 1982a, p. 64 and n. 17 on earlier versions of this composition. A more sweeping view of the Nieuwe Kerk from the southern aisle, with a curtain as in fig. 165, is dated 1651 (with Hoogsteder, The Hague, in 1991).

208 See Devapriam 1990, and Van Eck and Coebergh-Surie 1997.

209 Lokin in Delft 1996, p. 75, who was misled by Liedtke 1982a, pp. 65-66.

210 In this paragraph I am revising conclusions published in Liedtke 1982a, pp. 65-66; p. 99, nos. 1a and 3a; pp. 103-4, nos. 24, 25, figs. 51 and 25. At the time I was more trusting of information in sale catalogues (e.g., that my no. 1a is signed by Van Vliet and dated 1660) and less familiar with De Man.

211 Compare Saenredam's *Interior of the Mariakerk, Utrecht* (nave to the west, from the crossing), 1638, in the Hamburger Kunsthalle; Schwartz and Bok 1990, no. 158, fig. 141.

212 See Rotterdam 1991, no. 44, on the Teding van Berkhouts and this picture. The entry quotes Pieter Teding van Berkhout's diary entry referring to Vermeer and the very similar remark he made about Cornelis Bisschop's work.

213 See St. Petersburg 1990-91, pp. 44-45, fig. 20.

214 Liedtke 1982a, pp. 67-68, fig. 58; Trnek 1992, no. 128.

215 For example, an Oude Kerk view to the east (Louvre, Paris, R. F. 1969-2); Oude Kerk, nave to west (Liedtke 1982a, no. 53, sold at Christie's, New York, January 11, 1995, no. 240); another version of the latter (South Hadley 1979, no. 23, as "Delft School").

216 Rotterdam 1991, no. 45.

217 See Liedtke 1982a, figs. 56, 57; Rotterdam 1991, p. 220, fig. 1.

218 See Israel 1995, pp. 785-95.

219 Brière-Misme 1935, p. 9, does not give the source.

220 Liedtke 1982a, oeuvre list on pp. 123-24, which is preceded by five pages of discussion. My no. 297, which had just been in the London trade as a Houckgeest, is rightly assigned to Van Vliet in Rotterdam 1991, p. 220, fig. 1 (Mead Art Museum, Amherst College, Amherst, Mass.).

221 Two of the signed examples (those in Darmstadt and Leipzig) were illustrated in Brière-Misme 1935, pp. 10-12, figs. 4, 5, and were dated (too early) to 1655-60.

222 See Liedtke 1982a, pp. 99-104, nos. 3, 13 and 24 for a summary of these opinions published in Wheelock 1975-76 and in De Vries 1975.

223 See Liedtke 1982a, pp. 49-51, 101, nos. 11 and 11a.

224 Liedtke 1982a, p. 102 under no. 13; see also p. 122. Evidently, all interested parties now share this opinion, with the exception of P. G. de Boer, who accepts the 1972 auction attribution of the Louisville canvas to Houckgeest (De Boer 1988, Ch. VI). Without any mention of the figure style, the manner of execution, or another painting by De Man, De Boer resurrects De Vries's notion of a transitional work by Houckgeest – which De Vries himself abandoned in deference to my arguments (See Liedtke 1982a, p. 104 under no. 24, citing De Vries's correspondence, and De Vries 1984) – and offers a peculiar explanation for the composition's eccentricities, namely, that Houckgeest employed a tilted perspective frame ("scheef gehouden glasplat"; De Boer 1988, pp. 132-36, quoting from 134).

Other versions of the composition may also be ascribed to De Man: the panel (18.5 x 15 *pouces*) recorded by Lebrun's engraving (fig. 178); the panel of about the same size in Strasbourg (51 x 42 cm); and a very small version of the Louisville composition (panel, 13 x 12.4 cm) which appeared at Sotheby's, New York, January 30, 1997, no. 31, as "Attributed to Cornelis de Man" (following my oral advice). For the painting recorded by Lebrun see Liedtke 1982a, pp. 103-4, no. 24, and p. 111, no. 150, listing a panel (47.5 x 38.5 cm) sold as by Van Vliet at Lange, Berlin, April 16-17, 1943, no. 40 (ill.). The Strasbourg panel (51 x 42 cm) is Liedtke 1982a, nos. 26, 309, fig. 53, as attributed to De Man (alas, still unseen).

225 Liedtke 1982a, p. 120 (on the style), p. 123, no. 290, fig. 104. See also Delft 1996, pp. 82-83, fig. 67.

226 Christie's, London, December 15, 1989, no. 198, as by De Man (my attribution). For a version of this composition (London sale of 1967) see Liedtke 1982a, p. 112, no. 175, under "Attributed to Van Vliet" but suggesting "De Man?"

227 Ader Tajan at the Hôtel Drouot, Paris, December 14, 1992, no. 35 (ill.). My thanks to Eric Turquin.

228 Liedtke 1982a, pp. 121, 123, no. 293, fig. 106.

229 *CDM* in monogram. A panel in Orléans (Liedtke 1982a, pp. 121, 123, no. 299, fig. 105) reverses this view (north to south) and may be by De Man, as Hofstede de Groot suggested.

230 For the Laurenskerk view, see Liedtke 1982a, pp. 122-23, no. 291, fig. 107. A new oeuvre list of church interiors by De Man may await my intended book on architectural painting in the Netherlands.

231 Liedtke 1982a, figs. 98-101, and pl. XIV. See also Delft 1996, pp. 84-85, for the Chicago and Columbus paintings in color.

232 *Nieuwe Kerk in Delft, from the northern aisle to the southeast*, panel, 34.6 x 26.8 cm, called the Oude Kerk by a follower of Van Vliet, at Christie's, Amsterdam, November 29, 1988, no. 49 (ill.). A somewhat similar view in the Nieuwe Kerk was published in Liedtke 1982a, no. 296, fig. 103. My no. 295, another Nieuwe Kerk aisle view, was with Otto Naumann, New York, in 1989. The second newly identified De Man, a view from the northern aisle of the Oude Kerk to the southeast (with the small organ and the pulpit included), hangs as a De Lorme in Budweis (Czech Republic). It was kindly brought to my attention by J. W. L. Hilkhuijsen of the Gemeente Musea Delft (in 1990).

233 See Brière-Misme 1935, pp. 3, 17-18.

234 See De Jongh 1973.

235 For a survey of almost everything known about the artist, see Liedtke 1992c.

236 See Liedtke 1992c, figs. 8, 9 and 5, respectively, for these works formerly in Dessau, formerly with Hoogsteder, The Hague, and in the Abbaye de Chaalis at Fontaine-Chaalis (Oise).

237 Liedtke 1982a, no. 290, fig. 104.

238 See Liedtke 1992c, pp. 191-92, figs. 1, 2.

239 Compare Vredeman de Vries 1604-5, Part II, pl. 2. In this paragraph I slightly modify lines first published in Liedtke 1992c, p. 195, where references to publications about Philips Vingboons are provided.

Notes to Chapter Four

1 On the term "genre" see Sutton in Philadelphia-Berlin-London 1984, p. XIV, where the Dutch words mentioned below (*cortegarde*, etc.) are also reviewed.

2 Gowing 1970 (second edition); first published in 1952. In part II Gowing cites (often in the footnotes) the great majority of sources for and parallels to Vermeer's pictures that later scholars mention, often without citing the earlier book. His much followed reference to Koedijck (p. 109, n. 60) has a few antecedents, as noted by Sutton 1980a, p. 62, n. 32 (to which Bouchery 1957-58 may be added).

3 De Hooch may have removed a prominent figure (just to the left of the maid) for this reason. See MacLaren/Brown 1991, p. 198, "Pentimenti."

4 The quotes in the text come from five short paragraphs in Blankert 1978, pp. 29-31.

5 This tradition was previously discussed in Liedtke 1984b and Liedtke 1988a, from which a few paragraphs in this chapter are adopted. As noted in the preface, the name of the later province, "South Holland," is employed here for convenience, and refers to a geographic region.

6 Gowing 1970, p. 107.

7 Gowing 1970, pp. 106-7; see also p. 122 on Leiden. Alpers 1983, p. 224, entertains an exceedingly different notion of Vermeer's approach, which she supports in part by deftly selecting lines from Gowing.

8 Gowing 1970, p. 108.

9 Gowing 1970, pp. 108-9, with a discussion of priority in n. 59.

10 Sutton 1980a, p. 23.

11 Sutton 1980a, p. 81 under no. 25, writes that "it is unclear, however, which artist invented the design." Neither artist was the "inventor." The two paintings are contemporaneous permutations of a traditional and evolving type.

12 For example, Slive in Rosenberg-Slive-ter Kuile 1966, p. 115, concludes some insightful observations about Vermeer and Rembrandt with one that has no meaning at all: "Vermeer owes much in this phase of his art [*The Geographer*] to Carel Fabritius, who is the link between him and Rembrandt." The comparison with Rembrandt's etching of "Faust" is adopted from Gowing 1970 (first ed., 1952), pp. 148-49. On Bob Haak's refreshing review of local and regional styles (in Haak 1984), see Liedtke 1988a, p. 96. Lammertse 1998, no. 17, suggests plausibly that in the Rotterdam panel (fig. 221) Van Delen is responsible for the figures as well as the architecture, but that he followed some prototype by Pieter Codde.

13 In Washington-The Hague 1995-96, p. 172, no. 16, Vermeer's "Astronomer" and "Geographer" are identified as Van Leeuwenhoek. However, Klaas van Berkel, in The Hague 1996a, p. 14, maintains that "the still frequently voiced assumption that the astronomer in the painting is Van Leeuwenhoek is totally unfounded." The same authors also debate the issue in Frankfurt 1997.

14 For example, Gombrich 1972 and Gombrich 1975.

15 On this subject see Liedtke 1997.

16 Blankert 1978, pp. 29, 31.

17 Panofsky 1927; von Weiher 1937 and Würtenberger 1937.

18 Eisler 1923.

19 Alpers 1983, p. 38.

20 Ilja Veldman in Turner 1996, VIII, p. 669. The remark out-Finks Fink in Fink 1971.

21 See Sutton 1980a, Ch. III; Sutton in Philadelphia-Berlin-London 1984, pp. XXXVIII, XLI, XLIV-XLV, xlviii, li-liv, and nos. 50-52; Sutton in Turner 1996, XIV, pp. 732-34; and Sutton in Dulwich-Hartford 1998-99.

22 Bouchery 1957-58, p. 173. On this study and Plietzsch 1956, see Liedtke 1984b, pp. 320-23.

23 Sutton 1980a, pp. 11-14, 19-23; quotes from pp. 20 (on Van Bassen and Van Delen), 23 (camera obscura), and 15 (space commander).

24 Sutton 1980a, p. 21.

25 Sutton in Turner 1996, XIV, p. 733.

26 Rosenberg-Slive-ter Kuile 1966, p. 124.

27 See n. 12 above.

28 Regarding the period when the two painters were in Rembrandt's studio, see Liedtke 1995-96, pp. 26-28.

29 Houbraken 1718-21, II, pp. 34-35. On this point see Fleischer 1978 and Kuretsky 1979, p. 4.

30 See Sutton 1980a, p. 145, document nos. 14, 17. De Hooch and his future wife attended a baptism in her family on November 30, 1653, in Leiden. On Van der Burch see Sutton 1980b.

31 Sutton 1980a, pp. 9, 145-46, document nos. 15, 16, 23. The term *dienaer* in the document does not imply that De Hooch was a "servant" in the usual sense, but that the painter had a contractual relationship with the patron. The point was clarified in De Jongh 1980, p. 182, and missed in Franits 1989, where the painter's apparent sympathy for servants is linked to his slipper-fetching for De la Grange.

32 Sutton 1980a, pp. 9, 145-46, document nos. 18, 19, 21.

33 Michiel Kersten, in Delft 1996, p. 143, fig. 132, mentions works by the short-lived Van Gaesbeeck (ca. 1621-1650) as a parallel development to De Hooch, but he appears to become a follower later in the text (p. 198, fig. 195).

34 Sutton 1980a, p. 20. The idea refines that in Clark 1966, Ch. 5, n. 17 (see n. 71 below).

35 Gowing 1970, p. 147, n. 121, says of Vermeer, "unfortunately conjecture has proved itself the least useful of methods."

36 See Sutton's essay and the biographies in Philadelphia-Berlin-London 1984, and Brown 1984.

37 It was presumably in connection with a visit to The Hague that Ter Borch visited Delft, where in April 1653 he witnessed a deposition together with the twenty-year-old Johannes Vermeer (Montias 1977, pp. 280-81, no. 46a; Montias 1989, p. 308, no. 251).

38 See Kettering 1988, pp. 366-95, for wonderful examples of the young lady keeping up with the latest themes in genre painting (no. Gs 32 of 1658 is interesting for De Hooch and De Jongh).

39 Haak 1984 tends to bear this out (see his pp. 347-52 on the Republic in the third quarter of the century). His review of Dutch art in terms of local and regional developments works fairly well up until about 1650, but the pattern blurs as he turns to the following decades. He needs two sections on Amsterdam and much less space for places like Haarlem, where the local school is "characterized by the work of older artists" (p. 377). Many

younger ones, like Jacob van Ruisdael, had gone off to seek their fortunes in the big city.

40 For example, Sutton 1980a, pp. 13-14, asks whether "De Hooch had contact with the art of these painters" (Van den Eeckhout, Van Loo, and Gerard van Zijl), and compares De Hooch's *Tric-Trac Players* in Dublin with Van den Eeckhout's considerably more accomplished treatment of the same theme in 1651 (fig. 199). See also Blankert 1978, pp. 24-25, figs. 19 and 20 (Van den Eeckhout and Van Loo), who concludes sensibly that "these changes in elegant genre scenes reflect a more widespread stylistic shift in Dutch art of the period." Sutton in Philadelphia-Berlin-London 1984, p. XXXVIII, describes Ter Borch, De Hooch, and Van den Eeckhout as artists who "helped transform the guardroom tradition around 1650"; various breakthroughs are attributed to Ter Borch, Van Loo, and Van den Eeckhout on pp. XLIV (Ter Borch "fashioned a new genre"), XLV (the Amsterdam artists stimulate Ter Borch), XLIX (Huygens likes Van Loo in 1649). Walk-on rôles are assigned to Frans van Mieris ("his *Duet* of 1658 in Schwerin … had a strong impact on the Delft School"; p. XLI) and to Jan Steen (his "so-called *Burgher of Delft and his Daughter* of 1655 [fig. 205 here] … raises the possibility of his having played an innovative rôle in the rise of outdoor genre in Delft"; p. XLVIII).

41 This discussion is centered around the question of regional styles. Reindert Falkenburg, while reading it, raised the question of whether the "tug of tradition" or "return to type" might be a market phenomenon: that is, the making of a familiar product, with a proven history of sales. These are two sides of the same coin: taste. One might want to emphasize demand (fashion) or supply (artistic tradition) depending upon the particular circumstances, which were especially complex during this period in the Netherlands.

42 Rosenberg-Slive-ter Kuile 1966, Ch. 7.

43 Bouchery 1957-58, p. 157.

44 Plietzsch 1956, p. 180.

45 Von Weiher 1937, p. 2. See Alpers 1983, p. XXV on Van Eyck, Vermeer, and Italian art, and pp. 44-45 for a "textbook contrast between Renaissance art in the north and south of Europe."

46 Schneede 1965, p. 199; Sutton 1980a, p. 20.

47 Plietzsch 1956, p. 181.

48 See Fleischer 1989, figs. 31-48, for De Jongh's hunting scenes. One of the fox hunts is recorded in a drawing by Bramer (Fleischer's figs. 36-37).

49 See Fleischer 1989, figs. 93-95; Sutton 1980a, no. 60B (the attribution of Sutton's 60A, the version at Waddesdon Manor, is less certain in my view than that of the damaged picture in the City Art Museum, St. Louis). On De Jongh see also n. 116 below. For related subjects by Van der Heyden and Van Ruisdael in the National Gallery of Art, Washington, see Wheelock 1995b, pp. 107-12, 345-48.

50 See Liedtke 1982a, pp. 24-25, n. 16.

51 See Manke 1963, pp. 35, 49-50, on De Witte and Van Delen.

52 On the latter see Wieseman 1993-94.

53 See the entries on Van den Eeckhout and Van Loo, which refer to those on Buytewech and Van de Velde, in Philadelphia-Berlin-London 1984.

54 Keyes 1984, pp. 86-96 on their collaboration.

55 Sutton 1980a, p. 30.

56 Keyes 1984, pp. 87-88.

57 Sutton in Philadelphia-Berlin-London 1984, p. LV. By contrast, Michiel Kersten in Delft 1996, p. 162, maintains that "the designation [School of Pieter de Hooch] indicates succinctly what these painters have in common; in several cases there is even evidence of mutual influence."

58 The point has often been made, for example, by Brown 1981, p. 57.

59 See Wheelock in Washington-The Hague 1995-96, p. 16.

60 On Van Ostade's later interiors see Franits 1997.

61 Goossens 1977, pp. 85-87, fig. 43, dated about 1609; Philadelphia-Berlin-London 1984, p. XXXVII, fig. 45.

62 The compositions by Vredeman de Vries and Frans Francken II are preceded by the many versions of Pieter Coecke's *Last Supper*; numerous engravings after Maerten de Vos and Stradanus; kitchen and pantry interiors like Beuckelaer's *Slaughtered Pig* (1563) in Cologne; and paintings by the Brunswick Monogrammist (see Renger 1970, figs. 64-70).

63 See Haverkamp Begemann 1959, figs. 103, 126, 143.

64 See Amsterdam 1997b, p. 122, on the drawing illustrated here, and p. 265, for an anonymous etching after a similar interior by Esaias van de Velde. The Berlin drawing is catalogued in Keyes 1984 as no. D 39.

65 See Haverkamp Begemann 1959, figs. 108, 117, 148; see also Philadelphia-Berlin-London 1984, no. 26 on Buytewech's canvas in Budapest.

66 On this collaboration see Philadelphia-Berlin-London 1984, pp. 205-6. See also the dancing scene by Dirck Hals reproduced in Kolfin 1999, fig. 16 (art market, 1939).

67 Van Delen has also been thought to have painted the architecture in Jan Miense Molenaer's *Marriage Celebration of Willem van Loon and Margaretha Bas* of 1637 (Museum van Loon, Amsterdam; see Keyes 1984, p. 95, fig. 53). However, Dennis Weller (who is preparing a monograph) and the present writer think that Molenaer could have managed well enough on his own.

68 See Keyes 1984, p. 87, and Bredius 1915-22, part 1, pp. 321-24 for the document. Also described in Montias 1982, pp. 198-99.

69 For the Molenaer see Liedtke 1988a, fig. 5-14 (frontispiece to article). His well-known *Lady World* of 1633 (Toledo Museum of Art), cited below, is discussed in Philadelphia-Berlin-London 1984, no. 78. See the same catalogue, no. 46, for Dirck Hals's *Seated Woman with a Letter* in the Johnson Collection, Philadelphia Museum of Art, where the Mainz picture and a similar work – *The Dreamer*, formerly in Kiev – are also reproduced and discussed. A "shoe-box" (or Van Hoogstraten-box) type of interior – that is, a broad room defined by three walls, a ceiling, and floor – is found in Dirck Hals's *Musical Party* of the 1630s in the Fisher Gallery, University of Southern California, Los Angeles (Los Angeles 1987, pp. 20-21, ill.). See also the more loosely defined, deep "left-corner" interior in Hals's *Musical Company* of 1637 (Christie's, New York, May 31, 1990, no. 145), and the Van Delen-like interior with fifteen figures sold in Paris (*La Gazette de l'Hôtel Drouot*, XCVII, no. 20 [May 13, 1988], p. 1, ill.; sale on June 8, 1988) which the auction house's expert, Jacques Kantor, reasonably assigns to Dirck Hals alone.

70 See Goedde 1989, p. 156.

71 See Clark 1966, especially pp. 172-77; in Ch. 5, n. 17, the author claims (without evidence) that "by 1652 [Maes] was painting the type of interior which was to be perfected in 1656 [?] by De Hooch and Vermeer; and it was probably through him that Rembrandt's ideas of composition spread to the painters of Dordrecht and Delft."

72 See also Sumowski 1983-[94], II, nos. 399, 405, 412, 419, for other interiors of this type by Van den Eeckhout; and, for similar works by Salomon Koninck, III, nos. 1091, 1121 (*Old Goldweigher*, 1654, in Rotterdam), 1132-35. Another, otherwise unexpected work that one might place with these interiors by artists in Rembrandt's circle is Claes Moeyaert's *Calling of Matthew* dated 1639 (Braunschweig, Herzog Anton Ulrich-Museum, no. 228).

73 See Sumowski 1983-[94], nos. 501-11. In addition to the picture reproduced here, Sumowski's nos. 503 and 509 ("musical companies" of 1653 and 1655 in The Hague and Copenhagen) are relevant.

74 For this and similar interior views by Dou, see Philadelphia-Berlin-London 1984, no. 31 (fig. 2 for the panel in Edinburgh).

75 Discussed by Otto Naumann in Philadelphia-Berlin-London 1984, no. 33.

76 This description seems in accordance with the contemporary appreciation of Dou and his circle. See Eric Jan Sluijter's essay in Leiden 1988. On p. 29 Sluijter notes the absence of any emphasis on art theory, academic learning, and so on, which is perhaps consistent with the undemonstrative way in which Dou employs perspective.

77 In Delft 1996, p. 198, fig. 195, Michiel Kersten suggests that "it is not inconceivable that this canvas [sic; Van Gaesbeeck's panel in the Staatliche Kunsthalle, Karlsruhe] was in turn inspired by 'Delft' compositional schemes with vistas." But it is inconceivable, of course, given the fact that Van Gaesbeeck died in 1650. Despite the quotation marks around "Delft," Kersten's comparison is a good example of how strongly a South Holland type of composition has been associated with what he calls the "De Hooch School."

78 For examples by Brekelenkam see the illustrations in Lasius 1992.

79 Compare Sutton in Philadelphia-Berlin-London 1984, p. 230, where Koedijck seems more important for Delft. His interest in "the expressive possibilities of interior space" is said (in n. 9) to be "overlooked [by less astute scholars?] because of the loss at sea of two of his [undoubtedly] major works purchased from the famous Braamcamp Collection … by Catherine II of Russia." That is, there are missing links even on the ocean floor.

80 Sutton 1980a, p. 25.

81 Wheelock in Washington-The Hague 1995-96, p. 21, where the canvas by Steen is revealingly illustrated next to De Hooch's *Dutch Courtyard* of about 1658-60 in the National Gallery of Art, Washington.

82 See Van Hoogstraten 1678, pp. 237-38, and the discussion of this passage in Liedtke 1997. Chapman, in Washington-Amsterdam 1996-97, p. 121 and fig. 1 under no. 7, notes that Steen "quoted" (derived) the begging woman from Rembrandt's 1648 etching of a beggar family receiving alms at a doorway (see now Vinken 1998). This may suggest that Steen was influenced by Rembrandt's sharply receding house as well as by recent domestic interiors in Leiden, such as those by Koedijck, where one finds something like the man's "authoritative seated, frontal pose" (compare Koedijck's painting of 1650 in the Hermitage, fig. 203; the frontal presentation of the figure on a kind of platform also recalls Maes's sewing housewives: for example, in the Wallace picture [fig. 217], where one also finds a vase of flowers on the windowsill and of course a child). However, Chapman claims that "artistically, the painting fully participates in the distinctive visual culture of Delft … [which] was distinguished by a near-scientific interest in optics." The usual references to Houckgeest and De Witte follow, along with the obligatory forecast of Vermeer's "naturalistic rendering of light and space." Finally, Maes, "who like Fabritius had trained with Rembrandt," and Fabritius himself are thrown into the mix. *A View in Delft*, which evidently was on hand for everyone to see, "seems to have inspired Steen's composition and rendering of the town." It must be admitted that the repetition of conventional ideas is less obvious in Steen's canvas than in formal analyses of it.

83 See Naumann 1981 for a reliable chronology of Van Mieris, and Robinson 1974 on Metsu.

84 Naumann 1981, nos. 11, 12.

85 As Gowing 1970, p. 147, n. 121, supposed. The paintings are illustrated and just barely discussed in Robinson 1974, p. 62, figs. 145-46; see p. 37 for a few remarks on the Delft-type genre scene in relation to developments elsewhere.

86 Elkins 1988 discusses examples. On the panel in the Royal Collection see White 1982, no. 189, and Washington-Amsterdam 1996-97, no. 19.

87 On the "Dutch Teniers Group" see Heppner 1946; Klinge-Gross 1976; Philadelphia-Berlin-London 1984, no. 96; Schulz 1978; Schulz 1982; and the essay by James in Rotterdam 1994-95.

88 On the Haarlem hovels see Schnackenburg 1970. On Sorgh's painting in Rotterdam (fig. 206) see Rotterdam 1994-95, no. 51, and Lammertse 1998, no. 53.

89 On these Flemish genre painters see Boston-Toledo 1993-94, nos. 71-74, and the sources cited there; and Liedtke 1988a, p. 102 and fig. 5-24 (Van Craesbeeck).

90 See also Sorgh's *Kitchen Interior* in the Museum Briner und Kern, Winterthur (Oberlin-Allentown-Miami Beach-Sacramento 1989-90, no. 38); the *Kitchen Interior* dated 1643 in the Muzeum Narodowe, Warsaw (fig. 207 here); the inn scene sold at Christie's, London, December 13, 1985, no. 72; and *The Supper at Emmaus*, 1649, at the same auction house on July 5, 1991, no. 59. There are many similar works by Sorgh: see Schneeman 1982.

91 Sorgh's *Two Smokers* is illustrated in Sutton 1980a, fig. 2, and is described on p. 12 as a translation of "the Flemish tavern scene type."

92 See Fleischer 1989, figs. 74-77.

93 Sutton 1980a, pp. 12, 14.

94 Sutton 1980a, no. 18, pl. 17.

95 Both quotes are from Sutton 1980a, p. 21.

96 See Dordrecht 1992-93 and Liedtke 1995-96.

97 See Sutton 1980a, p. 13, nos. D20, D21, pls. 181, 182; Fleischer 1989, p. 69, figs. 77, 80.

98 Fleischer 1989, pp. 60-61, fig. 66.

99 Fleischer 1989, pp. 26 (n. 7), 65, 66, 79.

100 On Ochtervelt's debt to De Jongh see Kuretsky 1979, pp. 8 (n. 8), 12, 41, and Fleischer 1989, pp. 43, 56, 80, 85.

101 Sutton 1980a, no. 6, pl. 5, assigned the Hermitage panel to De Hooch, partly because of its similarity to the Zürich picture (Sutton no. 7, pl. 6); see also Dulwich-Hartford 1998-99, nos. 2 (Hermitage) and 3 (Zürich). Comparison with contemporary works by De Hooch in the Dulwich-Hartford exhibition made it clear that the Hermitage panel was indeed painted by De Hooch, not De Jongh. De Hooch's *Soldier Paying a Hostess* of 1658 (fig. 245) also adopts one of De Jongh's themes (Sutton, p. 13 and no. 27, acknowledging Fleischer 1978).

102 Fleischer 1989, p. 73.

103 Fleischer 1989, p. 70, fig. 83; see also Liedtke 1988a, p. 102, fig. 5-21.

104 See Sumowski 1983-[94], III, pp. 1962 (text), 1998 (color pl.), and no. 1351 for the Maes in Philadelphia. The *Apple Peeler* is discussed in Dordrecht 1992-93, no. 5, where the Maes is illustrated.

105 Sumowski 1983-[94], II, no. 894, 903. For the Louvre painting see Dordrecht 1992-93, p. 197, fig. 3, and Brusati 1995, pp. 83-86, 364, no. 88, fig. 50.

106 Spicer 1988, figs. 1, 2.

107 Bürger 1858, p. IX, quoted by Haskell 1976, p. 147. See my essay on the appreciation of Flemish painting in America, in Bauman and Liedtke 1992, pp. 11-28 (pp. 18-19 on Thoré, Motley et al.).

108 The quote is from Sutton 1980a, p. 20. On the artists who worked for the Princes of Orange see The Hague 1997-98a.

109 The quote, of course, is from Van Mander, as discussed by Reznicek 1963.

110 Montias in Rotterdam 1991, p. 25.

111 Keyes 1984, p. 87. For Groenewegen's panel in the manner of Breenbergh in the Rijksmuseum, Amsterdam, see Delft 1996, p. 34, fig. 26.

112 See Liedtke 1991a, pp. 39-41, following Staring 1965.

113 Hoogsteder 1986, I, pp. 60-63, nos. 8-10.

114 As Sutton 1980a, p. 20, describes them, referring to Vredeman, not Lyckle.

115 See Franits 1996, especially p. 13.

116 See F. Scholten, "Ludolf de Jongh en de aristocratisering van het genre," in Rotterdam 1994-95, pp. 143-52.

117 Franits 1989 does not approach the subject from this angle.

118 Philadelphia-Berlin-London 1984, no. 84.

119 See Boston-Toledo 1993-94, p. 391 for a biography of Coques and literature.

120 See Bol 1989, figs. 87-89.

121 See Jantzen 1910, Liedtke 1970 and Rotterdam 1991.

122 See, for example, the scientific study in which a Keplerian telescope is used to record sunspots, in Christophorus Scheiner's famous *Rosa Ursina* of 1630. The print is illustrated in Whitehead 1986 (fig. 30), which dismisses one of the wackier arguments that a Dutch artist used some kind of optical instrument (Frans Post and a reversed telescope).

123 Rosenberg-Slive-ter Kuile 1966, pp. 104, 109, 110.

124 De Vries 1977, p. 85.

125 Royalton-Kisch 1988.

126 According to a publication of 1649: see Royalton-Kisch 1988, pp. 40-41 on Van de Venne's life in The Hague.

127 As noted by Royalton-Kisch 1988, p. 41.

128 For example, Franits 1993a, Westermann 1997.

129 For *The Painting Shop in Middelburg* (private collection) see Royalton-Kisch 1988, p. 39, fig. 8. Versions of Bruegel's composition by his son Pieter are listed in Marlier 1969, pp. 435-40. See also Pieter de Bloot's related composition, *The Lawyer's Office*, 1628 (Rijksmuseum, Amsterdam), which is catalogued in Rotterdam 1994-95, no. 5.

130 On the style of Van de Venne's illustrations see Von Monroy 1964, pp. 60-63, 88, 97-98.

131 On the Flemish pictures see Filipczak 1987.

132 See Sutton 1980b (quote from p. 323). As Sutton's article makes clear for the first time, Van der Burch joined the Delft guild in 1649 but moved to Leiden by September 1655. He left for Amsterdam by 1659 but is recorded in Leiden in 1661 and 1662 and paid dues to the guild there in 1663. His last recorded child was baptized in Leiden in 1666, after which no further biographical details (including the date and place of his death) are known. It appears then, that all of the paintings by Van der Burch which remind one of De Hooch (after the De Jongh-style tavern scenes of the early 1650s) were painted either in Leiden or Amsterdam, and simply reflect the influence of De Hooch, perhaps De Jongh, Metsu, and others. He is one of a few artists who might be said (in auction-house terminology) to represent the "school of Pieter de Hooch" (which is how he figures in Delft 1996, pp.170-77), but as for place he represents South Holland, not Delft. On Van der Burch's residence in Leiden, see also Lunsingh Scheurleer et al. 1986-92, part vb, pp. 390, 409; vIa, pp. 22; vIb, pp. 728-29. The last pages (and I, pp. 23-24) are on Van der Burch's canvas of about 1658 in the Rijksmuseum, Amsterdam, *Graduation Ceremony at the University of Leiden*, which must owe something to De Hooch's courtyard pictures, and may be compared broadly with works by Vermeer and Daniel Vosmaer.

133 For a brief review of these figures see Broos's essay in Washington-The Hague 1995-96, pp. 47-51. Further thoughts on Antwerp painters in connection with the South Holland tradition are offered in Liedtke 1988a, pp. 102-3.

134 On this point see Liedtke 1995-96, pp. 30-31.

135 MacLaren 1960, p. 229.

136 However, Brown in MacLaren/Brown 1991, p. 241, pens a pithy corrective.

137 Sumowski 1983-[94], III, nos. 1342, 1343, 1347, 1356.

138 Delft 1996, p. 141, fig. 128.

139 See Fleischer 1989, figs. 92-95.

140 The paintings by De Hooch are catalogued in Sutton 1980a, nos. 12, 13, pls. 11, 12, and (Dublin) pl. II. On the Dublin picture, especially with regard to iconography, see Potterton 1986, pp. 67-68. *The Reprimand* by De Jongh (location unknown) is in Fleischer 1989, fig. 74.

141 Sutton 1980a, nos. 4, 5, pls. I (color) and 4. *The Empty Glass* was exhibited in Delft 1998, no. 143, and is catalogued in Lammertse 1998, no. 29.

142 Sutton 1980a, pp. 11-13. See also M. Kersten in Delft 1996, pp. 133-35. De Bloot painted tavern interiors of the Brouwer/early Teniers type in the mid- to late 1630s, for example, Rotterdam 1994-95, no. 7.

143 Sutton 1980a, nos. 1, 2, pls. 1, 2; Schulz 1978, pp. 8, 13-14, pl. 1.

144 Sutton 1980a, p. 14, pl. 3; Schulz 1978, pls. 2 (note the soldier silhouetted in the left foreground), 3, 5, 6, 8. Paintings by Saftleven turn up in Delft inventories. He has also been seen as influential for Bramer (see Delft 1994, p. 55, figs. 9, 10).

145 Sutton 1980a, nos. 11bis, pl. 9B.

146 See Schulz 1978, pls. 17, 21, 23, 28, etc.

147 Schulz 1978, p. 24.

148 As noted by Kersten in Delft 1996, pp. 133-34, figs. 117-20.

149 For similar works by Brouwer see, for example, Knuttel 1962, figs. 67, 78, and pl. x; Liedtke 1984b, pp. 335-36, fig. 20.

150 See Sutton 1980a, p. 13, and Gudlaugsson 1959-60, pls. 68-69, 73, 74, 94.

151 Sutton 1980a, nos. 10, 11, pls. 8, 9A. For the relevant Van den Eeckhouts see Sumowski 1983-[94], II, nos. 505, 506, 510, 511, etc. According to Sumowski his no. 505, fig. 199 here, is dated 1653; in earlier publications it is said to be dated 1651.

152 Fleischer 1989, pp. 65-69, pls. 74-76, 77, 80. On *Paying the Hostess* see also Fleischer and Reiss 1993, pp. 668-69.

153 On Duck see now Salomon 1998, which is concerned primarily with iconographic and gender issues.

154 Cats 1712, II, p. 494; reproduced in Bol 1989, fig. 133.

155 Discussed in Philadelphia-Berlin-London 1984, no. 70.

156 See Sumowski 1983-[94], III, nos. 1331, 1333, 1335, 1347. The De Hoochs in Paris and Switzerland are nos. 17 and 18, figs. 16 and 17 in Sutton 1980a.

157 Sutton 1980a, nos. 30, 31, 40A, 40B, 42, pls. 28, 29, 43, 44, 46.

158 For these paintings by Maes see Sumowski 1983-[94], III, nos. 1337, 1342-43, 1346-48, 1351.

159 Sutton 1980a, nos. 20, 21, 24, pls. III-v. See also no. 22, pl. 19 (lost).

160 Sumowski 1983-[94], III, nos. 1375-81.

161 Sutton 1980a, pp. 21-22, no. 16, pl. 15, as ca. 1654-57.

162 For example, the panel in Munich (Schneeman 1982, no. 25), in which the square tiles recede obliquely.

163 Similar paintings (with tiled floors) by Palamedesz include the following: a panel (55.6 x 86.4 cm) exhibited by Eugene Slatter (London?) in 1951; a panel (38 x 65 cm) at Hôtel Drouot, Paris, March 29, 1968; and another

(45.9 x 71.8 cm) at Christie's, Amsterdam, May 4, 1999, no. 56, and also September 1, 1999, no. 9. Christie's expert and an independent conservator confirmed that the floor tiles in the last painting are original, not added at a later date. See also Palamedesz's family portrait of the mid-1630s in the Koninklijk Museum voor Schone Kunsten, Antwerp.

164 See Sutton 1980a, pls. 18, 22-27, and VI.

165 Wheelock 1995b, pp. 26-30.

166 Gudlaugsson 1959-60, nos. 112, II; and 138.

167 See Gudlaugsson 1959-60, nos. 68-70.

168 Sutton 1980a, no. 15, pl. 13.

169 Salomon 1998a, uses the word in her title and describes the concept in her text. Compare Scholten's essay on "aristocratization" in the works of Ludolf de Jongh, in Rotterdam 1994-95.

170 As did Bramer of another De Jongh: see Fleischer 1989, fig. 67, and the article on Bramer's copies: Plomp 1986. Fleischer 1997 advances the problematic canvas in the National Gallery, London, known as *The Refused Glass*, as a De Jongh which in his view was singularly decisive for De Hooch's canvas of 1658 in the Louvre (fig. 243) and for Vermeer's wine-drinking scenes in Berlin and Braunschweig. This is precisely the sort of argument ("We can therefore date *The Refused Glass* to 1650-1655 and suggest that it was a source of inspiration for both De Hooch and Vermeer"; p. 252) that the present writer hoped to discourage with Liedtke 1988a (not cited by Fleischer). Of more immediate importance for Fleischer's thesis is that De Jongh's authorship is doubtful, and that, whoever painted the London picture, "it should probably be placed at the very earliest in the first half of the 1660s, that is, a few years after comparable works by de Hooch and Vermeer" (Brown in MacLaren/Brown 1991, p. 100, under no. 2552 as "Delft School"). As for the painting's long association with the "Delft School," this could mean nothing more than a minor artist influenced by De Hooch's work in Amsterdam during the early 1660s.

171 The quotes in this paragraph are from Sutton 1980a, p. 22. The advice about "light, colour, and atmosphere" is borrowed from Wheelock 1977a, p. 6, who also mentions perspective treatises (thus giving a particular meaning to the word) and then reminds the reader that "perspective was also a matter of light, color, and atmosphere."

172 Wadum in Washington-The Hague 1995-96, pp. 69-74, with diagrams.

173 As proposed in Seymour 1964 and elsewhere; see Wadum 1995 for a summary of opinions.

174 As suggested in Sutton 1980a, p. 23.

175 As noted by Blankert and Wadum in Washington-The Hague 1995-96, pp. 39, 73, and by Wheelock in earlier publications.

176 See Liedtke 1991b on Pepys's pursuit of wine, women, and oysters in relation to Dutch genre pictures.

177 The two paintings were seen together in Dulwich-Hartford 1998-99, nos. 14, 15.

178 It is surprising to read of "the improved disposition of the figures" in MacLaren/Brown 1991, p. 200, as if the same staffage had been shoved about. Compare Lokin in Delft 1996, p. 110, who emphasizes the difference in subjects. On the motif of a child and dog (or other animal in a child's care), see Bedaux 1990, pp. 109-69.

179 Sutton 1980a, p. 84 under no. 33, following MacLaren 1960, pp. 188-89 (repeated in MacLaren/Brown 1991, pp. 199-200).

180 The quote is from Sutton 1980a, p. 85 under no. 34.

181 Sutton 1980a, pp. 24-25 (quote from p. 24).

182 For the Ter Borch in Berlin and works by other artists that derive from it, see Zwolle 1997, pp. 46-47, and Delft 1996, pp. 106-7, fig. 90.

183 See Sumowski 1983-[94], III, nos. 1378-80.

184 Sutton 1980a, p. 85 under no. 35A, suggests that this may be a section of the old town wall in Delft, but it is domestic in scale and construction. Wheelock 1995b, p. 140, also considers the motif to be "presumably a section of the old city wall" (he credits Valentiner), although the other courtyard view in Washington (ibid., pp. 136-38) shows the "old town wall" as taller and with heavy buttresses on the inside.

185 *A Woman and Two Men in an Arbor*, a minor work of about 1657-60 in the Metropolitan Museum (Sutton 1980a, no. 23, pl. 20), has no architectural setting and could be said to reflect more closely the older type.

186 See Sutton 1980a, nos. 60A, 76, 91, 134; pls. 64, 79, 94, 137. The last painting represents a courtyard behind a great house on a canal.

187 Sutton 1980a, nos. 35A, 38, 39, pls. 34, 41, 42; Wheelock 1995b, pp. 136-42; Delft 1996, figs. 97, 100.

188 Sutton 1980a, nos. 36, 37, pls. 39, 40; White 1982, p. 61, no. 84 on both; Delft 1996, fig. 101 (private collection).

189 Sutton 1980a, no. 44, pl. 48 and pl. x; the quotes are from MacLaren/Brown 1991, p. 197, which convincingly places the London picture within De Hooch's Delft period, not during his visit there in 1663. "The identical pump" changes scale considerably.

190 Sutton 1980a, no. 45, pl. 49; Delft 1996, p. 117, fig. 105. As Sutton observes, the house reappears in *A Woman and a Maid with a Pail in a Courtyard* in the Hermitage (Sutton 1980a, no. 46, pl. XI; Delft 1996, p. 117, fig. 108).

191 See, for example, Sutton 1980a, p. 23, where De Hooch's use of primary (if not "pure unmixed") colors is rightly called the "correlative" of his balanced compositions (as Vermeer would have recognized immediately).

192 On the Koetser painting in Zürich and the *Young Woman in a Court* in Champaign, Illinois, see Lokin 1996, pp. 117-19, figs. 104, 107. On Van der Burch in general: Sutton 1980b.

193 Sutton 1980a, nos. 36, 38, pls. 37 (detail), 39, 41.

194 Sutton 1980a, and Dulwich-Hartford 1998-99.

Notes to Chapter Five

1 The quotes are from Wheelock's introductory essay in Washington-The Hague 1995-96, pp. 15-16.

2 Montias 1989, p. 351 in doc. no. 383 of 27 July, 1677.

3 Montias 1982, p. 181.

4 See Delft 1981, p. 204, figs. 248-49.

5 Gowing 1970, p. 85.

6 Montias 1989, p. 247. Silvercroon was the son of Van Ruijven's great-aunt, his mother's first cousin, and his sister's godfather. In the late 1630s he paid Dou an annual fee of five hundred guilders. On Van Ruijven's relationship with Vermeer see also Montias 1987.

7 Montias 1989, pp. 261-62.

8 See Manke 1963, p. 69, the document dated April 30, 1670; and Sutton 1980a, pp. 9, 145, doc. no. 15.

9 Nash 1991, p. 53, remarks: "It was perhaps soon after this [*The Procuress* of 1656] that Vermeer was discovered by his principal patron, Pieter van Ruijven, and Van Ruijven collected cabinet pictures." According to Kettering 1993, p. 104, "Jacob Dissius, son-in-law of Pieter Claesz van Ruijven (Vermeer's Maecenas), [had] three Ter Borch pictures in his collection." This would suggest that Van Ruijven was Ter Borch's patron. But Kettering kindly conceded in a letter to the writer (1998) that her statement is mistaken, and perhaps based upon confusion with the three

De Wittes that Van Ruijven owned. Van Ruijven and Dissius are not recorded as collectors of paintings by Ter Borch in Gudlaugsson 1959-60 or in Montias 1989.

10 Montias 1987, p. 69; Montias 1989, Ch. 13, and pp. 248, 312, doc. no. 271. Montias's thesis has been questioned by Wheelock in Washington-The Hague 1995-96, pp. 22-23, who writes of no absolute proof and then speculates implausibly about alternative scenarios. Wheelock's view is contradicted in the same catalogue by Broos, pp. 47, pp. 53-54, and by Wadum, p. 77, and is rebutted in Montias 1998a (see also Van der Veen 1992, p. 100, and Westermann 1997, p. 63).

As discussed by Montias, Van Ruijven was a wealthy brewer's son who had houses on the east side of the Oude Delft and on the Voorstraat in Delft. He and especially his wife, Maria de Knuijt, appear to have inherited most of their wealth and increased it through investments. His brother, the notary Jan van Ruijven, registered the betrothal of Vermeer and Catharina Bolnes on April 5, 1653. Pieter van Ruijven's only daughter and heir, Magdalena, married a printer's son, Jacob Dissius, in 1680, who had no financial resources of his own. Maria de Knuijt died in February 1681, six and a half years after her husband; their daughter died, aged twenty-seven, in June 1682. Her husband inherited the domain of Spalant, near Schiedam, and the entire Van Ruijven estate, including his paintings. Twenty works by Vermeer are listed in the inventory (April 1683) of property left by Magdalena Pieters van Ruijven to Jacob Dissius. The only asset said to belong to Dissius himself was a life annuity yielding 100 guilders a year. He died, shortly before his forty-second birthday, in October 1695. The Dissius collection, sold at auction in Amsterdam on May 16, 1696, included twenty-one paintings by Vermeer, three church interiors by De Witte, four landscapes by De Vlieger, other Dutch and some Italian works. Montias 1987, p. 72, suggests plausibly that the additional work by Vermeer was *The Little Street* (Rijksmuseum, Amsterdam), which may have been the unattributed painting of houses listed in the Dissius inventory of 1683. It is not clear that every work in the Dissius sale of 1696 was purchased by Pieter van Ruijven from Vermeer, but the great majority appear to have been. Of particular interest is the fact that Van Ruijven's wife, who made a separate testament when she and her husband made a joint testament in 1665, left 500 guilders to Vermeer (excluding his wife and children if he predeceased them). He was the only person not belonging to the Van Ruijven or De Knuijt families to be left a special bequest in either of their wills. For a concise review of these matters see Montias 1998a, pp. 93-99.

11 On visits to artists' studios as a gentlemanly pursuit, see Van de Wetering in Melbourne-Canberra 1997-98, pp. 60-62. On Vermeer's visitors see Broos in Washington-The Hague 1995-96, pp. 47-54. For Teding van Berkhout see Van der Veen 1992, p. 100, and sources cited.

12 See Montias 1989, pp. 102-3.

13 Some of the following material developed from Liedtke 1992b.

14 Hubert von Sonnenburg, Chief Conservator, Metropolitan Museum of Art, New York, in conversation, 1991. See his "Technical Comments" in Walsh 1973.

15 For a recent English translation see Liedtke 1995-96, p. 9.

16 Wheelock 1981, p. 64; Swillens 1950, p. 64, no. B. Swillens also rejected *Diana and her Companions*.

17 For the hypothesis that Bramer may have been Vermeer's teacher: Wheelock 1981, p. 16; Blankert 1978, p. 11; Gowing 1990, p. 159. Montias 1989, pp. 100, 103-4, on the evidence; see also Wheelock's essay in Milwaukee 1992-93.

18 Walsh 1973, figs. 29, 30, and adjacent text, makes the now well-known

comparison with Honthorst's *Procuress* of 1625 (Centraal Museum, Utrecht). Honthorst is not mentioned in Blankert 1978 or in Wheelock 1981, and only with respect to later paintings in Gowing 1970, pp. 126, 157.

19 On the origins of the quote see Reff 1960.

20 That is, Honthorst's silhouetted figure in the immediate foreground: compare Rembrandt's *Simeon in the Temple* of about 1627-28 (Hamburger Kunsthalle, Hamburg) and *The Supper at Emmaus* of 1629 (Musée Jacquemart André, Paris).

21 Wheelock 1981, p. 82, claims that "this work is exuberant and stresses momentary action," while Blankert 1978, p. 33, sees the figures as "frozen" by Vermeer's "meticulous technique," which "prevented him from creating an effective suggestion of movement." Is the action in Honthorst's *Procuress* (see n. 18) "momentary" or "frozen"?: the question reveals our post-photographic approach to Vermeer. The modern reading of action in his paintings must be very different from that of his contemporaries or even from that of Thoré-Bürger (on whom see Blankert 1978, pp. 67-69). Vermeer's pictures do not recall photography today but nineteenth-century photographs.

22 Wheelock 1981, p. 82, who finds the same effect in Dou and Carel Fabritius. The man's larger scale, which would be close to normal if he took off his hat and coat, may be an arbitrary exaggeration introduced both to enhance the sense of depth and to comment upon the couple's relationship.

23 On both see M. Kahr's perceptive review of Snow 1994 (the 1979 edition) in *The Art Bulletin*, LXIV (1982), pp. 338-40. On Snow's interpretations of Rilke see Michael Hoffmann in *The New York Review of Books*, April 28, 1996, p. 18 ("at their worst, his versions strike me as peculiar without being possible").

24 Wheelock, despite his keen interest in the device, has rightly emphasized Vermeer's many adjustments in compositional design: Wheelock 1981, in several commentaries to the plates; Wheelock 1987; and Wheelock 1988b. See also Wheelock in Washington-The Hague 1995-96, pp. 25-27.

25 Gombrich 1972; for most of the relevant literature see Parker 1990. A refreshing referral to Gombrich informs Ernst van de Wetering's essay, "Rembrandt's Manner: Technique in the Service of Illusion," in Berlin-Amsterdam-London 1991-92, pp. 12-39 (see especially pp. 24, 26).

26 This approach effectively began with Gowing 1970, Part II, and is now standard in Vermeer monographs.

27 Gowing 1970, Part I (the edition of 1970 is cited below).

28 A. K. Wheelock, review of Blankert 1978, in *The Art Bulletin*, LIX (1977), p. 440.

29 Blankert 1978, pp. 13-17, pls. 1, 2; Wheelock 1981, pp. 64-69, as ca. 1654-55 (Edinburgh) and ca. 1655-56 (The Hague); Slatkes 1981, pp. 15-19 (same dates as in Wheelock). For the connection with Jacob van Loo see Gowing 1970, p. 96 (two versions; the idea of a "direct quotation" is exaggerated); Blankert 1978, p. 15, fig. 6; Wheelock 1981, p. 68, fig. 61.

30 Slatkes 1981, pp. 16, 18.

31 For example, Wheelock in Washington-The Hague 1995-96, p. 98, where one reads of "an overwhelming sense of solemnity more associated with Christian than with mythological traditions."

32 Gowing 1970, p. 93.

33 For Van Loo's painting in Berlin (1648) see Gowing 1970, p. 93 (ill.), or Wheelock 1981, fig. 61. His canvas in Braunschweig (about 1650) is compared with the Vermeer in Washington-The Hague 1995-96, p. 96, fig. 1. The Copenhagen canvas by Van Loo (1654) is cited by Gowing 1970, p. 96, who claims unconvincingly that Vermeer's figures are quoted

directly from it. Similarly, in Broos 1993, p. 312, Vermeer is said to have "borrowed almost literally whole figures" from the Van Loo in Berlin.

34 Gowing 1970, p. 97, n. 37, maintains that "no comparison illuminates better the essentially different temperaments of the two masters." Wheelock, in Washington-The Hague 1995-96, p. 98, sees Rembrandt as influential for "Diana's blocky form," her "somber mood" (due perhaps to abrasion) and "thick impastos," and for the idea of casting "the faces in shadow to enhance the expressive potential of his scene."

35 See The Hague 1997-98a, nos. 10, 18 (p. 143 on "nymphs").

36 See n. 31. To my knowledge Callisto has not been identified before.

37 Wheelock in Washington-The Hague 1995-96, p. 98: "The quiet, reflective countenances of Diana and her attendants are those of individuals who singularly must come to terms with a shared grief." Another interpretation, taking into account the dog, thistle, basin, and Callisto, will be found in New York-London 2001.

38 Gowing 1970, pp. 94 (ill.), 96.

39 See the round panel, *Young Woman at her Toilet*, of about 1649, formerly in a private collection, Paris, and *The Toilet* of about 1651 in New York (Gudlaugsson 1959-60, nos. 77, 80; see fig. 292 below).

40 Foucart 1989, p. 18, figs. 2-4.

41 Wheelock in Washington-The Hague 1995-96, p. 98, on the act of foot-washing.

42 See Kettering 1983; Utrecht-Frankfurt-Luxemburg 1993-94; and The Hague 1997-98a.

43 New York 1985-86, no. 170.

44 Washington-The Hague 1995-96, no. 1, with previous literature (Hannema and Wright concur). Arasse 1994, p. 18, also accepts the work. Brown 1996, p. 281, rejects it, suggesting that the copyist might be Italian not Dutch.

45 Wheelock in Washington-The Hague 1995-96, p. 88. On the money and time required for a trip to Italy, see Montias 1982, pp. 46, 166.

46 The quote is from Broos 1993, p. 313.

47 Here I concur with Wheelock in Washington-The Hague 1995-96, p. 90, although much of his discussion differs from mine. His reference to the "important artistic and theological currents with which Vermeer contended at the beginning of his career" may be filed away for use in a monograph on Caravaggio or another more appropriate Baroque painter.

48 This question was explored with Guus van den Hout, Director of the Museum Amstelkring (O.L.H. op Zolder), Amsterdam. We agreed that the picture was probably not intended for the two or three Jesuit brothers who might have been living at any particular address in Delft. Montias 1989, p. 202, n. 94, supports this view on iconographic grounds. See Washington-The Hague 1995-96, no. 20.

49 See Westermann 1997, pp. 216-17, fig. 124, for an insightful interpretation, and comparison with Ter Borch.

50 The Hague 1997-98a, no. 5; see also p. 117, fig. 3 (the Achilles canvas at Pommersfelden), and no. 7. It seems a nice coincidence that the fathers of both Van Dyck and Vermeer made fine fabrics.

51 Compare Van Dyck's *Tribute Money* in the Palazzo Bianco, Genoa, and the *George Gage with Two Men* in The National Gallery, London: Washington 1990-91, nos. 30, 40. In the same catalogue, see no. 32 (*A Roman Clergyman* in the Hermitage, St. Petersburg), mostly for the hands; and no. 41 (*The Ages of Man* in Vicenza), to compare Martha's arm and hand.

52 As in *The Mystic Marriage of Saint Catherine* in the Royal Collection, London (Washington 1990-91, no. 55).

53 Van Dyck's composition, illustrated here (fig. 256), was engraved by Schelte à Bolswert, and is also known from workshop replicas and old copies: see Liedtke 1984a, pp. 80-81.

54 For Van Bronchorst, see Döring 1993; compare compositions like his *Arcadian Concert* in Braunschweig, Döring's no. A 19-1.

55 Washington-The Hague, 1995-96, nos. 1-3 (quote from p. 98).

56 Montias 1989, p. 310, doc. no. 256.

57 Washington-The Hague 1995-96, p. 90. The same view is stated more strongly in Wheelock 1981, p. 64.

58 Compare the plate in Wheelock 1981, p. 65, with those in Washington-The Hague 1995-96, p. 91, and in Slatkes 1981, p. 14. The second is the most reliable in color, but the last gives a better idea of the spatial effect.

59 The shape of this material echoes the contour of Martha's head and descends to her sleeve. Julia Lloyd Williams in Edinburgh kindly confirmed that the contour of the carpet behind Mary was modified and that the bottom of the door may have been corrected. The window sill in the background, which looks like it was rendered twice, remains a problem. There is no obvious sign (overpaint, transparency) of a pentimento having become visible, and it is not clear what the painter intended.

60 See Gowing 1970, pp. 80-81, who credits Trautscholdt 1940 (p. 267; many notions found in later literature go back to this remarkable entry in Thieme-Becker); also Wheelock 1981, p. 66, fig. 59; Wheelock in Washington-The Hague 1995-96, p. 92, fig. 2; etc.

61 This form was never clearly defined, to judge from radiographs and firsthand examination. If meant as a print, it would recall that in Pieter de Bloot's painting of the same subject: see New York 1985, no. 170. It is possible that Vermeer meant to suggest a corner behind Martha, which would also clarify that the wall behind Christ is receding.

62 In this paragraph I repeat lines from Liedtke 1992b, with some alteration; see there p. 104, nn. 33 and 35 for further description, and comparison with Ter Brugghen. Wheelock, in Washington-The Hague 1995-96, pp. 90-92, compares Ter Brugghen's *Saint Sebastian Tended by Saint Irene and her Maid*; the female types in that picture also anticipate Vermeer's idea of fetching and sturdy sisters. The pyramid of forms in the immediate foreground and sudden recession in the Ter Brugghen give the altarpiece extraordinary monumentality, a lesson learned by Vermeer. There is much in his light and rhythmic handling of drapery that may also be indebted to Ter Brugghen.

63 Montias 1989, pp. 105-7, on Vermeer in Utrecht or Amsterdam.

64 De Bruyn 1988, pp. 32-33, 61, and no. 180. For some reason Montias 1989, p. 105, has Quellinus in Amsterdam during the early 1650s.

65 According to Montias 1989, pp. 139-40. Like the Edinburgh painting, the *Holy Women* ("Three Marys") makes one wonder whether the subject was partly a tribute to Vermeer's mother-in-law, Maria Thins.

66 Wheelock 1981, p. 72; Montias 1989, pp. 254, 364.

67 See Döring 1993, nos. A 10 (compare Vermeer's *Diana* in design and mood), A 19-1 (see n. 52 above), A 25 (fig. 259 here) and A 26 (compare the *Girl with a Pearl Earring* in the Mauritshuis), A 28 (compare the Kenwood *Guitar Player*), and A 30 to A 37, which are various musical companies in half-length, mostly placed behind a parapet with a carpet draped over it (compare *The Procuress*).

68 Gowing 1970, p. 84, on *The Procuress*. Wheelock 1981, p. 70, by contrast, implies direct borrowings from big names, such as Honthorst, Baburen, and others who depicted this unsubtle sort of bordello scene.

69 Wheelock 1981, p. 72.

70 See Lynn Orr's entry in San Francisco-Baltimore-London 1997-98, no. 38.

71 For the two Baburens see Slatkes 1969, nos. A12, A20, figs. 17, 22. Nearly the same design is found in Honthorst's *Merry Company* of 1623 in Helsingör.

72 See n. 67 above on Van Bronchorst; The Hague 1997-98a, pp. 43-44, fig. 12, and Morren, Meischke and van der Wyck 1990, pp. 206-8, for De Grebber's designs.

73 Liedtke 1984a, pp. 5-10.

74 See Chapman's essay, "Jan Steen, Player in his own Paintings," in Washington-Amsterdam 1996-97, pp. 10-23, and Westermann 1997, pp. 94-95. For Metsu's picture: Robinson 1974, pp. 29, 32, fig. 34; Chapman 1990, p. 118, fig. 160.

75 Gudlaugsson 1959-60, II, p. 82 under no. 57; MacLaren/Brown 1991, pp. 34-39.

76 See M. J. Bok in Washington-Amsterdam 1996-97, p. 29, on Steen in Delft; Chapman in the same catalogue, p. 19, on Steen playing the wastrel; and Chapman 1990, pp. 114-20, on Rembrandt acting the part of the Prodigal Son.

77 See Chapman 1990, p. 118, where Palamedesz and Vermeer are mentioned, and Raupp 1984, pp. 311-28. Also of interest: Raupp 1978.

78 See Chapman's discussion of Steen's *Self-Portrait as a Lutenist*, in Washington-Amsterdam 1996-97, no. 25. The doublet is further discussed below.

79 See Hertel 1996, who on p. 1 quotes Jean Cocteau's response to *The Procuress* on, as it happens, the picture's 300th anniversary: "At the sight of this astonishing painting by Vermeer one stands as if confronted by a postcard sent from a better world." Of course, Cocteau's idea of a better world was not Billy Graham's.

80 Nash 1991, p. 50. On subsequent pages Nash offers perceptive remarks about the painting's formal qualities; see especially p. 53 on viewing distance and contrasts of scale.

81 Nash 1991, p. 52.

82 Compare the social triangle in the Braunschweig picture (fig. 272; see Washington-The Hague 1995-96, no. 6), where the lady wears a forced smile. Christ and Martha in the Edinburgh picture are oddly reminiscent of cavaliers and women in contemporary church interiors (see fig. 113), and of figures in the early inn scenes by De Hooch.

83 See Chapman 1990, pp. 69-71, fig. 101.

84 See Chapman 1990, pp. 10, 23-24, 71, fig. 23, on the Munich painting and related works.

85 See Wheelock 1981, pp. 70, 161, n. 59; Montias 1989, pp. 196, 230; etc.

86 Van Gelder 1958, p. 14; De Winkel 1998, pp. 332-34. See also Sluijter 1998a, pp. 269-71, 281, nn. 46-48. De Winkel notes that the slashed doublets in the two Vermeers are not the same and that the short doublet (called an "innocent") with narrow panes on the back and sleeves seen in *The Art of Painting* was usually worn by trend-setters of the early to mid-1660s. The latter point is qualified in Gordenker 1999, pp. 231-35.

87 As discussed in Gordenker 1999, pp. 231-33. Compare the collars in Van Dyck's *Self-Portrait with Endymion Porter* in the Prado, Madrid, and in his *Charles I and Henrietta Maria* in the Archbishop's Palace, Kremsier (The Hague 1997-98b, p. 213, fig. 187, for the latter).

88 Gowing 1970, p. 35, for the quotes in this paragraph; p. 34 on barriers, which he finds in all but three of twenty-six interior views. Scholars will react differently to Gowing's subjective remarks and to recent paraphrases of them (as in Arasse 1994, p. 66). Hertel 1996, p. 2, passim (see Gowing in her index) overlooks the unprecedented thoroughness with which Gowing related Vermeer to other artists, and treats the historian as someone who merely employed Vermeer "to invoke a paradigm of the metahistorical

aesthetic object." One misses any mention of Malraux's 1952 monograph in Hertel's book, which, notwithstanding its caricature of Gowing, has much to offer. Unfortunately, Arasse's monograph was too recent for discussion among essays "based upon the French paradigm" (p. 78).

89 See Nash 1991, pp. 52-53, on the spatial effect.

90 *The Terrace* (see Fleischer and Reiss 1993, pp. 673-74, fig. 11) is mentioned here as a parallel, not a source. Scholars since Eisler (1923, p. 192) have compared *The Letter Reader* with church interiors by Houckgeest and Van Vliet; Gowing 1970, p. 100, characteristically relates Vermeer's "immobile and independent ladies" to Van Vliet's "single pillar, which he often painted, standing alone in measured space and light."

91 Wheelock 1987, p. 410, fig. 21 (x-ray).

92 As in Maes's "Lacemakers" in the Mauritshuis and in the National Gallery of Canada, and in the *Sleeping Account Keeper* of 1656 in the St. Louis Art Museum. See Sumowski 1983-[94], III, nos. 1337, 1342, 1358 (etc.).

93 Quoted by Nash 1991, p. 53 (see his p. 127 for the source).

94 Wheelock 1995a, Ch. III for perceptive remarks on the technique. See also Gowing 1970, pp. 88-92; Wheelock 1981, p. 74; and Nash 1991, pp. 54-62.

95 Nash 1991, p. 57.

96 Wheelock 1995a, p. 40, suggests that the woman, "to judge from the costume and the pearl earrings … is not a maid, but the mistress of the house." However, De Winkel 1998, p. 328, considers the woman an overdressed maid, and cites contemporary criticism and a sumptuary law (Amsterdam, 1681) forbidding servants to wear silk garments and jewelry. That the figure is described as a "sleeping maid" in the sale of 1696 cannot be taken lightly, nor interpreted as a poetic reference to a "maiden."

97 See Walsh 1973, fig. 95, or Wheelock 1981, fig. 68, for an x-ray showing the man and dog. The situation and the type of dog (not small, not a "lap dog," not seated as stated in Slatkes 1981, p. 24) recall Ter Borch, for example, in *The Suitor's Visit* (National Gallery of Art, Washington), where the dog is somewhat smaller. The arrangement of the dog, doorway, and man in the background broadly brings to mind Frans Hals's so-called *Yonker Ramp and His Sweetheart* (Metropolitan Museum of Art, New York), but it is the naturalistic rush of space that makes the comparison interesting.

98 See Ainsworth et al. 1982, pp. 18-26. Close consideration of the picture's iconography began with Kahr 1972.

99 Wheelock 1995a, p. 39.

100 As observed in Nash 1991, pp. 58-59. The theme of melancholy surfaces with surprising frequency in Wheelock's interpretations of Vermeer and, it will be recalled, Fabritius. Kahr 1972 presents a detailed and convincing argument that the pose of the woman follows a long tradition of representing sleep or Sloth, which leads to other vices. The melancholic hypothesis, entertained in Wheelock 1981, p. 74, is not supported by more recent literature, such as Nanette Salomon's dissertation on sleep and idleness in Dutch art (Salomon 1984; see also Notarp 1996). Van Veen's emblem, "Love requires sincerity," which Kahr 1972, p. 130, introduced into discussion (also considered a clue in Wheelock 1981, p. 74, fig. 66, and in Wheelock 1995a, p. 41, fig. 24), differs substantially from the detail in Vermeer's painting, where the mask alone is "the more significant element" (Salomon 1998a, p. 101). Any further discussion of melancholy, as opposed to pleasant dreams, must deal with the lady's sweetly smiling lips.

101 Nash 1991, p. 62. A Dutch door?

102 As noted and discussed in Donhauser 1993.

103 On this point see the excellent discussion of *A Maid Asleep* in Salomon 1998b, pp. 316-19. Salomon compares open doors and entering men in earlier Netherlandish images, including paintings by Duck and an anonymous print of about 1630 inscribed in Dutch and French ("Compt vry inne … / Entre hardement Pierre …").

104 As noted in Slatkes 1981, p. 24. Salomon 1998a, pp. 98-103, offers valuable observations about the mask, pillow, chair, etc.

105 See Mayer-Meintschel 1978-79; Wheelock 1987, p. 410, fig. 21. The former presence of the *roemer* strengthens the comparison between *The Letter Reader* and a painting by Adam Pick (known from a drawing by Bramer); see Blankert 1978, p. 33, fig. 25. The similarity reveals common currency, not debt.

106 Compare Gudlaugsson 1959-60, I, nos. 77, 80, 81, 83, 110.

107 This is touched upon in Goodman-Soellner 1989, p. 77, and in Kettering 1993, pp. 101, 107-9.

108 Gowing 1970, p. 33.

109 Gowing 1970, p. 33, implying stress upon "own vein."

110 On the curtains in this painting and Parrhasios, see Nash 1991, pp. 90-91.

111 Montias 1989, p. 339.

112 See the large detail in Wheelock 1981, p. 79.

113 See the detail in Wheelock 1981, p. 73.

114 See Nash 1991, p. 53, on *The Procuress*: "But nothing is made clearer to view by approaching the picture more closely. Objects do not dissolve into brushstrokes, they simply continue to look as if they were at a distance."

115 For example, in the *Flower Still Life* dated 1652 in the Uffizi, Florence (Chiarini 1989, no. 1.3).

116 See the color plate in Goldscheider 1967, fig. 17. The mostly yellow fruit is textured in a manner like Kalf's and sparkles like the pointillé highlights on the carpet. Vermeer may have adopted the idea of spilling fruit across the composition from still lifes painted in Delft, for example, by Gillis de Bergh (ca. 1600-1669; see Vroom 1980, I, p. 124, fig. 164).

117 Compare, for example, the *Still Life with Nautilus Cup and Other Objects* in the Thyssen Collection: Gaskell 1989, no. 10. Wheelock 1995a, pp. 56-57, compares Kalf's textures and reflections to Vermeer's in the *Cavalier and Young Woman*.

118 See Wadum's diagram in Washington-The Hague 1995-96, pp. 69-70, fig. 5a.

119 Slatkes 1981, p. 28, suggests that she demands a coin, which is possible, but unclear.

120 On dummy-board figures by Cornelis Bisschop see my entry in Linsky Cat. 1984, pp. 95, 97, n. 8.

121 On the map see Welu 1975a, pp. 529-32; Welu 1981, p. 37; and Hedinger 1986, pp. 79-80, figs. 77, 78.

122 Wheelock in Washington-The Hague 1995-96, p. 27, suggests that "Vermeer's interest in the camera obscura seems to have been for its philosophical as well as for its artistic application."

123 This paragraph responds to the hyperbole about Vermeer's "interest in cartography, music, geography, astronomy, and optics, the study of which inevitably introduced him to Neoplatonic concepts" and whatnot (Wheelock in Washington-The Hague 1995-96, p. 27). For "een soldaet" in the Dissius sale of 1696, see Blankert 1978, p. 153, doc. no. 62.

124 The quote is from Washington-The Hague 1995-96, pp. 26-27. Wheelock contradicts this statement in other writings, suggesting that "compositional aid" was not quite what he meant.

125 Gowing 1970, pp. 104-6 (is the painting illustrated on p. 105 by Dirck Hals?). Compare also Ter Borch's placement of figures in the early 1650s: Gudlaugsson 1959-60, I, pls. 69, 70, 82, 83, etc. One of the more curious

anticipations of the figures' disposition in the *Cavalier and Young Woman* is found in Maerten van Heemskerck's *Venus and Mars Captured by Vulcan* in the Kunsthistorisches Museum, Vienna. Van Mander recommends silhouetting figures in this way, which Lievens (*The Feast of Esther* in Raleigh) and Rembrandt did in Leiden, mostly in response to Honthorst. Van Couwenbergh's versions of the device derive from the same source, but by the time Palamedesz and Vermeer modernized the motif in the 1650s it had become common currency (compare Joos van Craesbeeck's *Lute Player* in Liechtenstein; New York 1985, no. 194). One of the more revealing comparisons is with a detail of Brekelenkam's *Interior of a Tailor's Shop* of 1653 (fig. 204), where the lighting on the seated boys and their juxtaposition with the window on the left and the still life on the rear wall "anticipate" Vermeer's design. That is, formal devices suggest that the two artists worked in the same area of the Netherlands at about the same time.

126 See the radiograph in Wheelock 1981, p. 54, fig. 69; Wheelock 1995a, pp. 69-70, figs. 48, 49; Washington-The Hague 1995-96, p. 110, figs. 1, 2 (was there also an open window?).

127 Wheelock 1981, p. 86.

128 Gowing 1970, p. 110 (ill.).

129 White 1982, no. 42; Naumann 1981, no. 7 (I, pp. 117-19 for a penetrating account of the iconography).

130 Sumowski 1979-95, I, nos. 16, 18, 29, 30, etc.

131 Amsterdam-Vienna-New York-Cambridge 1991-92, no. 51.

132 See Franits 1993a, Ch. I.

133 See Dixon 1995, p. 117, and the sources cited in her n. 64. Duchamp's initials are pronounced "Elle a chaud au cul." Dixon, fig. 46, reproduces an extraordinary Flemish misericord (ca. 1531) which represents a smiling woman with a large jug in front of her, pursued by a man holding his genitals. On the jug depicted with its open neck facing the viewer, see Wuyts in Ghent 1986-87, pp. 32-33, and the sources cited in his n. 83.

134 See Brusati 1995, pp. 198-201.

135 Wheelock 1995a, pp. 63-64. A similar interpretation was offered by Sadja Herzog in an unpublished lecture, "Vermeer's Sermon on Domestic Virtue: *The Maidservant Pouring Milk*," College Art Association Annual Meeting, Washington, January 22-25, 1975. Wheelock in Washington-The Hague 1995-96, p. 110, gives a surprisingly innocent spin to the foot warmer, which "had emblematic associations with a lover's desire for constancy and caring" and which relates "to the maid's human warmth."

136 Poor Aristotle! The quotes are from Wheelock in Washington-The Hague 1995-96, pp. 108, 110.

137 Wuyts 1974-75; see also Washington-Boston 1983, no. 26. The slang meaning of "milking" may be more fully appreciated by watching a woman milk a cow.

138 This interpretation follows Van Regteren Altena 1983, I, p. 99, and II, no. 217. See also Amsterdam 1993-94a, no. 282.

139 See Wallen 1979, pp. 36-39, refering in particular to Aertsen's *Market Scene with Christ and the Woman Taken in Adultery*, 1559, in the Städelsches Kunstinstitut, Frankfurt. He notes that milk is a metaphor for earthly existence in Job's appeal to God (Job 10:10-11). On traditional costume in Dutch paintings of kitchenmaids, see Gordenker 1999, pp. 221-24. Falkenburg 1989, discusses market scenes and milkmaids, maintaining that Aertsen used "high" compositional principles for "low" subject matter, an approach he relates to the rhetorical literary genre of the "paradoxical encomium" (as in Erasmus's *Praise of Folly*). The suggestion is also interesting for Vermeer's picture and might partly explain why *The Milkmaid* has been seen as a "sermon on domestic virtue" (see n. 135).

140 The Brussels painting (no. 3828) attributed to Hofmann is returned to Snyders's studio in Antwerp-Münster 1990, p. 102, fig. 66 (see n. 27 on a presumed male pendant).

141 Pepys 1985, p. 47.

142 See Franits 1993a, pp. 90-92. In this excellent study Vermeer plays almost no part, which is perhaps one measure of what Gowing calls the artist's evasiveness. It will be remembered that a basket filled with material was once intended in Vermeer's *Milkmaid*. Franits, pp. 47-48, discusses the motif, which may relate to love and work (Franits quotes Krul, 1644: "My duty requires me to work, but Love will not allow me any rest," etc.).

143 Blankert in Washington-The Hague 1995-96, p. 40.

144 See Wheelock 1995a, pp. 65-70, for a thorough discussion of *The Milkmaid*'s variety of technique; also Gowing 1970, pp. 109-12, and Nash 1991, p. 94.

145 There appears to be a pentimento in the table's shape, improving its recession. Wheelock 1995a, p. 70, wonders if the table was custom-built for this composition, and of course it was. But a similar piece of furniture occurs in the background of *A Maid Asleep*.

146 See Roel James's esssay, "Van 'boerenhuysen' en 'stilstaende dinghen,'" in Rotterdam 1994-95, pp. 132-41.

147 Wheelock 1981, p. 116; Nash 1991, p. 96; Liedtke 1992b, pp. 102-3.

Notes to Chapter Six

1 As noted in Wheelock 1981, p. 90, by Kelch in Philadelphia-Berlin-London 1984, p. 339, and elsewhere.

2 It will be recalled that De Hooch had a similar problem with the distance construction in the London interior of 1658 (fig. 185). In Vermeer's Berlin painting, the thickness of the wall seen above the open window is inconsistent with the window ledge, but this is cleverly disguised. Similarly, the top of the bench and the floor do not join the left wall in a single plane, and the bottom of the bench runs off into the far corner rather hastily. The floor tiles flatten in the foreground because of the short distance construction.

3 Nash 1991, p. 68.

4 Compare the seated figures in Ter Borch's so-called *Parental Admonition* (versions in Amsterdam and Berlin) and also the *Woman Drinking Wine with a Sleeping Soldier* in a private collection (see Philadelphia-Berlin-London 1984, nos. 9, 11). Gowing 1970, pp. 113-17, draws attention to other offers of wine (or whatever) in paintings by Judith Leyster, De Hooch, Metsu et al.

5 See Netta 1998, p. 259, for somewhat similar remarks on *The Milkmaid*.

6 Blankert 1978, p. 159, no. 11 (nos. 8 and B2 for the Berlin and Frick paintings); see also Washington-The Hague 1995-96, no. 6.

7 The question of condition is considered below. Wheelock 1981, pp. 90, 92, dates the Berlin painting ca. 1658-60, and the Braunschweig picture ca. 1659-60.

8 A few misconceptions concerning the *Young Woman Interrupted at Music* might be mentioned here. The painting is a badly damaged work by Vermeer, not an old copy (as suggested by Blankert 1978, no. B2). The bird cage might be a later addition, but it could also be a reconstruction of Vermeer's original idea. The comparison of the Cupid with Otto van Veen's emblem maintaining that "perfect love is for but one lover" (Wheelock 1981, p. 98, and later authors) is implausible in this context.

9 Compare Westermann 1997, p. 217, on Steen's "versatile borrowing [which] of course participates in the rhetorical tradition of paying homage

to one's predecessors through emulation." For the most part Vermeer's adaptations from other artists in the 1650s are more a matter of shared language than emulation, but the latter is plausible in the case of similarities with Van Mieris.

10 Washington-The Hague 1995-96, p. 116, fig. 3.

11 See Naumann 1981, nos. 22, 23, 27, 31. In the last picture the old man in the background is oddly like Vermeer's "third wheel" in the Braunschweig picture, although they play different rôles.

12 Naumann 1981, no. 35.

13 See Naumann 1981, II, p. 26, on Van Mieris and Vermeer. Naumann's no. 13 (*A Smoking Soldier*, whereabouts unknown), ca. 1655-57, and other earlier works by Van Mieris are of some interest for Vermeer's approach to interior space.

14 See the large color detail and discussion in Washington-The Hague 1995-96, pp. 116-17; p. 119, n. 5, on a possible source in an actual window, with speculation about patronage. Weber 1998, p. 303, suggests that the figure in the window does not hold a bridle, but decorative bands like those attached to coats of arms. Despite the overstated endorsement in Gaskell 1998, p. 210, Weber's doubts seem completely unfounded. The bridle (head straps and bit) resembles standard issue in the sixteenth and seventeenth centuries (numerous examples are illustrated in Liedtke 1989).

15 As assumed in Wheelock 1981, p. 92. Compare Franits 1993a, p. 44, fig. 29, for a similar figure (awake, however) in a painting by Gerbrand van den Eeckhout, where melancholy comes from unrequited love.

16 Washington-The Hague 1995-96, p. 116 (see the large detail on p. 117).

17 Wheelock, in Washington-The Hague 1995-96, pp. 114-18, credits the woman with unusual awareness ("separating herself psychologically") and "self-control," and drags in Petrarch on the subject of unrequited love. The formal portrait in the background is almost certainly modelled on Van Miereveld or an engraving after him: compare Haak 1984, fig. 384, the slightly different *Portrait of P. C. Hooft* owned by the University of Amsterdam.

18 Salomon 1998b, pp. 319-22.

19 Gowing 1970, pp. 113-19 (quote from p. 114).

20 See Broos's part of the entry in Washington-The Hague 1995-96, pp. 118-19. Nash 1991, p. 70, suggests that restoration may account for the odd position of the figures in the foreground. For example, the man stands behind the white cloth hanging off the corner of the table.

21 For example, by Wheelock 1981, pp. 114-15; Wheelock 1995a, Ch. X; and Wheelock in Washington-The Hague 1995-96, no. 11, in each case as "ca. 1664-65." Blankert 1978, no. 12, suggests 1662. Gowing 1970, pp. 130-31, placed the New York picture with the one in Braunschweig, implying the early 1660s ("the most primitive of its type").

22 On *The Little Street*, which is also discussed in Ch. Four, see Wheelock 1981, p. 80; Wheelock 1995a, Ch. IV; and Wheelock in Washington-The Hague 1995-96, no. 4 (as ca. 1657-58). His dating follows Gowing 1970, pp. 109-12, who discusses *The Little Street* and *The Milkmaid* in a single commentary.

23 The last comparison is made in Wheelock 1981, p. 80, where the De Hooch in Washington is dated about 1657, and in Washington-The Hague 1995-96, p. 21, where the same picture is dated 1658-60.

24 See Chapter Two, n. 135, on the term *schilderachtig*, which was related above to the wall in Fabritius's *View in Delft*.

25 See Wheelock 1995a, p. 53, on "transience and permanence" in *The Little Street*.

26 See Washington-The Hague 1995-96, pp. 104-5.

27 See the infrared reflectogram reproduced in Washington-The Hague 1995-96, p. 104.

28 Wheelock, in Washington-The Hague 1995-96, pp. 102, 107. n. 2, interprets the vine in *The Little Street* as a reference to domestic or wifely virtue, but the reading is out of context. There is much of interest on Vermeer's compositional manipulations and his technique in Wheelock 1995a, Ch. IV.

29 Compare the choir screen doorway in the former Wetzlar painting of a Protestant church interior (Manke 1963, no. 118, fig. 27, correctly as about 1653-55).

30 See De Witte's *Amsterdam Exchange* of 1653 in Rotterdam and *The Old Amsterdam Fishmarket* in the Thyssen Collection (Manke 1963, nos. 210, 221, figs. 17, 18; and Gaskell 1989, no. 61, for the Thyssen picture).

31 See Chapter Four, n. 181.

32 On this subject see Chong 1992, pp. 9-14; Broos in Washington-The Hague 1995-96, pp. 59-60; and Hertel 1996, Part II.

33 Gowing 1970, p. 129.

34 For example, Blankert 1978, p. 40; Arasse 1994, pp. 63, 76. Nash 1991, pp. 6-10, is well worth reading, but essentially distills Wheelock and Kaldenbach 1982.

35 The best discussion in print is, in my view, Wheelock 1995a, Ch. VII. Also very good, but intended for a broader, Dutch-speaking audience, is Chong 1992. Wheelock's pages of 1995 completely supersede Wheelock 1981, pp. 94-96, and mercifully condense Wheelock and Kaldenbach 1982 (cited as "Wheelock 1982" in Washington-The Hague 1995-96, where the canvas is catalogued by Wheelock and Broos as no. 7). The best reproductions of the picture after its conservation in 1994 (on which see Wadum n.d. [1995]) are found in Washington-The Hague 1995-96, pp. 121, 124.

36 See Wheelock 1995a, p. 79 and fig. 55, and the large detail reproduced in Washington-The Hague 1995-96, p. 125. The logistics of the site are clarified by the bird's-eye view from above Vermeer's vantage point, a computer simulation published in Kaldenbach 1999, fig. 2.

37 See Wheelock 1995a, pp. 78-79, fig. 57, or Washington-The Hague 1995-96, p. 123, fig. 5.

38 Compare the composition of the *Interior of the Oude Kerk, Amsterdam*, 165(9?), in the Carter Collection: Manke 1963, no. 44, fig. 39; Los Angeles-Boston-New York 1981-82, no. 29.

39 Once again, see the large color detail in Washington-The Hague 1995-96, p. 125.

40 Wheelock 1995a, p. 80.

41 On the camera obscura in the seventeenth century see Hammond 1981; Kemp 1990, pp. 189-96; Delsaute 1998; and the best of all possible (if not most convenient) sources, Hammond 1986, Ch. VII ("The portable *camera obscura* in the 17th and 18th centuries"). Delsaute and Mary Hammond reach essentially the same conclusion, which is put bluntly in Hammond 1986, pp. 301-2: "Unfortunately, a number of historians, Waterhouse and Eder among them, have suggested that Zahn's [1685] solution was like the early photographic reflex camera. This error coupled with an erroneous publication date of 1665 given by Eder have been used as evidence that a practical portable drawing tool was available to artists in the mid-seventeenth century. Zahn's illustrations were, like Boyle's portable *camera obscura*, a means to demonstrate optical principles. Zahn's *cameras* were not intended for drawing." Compare Delsaute, p. 111, where "around 1590-1600" is an error for about 1690-1700; and pp. 119-20 (concluding remarks, for example: "it seems rash to continue to believe that the camera obscura was one of the tools with which he [Vermeer] worked").

42 Washington-The Hague 1995-96, p. 122.

43 Kemp 1990, p. 194. Arasse 1994, p. 103, n. 6, and p. 120, n. 34, treats Kemp's cogent remarks with Gallic condescension.

44 Wheelock 1995a, p. 76; Washington-The Hague 1995-96, p. 122.

45 See Wadum n.d. [1995], figs. 76, 77, 81.

46 For example, Alpers and De Jongh. In 1973, by contrast, John Walsh not only repeated Stechow's comparison between this composition and that of Esaias van de Velde's *View of Zierikzee* (Staatliche Museen Berlin), but considered its design to be "rivaled in power only by contemporary landscape panoramas of Koninck" (Walsh 1973, caption to fig. 30; compare Stechow 1966, p. 53). Thoré-Bürger, in 1866, compared Koninck and Rembrandt (see Wheelock 1995a, p. 73).

47 For the Munich picture see Walford 1991, pp. 121, 126, fig. 132; figs. 113, 134, for two *Haarlempjes*. The importance of Vermeer's diagonal recession is inadvertently demonstrated in Nash 1991, p. 7, where the reproduction of the cityscape is reversed and the sense of recession all but eliminated.

48 On this point see Montias 1989, p. 188.

49 Blankert 1978, pp. 153-54, doc. no. 62; Montias 1989, pp. 363-64, doc. no. 439.

50 On the cityscape and the church interiors by De Witte in the Dissius sale, see Montias 1989, pp. 250-51, 254-55. It is not at all likely that the De Wittes were Amsterdam paintings of non-Delft subjects.

51 Chong 1992, p. 27 (quoting from the original English manuscript).

52 Wheelock in Washington-The Hague 1995-96, p. 122 (Chong 1992 is cited in the literature, p. 127). On the same page we read, "Although no documentary evidence indicates that Vermeer actually worked with a camera obscura, it is worth noting that a house where he could have set one up" existed at the proper viewpoint for the cityscape.

53 Washington-The Hague 1995-96, p. 124.

54 Wheelock 1995a, p. 82.

55 Chong 1992, pp. 73-85.

56 See the photo in Wheelock and Kaldenbach 1982, fig. 22.

57 Wheelock 1995a, p. 80.

58 See Plomp 1996, figs. 3-5 for drawings of Delft by De Bisschop, Van Kessel, and Van den Eeckhout; Davies 1992, nos. 14, d 14, for Van Kessel's canvas (Fondation Custodia, Paris) and drawing; Beck 1972-73, II, no. 668, for Van Goyen's painting at Chatsworth. Plomp's map on p. 349 is reversed: compare Delft 1996, fig. 1 (Blaeu's plan of Delft, 1649).

59 Davies 1992, p. 88, observes similarly of Van Kessel's views of Delft, "it is easy to see how a sketch like the *Rotterdamse Poort at Delft* translates into a painting like the *Oostpoort* as they both transcend topographical pedanticism with their similar emphasis on monumentality and enlivening chiaroscuro effects." In this regard Van Kessel's views and Vermeer's are typical of the 1660s.

60 See Kemp 1990, p. 275, fig. 500, where the felicitous term "Aguilonian" is introduced.

61 See Kemp 1990, pp. 122-27.

62 Wheelock 1995a, Ch. VIII (1662-65), and in Washington-The Hague 1995-96, no. 8 (1662-64).

63 Gowing 1970, pp. 130-31, does not specify a date, but discusses the painting together with the Braunschweig picture, and he clearly has the early 1660s in mind.

64 Wheelock in Washington-The Hague 1995-96, p. 146. Compare Wheelock 1995a, pp. 105, 107-8, where the map in the same painting is thought perhaps to suggest "an absent loved one" in Flanders or Brabant (a platonic relationship?).

65 De Vries 1996a, referring to Wheelock 1995a, p. 157, where the Dublin canvas is thought to represent "a different concept of classicism than that which had guided his previous work, one tinged with the ideas of Neoplatonism."

66 For the latter comparison see Liedtke 1997, pp. 126-27.

67 Washington-The Hague 1995-96, p. 148, fig. 2, reproduces the Metropolitan Museum's infrared reflectogram.

68 A large detail of this passage is reproduced in Washington-The Hague 1995-96, p. 149.

69 See Naumann 1981, pl. 25.

70 See Martin 1913, pp. 106, 109-10, 115, 152; White 1982, nos. 43, 44, pls. 38, 39; Sumowski 1983-[94], I, nos. 291, 294. It is also possible that Dou himself synthesized these types in a lost painting that Vermeer had seen.

71 For example, Nash 1991, p. 96, in an excellent page on this painting.

72 See Washington-The Hague 1995-96, p. 172, fig. 1. Compare Van Berkel's essay on Vermeer and Van Leeuwenhoek in Frankfurt 1997, pp. 28-29, where Wheelock's suggestion is dismissed.

73 Wheelock in Washington-The Hague 1995-96, p. 132, n. 3.

74 See Wadum in Washington-The Hague 1995-96, pp. 69, 72, fig. 9.

75 Kemp 1990, pp. 194-96. Compare Swillens 1950, pls. 43-53.

76 The quote is from Wheelock 1995a, p. 90. Fock 1998 compares Dutch genre paintings of Vermeer's time with the most reliable evidence for the design and furnishing of actual interiors. This article takes us a long way from the days of attempting to reconstruct the actual room in which Vermeer worked. For example, marble floors, brass chandeliers, and window curtains were exceedingly uncommon in domestic interiors. In addition to these appointments, the very structure of the house depicted by De Witte in the canvas in Rotterdam (fig. 284) is implausible; the ceiling beams run perpendicular rather than parallel to the façade, and "an enfilade [of rooms] of this kind is out of the question in a Dutch house at that time, even in a country house" (Fock 1998, pp. 189-91; quote from the English summary, p. 244).

77 Naumann 1981, I, p. 74. See also Naumann's no. 64, *The Cavalryman's Boot* of 1666 in Munich, for a slightly later example of a couple placed deep in space, beyond a table in the immediate foreground.

78 On the date of the De Witte and on the version in Montreal, see Liedtke 1982a, pp. 127-28, note to fig. 114.

79 On the Van Hoogstraten see Brusati in Dordrecht 1992-93, p. 199, and Brusati 1995, p. 203. The Dissius sale of 1696 included a painting by Vermeer "in which a gentleman is washing his hands in a see-through room with sculptures, artful and rare" (Montias 1989, p. 364, doc. no. 439, lot no. 5). Here, too, one is reminded of perspective views by Van Hoogstraten, such as those in the Christie-Miller collection, Salisbury (Brusati 1995, nos. 93, 94, figs. 66, 67).

80 Wheelock 1995a, p. 90, properly interprets the reflection of the easel in Vermeer's mirror as an "artistic conceit." Gowing 1970, p. 126, n. 80, compared it to still-life objects in which one catches a glimpse of the painter at work.

81 For a summary of modern interpretations see Sutton in Philadelphia-Berlin-London 1984, no. 119.

82 Wheelock 1995a, pp. 86-89. See also Washington-The Hague 1995-96, no. 8. On the question of whether the viol was included in Vermeer's composition from the start (evidently yes), see Gifford 1998, pp. 192-93.

83 Wheelock 1995a, pp. 86-87, compares Steen's so-called *Music Master* of about 1659 (National Gallery, London) and allows the Cats-inspired reading of the viol ("two hearts can exist in total harmony even if they are

separated") to bounce over to Steen's big theorbo (not a lute) in the background. Westermann 1997, p. 215, favors the more obvious reading, which is that the theorbo held erect is one of Steen's rib-poking references to male libido, as is the inscription on the harpsichord, "Actions Prove the Man." This motto, *Acta Virum Probant*, was adopted as the painting's title in Washington-Amsterdam 1996-97, no. 10.

84 The man wears a silver-hilted smallsword in an embroidered baldric. It is rather unlikely that a Dutch music master of the time would sport such attributes of gentility. Donald LaRocca of the Arms and Armor department of the Metropolitan Museum of Art, New York, and Jan Piet Puype, Chief Curator of the Leger Museum in Delft, kindly considered the question (Michiel Plomp met with Mr. Puype on my behalf in May 1999).

85 Wheelock 1995a, p. 95.

86 My thanks to Ken Moore and other colleagues in that department.

87 Meilink-Hoedemaker and Broos 1996, pp. 22-23, revising Broos in Washington-The Hague 1995-96, p. 51. Fock 1998, p. 189, observes that the virginal was "een muziekinstrument dat regelmatig in inventarissen uit die tijd opduikt, vaak met de toevoeging dat het door de bekende familie Ruckers in Antwerpen was vervaardigd."

88 Delft 1994, pp. 245-47, no. 27, suggesting a date in the early 1650s.

89 See Snoep-Reitsma 1973, p. 215, on the cherry-picking parrots in two prints by Bosse, and Naumann 1981, II, p. 69 under no. 54.

90 See Amsterdam 1976, no. 27, and no. 55 for more on apes, and Sullivan 1981 on Bruegel's small painting of two chained monkeys (Berlin). Compare the chained monkey in Molenaer's *Woman Playing the Virginal* (Rijksmuseum, Amsterdam), which Naumann 1981, II, p. 26, cites in connection with a chained parrot and "the power of music to hold one captive."

91 See Wheelock 1995a, p. 93, fig. 67. In the Museum of Turkish and Islamic Art, Istanbul, Vermeer's *Music Lesson* is reproduced next to a large Usak carpet of the sixteenth century (no. 52), and his table carpet is identified as an example of the same type.

92 Wheelock 1995a, p. 94. See also Washington-The Hague 1995-96, no. 8.

93 Gowing 1970, p. 132, mentions "an optical device" in connection with this painting's "contrast of tone." Wheelock 1981, p. 112, associates the juxtaposition of near and far objects with a perspective frame or camera obscura.

94 See Washington-The Hague 1995-96, no. 15.

95 See Blankert 1978, p. 171 under no. B1.

96 Cats's emblem concerning sympathetic heartstrings may be worth mentioning in this case. The first to do so was evidently Slatkes 1981, p. 60; Sutton in Philadelphia-Berlin-London 1984, pp. 340-41, n. 3, quotes the text. A bow rests on the viol in the *Woman with a Lute*, but it is not clear whether it would prevent the strings from vibrating.

97 Sutton, in Philadelphia-Berlin-London 1984, no. 118, says that her pregnancy "seems undeniable." Salomon 1983, p. 217, insists that "the woman's pregnancy is an undeniable fact of the painting and one which cannot be dismissed as a misunderstanding of costume or fashion." However, the "fact" was overlooked in the Dissius sale ("Een Juffrouw die goud weegt, in een kasje van J. vander Meer van Delft, extraordinaer konstig en kragtig geschildert"; see n. 99), and was never mentioned before the 1970s (dawn of the golden age of flat stomachs). Wheelock 1995a, p. 100, skirts the issue, but in Washington-The Hague 1995-96, p. 144, n. 3, he allows that the woman's pregnancy "seems unlikely."

98 See De Winkel 1998, pp. 331-32, who reviews some of the reasons why "it seems unlikely that Vermeer intended his women to appear in this state." Hollander 1975, pp. 108-10, is also of interest. Rena Hoisington, in

a paper prepared for me at the Institute of Fine Arts, New York University, in 1996, came to the same conclusion based on costume history and questions such as: What would this have meant to Van Ruijven? Are there other instances of pregnancy presented in similar pictorial contexts? Perhaps the only pregnant woman in Vermeer's oeuvre was identified for the first time in the previous chapter: Callisto in *Diana and her Companions*.

99 The same arrangement of weights and coins occurs in De Hooch's *Woman Weighing Gold* of about 1664-65 in Berlin (see Sutton 1980a, no. 64, pl. xiv, where the weights are mistaken for silver coins).

100 See n. 97 for the Dutch. For the document, see Blankert 1978, p. 153, no. 16, where "box" for *casje* is misleading; and Montias 1989, p. 363.

101 See Blankert 1978, p. 44, fig. 33.

102 See Kersten in Delft 1996, pp. 192-94, for a similar interpretation. Sutton comes to a surprisingly different conclusion in New York 1999, p. 52.

103 Sutton 1980a, p. 96 under no. 64; Wheelock 1995b, p. 143, fig. 2 (radiograph).

104 See the 1978 *Catalogue of Paintings* (Staatliche Museen Berlin), p. 206, no. 656A. A gold goblet stands in the foreground.

105 On the latter see Vergara 1998.

106 See Wheelock 1995b, pp. 374-75, and Wheelock in Washington-The Hague 1995-96, pp. 140, 142, 144-45 (nn. 2-10). De Jongh 1998, pp. 360-61, reviews various interpretations and illustrates engravings used on coin-weight boxes of the period. His appeal to "Conscience" is consistent with the notion of moderation.

107 For earlier authors who employed this approach, see Ch. Two, n. 7. Cunnar 1990, pp. 504, 506, detected "the silhouetted dragon on the table support."

108 Wheelock 1995b, p. 371.

109 On this point see De Jongh 1998, p. 361 and n. 58.

110 See Gaskell 1984, p. 557, who notes the absence of Saint Michael and suggests usefully that "it would be better to attend to what is represented."

111 As discussed in Cunnar 1990.

112 See Perlove 1995, pp. 163-64, for a concise and reliable account of Remonstrant views on this question.

113 Kahr 1972, p. 131, discusses free will in connection with *A Maid Asleep*. See De Jongh 1998, pp. 352-58, on Vermeer's multivalence.

114 See, for example, Gowing 1970, p. 135.

115 Blankert 1978, p. 153.

116 Wheelock 1987, p. 411, fig. 23; Washington-The Hague 1995-96, p. 154, fig. 2.

117 Washington-The Hague 1995-96, pp. 153, 154.

118 Wheelock in Washington-The Hague 1995-96, p. 152, fig. 1, considers "the closest prototype" to be Van Mieris's *Young Woman Before a Mirror* of about 1662 (also in Berlin), which is an observation original with either Naumann 1981, 1, p. 68, or Slatkes 1981, p. 53. Naumann considers the Van Mieris to have been inspired by Ter Borch's painting in New York (fig. 292 here).

119 See Sluijter 1991-92 and especially Sluijter 1998b.

120 See Franits 1993a, pp. 126-27, fig. 104. Compare also the images discussed in Amsterdam 1976 under no. 47.

121 Washington-The Hague 1995-96, p. 154.

122 The same point is made differently by Wheelock in Washington-The Hague 1995-96, p. 154. Franits 1993a, pp. 124-29, discusses basins and mirrors as well as combs and Cats; see also pp. 97-100 on brooms.

123 Gudlaugsson 1959-60, nos. 169, 188.

124 Wheelock in Washington-The Hague 1995-96, p. 134, describes the design very differently ("perhaps he worked with a compass and ruler"),

and reproduces a radiograph showing that Vermeer adjusted the map and trimmed the back of the woman's jacket. The fact that it originally flared out considerably more behind the woman (see Wheelock's fig. 2) is interesting for its shape in front. Wheelock considers the figure "matronly, perhaps as a result of fashion, but more likely, because she is pregnant" (p. 136). But not according to Blankert, in the same publication, p. 39.

125 The term "feminine" here will set some readers off. But the subject is Vermeer, not modern social issues. The latter pertain more closely to the words "girl" and "lady" which are employed sparingly in this text.

126 Wheelock in Washington-The Hague 1995-96, p. 136.

127 The notion that the letter is received by a pregnant woman puts scholars in a bind, from which Wheelock wriggles by writing that Vermeer "remains entirely circumspect about the circumstances of the woman's life, allowing each viewer to ponder the image anew in his or her own way" (Washington-The Hague 1995-96, pp. 134-35).

128 Wheelock 1981, p. 132.

129 As noted nicely by Wheelock in Washington-The Hague 1995-96, p. 168, where Van Mieris's *Portrait of the Artist's Wife* is also mentioned. On Sweerts's canvas in the Metropolitan Museum see Liedtke 1983, and Kultzen 1996, no. 120.

130 See also Kultzen 1996, nos. 92, 123, pls. 91, 123, the *Unequal Lovers* in the Louvre and the *Double Portrait* in the Getty Museum.

131 Wheelock 1981, p. 124, and in Washington-The Hague 1995-96, pp. 38, 156. See also Frankfurt 1993-94, nos. 8, 85.

132 See Gudlaugsson 1959-60, nos. 114, 125, 168, 188, 190.

133 Washington-The Hague 1995-96, p. 158: "By means of the letter-writing theme he achieved a convincing sense of naturalism that formal portraits often lacked." The discussion of the subject in Wheelock 1995b, pp. 380-81, is less surprising.

134 Budde 1930, p. 132, no. 884. Compare also Rembrandt's *Portrait of a Man at a Writing Desk*, 1631, in the Hermitage, St. Petersburg (*Corpus* A44), and *A Scholar* by Jan Olis in the Mauritshuis, The Hague.

135 See Wheelock 1995b, pp. 380-81, on the iconography.

136 See Blankert 1978, p. 153, doc. no. 62, no. 35 in the Dissius sale: "Een Schryvende Juffrouw heel goet."

137 See the color plates in Washington-The Hague 1995-96, pp. 85, 157.

138 See Wheelock 1995a, pp. 142, 200, n. 1 of Ch. XIV, correcting the suggestion that the painting was not finished by Vermeer. De Jongh 1998, pp. 362-63, for some curious thoughts on the picture's subject.

139 The pensive gesture of the seated woman's left hand recalls Sweerts's so-called *Portrait of Jeronimus Deutz* in the Rijksmuseum, Amsterdam (Kultzen 1996, no. 86). The sitter is identified as Gideon Deutz in Bikker 1998 (pp. 294-95, fig. 8), where the Deutz family's connections with Carel Fabritius are explained (pp. 291-92).

140 For example, Gudlaugsson 1959-60, nos. 81, 98, 114, 125, 127, 129, 140, 144, 169, 188-90.

141 Wheelock 1995a, p. 147. See the same text, pp. 144-47, on niceties of design (parallel arms) and especially on Vermeer's technical means of achieving soft contours and other realistic effects.

142 See Wheelock in Washington-The Hague 1995-96, no. 14, and Broos under no. 15 (p. 168 and n. 9). On the *Girl with a Red Hat* see also Wheelock 1981, p. 130; Wheelock 1995a, Ch. XII; and Wheelock 1995b, pp. 382-87.

143 Blankert 1978, pp. 73-74, 172, no. B3; De Vries 1996a; Brown 1996, p. 283. The reproduction of the face enlarged about three times in Washington-The Hague 1995-96, p. 164, will not contribute to intelligent discussion.

144 Washington-The Hague 1995-96, p. 162.

145 Huygens 1971, p. 81. See my discussion in New York 1995-96, no. 2.

146 Wheelock in Washington-The Hague 1995-96, p. 162.

147 The fact that the panel had been used previously by a different painter is immaterial. See Washington-The Hague 1995-96, pp. 162-63, figs. 3, 4, where the man's bust-length portrait (?) is considered to be possibly a *tronie* by Carel Fabritius. This is wild speculation, quite apart from the question of why Vermeer would destroy such a picture just for the wood. On *tronies* attributed to Fabritius see Brown 1981, pp. 49-50, 129, nos. A1-A3, pls. 10-12. Brown's no. 3, the *Man in a Helmet* in Groningen, is "securely attributable to Fabritius" and somewhat larger (38.5 x 31 cm).

148 Sumowski 1983-[94], I, nos. 31, 32; compare also no. 36, Backer's well-known *Self-Portrait as a Shepherd* in the Mauritshuis (Broos 1987, p. 390, made the connection).

149 See, most recently, Melbourne-Canberra 1997-98, nos. 13 (the Rembrandt), 45 (Bol).

150 See, for example, the Flincks in Sumowski 1983-[94], II, nos. 675, 680, 681 and 683 (the last is now in the Museo Nacional de Bellas Artes, Buenos Aires, Argentina).

151 See Kultzen 1996, pls. XXIV-XXVII and XXX and Gaskell 1989, no. 49.

152 The finial in question could be the right-hand finial of a chair extending out of the composition to the left. Another finial could be covered by the woman's drapery. But it is clear that Vermeer placed the motif where he wanted it, at an angle that can hardly be faulted in terms of design.

153 De Vries 1996a is unhappy with this.

154 Brown 1996, p. 283, puzzles over the hat.

155 Many pictures of this type feature exotic fabrics (e.g., furs, silks) and headgear brought from distant lands. Consider the item seen by Montaigne at the auction of Cardinal Orsini's effects in Venice: "Among other rare things was a taffeta coverlet lined with swansdown. In Siena you see a good many of these swans' skins complete with feathers, and I was asked no more than a crown and a half for one, all prepared" (quoted, without giving the source, by James Fenton, "A Room of One's Own," *The New York Review of Books*, August 13, 1998, p. 53).

156 Wheelock 1981, pp. 118, 132, on both pictures. On the Mauritshuis painting, Broos 1987, no. 54; Washington-The Hague 1995-96, no. 15; Wadum n.d. [1995], pp. 18-29; Gifford 1998, pp. 187-89; Groen et al. 1998.

157 For example, the *Maidservant* in a private collection, Paris; *Girl Wearing a Hood* in the Leicester Art Gallery; *Head of a Boy* in the Fine Art Museums of San Francisco; and several other works (Kultzen 1996, pls. XXIV-XXVII, and pls. 94-96).

158 Kultzen 1996, nos. E7-E19, pls. 131-43.

159 The terms are quoted from Washington-The Hague 1995-96, p. 116 under no. 15.

160 Döring 1993, no. A25.

161 Compare Wheelock 1995a, p. 126.

162 See Van de Wetering 1993.

163 See New York 1995-96, II, p. 44.

164 Groen et al. 1998, pp. 177-78.

165 Brown 1996, p. 283.

166 See the photos taken after cleaning in Wheelock 1995b, p. 389, and in Washington-The Hague 1995-96, p. 205.

167 For example, Blankert 1978, p. 73, who writes off both the small panels in Washington as possibly French "at the time of Napoleon III." Gowing 1970 (that is, his publisher) featured the *Girl with a Flute* on the dust jacket.

168 See Washington-The Hague 1995-96, p. 206. The fur panels were evidently squared off at the top "to cover the lower part of the original V-shaped neck opening." But compare the jacket worn by the standing woman in the Gardner picture (fig. 304).

169 Wheelock 1981, p. 120, and in later publications, suggests ca. 1665-66.

170 Wheelock 1995a, Ch. XI.

171 See Wheelock 1995a, who has noted this kind of alternating contrast in a number of paintings by Vermeer. It was actually a common device, although rarely employed this subtly.

172 Wheelock 1995a, p. 117. The gesture differs somewhat from the one found in paintings by Ter Borch (see Gudlaugsson 1959-60, nos. 126, 220, 221). However, the same reading is probably intended. Compare also the De Hooch in Cleveland (fig. 251), and the well-known Molenaer in the Virginia Museum of Fine Arts. The latter is compared with *The Concert* in Moreno 1982, where the singer is said to be pregnant, the viewer is deemed "a suitor of the young woman playing the virginal" (p. 57, meaning the harpsichord), and the cittern (Wheelock's lute) is described as a violin.

173 Wheelock 1995a, pp. 113-16, treats the pendant question at length, rejecting the hypothesis. *The Music Lesson* was in the Dissius sale, but *The Concert* was not (Blankert 1978, p. 162, cat. nos. 16, 17).

174 As discussed more fully in Wheelock 1995a, pp. 117-19 (quotes from p. 119).

175 Wheelock 1981, p. 128, and Wheelock 1995a, Ch. XIII, date the Vienna canvas to about 1666-67 but do not argue the case. When comparing reproductions of these pictures it is helpful to consider their actual size: the two paintings of male figures, in their frames, would cover only half *The Art of Painting*.

176 Wheelock 1981, p. 98; Wheelock 1995a, pp. 129-34; dismissed in Sluijter 1998a, pp. 267, 279, nn. 20, 21.

177 Wheelock 1995a, p. 138.

178 Wheelock 1995a, p. 154, and in Washington-The Hague 1995-96, pp. 176-78.

179 Kemp 1990, p. 190; see also Hammond 1986, pp. 295-305.

180 Kemp 1990, p. 193; see p. 194 on the arbitrary use of optical effects in *The Lacemaker*.

181 Wheelock 1995a, p. 139, opposing this idea to that of directly transcribing a scene with the optical aid.

182 Wheelock 1995a, p. 139.

183 Brusati 1995, p. 71, for the passage in translation.

184 On *houding* see Taylor 1992.

185 See the discussion of Van Hoogstraten on art and observation in Liedtke 1997, pp. 118, 120, 124-25.

186 On the latter in relation to *The Art of Painting* see Miedema 1998. Sluijter 1998a reviews other interpretations and offers the most convincing analysis now in print of the picture's significance.

187 Sluijter 1998a, p. 265.

188 Several are compared in Sluijter 1998a.

189 Sluijter 1998a, p. 269. For other interpretations see Gowing 1970, p. 139; Nash 1991, p. 122; and Wheelock 1995a, p. 136.

190 See De Winkel 1998, pp. 333-34, and Gordenker 1999, pp. 227-35. Gordenker especially stresses that the artist's dress, while based on contemporary forms, is unconventional. In summary, she suggests, "Vermeer's portrayal of clothing is analogous to his depiction of the studio – like the tapestry, the table, the chandelier, the map, and the light streaming in from the window at the left, all seems familiar and domestic, and yet so evidently partakes in the construction of an allegory of painting" (p. 235). See also Sluijter 1998a, pp. 269, 281, n. 47.

191 See Ch. Five, n. 11 above, and Sluijter 1998a, pp. 266, 278, n. 10.

192 See Sluijter 1993 and Sluijter 1998a, pp. 266-67.

193 Sluijter 1998a, pp. 267-71.

194 Nash 1991, p. 126.

195 See Sluijter 1998a, pp. 267, 279, referring to Wheelock 1981, p. 98, and other literature.

196 See Sluijter 1998a, p. 281, n. 49. For the phoenix idea, see Eiche 1982. Maps are a common feature in views of artists' studios, including Van Craesbeeck's (fig. 306). What some writers regard as (so to speak) the "Crease of Breda" (Wheelock 1995a, p. 138, for a color detail) places a strong accent just above the painter's eyes, quite as the black horizontal border of the map proper carries his gaze across to the model.

197 See the detail illustrated in Wheelock 1995a, p. 133.

198 See Linsky Cat. 1984, p. 90.

199 See Van de Wetering in Melbourne-Canberra 1997-98, pp. 61-62, fig. 6. He suggests that the figure by the globe in the corner may be an engraver. This seems plausible, although he may be meant as a model posing as a scholar in his study. In any case, the painter appears to be working on a similar figure.

200 Which, of course, he was, if he saw the painting in Vermeer's studio. Sluijter's interpretation, only some of which is adumbrated here, may help to explain why Vermeer's widow treated the painting as a family heirloom (see Montias 1989, pp. 338-39, doc. no. 363).

201 Gowing 1970, pp. 140-41. This is like saying that Shakespeare had a good grasp of contemporary English usage, a point helpful to readers who don't.

202 See especially Nash 1991, pp. 122-26, and Wheelock 1995a, pp. 134-38.

203 Gowing 1970, p. 141, where the Hermitage picture is thought to be by Job Berckheyde (hence the Haarlem reference). See Fleischer 1988 on the attribution. Sluijter 1998a, pp. 273, 276-77, fig. 12, plausibly suggests that Vermeer was influenced by Van Mieris's *Artist's Studio* formerly in Dresden.

204 See the essays by Brusati, Goedde, and Liedtke in Franits 1997, and the editor's introductory remarks, pp. 5-6.

205 For example, in Wheelock 1995a, Ch. XI on *The Concert*, and later chapters.

206 See Wheelock 1995a, Ch. XV, especially fig. 105.

207 The quotes are from Wheelock 1995a, pp. 154, 155, and 157.

208 Compare these motifs in *The Slippers* attributed to Van Hoogstraten (Paris, Musée du Louvre); Sumowski 1983-[94], II, no. 894, and Brusati 1995, p. 204, fig. 50, and p. 364, no. 88. Two doors (one in the immediate foreground) have been opened; the broom, the shoes on the mat in the foyer, and the keys in the lock suggest that a maid has answered the front door and hastened in to her mistress (who has a surrogate in the painting on the wall). Brusati's interpretation of the candle ("when the candle goes out all shame is extinguished") does not work in this light-filled interior.

209 Franits 1993a, p. 48. It will be recalled that a basket of clothing was painted out of *The Milkmaid*.

210 Goodman-Soellner 1989, pp. 78-79, offers the most reliable analysis, which, like the Franits reference (see previous note), might have been mentioned in Washington-The Hague 1995-96, p. 182 (in n. 11 especially).

211 Blankert 1978, p. 153, doc. no. 62, lot 7. See Washington-The Hague 1995-96, pp. 184-85, n. 14. Slatkes 1981, p. 73, favors the Rijksmuseum picture as the one in the Dissius sale because of the supposedly "unfinished state of the Frick work."

212 The quotes in this paragraph are from Wheelock 1981, p. 140. Gowing 1970, p. 57, differs in his nearly inimitable way: "the prosaic descriptiveness

which was a commonplace in the style of his contemporaries is here, with every precaution and the most ingenious saving clauses, brought within his compass."

213 The quotes are from Wheelock 1995a, pp. 149 (late virility), 154.

214 As in Daumier's lithograph of 1862, *Nadar élevant la Photographie à la Hauteur de l'Art*. See Gernsheim 1969, figs. 311, 312, for the Daumier print and an aerial photo by Nadar (which is composed like Van Ruisdael's *Panorama of Amsterdam*, in a private collection; The Hague-Cambridge 1981-82, no. 46).

215 Montias 1989, p. 212; pp. 203-15 on Vermeer's life in this period (1670-75).

216 There is much of interest for this subject in Kemmer 1998.

217 Liedtke 1982a, p. 96, fig. 90, pl. XII.

218 This is evident from, for example, a direct confrontation of the figure in the *Allegory of the Faith* with the female figure in De Lairesse's *Apollo and Aurora* of 1671 (both in the Metropolitan Museum of Art, New York). Faith's blue dress is summarized in the same manner as Saint John's in the Crucifixion scene by Jacob Jordaens behind her.

219 Rotterdam 1991, no. 47.

220 Washington-Amsterdam 1996-97, no. 19. In Steen's painting the pair of shoes on the floor are the mistress's and, like the stocking, is a sexual reference (see Amsterdam 1976, nos. 64, 68). This suggests a possible double-entendre in *The Love Letter*, and in *The Slippers* attributed to Van Hoogstraten (compare Brusati 1995, p. 204).

221 See Washington-The Hague 1995-96, pp. 180, 184, n. 5, on De Hooch's perspective scheme; p. 184, n. 7, on the signature and date (the same confirmation that the canvas bears the remains of a signature and the date "f 1668" above the door in the background was kindly sent to this writer by Ekkehard Mai on September 30, 1998). Sutton 1980a, no. 122, dated the De Hooch a decade later. See also Dulwich-Hartford 1998-99, no. 40, where the work is dated to about 1675-77, despite fresh examination of the canvas in 1996.

222 Gowing 1970, p. 153, cites the Dresden *Letter Reader*; Nash 1991, p. 84, *The Music Lesson* and *The Concert*.

223 Gowing 1970, p. 153.

224 Wheelock 1995a, p. 159.

225 See Kemmer 1998, pp. 94-104, on "the problem of 'burgerlyk' beauty" and "the problem of the passions."

226 As noted by Blankert in Washington-The Hague 1995-96, p. 39. Compare the stick and seal in Van Hoogstraten's *Letter Rack* in Karlsruhe (Brusati 1995, pl. XIII).

227 For different suggestions see Washington-The Hague 1995-96, p. 188. In Wheelock 1995a, p. 162, the letter on the floor is thought to have been "cast aside in haste and in anger."

228 There is general agreement that Vermeer avoids a clear narrative in this picture. See Gowing 1970, p. 153; Slatkes 1981, p. 101; Nash 1991, p. 84; Blankert in Washington-The Hague 1995-96, pp. 39, 44, n. 48; and Wheelock in Washington-The Hague 1995-96, p. 188.

229 Wheelock in Washington-The Hague 1995-96, p. 188. The idea goes back to Wheelock 1981, p. 146, but was advanced somewhat differently in Wheelock 1995a, p. 162.

230 See Delft 1996, pp. 42, 44, fig. 31, for this painting of 1622 by Pieter van Bronckhorst.

231 See Broos in Washington-The Hague 1995-96, p. 188, and sources cited.

232 Wheelock 1981, p. 144, and Wheelock in Washington-The Hague 1995-96, no. 17. Blankert 1978, no. 26, suggests 1670-71. Goldscheider 1967, p. 130, no. 22, dated the painting to about 1665.

233 See the detail of the Beit painting which serves as a frontispiece in Washington-The Hague 1995-96, where the two pictures are catalogued as nos. 17 and 19.

234 The quotes are from Wheelock's discussion of the Louvre picture in Washington-The Hague 1995-96, p. 176.

235 Goldscheider 1967, p. 21, figs. 9, 10.

236 For the drawing in Stockholm see Slive 1965, no. 232, or Stockholm 1992-93, no. 142. Compare also Rembrandt's etching of 1648, *Self-Portrait Drawing at a Window* (B 22).

237 Jacques de Gheyn II is a good example (see Van Regteren-Altena 1983). To cite a few other examples almost at random: Cornelis Saftleven's drawing of a boy picking off fleas, dated 1626 (Amsterdam, Rijksprenten-kabinet; Amsterdam-Washington 1981-82, p. 78, no. 88); illustrations in Crispijn van de Passe's drawing book of 1643 (see Bolten 1985, pp. 26-47, especially p. 42, fig. a, two studies of a young man reading at a table, after Guercino); Drost's self-portrait etching of 1652 (New York 1995-96, II, p. 29, fig. 39); numerous Rembrandt school drawings reproduced in Sumowski 1979-95.

238 On Van Everdingen's painting and the replica in Southampton see Blankert 1991b.

239 See Dulwich 1993, which discusses some of the related paintings by Bol, Flinck, Van Hoogstraten, Maes, and others.

240 See "Provenance" in Washington-The Hague 1995-96, p. 176.

241 On the objects in *The Lacemaker* see Blankert and Grijp 1995.

242 For example, Rembrandt's use of the butt of the brush, or Otto Marseus van Schrieck's blotting method of describing forest floors. Compare also Rembrandt's liquid handling of the carpet fringe in *Jeremiah* of 1630, as illustrated in Van de Wetering 1997, pp. 180-81, figs. 236-38.

243 See Sluijter 1993, Ch. IV, especially pp. 43, 47, 52, 56-58 (on "Illusie en manier van schilderen" and on Dou's "lossicheyt" as noted by Angel).

244 See n. 75 in this chapter.

245 Wheelock 1981, p. 154.

246 The quotes are from Washington-The Hague 1995-96, p. 196.

247 See MacLaren/Brown 1991, pp. 467, 469.

248 See Washington-The Hague 1995-96, nos. 21, 22 (the quotes are from p. 200).

249 See MacLaren/Brown 1991, pp. 466-68, and Washington-The Hague 1995-96, nos. 21, 22.

250 See Broos in Washington-The Hague 1995-96, p. 202.

251 Washington-The Hague 1995-96, pp. 48, 198, 202. For a different connection between Delft and Antwerp, that of De Cooge and Musson, see n. 253 below.

252 Duarte may have wanted only one painting by Vermeer, or one picture featuring a virginal – there are many possibilities. Among the several uncertainties of provenance is whether the entry, "Een juff[e]r spelend op de Clavecimbael door Vermeer," in the inventory of household goods owned by Nicolaes van Assendelft's widow (Delft, 1711) refers to either of the paintings in the National Gallery, London (as assumed by Broos in Washington-The Hague 1995-96, pp. 48, 198, 203). Another candidate might be the canvas in the Rolin collection, Brussels (Gowing 1970, p. 157, pl. 80; rejected in Wheelock 1981, p. 45, fig. 53). The painting was recently examined by curators and conservators at the Metropolitan Museum of Art, New York, and considered to be possibly authentic. The picture's condition and the quality of published photographs make it exceedingly difficult to form a proper impression of the work.

253 What evidence survives tends to suggest that the idea of pendants (apart from portraits) was treated more casually in seventeenth-century Holland than it is by present-day scholars of Dutch art. For example, in the Dissius sale of 1696 (see Montias 1989, p. 364; Aillaud et al. 1986, p. 208, for the Dutch), no. 39, "Nog een dito [Tronie] Vermeer," is followed by no. 40, "Een weerga [pendant] van denzelven," but this hardly proves that the artist intended two *tronies* as pendants. Similarly, in an Amsterdam auction of 1620 two pictures including King David, one by Pieter Lastman and one by Jan or Jacob Pynas, were apparently presented as a pair (Montias 1998b, pp. 291-92). In 1667 the Delft dealer Abraham de Cooge offered the Antwerp dealer Matthijs Musson a battle scene by Palamedes Palamedesz (1607-1638), for which De Cooge would ask his friend Philips Wouwerman to paint a pendant (Montias 1996, pp. 165-66). Of course, these cases involve creating pendants, not splitting them, but they suggest that neither operation would have been unusual in the Dutch art market of Vermeer's time.

254 See MacLaren/Brown 1991, pp. 466-69, where Brown reviews the question and concludes that "the paintings simply allude in a non-specific way to the traditional association of music and love" (p. 467).

255 De Jongh 1967, pp. 49-50; see MacLaren/Brown 1991, p. 466-67, and Wheelock in Washington-The Hague 1995-96, p. 198.

256 See MacLaren/Brown 1991, p. 467, crediting Christine Armstrong's paper given at the Frick Collection in 1976. Sutton supports the idea in Amsterdam-Boston-Philadelphia 1987-88, pp. 14-15. The landscape on the wall in *A Young Woman Standing at a Virginal* might simply amplify the idea of rugged terrain, or serve a purely formal purpose. But in Goodman-Soellner 1989, p. 83, it is suggested that the "arcadian landscape … also projects a female musician's beauty into nature, adding to the theme of ideal beauty the acclaim of ideal love."

257 Washington-The Hague 1995-96, pp. 200-202 (quote from p. 200).

258 See this chapter, n. 83, on an example by Steen.

259 As noted already in Slatkes 1981, p. 92.

260 Wheelock in Washington-The Hague 1995-96, p. 202, where the strong light falling on the seated woman is thought to disassociate her somehow from the after-hours ambiance. Compare Wheelock's sanitized interpretation of the *Woman with a Pearl Necklace* (fig. 291), in Washington-The Hague 1995-96, p. 154. Another sign of strain in Wheelock's explication of the London pictures is his description of the landscape on the virginal in the daylit interior as "pastoral" (p. 198). For mountain goats?

261 Westermann 1996, p. 186, on Alpers 1983.

262 The first quote is from Wheelock's entry in Washington-The Hague 1995-96, p. 194, while the others are from Wheelock 1981, p. 148.

263 As argued in Montias 1989, p. 202, n. 94, rejecting the suggestion made in De Jongh 1975-76, p. 75. See also Ch. Five, n. 48, above.

264 Wheelock in Washington-The Hague 1995-96, p. 192 ("since Ripa mentioned none of these objects, and all were important for the meaning of the allegory, it stands to reason that Vermeer, not a patron, decided to incorporate them").

265 Hertel 1996, Ch. XII.

266 Ter Kuile 1976, no. 79, fig. 21 (Binnenhof, The Hague).

267 Compare Washington-Detroit-Amsterdam 1980-81, nos. 64, 66, 68 (by Dujardin, Adriaen van de Velde, and De Lairesse, respectively); and Roy 1992, nos. P 19, 37-42, 75-79, 83, passim (works of the 1670s by De Lairesse).

268 Broos 1993, p. 209.

269 On Huygens's contribution to the Oranjezaal decorations see most recently The Hague 1997-98a, pp. 52-55. On Hanneman and the Huygens family in the 1660s see Ter Kuile 1976, pp. 25-26.

270 Hertel 1996, p. 214, criticizing Pops 1984.

271 Hertel 1996, p. 214.

272 On the sphere see Hertel 1996, pp. 220, 226-28, and Wheelock in Washington-The Hague 1995-96, pp. 192, 195, n. 12. As noted by Wheelock, De Jongh (1975-76, pp. 73-74) compared the sphere in an emblem by the Jesuit writer Willem Hesius. In his verse, the sphere is compared with "the vast universe" and the mind that believes in God. Hesius's *Emblemata sacra de fide, spe, charitate*, was published in Antwerp in 1636, and it appears plausible that Vermeer referred or was referred to it. Whether this "extends the Jesuit content of the allegory" (Washington-The Hague 1995-96, p. 192) is another question. Actual glass spheres evidently appealed to Vermeer's contemporaries for their illusionistic representation of everything around them in microcosmic form (a floating glass sphere accompanies Thalia, "de Kluchtspeelster," in the frontispiece of the fifth book in Van Hoogstraten 1678; see Hertel 1996, p. 227, fig. 53). The object was assigned vanitas significance when reproduced in still lifes (see fig. 61) and in genre paintings (for example, De Hooch's *Musical Company* of about 1674 in Copenhagen; Hertel 1996, pp. 49, 226, fig. 14; see also her p. 259, n. 216).

273 See Wheelock in Washington-The Hague 1995-96, pp. 190, 195, n. 7.

274 On John, whose attribute is a chalice with a snake, see Hertel 1996, pp. 211-17.

275 Knauer 1998, especially p. 72 ("Ihre Ehe galt unter anderem als ein Symbol der Seele, wie auch der Kirche als Braut Christi"). Unfortunately for this thesis, the figure of Rebecca is obscured by a fold, and a medieval tower appears in the background. For this common type of tapestry see, for example, *The Journey of Jacob and his Family to Egypt* (Audenarde, ca. 1560-80), in the Bowes Museum, Barnard Castle, County Durham, England (Audenarde 1999, pp. 169-70, no. 30, reproduced with a second example in the trade; my thanks to Tom Campbell of the Metropolitan Museum for this reference). On the left, a man on foot leads a young lady on horseback; behind her, two camels serve as pack animals. Vermeer could easily have seen such a composition and hit upon the idea of placing the woman on a camel (which is mounted and bridled as if it were equine), perhaps to create a compact image of Old Testament times.

276 The signature and date of 1669 on *The Geographer* are said not to be original in Washington-The Hague 1995-96, p. 170. This conclusion is emphatically overruled by Peter Waldeis in Frankfurt 1997, pp. 41-43, 54, who also considers the signature and date of 1668 on *The Astronomer* to be original (pp. 42, 68).

277 Wheelock 1981, pp. 136-38; Wheelock in Washington-The Hague 1995-96, p. 172; Wheelock in Frankfurt 1997, pp. 19-20.

278 See Klaas van Berkel's essay, "Johannes Vermeer und Antoni van Leeuwenhoek," in Frankfurt 1997, pp. 23-30, where the identification of Van Leeuwenhoek with Vermeer's model in the Frankfurt and Paris pictures is carefully analyzed and dismissed (pp. 28-29). In his excellent contribution to The Hague 1996a, "Vermeer and the Representation of Science," Van Berkel flatly states that "the still frequently voiced assumption that the astronomer in the [Louvre] painting is Van Leeuwenhoek is totally unfounded" (p. 14).

279 As suggested, for example, in Washington-The Hague 1995-96, p. 172, where their early provenance is reviewed. Moiso-Diekamp 1987, p. 502 under D 1, doubts the pendant relationship despite the common provenance, and for unimaginative reasons.

280 Maes's drawing of a scholar in his study is compared with *The Geographer* in Gowing 1970, pp. 148-50 (ill.). See also Dou's *Astronomer* of 1657 in Braunschweig; Bol's *Astronomer* of 1652 in the National Gallery, London;

Kneller's *Old Scholar* in Lübeck; and Olis's *Scholar* in the Mauritshuis. Gowing refers to "the numerous pictures of scholars in their studies by Rembrandt and his circle"; see, for example, Sumowski 1983-[94], I, nos. 124 and 127 (Bol); pp. 517 and 521 for works by Slabbert and Matthiesen (discussed in the introduction to Dou, pp. 501-2); and nos. 274, 283 (Dou); and III, nos. 973-74a (Kneller) and 1119, 1132-35 (Koninck). Of special interest, of course, are De Man's paintings of scholars in the Kunsthalle, Hamburg, and in a private collection in the Netherlands (Delft 1996, figs. 191-92; Zandvliet 1998, pp. 250-54).

281 As in Van Dyck's portrait of Lucas van Uffel (Liedtke 1984a, pp. 56-64) and in De Keyser's portrait of Constantijn Huygens (MacLaren/Brown 1991, pp. 215-17).

282 See Sumowski 1983-[94], I, p. 531, no. 274, on Dou's allegorical self-portrait of 1647 in Dresden.

283 As noted in Washington-The Hague 1995-96, pp. 172, 175, n. 18, citing Hoet. These considerations arouse one's curiosity about lot no. 3 in the Dissius sale of 1696: "The portrait of Vermeer in a room with various accessories uncommonly beautifully painted by him" (Blankert 1978, p. 153, doc. no. 62; Montias 1989, p. 364 under doc. no. 439). However, if this referred to *The Astronomer* or *The Geographer*, it would mean that the pictures had been separated and then reunited before the 1713 sale.

284 The comparison of *The Geographer* with Rembrandt's etching *Faust* goes back to Thoré-Bürger, as noted by Broos in Washington-The Hague 1995-96, p. 174.

285 See Wadum's discussion and diagrams in Frankfurt 1997, pp. 31-38.

286 The carpets are actually tapestries; an example of the type of verdure that is seen in *The Astronomer* is catalogued in Frankfurt 1997, as no. 15. The same exhibition included examples of the book, the globe, and the type of astrolabe that are represented in the Paris picture.

287 An example of this chart, which was first published by W. J. Blaeu in 1600, is featured in Frankfurt 1997, no. 4.

288 The Hague 1996a, p. 14. See also the same author's comments in Frankfurt 1997, pp. 18, 29. Van Berkel's remarks about the symbiosis of ancient learning and new science in the seventeenth century are very much in accord with the thesis of Grafton 1991.

Bibliography

van der Aa 1852-78
A. J. van der Aa, *Biographisch Woordenboek der Nederlanden*, Haarlem, 1852-78 (21 vols.)

Abels and Wouters 1994
P. H. A. M. Abels and A. Ph. F. Wouters, *Nieuw en Ongezien: Kerk en samenleving in de classis Delft en Delfland 1572-1621, 2. De nieuw samenleving*, Delft, 1994

van Ackere 1972
Jules van Ackere, *Baroque and Classic Art in Belgium (1600-1789): Architecture, Monumental Art*, Brussels, 1972

Aillaud et al. 1986
Gilles Aillaud, Albert Blankert, and John Michael Montias, *Vermeer*, Paris, 1986

Ainsworth et al. 1982
Maryan Wynn Ainsworth, John Brealey, Egbert Haverkamp-Begemann, and Pieter Meyers, with the assistance of Karin Groen, Maurice J. Cotter, Lambertus van Zelst, and Edward V. Sayre, *Art and Autoradiography: Insights into the Genesis of Paintings by Rembrandt, Van Dyck, and Vermeer*, The Metropolitan Museum of Art, New York, 1982

Alpers 1983
Svetlana Alpers, *The Art of Describing: Dutch Art in the Seventeenth Century*, Chicago, 1983

Amman 1973
Jost Amman and Hans Sachs (tr. by Stanley Appelbaum, intro. by Benjamin A. Rifkin), *The Book of Trades*, New York, 1973 (reprint of H. Sachs, *Eygentliche Beschreibung aller Stände auff Erden*, Frankfurt am Main, 1568)

Amsterdam 1976
Tot Lering en Vermaak. Exhibition catalogue, by E. de Jongh. Amsterdam, Rijksmuseum, 1976. Amsterdam, 1976

Amsterdam 1984
Masters of Middelburg. Exhibition catalogue, by Noortje Bakker, Ingvar Bergström, Guido Jansen, Simon H. Levie, and Sam Segal. Amsterdam, Waterman Gallery, 1984

Amsterdam 1986
Kunst voor de beeldenstorm. Exhibition catalogue, by J. P. Filedt Kok, W. Halsema-Kubes, and W. Th. Kloek (eds.), with introductions by B. Dubbe and W. H. Vroom, David Freedberg, J. R. J. van Asperen de Boer, M. Faries, and J. P. Filedt Kok, and catalogue entries by many contributors. Amsterdam, Rijksmuseum, 1986, and The Hague, 1986

Amsterdam 1989-90
De Hollandse Fijnschilders: Van Gerard Dou tot Adriaen van der Werff. Exhibition catalogue, by Peter Hecht. Amsterdam, Rijksmuseum, 1989-90. Amsterdam, Maarssen, and The Hague, 1989

Amsterdam 1992A
De wereld binnen handbereik: Nederlandse kunst- en rariteitenverzamelingen, 1585-1735. Catalogus. Exhibition catalogue, by Ellinoor Bergvelt and Renée Kistemaker, ed., with contributions by twenty-two authors. Amsterdam, Amsterdams Historisch Museum, 1992. Amsterdam, 1992

Amsterdam 1992B
Episcopius: Jan de Bisschop (1628-1671) advocaat en tekenaar. Exhibition catalogue, by Renske E. Jellema and Michiel Plomp. Amsterdam, Museum Het Rembrandthuis, 1992. Amsterdam and Zwolle, 1992

Amsterdam 1993-94A
Dawn of the Golden Age: Northern Netherlandish Art 1580-1620. Exhibition catalogue, by Ger Luijten and Ariane van Suchtelen (eds.), Reinier Baarsen, Wouter Kloek, and Marijn Schapelhouman, with contributions by Marten Jan Bok, J. Bruyn, Huigen Leeflang, Ger Luijten, Hessel Miedema, Nadine Orenstein, Christiaan Schuckman, and others (see p. 298). Amsterdam, Rijksmuseum, 1993-94. Amsterdam and Zwolle, 1993

Amsterdam 1993-94B
Nederland naar 't leven: Landschapsprenten uit de Gouden Eeuw. Exhibition catalogue, by Boudewijn Bakker and Huigen Leeflang, with essays by Ed de Heer, Nadine Orenstein, and Jan Peeters. Amsterdam, Museum Het Rembrandthuis, 1993-94. Amsterdam and Zwolle, 1993

Amsterdam 1995
Jacob van Campen: Het klassieke ideaal in de Gouden Eeuw. Exhibition catalogue, ed. by Jacobine Huisken, Koen Ottenheym, and Gary Schwartz. Amsterdam, Royal Palace, 1995. Amsterdam, 1995

Amsterdam 1997A
The Royal Palace of Amsterdam in Paintings of the Golden Age. Exhibition catalogue, by Jan Peeters, Peter C. Sutton, Eymert-Jan Goossens, and Deirdre Carasso. Amsterdam, Royal Palace, 1997. Zwolle, 1997

Amsterdam 1997B
Mirror of Everyday Life: Genreprints in the Netherlands 1550-1700. Exhibition catalogue, by Eddy de Jongh and Ger Luijten (trans. by Michael Hoyle). Amsterdam, Rijksprentenkabinet, Rijksmuseum, 1997. Amsterdam, 1997

Amsterdam-Boston-Philadelphia 1987-88
Masters of 17th-Century Dutch Landscape Painting. Exhibition catalogue, by Peter C. Sutton, with contributions by Albert Blankert, Josua Bruyn, C. J. de Bruyn Kops, Alan Chong, Jeroen Giltaij, Simon Schama, and Marjorie Elizabeth Wieseman. Amsterdam, Rijksmuseum; Boston, Museum of Fine Arts; and Philadelphia, Philadelphia Museum of Art, 1987-88. Boston, 1987

Amsterdam-Jerusalem 1991-92
Het Oude Testament in de Schilderkunst van de Gouden Eeuw. Exhibition catalogue, by Christian Tümpel, in collaboration with Jacqueline Boonen, Peter van der Coelen, Judith van Gent, Marloes Huiskamp, Netty van de Kamp, Gabriël Pastoor, and Ulrike Wegener. Amsterdam, Joods Historisch Museum, and Jerusalem, Israel Museum, 1991-92. Amsterdam and Zwolle, 1991

Amsterdam-Toronto 1977
The Dutch Cityscape in the 17th Century and its Sources. Exhibition catalogue, by Richard J. Wattenmaker, with contributions by Boudewijn Bakker, Dedalo Carasso, and Bob Haak. Amsterdam, Amsterdams Historisch Museum, and Toronto, Art Gallery of Ontario, 1977. Amsterdam and Toronto, 1977

Amsterdam-Vienna-New York-Cambridge 1991-92
Seventeenth-Century Dutch Drawings: A Selection from the Maida and George Abrams Collection. Exhibition catalogue, by William W. Robinson, introduction by Peter Schatborn. Amsterdam, Rijksprentenkabinet, Rijksmuseum; Vienna, Graphische Sammlung Albertina; New York, Pierpont Morgan Library; and Cambridge, Mass., The Fogg Art Museum, Harvard University, 1991-92. Lynn, Mass., 1991

AMSTERDAM-WASHINGTON 1981-82
Dutch Figure Drawings from the Seventeenth Century. Exhibition catalogue, by Peter Schatborn. Amsterdam, Rijksprentenkabinet, Rijksmuseum, and Washington, National Gallery of Art, 1981-82. The Hague, 1981

ANTWERP 1994
Muziek en Grafiek: Burgermoraal en muziek in de 16de- en 17de-eeuwse Nederlanden. Exhibition catalogue, by Karel Moens, with contributions by Iris Kockelbergh. Antwerp, Hessenhuis, 1994. Antwerp, 1994

ANTWERP-MÜNSTER 1990
Jan Boeckhorst 1604-1668, medewerker van Rubens. Exhibition catalogue, by Paul Huvenne and Jochen Luckhardt (ed.), with contributions by Arnout Balis, Mechthild Beilmann, Helmut Lahrkamp, Ann-Marie Logan, Katlijne Van der Stighelen, Dirk Strohmann, Isabelle Van Tichelen, and Hans Vlieghe. Antwerp, Rubenshuis, and Münster, Westfälisches Landesmuseum für Kunst und Kulturgeschichte, 1990. Freren, Germany, 1990

ARASSE 1994
Daniel Arasse, *Vermeer: Faith in Painting* (trans. by Terry Grabar), Princeton, 1994

ATHENS 1996
Images of Women in Seventeenth-Century Dutch Art: Domesticity and the Representation of the Peasant. Exhibition catalogue, by Patricia Phagan (ed.), with essays by Wayne Franits, Lisa Rosenthal, Nanette Salomon, and S. William Pelletier. Athens, Georgia, Georgia Museum of Art, University of Georgia, 1996. Athens, 1996

AUCKLAND 1982
Still-Life in the age of Rembrandt. Exhibition catalogue, by E. de Jongh, with the assistance of Titia van Leeuwen, Andrea Gasten, and Hilary Sayles. Auckland, New Zealand, Auckland City Art Gallery, 1982. Auckland, 1982

AUDENARDE 1999
Tapisseries d'Audenarde du XVI-e au XVIII-e siècle. Exhibition catalogue, by Ingrid De Meûter and Martine Vanwelden, with the collaboration of Luc Dhondt, Françoise Vandevijvere, and Jan Wouters. Audenarde, Lakenhalle and other institutions, 1999. Tielt, 1999

AUGSBURG-CLEVELAND 1975-76
Johann Liss. Exhibition catalogue, by Rüdiger Klessmann, Ann Tzeutschler Lurie, and Louise S. Richards, with essays by Bruno Bushart, Rüdiger Klessmann, Ann Tzeutschler Lurie, and Louise S. Richards. Augsburg, Rathaus, and Cleveland, Ohio, The Cleveland Museum of Art, 1975-76. Augsburg, 1975

BAETJER 1995
Katharine Baetjer, *European Paintings in The Metropolitan Museum of Art by artists born before 1865: A Summary Catalogue*, New York, 1995

BAKKER 1995
Boudewijn Bakker, "*Schilderachtig*: discussions of a seventeenth-century term and concept," *Simiolus*, XXIII (1995), pp. 147-62

BALDINUCCI 1845-47
F. Baldinucci (edited by F. Ranalli), *Notizie dei Professori del Disegno da Cimabue in qua*, Florence, 1845-47 (5 vols.)

BALFOORT 1981
D. J. Balfoort (intro. and ed. by Rudolf Rasch), *Het muziekleven in Nederland in de 17de en 18de eeuw*, The Hague, 1981 (1st ed., 1938)

BALTRUŠAITIS 1977
Jurgis Baltrušaitis, *Anamorphic Art* (trans. by W. J. Strachan), New York, 1977

BANGS 1997
Jeremy Dupertuis Bangs, *Church Art and Architecture in the Low Countries before 1566*, Kirksville, Missouri, 1997

BAUER 1982
George C. Bauer, "From architecture to scenography: the full-scale model in the Baroque tradition," in Schnapper 1982, pp. 141-49

BAUMAN AND LIEDTKE 1992
Guy C. Bauman and Walter A. Liedtke, *Flemish Paintings in America: A Survey of Early Netherlandish and Flemish Paintings in the Public Collections of North America*, Antwerp, 1992

BAX 1981
D. Bax, *Catalogue of the Michaelis Collection: The Old Town Hall Cape Town*, Cape Town, 1981

BECK 1972-73
Hans-Ulrich Beck, *Jan van Goyen, 1596-1656*, Amsterdam, 1972-73 (2 vols.)

BEDAUX 1990
Jan Baptist Bedaux, *The reality of symbols: Studies in the iconology of Netherlandish art 1400-1800*, The Hague and Maarssen, 1990

van BERESTEYN 1936
E. A. van Beresteyn, *Nieuwe Kerk te Delft, grafmonumenten en grafzerken in het koor*, Delft, 1936

van BERESTEYN 1938
E. A. van Beresteyn, *Grafmonumenten en grafzerken in de Oude Kerk te Delft*, Assen, 1938

BERLIN 1984
Holländische Malerei aus Berliner Privatbesitz. Exhibition catalogue, by Jan Kelch, with the collaboration of Ingeborg Becker. Berlin, Gemäldegalerie SMPK, 1984. Berlin, 1984

BERLIN-AMSTERDAM-LONDON 1991-92
Rembrandt: the Master & his Workshop (Paintings). Exhibition catalogue, by Christopher Brown, Jan Kelch, and Pieter van Thiel, with essays by Ernst van de Wetering, A. Th. van Deursen, Sebastian Dudok van Heel, Josua Bruyn, Jeroen Boomgaard, and Robert Scheller. Berlin, Gemäldegalerie SMPK at the Altes Museum; Amsterdam, Rijksmuseum; and London, The National Gallery, 1991-92. New Haven and London, 1991

BERNT 1957-58
Walther Bernt, *Die niederländischen Zeichner des 17. Jahrhunderts*, Munich, 1957-58 (2 vols.)

BERNT 1970
Walther Bernt, *The Netherlandish Painters of the Seventeenth Century*, London, 1970 (3 vols.)

BEZEMER SELLERS
Vanessa Bezemer Sellers, *Courtly Gardens in Holland 1600-1650: The House of Orange and the Hortus Batavus* (forthcoming)

de BIE 1661
Cornelis de Bie, *Het Gulden Cabinet van de edele vry Schilderconst*, Antwerp, 1661

BIKKER 1998
Jonathan Bikker, "The Deutz brothers, Italian paintings and Michiel Sweerts: new information from Elisabeth Coymans's *Journael*," *Simiolus*, XXVI (1998), pp. 277-311

BLADE 1971
Timothy Trent Blade, "Two interior views of the Old Church in Delft," *Museum Studies* (Art Institute of Chicago), VI (1971), pp. 34-50

BLADE 1976
Timothy Trent Blade, "The Paintings of Dirck van Delen," Ph.D. Diss., University of Minnesota, Minneapolis, 1976

BLANKERT 1978
Albert Blankert (with the collaboration of Rob Ruurs and W. L. van de Watering), *Vermeer of Delft*, Oxford, 1978

BLANKERT 1991A
Albert Blankert, *Museum Bredius: Catalogus van de schilderijen en tekeningen*, Zwolle and The Hague, 1991

BLANKERT 1991B
Albert Blankert, "Vrouw 'Winter' door Caesar van Everdingen," *Bulletin van het Rijksmuseum*, XXXIX (1991), pp. 505-23

BLANKERT AND GRIJP 1995
Albert Blankert and Louis P. Grijp, "An Adjustable Leg and a Book: Lacemakers by Vermeer and Others, and Bredero's *Groot Lied-boeck* in One by Dou," in *Shop Talk: Studies in Honor of Seymour Slive*, Cambridge, Mass., 1995, pp. 40-43

VAN BLEYSWIJCK 1667
Dirck van Bleyswijck, *Beschryvinge der Stadt Delft*, Delft, 1667[-80]

BOCK AND GAEHTGENS 1987
Henning Bock and Thomas W. Gaehtgens (eds.), *Holländische Genremalerei im 17. Jahrhundert: Symposium Berlin 1984* (*Jahrbuch Preussischer Kulturbesitz*, Sonderband 4), Berlin, 1987

BODE 1921
Wilhelm von Bode, *Studien über Leonardo da Vinci*, Berlin, 1921

DE BOER 1988
Peter Guido de Boer, *Enkele Delftse zeventiende eeuwse kerkportretten opnieuw bekeken*, printed Ph.D. Diss., Technische Universiteit Delft, 1988

BOL 1989
Laurens J. Bol, *Adriaen Pietersz. van de Venne, Painter and Draughtsman* (trans. by Jennifer Kilian and Majorie Wieseman), Doornspijk, 1989

BOLTEN 1985
Jaap Bolten, *Method and Practice: Dutch and Flemish Drawing Books 1600-1750*, Landau (Pfalz), 1985

BOMFORD 1998
David Bomford, "Perspective, Anamorphosis, and Illusion: Seventeenth-Century Dutch Peep Shows," in Gaskell and Jonker 1998, pp. 125-35

BORING 1942
E. G. Boring, *Sensation and Perception in the History of Experimental Psychology*, London and New York, 1942

BOSSE 1653
Abraham Bosse, *Moyen universel de pratiquer la perspective sur les tableaux, ou surfaces irrégulières …*, Paris, 1653

BOSTON-TOLEDO 1993-94
The Age of Rubens. Exhibition catalogue, by Peter C. Sutton, in collaboration with Marjorie E. Wieseman, and with contributions by David Freedberg, Jeffrey M. Muller, Lawrence W. Nichols, Konrad Renger, Hans Vlieghe, Christopher White, and Anne T. Woollett. Boston, Museum of Fine Arts, and Toledo, Ohio, Toledo Museum of Art, 1993-94. Boston and Ghent, 1993

BOUCHERY 1957-58
H. F. Bouchery, "De ontwikkeling van het binnenhuis-tafereel in de Vlaamse en de Hollandse schilderkunst van de XV-e tot de XVII-e eeuw," *Gentse Bijdragen*, XVII (1957-58), pp. 157-74

BRAUNSCHWEIG 1978
Die Sprache der Bilder: Realität und Bedeutung in der niederländischen Malerei des 17. Jahrhunderts. Exhibition catalogue, by Rüdiger Klessmann, Wolfgang J. Müller, and Konrad Renger, with contributions by E. de Jongh and Lothar Dittrich. Braunschweig, Herzog Anton Ulrich-Museum, 1978. Braunschweig, 1978

BRAUNSCHWEIG 1983
Niederländische Malerei aus der Kunstsammlung der Universität Göttingen. Exhibition catalogue, by Rüdiger Klessmann, with essays by Ulrich Mävers and Marianne Menze, and catalogue entries by Wolfgang Stechow et al. Braunschweig, Herzog Anton Ulrich-Museum, 1983. Braunschweig, 1983

BREDEROO ET AL. 1988
Nico J. Brederoo, Leendert D. Couprie, Mireille J. H. Madou, and Gerhard J. Nauta (eds.), *Oog in oog met de spiegel*, Amsterdam, 1988

BREDIUS 1908
A. Bredius, "Michiel Jansz van Mierevelt, een nalezing," *Oud-Holland*, XXVI (1908), pp. 1-17

BREDIUS 1915-22
Abraham Bredius, *Künstler-Inventare: Urkunden zur Geschichte der holländischen Kunst des XVI., XVII., und XVIII. Jahrhunderts*, The Hague, 1915-22 (8 parts)

BRIELS 1976
Johannes Gerardus Carolus Antonius Briels, *De Zuidnederlandse Immigratie in Amsterdam en Haarlem omstreeks 1572-1630*, printed Ph.D. Diss., Utrecht, 1976

BRIELS 1987
Jan Briels, *Vlaamse Schilders in de Noordelijke Nederlanden in het begin van de Gouden Eeuw 1585-1630*, Antwerp, 1987 (published simultaneously in French as *Peintres flamands en Hollande au début du Siècle d'Or 1585-1630*)

BRIELS 1997
Jan Briels, *Vlaamse schilders en de dageraad van Hollands Gouden Eeuw 1585-1630*, Antwerp, 1997

BRIÈRE-MISME 1927
Clothilde Brière-Misme, "Tableaux inédits ou peu connus de Pieter de Hooch," *Gazette des Beaux-Arts*, 5th series, vol. XV (1927), pp. 361-80; vol. XVI (1927), pp. 51-79 and 258-86

BRIÈRE-MISME 1935
Clothilde Brière-Misme, "Un émule de Vermeer et de Pieter de Hooch, Cornélis de Man," *Oud-Holland*, LII (1935), pp. 1-26, 97-120

BRIÈRE-MISME 1950
Clothilde Brière-Misme, "Un Petit Maître hollandais, Cornelis Bisschop (1630-1674)," *Oud-Holland*, LXV (1950), pp. 24-40, 104-16, 139-51, 178-92, 227-40

TEN BRINK GOLDSMITH: see TEN BRINK GOLDSMITH

VAN DEN BRINK 1993
Peter van den Brink, "Striptekenaar avant la lettre," *Tableau*, XVI, no. 2 (November 1993), pp. 46-53

BROOS 1987
Ben Broos, *Meesterwerken in het Mauritshuis*, The Hague, 1987 (see also Paris 1986)

BROOS 1993
Ben Broos, *Intimacies and Intrigues: History Painting in the Mauritshuis*, The Hague, 1993

BROWN 1981
Christopher Brown, *Carel Fabritius*, Oxford, 1981

BROWN 1984
Christopher Brown, *Images of a Golden Past: Dutch Genre Painting of the 17th Century*, New York, 1984

BROWN 1995
Christopher Brown, "Leonaert Bramer in Italy," in *Shop Talk: Studies in Honor of Seymour Slive*, Cambridge, Mass., 1995, pp. 46-48

BROWN 1996
Christopher Brown, review of Washington-The Hague 1995-96, in *The Burlington Magazine*, CXXXVIII (1996), pp. 281-83

BROWN: see also MACLAREN/BROWN

BROWN, BOMFORD, PLESTERS AND MILLS 1987
Christopher Brown, David Bomford, Joyce Plesters, and John Mills, "Samuel van Hoogstraten: Perspective and Painting," *National Gallery Technical Bulletin*, XI (1987), pp. 60-85

BRUSATI 1995
Celeste Brusati, *Artifice and Illusion: The Art and Writing of Samuel van Hoogstraten*, Chicago and London, 1995

Bruyn: see De Bruyn

BUDDE 1930
Illa Budde, *Beschreibender Katalog der Handzeichnungen in der Staatliche Kunstakademie Düsseldorf*, Düsseldorf, 1930

BUIJSEN 1993
Edwin Buijsen, *The Sketchbook of Jan van Goyen from the Bredius-Kronig Collection*, The Hague, 1993 (2 vols., one a facsimile of the 1644 sketchbook)

CAEN-PARIS 1990-91
Les Vanités dans la peinture au XVIIe siècle: Méditations sur la richesse, le dénouement et la rédemption. Exhibition catalogue, by Alain Tapié, with the collaboration of Jean-Maris Dautel and Philippe Rouillard, and contributions by André Chastel, Louis Marin, Marie-Claude Lambotte, François Bergot, Ingvar Bergström, and Jacques Foucart. Caen, Musée des Beaux-Arts, and Paris, Musée du Petit Palais, 1990-91. Caen, 1990

CARTER 1970
B. A. R. Carter, "Perspective," in H. Osborne (ed.), *The Oxford Companion to Art*, Oxford, 1970, pp. 840-61

CATS 1712
Alle de Wercken van den Heere Jacob Cats, Amsterdam, 1712 (2 vols.)

CHAPMAN 1990
H. Perry Chapman, *Rembrandt's Self-Portraits: A Study in Seventeenth-Century Identity*, Princeton, 1990

CHAPMAN 1997
H. Perry Chapman, review of Brusati 1995 and other books, in *The Art Bulletin*, LXXIX (1997), pp. 328-34

CHIARINI 1989
Marco Chiarini, *I Dipinti Olandesi del Seicento e del Settecento (Gallerie e Musei Statali di Firenze)*, Rome, 1989

CHIHAYA 1992
Toshio Chihaya, "Über den Wortsinn in der holländischen Kunstliteratur des 17. Jahrhunderts, 'schilderachtich'," *Bigaku (Aesthetics)*, XLII, no. 4 (spring 1992), pp. 46-56

CHONG 1992
Alan Chong, *Johannes Vermeer: Gezicht op Delft*, Bloemendaal, 1992

CLARK 1966
Kenneth Clark, *Rembrandt and the Italian Renaissance*, New York, 1966

COLE 1978
Ellen Berger Cole, "A Discourse on Fabritius's 'View of Delft' as Analyzed by Liedtke and Wheelock" (M.A. Thesis), California State University, Long Beach, 1978

COLLINS BAKER 1925
C. H. Collins Baker, *Masters of Paintings. Pieter de Hooch*, London, 1925

CONFORTI 1993
Claudia Conforti, *Vasari architetto*, Milan, 1993

CRARY 1992
Jonathan Crary, *Techniques of the Observer: On Vision and Modernity in the Nineteenth Century*, Cambridge, Mass., and London, 1992

CUNNAR 1990
Eugene R. Cunnar, "The Viewer's Share: three sectarian readings of Vermeer's Woman with a Balance," *Exemplaria*, II (1990), pp. 501-36

CZYMMEK 1981
Sabine Czymmek, *Die architektur-illusionistische Deckenmalerei in Italien und Deutschland von den Anfängen bis in die Zeit um 1700*, printed Ph.D. Diss., Johannes Gutenberg-Universität (Mainz), Cologne, 1981

DALAI EMILIANI 1980
Marisa Dalai Emiliani (ed.), *La Prospettiva Rinascimentale: Codificazioni e Trasgressioni*, vol. I, Florence, 1980

DANE 1998
Jacques Dane (ed.) (with essays by nine authors), *1648. Vrede van Munster: feit en verbeelding*, Zwolle, 1998

DAVIES 1992
Alice I. Davies, *Jan van Kessel (1641-1680)*, Doornspijk, 1992

DAVIS 1980
Margaret Daly Davis, "Carpaccio and the Perspective of Regular Bodies," in Dalai Emiliani 1980, pp. 183-200

DE BRUYN 1988
Jean-Pierre De Bruyn, *Erasmus II Quellinus (1607-1678), De Schilderijen met Catalogue Raisonné*, Freren, 1988

DELFT 1974-75
Delftse Deurzigten: tentoonstelling naar aanleiding van het werk van Gerard Houckgeest ca. 1600-1661. Exhibition catalogue, by Kees van der Ploeg and Joop van Roekel under the direction of Lyckle de Vries. Delft, Stedelijk Museum Het Prinsenhof, 1974-75. Delft, 1974

DELFT 1981
De Stad Delft, cultuur en maatschappij van 1572 tot 1667. Exhibition catalogue, by forty-nine authors. Delft, Stedelijk Museum Het Prinsenhof, 1981. Delft, 1981 (2 vols.)

DELFT 1994
Leonaert Bramer 1596-1674 Ingenious Painter and Draughtsman in Rome and Delft. Exhibition catalogue, by Jane Ten Brink Goldsmith, Paul Huys Janssen, Michiel Kersten, John Michael Montias, Michiel Plomp, and Adrienne Quarles van Ufford. Delft, Stedelijk Museum Het Prinsenhof, 1994. Delft and Zwolle, 1994

DELFT 1996
Delft Masters, Vermeer's Contemporaries: Illusionism through the Conquest of Light and Space. Exhibition catalogue, by Michiel C. C. Kersten and Daniëlle H. A. C. Lokin, with the collaboration of Michiel C. Plomp. Delft, Stedelijk Museum Het Prinsenhof, 1996. Delft and Zwolle, 1996

DELFT 1998
Beelden van een strijd: Oorlog en kunst vóór de Vrede van Munster 1621-1648. Exhibition catalogue, by Michel P. van Maarseveen, Jos W. L. Hilkhuijsen and Jacques Dane (eds.), with essays by Jos W. L. Hilkhuijsen, Michiel C. C. Kersten, Michel P. van Maarseveen, Fatima M. B. van der Maas, Erik Spaans and H. L. Zwitzer. Delft, Stedelijk Museum Het Prinsenhof, 1998. Delft and Zwolle, 1998

DELSAUTE 1998
Jean-Luc Delsaute, "The Camera Obscura and Painting in the Sixteenth and Seventeenth Centuries," in Gaskell and Jonker 1998, pp. 111-23

DESCARGUES 1977
Pierre Descargues, (trans. by I. Mark Paris), *Perspective*, New York, 1977

DESTOT 1994
Marcel Destot, with the collaboration of Jacques Foucart, *Peintures des écoles du Nord. La collection du musée de Grenoble*, Paris, 1994

VAN DEURSEN 1991
A. T. van Deursen (tr. by Maarten Ultee), *Plain Lives in a Golden Age: Popular Culture, Religion, and Society in Seventeeth-Century Holland*, Cambridge and New York, 1991

DEVAPRIAM 1990
Emma Devapriam, "*The Interior of St Janskerk at Gouda* by Hendrick Cornelisz van der Vliet," *Art Bulletin of Victoria*, no. 31 (1990), pp. 40-43

DIXON 1995
Laurinda S. Dixon, *Perilous Chastity: Women and Illness in Pre-Enlightenment Art and Medicine*, Ithaca, N.Y., and London, 1995

DON 1985
Peter Don (ed.), *Kunstreisboek Zuid-Holland*, Zeist, 1985

DONHAUSER 1993
Peter L. Donhauser, "A Key to Vermeer?," *Artibus et Historiae*, XIV (1993), pp. 85-101

DORDRECHT 1992-93
De Zichtbaere Werelt: schilderkunst uit de Gouden Eeuw in Hollands oudste stad. Exhibition catalogue, edited by Peter Marijnissen, Wim de Paus, Peter Schoon, George Schweitzer, with contributions by Celeste Brusati, Alan Chong, John Loughman, and Marjorie E. Wieseman. Dordrecht, Dordrechts Museum, 1992-93. Dordrecht and Zwolle, 1992

DÖRING 1993
Thomas Döring, *Studien zur Künstlerfamilie Van Bronchorst: Jan Gerritsz. (ca. 1603-1661), Johannes (1627-1656) und Gerrit van Bronchorst (ca. 1636-1673) in Utrecht und Amsterdam*, printed Ph.D. Diss., Rheinischen Friedrich-Wilhelms-Universität, Bonn, 1993

DÜCHTING 1996
Hajo Düchting, *Jan Vermeer van Delft im Spiegel seiner Zeit*, Erlangen, 1996

DULWICH 1993
Rembrandt van Rijn: Girl at a Window. Exhibition catalogue, with contributions by Christopher Brown, Görel Cavalli-Björkman, Sophia Plender, Michiel Roscam Abbing, and Ann Sumner. Dulwich (London), Dulwich Picture Gallery, 1993. Dulwich, 1993

DULWICH-HARTFORD 1998-99
Pieter de Hooch, 1629-1684. Exhibition catalogue, by Peter C. Sutton. Dulwich (London), Dulwich Picture Gallery, and Hartford, Connecticut, Wadsworth Atheneum, 1998-99. London and New Haven, 1998

DUMAS 1991
Charles Dumas, *Haagse Stadsgezichten 1550-1800: topografische schilderijen van het Haags Historisch Museum*, Zwolle, 1991

VAN ECK AND COEBERGH-SURIE 1997
Xander van Eck and Christiane Coebergh-Surie, "'Behold, a greater than Jonas is here': the iconographic program of the stained-glass windows of Gouda, 1552-72," *Simiolus*, XXV (1997), pp. 5-44

EDINBURGH 1984
Dutch Church Painters: Saenredam's Great Church at Haarlem in context. Exhibition catalogue, by Hugh Macandrew. Edinburgh, National Galleries of Scotland, 1984. Edinburgh, 1984

EICHE 1982
Sabine Eiche, "'The Artist in His Studio' by Jan Vermeer: About a Chandelier," *Gazette des Beaux-Arts*, XCIX (Jan.-June 1982), pp. 203-4

EISLER 1916
Max Eisler, "Der Raum bei Jan Vermeer," *Jahrbuch der Kunsthistorischen Sammlungen des Allerhöchsten Kaiserhauses*, XXXIII (1916), pp. 213-91

EISLER 1923
Max Eisler, *Alt-Delft, Kultur und Kunst*, Vienna, 1923

EKKART 1995
R. E. O. Ekkart, *Nederlandse portretten uit de 17e eeuw: Eigen collectie/ Dutch portraits from the Seventeenth Century: Own collection*, Museum Boijmans Van Beuningen, Rotterdam, 1995

ELKINS 1988
James Elkins, "'Das Nüsslein beisset auf, ihr Künstler!': Curvilinear perspective in seventeenth century Dutch art," *Oud Holland*, CII (1988), pp. 257-76

ELOVSSON 1991
Per-Olov Elovsson, "The Geographer's Heart: A Study of Vermeer's Scientists," *Konsthistorisk Tidskrift*, LX (1991), pp. 17-25

EMMENS 1968
J. A. Emmens, *Rembrandt en de regels van de kunst*, Utrecht, 1968 (republished in *Verzameld Werk*, II, Amsterdam, 1979)

ENKHUIZEN 1990
Portret van Enkhuizen in de gouden eeuw. Exhibition catalogue, by Rudolf E. O. Ekkart, with an introduction by Gusta Reichwein. Enkhuizen, Zuiderzeemuseum, 1990. Zwolle and Enkhuizen, 1990

EVELYN 1955
E. S. de Beer (ed.), *The Diary of John Evelyn*, London, 1955 (6 vols.)

FALKENBURG 1989
Reindert L. Falkenburg, "'Alter Einoutus': Over de aard en herkomst van Pieter Aertsens stilleven-conceptie," *Nederlands Kunsthistorisch Jaarboek*, XL (1989), pp. 41-66

FIELD 1997
J. V. Field, *The Invention of Infinity: Mathematics and Art in the Renaissance*, Oxford, New York, and Tokyo, 1997

FILIPCZAK 1987
Zirka Zaremba Filipczak, *Picturing Art in Antwerp, 1550-1700*, Princeton, 1987

FINDLEN 1994
Paula Findlen, *Possessing Nature: Museums, Collecting, and Scientific Culture in Early Modern Italy*, Berkeley, Los Angeles, and London, 1994

FINK 1971
Daniel A. Fink, "Vermeer's use of the camera obscura – a comparative study," *The Art Bulletin*, LIII (1971), pp. 493-505

FISCHER 1975
Pieter Fischer, *Music in Paintings of the Low Countries in the Sixteenth and Seventeenth Centuries*, Amsterdam, 1975

FLEISCHER 1978
Roland E. Fleischer, "Ludolf de Jongh and the Early Work of Pieter de Hooch," *Oud Holland*, XCII (1978), pp. 49-67

FLEISCHER 1988
Roland E. Fleischer, "Quirijn van Brekelenkam and 'The Artist's Workshop' in the Hermitage Museum," in R. E. Fleischer and S. S. Munshower (eds.), *The Age of Rembrandt: Studies in Seventeenth-Century Dutch Painting (Papers in Art History from The Pennsylvania State University*, Volume III), University Park, Penn., 1988, pp. 70-93

FLEISCHER 1989
Roland E. Fleischer, *Ludolf de Jongh (1616-1679) Painter of Rotterdam*, Doornspijk, 1989

FLEISCHER 1997
Roland E. Fleischer, "Ludolf de Jongh's *The Refused Glass* and its Effect on the Art of Vermeer and de Hooch," in Roland E. Fleischer and Susan Clare Scott (eds.), *Rembrandt, Rubens, and the Art of their Time: Recent Perspectives (Papers in Art History from The Pennsylvania State University*, Volume XI), University Park, Penn., 1997, pp. 250-66

FLEISCHER AND REISS 1993
Roland E. Fleischer and Stephen Reiss, "Attributions to Ludolf de Jongh: some old, some new," *The Burlington Magazine*, CXXXV (1993), pp. 668-77

FLORENCE 1985
Disegni di Architetti Fiorentini 1540-1640. Exhibition catalogue, by Andrew Morrogh (trans. by Silvia Dinale). Florence, Gabinetto Disegni e Stampe degli Uffizi, 1985. Florence, 1985

FOCK 1979
C. Willemijn Fock, "The Princes of Orange as Patrons of Art in the Seventeenth Century," *Apollo*, CX (1979), pp. 466-75

FOCK 1998
C. Willemijn Fock, "Werkelijkheid of schijn. Het beeld van het Hollandse interieur in de zeventiende-eeuwse genreschilderkunst," *Oud Holland*, CXII (1998), pp. 187-246

FOCKEMA ANDREAE ET AL. 1948
S. J. Fockema Andreae, E. H. ter Kuile and M. D. Ozinga, *Duizend jaar bouwen in Nederland*, I. *De Bouwkunst van de Middeleeuwen*, Amsterdam, 1948

FOCKEMA ANDREAE ET AL. 1957
S. J. Fockema Andreae, E. H. ter Kuile and R. C. Hekker, *Duizend jaar bouwen in Nederland*, II. *De Bouwkunst na de Middeleeuwen*, Amsterdam, 1957

FOUCART 1975
Jacques Foucart, "Anmerkungen zu einigen weiteren Bildern von Houckgeest in französischem Besitz," *Jahrbuch der Hamburger Kunstsammlungen*, XX (1975), pp. 57-60 (appended to De Vries 1975)

FOUCART 1989
Jacques Foucart, "Peter Lely, Dutch History Painter," *Mercury*, no. 8 (1989), pp. 17-26

FRANGENBERG 1986
Thomas Frangenberg, "The image and the moving eye: Jean Pélerin (Viator) to Guidobaldo del Monte," *Journal of the Warburg and Courtauld Institutes*, XLIX (1986), pp. 150-71

FRANITS 1989
Wayne E. Franits, "The depiction of servants in some paintings by Pieter de Hooch," *Zeitschrift für Kunstgeschichte*, LII (1989), pp. 559-66

FRANITS 1993A
Wayne E. Franits, *Paragons of Virtue: Women and Domesticity in Seventeenth-Century Dutch Art*, Cambridge (UK), New York and Melbourne, 1993

FRANITS 1993B
Wayne E. Franits, "Wily Women?: On Sexual Imagery in Dutch Art of the Seventeenth Century," in Theo Hermans and Reinier Salverda (eds.), *From Revolt to Riches: Culture and History of the Low Countries 1500-1700, International and Interdisciplinary Perspectives*, London, 1993, pp. 300-319

FRANITS 1996
Wayne Franits, "Domesticity, Privacy, Civility, and the Transformation of Adriaen van Ostade's Art," in Athens 1996, pp. 3-25

FRANITS 1997
Wayne Franits (ed.), *Looking at Seventeenth-Century Dutch Art: Realism Reconsidered*, Cambridge (UK), New York, and Melbourne, 1997 (essays by fourteen authors; intro. by Franits)

FRANKFURT 1993-94
Leselust: Niederländische Malerei von Rembrandt bis Vermeer. Exhibition catalogue, edited by Sabine Schulze, with contributions by Ann Jensen Adams, Jochen Becker, Görel Cavalli-Björkman, Frans Grijzenhout, E. de Jongh, Justus Müller Hofstede, Anja Petz, M. A. Schenkeveld-van der Dussen, Sabine Schulze, and Bettina Werche. Frankfurt am Main, Schirn Kunsthalle Frankfurt, 1993-94. Stuttgart, 1993

FRANKFURT 1997
Johannes Vermeer: Der Geograph und der Astronom nach 200 Jahren wieder vereint. Exhibition catalogue, by Michael Maek-Gérard, with essays by Klaas van Berkel, Jørgen Wadum, Peter Waldeis, and Arthur K. Wheelock. Frankfurt am Main, Städelsches Kunstinstitut und Städtische Galerie, 1997. Frankfurt am Main, 1997

FRANSEN 1997
Hans Fransen (in collaboration with the Netherlands Institute for Art History, The Hague), *Michaelis Collection, The Old Town House, Cape Town: Catalogue of the Collection of Paintings and Drawings*, Zwolle, 1997

FREEDBERG 1950
Sydney J. Freedberg, *Parmigianino: His Works in Painting*, Cambridge, Mass., 1950

GASKELL 1984
Ivan Gaskell, "Vermeer: Judgment and Truth," *The Burlington Magazine*, CXXVI (1984), pp. 557-61

GASKELL 1989
Ivan Gaskell, *The Thyssen-Bornemisza Collection: Seventeenth-century Dutch and Flemish Painting*, London, 1989

GASKELL 1998
Ivan Gaskell, review of Hertel 1996, *The Burlington Magazine*, CXL (1998), pp. 209-10

GASKELL AND JONKER 1998
Ivan Gaskell and Michiel Jonker (eds.), *Vermeer Studies* (*Studies in the History of Art*, 55), National Gallery of Art, Washington, 1998

VAN GELDER 1958
J. G. van Gelder, *De schilderkunst van Jan Vermeer*, Utrecht, 1958

GERNSHEIM 1969
Helmut Gernsheim in collaboration with Alison Gernsheim, *The History of Photography from the camera obscura to the beginning of the modern era*, London and New York, 1969

GHENT 1986-87
Joachim Beuckelaer: Het markt- en keukenstuk in de Nederlanden 1550-1650. Exhibition catalogue, by Paul Verbraeken, with essays by twelve authors. Ghent, Museum voor Schone Kunsten, 1986-87. Ghent, 1986

GIBBONS 1977
Felton Gibbons, *Catalogue of Italian Drawings in the Art Museum, Princeton University*, Princeton, 1977 (2 vols.)

GIFFORD 1995
E. Melanie Gifford, "Style and Technique in Dutch Landscape Painting in the 1620s," in Arie Wallert, Erma Hermens, and Marja Peek (eds.), *Historical Painting Techniques, Materials, and Studio Practice: Preprints of a Symposium, University of Leiden, the Netherlands, 26-29 June 1995*, Lawrence, Kansas (The J. Paul Getty Trust), 1995, pp. 140-47

GIFFORD 1998
E. Melanie Gifford, "Painting Light: Recent Observations on Vermeer's Technique," in Gaskell and Jonker 1998, pp. 185-99

GILMAN 1978
Ernest B. Gilman, *The Curious Perspective: Literary and Pictorial Wit in the Seventeenth Century*, New Haven and London, 1978

GIOSEFFI 1965-66
Decio Gioseffi, "Optical Concepts," *Encyclopedia of World Art*, X, (1965), cols. 758-70; "Perspective," XI (1966), cols. 183-222, New York, 1959-87 (27 vols.)

GISKES 1994
J. H. Giskes, "Tussen klankbodem en schilderslinnen: Muziekinstrumentmakers en schilders in Rembrandts tijd," *Amstelodamum*, LXXXI (1994), pp. 65-76

GODWIN 1979
Joscelyn Godwin, *Athanasius Kircher. A Renaissance Man and the Quest for Lost Knowledge*, London, 1979

GOEDDE 1989
Lawrence Otto Goedde, *Tempest and Shipwreck in Dutch and Flemish Art: Convention, Rhetoric, and Interpretation*, University Park, Penn., and London, 1989

GOLDSCHEIDER 1967
Ludwig Goldscheider, *Jan Vermeer. The Paintings: Complete Edition*, London, 1967 (1st ed., 1958)

GOMBRICH 1972
E. H. Gombrich, *Art and Illusion: A Study in the Psychology of Pictorial Representation*, London, 1972

GOMBRICH 1975
E. H. Gombrich, "Mirror and Map: theories of pictorial representation," *Philosophical Transactions of the Royal Society in London*, CCLXX (1975), pp. 119-49

GOODMAN-SOELLNER 1989
Elise Goodman-Soellner, "The Landscape on the Wall in Vermeer," *Konsthistorisk Tidskrift*, LVIII (1989), pp. 76-88

GOOSSENS 1977
Korneel Goossens, *David Vinckboons*, Soest, 1977 (1st ed., Antwerp and The Hague, 1954)

GORDENKER 1999
Emilie E. S. Gordenker, "Is the History of Dress Marginal? Some Thoughts on Costume in Seventeenth-Century Painting," *Fashion Theory*, III (1999), pp. 219-40

GOWING 1970
Lawrence Gowing, *Vermeer*, London, 1970 (1st ed., 1952)

GOWING 1990
Lawrence Gowing, "Counterfeiter of grace" (review of Montias 1989), *Times Literary Supplement*, February 16-22, 1990, p. 159

GRAFTON 1991
Anthony Grafton, *Defenders of the Text. The Traditions of Scholarship in an Age of Science, 1450-1800*, Cambridge, Mass., and London, 1991

GROEN ET AL. 1998
Karin M. Groen, Inez D. van der Werf, Klaas Jan van den Berg, and Jaap J. Boon, "Scientific Examination of Vermeer's *Girl with a Pearl Earring*," in Gaskell and Jonker 1998, pp. 169-83

DE GROOT 1979
Irene de Groot, *Landscape Etchings by the Dutch Masters of the Seventeenth Century*, Maarssen, 1979

GUDLAUGSSON 1952
S. J. Gudlaugsson, "Crijn Hendricksz Volmarijn, een Rotterdamse Caravaggist," *Oud-Holland*, LXVII (1952), pp. 241-47

GUDLAUGSSON 1959-60
S. J. Gudlaugsson, *Gerard ter Borch*, The Hague, 1959-60 (2 vols.)

HAAK 1984
Bob Haak, *The Golden Age: Dutch Painters of the Seventeenth Century* (trans. and edited by Elizabeth Willems-Treeman), New York, 1984

HAEGER 1986
Barbara Haeger, "Frans Hals' so-called *Jonker Ramp and his Sweetheart* Reconsidered," *Konsthistorisk Tidskrift*, LV (1986), no. 4, pp. 141-48

HAGEN 1980
Margaret A. Hagen (ed.), *The Perception of Pictures*, New York, etc., 1980 (2 vols. of essays by various authors: vol. 1, *Alberti's Window: The Projective Model of Pictorial Information*; vol. 2, *Dürer's Devices: Beyond the Projective Model of Pictures*)

THE HAGUE 1982
Terugzien in bewondering / A Collectors' Choice. Exhibition catalogue, by H. R. Hoetink and F. J. Duparc, with the collaboration of W. L. van de Watering. The Hague, Mauritshuis, 1982. The Hague, 1982

THE HAGUE 1994-95
Paulus Potter: Paintings, drawings and etchings. Exhibition catalogue, by Amy Walsh, Edwin Buijsen, and Ben Broos. The Hague, Mauritshuis, 1994-95. The Hague and Zwolle, 1994

THE HAGUE 1996A
The scholarly world of Vermeer. Exhibition catalogue, edited by Ton Brandenbarg and Rudi Ekkart, with contributions by Klaas van Berkel, Rudi Ekkart, Anne van Helden, Jørgen Wadum, and Kees Zandvliet. The Hague, Museum van het Boek/Museum Meermanno-Westreenianum, 1996. Zwolle, 1996

THE HAGUE 1996B
Dutch society in the age of Vermeer. Exhibition catalogue, edited by Donald Haks and Marie Christine van der Sman, with contributions by Paul Abels, Edwin Buijsen, Donald Haks, Dirk Jaap Noordam, Harry Peeters, Marie Christine van der Sman, Jaap van der Veen, Kees van der Wiel, and Bas van der Wulp. The Hague, Haags Historisch Museum, 1996. Zwolle, 1996

THE HAGUE 1997-98A
Princely Patrons: The Collection of Frederick Henry of Orange and Amalia of Solms in The Hague. Exhibition catalogue, by Peter van der Ploeg and Carola Vermeeren, with contributions by Ben Broos, C. Willemijn Fock, Simon Groenveld, Jørgen Hein, Michiel Jonker, Wolfgang Savelsberg, and Jaap van der Veen. The Hague, Mauritshuis, 1997-98. The Hague and Zwolle, 1997

THE HAGUE 1997-98B
Princely Display: The Court of Frederik Hendrik of Orange and Amalia of Solms. Exhibition catalogue, compiled and edited by Marika Keblusek and Jori Zijlmans, with contributions by Vanessa Bezemer Sellers, Marie-Ange Delen, Willem Frijhoff, Irene Groeneweg, Marika Keblusek, Olaf Mörke, Koen Ottenheym, Marie Christine van der Sman, Marieke Tiethoff-Spliethoff, and Jori Zijlmans. The Hague, Haags Historisch Museum, 1997-98. The Hague and Zwolle, 1997

THE HAGUE 1998-99A
Haagse Schilders in de Gouden Eeuw. Exhibition catalogue, by Edwin Buijsen, with contributions by Charles Dumas, Rudolf E. O. Ekkart, Marijke C. de Kinkelder, Erik Löffler, Fred G. Meijer, Johan R. ter Molen, Els Neuman, Carola Vermeeren, and Christina J. A. Wansink. The Hague, Haags Historisch Museum, 1998-99. The Hague and Zwolle, 1998

THE HAGUE 1998-99B
Rembrandt under the scalpel: The Anatomy Lesson of Dr Nicolaes Tulp Dissected. Exhibition catalogue, by Norbert Middelkoop, Petria Noble, Jørgen Wadum, and Ben Broos. The Hague, Mauritshuis, 1998-99. The Hague and Amsterdam, 1998

THE HAGUE-ANTWERP 1994
Music & Painting in the Golden Age. Exhibition catalogue, by Edwin Buijsen and Louis Peter Grijp, with contributions by Willem Jan Hoogsteder, Geert Karman, Magda Kyrova, Michael Latcham, Eva Legêne, Fred Meijer, Karel Moens, Grant O'Brien, Matthew Spring, and Paul Verbraeken. The Hague, Hoogsteder & Hoogsteder, and Antwerp, Hessenhuis Museum, 1994. The Hague and Zwolle, 1994

THE HAGUE-CAMBRIDGE 1981-82
Jacob van Ruisdael. Exhibition catalogue, by Seymour Slive and H. R. Hoetink; introduction and catalogue by Seymour Slive. The Hague, Mauritshuis, and Cambridge, Mass., The Fogg Art Museum, Harvard University, 1981-82. New York, 1981

HAHN 1996
Andreas Hahn, ". . . dat zy de aanschouwers schynen te willen aanspreken": Untersuchungen zur Rolle des Betrachters in der Niederländischen Malerei des 17. Jahrhunderts, Munich, 1996

HAMMOND 1981
John Hammond, *The Camera Obscura. A Chronicle*, Bristol, 1981

HAMMOND 1986
Mary Sayer Hammond, "The Camera Obscura: A Chapter in the Pre-History of Photography," Ph.D. Diss., Ohio State University, Columbus, 1986 (UMI facsimile, Ann Arbor, Michigan, 1990)

HANOVER-RALEIGH-HOUSTON-ATLANTA 1991-93
The Age of the Marvelous. Edited by Joy Kenseth, with essays by Joy Kenseth, Elisabeth B. MacDougall, James V. Mirollo, Mark S. Weil, Arthur K. Wheelock, Jr., and Zirka Zaremba Filipczak, and catalogue entries by Hilliard Goldfarb, Liz Guenther, Katherine Hart, Walter Karcheski, Joy Kenseth, and Ann Trautman. Hanover, New Hampshire, Hood Museum of Art, Dartmouth College; Raleigh, North Carolina Museum of Art; Houston, Museum of Fine Arts; and Atlanta, High Museum of Art, 1991-93. Hanover, 1991

HARWOOD 1988
Laurie B. Harwood, *Adam Pynacker (c.1620-1623)*, Doornspijk, 1988

HASKELL 1976
Francis Haskell, *Rediscoveries in Art: Some Aspects of Taste, Fashion and Collecting in England and France*, Ithaca, N.Y., 1976

HAVARD 1888
Henry Havard, *Van de Meer de Delft*, Paris, 1888

HAVERKAMP BEGEMANN 1959
Egbert Haverkamp Begemann, *Willem Buytewech*, Amsterdam, 1959

HEDINGER 1986
Bärbel Hedinger, *Karten in Bildern: Zur Ikonographie der Wandkarte in holländischen Interieurgemälde des 17. Jahrhunderts*, Hildesheim, Zürich, and New York, 1986

HEMPSTEAD 1991
Street Scenes: Leonard Bramer's Drawings of 17th-century Dutch Daily Life. Exhibition catalogue, by Donna R. Barnes and Jane Ten Brink Goldsmith. Hempstead, New York, Hofstra Museum, Hofstra University, 1991. Hempstead, 1991

HEMPSTEAD 1995
The Butcher, The Baker, The Candlestick Maker: Jan Luyken's Mirrors of 17th-Century Dutch Daily Life. Exhibition catalogue, by Donna R. Barnes, with essays by Michiel Jonker and Herman W. J. Vekeman. Hempstead, New York, Hofstra Museum, Hofstra University, 1991. Hempstead, 1995

HEPPNER 1946
A. Heppner, "Rotterdam as the Centre of a 'Dutch Teniers Group'," *Art in America*, XXXIV (1936), pp. 15-30

HERTEL 1996
Christiane Hertel, *Vermeer: Reception and Interpretation*, Cambridge (UK), New York and Melbourne, 1996

HEYDE 1994
Herbert Heyde, *Musikinstrumentenbau in Preussen*, Tutzing, 1994

HINKS 1955
Roger Hinks, "Peepshow and roving eye," *Architectural Review*, CXVIII (1955), pp. 161-64

HODENPIJL 1900
C. G. Hodenpijl, "De oprichting van het mausoleum der Oranjes," *Elsevier's Geïllustreerd Maandschrift*, XIX (1900), pp. 152-68

HOETINK ET AL. 1985
H. R. Hoetink (ed.), with contributions by A. Blankert, A. Chong, R. E. O. Ekkart, E. Haverkamp Begemann, W. A. Liedtke, S. Segal, N. C. Sluijter-Seijffert, P. C. Sutton, and H. Vlieghe, *The Royal Picture Gallery Mauritshuis*, Amsterdam and New York, 1985

HOFSTEDE DE GROOT 1907-27
Cornelis Hofstede de Groot, *A Catalogue Raisonné of the Works of the Most Eminent Dutch Painters of the Seventeenth Century* (trans. by Edward G. Hawke), London, 1907-27 (8 vols.)

HOLLANDER 1975
Anne Hollander, *Seeing Through Clothes*, Berkeley, Los Angeles, and London, 1975

HOLLY 1984
Michael Ann Holly, *Panofsky and the Foundations of Art History*, Ithaca, N.Y., and London, 1984

HOLMES 1923
Charles Holmes, "Honthorst, Fabritius, and De Witte," *The Burlington Magazine*, XLII (1923), pp. 82-88

HONDIUS 1622
Hendrick Hondius, *Institutio Artis Perspectivae*, The Hague, 1622

HOOGSTEDER 1986
Willem-Jan Hoogsteder, *De Schilderijen van Frederik en Elizabeth Konig en Koningin van Bohemen* (printed *doctoraalscriptie*), Utrecht, 1986 (3 vols.)

VAN HOOGSTRATEN 1678
Samuel van Hoogstraten, *Inleyding tot de Hooge Schoole der Schilder-konst . . .* , Rotterdam, 1678

HOUBRAKEN 1718-21
Arnold Houbraken, *De groote schouburgh der Nederlantsche konstschilders en schilderessen . . .* , Amsterdam, 1718-1721 (3 vols.)

HULTÉN 1952
Karl G. Hultén, "A Peep Show by Carel Fabritius," *Art Quarterly*, XV (1952), pp. 278-90

HUYGENS 1911-17
Constantijn Huygens, *De Briefwisseling (1608-1687)*, edited by J. A. Worp, The Hague, 1911-17 (6 vols.)

HUYGENS 1971
A. H. Kan, *De Jeugd van Constantijn Huygens door hemzelf beschreven* (trans. and ed.), Rotterdam, 1971 (Dutch edition of Huygens's *Vita* of about 1630)

ISRAEL 1995
Jonathan I. Israel, *The Dutch Republic: Its Rise, Greatness, and Fall 1477-1806*, Oxford, 1995

JANTZEN 1910
Hans Jantzen, *Das niederländische Architekturbild*, Leipzig, 1910

JANTZEN 1951
Hans Jantzen, *Über den gotischen Kirchenraum und andere Aufsätze*, Berlin, 1951

JANTZEN 1979
Hans Jantzen, *Das niederländische Architekturbild* (2nd ed.), Braunschweig, 1979

JIMKES-VERKADE 1981
Els Jimkes-Verkade, "De ikonologie van het grafmonument van Willem I, Prins van Oranje," in Delft 1981, pp. 214-27

DE JONGH 1967
E. de Jongh, *Zinne- en Minnebeelden in de Schilderkunst van de 17de eeuw*, Amsterdam, 1967

DE JONGH 1973
E. de Jongh, "''t Gotsche krullig mall.' De houding tegenover de gotiek in het zeventiende-eeuwse Holland," *Nederlands Kunsthistorisch Jaarboek*, XXIV (1973), pp. 85-145

DE JONGH 1975-76
E. de Jongh, "Pearls of Virtue and Pearls of Vice," *Simiolus*, VIII (1975-76), pp. 69-97

DE JONGH 1980
E. de Jongh, review of Sutton 1980a, in *Simiolus*, XI (1980), pp. 181-85

DE JONGH 1998
Eddy de Jongh, "On Balance," in Gaskell and Jonker 1998, pp. 351-65

JUDSON 1955
J. Richard Judson, "Possible additions to Crijn Hendricksz Volmarijn," *Oud-Holland*, LXX (1955), pp. 181-88

KALDENBACH 1999
Kees Kaldenbach, "Ein Flug über die 'Ansicht von Delft'," *Weltkunst*, LXIX, no. 2 (February 1999), pp. 308-10

KALDENBACH: see also WHEELOCK AND KALDENBACH 1982

KAN: see HUYGENS 1971

KAHR 1972
Madlyn Millner Kahr, "Vermeer's Girl Asleep, A Moral Emblem," *Metropolitan Museum Journal*, VI (1972), pp. 115-32

KAUFMANN 1993
Thomas DaCosta Kaufmann, *The Mastery of Nature: Aspects of Art, Science, and Humanism in the Renaissance*, Princeton, 1993

KAUFMANN 1995
Thomas DaCosta Kaufmann, *Court, Cloister, and City: The Art and Culture of Central Europe 1450-1800*, Chicago, 1995

KEITH 1994
Larry Keith, "Carel Fabritius' *A View in Delft*: Some Observations on its Treatment and Display," *National Gallery Technical Bulletin*, XV (1994), pp. 54-63

KEMMER 1998
Claus Kemmer, "In search of classical form: Gerard de Lairesse's *Groot schilderboek* and seventeenth-century Dutch genre painting," *Simiolus*, XXVI (1998), pp. 87-115

KEMP 1986
Martin Kemp, "Simon Stevin and Pieter Saenredam: A Study of Mathematics and Vision in Dutch Science and Art," *The Art Bulletin*, LXVIII (1986), pp. 237-52

KEMP 1990
Martin Kemp, *The Science of Art: Optical themes in western art from Brunelleschi to Seurat*, New Haven and London, 1990

KEMP 1991-92
Martin Kemp, "The Mean and Measure of All Things," in Washington 1991-92, pp. 95-111

KETTERING 1983
Alison McNeil Kettering, *The Dutch Arcadia: Pastoral Art and its Audience in the Golden Age*, Montclair, N. J., 1983

KETTERING 1988
Alison McNeil Kettering, *Drawings from the Ter Borch Studio Estate*, The Hague, 1988 (2 vols.)

KETTERING 1993
Alison McNeil Kettering, "Ter Borch's Ladies in Satin," *Art History*, XVI (1993), pp. 95-124 (reprinted in Franits 1997)

KEYES 1984
George S. Keyes, *Esaias van de Velde 1587-1630*, Doornspijk, 1984

KLEMM 1986
Christian Klemm, *Joachim von Sandrart, Kunstwerke und Lebenslauf*, Berlin, 1986

KLESSMANN 1999
Rüdiger Klessmann, *Johann Liss* (trans. by Diane Webb), Doornspijk, 1999

KLINGE-GROSS 1976
M. Klinge-Gross, "Herman Saftleven als Zeichner und Maler bäuerlicher Interieurs. Zur Entstehung des südholländischen Bildtyps mit Stilleben aus ländlichem Hausrat und Gerät," *Wallraf-Richartz-Jahrbuch*, XXXVIII (1976), pp. 68-91

KNAUER 1998
Elfriede R. Knauer, "Vermeers 'Allegorie des Glaubens' und *Genesis* 24, 1-67," *Zeitschrift für Kunstgeschichte*, LXI (1998), pp. 66-76

KNUTTEL 1962
Gerard Knuttel, *Adriaen Brouwer, The Master and His Work*, The Hague, 1962

KOLFIN 1999
Elmer Kolfin, "'Betaamt het de Christen de dans te aanschouwen?' Dansende elite op Noordnederlandse schilderijen en prenten (circa 1600-1645)," in Jan de Jongste, Juliette Roding, and Boukje Thijs (eds.), *Vermaak van de elite in de vroegmoderne tijd*, Hilversum, 1999, pp. 153-73

KOOZIN 1989
Kristine Koozin, *The Vanitas Still Lifes of Harmen Steenwyck: Metaphoric Realism*, Lewiston, N.Y., 1990

KOSLOW 1967
Susan Koslow, "De Wonderlijke Perspectyfkas: An Aspect of Seventeenth Century Dutch Painting," *Oud Holland*, LXXXII (1967), pp. 35-56

KRUL 1644
Jan Hermansz Krul, *Pampiere wereld*, Amsterdam, 1644 (4 pts.)

TER KUILE 1976
O. ter Kuile, *Adriaen Hanneman 1604-1671 een haags portretschilder*, Alphen aan den Rijn, 1976

KUIPER 1994
G. C. Kuiper, "Huygens, Heinsius en het grafinschrift voor Oranje," *Jaarboek Oranje-Nassau Museum*, 1994, pp. 103-17

KULTZEN 1996
Rolf Kultzen, *Michael Sweerts, Brussels 1618 - Goa 1664* (trans. by Diane Webb), Doornspijk, 1996

KURETSKY 1979
Susan Donahue Kuretsky, *The Paintings of Jacob Ochtervelt (1634-1682)*, Montclair, N.J., 1979

KUYPER 1980
W. Kuyper, *Dutch Classicist Architecture*, Delft, 1980

KUYPER 1994
W. Kuyper, *The Triumphant Entry of Renaissance Architecture into the Netherlands: The Joyeuse Entrée of Philip of Spain into Antwerp in 1549, Renaissance and Mannerist Architecture in the Low Countries from 1530 to 1630*, Alphen aan den Rijn, 1994 (2 vols.)

LAKENHAL 1983
Stedelijk Museum De Lakenhal, *Catalogus van de schilderijen en tekeningen*, Leiden, 1983

LAMMERTSE 1998
Friso Lammertse, with contributions by Jeroen Giltaij and Anouk Janssen, *Dutch Genre Paintings of the 17th Century: Collection of the Museum Boijmans Van Beuningen*, Rotterdam, 1998

LASIUS 1992
Angelika Lasius, *Quiringh van Brekelenkam* (trans. by Diane Webb), Doornspijk, 1992

LAWRENCE 1991
Cynthia Lawrence, *Gerrit Adriaensz. Berckheyde (1638-1698), Haarlem Cityscape Painter*, Doornspijk, 1991

LAWRENCE 1994
Cynthia Lawrence, "The Monument of Elisabeth Morgan: Issues and problems in late Renaissance sepulchral art," *Nederlands Kunsthistorisch Jaarboek*, XLV (1994), pp. 325-47

LAWRENCE-NEW HAVEN-AUSTIN 1983-84
Dutch Prints of Daily Life: Mirrors of Life or Masks of Morals? Exhibition catalogue, by Linda A. Stone-Ferrier. Lawrence, Kansas, Spencer Museum of Art, University of Kansas; New Haven, Yale University Art Gallery; and Austin, Texas, The Huntington Gallery, University of Texas at Austin, 1983-84. Lawrence, 1983

LEEMAN 1976
Fred Leeman, in collaboration with Joost Elffers and Mike Schuyt, *Hidden Images: Games of Perception, Anamorphic Art, Illusion from the Renaissance to the Present*, New York, 1976

LEIDEN 1988
Leidse Fijnschilders: Van Gerrit Dou tot Frans van Mieris de Jonge 1630-1760. Exhibition catalogue, edited by Eric J. Sluijter, Marlies Enklaar, and Paul Nieuwenhuizen, with an introduction and essay by Eric J. Sluijter. Leiden, Stedelijk Museum De Lakenhal, 1988. Leiden and Zwolle, 1988

LEONARDO 1651
Traité de la peinture de Leonard de Vinci donné au public et traduit d'italien en français par R. F. S. D. C. [Roland Fréart Sieur de Chambray], Paris, 1651

LIEDTKE 1970
Walter Liedtke, "From Vredeman de Vries to Dirck van Delen: Sources of Imaginary Architectural Painting," *Bulletin of Rhode Island School of Design*, LVII, no. 2 (December 1970), pp. 14-25

LIEDTKE 1971
Walter Liedtke, "Saenredam's Space," *Oud Holland*, LXXXVI (1971), pp. 116-41

LIEDTKE 1974
Walter Liedtke, "Architectural Painting in Delft 1650-1675," Ph.D. Diss., Courtauld Institute of Art, University of London, 1974

LIEDTKE 1975-76
Walter Liedtke, "The New Church in Haarlem Series: Saenredam's sketching style in relation to perspective," *Simiolus*, VIII (1975-76), pp. 145-66

LIEDTKE 1976A
Walter Liedtke, "The *View in Delft* by Carel Fabritius," *The Burlington Magazine*, CXVIII (1976), pp. 61-73

LIEDTKE 1976B
Walter Liedtke, "Faith in Perspective: The Dutch Church Interior," *Connoisseur*, CXCIII (October 1976), pp. 126-33

LIEDTKE 1977
Walter Liedtke, "The Three 'Parables' by Barend Fabritius, with a chronological list of his paintings dating from 1660 onward," *The Burlington Magazine*, CXIX (1977), pp. 316-27

LIEDTKE 1979A
Walter Liedtke, "Pride in Perspective: The Dutch Townscape," *Connoisseur*, CC (April 1979), pp. 264-73

LIEDTKE 1979B
Walter Liedtke, "Hendrik van Vliet and the Delft School," *Museum News*, Toledo Museum of Art, fall 1979, pp. 40-52

LIEDTKE 1979C
Walter Liedtke, review of Wheelock 1977A, in *The Art Bulletin*, LXI (1979), pp. 490-96

LIEDTKE 1982A
Walter Liedtke, *Architectural Painting in Delft: Gerard Houckgeest, Hendrick van Vliet, Emanuel de Witte*, Doornspijk, 1982

LIEDTKE 1982B
Walter Liedtke, "Cornelis de Man as a painter of church interiors," *Tableau*, V, no. 1 (Sept.-Oct. 1982), pp. 62-66

LIEDTKE 1982C
Walter Liedtke, review of Brown 1981, in *The Burlington Magazine*, CXXIV (1982), pp. 303-4

LIEDTKE 1983
Walter Liedtke, "*Clothing the Naked* by Michiel Sweerts," *Apollo*, CXVII (1983), pp. 21-23

LIEDTKE 1984A
Walter Liedtke, *Flemish Paintings in The Metropolitan Museum of Art*, New York, 1984 (2 vols.)

LIEDTKE 1984B
Walter Liedtke, "Toward a History of Dutch Genre Painting," in *De Arte et Libris: Festschrift Erasmus 1934-1984*, Amsterdam, 1984, pp. 317-36

LIEDTKE 1985A
Walter Liedtke, "Architectural Painting," in Hoetink et al. 1985, pp. 68-80

LIEDTKE 1985B
Walter Liedtke, review of Edinburgh 1984, *The Burlington Magazine*, CXXVII (1985), p. 164

LIEDTKE 1986
Walter Liedtke, "De Witte and Houckgeest: Two new paintings from their years in Delft," *The Burlington Magazine*, CXXVIII (1986), pp. 802-5

LIEDTKE 1988A
Walter Liedtke, "Toward a History of Dutch Genre Painting – II: The South Holland Tradition," in R. E. Fleischer and S. S. Munshower (eds.), *The Age of Rembrandt: Studies in Seventeenth-Century Dutch Painting* (*Papers in Art History from The Pennsylvania State University*, Volume III), University Park, Penn., 1988, pp. 94-131

LIEDTKE 1988B
Walter Liedtke, review of Ruurs 1987, *The Burlington Magazine*, CXXX (1988), p. 39

LIEDTKE 1989
Walter Liedtke, *The Royal Horse and Rider: Painting, Sculpture, and Horsemanship 1500-1800*, New York, 1989

LIEDTKE 1991A
Walter Liedtke, "The Court Style: Architectural Painting in The Hague and London," in Rotterdam 1991, pp. 30-42

LIEDTKE 1991B
Walter Liedtke, "Pepys and the Pictorial Arts," *Apollo*, CXXXIII (April 1991), pp. 227-37

LIEDTKE 1992A
Walter Liedtke, "The Delft School, circa 1625-1675," in Milwaukee 1992-93, pp. 23-35

LIEDTKE 1992B
Walter Liedtke, "Vermeer Teaching Himself," in Stockholm 1992, pp. 89-105

LIEDTKE 1992C
Walter Liedtke, "Johannes Coesermans, painter of Delft," *Oud Holland*, CVI (1992), pp. 191-198

LIEDTKE 1995
Walter Liedtke, "Pentimenti in our Pictures of Salomon van Ruysdael and Jan van Goyen," in *Shop Talk: Studies in Honor of Seymour Slive*, Cambridge, Mass., 1995, pp. 154-57

LIEDTKE 1995-96
Walter Liedtke, "Rembrandt and the Rembrandt Style in the Seventeenth Century," in New York 1995-96, II, pp. 3-39

LIEDTKE 1996
Walter Liedtke, "Architectural Pictures: c. 1550-c. 1700," in Turner 1996, II, pp. 340-42

LIEDTKE 1997
Walter Liedtke, "Style in Dutch Art," in Franits 1997, pp. 116-28, 228-31

LILIENFELD 1924
Karl Lilienfeld, "Pieter de Hooch," in Thieme/Becker 1907-50, XVII, pp. 454-54

LINSKY CAT. 1984
The Jack and Belle Linsky Collection in The Metropolitan Museum of Art, New York, 1984.
Collection catalogue, with introductions by John Pope-Hennessy and by Olga Raggio, and
catalogue entries by thirteen authors

LOKIN 1996
Daniëlle H. A. C. Lokin, "The Delft Church Interior 1650-1675," in Delft 1996, pp. 41-86

LONDON 1986
Dutch Landscape, The Early Years: Haarlem and Amsterdam 1590-1650. Exhibition catalogue,
by Christopher Brown, with essays by Christopher Brown, David Bomford, E. K. J.
Reznicek, Margarita Russell, M. A. Schenkeveld-van der Dussen, and Jan de Vries.
London, National Gallery, 1986. London, 1986

LONDON 1997-98
Making and Meaning: Holbein's Ambassadors. Exhibition catalogue, by Susan Foister, Ashok
Roy, and Martin Wyld. London, National Gallery, 1997-98. London, 1997.

LOS ANGELES 1987
Masterworks from the 16th & 17th Centuries. Exhibition catalogue, by Michael L. Bosler et
al. Los Angeles, Fisher Gallery, University of Southern California, 1987. Los Angeles,
1987

LOS ANGELES-BOSTON-NEW YORK 1981-82
*A Mirror of Nature: Dutch Paintings from the Collection of Mr. and Mrs. Edward William
Carter*. Exhibition catalogue, by John Walsh, Jr., and Cynthia P. Schneider. Los Angeles,
Los Angeles County Museum of Art; Boston, Museum of Fine Arts; and New York, The
Metropolitan Museum of Art, 1981-82. Los Angeles, 1981

LOWENTHAL 1996
Anne W. Lowenthal (ed.), *The Object as Subject: Studies in the Interpretation of Still Life*,
Princeton, 1996

LUNSINGH SCHEURLEER ET AL. 1986-92
Th. H. Lunsingh Scheurleer, C. Willemijn Fock, and A. J. van Dissel (eds.),
Het Rapenburg: Geschiedenis van een Leidse gracht, Leiden, 1986-92 (6 parts in 10 vols. plus
register)

MACLAREN 1960
Neil MacLaren, *The Dutch School (National Gallery Catalogues)*, London, 1960

MACLAREN/BROWN 1991
Neil MacLaren, revised and expanded by Christopher Brown, *The Dutch School 1600-1900
(National Gallery Catalogues)*, London, 1991

MCMAHON 1956
A. P. McMahon, *Treatise on Painting by Leonardo da Vinci*, Princeton, 1956

MCTIGHE 1998
Sheila McTighe, "Abraham Bosse and the Language of Artisans: Genre and Perspective in
the Académie royale de peinture et de sculpture, 1648-1670," *Oxford Art Journal*, XXI
(1998), pp. 1-26

DE' MAFFEI 1966
Fernanda de' Maffei, "Perspectivists," *Encyclopedia of World Art*, XI (1966), cols. 222-44,
New York, 1959-87 (27 vols.)

MAIER-PREUSKER 1991
Wolfgang C. Maier-Preusker, "Christiaen van Couwenbergh (1604-1667): Oeuvre und
Wandlungen eines holländischen Caravaggisten," *Wallraf-Richartz-Jahrbuch*, LII (1991),
pp. 163-236

MALTESE 1980
Corrado Maltese, "La prospettiva curva di Leonardo da Vinci e uno strumento di
Baldassarre Lanci," in Dalai Emiliani 1980, pp. 417-25

VAN MANDER 1604
Karel van Mander, *Het Schilder-Boeck* . . . , Haarlem, 1604

VAN MANDER 1994
Karel van Mander, *The Lives of the Illustrious Netherlandish and German Painters*
. . . , edited by Hessel Miedema, I (text), Doornspijk, 1994 (tr. by Michael Hoyle,
Jacqueline Pennial-Boer and Charles Ford)

MANKE 1963
Ilse Manke, *Emanuel de Witte 1617-1692*, Amsterdam, 1963

MANKE 1972
Ilse Manke, "Nachträge zum Werkkatalog von Emanuel de Witte," *Pantheon*, XXX (1972),
pp. 389-91

MANS 1992
Karin Mans, *Architectuurgids van Delft*, Delft, 1992

MARLIER 1969
Georges Marlier, *Pierre Bruegel le Jeune*, Brussels, 1969

MARTIN 1913
W. Martin, *Gerard Dou, des Meisters Gemälde (Klassiker der Kunst)*, Stuttgart and Berlin,
1913

MARTIN 1936
W. Martin, *De Hollandsche schilderkunst in de zeventiende eeuw*, II. *Rembrandt en zijn tijd*,
Amsterdam, 1936

MARTIN 1944
Wilhelm Martin, *Nederlandsche Schilderkunst*, Amsterdam, 1944

MATTHEY 1973
Ignaz Matthey, "De Betekenis van de Natuur en de Natuurwetenschappen voor
Constantijn Huygens," in Hans Bots (ed.), *Constantijn Huygens: zijn plaats in geleerd Europa*,
Amsterdam, 1973, pp. 334-459

MAYER-MEINTSCHEL 1978-79
Annaliese Mayer-Meintschel, "Die Briefleserin von Jan Vermeer van Delft – zum Inhalt
und zur Geschichte des Bildes," *Jahrbuch der Staatlichen Kunstsammlungen Dresden*, XI
(1978-79), pp. 91-99

MEILINK-HOEDEMAKER AND BROOS 1996
Laura Meilink-Hoedemaker and Ben Broos, "Vermeer geeft muziekles," *Mauritshuis in
focus*, IX, no. 2 (September 1996), pp. 19-27

MELBOURNE-CANBERRA 1997-98
Rembrandt: A Genius and His Impact. Exhibition catalogue, by Albert Blankert, with
contributions by Marleen Blokhuis, Ben Broos, Jeroen Giltaij, Volker Manuth, Timothy
Potts, William W. Robinson, Peter C. Sutton, Jaap van der Veen, Ernst van de Wetering,
Christopher White, and Irena Zdanowicz. Melbourne, National Gallery of Victoria, and
Canberra, National Gallery of Australia, 1997-98. Melbourne, Sydney and Zwolle, 1997

MIEDEMA 1985
Hessel Miedema, "De St. Lucasgilden van Haarlem en Delft in de zestiende eeuw," *Oud
Holland*, XCIX (1985), pp. 77-109

MIEDEMA 1998
Hessel Miedema, "Johannes Vermeer's *Art of Painting*," in Gaskell and Jonker 1998, pp.
285-93

MILWAUKEE 1992-93
Leonaert Bramer (1596-1674): A Painter of the Night. Exhibition catalogue, by Frima Fox
Hofrichter, with essays by Walter Liedtke, Leonard J. Slatkes, and Arthur K. Wheelock,
Jr. Milwaukee, The Patrick and Beatrice Haggerty Museum of Art, Marquette University,
1992-93. Milwaukee, 1992

DE MIRIMONDE 1966-67
A. P. de Mirimonde, " La musique dans les allégories de l'amour," *Gazette des Beaux-Arts*,
LXVIII (1966), pp. 265-90, and LXIX (1967), pp. 319-46

DE MIRIMONDE 1978-79
A. P. de Mirimonde, "Les vanités à personnages et à instruments de musique," *Gazette des Beaux-Arts*, XCII (1978), pp. 115-30, and XCIV (1979), pp. 61-68

MOENS 1986
Karel Moens, "De Vrouw in de huismuziek: een iconografische studie naar 16de- en 17de-eeuwse schilderijen en prenten uit de Nederlanden," in G. Huybens and D. Snellings (eds.), *De Eodem et Diverso: Bundel essays over diverse themata van het oude muziek-onderzoek*, Peer (The Netherlands), 1986, pp. 43-63

MOES 1897-1905
E. W. Moes, *Iconographia Batava: beredeneerde lijst van geschilderde en gebeeldhouwde portretten van Noord-Nederlanders in vorige eeuwen*, Amsterdam, 1897-1905 (2 vols.)

MOISO-DIEKAMP 1987
Cornelia Moiso-Diekamp, *Das Pendant in der holländischen Malerei des 17. Jahrhunderts*, Frankfurt am Main, Bern, and New York, 1987

DE MONCONYS 1665-66
Balthasar de Monconys, *Journal des voyages de monsieur de Monconys*, Lyons, 1665-66 (2 vols.)

VON MONROY 1964
Ernst F. von Monroy (H. M. von Erffa, ed. and commentary), *Embleme und Emblembücher in den Niederländen 1560-1630, Eine Geschichte der Wandlungen ihres Illustrationsstils*, Utrecht, 1964

MONTIAS 1977
John Michael Montias, "New Documents on Vermeer and His Family," *Oud Holland*, XCI (1977), pp. 267-87

MONTIAS 1978-79
John Michael Montias, "Painters in Delft, 1613-1680," *Simiolus*, x (1978-79), pp. 84-114

MONTIAS 1982
John Michael Montias, *Artists and Artisans in Delft: A Socio-Economic Study of the Seventeenth Century*, Princeton, 1982

MONTIAS 1987
John Michael Montias, "Vermeer's Clients and Patrons," *The Art Bulletin*, LXIX (1987), pp. 68-76

MONTIAS 1989
John Michael Montias, *Vermeer and his Milieu: A Web of Social History*, Princeton, 1989

MONTIAS 1990
John Michael Montias, "Socio-Economic Aspects of Netherlandish Art from the Fifteenth to the Seventeenth Century: A Survey," *The Art Bulletin*, LXXII (1990), pp. 359-73

MONTIAS 1991A
John Michael Montias, "A Postscript on Vermeer and his Milieu," *The Hoogsteder Mercury*, no. 12 (1991), pp. 42-52

MONTIAS 1991B
John Michael Montias, "Works of Art in Seventeenth-Century Amsterdam: An Analysis of Subjects and Attributions," in David Freedberg and Jan de Vries (eds.), *Art in History / History in Art: Studies in seventeenth-century Dutch culture*, Santa Monica, 1991, pp. 331-72

MONTIAS 1993
John Michael Montias, *Vermeer en zijn Milieu* (trans. by Hans Bronkhorst), Baarn, 1993

MONTIAS 1996
John Michael Montias, *Le Marché de l'art aux Pays-Bas* (XVe-XVIIe siècles), Paris, 1996

MONTIAS 1998A
John Michael Montias, "Recent Archival Research on Vermeer," in Gaskell and Jonker 1998, pp. 93-109

MONTIAS 1998B
John-Michael Montias, "Trois ventes de tableaux aux enchères à Amsterdam vers 1620," in Olivier Bonfait, Véronique Gerard Powell, and Philippe Sénéchal (eds.), *Curiosité: Etudes d'histoire de l'art en l'honneur d'Antoine Schnapper*, Paris, 1998, pp. 285-95

MORENO 1982
Ignacio L. Moreno, "Vermeer's *The Concert*: A Study in Harmony and Contrasts," *Rutgers Art Review*, III (1982), pp. 50-57

MORREN, MEISCHKE AND VAN DER WYCK 1990
Th. Morren, R. Meischke, and H. W. M. van der Wyck, *Het Huis Honselaarsdijk*, Alphen aan den Rijn, 1990

MOXEY 1989
Keith Moxey, *Peasants, Warriors, and Wives: Popular Imagery in the Reformation*, Chicago and London, 1989

MULLER 1997
Sheila D. Muller (ed.), *Dutch Art: An Encyclopedia*, New York and London, 1997

NASH 1991
John Nash, *Vermeer*, London, 1991

NAUMANN 1981
Otto Naumann, *Frans van Mieris the Elder (1635-1681)*, Doornspijk, 1981 (2 vols.)

NETTA 1998
Irene Netta, "The Phenomenon of Time in the Art of Vermeer," in Gaskell and Jonker 1998, pp. 257-63

NEURDENBURG 1930
Elizabeth Neurdenburg, *Hendrick de Keyser, beeldhouwer en bouwmeester van Amsterdam*, Amsterdam, 1930

NEURDENBURG 1948
Elizabeth Neurdenburg, *De zeventiende eeuwsche beeldhouwkunst in de Noordelijke Nederlanden*, Amsterdam, 1948

NEW YORK 1985-86
Liechtenstein: The Princely Collections. Exhibition catalogue, by Reinhold Baumstark et al. New York, The Metropolitan Museum of Art, 1985-86. New York, 1985

NEW YORK 1992-93
Masterworks from the Musée des Beaux-Arts, Lille. Exhibition catalogue, by Arnauld Brejon de Lavergnée, William Griswold, Walter Liedtke et al. New York, The Metropolitan Museum of Art, 1992-93. New York, 1992

NEW YORK 1995-96
Rembrandt/ Not Rembrandt in The Metropolitan Museum of Art: Aspects of Connoisseurship. Exhibition catalogue. Volume I, *Paintings: Problems and Issues*, by Hubert von Sonnenburg; Volume II, *Paintings, Drawings, and Prints: Art-Historical Perspectives*, by Walter Liedtke, Carolyn Logan, Nadine M. Orenstein, and Stephanie S. Dickey. New York, The Metropolitan Museum of Art, 1995-96. New York, 1995

NEW YORK 1998-99
From Van Eyck to Bruegel: Early Netherlandish Painting in The Metropolitan Museum of Art. Exhibition catalogue, by Maryan W. Ainsworth and Keith Christiansen (eds.), with contributions by Maryan W. Ainsworth, Julien Chapuis, Keith Christiansen, Everett Fahy, Nadine M. Orenstein, Véronique Sintobin, Della C. Sperling, and Mary Sprinson de Jesus. New York, The Metropolitan Museum of Art, 1998-99. New York, 1998

NEW YORK 1999
Old Master Paintings. Sale catalogue, by Peter C. Sutton, with contributions by Marjorie E. Weiseman. New York, Otto Naumann, Ltd., 1999

NEW YORK-BOSTON-CHICAGO 1972-73
Dutch Genre Drawings of the Seventeenth Century. A Loan Exhibition from Dutch, Museums, Foundations, and Private Collections. Exhibition catalogue. New York, Pierpont Morgan Library; Boston, Museum of Fine Arts; and Chicago, The Art Institute of Chicago. Washington, 1972

NEW YORK-LONDON 2001
Vermeer and the Delft School. Exhibition catalogue, by Walter Liedtke, with Michiel Plomp and Axel Rüger, and contributions by six other authors. New York, The Metropolitan Museum of Art, and London, The National Gallery. New York, 2001. New York, 2001

NOTARP 1996
Gerlinde Lütke Notarp, "Jacques de Gheyn II's *Man resting in a field*: an essay on the iconography of melancholy," *Simiolus*, XXIV (1996), pp. 311-19

OBERLIN-ALLENTOWN-MIAMI BEACH-SACRAMENTO 1989-90
Images of Reality, Images of Arcadia: Seventeenth-Century Netherlandish Paintings from Swiss Collections. Exhibition catalogue, by Margarita Russell, with contributions by Claude Lapaire, Peter Wegmann, and Arthur K. Wheelock, Jr. Oberlin, Ohio, Oberlin College, Allen Memorial Art Museum; Allentown, Pennsylvania, The Allentown Art Museum; Miami Beach, Florida, Bass Museum of Art; Sacramento, California, Crocker Art Museum, 1989-90. Organized by the Musée d'Art et d'Histoire, Geneva; Kunstmuseum, Winterthur; Jakob Briner Foundation, Winterthur; and the City of Winterthur. Washington and Winterthur, 1989

OBREEN 1877-90
F. D. O. Obreen, *Archief voor Nederlandsche Kunstgeschiedenis*, Rotterdam, 1877-90 (7 vols.)

ORENSTEIN 1990
Nadine Orenstein, "A View of the Court in The Hague etched by Simon Frisius," *Delineavit et Sculpsit*, no. 4 (Dec. 1990), pp. 24-30

ORENSTEIN 1994
Nadine Orenstein, *Hendrick Hondius (The New Hollstein: Dutch & Flemish Etchings, Engravings and Woodcuts 1450-1700)*, Roosendaal, 1994

ORENSTEIN 1996
Nadine M. Orenstein, *Hendrick Hondius and the Business of Prints in Seventeenth-Century Holland*, Rotterdam, 1996

ORNSTEIN 1928
Martha Ornstein, *The Rôle of Scientific Societies in the Seventeenth Century*, Chicago, 1928

D'OTRANGE MASTAI 1975
M. L. d'Otrange Mastai, *Illusion in Art: Trompe l'Oeil, A History of Pictorial Illusionism*, New York, 1975

OXFORD 1985-86
Patronage and Collecting in the Seventeenth Century: Thomas Howard, Earl of Arundel. Exhibition catalogue, by D. Howarth, N. Penny et al. The Ashmolean Museum, Oxford, 1985-86. Oxford, 1985

PANOFSKY 1927
Erwin Panofsky, "Die Perspektive als 'symbolische Form'," *Vorträge der Bibliothek Warburg*, 1924-25, Berlin and Leipzig, 1927, pp. 258-330

PANOFSKY 1962
Erwin Panofsky, *Studies in Iconology: Humanistic Themes in the Art of the Renaissance*, New York, 1962 (1st ed. 1939)

PARIS 1983
Reflets du siècle d'or. Tableaux hollandais du dix-septième siècle. Exhibition catalogue, by Saskia Nihom-Nijstad. Paris, Institut Néerlandais, 1983. Paris, 1983

PARIS 1986
De Rembrandt à Vermeer: Les peintres hollandais au Mauritshuis de La Haye. Exhibition catalogue, by Ben Broos, with contributions by Hans Hoetink, Beatrijs Brenninkmeyer-de Rooij, and Jean Lacambre. Paris, Galeries Nationales du Grand Palais, 1986. The Hague, 1986

PARIS-MONTPELLIER 1998
Tableaux flamands et hollandais du Musée Fabre de Montpellier. Exhibition catalogue, by Quentin Buvelot, Michel Hilaire, and Olivier Zeder. Paris, Institut Néerlandais, and Montpellier, Musée Fabre, 1998. Paris and Zwolle, 1998

PARKER 1990
D. M. Parker and J. B. Deregowski, *Perception and Artistic Style (Advances in Psychology*, no. 73, ed. by G. E. Stelmach and P. A. Vroon), Amsterdam, 1990

PEDRETTI 1965
Carlo Pedretti, *Leonardo da Vinci on Painting, A Lost Book (Libro A)*, London, 1965

PEDRETTI 1969
Carlo Pedretti, "Belt 35: A New Chapter in the History of Leonardo's Treatise on Painting," in C. D. O'Malley (ed.), *Leonardo's Legacy*, Berkeley, 1969, pp. 149-70

VAN PEER 1968
A. J. J. M. van Peer, "Jan Vermeer van Delft: Drie archiefvondsten," *Oud Holland*, LXXXIII (1968), pp. 220-24

PEPYS 1985
Samuel Pepys. *The Shorter Pepys*, edited by Robert Latham, Berkeley, Cal., 1985

PÉREZ-GÓMEZ AND PELLETIER 1995
Alberto Pérez-Gómez and Louise Pelletier, *Anamorphosis: An Annotated Bibliography with Special Reference to Architectural Representation*, Montreal, 1995

PERLOVE 1995
Shelley Perlove, "*Templum Christianum*: Rembrandt's *Jeremiah Lamenting the Destruction of Jerusalem* (1630)," *Gazette des Beaux-Arts*, CXXVI (July-Dec. 1995), pp. 159-70

PHILADELPHIA-BERLIN-LONDON 1984
Masters of Seventeenth-Century Dutch Genre Painting. Exhibition catalogue, by Peter C. Sutton, with contributions by Christopher Brown, Jan Kelch, Otto Naumann, William Robinson, and Cynthia von Bogendorf-Rupprath. Philadelphia, Philadelphia Museum of Art; Berlin, Gemäldegalerie, SMPK; and London, Royal Academy of Arts, 1984. Philadelphia, 1984

PHILIPPOT 1966
Paul Philippot, "Les grisailles et les 'degrés de réalité' de l'image dans la peinture flamande des XVe et XVIe siècles," *Bulletin des Musées Royaux des Beaux-Arts de Belgique*, XV (1966), pp. 225-42

PIRENNE 1970
M. H. Pirenne, *Optics, Painting & Photography*, London, 1970

PLIETZSCH 1956
Eduard Plietzsch, "Randbemerkungen zur holländischen Interieurmalerei am Beginn des 17. Jahrhunderts," *Wallraf-Richartz-Jahrbuch*, XVIII (1956), pp. 174-96

PLIETZSCH 1960
Eduard Plietzsch, *Holländische und Flämische Maler des XVII. Jahrh.*, Leipzig, 1960

PLOMP 1986
Michiel Plomp, "'Een merkwaardige verzameling Teekeningen' door Leonaert Bramer," *Oud Holland*, C (1986), pp. 81-153

PLOMP 1996
Michiel Plomp, "Langs de wallen van Delft: Een stadswandeling via zeventiende-eeuwse gezichten," *Antiek*, XXX, no. 8 (March 1996), pp. 348-61

PLOMP 1997
Michiel C. Plomp, *The Dutch Drawings in the Teyler Museum*, II. *Artists born between 1575 and 1630*, Haarlem, Ghent, and Doornspijk, 1997

POPS 1984
Martin Pops, *Vermeer: Consciousness and the Chamber of Being*, printed Ph. D. Diss., Ann Arbor, Michigan, 1984

POTTERTON 1986
Homan Potterton, *Dutch Seventeenth and Eighteenth Century Paintings in the National Gallery of Ireland: A Complete Catalogue*, Dublin, 1986

PROFUMO 1992
Rodolfo Profumo (ed.), *Trattato pratico di prospettiva di Ludovico Cardi detto il Cigoli (Manoscritto Ms 2660A del Gabinetto dei Disegni e delle Stampe degli Uffizi)*, Rome, 1992

RAGGIO AND WILMERING 1996
Olga Raggio and Antoine M. Wilmering, "The Liberal Arts *Studiolo* from the Ducal Palace at Gubbio," *The Metropolitan Museum of Art Bulletin*, LIII, no. 4 (spring 1996)

RAUPP 1978
Hans-Joachim Raupp, "Musik im Atelier. Darstellungen musizierender Künstler in der niederländischen Malerei des 17. Jahrhunderts," *Oud Holland*, XCII (1978), pp. 106-129

RAUPP 1984
Hans-Joachim Raupp, *Untersuchungen zu Künstlerbildnis und Künstlerdarstellung in den Niederlanden im 17. Jahrhundert*, Hildesheim, Zürich, and New York, 1984

RAUPP 1986
Hans-Joachim Raupp, *Bauernsatiren: Entstehung und Entwicklung des bäuerlichen Genres in der deutschen und niederländischen Kunst ca. 1470-1570*, Niederzier, 1986

REFF 1960
Theodore Reff, "Cézanne and Poussin," *Journal of the Warburg and Courtauld Institutes*, XXIII (1960), pp. 150-74

VAN REGTEREN-ALTENA 1983
I. Q. van Regteren Altena, *Jacques De Gheyn: Three Generations*, The Hague, Boston, and London, 1983 (3 vols.)

RENGER 1970
Konrad Renger, *Lockere Gesellschaft: Zur Ikonographie des verlorenen Sohnes und von Wirtshausszenen in der niederländischen Malerei*, Berlin, 1970

REZNICEK 1963
E. K. J. Reznicek, "Realism as a 'Side Road or Byway' in Dutch Art," in *Studies in Western Art: Acts of the Twentieth International Congress of the History of Art*, II (*The Renaissance and Mannerism*), Princeton, 1963, pp. 247-53

RICHARDSON 1937
E. P. Richardson, "Samuel van Hoogstraten and Carel Fabritius," *Art in America*, XXV (1937), pp. 141-52

RIJKSCOMMISSIE 1969
Rijkscommissie voor de Monumentenbeschrijving, *Kunstreisboek voor Nederland*, Amsterdam, 1969

RIJKSDIENST BEELDENDE KUNST 1992
Rijksdienst Beeldende Kunst, *Old Masters Paintings: An Illustrated Summary Catalogue*, Zwolle, 1992

ROBINSON 1974
Franklin W. Robinson, *Gabriel Metsu (1629-1667): A Study of His Place in Dutch Genre Painting of the Golden Age*, New York, 1974

ROOSEN-RUNGE 1966
Heinz Roosen-Runge, "Perspektive und Bildwirklichkeit in holländischen Gemälden des 17. Jahrhunderts," *Kunstchronik*, XIX (1966), pp. 304-5

ROSENBERG, SLIVE, TER KUILE 1966
Jakob Rosenberg, Seymour Slive, and E. H. ter Kuile, *Dutch Art and Architecture: 1600-1800*, Harmondsworth and Baltimore, 1966 (rev. eds. 1972, 1977)

ROTTERDAM 1991
Perspectives: Saenredam and the architectural painters of the 17th century. Exhibition catalogue, by Jeroen Giltaij and Guido Jansen, with contributions by Walter Liedtke, J. M. Montias, and Rob Ruurs. Rotterdam, Museum Boijmans Van Beuningen, 1991. Rotterdam, 1991

ROTTERDAM 1994-95
Rotterdamse Meesters uit de Gouden Eeuw. Exhibition catalogue, edited by Nora Schadee, with contributions by Sasja Delahay, Rudolf E. O. Ekkart, Eymert-Jan Goossens, Xenia Henny, Ingrid de Jager, Roel James, A. M. Meyerman, Annelien Roelofsz, Nora Schadee, Frits Scholten, Charles Thiels, Margriet Verhoef, and Liesbeth van der Zeeuw. Rotterdam, Historisch Museum, 1994-95. Rotterdam and Zwolle, 1994

ROY 1992
Alain Roy, *Gérard de Lairesse, 1640-1711*, Paris, 1992

ROYALTON-KISCH 1988
Martin Royalton-Kisch, *Adriaen van de Venne's Album in the Department of Prints and Drawings in the British Museum*, London, 1988

RUURS 1981-82
Rob Ruurs, review of Brown 1981, *Simiolus*, XII (1981-82), pp. 263-65

RUURS 1987
Rob Ruurs, *Saenredam: The Art of Perspective*, Amsterdam, 1987

ST. PETERSBURG 1990-91
Art and Life in Northern Europe, 1500-1800: The Gilbert Collection. Exhibition catalogue, by Debra Miller. St. Petersburg, Florida, Museum of Fine Arts, 1990-91. St. Petersburg, 1990

SALOMON 1983
Nanette Salomon, "Vermeer and the Balance of Destiny," in *Essays in Northern European Art Presented to Egbert Haverkamp-Begemann on his Sixtieth Birthday*, Doornspijk, 1983, pp. 216-21

SALOMON 1984
Nanette Salomon, "Dreamers, Idlers and Other Dozers: Aspects of Sleep in Dutch Art," Ph.D. Diss., New York University, 1984

SALOMON 1998A
Nanette Salomon, *Jacob Duck and the Gentrification of Dutch Genre Painting*, Doornspijk, 1998

SALOMON 1998B
Nanette Salomon, "From Sexuality to Civility: Vermeer's Women," in Gaskell and Jonker 1998, pp. 309-25

SALOMONSON 1990-91
J. W. Salomonson, "A self-portrait by Michiel van Mierevelt: the history, subject and context of a forgotten painting," *Simiolus*, XX (1990-91), pp. 240-86

SAN FRANCISCO-BALTIMORE-LONDON 1997-98
Masters of Light: Dutch Painters in Utrecht during the Golden Age. Exhibition catalogue, by Joaneath A. Spicer with Lynn Federle Orr, and essays by Marten Jan Bok, Jan de Vries, Wayne Franits, Benjamin Kaplan, George Keyes, Ben Olde Meierink, and Angelique Bakker. San Francisco, Fine Arts Museums of San Francisco; Baltimore, The Walters Art Gallery; and London, The National Gallery, 1997-98. San Francisco and Baltimore, 1997

SAN MINIATO 1959
Mostra del Cigoli e del suo ambiente. Exhibition catalogue, by Mario Bucci, Anna Forlani, Luciano Berti, and Mina Gregori. San Miniato, Accademia degli Euteleti, 1959. San Miniato, 1959

SAUERLÄNDER 1994
Willibald Sauerländer, "Die Raumanalyse in der wissenschaftlichen Arbeit Hans Jantzens," in Bärbel Hamacher and Christl Karnehm (eds.), *Pinxit/sculpsit/fecit, Kunsthistorische Studien: Festschrift für Bruno Bushart*, Munich, 1994, pp. 361-70

SCHNACKENBURG 1970
Bernhard Schnackenburg, "Die Anfänge des Bauerninterieurs bei Adriaen van Ostade," *Oud Holland*, LXXXV (1970), pp. 158-69

SCHNAPPER 1982
Antoine Schnapper (ed.), *La Scenografia Barocca (Atti del* XXIV *Congresso Internazionale di Storia dell'Arte)*, Bologna, 1982

SCHNEEDE 1965
Uwe M. Schneede, "Das repräsentative Gesellschaftsbild in der niederländischen Malerei des 17. Jahrhunderts und seine Grundlagen bei Hans Vredeman de Vries," Ph.D. Diss., Christian-Albrechts-Universität, Kiel, 1965

SCHNEEDE 1967
Uwe M. Schneede, "Interieurs von Hans und Paul Vredeman," *Nederlands Kunsthistorisch Jaarboek*, XVIII (1967), pp. 125-66

SCHNEEDE 1968
Uwe M. Schneede, "Gabriel Metsu und der holländische Realismus," *Oud Holland*, LXXXIII (1968), pp. 45-61

SCHNEEMAN 1982
Liane T. Schneeman, "Hendrick Martensz. Sorgh: A Painter of Rotterdam," Ph.D. Diss., The Pennsylvania State University, 1982

SCHOTEL 1868
G. D. J. Schotel, *Het Oud-Hollandsch Huisgezin der Zeventiende Eeuw*, Haarlem, 1868

SCHOLTEN 1992
Frits Scholten, review of Fleischer 1989, in *Oud Holland*, CVI (1992), pp. 49-54

SCHULZ 1978
Wolfgang Schulz, *Cornelis Saftleven 1607-1681. Leben und Werke*, Berlin and New York, 1978

SCHULZ 1982
Wolfgang Schulz, *Herman Saftleven 1609-1685. Leben und Werke*, Berlin and New York, 1982

SCHUTTE 1988
O. Schutte, "Rouwborden in de Grote of St. Geertrudiskerk te Bergen op Zoom in de zeventiende eeuw," *De Nederlandsche Leeuw*, CV (1988), pp. 326-44

SCHUURMAN 1947
K. E. Schuurman, *Carel Fabritius*, Amsterdam, n.d. (1947)

SCHWARTZ 1966-67
Gary Schwartz, "Saenredam, Huygens and the Utrecht Bull," *Simiolus* I (1966-67), pp. 69-93

SCHWARTZ AND BOK 1990
Gary Schwartz and Marten Jan Bok, *Pieter Saenredam: The Painter and His Time*, Maarssen and The Hague, 1990

SCHWARZ 1966
Heinrich Schwarz, "Vermeer and the Camera Obscura," *Pantheon*, XXIV (1966), pp. 170-82

SCHWARZ 1985
Heinrich Schwarz, *Art and Photography: Forerunners and Influences* (selected essays edited by William E. Parker), Layton, Utah, 1985

SEGAL 1989
Sam Segal, *A Prosperous Past: The Sumptuous Still Life in the Netherlands 1600-1700*, The Hague, 1989

SEYMOUR 1964
Charles Seymour, Jr., "Dark Chamber and Light-filled Room: Vermeer and the Camera Obscura," *The Art Bulletin*, XLVI (1964), pp. 323-31

SLATKES 1969
Leonard J. Slatkes, *Dirck van Baburen (c. 1595-1624), a Dutch Painter in Utrecht and Rome*, Utrecht, 1969 (1st ed., 1965)

SLATKES 1981
Leonard J. Slatkes, *Vermeer and His Contemporaries*, New York, 1981

SLIVE 1965
Seymour Slive, *Drawings of Rembrandt, With a Selection of Drawings by His Pupils and Followers*, New York, 1965 (2 vols.)

SLIVE 1995
Seymour Slive, *Dutch Painting 1600-1800*, New Haven and London, 1995

SLUIJTER 1991-92
Eric Jan Sluijter, "Venus, Visus en Pictura," *Nederlands Kunsthistorisch Jaarboek*, XLII-XLIII (1991-92), pp. 337-96

SLUIJTER 1993
Eric J. Sluijter, *De lof der schilderkunst: Over schilderijen van Gerrit Dou (1613-1675) en een traktaat van Philips Angel uit 1642*, Hilversum, 1993

SLUIJTER 1998A
Eric Jan Sluijter, "Vermeer, Fame, and Female Beauty: The *Art of Painting*," in Gaskell and Jonker 1998, pp. 265-83

SLUIJTER 1998B
Eric Jan Sluijter, "Rembrandt's Bathsheba and the conventions of a seductive theme," in Ann Jensen Adams (ed.), *Rembrandt's Bathsheba Reading King David's Letter*, Cambridge and New York, 1998, pp. 48-99

SLUIJTER-SEIJFFERT 1984
Nicolette Sluijter-Seijffert, *Cornelis van Poelenburch, ca. 1593-1667*, printed Ph.D. Diss., University of Leiden, 1984

SMITH 1957-59
Molly Teasdale Smith, "The Use of Grisaille as a Lenten Observance," *Marsyas*, VIII (1957-59), pp. 43-54

SNOEP 1969
D. P. Snoep, "Honselaersdijk: restauraties op papier," *Oud Holland*, LXXXIV (1969), pp. 270-94

SNOEP-REITSMA 1973
Ella Snoep-Reitsma, "Chardin and the Bourgeois Ideals of His Time," *Nederlands Kunsthistorisch Jaarboek*, XXIV (1973), pp. 147-243

SNOW 1994
Edward Snow, *A Study of Vermeer* (revised and enlarged edition), Berkeley, Los Angeles, and Oxford, 1994

SOUTH HADLEY 1979
Baroque Painting in the Low Countries: Selections from the Bader Collection. Exhibition catalogue, by John L. Varriano. South Hadley, Mass., Mount Holyoke College Art Museum, 1979

SPICER 1988
Joaneath Spicer, "An Experiment with Perspective by Gabriel Metsu," *Zeitschrift für Kunstgeschichte*, LI (1988), pp. 574-83

STARING 1965
A. Staring, "Een raadselachtige kamerbeschildering," *Bulletin van het Rijksmuseum*, XIII (1965), pp. 3-13

STECHOW 1966
Wolfgang Stechow, *Dutch Landscape Painting of the Seventeenth Century*, London, 1966

STOCKHOLM 1992-93
Rembrandt och hans Tid/ Rembrandt and his Age. Exhibition catalogue, by Görel Cavalli-Björkman, in collaboration with Cecilia Engellau-Gullander, Börje Magnusson, and Mårten Snickare, and with contributions by Albert Blankert, Görel Cavalli-Björkman, Egbert Haverkamp-Begemann, Walter Liedtke, and Peter C. Sutton. Stockholm, Nationalmuseum, 1992-93. Stockholm, 1992

STRIEDER 1989
Peter Strieder, *Albrecht Dürer: Paintings, Prints, Drawings* (trans. by Nancy M. Gordon and Walter L. Strauss), New York, 1989

SULLIVAN 1981
Margaret A. Sullivan, "Peter Bruegel the Elder's *Two Monkeys*: A New Interpretation," *The Art Bulletin*, LXIII (1981), pp. 114-26

SUMOWSKI 1979-95
Werner Sumowski, *Drawings of the Rembrandt School* (edited and translated by Walter L. Strauss), New York, 1979-95 (10 vols. to date)

SUMOWSKI 1983-[94]
Werner Sumowski, *Gemälde der Rembrandt-Schüler*, Landau (Pfalz), 1983-[94] (6 vols.)

SUTTON 1980A
Peter C. Sutton, *Pieter de Hooch: Complete Edition with a catalogue raisonné*, Ithaca, N. Y., 1980

SUTTON 1980B
Peter C. Sutton, "Hendrick van der Burch," *The Burlington Magazine*, CXXII (1980), pp. 315-26

SUTTON 1990
Peter C. Sutton, *Northern European Paintings in the Philadelphia Museum of Art from the Sixteenth through the Nineteenth Century*, Philadelphia, 1990

VAN SWIGCHEM 1987
C. A. van Swigchem, "Kerkborden en kolomschilderijen in de St.-Bavo te Haarlem 1580-1585," *Bulletin van het Rijksmuseum*, XXXV (1987), pp. 211-23

VAN SWIGCHEM, BROUWER, AND VAN OS 1984
C. A. van Swigchem, T. Brouwer, and W. van Os, *Een huis voor het Woord: Het protestantse kerkinterieur in Nederland tot 1900*, The Hague, 1984

SWILLENS 1950
Pieter T. A. Swillens, *Johannes Vermeer Painter of Delft: 1632-1675*, Utrecht and Brussels, 1950

TACKE 1995
Andreas Tacke, *Die Gemälde des 17. Jahrhunderts im Germanischen Nationalmuseum*, Mainz, 1995

TAYLOR 1992
Paul Taylor, "The Concept of *Houding* in Dutch Art Theory," *Journal of the Warburg and Courtauld Institutes*, LV (1992), pp. 210-32

TEN BRINK GOLDSMITH 1984
Jane Ten Brink Goldsmith, "From Prose to Pictures: Leonaert Bramer's Illustrations for the *Aeneid* and Vondel's Translation of Virgil," *Art History*, VII (1984), pp. 21-37

THE HAGUE: see under HAGUE

VAN THIEL ET AL. 1976
Pieter J. J. van Thiel et al., *All the paintings of the Rijksmuseum in Amsterdam: A completely illustrated catalogue*, Amsterdam and Maarssen, 1976

THIEME/BECKER 1907-50
U. Thieme and F. Becker, *Allgemeines Lexikon der bildenden Künstler von der Antike bis zur Gegenwart*, Leipzig, 1907-1950 (37 vols.)

THORÉ-BÜRGER 1858
W. Bürger [Théophile Thoré], *Musées de la Hollande: Amsterdam et La Haye – Etudes sur l'école hollandaise*, Paris, 1858

THORÉ-BÜRGER 1866
William Bürger [Théophile Thoré], "Van der Meer de Delft," *Gazette des Beaux-Arts*, XXI (1866), pp. 297-330, 458-70, 542-75

THORNTON 1997
Dora Thornton, *The Scholar in his Study: Ownership and Experience in Renaissance Italy*, New Haven and London, 1997

TIERIE 1932
G. Tierie, *Cornelis Drebbel*, Amsterdam, 1932

TRAUTSCHOLDT 1940
E. Trautscholdt, "Johannes Vermeer," in Thieme/Becker 1907-50, XXXIV, pp. 265-75

TRNEK 1992
Renate Trnek, *Die holländischen Gemälde des 17. Jahrhunderts in der Gemäldegalerie der Akademie der bildenden Künste in Wien*, Vienna, Cologne, and Weimar, 1992

TÜMPEL 1986
Christian Tümpel, *Rembrandt: Mythos und Methode*, Antwerp and Königstein im Taunus, 1986

TURNER 1996
Jane Turner (ed.), *The Dictionary of Art*, London, 1996 (34 vols.)

UNGER 1891
J. H. W. Unger, "Brieven van eenige schilders aan Constantijn Huygens," *Oud-Holland*, IX (1891), pp. 188-206

UTRECHT 1961
Catalogue Raisonné van de werken van Pieter Jansz. Saenredam. Exhibition catalaogue. Utrecht, Centraal Museum, 1961. Utrecht, 1961

UTRECHT-BRAUNSCHWEIG 1986-87
Nieuw Licht op de Gouden Eeuw: Hendrick ter Brugghen en tijdgenoten. Exhibition catalogue, by Albert Blankert and Leonard J. Slatkes, with essays by Marten Jan Bok, Dirk E. A. Faber, Sabine Jacob, Paul Huys Janssen, Guido Jansen, J. Richard Judson, Rüdiger Klessmann, Cora Rooker, and Mieke Vermeer. Utrecht, Centraal Museum, and Braunschweig, Herzog Anton Ulrich-Museum, 1986-87. Braunschweig and Utrecht, 1986

UTRECHT-FRANKFURT-LUXEMBURG 1993-94
Het gedroomde land. Pastorale schilderkunst in de Gouden Eeuw. Exhibition catalogue, by Peter van den Brink et al. Utrecht, Centraal Museum; Frankfurt, Schirn Kunsthalle; and Luxemburg, Musée National d'Histoire et d'Art, 1993-94. Utrecht and Zwolle, 1993

VALENTINER 1926
Wilhelm R. Valentiner, "Pieter de Hooch, Part One," *Art in America*, XV (Dec. 1926), pp. 45-64

VALENTINER 1927
Wilhelm R. Valentiner, "Pieter de Hooch, Part Two," *Art in America*, XV (Feb. 1927), pp. 67-77

VALENTINER 1930
Wilhelm R. Valentiner, *Pieter de Hooch*, New York, 1930

VALENTINER 1932
Wilhelm R. Valentiner, "Zum 300. Geburtstag Jan Vermeers, Oktober 1932. Vermeer und die Meister der holländischen Genremalerei," *Pantheon*, X (1932), pp. 305-24

VECA 1981
Alberto Veca, *Vanitas. Il simbolismo del tempo*, Bergamo (Galleria Lorenzelli), 1981

VAN DER VEEN 1992
J. A. van der Veen, review of Montias 1989, in *Oud Holland*, CVI (1992), pp. 99-101

VELTMAN 1979
Kim Veltman, review of Wheelock 1977a, *Zeitschrift für Kunstgeschichte*, XLII (1979), pp. 81-82

VELTMAN AND KEELE 1986
Kim H. Veltman in collaboration with Kenneth D. Keele, *Studies on Leonardo da Vinci I: Linear Perspective and the Visual Dimensions of Science and Art*, Munich, 1986

VERGARA 1998
Lisa Vergara, "*Antiek* and *Modern* in Vermeer's *Lady Writing a Letter with Her Maid*," in Gaskell and Jonker 1998, pp. 235-55

VERMEULEN 1928-41
F. A. J. Vermeulen, *Handboek tot de Geschiedenis der Nederlandsche Bouwkunst*, The Hague, 1928-41 (3 parts in 6 vols.)

VERMEULEN 1995
Jan Willem Vermeulen, *Maurits Escher, een eigenzinnig talent*, Kampen, 1995

VINKEN 1998
Pierre Vinken, "Een embleem van Coornhert als bron van Jan Steens zogenaamde *Burgemeester van Delft*," *Oud Holland*, CXII (1998), pp. 253-58

VREDEMAN DE VRIES 1604-5
Hans Vredeman de Vries, *Perspective*, The Hague and Leiden, 1604-5

DE VRIES 1975
Lyckle de Vries, "Gerard Houckgeest," *Jahrbuch der Hamburger Kunstsammlungen*, XX (1975), pp. 25-56

DE VRIES 1977
Lyckle de Vries, *Jan Steen 'de kluchtschilder'*, printed Ph.D. Diss., Groningen, 1977

DE VRIES 1984
Lyckle de Vries, review of Liedtke 1982a, in *Simiolus*, XIV (1984), pp. 137-40

DE VRIES 1985
Lyckle de Vries, "Hat es je eine Delft Schule gegeben?," *Probleme und Methoden der Klassifizierung (Akten des XXV. internationalen Kongresses für Kunstgeschichte*, III), Vienna, 1985, pp. 79-88

DE VRIES 1992
Lyckle de Vries, review of Rotterdam 1991, in *The Burlington Magazine*, CXXXIV (1992), pp. 51-54

DE VRIES 1996A
Lyckle de Vries, review of Wheelock 1995a, in *The Burlington Magazine*, CXXXVIII (1996), p. 201

DE VRIES 1996B
Lyckle de Vries, review of Slive 1995, in *The Burlington Magazine*, CXXXVIII (1996), pp. 758-59

VROOM 1980
N. R. A. Vroom, *A Modest Message as Intimated by the Painters of the "Monochrome banketje"*, Schiedam, 1980 (2 vols.)

WADUM 1994
Jørgen Wadum, *Vermeer Illuminated. Conservation, Restoration and Research*, The Hague, 1994

WADUM 1995
Jørgen Wadum, "Vermeer's Use of Perspective," in Arie Wallert, Erma Hermens, and Marja Peek (eds.), *Historical Painting Techniques, Materials, and Studio Practice: Preprints of a Symposium, University of Leiden, the Netherlands, 26-29 June 1995*, Lawrence, Kansas (The J. Paul Getty Trust), 1995, pp. 148-54

WADUM N.D. [1995]
Jørgen Wadum, with contributions by René Hoppenbrouwers and Luuk Struick van der Loeff, *Vermeer illuminated: conservation, restoration and research*, The Hague, n.d. [1995]

WAGNER 1971
Helga Wagner, *Jan van der Heyden 1637-1712*, Amsterdam and Haarlem, 1971

WALFORD 1991
E. John Walford, *Jacob van Ruisdael and the Perception of Landscape*, New Haven and London, 1991

WALLEN 1979
Burr Wallen, "Joachim Beuckelaer's *Poultry Sellers*," *Museum News*, Toledo Museum of Art, fall 1979, pp. 33-39

WALSH 1973
John Walsh, Jr., "Vermeer," *The Metropolitan Museum of Art Bulletin*, XXXI, no. 4 (summer 1973), unpaginated

WANSINK 1987
Christina J. A. Wansink, "History and Genre Paintings by Willem van der Vliet," *The Hoogsteder Mercury*, no. 6 (1987), pp. 3-10

WASHINGTON 1978
The William A. Clark Collection. Exhibition catalogue, by Lewis Hall et al. Washington, The Corcoran Gallery of Art, 1978. Washington, 1978

WASHINGTON 1990-91
Anthony van Dyck. Exhibition catalogue, by Arthur K. Wheelock, Jr., Susan Barnes, and Julius S. Held, with contributions by Christopher Brown, Carol Christensen, Zirka Zaremba Filipczak, Oliver Millar, Jeffrey M. Muller, and J. Douglas Stewart. Washington, National Gallery of Art, 1990-91. Washington, 1990

WASHINGTON 1991-92
Circa 1492. Exhibition catalogue, edited by Jay A. Levenson, with contributions by numerous authors. Washington, National Gallery of Art, 1991-92. Washington, New Haven, and London, 1991

WASHINGTON-AMSTERDAM 1996-97
Jan Steen, Painter and Storyteller. Exhibition catalogue, by H. Perry Chapman, Wouter Th. Kloek, and Arthur K. Wheelock, Jr., with contributions by Martin Bijl, Marten Jan Bok, Eddy de Jongh, Lyckle de Vries, and Mariët Westermann (Guido M. C. Jansen, ed.). Washington, National Gallery of Art, and Amsterdam, Rijksmuseum, 1996-97. Washington, Amsterdam, New Haven, and London, 1996

WASHINGTON-BOSTON 1983
The Prints of Lucas van Leyden & His Contemporaries. Exhibition catalogue, by Ellen S. Jacobowitz and Stephanie Loeb Stepanek. Washington, National Gallery of Art, and Boston, Museum of Fine Arts, 1983. Washington, 1983

WASHINGTON-DETROIT-AMSTERDAM 1980-81
Gods, Saints and Heroes: Dutch Painting in the Age of Rembrandt. Exhibition catalogue, by Albert Blankert, Beatrijs Brenninkmeyer-de Rooij, Christopher Brown, Susan Donahue Kuretsky, Eric J. Sluijter, D. P. Snoep, Pieter van Thiel, Astrid Tümpel, Christian Tümpel, and Arthur K. Wheelock, Jr. Washington, National Gallery of Art; Detroit, Detroit Institute of Arts; and Amsterdam, Rijksmuseum, 1980-81. Washington, 1980

WASHINGTON-THE HAGUE 1995-96
Johannes Vermeer. Exhibition catalogue, by Arthur K. Wheelock, Jr. (ed.), with contributions by Albert Blankert, Ben Broos, Jørgen Wadum, and Arthur K. Wheelock, Jr. Washington, National Gallery of Art, and The Hague, Mauritshuis, 1995-96. Washington, The Hague, New Haven and London, 1995

WEBER 1998
Gregor J. M. Weber, "Vermeer's Use of the Picture-within-a-Picture: A New Approach," in Gaskell and Jonker 1998, pp. 295-307

VON WEIHER 1937
Lucy von Weiher, *Der Innenraum in der holländischen Malerei des 17. Jahrhunderts*, Würzburg, 1937

WELU 1975A
James A. Welu, "Vermeer: His Cartographic Sources," *The Art Bulletin*, LVII (1975), pp. 529-47

WELU 1975B
James A. Welu, "'Card Players and Merrymakers': A Moral Lesson," *Worcester Art Museum Bulletin*, IV, no. 3 (May 1975), pp. 8-16

WELU 1981
James A. Welu, *Vermeer and Cartography*, printed Ph.D. Diss., Ann Arbor, Michigan, 1981

WELU 1986
James Welu, "Vermeer's *Astronomer*: Observations on an Open Book," *The Art Bulletin*, LXVIII (1986), pp. 263-67

WESTERMANN 1996
Mariët Westermann, *A Worldly Art: The Dutch Republic 1585-1718*, New York, 1996

WESTERMANN 1997
Mariët Westermann, *The Amusements of Jan Steen: Comic Painting in the Seventeenth Century*, Zwolle, 1997

VAN DE WETERING 1993
Ernst van de Wetering, "Het satijn van Gerard ter Borch," *Kunstschrift*, XXXVII (1993), pp. 28-37

VAN DE WETERING 1997
Ernst van de Wetering, *Rembrandt: The Painter at Work*, Amsterdam, 1997

WHEELOCK 1973
Arthur K. Wheelock, Jr., "Carel Fabritius: Perspective and Optics in Delft," *Nederlands Kunsthistorisch Jaarboek*, XXIV (1973), pp. 63-83

WHEELOCK 1975-76
Arthur K. Wheelock, Jr., "Gerard Houckgeest and Emanuel de Witte: architectural painting in Delft around 1650," *Simiolus*, VIII (1975-76), pp. 167-85

WHEELOCK 1977A
Arthur K. Wheelock, Jr., *Perspective, Optics, and Delft Artists around 1650*, printed Ph.D. Diss., New York, 1977

WHEELOCK 1977B
Arthur K. Wheelock, Jr., "Constantijn Huygens and early attitudes towards the camera obscura," *History of Photography*, I (1977), pp. 93-103

WHEELOCK 1981
Arthur K. Wheelock, Jr., *Jan Vermeer*, New York, 1981

WHEELOCK 1986
Arthur K. Wheelock, Jr., review of Liedtke 1982A, in *The Art Bulletin*, LXVIII (1986), pp. 169-72

WHEELOCK 1987
Arthur K. Wheelock, Jr., "Pentimenti in Vermeer's Paintings: Changes in Style and Meaning," in Bock and Gaehtgens 1987, pp. 385-412

WHEELOCK 1988A
Arthur K. Wheelock, Jr., *Jan Vermeer* (2nd revised edition), New York, 1988

WHEELOCK 1988B
Arthur K. Wheelock, Jr., "The Art Historian in the Laboratory: Examinations into the History, Preservation, and Techniques of 17th Century Dutch Painting," in R. E. Fleischer and S. S. Munshower (eds.), *The Age of Rembrandt: Studies in Seventeenth-Century Dutch Painting* (Papers in Art History from The Pennsylvania State University, Volume III), University Park, Penn., 1988, pp. 214-45

WHEELOCK 1995A
Arthur K. Wheelock, Jr., *Vermeer and the Art of Painting*, New Haven and London, 1995

WHEELOCK 1995B
Arthur K. Wheelock, Jr., *Dutch Paintings of the Seventeenth Century (The Collections of the National Gallery of Art Systematic Catalogue)*, Washington, 1995

WHEELOCK AND KALDENBACH 1982
Arthur K. Wheelock, Jr. and C. J. Kaldenbach, "Vermeer's *View of Delft* and His Vision of Reality," *Artibus et Historiae*, VI (1982), pp. 9-35

WHITE 1982
Christopher White, *The Dutch Pictures in the Collection of Her Majesty the Queen*, Cambridge (UK), 1982

WHITEHEAD 1986
Peter J. P. Whitehead, "Frans Post and the reversed Galilean telescope," *The Burlington Magazine*, CXXVIII (1986), pp. 805-7

WICHMANN 1923
Heinrich Wichmann, *Leonaert Bramer, sein Leben und seine Kunst*, Leipzig, 1923

WICHMANN 1924
H. Wichmann, "Gerard Houckgeest," in Thieme/Becker 1907-50, XVII, pp. 557-58

WIESEMAN 1991
Majorie Elizabeth Wieseman, "Caspar Netscher and Late Seventeenth Century Dutch Painting," Ph.D. Diss., Columbia University, New York, 1991

WIESEMAN 1993-94
Marjorie E. Wieseman, "The Art of 'Conversatie': Genre Portraiture in the Southern Netherlands in the Seventeenth Century," in Boston-Toledo 1993-94, pp. 183-93

WIJBENGA 1990
D. Wijbenga, *De Oude Kerk van Delft: 750 Jaar in Woord en Beeld*, Delft, 1990

WIJNMAN 1931
H. F. Wijnman, "De Schilder Carel Fabritius (1622-1654): Een reconstructie van zijn leven en werk," *Oud-Holland*, XLVIII (1931), pp. 100-41

WIJSENBEEK-OLTHUIS 1987
Thera Wijsenbeek-Olthuis, *Achter de gevels van Delft: Bezit en bestaan van rijk en arm in een periode van achteruitgang (1700-1800)*, Hilversum, 1987

DE WINKEL 1998
Marieke de Winkel, "The Interpretation of Dress in Vermeer's Paintings," in Gaskell and Jonker 1998, pp. 327-39

WORCESTER 1979
17th Century Dutch Painting: Raising the Curtain on New England Private Collections. Exhibition catalogue, by James A. Welu. Worcester, Mass., Worcester Art Museum, 1979. Worcester, 1979

WORP: see HUYGENS 1911-17

WÜRTENBERGER 1937
Franzsepp Würtenberger, *Das holländische Gesellschaftsbild*, Schramberg (Schwarzwald), 1937

WURZBACH 1906-11
Alfred von Wurzbach, *Niederländisches Künstler-Lexikon*, Vienna and Leipzig, 1906-11 (3 vols.)

WUYTS 1974-75
Leo Wuyts, "Lucas van Leydens 'Melkmeid,' een proeve tot ikonologische interpretatie," *De Gulden Passer*, LII-LIII (1974-75), pp. 441-53

ZANDVLIET 1998
Kees Zandvliet, *Mapping for Money: Maps, plans and topographic paintings and their role in Dutch overseas expansion during the 16th and 17th centuries*, Amsterdam, 1998

ZWOLLE 1997
Zwolle in de Gouden Eeuw: cultuur en schilderkunst. Exhibition catalogue, by Jean Streng and Lydie van Dijk. Zwolle, Stedelijk Museum Zwolle, 1997. Zwolle, 1997

Index